PICTURA ET POESIS

Interdisziplinäre Studien zum Verhältnis von Literatur und Kunst

Herausgegeben von
Ulrich Ernst · Christel Meier

Band 35

Pia Rudolph

Im Garten der Gesundheit

Pflanzenbilder zwischen Natur, Kunst und Wissen in gedruckten
Kräuterbüchern des 15. Jahrhunderts

BÖHLAU VERLAG WIEN KÖLN WEIMAR

Bibliografische Information der Deutschen Bibliothek:
Die Deutsche Nationalbibliothek verzeichnet diese Publikation in der
Deutschen Nationalbibliografie; detaillierte bibliografische Daten
sind im Internet über https://dnb.de abrufbar.

Umschlagabbildung: Knoblauch, Cap. iiij, in: Bernhard von Breydenbach/Johann Wonnecke von
Kaub/Erhard Reuwich: Gart der Gesundheit. Mainz: Peter Schöffer, 28.3.1485. München, Bayerische
Staatsbibliothek, 2 Inc.c.a. 1601.
Umschlagabbildung: Michael Haderer, Wien
Satz: Bettina Waringer, Wien
Druck und Bindung: Hubert & Co. BuchPartner, Göttingen
Printed in the EU

Vandenhoeck & Ruprecht Verlage | www.vandenhoeck-ruprecht-verlage.com

ISBN 978-3-412-51759-5

INHALT

DANK

Das vorliegende Buch ist die überarbeitete Fassung meiner Dissertationsschrift, die im Herbst 2016 von der Fakultät für Geschichts- und Kunstwissenschaften an der Ludwig-Maximilians-Universität München als Qualifikationsarbeit angenommen wurde.

Sein Buch, den „Gart der Gesundheit", bezeichnete Bernhard von Breydenbach als Garten. Tatsächlich könnte diese Metapher kaum treffender sein; auch für dieses Buch sei den zahlreichen helfenden Händen, die zur Gestaltung des „Gartens" beigetragen haben, für ihre Unterstützung und Zeit gedankt. An erster Stelle meinem Doktorvater, Ulrich Pfisterer, der dieses Thema an mich herangetragen, jahrelang intensiv begleitet und mit neuen Impulsen versorgt hat. Ebenso meinem Zweitbetreuer, Michael F. Zimmermann, der den Boden in vieler Hinsicht bereitet hat. Die Anstellungen an seinem Lehrstuhl an der Katholischen Universität Eichstätt-Ingolstadt haben diese Arbeit ermöglicht. In Gesprächen und Seminaren in Kooperation mit meinen dortigen Kolleginnen und Kollegen habe ich viel Erfahrung sammeln können. Karin Leonhard, die stets zu motivieren weiß und ihr reiches Wissen gerne teilt, Kerstin Merkel, Eva Wattolik, Dominik Brabant, Semjon Aron Dreiling, Wolfgang Drost, Thomas Frangenberg (†), Bruno Grimm, dessen präzise und kluge Kritik immer eine große Bereicherung ist, Gernot Müller, Sebastian Schmidt, Marek Verčík und Gerhard Zimmer seien namentlich genannt.

Erste Gedanken wurden am Zentralinstitut für Kunstgeschichte entwickelt, gefördert durch ein Stipendium des Vereins Conivncta Florescit, dem für diese Möglichkeit gedankt sei. Die ersten Jahre der Arbeit an der Dissertation wurden zudem durch die Aufnahme in die Nachwuchsforschergruppe „Kulturelle und religiöse Diversität in Mittelalter und Renaissance", koordiniert durch Georg Strack, am Zentrum für Mittelalter und Renaissance der LMU München bereichert. Aus der Reihe der zahlreichen engagierten Dozierenden sei Claudia Märtl hervorgehoben, der darüber hinaus auch als Drittprüferin für ihre Zeit und ihr Interesse an dieser Arbeit gedankt sei.

Zuletzt hat die Mitarbeit am Projekt „Katalog für deutschsprachige illustrierte Handschriften des Mittelalters", geleitet durch Jan-Dirk Müller, an der Bayerischen Akademie der Wissenschaften in München neue Blickwinkel eröffnet. Bei meiner Kollegin, Nicola Zotz, möchte ich mich herzlich für ihre kritische und sorgsame Lektüre bedanken, die der Arbeit den letzten Schliff abverlangte. Für ihre Unterstützung und Lektüre danke ich Kristina Freienhagen-Baumgardt sehr. Lange, inspirierende Gespräche verdanke ich Bernhard Schnell, der mir großzügig seine diversen Beiträge zur Pflanzenmedizin im Mittelalter – auch vorab – zur Verfügung stellte.

Für die Aufnahme in die Reihe „pictura et poesis" im Böhlau Verlag gebührt den Herausgebern großer Dank, insbesondere Christel Meier-Staubach. Für die umsichtige Betreuung bei der Drucklegung bedanke ich mich bei den engagierten Mitarbeiterinnen und Mitarbeitern des Verlags.

Motivierenden Sonnenschein und die wichtigen Wurzeln haben Freunde und Familie beigetragen: Pauline Füg, Sebastian Kneißl, Katherina Müller, Laura Unsöld, Christos Ioannidis und Familie, Familie Rudolph und Heller. Meiner Großmutter und begabten Gärtnerin, Walburga, sowie meiner Mutter, Wilma, ist dieses Buch gewidmet.

1. „Wiedererwachsung" der Kräuterbücher

Für das Studium der Pflanze empfahl man im 16. Jahrhundert einen botanischen Garten anzulegen. Wie Antonius Castor[1] im alten Rom sollte jeder, der es sich leisten könne, einen Garten haben, mit Pflanzen aus fremden Ländern und einem Gärtner, der um die „Art und Natur" der Kräuter weiß, damit dieses Wissen auch erhalten bleibe.[2] Neben diesem ephemeren Ort bot es sich an, ein illustriertes Kräuterbuch zu beschaffen,[3] das das Wissen[4] um die Pflanze in Bild und Text zugänglich machte. Als substituierendes Objekt ist das Kräuterbuch im Gegensatz zum Garten transportabel, reproduzierbar und bewahrt die Pflanze über ihre eigene Lebensdauer hinweg auf. Während man im Sommer den Kräutergarten als Studienort bevorzugte, griff man in den medizinischen Fakultäten im Winter auf Kräuterbücher zurück,[5] die mitunter auch in die – bis in die Antike zurückreichende – Geschichte der illustrierten Herbarien einführten.[6]

Die Auseinandersetzung mit der Pflanzenwelt hatte in erster Linie den Zweck, die Pflanze auf ihre Nützlichkeit für die menschliche Gesundheit hin zu beurteilen. Kräuterbücher waren bis weit in die Frühe Neuzeit keine botanischen, sondern medizinische Werke, in denen der Gegenstand „Pflanze"[7] als Heilmittel beschrieben wurde.[8] Hinzu kam im 16. Jahrhundert das

1 Laut Plinius d. Ä. wurde Antonius Castor (1. Jahrhundert n. Chr.) über 100 Jahre alt, weil er die Geheimnisse der Kräuter kannte und diese in seinem berühmten Garten studierte. Plinius (1985), Buch 25, Kap. V.

2 Zur besseren Lesbarkeit wurden frühneuhochdeutsche Zitate der modernen Schreibweise angepasst, der Wortlaut wurde jedoch so weit wie möglich beibehalten. Brunfels (1532), Vorwort, XXI. Capitel: Jeder solle „einen garten haben, doran auch keinen kosten sparen, vnd auß frembden landen frembden kreüter daryn bringen, eygen gártenmeyter haben, die solicher kreüter art vnnd naturen wiszten damit sye solice wiszten zú halten."

3 Der Verleger Wendel Rihel empfahl 1539 in seinem Vorwort zum Kräuterbuch des Autors Hieronymus Bock, zusätzlich zu einem nicht illustrierten auch noch ein bebildertes Kräuterbuch zu kaufen (dazu weiter: Kap. 6). Rihel (1539), S. 1.

4 Der Medientheoretiker Giesecke definiert „Wissen" um 1500 als: „- gewonnen durch normierte Prozesse visueller Wahrnehmung von einem außenstehenden Betrachter, - typographisch gespeichert und - über den freien Markt verbreitet [...]." Giesecke (2006), S. 677.

5 Kusukawa (2012), S. 1.

6 Z. B. bei Brunfels (1532), Vorwort, XX.–XXI. Capitel. Dass es seit dem Ende des 15. Jahrhunderts wieder Interesse an der Geschichte der Naturwissenschaft gibt, ist bemerkenswert, da es, wie Reeds und Kinukawa für das Abendland im Mittelalter festhalten, für Naturkunde beinahe keine Ansätze oder Orte gab: „[...] natural history had no standing [...]. It offered no employment. It brought no honours." Reeds / Kinukawa (2013), S. 569.

7 „Pflanze" und „Kraut" wird im Spätmittelalter nicht unterschieden, weshalb die Begriffe hier synonym verwendet werden.

8 Niekrasz / Swan (2006), S. 773. Vor allem die Klassifikation der Pflanzen durch den Mediziner Carl

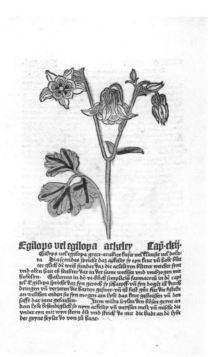

Abb. 1: Akelei: Gart der Gesundheit. Mainz 1485.
München, Bayerische Staatsbibliothek, 2 Inc.c.a. 1601.

Ansinnen der Kräuterbuchautoren und Humanisten, die Kenntnisse antiker Ärzte wieder aufleben zu lassen und zu übertreffen.[9] Kaum etwas versprach mehr Ruhm, als den Pflanzen ihre Geheimnisse um ein langes, gesundes Leben zu entlocken. Nichts, so Plinius d. Ä., bringe mehr Bewunderung hervor als die Kenntnis der Pflanzen.[10]

Ein erster Höhepunkt und gleichzeitig ein Ausgangspunkt dieses ambitionierten Strebens kann in den 1480er Jahren angesetzt werden, in denen vor allem im deutschsprachigen Raum gedruckte Kräuterbücher wie Pilze aus dem Boden schießen. Das meistverkaufte unter ihnen war der „Gart der Gesundheit"[11] (im Folgenden auch kurz: „Gart"), der mit seinen Pflanzenbildern (Abb. 1) und volkssprachigem Text offenbar genau darbot, was gerade auf dem Buchmarkt gefragt war, wie aus der großen Verbreitung und seiner langen Wirkungsgeschichte zu schließen ist. Der „Gart", so soll ferner gezeigt werden, war als Kräuterbuch auch deshalb so erfolgreich, weil man mit ihm an antike Traditionen anknüpfte.

Im 15. Jahrhundert existierten im deutschsprachigen Raum keine illustrierten handschriftlichen Kräuterbücher der Antike, die man im Buchdruck hätte reproduzieren können, um sie im Sinne der Renaissance wieder aufblühen zu lassen.[12] Wollte man sich eine Vorstellung von

von Linné (gest. 1778) sollte das Fach „Botanik" und die illustrierten Pflanzenbücher entscheidend prägen. Ford (2003), S. 567 f.

9 Für diese Überbietungsgesten spielen beispielsweise Entdeckungen bislang unbekannter Pflanzen eine große Rolle. Kusukawa (2012), S. 101–103.

10 Plinius (1985), Buch 25, Kap. V: „Wir hatten wenigstens die Möglichkeit, die übrigen Pflanzen, ganz wenige ausgenommen, unter Anleitung des Antonius Castor, der zu unserer Zeit das größte Ansehen in dieser Kunst hatte, kennenzulernen, indem wir seinen kleinen Garten besuchten, in dem er die meisten [Pflanzen] zog; er erreichte ein Alter von über 100 Jahren, ohne mit irgendeinem Leiden belastet zu sein und ohne dass sein Gedächtnis oder seine Lebenskraft durch das Alter beeinträchtigt waren. Auch wird man nichts finden, was im Altertum mehr Bewunderung fand [als die Botanik]."

11 Bernhard von Breydenbach / Johann Wonnecke von Kaub / Erhard Reuwich: Gart der Gesundheit. Mainz: Peter Schöffer, 28.3.1485. GW M09766.

12 In Italien hatten sich Kopien erhalten: s. u. Das älteste erhaltene Kräuterbuch mit Illustrationen ist der sog. „Wiener Dioskurides" (ÖNB, Cod. Med. gr. 1), der im 6. Jahrhundert in Konstantinopel entstand und den man im Westen, wenn überhaupt, nur über Kopien kannte. Erst 1569 kam der Codex nach Wien. Mazal (1981). Zum „Wiener Dioskurides" und der Verbreitung griechischer Herbarien: Collins (2000), S. 31–114.

antiken Pflanzentexten und -bildern machen, war man auf Texte aus dieser Zeit angewiesen, die das Aussehen von Herbarien beschrieben. Einzig auf eine kurze Passage aus Plinius d. Ä. konnte man hierbei zurückgreifen, der sich in seiner „Naturalis historia" aus dem 1. Jahrhundert unter anderem über illustrierte Herbarien äußerte.[13] Darin handelt Plinius von Werken, die ein umfassendes Wissen über alle Pflanzen und ihren medizinischen Gebrauch vermittelten, den Illustrationen, die eine möglichst genaue Wiedergabe der Pflanzen zu leisten hatten, sowie von den Schwierigkeiten der exakten Naturstudie. Kräuterbuchautoren seien außerdem an entlegene Orte gereist, um ihre Kenntnisse der Heilkräuter zu erweitern. Durch wiederholtes Kopieren der Kräuterbücher und schlechte Illustratoren sei es jedoch zu einem Verfall gekommen,[14] sodass es – so hält Plinius schon für das erste Jahrhundert fest – keine guten bebilderten Herbarien mehr gebe. Völlig unzureichend seien Texte, die nur die Namen der Heilkräuter nennen würden, ohne zumindest das Aussehen der Pflanzen zu beschreiben.[15]

Orientierte man sich an dieser zur Verfügung stehenden antiken Quelle, stellten naturnahe Abbildungen in großer Anzahl von einem talentierten Illustrator ein zentrales Kriterium für das Wiederaufleben antiker Pflanzenbuch-Traditionen dar.[16] Betrachtet man den „Gart", so scheinen die Herausgeber dieses ehrgeizigen Projekts alle von Plinius angeführten Merkmale umgesetzt zu haben. Zum einen werden möglichst naturnahe Pflanzenabbildungen gezeigt (Abb. 1, 5), zum anderen bemühte man sich, Pflanzen aus der ganzen Welt zusammenzutragen und so eine vollständige Beschreibung aller pflanzlichen Heilmittel zu leisten. Insgesamt umfasst der „Gart" 378 Holzschnitte, für die der aus Utrecht stammende und in Mainz tätige Künstler Erhard Reuwich (ca. 1450–1505) verantwortlich war. Der Text des Kräuterbuchs ist eine Kompilation des Mainzer Arztes Johann Wonnecke von Kaub (auch: Johannes de Cuba, ca. 1430–1503) aus verschiedenen mittelalterlichen und antiken Quellen, worin 435 pflanzliche, tierische sowie mineralische Heilmittel beschrieben werden.[17] Der „Gart" entstand in der Offizin Peter Schöf-

13 Die „Naturalis historia" von Plinius d. Ä. war bereits 1469 im Druck in Venedig erschienen, man kann also tatsächlich von einem gewissen Bekanntheitsgrad seiner Ausführungen ausgehen. Plinius Secundus, Gaius: Historia naturalis. Venedig: Johann von Speyer, 1469 GW M34312. Zu Plinius' Aussagen über illustrierte Kräuterbücher auch: Collins (2000), S. 37 f.

14 Plinius (1985), Buch 25, Kap. IV: Die griechischen Autoren „haben nämlich die Pflanzen in Bildern dargestellt und ihre Wirkung darunter geschrieben. Aber auch die Malerei trügt bei so zahlreichen Farben, zumal wenn man die Natur nachzuahmen trachtet, und auch die Fahrlässigkeit der Kopisten verdirbt viel. Außerdem hat es wenig Sinn, die Pflanzen nur in einer einzigen Altersstufe abzubilden, da sie in den vier verschiedenen Jahreszeiten ihr Aussehen verändern." / „pinxere namque effigies herbarum atque ita subscripsere effectus. verum et pictura fallax est coloribus tam numerosis, praesertim in aemulationem naturae, multumque degenerat transcribentium socordia. praeterea parum est singulas earum aetates pingi, cum quadripertitis varietatibus anno faciem mutent."

15 Plinius (1985), Buch 25, Kap. V: „Die übrigen Autoren haben [die Pflanzen] deshalb mit Worten beschrieben; einigen gaben aber nicht einmal die Gestalt an und begnügten sich meistens allein mit der Anführung der Namen, weil es ihnen genug schien, die Kräfte und die Wirkung für die darzustellen, die sie suchen wollten."

16 Dass sich nordalpine Künstler und Humanisten intensiv mit den wenigen Aussagen aus der Antike auseinandersetzten, um nicht erhaltenen, aber schriftlich überlieferten antiken Bildkünsten (Porträts, Landschaftsdarstellungen, Pflanzenillustrationen) möglichst nahe zu kommen, kann beispielsweise Schmidt (2010) für das Porträt anhand von Dürers Selbstbildnis im Pelzrock nachweisen.

17 Neue Zählung durch Schnell (2017), im Verhältnis etwa: 382 pflanzliche, knapp 20 tierische und etwa 30 mineralische Heilmittel; die Grenzen sind häufig fließend, da noch keine exakte botanische

fers (ca. 1425–1503) im Auftrag des Mainzer Domdekans Bernhard von Breydenbach (auch: Breidenbach, ca. 1440–1497), der auch das Vorwort verfasste (siehe S. 241–245).[18] Zuerst wurde das 360 Blätter starke Werk im Folio-Format am 28.3.1485 herausgegeben.[19]

Um wirklich alle Pflanzen aus eigener Anschauung zu kennen und abbilden zu können, hatte der Auftraggeber des Kräuterbuchs den Künstler Erhard Reuwich engagiert und sogar mit auf seine Pilgerreise nach Jerusalem genommen.[20] Die Bedeutsamkeit, dass Auftraggeber und Künstler die Pflanzen mit ihren eigenen Augen gesehen haben, wird im Vorwort des „Gart" besonders unterstrichen.[21] Diesen Anspruch an ein Herbarium zu formulieren, war zu diesem Zeitpunkt einzigartig und kann ebenso wie andere Besonderheiten dieses Unternehmens damit begründet werden, dass man mit dem „Gart" an antike Vorbilder anknüpfen wollte: Man gab alle bekannten Pflanzen und ihren Nutzen in sorgfältigen Beschreibungen wieder, griff dabei auf antike Autoren zurück (zu den Quellen siehe Kap. 3.3.) und illustrierte beinahe alle Textabschnitte mit Pflanzenbildern. Das Naturstudium auf Reisen als Grundlage der Darstellungen diente laut Auftraggeber der Wahrheit.[22]

Dem durch Plinius formulierten Dilemma, illustrierte Kräuterbücher könnten nicht dauerhaft in guter Qualität von Hand reproduziert werden, konnte mit Hilfe des mechanischen Buchdrucks begegnet werden. Vielmehr ging, laut William M. Ivins, mit der exakten Reproduzierbarkeit auch der Beginn des glaubwürdigen Bilds einher, auf das naturwissenschaftliche Texte[23] sogar angewiesen gewesen seien.[24]

Der „Gart" war nicht das einzige Herbarium der 1480er Jahre, das auf antike Vorbilder zurückgeführt werden kann. Um 1482 erschien in lateinischer Sprache das erste gedruckte und illustrierte Kräuterbuch, das Herbarium Apuleii Platonici (Abb. 2), in Rom bei Johannes Phi-

Abgrenzung existierte. Pflanzen waren der elementare Bestandteil von Medikamenten, erst an zweiter Stelle folgten Mineralien und schließlich tierische Bestandteile (z. B. Elfenbein, Knochen, einzelne Organe).

18 Eine ausführliche Beschreibung des Mainzer Domdekans liefert: Timm (2006).

19 Bei dem „Gart"-Exemplar, das in dieser Arbeit hauptsächlich behandelt wird, handelt es sich um eine Erstausgabe, die heute in München in der Bayerischen Staatsbibliothek unter der Signatur 2 Inc.c.a. 1601 aufbewahrt wird.

20 Baumann / Baumann (2010), S. 111–139. Zwar ist Erhard Reuwich nicht namentlich als Künstler für den „Gart" belegt, die weitere Zusammenarbeit von Bernhard von Breydenbach und Reuwich sowie das Vorwort des „Gart" machen aber deutlich, dass Reuwich für das Illustrationsprogramm im „Gart" verantwortlich war.

21 Da das Vorwort Bernhards von Breydenbach noch genauer analysiert werden soll, wird es transkribiert und ins Neuhochdeutsche übertragen wiedergegeben (S. 241–245).

22 Wenn im Weiteren von „wahren" Bildern die Rede ist, hat dies nichts mit dem Wahrheitsbegriff der Moderne zu tun, sondern mit dem glaubhaften Bild, das Nähe zum Original vermitteln soll. Ebenso ist der Wissensbegriff nicht mit der Auffassung des 19. Jahrhunderts von „Wissen" zu verwechseln. Zu Begriffsfragen in der Frühen Neuzeit („Natur"; „Kontrafaktur", „Wissen" etc.) liefert die Enzyklopädie der Neuzeit hilfreiche Beiträge: Jaeger (2005–2012).

23 „Naturwissenschaft" ist ein moderner Begriff, der hier für Texte gebraucht wird, die sich mit Natur auseinandersetzen. Blair kann zeigen, dass stattdessen im wissenschaftshistorischen Kontext häufig der Begriff „Naturphilosophie" verwendet wird, der allerdings nicht weniger anachronistisch sei. Daher findet der Begriff „Naturwissenschaft" hier im Weiteren Verwendung. Blair (2006), S. 365 f., 380.

24 Ivins (1969), S. 3.

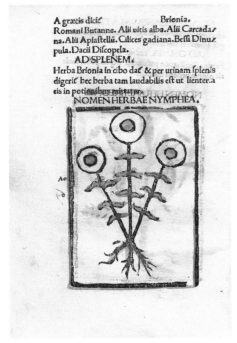

Abb. 2: „Nymphea": Herbarium Apuleii Platonici. Rom 1481/82. München, Bayerische Staatsbibliothek, 4 Inc.s.a. 179.

Abb. 3: Pseudo-Apuleius Platonicus, um 1150. London, British Library, Harley 1585, fol. 22r.

lippus de Lignamine, einem Angehörigen des Hofs Papst Sixtus' IV.[25] Viel ist über den wenig verbreiteten Druck nicht bekannt.[26] Seine Textgrundlage bildete eine illustrierte Handschrift aus Süditalien, die Apuleius zugeschrieben wurde, den man als Schüler von Platon betrachtete. Auch die Bilder des Drucks gehen auf den Traditionstyp der Pseudo-Apuleius-Überlieferungen zurück (Abb. 3). Man war offenbar davon ausgegangen, dass es sich um die relativ genaue Abschrift einer antiken Handschrift handelte, die man nun im neuen Medium auflegte.[27] Der Druck von Johannes Philippus schien beste Voraussetzungen zu haben, trotzdem war ihm kaum Erfolg beschieden. Das römische Kräuterbuch zeigt schematische, zwei-dimensionale Abbildungen, die sich nicht durch Nähe zur Natur auszeichnen.[28] Im Vergleich mit dem „Gart" wird deutlich, dass den Käufern offenbar mehr an den plastischen naturnahen Abbildungen

25 [Rom: Johannes Philippus de Lignamine, um 1481/82]. GW 2300. Zum „Pseudo-Apuleius Platonicus": Baumann / Baumann (2010), S. 69–74. Zur Text- und Bildüberlieferung des Pseudo-Apuleius: Collins (2000), S. 164–220.

26 Scheinbar gab es weder eine besonders hohe Auflage des Drucks noch einen größeren Rezipientenkreis. Olariu (2014), S. 49 f.

27 In Italien hatte man also im Gegensatz zu Deutschland zumindest Kopien vorgefunden, die einen visuellen Eindruck vermitteln konnten. Ob Johannes Philippus de Lignamine die Handschrift als lateinische Abschrift einer griechischen Vorlage aus der Zeit von Kaiser Augustus betrachtete, ist unklar. In jedem Fall hatte er aber eine Handschrift gefunden, die, wie er im Vorwort schreibt, zweifellos auf antike Vorbilder zurückging. Olariu (2014), S. 49 f.

28 Olariu (2014), S. 53.

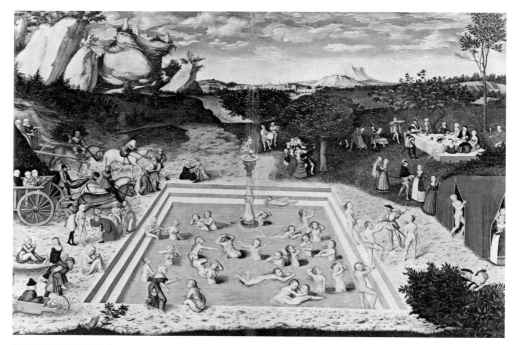

Abb. 4: Lucas Cranach d. Ä.: Jungbrunnen, 1546, Öl auf Holz. Berlin, Gemäldegalerie, Inv.-Nr. 593.

gelegen war, wie sie der „Gart" bot, als an einer vermeintlich antiken Vorlage. Die Pflanzenillustrationen des „Gart" suggerierten ein direktes Naturstudium durch den Künstler und führten damit die Wiederbelebung der „wahren Kunst"[29] der Antike direkt vor Augen.

Was in Italien als Renaissance, als Wiedergeburt, bezeichnet wurde, nannte Albrecht Dürer in seiner Proportionslehre „Wiedererwachung".[30] Hierin deutet sich ein biologisches Geschichtsverständnis an: Die Antike kann als wieder aufblühende Pflanze im Frühjahr – nach dem mittelalterlichen Winter – gedacht werden oder als neu sprießender Baum, der bereits als abgestorben galt.[31] Dieses Denken schlägt sich auch in der Kunst nieder. Warnke hat Cranachs Bilddetail des aufgepfropften Baums vor dem Jungbrunnen (Abb. 4), in den die Alten gezogen werden, um jung, erneuert und erfrischt zu werden, als Motiv der Erneuerungs- und Reform-

29 Z. B. bei Brunfels (1532), Vorwort, XX. Capitel.

30 Dürer verwendete den Begriff „widererwaxsung" in einem Entwurf zur Einleitung der Proportionslehre, die 1532 nach seinem Tod herausgegeben wurde. Dürer (1966), S. 114.

31 Auf den „biologischen Renaissancebegriff" hat Trier (1961) aufmerksam gemacht. Zur Umsetzung
 dieses Modells bei Dürer: Schmidt (2010).

metaphorik gedeutet. Der „wiedererwachsene" Baum stehe emblematisch für das regenerative Potential der Frühen Neuzeit, das goldene Zeitalter.[32]

Im 16. Jahrhundert sah man den Beginn dieses Wiedererwachsens der Antike in den 1480er Jahren. In seiner Geschichte der Kräuterbücher aus dem Jahr 1532[33] schrieb der Kräuterbuchautor Otto Brunfels, dass das „fürnemen der Alten" 50 Jahre vor seiner Zeit begonnen habe.[34] Der Bezug auf die „Alten", die Antike, werde durch die Wiederaufnahme der „wahren Kunst" sichtbar.[35] Es wird noch ausführlicher zu zeigen sein, inwiefern der „Gart" auch zu seiner Entstehungszeit als Rückgriff auf antike Traditionen verstanden wurde. Mit diesem Rückbezug auf die Antike, die Brunfels in die 1480er Jahre datiert,[36] ist zweifellos der „Gart der Gesundheit" gemeint.

Die besondere Stellung des „Gart" steht im Gegensatz zu seiner wissenschaftlichen Bearbeitung, in der man das Augenmerk bislang auf die Kräuterbücher des 16. Jahrhunderts richtete. Zwar wird er bisweilen als zentraler Ausgangspunkt für die illustrierten naturwissenschaftlichen Werke der Frühen Neuzeit begriffen,[37] dennoch ist eine ausführliche Analyse dieses „Initialbuchs" als zentraler Bestandteil der Wissenschaftsgeschichte sowie seiner Abbildungen als epistemische Objekte bislang ausgeblieben. Diese Lücke soll mit der vorliegenden Arbeit geschlossen werden.

Der Buchdruck als Bedingung für neue Bildstrategien sowie Pflanzenbilder als Objekte der Etablierung und Vermittlung von Erkenntnis sind nur einige der Aspekte, hinsichtlich derer die Illustrationen des „Gart der Gesundheit" untersucht werden sollen.[38] Neben den Bildern gilt es, das Buch in seiner Gesamtheit zu analysieren, weshalb sämtliche Akteure, also Drucker, Autor, Auftraggeber, Künstler, und auch mögliche Rezipienten berücksichtigt werden (Kap. 3). In jedem Stadium der Buchherstellung war man gezwungen, die Herstellungsmethoden, Anordnung, nötige Zwischenschritte, Visualisierungsstrategien etc. zu reflektieren, um ein geschlossenes und überzeugendes Ergebnis hervorzubringen. Das illustrierte Kräuterbuch brachte

32 Zum „wiedererwachsenen" Baum bei Cranach: Warnke (2009), S. 74–77. Zur Pflanzensymbolik in der Renaissance ausführlich: Ladner (1969). Die Liste der biologischen Metaphern der Renaissance lässt sich weiter fortsetzen: Fehrenbach (2003), Pfisterer (2014).

33 Otto Brunfels: Contrafayt Kreüterbúch. Straßburg 1532. VD16 B 8503.

34 Das Geschichtsmodell gleicht dem zyklischen Modell Giorgio Vasaris: Erzählt wird von der ruhmreichen Antike über das finstere Mittelalter hinweg bis zum Wiederbeleben der Antike in der Neuzeit. Weitere Einsichten zum Geschichtsmodell Vasaris: Blum (2010). Dass sich die Vorstellung vom Verlauf der Geschichte im deutschsprachigen Raum im 15. Jahrhundert anders darstellen konnte, zeigt Wood (2008), S. 63–84: Das Mittelalter müsse hier nicht überwunden werden, da es nördlich der Alpen im römischen Reich die Empfindung eines Bruchs mit der Antike nicht gegeben habe – die antike Tradition wird schlicht fortgeführt.

35 Brunfels (1532), Vorwort, XX. Capitel: „Dieses fürnemen der Alten haben ynnerthalb fünfftzig jaren auch wider angefangen."

36 Zu Beginn seines Studiums war Brunfels (geb. 1488 in Mainz) an der Universität in Mainz eingeschrieben, man kann davon ausgehen, dass er dort den „Gart" gesehen hat. Kat.Ausst. Schweinfurt (2011), S. 97 f.

37 Landau / Parshall (1994), S. 254. Schmidt (2000), S. 591.

38 Landau / Parshall (1994), S. 245–260. In medientheoretischen Texten über die Zeit des Buchdrucks wird schon länger auf die Bedeutung des „Gart" für die Wissenschaftsgeschichte hingewiesen: Ivins (1969). Eisenstein (1997), S. 170–230. Giesecke (2006), S. 329–390.

spezielle Herausforderungen mit sich,[39] da hier in Bild und Text die Versuche zusammenkommen, die Gestalt der Pflanzen systematisch zu erfassen. Sowohl Künstler als auch Mediziner bzw. Naturwissenschaftler erforschten die Natur und orientierten sich dafür bisweilen an den Techniken und Materialien des anderen.[40]

Ein zentraler Teil dieser Arbeit befasst sich mit dem Künstler, der an den Pflanzenbildern arbeitet, der mithin Natur formt und färbt (Kap. 4). Vergleicht man den aufwendigen Herstellungsprozess von Darstellungen für ein Kräuterbuch mit der Vorstellung von der formenden Natur, existieren Parallelen, die auch den zeitgenössischen Künstlern aufgefallen sein mögen. Gleichzeitig mit der „Arbeit an der Natur" steht der Künstler des „Gart" einer langen Überlieferungstradition gegenüber. Das Illustrationsprogramm des „Gart" stellt ein zentrales Bindeglied zwischen den Bildtraditionen des Mittelalters und der Frühen Neuzeit dar, vor allem deshalb, weil *traditio* ein mindestens ebenso, wenn nicht sogar beweiskräftigeres Argument für eine überzeugende Pflanzenillustration ist als die *innovatio* der Pflanzenholzschnitte nach der Natur.[41] Glaubhaftigkeit wird im Pflanzenbild dadurch vermittelt, dass die Tradition aufgerufen wird und zumindest als Zitat früherer Vorlagen noch vorhanden ist. Andererseits werden hier erstmals naturnahe Abbildungen, Konterfeis, als beweiskräftige Naturbeobachtung herangezogen.[42] Damit wird gleichzeitig der Künstler, der sich von einem konstanten Bildkanon zu lösen beginnt oder traditionelle Überlieferungen mit Naturbeobachtung zusammenbringt, zur unübersehbaren Größe im Netzwerk der Naturwissenschaften.

Ein wesentliches Augenmerk liegt ferner auf den vielfältigen Rezeptionszusammenhängen des „Gart" (Kap. 5). Dabei steht zum einen die Medizin, die die Natur zu erfassen versucht,[43] im Fokus, die im universitären Bereich im 15. Jahrhundert stark an Bedeutung gewann. Insbesondere die Beobachtung an der Natur und am Körper sowie die Beurteilung des Erfahrenen durch die Sinne spielte eine entscheidende Rolle.[44] Zum anderen sollen die Evidenzverfahren des „Gart" analysiert werden, die für andere Künstler und Buchprojekte eine Rolle spielten.[45] Für den „Gart" wurden Illustrationen entwickelt, die Evidenz vermitteln sollten, die also das

39 In ihrer Monographie „Picturing the Book of Nature" macht Kusukawa deutlich auf die besonderen Bedingungen des Mediums „Buch", für das wissenschaftliche Illustrationen angefertigt werden, aufmerksam: Kusukawa (2012), S. 29–47. Ebenso: Frasca-Spada / Jardine (2000).

40 Niekrasz / Swan (2006), S. 774.

41 Saurma-Jeltsch (2006).

42 Dies hat Timm schon für den Reisebericht von Bernhard von Breydenbach herausgearbeitet: Timm (2006), S. 357–359. Puff bezeichnet Reuwichs Bilder darin als „Bildtexte" und betont damit die Engführung von Schrift und Bild, die gemeinsam eine beweiskräftige Einheit bilden. Puff (2014), S. 327 f. Bedenkt man Latours Ausführungen zur „Forschungsreise" (als die die Pilgerreise Bernhards von Breydenbach von Giesecke bezeichnet wurde), konnten die dort gesammelten Informationen erst durch den Druck in Bild und Text in ein europäisches Gelehrtennetzwerk Eingang finden. Giesecke (2006), S. 338. Latour (2006).

43 Naturbeobachtung als Basis für Erkenntnis ist durchaus nicht selbstverständlich und muss sich, ebenso wie das Bild als Übermittlungsinstanz von Beobachtung, erst im naturwissenschaftlichen Kontext etablieren. Hierzu: Daston (2011).

44 Zur immer enger werdenden Verbindung von universitärer Medizin und Naturbeobachtung um 1500: Cook (2007), S. 407 f.

45 Zum beweiskräftigen, „wahren Bild", das das Objekt ersetzen kann: Daston (2005). Wood (2008), S. 36–53. Sowie der Sammelband „Evidentia": Wimböck u. a. (2007), darin zum Begriff der Evidenz: Müller (2007).

abwesende, nicht erreichbare Objekt ersetzen konnten. Es stellt sich die Frage, wie ein solches Abbild konstruiert sein musste: *Wann* war ein Pflanzenbild evident? Am „Gart" kann außerdem nachvollzogen werden, *wie* evidente Bilder, die vom lebenden Objekt (*ad vivum*) gestaltet wurden – oder dies zumindest von sich behaupteten –, in den naturwissenschaftlichen Diskurs einbezogen wurden. Dass etwas „nach der Natur" gestaltet ist, bekam insbesondere im 16. Jahrhundert einen dokumentierenden Charakter, die Worte *ad vivum* erhöhten den Wahrheitsgehalt[46] des Bilds und damit auch seinen Wert im naturwissenschaftlichen Diskurs.[47] Die Künstler beglaubigten mit dieser Wendung das „epistemologische Dekorum" („epistemological decorum") ihrer Bilder.[48] Einblattdrucke, wie Dürers Rhinozeros,[49] und Inkunabeln, wie die Schedel'sche Weltchronik,[50] die ungewöhnliche Naturphänomene bzw. Naturbeobachtung darstellten und in Umlauf brachten,[51] orientierten sich, wie gezeigt werden soll, am Bildvokabular, das maßgeblich von Erhard Reuwich konzipiert worden war, und zwar neben dem „Gart" auch für ein weiteres Werk, das er für Bernhard von Breydenbach illustriert hatte, die „Peregrinatio in terram sanctam" (1486).[52]

Es sollen auch die Darstellungen von Pflanzen in anderen Gattungen der Zeit zum Vergleich herangezogen werden. Abbildungen von Pflanzen treten besonders seit dem 15. Jahrhundert in diversen Medien und in einer enormen Bandbreite auf, man denke beispielsweise an Stundenbücher, Teppiche, Holzschnitte, Kupferstiche sowie die Wand- und Tafelmalerei.[53] Ihre Funktion kann es sein, zu beschreiben, zu identifizieren und zu substituieren oder auch symbolische Verknüpfungen herzustellen. Herrscher können durch Naturrepräsentationen Macht, Gesundheit und Gelehrsamkeit zur Schau stellen.[54] Anhand des „Gart" kann ein differenzierteres Verständnis für die medizinische Theorie und den Einsatz der Heilkräuter sowie Pflanzenbilder im Spätmittelalter aufgefächert werden – in Wissenschaft und Kunst.[55]

46 Für Daston ist die Wahrheit eine „epistemische Tugend", die viel älter ist als die „Objektivität". Wissenschaftliches Wissen existiert für sie, lange bevor es „Objektivität" gab, die ein „Neuankömmling" gegenüber der „Wahrheit" ist. Wissenschaft vor dem 19. Jahrhundert versuche sie daher zunächst ohne „Objektivität" zu denken: Daston (2005).

47 Zur Wendung *Ad vivum* existieren zahlreiche Aufsätze, u. a. von Parshall (1993), Swan (1995) oder Felfe (2013). Ebenso bei: Egmond (2017), S. 93–99.

48 Niekrasz / Swan (2006), S. 796.

49 Dackerman bezeichnet Dürers Kreation des Rhinozeros, die mit Hilfe einer Beschreibung des Tiers entstanden war, die er aus Lissabon erhalten hatte, als „indexikalische Fantasie". Obwohl er das Nashorn nie gesehen hatte, ging Dürers Holzschnitt von 1515 in die Naturbücher ein. Dackerman (2011).

50 Ausführlich zum Buchprojekt Schedel'sche Weltchronik: Füssel (2001).

51 Kat.Ausst. Cambridge, Mass. (2011). Für die Ausstellung wurde ein großes Spektrum an Druckgraphiken herangezogen, die zum Zweck der Informationsgenerierung und -weitergabe entstanden sind. Darüber hinaus sind im Katalog zentrale Autoren (z. B. Swan, Daston, Reeds) versammeln, die sich mit dem Bild in der Wissenschaftsgeschichte auseinandersetzen.

52 Bernhard von Breydenbach / Erhard Reuwich: Peregrinatio in terram sanctam. Mainz 11.2.1486. GW 5075. Noch im selben Jahr auf Deutsch: Bernhard von Breydenbach / Erhard Reuwich: Die heyligen reyßen gen Jherusalem zuo dem heiligen grab. Mainz 21.6.1486. GW 5077. Der frühneuhochdeutsche Text mit Übertragung als Edition: Bernhard von Breydenbach (2010).

53 Zu Pflanzendarstellungen im Kirchenraum: Behling (1957). Behling (1964). Dressendörfer (2012). Comes (2013).

54 Niekrasz / Swan (2006), S. 782. Smith (2008).

55 Kusukawa (2011), S. 202 f.: „Pictures were a valuable way to establish, examine and share knowledge

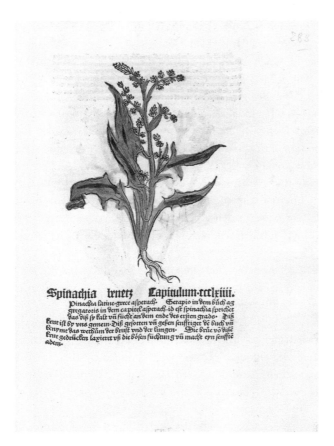

Abb. 5: Spinat: Gart der Gesund-
heit. Mainz 1485. München,
Bayerische Staatsbibliothek,
2 Inc.c.a. 1601.

Ende des 15. und im 16. Jahrhundert wurden Bilder zum festen Inventar im naturwissen-
schaftlichen Kontext (Kap. 6). Ihre „Modernität", was so viel bedeutet wie ihre Nähe zur
Natur, bestimmte auch den Wert, den man den Werken beimaß, die sie begleiteten.[56] Im
„Gart" ist die „Modernität" nicht immer auf den ersten Blick sichtbar, da er im Gegensatz
zum 16. Jahrhundert auch noch mittelalterliche Traditionen aufnahm.[57] Dafür fungiert er als
impulsgebende Schnittstelle für spätere naturwissenschaftliche Werke, die sich bewusst oder
unterbewusst an den visuellen Strategien des „Gart" orientierten. Je nach Fokus kann man den
„Gart" als letztes „mittelalterliches" oder erstes „modernes" Kräuterbuch betrachten, ebenso
kann der Blickwinkel entweder auf seinen künstlerischen oder seinen naturwissenschaftlichen
Charakter gerichtet sein, wobei jede Option zwangsweise etwas Einschränkendes oder Sub-

<hr />

about a scientific object [...]. What can be established about this period [Renaissance] is that natu-
ralists, artists and patrons alike appreciated and understood the different levels at which images of
nature could operate – nature could be an object of study and nature was also beautiful."

56 Swan (2011), S. 187. Swan greift hier eine Beobachtung von Arber auf, die die Naturnähe und die
 „Modernität" der Kräuterbuchillustrationen des 16. Jahrhunderts mit dem Schlagwort der „botani-
 schen Renaissance" beschreibt. Arber (1912), S. 55.

57 „Naturalismus" und „Modernität" analysiert Ackerman als Fortschrittskonzepte in der wissenschaft-
 lichen Illustration der Frühen Neuzeit, die vom Künstler kreiert und über das Bild an den Betrachter
 vermittelt werden sollen. Ackerman (1985).

ordinierendes in sich birgt, weshalb in dieser Arbeit eine übergreifende Perspektive gewählt wurde.[58]

In der Bildwissenschaft hat man die Grenzen zwischen Kunst und Wissenschaftsgeschichte mittlerweile aufgelöst und darauf aufmerksam gemacht, dass Werke, die Informationen weitergeben wollten, auch so beschaffen waren, dass sie den Rezipienten ästhetisch ansprechen oder sogar überwältigen sollten.[59] Eine Neubeurteilung des „Gart" hat dabei jedoch bislang nicht stattgefunden, da man sich weitestgehend mit den „modernen" naturwissenschaftlichen Illustrationen des 16. Jahrhunderts auseinandersetzt und die nicht ohne Widersprüche auskommende Nahtstelle zwischen Mittelalter und Früher Neuzeit meidet.[60] Dabei hat man mit dem „Gart der Gesundheit" eines der innovativsten Druckwerke des 15. Jahrhunderts übersehen, dessen Rückgriff auf die Tradition und dessen Weiterwirken im 16. Jahrhundert ihn zu einem idealen Untersuchungsgegenstand dieser Nahtstelle macht.

58 Swan (2011), S. 188.

59 Als maßgebend für diese Beurteilung darf auch die Ausstellung „Prints and the Pursuit of Knowledge" (Cambridge, Mass.) von 2011 gelten. Hierzu die Rezension von Marr (2012).

60 Zum Beispiel stammte ein Großteil der Objekte der Ausstellung „Prints and the Pursuit of Knowledge" aus dem 16. Jahrhundert: Kat.Ausst. Cambridge, Mass. (2011).

2. VIELFALT DER PERSPEKTIVEN: DIE KRÄUTERBUCHFORSCHUNG

2.1. Pflanzenbücher auflisten

Das Interesse an Pflanzenbüchern des Mittelalters entzündete sich an den erhaltenen Dioscurides-Überlieferungen.[1] Ihr Seltenheitswert und die qualitativ hochwertige Ausstattung lenkten den Fokus auf diese singulären Prachthandschriften. Dabei verfolgten unterschiedliche Fachgebiete eigene Schwerpunkte bei der Erforschung mittelalterlicher und frühneuzeitlicher Herbarien. Mediziner und Botaniker suchten nach den Wurzeln und der Entwicklungsgeschichte ihres Fachs von der Antike bis in die Neuzeit. Kunsthistoriker widmen sich besonders den Fragen nach der Entwicklung der Naturdarstellung und symbolischen Kodierung der Pflanzen in der Kunst. Kodikologen erstellten die für die Forschung zentralen Bestandsaufnahmen der bekannten und noch erhaltenen Kräuterbücher seit der Antike.

In den 1910er und 1920er Jahren entstanden erste Grundlagen- und Überblickswerke zu illustrierten und nicht-illustrierten Kräuterbüchern. In den Vereinigten Staaten erschien bereits 1917 und 1918 die Listen von Arnold C. Klebs „Herbals of the Fifteenth Century".[2] 1924 folgte in Deutschland Wilhelm Ludwig Schreibers kommentiertes Nachschlagewerk „Die Kräuterbücher des XV. und XVI. Jahrhunderts", das die Mainzer Inkunabeln und ihre Nachdrucke und Nachfolger nennt. Initialpunkt wissenschaftlicher Naturforschung sind für Schreiber die Kräuterbücher von Brunfels (1530 und 1532).[3] Daneben werden kleinere Abhandlungen geschrieben, wie die Dissertation des Zahnmediziners Hans Amsler von 1925.[4]

Als Standardwerk kann Hermann Fischers „Mittelalterliche Pflanzenkunde" von 1929 gelten.[5] Der Naturwissenschaftler promovierte zunächst mit einer Arbeit zum unterfränkischen Triasgestein und habilitierte sich im Bereich der angewandten Pflanzenphysiologie. Im Anschluss

1 Eine ausführliche Beschreibung zum illustrierten „Wiener Dioskurides", der Anfang des 6. Jahrhunderts entstand, findet sich bei: Mazal (1981). Die Dioscurides-Handschriften wurden schon um 1900 intensiv erforscht, vgl. Stadler (1896–1900). Einen Überblick über die Überlieferung spätantiker, medizinischer Bilderhandschriften, die vor allem Tiere und Pflanzen zeigen, liefert Grape-Albers (1977).

2 Klebs (1918).

3 Schreiber (1924). Bereits 1904 erschien in der „Zeitschrift für Bücherfreunde" ein Aufsatz von Schreiber zum Thema: „Die alten Kräuterbücher, ein Beitrag zur Geschichte des Nachdrucks".

4 Amsler (1925). Amslers Dissertation setzt sich auch in aller Kürze mit dem „Gart" auseinander.

5 Fischer (1929). Fischer greift stark auf Meyers „Geschichte der Botanik" (Bd. 4 zur Frühen Neuzeit: 1857) aus dem 19. Jahrhundert und Schreiber (1924) zurück. Daneben erstellte Fischer 1928 und 1929 kurze Listen von Naturselbstdrucken des 15. Jahrhunderts und neu entdeckten Herbarien. 1927 erschien seine Monographie zu Hildegard von Bingen als erster Naturforscherin: Fischer (1927).

wandte er sich der Wissenschaftsgeschichte zu und spezialisierte sich auf die pflanzenkundliche Literatur des Mittelalters. Das Glossar, das er in seiner „Mittelalterlichen Pflanzenkunde" erstellte, war für die Forschung über einen langen Zeitraum hinweg das einzige Nachschlagewerk, das eine Zuordnung von mittelalterlichen zu heutigen Pflanzennamen erlaubte.[6] Da in der Antike und im Mittelalter keine einheitliche Nomenklatur für Pflanzen existierte, stellen solche Zuweisungen bis heute ein Problem dar.[7] In fünf Teilen entwickelt Fischer seinen Überblick über die botanische Literatur des Mittelalters von den Anfängen über Albertus Magnus bis hin zu den ersten Drucken. Dabei bezieht er arabische, italienische, französische, deutschsprachige sowie englische Quellen ein und spannt einen Bogen zur Medizingeschichte und zum Gartenbau. Das dritte und kleinste Kapitel ist den Pflanzenbildern vorbehalten, worin er auf Illustrationen sowie Naturdarstellungen in der Tafelmalerei gleichermaßen eingeht und die herausragende Stellung der Pflanzenbilder des Vitus Auslasser[8] und der Erstausgabe des „Gart der Gesundheit" betont. Vitus Auslassers „Herbarius" listete Anfang des 15. Jahrhunderts über 200 deutsche und lateinische Pflanzennamen auf, was zeigt, dass das Problem der einheitlichen Nomenklatur in einer Zeit, in der immer mehr Bücher in Volkssprache erschienen,[9] zunehmend drängend wurde.

1951 legte Claus Nissen eine umfassende Geschichte und Bibliographie der botanischen Buchillustration vor, die selbst allerdings ganz ohne Abbildungen auskommt.[10] Dem ersten Band zur überregionalen Geschichte der Pflanzendarstellung von der Antike bis ins barocke Zeitalter ließ Nissen einen ausführlichen bibliographischen Teil folgen. Gleiches leistete er für die zoologische Buchillustration. Seinen Standpunkt zur Naturillustration macht er am Beispiel der „Botanikmalerei" deutlich:

> Nicht anders als bei der gesamten naturwissenschaftlichen Illustration oder dem technischen Zeichnen, handelt es sich bei ihr [der Naturillustration] um eine Anwendung zeichnerischer Fertigkeit, in unserem Falle zur Darstellung botanischer Objekte. Wie alles Kunsthandwerk gehört somit auch sie jenem Zwischenreich an, in dem nicht der freischaffende Wille des Künstlers, sondern der zwingende, fordernde Zweck des Auftraggebers herrscht. [...] Gipfelgestalten wie Dürer oder Leonardo [...] lassen aber klarwerden, dass im Grunde die Kunst so gut Forschung ist, wie die Wissenschaft Gestaltung.[11]

6　　Vgl. das Vorwort von Johannes Steudel zum Nachdruck von Fischers „Mittelalterlicher Pflanzen-kunde" aus dem Jahr 1967, S. V f.

7　　Eine einheitliche Nomenklatur wurde erst im 18. Jahrhundert durch Carl von Linné geschaffen. Su-sanne Baumann schreibt, dass bereits Hieronymus Bock erste „Familienähnlichkeiten" von Pflanzen beobachtete und in seinem unbebilderten Kräuterbuch von 1539 unterschied. Erst die naturgetreuen Abbildungen in den Pflanzenbüchern der „Väter der Botanik" (Hieronymus Bock, Otto Brunfels, Leonhart Fuchs) hätten die Grundlage für eine einheitliche Systematik geliefert: Baumann (1998), S. 225 f. Für die Mainzer Kräuterbuchinkunabeln sind die Listen von Baumann / Baumann (2010) ein hilfreiches Arbeitsinstrument, da die Apotheker hier versuchen, den beschriebenen Drogen einen modernen Pflanzennamen zuzuordnen.

8　　Schon 1924 hatte Fischer sich mit den Pflanzenillustrationen des Benediktiners Vitus Auslasser be-schäftigt. Weiter zu Auslasser und seinen Pflanzenbildern: Mayer (2001) und Mayer u. a. (2009).

9　　Regelmäßig erscheinen Sammelbände zur „Fachsprachenforschung", z. B. Vaňková (2014).

10　　Nissen (1951/1966) und – nun mit Abbildungen zu „Kräuterbüchern aus fünf Jahrhunderten": Nissen (1956).

11　　Nissen (1951/1966), Bd. 1, S. 1.

Der hier angedeutete enge Zusammenhang zwischen empirischer Naturbeobachtung und ihrer Dokumentation im Bild wird aktuell insbesondere an der Schnittstelle von Wissenschaftsgeschichte und Bildtheorie diskutiert.[12]

Die im Jahr 2000 veröffentlichte Dissertation von Minta Collins „Medieval herbals. The illustrative traditions" ist ein ausführlich kommentierter Katalog, der sich ausdrücklich an Kunsthistoriker richtet und weitere Forschungsarbeiten zum illustrierten Kräuterbuch anregen soll.[13] Sie beurteilt die illustrierte „Tractatus de herbis"-Handschrift Egerton MS 747[14] (Abb. 7) von ca. 1300 als ältestes erhaltenes Kräuterbuch, in dem wieder erste Reflexe von Naturbeobachtung seit der Antike sowie das Wiedererwachen von Naturbewusstsein erkennbar wurde. Außerdem sei der Codex die Grundlage für die französischen „Livres des simples médecines" (Abb. 90–92) aus dem 15. Jahrhundert.[15]

Im „Katalog der deutschsprachigen illustrierten Handschriften des Mittelalters" werden von Bernhard Schnell in der Stoffgruppe „Kräuterbücher" deutschsprachige illustrierte Herbarien kommentierend erfasst.[16] Auch wenn Schnell zu Recht festhält, dass Kräuterbücher zunächst keinen botanischen, sondern medizinischen Charakter haben,[17] war es doch eine Botanikerin, Agnes Arber, die 1912 eine Geschichte der Herbarien verfasste.

2.2. Herbarien in historischen Überblickswerken

Arbers „Herbals. Their origin and evolution. A chapter in the history of botany 1470–1670" wurde zuletzt 1990 noch einmal aufgelegt.[18] Sie erstellte keinen Katalog, sondern ging auf die Suche nach den Anfängen der Botanik in den gedruckten Werken des 15. bis 17. Jahrhunderts. Unter früher Botanik versteht sie v. a. die naturphilosophischen Schriften von Aristoteles oder Albertus Magnus.[19] Weiterhin behandelt sie lediglich bebilderte Drucke, sodass die Illustration in dieser Geschichte der Botanik mitunter zum zentralen Thema wird. Mehr Freiheit und Realismus, als es in Pflanzenabbildungen des Mittelalters gegeben war, zeichneten die Bilder des „Gart der Gesundheit" aus, die in den nächsten Jahrzehnten kopiert und verbreitet wurden, bis Brunfels seine Kräuterbücher auf den Markt brachte.[20] Hiermit beginnt für Arber die „botanische Renaissance". Als ausschlaggebend für eine Renaissance und den Anfang der Botanik erwiesen sich die Pflanzenbilder, die der Künstler Hans Weiditz anfertigte (Abb. 6):

The plants are represented as they are, and not in the conventionalized aspect which had become traditional in the earlier herbals through successive copying of each drawing from a previous one,

12 Z. B. Givens u. a. (2006). Kat.Ausst. Cambridge, Mass. (2011).

13 Collins (2000), S. 13, 299.

14 Im Kap. 4.2.2. werden die Abbildungen aus Egerton 747 mit dem „Gart" verglichen.

15 Collins (2000), S. 13 f.

16 Schnell (2017). Einen Überblick zum deutschsprachigen Kräuterbuch des Mittelalters liefert Schnell (2005).

17 Schnell (2009).

18 Arber (1912).

19 Arber (1912), S. 1–12.

20 Arber (1912), S. 26.

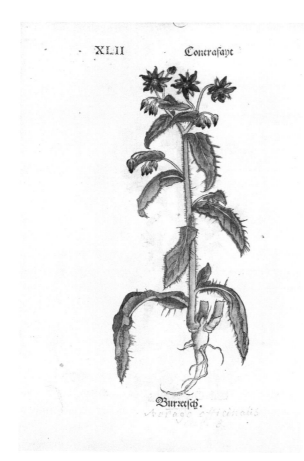

without reference to the plant themselves. [...] The pictures in the *Herbarum vivae eicones* are incomparably better than the text.[21]

Der Umbruch in der Botanik geht für sie von naturgetreuen Darstellungen und nicht von neuen Beschreibungen aus, ein Umstand, der besondere Aufmerksamkeit verdient. Um im modernen Sinne als gelungenes und brauchbares Pflanzenbuch zu gelten, müssen demnach naturnahe Abbildungen gezeigt werden.

Im siebten Kapitel legt Arber ihr Augenmerk ausschließlich auf die „evolution of the art of botanical illustration".[22] Dürer und Leonardo werden darin als Künstler genannt, die das exakte Naturstudium von Hans Weiditz, dem Illustrator für Otto Brunfels' Kräuterbücher von 1530 und 1532, vorwegnahmen. Die letzten Kapitel widmen sich dem beginnenden Interesse an botanischen Fragestellungen: Die gesundheitsstiftende Wirkung der Pflanzen bildete in der Antike das Fundament der Beschäftigung mit Heilkräutern, was in der frühen Neuzeit in eine botanische Auseinandersetzung mit der Flora mündete.

21 Arber (1912), S. 55.
22 Arber (1912), S. 185.

Weitere historische Aufarbeitungen seit den 1950er Jahren finden sich bei Heilmann „Kräuterbücher in Bild und Geschichte", Frank J. Anderson „An illustrated history of the herbals" oder Wilfrid Blunt[23] mit Sandra Raphael „The illustrated herbal".[24]

2.3. Pflanzendarstellungen aus kultur- und kunsthistorischer Sicht

Der Wiener Kunsthistoriker und Handschriftenforscher Otto Pächt veröffentlichte 1950 den wegweisenden Aufsatz „Early Italian Nature Studies and the Early Calendar Landscape", in dem er sich mit der „Frührenaissance" und ihrem Verhältnis zur Naturnachahmung auseinandersetzte. Seine Ausführungen gaben der Forschung zum „Naturporträt" im 15. Jahrhundert neue Impulse.[25] Am Beginn des „Naturalismus" steht für Pächt die Malkunst Giottos. Zwar können die dargestellten Pflanzen Giottos nicht identifiziert werden, aber ein neuer Umgang mit der Natur sei in seinem Werk spürbar.[26] In den Zeichenbüchern der italienischen Künstler werden nun direkte, porträthafte Naturbeobachtungen festgehalten, „a kind of pictorial off-set from nature"[27]. Befreit vom symbolhaften Denken des Mittelalters, könne der Künstler der eigenen Neugier an der Betrachtung der Natur nachgehen.

Hier beginnt nach Pächt die empirische Wissenschaft, die nach Evidenz strebt. Trotzdem bleibe die Bildtradition des Mittelalters ein wichtiger Träger von Überlieferung, sodass weiterhin Naturenzyklopädien kopiert wurden. Des Weiteren können innerhalb einer Handschrift verschiedene Arten der Illustration erfolgen: zum einen das Kopieren älterer Vorlagen, zum anderen das Naturstudium von gepressten oder noch lebenden Pflanzen.[28] Damit spricht er ein Hauptthema der Forschung zur Naturdarstellung an, nämlich das Oszillieren der Darstellungen zwischen Typisierung und Naturnachahmung.

Pächt bemerkt zudem, dass Illustratoren begannen, sich von botanisch bzw. medizinisch relevanten Beobachtungen, wie z. B. dem Wurzelwerk, zu lösen und einen stärkeren Fokus auf die

23 Des Weiteren erschien 1950 eine umfassende Geschichte der botanischen Illustration von Blunt.

24 Heilmann (1964). Anderson (1977). Blunt / Raphael (1979). Ebenso bei: Isphording (2008) anhand der Sammlung botanischer Werke des Germanischen Nationalmuseums, Nürnberg.

25 Ernst H. Gombrich antwortete 1960 auf Pächts Thesen mit seiner Monographie „Art and Illusion". Siehe hierzu Karl Clausbergs Besprechung: „Gombrichs auf rund vierhundert Buchseiten ausgebreitete Kernthese von *Art and Illusion* besagte, dass neuzeitliche Künstler (in einer Popperschen Abfolge von ‚conjectures and refutations') wie Naturwissenschaftler experimentierten und demnach in gegebenen ‚frames of reference' eine relativ freie Wahl der Gestaltungsmöglichkeiten hätten. Dagegen machte Pächt geltend, dass solche Freiheit, die an Beliebigkeit grenze, nicht zu erklären vermöge, wieso sich bestimmte allgemeine Tendenzen abzeichnen und durchsetzen können." Clausberg (2006), S. 105 f. Gombrichs Buch stelle eine „Absage an den Naturalismus als durchgängiges Universalziel der abbildenden Künste" dar. Wiederholt schrieb Gombrich zu diesem Thema: Gombrich (1973). Gombrich (1982). Gombrich (1994). Gombrich (1999).

26 Pächt (1950), S. 13: „It was not until the end of the century that nature observation, the study of the individual appearance of the external world, became of topical interest to Italian artists."

27 Pächt (1950), S. 17.

28 Pächt (1950), S. 25: „Or rather we observe that the more easily we recognize the objects represented, the more difficult it becomes to sense the style of their representation. To be consistent in style and at the same time to be true to nature seems at first to have been difficult to combine."

ästhetische Qualität ihrer Abbildung zu legen.[29] Während die Künstler im Süden Einzelporträts der Pflanzen herstellten, bildeten gleichzeitig im Norden die Maler homogene Naturkomplexe und entdeckten so die Landschaftsmalerei.

Die im Aufsatz wachgerufenen Fragestellungen zur Naturdarstellungen bleiben weiterhin von kunsthistorischem Interesse: Welche Arten der Naturillustration sind möglich, welchen Bezugsrahmen hat das Zusammenspiel von Naturnachahmung und künstlerischem Anspruch, und schließlich welchen „Wahrheitsanspruch" besitzen Bilder?[30]

Die Auseinandersetzung mit Pflanzendarstellungen gilt von kultur- und kunsthistorischer Seite insbesondere der symbolischen Entschlüsselung der Pflanzen. Als Attribute von Heiligen und Göttern gleichermaßen regen die Dinge der Natur dazu an, sie auf ihren Sinngehalt zu hinterfragen. Das aufwendige Werk von Mirella Levi D'Ancona „The Garden of the Renaissance. Botanical Symbolism in Italian Painting"[31] ist in diesem Sinne Erwin Panofsky, „The Great Master of Iconology", gewidmet. Hierin kann der Leser zu 160 Pflanzen symbolische Bedeutungen nachschlagen, die durch entsprechende Quellen belegt werden sollen.[32]

Lottlisa Behling verbindet in ihrer mehrfach aufgelegten und quellenreichen Studie „Die Pflanzen in der mittelalterlichen Tafelmalerei"[33] ihre beiden Studienfächer – Naturwissenschaften und Kunstgeschichte – miteinander:

> Man muss botanisch unterrichtet sein, um die Pflanzen in der mittelalterlichen Kunst naturwissenschaftlich zu erfassen, und man muss mit kunstwissenschaftlicher Methode vertraut sein, um das über die Natur hinausgehende eigene Form- und Gestaltungsgesetz und den symbolischen Sinn mittelalterlicher Kunst zu erkennen.[34]

Neben Überlegungen zur Symbolik finden sich in der Forschung Fragestellungen zur Verknüpfung von Menschen- und Pflanzenwelt. Dazu liefern Bücher wie Helmut Birkhans „Pflanzen im Mittelalter. Eine Kulturgeschichte"[35] oder Werner Teleskos „Die Weisheit der Natur"[36] einen Überblick. Besonderes Aufsehen erregte Fritz Koreny, der 1988 das veristische

29 Dies kann für Kräuterbücher des 16. Jahrhunderts nicht behauptet werden: Fuchs oder Brunfels legten sogar explizit Wert auf die Abbildung der Wurzel, die häufig der wichtigste medizinische Bestandteil der Pflanze ist. Swan (2011), S. 187.

30 Hierzu insbesondere die Sammelbände zu „Autorität" von Büttner / Wimböck (2004) und „Evidentia" von Wimböck u. a. (2007).

31 Levi D'Ancona (1977).

32 Levi D'Ancona (1977), S. 7: „About 160 plants are systematically explained, over 1000 publications have been consulted for the meanings and sources of plant symbolism here included and over 25,000 paintings have been examined for the tabulation of their plant motifs."

33 Behling (1957). Darin, S. 85–100: ein Exkurs zum „Gart der Gesundheit". Behling erforschte auch Dürers Pflanzenstudien: Behling (1989). Weiter zur symbolischen Entzifferung von Pflanzendarstellungen: Schiedermair (2007). Schiedermair verwendete Brunfels' Kräuterbuch aus dem 16. Jahrhundert, um die gemalten Pflanzen im Kirchenraum zu identifizieren und ihren Symbolcharakter zu ermitteln. Die Nachfrage nach solchen Lesarten gemalter Pflanzen in sakralen Räumen unterstreichen die Veröffentlichungen von: Dressendörfer (2012) und Comes (2013).

34 Behling (1957), S. 7.

35 Birkhan (2012).

36 Telesko (2001).

Aquarell einer Pfingstrose von der Hand Martin Schongauers entdeckte und damit die „mit Abstand früheste Naturstudie der deutschen Renaissance".[37] Seine Auseinandersetzungen mit Tier- und Pflanzenstudien der Renaissance sind für die Beschäftigung mit Naturdarstellungen der Frühen Neuzeit grundlegend geworden.[38] Pächts Überlegungen zum „Naturporträt" hallen bei Koreny nach. Die Naturstudie gilt für ihn als markantes Merkmal für den Renaissancekünstler im Gegensatz zum mittelalterlichen Maler:

> Als Vertreter der „artes liberales" erfüllt von neuem Selbstverständnis, nähert sich der Künstler in der schauenden Erforschung der Natur der Wissenschaft. Von Giotto über Giovannino de' Grassi oder Pisanello können wir eine ständig zunehmende Naturgenauigkeit beobachten, die an der Wende des 15. zum 16. Jahrhundert, am Beginn der Renaissance, bei Leonardo und Dürer mit der Aussage des Künstlers und der Sachlichkeit des Naturforschers zu jener Art von Naturdarstellung verschmolz, deren zeichnerische Umsetzung in signifikanter Weise zum Resultat sehenden Erkennens wurde.[39]

Dieser Ansatz, dass Sehen bzw. das Bild als Ersatz für das Sehen aus erster Hand zur Erkenntnis führen kann, wurde vor allem in der Wissenschaftsgeschichte und Bildwissenschaft wieder aufgegriffen.

2.4. Pflanzenbilder in Bildwissenschaft und Wissenschaftsgeschichte

Der Blick eines Mediziners oder Botanikers auf die Pflanzenillustrationen bzw. medizinischen Illustrationen im Allgemeinen stellt sich mitunter völlig anders dar.[40] Neben ihren Ausführungen zur Geschichte des Kräuterbuchs hat sich Arber auch zum „Sehen und Denken in der biologischen Forschung" geäußert. Im Kapitel „Auge und Geist" schreibt sie:

> Betrachtet er [der Biologe] eine Pflanze oder ein Tier, so sieht er sie leicht nicht, so wie sie sind, sondern von seinem anthropozentrischen Standpunkt aus. Mit dem Ergebnis, dass der visuelle Eindruck nicht seinen vollen Inhalt hergibt, wie er ihn nur einem Geist bieten kann, der mit

37 Koreny (1991), S. 111. Die Darstellung der Pfingstrose wurde 1991 in Colmar erstmals ausgestellt und Martin Schongauer zugeschrieben. Zuletzt erschienen zwei Habilitationsschriften zu Schongauer: Kemperdick (2004) und Heinrichs (2007). Es gibt Hinweise, dass Dürer die Pfingstrosenstudie selbst besaß, vermutlich sogar von den Brüdern Martin Schongauers bei einem Aufenthalt in Colmar geschenkt bekam. Siehe auch: Kat.Ausst. Frankfurt a. M. (2013), Nr. 2.3.

38 Kat.Ausst. Wien (1985). Koreny (1989).

39 Kat.Ausst. Wien (1985), S. 13 f.

40 Von botanischer, pharmazeutischer und medizinhistorischer Seite sind zahlreiche Namen zu nennen, die sich mit der Historie der Pflanzenillustration auseinandersetzen, insbesondere der Philologe und Medizinhistoriker Bernhard Schnell, die Medizinhistoriker Johannes Gottfried Mayer und Gundolf Keil sowie die Pharmaziehistoriker Wolf-Dieter Müller-Jahncke und Werner Dressendörfer. Ihre Arbeiten bewegen sich zwischen Theorie und Anwendung von Heilpflanzen im Mittelalter sowie ihrer Darstellung in Bild und Text. Gerhardt / Schnell (2002). Schnell (2003). Schnell (2009). Schnell / Crossgrove (2003). Mayer u. a. (2009). Keil (1993). Müller-Jahncke (1984). Müller-Jahncke (1987). Müller-Jahncke (1995). Dressendörfer (2003).

dem Geschehen eins wird und so die starre Trennungswand zwischen Subjekt und Objekt nie-
derreißt.[41]

Mit ihrer Problematisierung des Bildwerdens von Beobachtungen[42] stößt die Biologin an eine
zentrale Fragestellung, die seit der Antike erörtert wurde: Sollten medizinische Traktate oder
Herbarien illustriert werden? Bergen Bilder nicht zu viele Missverständnisse und Übertragungs-
fehler für die menschliche Wahrnehmung in sich?[43] Diese Fragen legen zunächst die Berüh-
rungspunkte der Bildwissenschaft, der „Visual Culture" und der Naturwissenschaft fest,[44] die
sich mit der medizinischen Illustration und ihrer Geschichte beschäftigen und die das (schein-
bar) objektive Bild diskutieren.[45]

Eine Grundlage legte Felix Andreas Baumann mit seiner Habilitationsschrift zum „Erbario
Carrarese" und der Bildtradition des „Tractatus de herbis".[46] Seine Kriterien und Begriffe zur
Beschreibung von Pflanzenillustration als „Schema", „Schema mit Naturbeobachtung", „be-
ginnende Naturbeobachtung" etc. lieferten Kategorien und das Vokabular, um Pflanzenstudien
zunächst möglichst „objektiv" zu analysieren.[47] Dieses Ordnungssystem ist nur ein möglicher
Weg, sich Naturillustrationen anzunähern.[48] Baumann „ist sich bewusst, dass es gefährlich ist,

41 Arber (1960), S. 105. Arbers „The mind and the eye. A study of the biologist's standpoint" erschien
 erstmals 1954.

42 Zur Naturbeobachtung: Daston (2011).

43 Bspw. schreibt Ulrich Pfisterer zu diesem Thema: „Der Mensch begeht Fehler, erliegt vermeintlich
 seinen Sinnen gerade nicht aufgrund unzureichender Sinnesorgane, sondern durch mangelhafte in-
 tellektuelle Verarbeitung und Kontrolle der Informationen. Vor diesem Hintergrund wird unmittel-
 bar verständlich, warum Ausführungen zur Wahrnehmung vielfach – so etwa bei Albertus Magnus
 und Thomas von Aquin – im Rahmen von Tugendlehren abgehandelt werden [...]: Die Sinneswahr-
 nehmung als solche ist sozusagen wertneutral, erst die intellektuelle Verarbeitung entscheidet über
 richtig und falsch, über gut oder schlecht." Pfisterer (2004), S. 165 f.

44 Arbers Ausführungen beziehen sich auf den Wissenschaftstheoretiker Ludwig Fleck. Dieser hatte 1947
 seinen Aufsatz „Schauen, Sehen, Wissen" veröffentlicht; zuletzt herausgegeben in einem Sammelband
 von 2011: Fleck (2011). Der Theoretiker erklärt darin kurz, dass wir sehen, was wir wissen. Wissenschaft-
 liche Objektivität beruhe für ihn auf dem Wissensvorrat, der Erfahrung und Tradition eines Denk-
 kollektivs. Dieser „Denkstil" sei ausschlaggebend für die Wahrnehmung des „objektiven" Wissen-
 schaftlers. Hierzu weiter: Rimmele / Stiegler (2012), S. 144–156: „Das wissenschaftliche Auge". Ebenso:
 Breidbach (2005) zur „Kulturgeschichte wissenschaftlicher Wahrnehmung" oder Kemp (2005).

45 Für die Naturwissenschaftshistorikerin Brigitte Hoppe entstanden z. B. erst Mitte des 15. Jahrhun-
 derts in Italien und im süddeutschen Raum erste sachliche Illustrationen von naturwissenschaftlicher
 Bedeutung: Hoppe (1970). Zum Schlagwort „Objektivität": Daston / Galison (2007).

46 Baumann (1974). Gleichzeitig zu einer „Sehschule" lieferte Baumann eine Übersicht zur Bildtradi-
 tion der Carrara-Handschrift, mit der er sich in seiner Studie intensiv auseinandersetzte. Dabei ent-
 stand eine bedeutende Bestandsübersicht spätmittelalterlicher illustrierter Pflanzenbücher in Italien,
 Frankreich und Deutschland.

47 Auch die Apothekerin Susanne Baumann weist in ihren wissenschaftlichen Ausführungen Ähnlich-
 keit zu Felix Andreas Baumanns Begrifflichkeiten auf: Baumann (1998). Ebenso die Apotheker Bau-
 mann und Baumann, die eine ausführliche Auflistung anhand der Kategorien „Naturbeobachtung"
 bis „Schematisierung" zum „Gart der Gesundheit" und den Mainzer Kräuterbuchinkunabeln gelie-
 fert haben: Baumann / Baumann (2010), S. 159–176.

48 Dass diese an die Kräuterbücher herangetragene „Objektivität" scheitern muss, kann man bei Daston
 nachlesen: Daston (2005) oder auch Daston /Galison (2007).

aus unserer heutigen Sicht heraus Kategorien aufzustellen, nach denen das Verhältnis zur Natur beurteilt werden soll [...]."[49] Da es zu keinem Zeitpunkt das alleinige Kriterium von Abbildungen in naturwissenschaftlichen Texten gewesen sein kann, ein naturnahes Bild zu erzeugen (die Überlieferung bekannter Bildtraditionen ist beispielsweise ebenso ein Kriterium), ist es notwendig, sich von der ständigen Überprüfung, ob das Bild im Pflanzenbuch naturnah ist oder nicht, zu lösen. Die Illustrationen des „Gart" sollen deshalb im Folgenden vielmehr als Teil der visuellen Kultur der Wissenschaftsgeschichte analysiert werden.

Mit diesen Überlegungen zur Illustration im naturwissenschaftlichen Kontext sind unweigerlich Aspekte der Bildtheorie verbunden, die von kunsthistorischer und wissenschaftshistorischer Seite verhandelt werden. Die Biologin Kärin Nickelsen hat dafür plädiert, dass nicht die künstlerische Originalität zur Beurteilung von Pflanzenbildern herangezogen werden dürfe. Vielmehr verkenne der moderne Forscher, der seinen Blick auf die Ästhetik botanischer Malerei richtet, die inhaltlichen Dimensionen der Pflanzendarstellungen. Abbildungen von Pflanzen begreift Nickelsen als Ergänzungen zu Herbarien und Gärten sowie als Grundlage botanischer Forschung und wissenschaftlichem Austausch. Hierzu müssten, über zeitliche und geographische Distanzen hinweg, die Objekte zugänglich gemacht werden. Als Wissenschaftshistorikerin betont sie, dass sich mit neuem Erkenntnisgewinn ebenso die Repräsentation und die Interpretation der Pflanzenbilder verändern, was die Darstellungen als epistemische Objekte qualifiziert.[50]

Diskurse, die sowohl die Ästhetik als auch den wissenschaftlichen Gehalt der Pflanzendarstellungen berücksichtigen, gibt es spätestens seit Ernst Gombrichs Ausführungen in „Kunst und Illusion".[51] Aktuell untersuchen unter anderem Sachiko Kusukawa, Karen Reeds und Claudia Swan den Künstler als Naturwissenschaftler und die Naturwissenschaftler mit dem Auge für Kunst neu.[52] Ihre Ansätze im Umgang mit naturwissenschaftlichen Illustrationen wurden an

49 Baumann (1974), S. 22.
50 Nickelsen (2000), S. 9 f.
51 Seit Gombrichs Monographie „Kunst und Illusion" wurde die Vorstellung, dass der „Renaissance-künstler" die Natur im Bild widerspiegelt, weitgehend revidiert. Auch die Illustrationen der Pflanzenbücher stehen damit auf dem Prüfstand. Denn, wie Gombrich betont, gibt es kein Auge, das „unschuldig" das Gesehene ins Bild setzt. Immer erzeugt, erfasst und organisiert es den zu vermittelnden Gegenstand. Gombrich (1960), S. 320–362. Hieran schließen sich u. a. die Schriften von Ackerman (1985), Goodman (1997) und Kemp (2004) an. Mit der Etablierung des naturnahen Bilds im naturwissenschaftlichen Kontext des 16. Jahrhunderts sind häufig Probleme in der Beurteilung durch den Betrachter – insbesondere von Abbildungen vor 1500 – verbunden. Reeds und Kusukawa haben im Anschluss an Gombrich darauf hingewiesen, dass eine nach allen Regel der Kunst gestaltete, eine naturalistisch anmutende Abbildung nicht automatisch auch „wahr" sei. Der Betrachter überlasse sich jedoch der Illusion der Authentizität des „schönen", „naturnahen" Bilds allzu gerne, wobei „naturnah", „schön", „richtig" und „wahr" ineinander fallen. Reeds (1990), S. 766–768. Reeds (2006), S. 205–207. Kusukawa (2012), S. 4–8. Den Zusammenhang von moralisch „gut", „wahr" und „schön" arbeitet Pfisterer nicht nur für die Naturillustration, sondern allgemeiner für die Kunst um 1500 heraus: Pfisterer (2004).
52 Ebenso: Bredekamp u. a. (2008). Dackerman (2011). Egmond (2017). Givens (2005). Ogilvie (2008). Reeds (1991). Smith / Findlen (2002). Smith (2006). Smith / Schmidt (2007). Swan (2006). Für das 16. und 17. Jahrhundert liefern zudem wichtige Beiträge: Felfe (2015a), Felfe (2015b) und Fischel (2009). Siehe auch das u. a. von Horst Bredekamp 2003 initiierte Jahrbuch: Bildwelten des Wissens. Ein zentrales Nachschlagewerk zur Wissenschaftsgeschichte mit zahlreichen Beiträgen zur naturwissenschaftlichen Illustration ist die „Cambridge History of Science": Lindberg u. a. (2003–2013).

den „Gart" bislang nicht herangetragen. Gerade Kusukawas erfolgreiche Monographie „Picturing the Book of Nature"[53] hebt das Bild als argumentative Größe im wissenschaftlichen Kontext des 16. Jahrhunderts hervor, das nicht nur illustrativ neben dem Text herläuft. Zentrale Figuren ihrer Studie sind der Mediziner und Kräuterbuchautor Leonhart Fuchs (Abb. 155, 159–160) sowie der Anatom Andreas Vesalius, die ihre Buchillustrationen als „visuelle Argumente" einsetzten, die neuestes botanisches und anatomisches Wissen veranschaulichen sollten.[54] Ohne bildliche Darstellungen ergäben die naturwissenschaftlichen Texte von Fuchs und Vesalius keinen Sinn. Dass die Abbildung, insbesondere von etwas Abwesendem, wie einer fremden Pflanze oder dem Inneren des Körpers, im Mittelalter nicht als Teil eines Arguments oder als Argument selbst eingesetzt werden konnte, hat bereits Daston betont. Erst in der Frühen Neuzeit könne das Bild den abwesenden Forschungsgegenstand ersetzen und Diskussionsgrundlage werden.[55] Es wird zu zeigen sein, inwiefern sich im „Gart der Gesundheit" Anfänge eines neuen Einsetzens von Bildern als Basis wissenschaftlicher Auseinandersetzung und Erkenntnis abzeichnen. Fuchs' Illustrationen analysiert Kusukawa als Kompositionen, als „absolute Bilder", die ein Exemplar darstellen sollen und dennoch über direkte Beobachtung entstanden sind sowie darüber hinaus auch als Kunstwerke wahrgenommen werden.[56]

Das Anatomiebuch von Vesalius und das Kräuterbuch von Fuchs stehen bei Kusukawa am Ende einer im 15. Jahrhundert beginnenden Entwicklung, die, so die These des vorliegenden Buchs, im „Gart der Gesundheit" ihren Anfang nahm. Es ist auffällig, dass Kusukawa den „Gart" nicht in ihre Analysen einbezieht, lediglich der etwas später entstandene „Hortus sanitatis" wird erwähnt, um die Überlegenheit der Abbildungen der Kräuterbücher von Leonhart Fuchs vorzuführen.[57] Durch den Blick vom 16. Jahrhundert zurück auf das Spätmittelalter blieb die Bedeutung des „Gart" für die naturwissenschaftliche Illustration weiter unbeachtet.

2.5. Der „Gart der Gesundheit" in der Forschung

„Fachliteratur"

Handschriften, Sammelhandschriften und frühe Drucke, die sich mit spezifischen Sachthemen auseinandersetzen, werden außerdem von der „Fachprosaforschung" bearbeitet. Der „Gart der Gesundheit" ist ein Werk, das Wissen vermitteln soll, und wird unter diesem Aspekt in der Germanistik als „Fachliteratur"[58] behandelt:

53 Kusukawa (2012). Vgl. auch die ausführliche Rezension von Ambrosio (2015).
54 Z. B. Kusukawa (2012), S. 100–123. Kusukawa kann anhand z. T. gerichtlicher, schriftlicher Auseinandersetzungen die Bedeutung des Bilds im naturwissenschaftlichen Diskurs des 16. Jahrhunderts aufzeigen. Dabei werde nicht nur mit Worten, sondern auch mit und durch Bilder argumentiert.
55 Daston (2005).
56 Kusukawa (2012), S. 114–123.
57 Kusukawa (2012), S. 17 f.
58 Synonyme: Fachprosa, Sachliteratur, Gebrauchsliteratur, Wissensliteratur, Ratgeberliteratur etc. Den Begriff führte der Heidelberger Mediävist Gerhard Eis in die Literaturwissenschaft ein. Einen kurzen Überblick liefert: Heydeck (2003), S. 340 f. Zur medizinischen Fachsprache: Riha (1994). Riha (1995). Zur Fachsprache in Kräuterbüchern: Habermann (2001). Stannard (1990). Stannard / Stannard (1999). Speziell zur Sprache des „Gart der Gesundheit": Morgan (1985). Darüber hinaus existie

Ein fachliterarischer Text ist an einen konkreten Gegenstand und um seiner Autorität beim Leser willen vor allem an Klarheit in der Darstellung, Wahrheitstreue und Objektivität gebunden. [...] Sprachlicher Rang zeigt sich hier in der Meisterung komplizierter Sachverhalte und vor allem in der Fähigkeit des Autors, dem Leser einen Erkenntnisgewinn zu verschaffen.[59]

Wichtige Hinweise und zentrale Termini zur Bebilderung von Sachtexten[60] gibt Lieselotte E. Saurma-Jeltsch in ihrem Aufsatz „Vom Sachbuch zum Sammlerobjekt".[61] Mögliche Interpretationsansätze und Gebrauchszusammenhänge werden von Saurma-Jeltsch zum „Buch der Natur" zur Verhandlung gestellt und können auch an andere illustrierte Sachbücher des 15. Jahrhunderts herangetragen werden. In ihrem Beitrag begreift die Handschriftenexpertin die Illustration nicht nur als „Orientierungs- und Gedankenstütze", sondern die Bilder versicherten auch die „Wahrheit der Dinge". Darüber hinaus betont sie das Potential der Darstellungen, Erkenntnisse zu vermehren, indem sie eine „Vernetzung des Sehens" über den zu illustrierenden Text hinaus auf andere Texte oder andere Medien ermöglichen. Das „Buch der Natur" kann beispielsweise auf Prosatexte verweisen, auf Reiseliteratur oder auf Tafelmalerei. Den Besitzer von illustrierten Sachbüchern analysiert sie mit Bredekamp[62] als „neuen Prometheus", der das Sammeln und Ordnen in Natur- und Wunderkammern vorwegnimmt und in einen „kreativen, bearbeitenden und wissbegierigen Umgang mit der Natur"[63] eintritt.

Problematisch für die Erforschung des „Gart" ist das Fehlen einer kritischen Ausgabe, sodass auch im Folgenden nur wenig konkrete Aussagen über die Textquellen des Kräuterbuchs getroffen werden können.[64] Allgemein kann Habermann für den Text des „Gart der Gesundheit" im Vergleich zu den nachfolgenden Herbarien des 16. Jahrhunderts nachweisen, dass der Inhalt der Kräuterbücher relativ konstant blieb.[65] Anhand einzelner Pflanzenbeschreibungen in verschiedenen Werken zeigt sie über einen Zeitraum von 300 Jahren auf, dass sich Anordnung und Textgliederung – ergänzend müsste man hier auch die Illustrationen nennen – der Fachtexte, also die Art und Weise der Wissensvermittlung, stärker veränderten als deren Inhalt. Kräuterkundliche Fachtexte weisen eine enorme Beständigkeit in der Tradierung vom Mittelalter bis in die Neuzeit auf. Habermann stellt einzig eine intensiver werdende Entwicklung innerhalb der Ergänzung des tradierten Wissens durch empirische Erkenntnisse der Autoren heraus.[66] Dabei

ren diverse Sammelbände zu Fachtexten: Vaňková (2014). Goehl (2000). Keil (1995). Keil (1982). Zur medizinischen „Sachillustration" im Mittelalter: Grape-Albers (1977).

59 Heydeck (2003), S. 340.

60 Einen vielseitigen Überblick zu illustrierten Fachtexten zur Zeit des Buchdrucks gibt der Ausstellungskatalog „Prints and the Pursuit of Knowledge in Early Modern Europe": Kat.Ausst. Cambridge, Mass. (2011). Eine Einzelstudie zum „Buch der Natur" mit entsprechenden Literaturhinweisen liefert: Spyra (2005).

61 Saurma-Jeltsch (2006). Die dort genannten und kontextualisierten Begriffe „Kolumnenillustration", „Schautafel", „Gelehrtenbilder" finden auch in dieser Arbeit Verwendung.

62 Bredekamp (1993), S. 26–33.

63 Saurma-Jeltsch (2006), S. 463.

64 Schnell (2017), Nr. 70.3.

65 Habermann (2001), S. 376. So auch bereits Arber (1912), S. 55.

66 Als Beispiele nennt Habermann: Fuchs, Bock und Camerarius. Joachim Camerarius d. J. gab, ca. eine Generation nach Fuchs und Bock, 1586 ein deutsches und 1588 ein lateinisches Kräuterbuch heraus: Kreutterbuch Desz Hochgelehrten vnnd weitberühmten Herrn D. Petri Andreae Matthioli.

wurden die botanischen Anteile nur um Weniges umfangreicher, der heilkundliche Anteil bei Kräuterbüchern überwiege häufig bis ins 18. Jahrhundert. Den Text des „Gart der Gesundheit" stuft Habermann für die Kräuterbuchliteratur als „besonders wirkmächtig" ein.[67]

Die Illustrationen des „Gart der Gesundheit"

Kurze Erwähnung finden die Illustrationen des „Gart" häufig als Vorläufer für die Abbildungen der Kräuterbücher von Otto Brunfels, Leonhart Fuchs und Hieronymus Bock, die ca. 50 Jahre nach dem „Gart" erschienen sind. Im Vergleich mit den „New Kreüterbuchern", wie Fuchs seine Werke dezidiert betitelte, hat man die Abbildungen des „Gart" häufig abgewertet.[68] Sie wurden als „schlecht" beurteilt, als „roh, schematisch, nicht akkurat, unidentifizierbar".[69]

Neue Aspekte bringen vor allem Landau mit Parshall, Schmidt oder Ivins, die die Abbildungen unabhängig von ihren „Nachfolgern" beleuchten und als Kulminationspunkt der Kräuterbuchillustration zum Zeitpunkt ihres Erscheinens begreifen.[70] Darüber hinaus wurden die Illustrationen auch von medizin- bzw. pharmaziehistorischer Seite erforscht. Dabei arbeitete Müller-Jahncke heraus, dass einige der gemalten Pflanzendarstellungen aus dem „Codex Berleburg" als Vorlage für die „Gart"-Holzschnitte dienten.[71]

Die erste intensivere Analyse des „Gart" erfolgte durch Julius Schlosser in seiner „Studie zur Geschichte der Naturwissenschaften und Medizin des Mittelalters". Als Forscher in Berlin war er mit dem Codex Hamilton 407[72] vertraut (Abb. 8), der sich noch heute in der Berliner Staatsbibliothek befindet. Diese medizinische Sammelhandschrift, die vermutlich um 1400 in Frankreich entstand, zeigt auf Blatt 229–282 Darstellungen von 210 Pflanzen (oder Tieren), die medizinischen Nutzen versprechen. Die Kräuter sind alphabetisch angeordnet in französischer oder lateinischer Sprache. In seinem Beitrag vergleicht Schuster die Illustrationen dieser Handschrift und einer weiteren aus Königsberg, die derselben Traditionslinie folgt, mit denen

 Frankfurt: Feyerabend und Dack, 1586. VD16 M 1614. Hortvs Medicvs Et Philosophicvs. Frankfurt: Feyerabend, 1588. VD16 C 558.

67 Habermann (2001), S. 504.

68 Zu den „Gart"-Illustrationen u. a.: Schuster (1926). Behling (1957). Fuchs (2009) [1. Aufl. 1958]. Müller-Jahncke (1977). Landau / Parshall (1994). Niehr (1998). Schmidt (2000). Isphording (2008), S. 115–118. Schnell (2009). Baumann / Baumann (2010). Kat.Ausst. Schweinfurt (2011), S. 92 f. Schnell (2017), Nr. 70.3. Bakker (2018). 1966 gab Kölbl ein Faksimile des „Gart" unter dem Titel „Hortus sanitatis" heraus: Kölbl (1966). Zum „Gart" und seinen Illustrationen aus kommunikationswissenschaftlicher Sicht: Ivins (1969) [1. Aufl.: 1953]. Eisenstein (1997). Giesecke (2006). Im Anschluss an Kölbls Faksimile spricht Giesecke im Zusammenhang mit dem „Gart" stets von „Hortus sanitatis".

69 Reeds (2006), S. 237.

70 Schmidt bezeichnet den „Gart" als „Meilenstein der naturkundlichen Illustration": Schmidt (2000), S. 591.

71 Müller-Jahncke (1977). Müller-Jahncke urteilt, dass die Illustrationen des „Gart" hinter vergleichbaren Buchillustrationen und Tafelwerken der Zeit zurückbleiben. Allerdings bleibt offen, inwiefern die verschiedenen Medien miteinander vergleichbar sind: Müller-Jahncke (1977), Sp. 1671. Zum Verhältnis von „Codex Berleburg" und „Gart" siehe weiter: Kap. 4.2.3.

72 In Kap. 4.2.2. werden die Abbildungen des „Gart" mit denen des Cod. Ham. 407 verglichen. Zur Texttradition siehe unten S. 41 f.

des gedruckten „Gart" und beobachtet dabei diverse Gemeinsamkeiten. Alle Illustrationstypen führt er auf die „Secreta Salernitana", also die „Tractatus de herbis"-Tradition (Abb. 7), zurück[73] und kommt zu dem Schluss, dass von 379 Abbildungen des „Gart" 94 Abbildungen aus dem „Circa instans"-Bereich stammen, deren visuelle Veränderungen mehr oder weniger beabsichtigt seien. Er geht daher von einer heute unbekannten Vorlage aus, die der Holzschneider des „Gart" benutzt haben soll und die um 1400 entstanden sein muss.[74] Die restlichen Abbildungen des „Gart" seien häufig nach der Natur beobachtete Illustrationen. Der Botaniker deutet damit bereits in die richtige Richtung: Die „Tractatus de herbis"-Handschriften waren schließlich die Kräuterbücher, die im 15. Jahrhundert am umfassendsten illustriert waren.

Wie Schuster bemerkt auch Behling das „Auseinanderfallen" des „Gart" zwischen schematischen Abbildungen und solchen, „die mit erstaunlicher Prägnanz und zeichnerischer Vollendung die natürliche Erscheinungsform der Pflanze wiedergeben".[75] Dabei stellt sie Kritiker in Frage, die einen Widerspruch zwischen der angekündigten Naturtreue im Vorwort des „Gart" und den schematischeren Darstellungen sehen. In ihrer Analyse der Holzschnitte geht sie auf deren künstlerische Aspekte und die Naturnähe der Illustrationen ein und hält fest, dass in der Regel die wesentlichen Merkmale der Pflanze beobachtet und wiedergegeben wurden. Sie nimmt außerdem durchaus botanische Kenntnisse beim Künstler wahr.[76]

Unter kommunikationsgeschichtlichen Gesichtspunkten werden die Illustrationen des „Gart" in William W. Ivins' Studie untersucht. Zwar schreibt er zu den Abbildungen, sie seien „schön und gut gemacht", allerdings kommt es ihm vielmehr auf den „epochemachenden" Charakter des Werks an.[77] Ivins versteht die Renaissance nicht als Wiederentdeckung antiker Quellen,[78]

73 Schuster (1929), S. 206.

74 Schuster (1929), S. 218 f. Baumann / Baumann (2010) repetieren im Grunde diesen Befund, S. 116–122.

75 Behling (1957), S. 92.

76 Gleichzeitig griff Behling noch einmal die von Graf Solms angestoßene Diskussion auf, der als Identifizierung des sog. Hausbuchmeisters (bzw. Meister des Amsterdamer Kabinetts) den Künstler des „Gart der Gesundheit", Erhard Reuwich, vorschlug. Diese These stieß auf wenig Einigkeit. Behling führte weitere Argumente auf, die ihrer Meinung nach für eine solche Identifikation sprechen könnten. Behling (1957), S. 96–100. Eine Übersicht zu dieser Diskussion, neue Hypothesen sowie Quellenmaterial zum Künstler – allerdings auch ohne eindeutiges Ergebnis – liefert: Timm (2006), S. 287–313. Es sind Publikationen von Stephan Hoppe in Vorbereitung, die anhand der Route Reuwichs von Utrecht nach Mainz aufzeigen können, dass es sich beim Hausbuchmeister um Reuwich handeln könnte bzw. dass die Künstler eng zusammengearbeitet haben. Dabei zieht er unter anderem ein Stundenbuch von ca. 1480 heran, das dem Hausbuchmeister zugeschrieben und mit Kräutern ausgestaltet ist, die den Holzschnitten Reuwichs gleichen: London, British Library, Egerton 1146. Zu diesem Zeitpunkt könnte Reuwich durchaus das Stundenbuch (sog. „The Hunting Hours") angefertigt haben (Abb. 165). Weiterhin gibt es auffällige Übereinstimmungen architektonischer Elemente im Werk beider Künstler; vgl. den Vortrag von Hoppe „Erhard Reuwich zu Mainz. Ein Pictor Doctus vor Dürer" (2018, Zentralinstitut für Kunstgeschichte, München), der auch online zu finden ist (https://vimeo.com/showcase/5735760/video/271231124; letzter Zugriff: 13.09.2019). An dieser Stelle sei Stephan Hoppe herzlich für seine Ausführungen und Hinweise gedankt, die nicht mehr hinreichend in diese Arbeit einfließen konnten und hier nur angedeutet sind.

77 Ivins (1969), S. 34.

78 Ivins (1969), S. 16. Einzig in Geometrie und Astronomie, so Ivins, seien den Griechen herausragende Erkenntnisse gelungen.

„die Wende" entsteht für ihn aufgrund materieller und technischer Voraussetzungen.[79] Die Dru-
cke des „Gart der Gesundheit" sind vor allem als Informationsspeicher und zur Weitergabe von
Informationen zu denken, wobei die Bilder eine zentrale Funktion erfüllen mussten: Sie vermit-
teln und stellen dar, was nicht in Worte gefasst werden kann. Für Ivins entwickelten die Bilder
aufgrund ihrer weiten Verbreitung durch den Buchdruck ein eigenes von Worten unabhängiges
visuelles Symbol- oder Zeichensystem. Die Herausforderung für die Künstler bestand darin, so
effektiv die Umsetzung vom Objekt in den Druck zu meistern, dass die Bild-Information einem
größtmöglichen Publikum zur Verfügung gestellt werden konnte. Diese „Übertragungsleistung"
bedeutete für den Künstler sowohl eine formale Umsetzung vom Objekt in die Zeichnung als
auch eine technische Weitergabe von der Zeichnung zum Holzschnitt. Für Ivins stellt dies die
Basis für die wissenschaftliche Entwicklung der Frühen Neuzeit dar. Nicht nur ist der „Gart"
Teil der Wissenschaftsgeschichte, sondern auch der frühen gedruckten Buchkultur und Medien-
geschichte.

Parshall und Landau greifen in ihrer grundlegenden Monographie „The Renaissance Print"
auf diese Ausführungen von Ivins zur Übertragungsleistung zurück. Botanische Illustrationen
der Inkunabelzeit spielen bei ihnen eine entscheidende Rolle für die Entwicklung empirischer
Wissenschaft. Sie betonen die Bedeutung der Künstler als Augenzeugen.[80] Die „beschreibende
Wissenschaft", zu der sie die Botanik zählen, begann – beschleunigt und bestärkt durch den
Buchdruck – Objekte systematisch festzuhalten.[81]

Der „Gart" zwischen Wissenschaftsgeschichte und Bildtheorie

Über das gesamte Mittelalter hinweg waren Kräuterbücher die einzigen medizinischen
Werke, die ein durchgängiges Illustrationsprogramm mit kontinuierlicher Bildtradition
ausgebildet hatten.[82] Für die Bildwissenschaft und Medizingeschichte gelten sie daher als
wichtiges Bindeglied zwischen den Disziplinen. Darüber hinaus können erste botanische
Beobachtungen, die zu einer Ausdifferenzierung der naturwissenschaftlichen Teilgebiete
führten, an Kräuterbuchillustrationen nachvollzogen werden.[83] So wurden beispielsweise für
die Abbildungen des „Gart" feine morphologische Unterschiede und distinguierende Merkmale
von Pflanzen herausgearbeitet.[84] Am „Gart" kann außerdem der darin beschriebene Nutzen der
Medizin erfahrbar werden, die im 15. Jahrhundert als universitäres Fach immer stärker an Be-
deutung gewann. Daran schloss sich ein gesteigerter Bedarf an medizinischer Literatur an, die
meist auch bebildert war.[85]

79 Ivins (1969), S. 22 f.
80 Landau / Parshall (1994), S. 254.
81 Landau / Parshall (1994), S. 247.
82 Vgl. hierzu die Überblickswerke zur medizinischen Illustration im Mittelalter von: Sudhoff (1907)
 und Grape-Albers (1977).
83 Niekrasz / Swan (2006), S. 782–782.
84 Siehe Kap. 4.4.1.
85 Zu diesem wechselseitigen Verhältnis siehe beispielsweise den Sammelband „Books and the Sciences
 in History" mit einem Beitrag von Kusukawa („Illustrating Nature"): Frasca-Spada / Jardine (2000)
 oder Kap. 5.1.

Für das späte 15. und gesamte 16. Jahrhundert ist zu beobachten, dass sich illustrierte Werke mit dem Anspruch, Informationen zu tradieren und zugänglich zu machen, über ihren Gegenstand hinaus auch mit dem Bild an sich befassen.[86] Illustrationen, die Wissen festhalten, veranschaulichen, multiplizieren sollen, veranlassen die Autoren von Fachtexten dazu, zu den Möglichkeiten der Bilder in ihren Schriften Stellung zu nehmen. Dabei entsteht eine theoretische Beschäftigung mit dem Bild, die um 1500 gerade im deutschsprachigen Raum sonst nicht schriftlich dargelegt wird – abgesehen von Dürers Schriften zur Kunst – besonders im Vergleich zu den zahlreichen kunsttheoretischen Traktaten Italiens im 15. und 16. Jahrhundert. Dass Bernhard von Breydenbach 1485 in seinem Vorwort zum deutschsprachigen „Gart" über die Illustrationen seines Werks schreibt, macht ihn nicht zum Kunsttheoretiker, verschafft aber einen für diese Zeit äußerst bemerkenswerten Eindruck von seinem Verständnis zu den Herausforderungen und Möglichkeiten, die die gedruckte Illustration bietet, und den künstlerisch-technischen Bedingungen, denen ein evidentes Bild vorangeht: Er engagierte einen Maler, nahm ihn mit auf seine Pilgerfahrt nach Jerusalem und ließ ihn währenddessen Pflanzen „in ihrer rechten Farbe und Gestalt abbilden und entwerfen".[87] Neben Überlegungen zu Bildern in illustrierte Naturbücher setzte man sich in den Vorworten mancher Kräuterbücher auch theoretisch mit den Künstlern auseinander, die die Darstellungen anfertigten, sodass ebenfalls Aussagen zum Verständnis des Künstlers getroffen werden können.[88]

Darüber hinaus wird zu bedenken gegeben, dass die folgenden Analysen zu Pflanzenbildern häufig Rückschlüsse auf die Rolle des Bilds im 15. Jahrhundert im Allgemeinen zulassen, da eine strenge Unterscheidung zwischen wissenschaftlicher Illustration und Kunstwerk zu dieser Zeit nicht getroffen wurde.[89]

86 Kusukawa (1997). Kusukawa (2012).

87 „in iren rechten farben vnd gestalt laißen kunterfeyen vnd entwerffen": Bernhard von Breydenbach (1485), fol. 2v.

88 Zu Bernhard von Breydenbach und Reuwich: Kap. 3.5. Zum Künstler in Kräuterbüchern des 16. Jahrhunderts haben v. a. Egmond, Kusukawa, Smith und Swan intensiv geforscht, z. B. Egmond (2017). Kusukawa (1997). Kusukawa (2010). Kusukawa (2011). Kusukawa (2012). Smith (2004). Smith (2008). Swan (2008).

89 Niekrasz / Swan (2006), S. 791–796.

3. Im Garten der Gesundheit

Im ersten Hauptkapitel werden die Beteiligten an dem umfassenden Buchprojekt „Gart der Gesundheit" genauer beleuchtet. Dabei zeigt sich auf den ersten Blick der hohe Anspruch des Auftraggebers, der sowohl mit dem Autor als auch mit Drucker und Künstler etablierte Kenner auf ihren jeweiligen Gebieten engagierte, um ein neues Kräuterbuch zu kreieren. Außerdem werden der Aufbau und die Bild-Text-Struktur des Buchs untersucht; ein weiterer Abschnitt geht der Rezeption des Texts nach.

3.1. Pflanzen als Basis der Medizin

Vor einem tieferen Einblick in den „Gart der Gesundheit" sollen einige Grundlagen gelegt werden. Zuerst wird der Begriff des Kräuterbuchs präzisiert, im Anschluss erfolgt ein Überblick über die verschiedenen Textquellen für Kräuterbücher. Außerdem soll die Frage geklärt werden, wie man sich die körperlich-medizinische Wirkung von Pflanzen vorstellte. Abschließend wird die Marktlage für Pflanzenbücher und allgemeiner für gedruckte Bücher mit medizinischen Inhalten abgesteckt, um die Konkurrenzsituation auf dem Buchmarkt im 15. Jahrhundert verdeutlichen zu können.

„Kräuterbuch" – ein Anachronismus

Der „Gart" ist ein Kräuterbuch, das einfache medizinische Stoffe (*simplicia*) festhält, d. h. medizinische Mittel aus Pflanzen, Tieren und Mineralien, die nicht weiter verarbeitet werden mussten. Der Begriff „Kräuterbuch" ist für das 15. Jahrhundert ein Anachronismus, erst im 16. Jahrhundert taucht er für deutschsprachige Werke, die Heilpflanzen beschreiben, auf.[1] In der Schlusszeile der Erstausgabe des „Gart" heißt es, dass dieser „herbarius" am 28.3.1485 in Mainz gedruckt wurde. Eine Übersetzung von „herbarius" zu „Kräuterbuch" wurde in dem Werk nicht gegeben, sodass man streng genommen vom „Gart" stets als „Herbarius" sprechen müsste. Im Vorwort wird das Werk als „Gart der Gesundheit" bezeichnet, was sich bis ca. 1500 als Titel durchsetzte. Im 16. Jahrhundert wurden die Bearbeitungen des „Gart" zunehmend unter dem Titel „Kräuterbuch" herausgegeben.[2]

[1] Z. B. gibt Brunfels 1532 sein Buch mit dem Titel „Contrafayt Kreüterbúch" heraus. Ab dem 16. Jahrhundert meint der Begriff „Herbarium" eine Sammlung getrockneter, gepresster Pflanzen. Zur Begriffsgeschichte siehe: Schmitz (1998), Bd. 1, S. 385 f. und Schmitz (2005), Bd. 2, S. 101 f.

[2] Zu den Bearbeitungen des „Gart" bis ins 16. Jahrhundert: Mayer (2011).

Unter „Herbarius" verstand man bis ins 15. Jahrhundert einerseits die Gesamtheit aller Heil-
pflanzen (*herbae*), die der Mensch aus der Natur gewinnen konnte, und andererseits die Texte,
die das Wissen um die Heilpflanzen festhielten. In deutschsprachigen Texten wird kaum zwi-
schen „Kräutern" und „Pflanzen" oder „heilsamen Pflanzen" unterschieden. Im „Herbarius"
wiederum werden alle heilenden Pflanzen, Mineralien[3] und auch tierische Bestandteile (Kno-
chen, Haut etc.) versammelt. Zunächst sollte ein „Herbarius" möglichst alle aus der Natur ge-
wonnenen medizinischen Stoffe festhalten, ordnen und klassifizieren (nach dem Alphabet, nach
dem Wirkungsgrad o. ä.).[4]

„Herbarius" bezeichnet darüber hinaus bis ins 16. Jahrhundert auch den Kräuterkundigen
oder den Kräutergarten bzw. Orte, an denen die Heilpflanzen wachsen.[5] Der Begriff hat sich
für den „Gart der Gesundheit" und andere Herbarien des 15. Jahrhunderts etabliert und wird,
neben Kräuterbuch, auch im Folgenden verwendet. In der Regel lässt man mit dem „Gart" die
Literaturgattung der frühneuzeitlichen Kräuterbücher beginnen, deren integraler Bestandteil
das Bild der Pflanze ist.[6]

Zur Überlieferung von Pflanzenkompendien

Für den „Gart" als Heilmittelsammlung ist es wichtig, die zentralen Überlieferungsstationen
der antiken und mittelalterlichen Kräuterkompendien und ihre Überlieferung bis in die Neu-
zeit kurz darzustellen.[7] Die 435 Pflanzenkapitel des „Gart" setzen sich aus diversen Quellen
zusammen, über die man sich mangels einer kritischen Ausgabe nur zum Teil einigen konnte.

Die wichtigsten Auflistungen von Heilmitteln sowie systematische Ordnungsversuche der
Pflanzenwelt wurden im 15. Jahrhundert auf Aristoteles zurückgeführt. Die Schriften seines
Schülers und Nachfolgers Theophrast von Eresos (gest. um 290 v. Chr.) zur Pflanzenkunde
(„De causis plantarum", „Historia plantarum") beinhalten ca. 550 Pflanzenbeschreibungen, die
bis ins 16. Jahrhundert rezipiert werden.[8] Die medizinischen Schriften des griechischen Arz-
tes Dioscurides (1. Jahrhundert n. Chr.) wurden im 7. Jahrhundert von Isidor von Sevilla ins
Lateinische („De materia medica") übersetzt. Dioscurides' Autorität und sein Wissen zu Heil-
pflanzen sind während des gesamten Mittelalters bis in die Frühe Neuzeit unbestritten, sowohl
im christlichen als auch im arabischen Raum. Insgesamt führte er über 1000 Heilmittel an,
die sowohl pflanzliche als auch tierische und mineralische Stoffe umspannen und ausführlich
Standort, Aussehen, Vorkommen und Anwendungsgebiete der Heilmittel beschreiben.[9]

Isidor von Sevilla gab eine Pflanzenliste mit 310 Pflanzennamen nach Dioscurides wieder,
die eine zentrale Quelle des Mittelalters darstellte. Er übersetzte griechische Pflanzennamen ins

3 In der Regel sind Mineralien, Metalle, Edelsteine etc. im Kräuterbuch unter dem allgemeinen Begriff
 „Steine" aufgeführt.
4 Schmitz (1998), Bd. 1, S. 285 f.
5 Dilg / Keil (1991), Sp. 1476 f.
6 Dressendörfer (2003), S. 11. Dilg / Keil (1991), Sp. 1476 f. Schnell (2009).
7 Schmitz (1998), Bd. 1, S. 285 f.
8 Schulze (2011), S. 11 f.
9 Weiter zur antiken Überlieferungsgeschichte: Isphording (2008), S. 18–26. Schulze (2011). Collins
 (2000), S. 31–238, darunter auch ausführlich zur arabischen Tradition.

Lateinische – z. T. sogar ins Spanische – was eine einheitliche Benennung der Pflanzen über regionale Grenzen ermöglichte. Dies ist ein entscheidender Faktor für jede weitere Beschäftigung mit dem Gegenstand „Pflanze", der eindeutig identifiziert und beschrieben werden muss. Man nimmt an, dass die weiteren Heilmittelsammlungen des Mittelalters zunächst von Isidor beeinflusst waren.[10] So auch das im 11. Jahrhundert entstandene und als Textquelle für den „Gart der Gesundheit" wichtige Lehrgedicht „Macer floridus",[11] welches 2269 Hexameter umfasste und mehr als 60 Heilpflanzen mit ihrer medizinischen Wirkung beschrieb. Das Gedicht wurde vielfach erweitert, aus dem Lateinischen übersetzt und fand bis in die Frühe Neuzeit als Lehrtraktat Verwendung. 1477 wurde der „Macer floridus" erstmals in Neapel abgedruckt.[12]

Auch die erhaltenen Werke von Albertus Magnus (z. B. „De vegetabilibus") weisen auf eine breite und kontinuierliche Rezeption hin. Albertus Magnus stellte eine Kompilation von 500 Pflanzenarten zusammen, wobei er besonders auf Aristoteles und Theophrast zurückgriff. Albertus Magnus gilt, neben seinem zeitweiligen Schüler Thomas von Aquin,[13] als wichtigster Kommentator von Aristoteles im 13. Jahrhundert, den er als *princeps philosophorum* bezeichnete.[14]

Neben der Wiederbelebung der antiken Schriften des Aristoteles war die Rezeption und Übersetzung arabischer Schriftquellen zur Medizin die zentrale Bedingung für die Entfaltung medizinischer Werke im spätmittelalterlichen Europa. Ausgehend von den in der Schule von Salerno praktizierenden Ärzten, die auch als Autoren und Übersetzer aus dem Arabischen tätig waren, entstanden die wichtigsten Heilmittelkompendien, auf die auch der „Gart der Gesundheit" zurückgeführt werden kann.[15] Um 1150 entstand in Salerno die für den Text des „Gart" maßgebliche „Circa instans"-Tradition. Die Autorschaft des „Circa instans" wird einem Johannes oder Matthaeus Platearius zugeschrieben. Das Werk wird auch als „Liber de simplici medicina" bezeichnet.[16]

Erweiterte Versionen des „Circa instans" waren unter dem Titel „Secreta Salernitana" oder „Tractatus de herbis" seit etwa 1220 im Umlauf. Die „Tractatus de herbis"-Handschriften wurden in der Regel bebildert (Abb. 7–8). Die so entstandene Bildtradition, die bis zu 400 Illus-

10 Schmitz (1998), Bd. 1, S. 226. Baumann / Baumann (2010), S. 5–13.

11 Eigentlich heißt das Gedicht „De viribus herbarum" und wurde im Mittelalter einem Macer Floridus zugeschrieben. Als Verfasser gilt Odo de Meung, über den jedoch nichts Genaueres bekannt ist. Schon im 13. Jahrhundert wurde der „Macer" ins Mittelhochdeutsche übertragen („Älterer Deutsche Macer"), im frühen 15. Jahrhundert ins Frühneuhochdeutsche („Jüngerer Deutscher Macer"). Baumann / Baumann (2010), S. 57 f.

12 Macer Floridus: De viribus herbarum. Neapel: Arnold von Brüssel, 9.5.1477. GW M19661. Angeblich existiert eine illustrierte Ausgabe des „Macer floridus" von 1482 (gedruckt in Mailand bei Antonius Zarotus), so zumindest bei: Anderson (1977), S. 35. Bislang konnte keine illustrierte Ausgabe von 1482 ermittelt werden, ein illustriertes Exemplar erschien wohl um 1500 in Genf, das sich in der Bebilderung stark am „Gart der Gesundheit" orientierte. GW M19663. Antonius Zarotus gab 1473 in Mailand einen nicht illustrierten „Liber aggregatus in medicinis simplicibus" heraus. GW M41685.

13 Zum Verhältnis von Kunst und Natur bei Thomas von Aquin: Krause (2010).

14 Zu Albertus Magnus: Reeds / Kinukawa (2013), S. 573–578. Hauschild (2005).

15 Collins (2000), S. 239–287.

16 Die Schrift setzt mit den Worten ein: „Circa instans negotium [...]". Entstehung und Autorschaft des Werks sind unklar. Die Platiarii waren jedenfalls eine Ärztefamilie aus Salerno. Den einschlägigen Überblick zu den „Tractatus de herbis"-Handschriften liefert Baumann (1974), S. 102–115. Weiter zum „Tractatus de herbis": Givens (2006). Collins (2000), S. 239–255. Palmer / Speckenbach (1990).

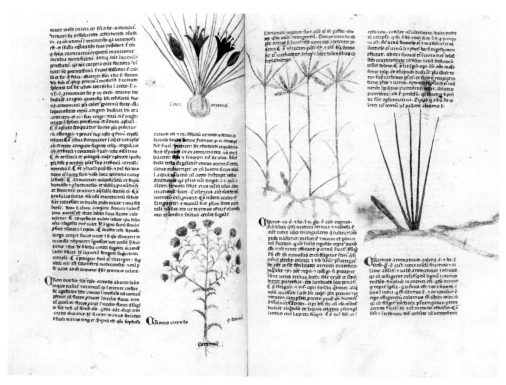

Abb. 7: Tractatus de herbis. Salerno, um 1300, Pergament, 147 Bl. London, British Library, Egerton 747, fol. 24v–25r.

trationen umfasst, bildet die Grundlage für die französischen Übersetzungen des „Tractatus de herbis", die „Livres des simples médecines" mit bis zu 490 Pflanzenbeschreibungen,[17] und für den „Gart der Gesundheit". Diese Abbildungen, die äußerst konstant weitergegeben wurden, müssen als besonders glaubwürdig und daher wirkmächtig betont werden. Ein verkürzter Text des „Circa instans" wird zusammen mit anderen Pflanzentraktaten und medizinischen Schriften[18] erstmals 1488 in Ferrara und kurz danach 1497 in Venedig abgedruckt.[19]

Ebenfalls aus der „Schule von Salerno" stammte der Arzt Matthaeus Silvaticus, der Anfang des 14. Jahrhunderts sein „Opus pandectarum medicinae" abschloss, worin er die medizinische Behandlung durch Heilkräuter beschreibt. Als Quellen für seine alphabetisch geordneten Heilmittel, die v. a. aus Pflanzen bestehen, dienten ihm insbesondere Schriften des Dioscurides und des persischen Arztes Avicenna (gest. 1037).[20] Sein Werk wurde 1474 vermutlich in Bolo-

17 Differenzierter führen das Verhältnis von „Circa instans" zu „Tractatus de herbis" aus: Baumann (1974), S. 99–101. Mayer (2014), S. 133–142. Für eine klärende Ausdifferenzierung danke ich Bernhard Schnell.

18 Darunter auch der „Liber aggregatus in medicinis simplicibus" und Galens „De virtute centaureae ad Papiam".

19 Johannes Serapion: Breviarium medicinae. Ferrara 1488. GW M41681. Johannes Serapion: Breviarium medicinae. Venedig 16.12.1497. GW M41687.

20 Durch Hartmann Schedels Aufzeichnungen zu Studienzeiten ist bekannt, dass die Schriften von Avicenna, Galen, Hippokrates etc. zum Medizinstudium gehörten – zumindest in Padua. Aus dem

Abb. 8: Abbildungen nach der „Tracta-
tus de herbis"-Tradition in einer medizi-
nischen Sammelhandschrift: Frankreich,
um 1400, Pergament, 286 Bl. Berlin,
Staatsbibliothek zu Berlin, Cod. Ham.
407, fol. 241v.

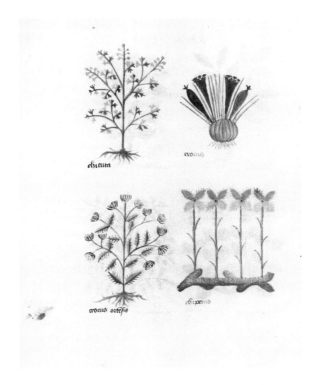

gna erstmals gedruckt.[21] Neben Salerno übertrug man vor allem in Spanien Schriften aus dem
Arabischen ins Lateinische. Ende des 13. Jahrhunderts wurde dort der „Aggregator" übersetzt,
der dem syrischen Arzt Johannes Serapion aus dem 9. Jahrhundert zugeschrieben wurde. Die
Schrift fand unter dem Namen „Liber Serapionis aggregatus in medicinis simplicibus" eine
ebenso große Verbreitung wie der „Circa instans". Mit der Nennung von 462 Drogen, die nach
ihren Wirkungsgraden geordnet wurden, bildete der „Aggregator" mit dem „Circa instans" zu-
sammen das Fundament für die Kompendien des 15. Jahrhunderts. Die medizinischen Grund-
lagen des „Aggregator" bildete unter anderem die Lehre Avicennas.[22]

Nicht nur der reiche Quellenbestand des „Gart", der sich hier nur ansatzweise andeutet,
stellt für die Forschung eine Herausforderung dar, auch das Bildprogramm mit 379 Holzschnit-
ten ist längst nicht hinreichend analysiert.

Nachlass seines Vorgängers als Stadtarzt von Nürnberg erbte Schedel außerdem mehrere medizini-
sche Handschriften, die Übersetzungen von Hippokrates und Galen enthielten. Kat.Ausst. München
(2014), S. 65–68.

21 Liber pandectarum medicinae, omnia medicine simplicia continens. [Bologna] 1474. GW M42128.
Weitere nicht illustrierte Drucke folgten bis ins 16. Jahrhundert. Hartmann Schedel besaß ein hand-
schriftliches Exemplar, in das er sein Porträt (?) (Abb. 33) einfügen ließ oder selbst einfügte (Mün-
chen, Bayerische Staatsbibliothek, Clm 30). Kat.Ausst. München (2014), S. 78.

22 Mayer (2014), S. 135 f. Zur Rezeption von Avicenna: Reeds / Kinukawa (2013), S. 572–576.

Wie wirken Pflanzen?

Die heilende Wirkung von Pflanzen auf den Menschen wird in praktisch allen medizinischen Schriften mit der Viersäftelehre erklärt. Auch dem „Gart der Gesundheit" liegt als medizinische Theorie der Zeit die Lehre der vier Säfte zu Grunde. Die „Viersäftelehre" oder „Humoralpathologie" wird von den Zeitgenossen auf die antiken Ärzte Hippokrates und Galen zurückgeführt.[23] Ihre Vorstellung von den Wirkkräften der Seele und der vier im Körper wirkenden Säfte wurde bis in die Frühe Neuzeit tradiert.[24] Die vier Temperamente bzw. „Komplexionen" (Sanguiniker, Phlegmatiker, Choleriker, Melancholiker) des Menschen wurden von Galen auf die sie dominierenden Säfte zurückgeführt.[25] Bei einer Störung der Körpersäfte, was im Gegensatz zum Einklang (Eukrasie) der Säfte als Dyskrasie bezeichnet wurde, könne der Mensch krank werden.

Ein Gleichgewicht der Säfte kann nach dieser Theorie durch Einnahme von Pflanzen bzw. Pflanzenextrakten erreicht werden, die ebenfalls die Qualitäten feucht, kalt, trocken und warm besitzen und damit Einfluss auf den Körper nehmen.[26] Dabei unterschied Galen vier verschiedene Wirkungsgrade eines Heilmittels: Im ersten Grad ist die Wirkung kaum spürbar, im zweiten Grad nehmen die Sinne die Wirkung deutlich wahr. Im dritten Grad kann das Mittel bereits leichte bis heftige Schäden verursachen. Mittel im vierten Grad sind mit Vorsicht einzunehmen, da sie tödlich sein können.[27] Im „Gart der Gesundheit" werden immer die Qualitäten der Pflanze (warm, kalt, feucht, trocken) angeführt und in der Regel auch ihr Wirkungsgrad angegeben.

Gesundheit als Verkaufsargument

Besonders medizinische Inhalte erfreuen sich Ende des 15. Jahrhunderts wachsender Beliebtheit am Buchmarkt, wo sich vor allem volkssprachige Drucke etablieren konnten.[28] Gerade

23 Schmitz (1998), Bd. 1, S. 195 f. Hippokrates von Kos starb um 370 v. Chr. Der griechische Arzt Galen praktizierte im 2. Jahrhundert n. Chr. in Rom.

24 In der Säftelehre werden die vier Grundelemente (Feuer, Wasser, Luft, Erde) mit Qualitäten (feucht, trocken, warm, kalt) und Geschmäckern (süß, bitter, sauer-scharf, salzig) in Beziehung gesetzt, die wiederum mit den vier menschlichen Körpersäften in Verbindung stehen (gelbe Galle, Schleim, Blut, schwarze Galle). Zudem existierte seit Hippokrates die Analogiesetzung der Säfte mit den Jahreszeiten und den vier Stufen des Lebens. Genauere Ausführungen findet man z. B. bei Klemm (2008).

25 Der Sanguiniker werde vom warmen, feuchten Blut beherrscht und damit dem Element der Luft zugeordnet. Im Körper des Phlegmatikers überwiege der Schleim, der ebenso feucht und kalt ist wie Wasser. Das Temperament der Choleriker wurde auf zu viel gelbe Galle zurückgeführt, die mit ihrer trockenen und warmen Disposition dem Feuer gleicht. Die trockene, kalte schwarze Galle ist analog gesetzt zum Element der Erde und damit auch zum Temperament des Melancholikers. Dressendörfer (2003), S. 16 f.

26 Zu Pflanzen als Heilmittel: Kap. 5.1.

27 Zur Lehre von den „Quattuor Humores": Klibansky / Panofsky / Saxl (1992), S. 40–54.

28 Habermann (2001), S. 1. Stellvertretend seien hier ins Gedächtnis gerufen: Rudolf von Hohenberg: Regimen sanitatis, das ist von der Ordnung der Gesundheit. Augsburg 1475. GW M37273. Heinrich Steinhöwel: Büchlein der Ordnung der Pestilenz, mit Widmungsvorrede des Autors an die Bürgerschaft von Ulm. Nürnberg, um 1484. GW M43857. Bartholomäus Metlinger: Regiment der jungen Kinder. Augsburg 1474. GW M23083.

in dichter bevölkerten Gegenden konnten regelmäßig Epidemien ausbrechen, was den Markt für medizinische Ratgeber[29] begünstigte.[30] Im Vorwort des „Gart" wird dem Leser deutlich gemacht, dass sich der Mensch seiner Gesundheit nie sicher sein soll: „So steht der Mensch tausend und abertausend Gefahren gegenüber, keinen Augenblick ist er seiner Gesundheit oder seines Lebens ganz sicher."[31] Dass im Titel des Werks bereits das Wort „Gesundheit" steckt, wird kein Zufall gewesen sein, denn der Schutz vor Krankheiten war ein Verkaufsargument. Der Erhalt der Gesundheit und die Krankheitsprävention durch die Anwendung der Viersäftelehre standen dabei im Vordergrund. Marsilio Ficinos „De vita" wird 1489 in Florenz gedruckt. Seine Ratschläge – besonders für geistig tätige Humanisten – zur Diätetik und zur Vorbeugung von Melancholie und der damit einhergehenden Austrocknung fanden europaweit Verbreitung.[32] Die deutsche Übersetzung Ficinos durch Johannes Adelphus Muling „Zum langen und gesunden Leben"[33] wurde zwischen 1505 und 1531 sieben Mal aufgelegt, u. a. zusammen mit dem Destillierbuch von Hieronymus Brunschwig.[34]

Die Initiatoren des „Gart" standen schon in den 1480er Jahren einer enormen Konkurrenz am Buchmarkt für medizinische Werke und Pflanzenheilkunde gegenüber. In der letzten Hälfte des 15. Jahrhunderts wurden diverse Nachschlagewerke zur Pflanzenheilkunde und die Geschichte der Kräuterbücher gedruckt: Die „Naturalis historia", Plinius' 37 Bücher zur Naturgeschichte mit Erläuterungen zur Medizin, zum Pflanzenreich und zur Heilmittelkunde,[35] war 1469 in Venedig herausgekommen.[36] Die deutsche „Ruralia commoda", ein um 1300 in Bologna entstandener Traktat zur erfolgreichen Landwirtschaft des Petrus de Crescentiis, erschien 1493.[37] Darin wurden Kräuter und Pflanzen nicht nur als Bestandteil der Landwirtschaft betrachtet, sondern auch ihre medizinische Wirkung auf den Menschen reflektiert.[38] In Magdeburg wurde 1483 das sogenannte „Promptuarium Medicinae" verlegt, das neben Aderlassregeln auch 338 pflanzliche und tierische Heilmittel festhielt, ohne sie abzubilden.[39] Ein mit Illustrationen ausgestattetes, gedrucktes Kräuterbuch hatte es vor dem „Gart" erst zweimal gegeben:

29 Meist „Fachbücher" oder „Sachbücher" genannt; nicht nur Fachbücher zur Gesundheit werden gedruckt, der Hang zur „Ratgeberliteratur" ist allgegenwärtig. In Nürnberg erschienen beispielsweise zwischen 1470 und 1490 diverse Bücher zum Handwerk und zur Technik sowie Kochbücher, Rechtsliteratur, chirurgische und mathematische Werke oder Wörterbücher und die Weltchronik des Hartmann Schedel. Kat.Ausst. Nürnberg (2012), S. 23 f.

30 1482 erlebte man beispielsweise in Mainz, dem Druckort des „Gart", eine Pestwelle. Kat.Ausst. Mainz (2000), S. 223.

31 Bernhard von Breydenbach (1485), fol. 2v.

32 Marsilio Ficino: De triplici vita. Florenz 3.12.1489. GW 9882. Immer noch grundlegend zu Ficino: Kristeller (1972), zu seiner Diätetik und Wahrnehmungstheorie insbesondere: Klemm (2013), S. 178–242.

33 Hieronymus Brunschwig: Medicinarius, Das buch der Gesuntheit Liber de arte distillandi Simplicia et Composita. [Straßburg] 1505. VD16 B 8718.

34 Mayer (2011). Siehe unten S. 165 f.

35 Schmitz (1998), Bd. 1, 179. Zum Pflanzenreich: Buch 12–19, zu Heilpflanzen: Buch 20–27, zur Medizin: Buch 20–32.

36 Plinius Secundus, Gaius: Historia naturalis. Venedig: Johann von Speyer, 1469. GW M34312.

37 Ruralia commoda. Petrus de Crescentiis zu teutsch, mit Figuren. [Speyer] 1.10.1493. (Folio, 236 Bl.). GW 7831.

38 Siehe dazu: Kap. 5.3. sowie die zweibändige Edition: Petrus de Crescentiis (2007/2008).

39 Magdeburg: Bartholomäus Ghotan, 31.7.1483. GW M35662. Dazu: Baumann / Baumann (2010), S. 75–98.

einmal den „Pseudo-Apuleius Platonicus"[40] (Abb. 2), der um 1482 in Rom erschien, sowie den sog. „Herbarius Moguntinus" von 1484 (Abb. 11).[41] Mit dem „Gart" kam 1485 ein Buch auf den Markt, das sich sowohl international als auch in Mainz und sogar im eigenen Verlag zunächst einmal durchsetzen musste (siehe Kap. 3.4.).

3.2. Der Aufbau des „Gart der Gesundheit"

Der „Gart der Gesundheit" wurde auf Papier gedruckt, umfasst 360 Blätter und erschien in der ersten Auflage im Folio-Format (ca. 280 × 200 mm). Der Text ist einspaltig und 42-zeilig angelegt, nur die Register sind zwei- bzw. dreispaltig.

Grundstruktur: Fünf Teile

Das Vorwort enthält eine ausführliche Erklärung zur Struktur des „Gart", der aus fünf Teilen besteht:

> Dieses Buch wurde in fünf Teile geteilt. Der erste ist die **Vorrede**, jetzt und hier, der zweite Teil ist von den **Wirkungen und Tugenden der Kräuter** und anderen Geschöpfen in alphabetischer Reihenfolge. Der dritte Teil wird ein **Register sein von Kräutern**, die abführen, die kräftigen, die wohl riechen [...]. Der vierte Teil **von allen Farben des Harns** und was eine jede Farbe bedeutet. Der fünfte und letzte Teil wird ein **Register** sein, damit man leichter alle Gebrechen und Krankheiten der Menschen, welcher Art auch immer, finden kann.[42]

Vor dem Vorwort wird ein Titelbild gezeigt, das nicht mit gedruckt, sondern nachträglich eingeklebt wurde (siehe Kap. 3.6.4.).[43] Das dreiseitige Vorwort ist gleichzeitig der erste Teil des Werks (fol. 2r–3r)[44], es folgt der ausführliche zweite Teil mit 435 Kapiteln zu medizinischen Drogen (fol. 4r–338v).

Der dritte Teil (fol. 339r–340v), ein vierseitiges Register, ist zweispaltig gesetzt. Es unterteilt die Pflanzen in acht Unterkategorien (Mittel, die Stuhlgang erzeugen; Kräuter, die wohl riechen

40 Siehe Kap. 1. und ausführlich bei: Olariou (2014), S. 51–53.

41 Herbarius Moguntinus. Mainz: Peter Schöffer, 1484. GW 12268. Der „Herbarius Moguntinus" zeigt Verknüpfungen mit dem Pseudo-Apuleius und dem „Promptuarium" und stellt v. a. eine erweiterte, verbesserte Fassung des Pseudo-Apuleius dar. Baumann und Baumann bezeichnen das Kräuterbuch als optimierte Fassung des Pseudo-Apuleius. Baumann / Baumann (2010), S. 99–110. Siehe auch: Schwabe (2006).

42 Bernhard von Breydenbach (1485), fol. 3r [eigene Hervorhebung].

43 Die Nachschnitte, die das Titelblatt teilweise auch mit drucken, zeigen, dass es von der Werkstatt von Anfang an für diese Position im Buch vorgesehen war.

44 Da der „Gart" nicht paginiert wurde, können die Blattangaben von Exemplar zu Exemplar abweichen, hier werden die Blattangaben gemacht (nach: 2 Inc.c.a. 1601, BSB München), um einen Eindruck vom jeweiligen Umfang der Teile zu vermitteln. Im Folgenden werden in der Regel keine Blattangaben für den „Gart" gebraucht, sondern die Kapitelnummern zur Orientierung im Buch angegeben.

und dadurch kräftigen; gummiartige Pflanzen; Früchte; Samen; Wurzeln; Edelsteine; Tiere und
was Nützliches aus ihnen entspringt). Durch eine größere Schrifttype und Absätze im Text sind
die Zwischenüberschriften im Register, die die Unterkategorien noch einmal benennen, leicht
erkennbar. Außerdem gibt es zu Beginn des Registers einen kurzen erklärenden Text (einspaltig)
zum dritten Teil, der als Hauptüberschrift fungiert und erklärt, was mit Hilfe des Registers ge-
funden werden kann.[45]

Auf der nächsten Seite beginnt der siebenseitige Urintraktat (fol. 341r–344r) mit einem Titel-
bild und der Überschrift: „Diß ist das vierde deyl deß buchs vnd saget vns von allen farben deß
harns".[46]

Das letzte Register, der fünfte Teil, umfasst 31 Seiten (fol. 344v–359v) und ist nach diversen
Bereichen geordnet, bei denen Kräuter Abhilfe verschaffen können, dieser Teilbereich wurde
dreispaltig gesetzt. Es beginnt mit einer einspaltigen Titelseite. Für den Leser werden hier, unter
anderem, Krankheiten aufgezählt, die den Leib innen oder außen befallen können. Dem Nut-
zer des Registers wird erklärt, wie die Hinweise auf die Paragraphen aufzulösen sind, sowie die
Abkürzungen der Namen (Gal. für Galenus; Aui. für Avicenna etc.), denn das Register ver-
merkt auch die Namen der Meister, die als Quellen verwendet wurden.[47] Das Register folgt kei-
ner völlig stringenten Ordnung, man versuchte aber zuerst relativ hierarchisch vorzugehen:[48] Es
beginnt zunächst bei den oberen Körperbereichen des Menschen, dem Haupt (z. B. bei Kopf-
schmerzen, bei Schwindelgefühl, für ein gutes Gedächtnis, zum Gehirn) und dazu gehörenden
Teilbereichen: Augen, Ohren, Nase, Mund bzw. Zähne, Antlitz. Danach geht man weiter nach
unten in Richtung Hals und Lunge (zur Stimme, die Kehle, gegen Husten), es folgen die in-
neren Organe mit diversen Hinweisen zu Leber, Herz, Milz, Magen, Darm bzw. Krankheiten
in diesem Bereich wie Wassersucht, Gelbsucht oder gegen Übelkeit und weiter zu den Nieren,
Lenden, zur Blase etc. Mehrere Bereiche widmen sich speziellen Themen, wie Frauenkrankhei-
ten, Blut, Geschwüren, Wundarznei. Einzelfälle werden gegen Ende des Registers benannt, z. B.
Pestilenz, heiliges Feuer sowie welche Kräuter Wärme oder Kälte bringen oder aber gegen die
Unkeuschheit, Gifte oder Melancholie helfen. Einzelne „Hausmittelchen" werden dazwischen
eingestreut, z. B. ein Mittel gegen die Flecken, die die Sonne erzeugt; gegen Schweiß- oder
Knoblauchgeruch.

45 Johann Wonnecke von Kaub (1485), fol. 339r. Der Text wird, leicht verändert, auch im Vorwort ge-
 geben.

46 Johann Wonnecke von Kaub (1485), fol. 341r. Weiter zum Urintraktat: Kap. 5.2.

47 Fol. 344v: „Hie nach volget das funffte deyl vnd das lest diß buchs vnd ist ein register behende zu
 finden von allen krangheyten der menschen vßwendug vnd ynwendig des gantzen lybes vnd auch
 vil ander bewerter vnd boßlicher stuck Vnd salt mercken das in dißem register verzeychnet sint die
 paragrophi wan in iglichen capitel findestu paragraphes in einem meen in den anderen mynner nach
 dem das capitel vil oder wenig dogent hait. Auch sint verzeychet in dissem register die meister vns
 solich artzneyen geben des verzeychten capitels vnd wan du liesest pa. oder para. das ist paragraphus
 vnd den zele in dem selbigen capitel oder zeichen selber die zal vf spacium der capitel so darfestu
 dester mynner alle zyt die paragraphons zelen vnd die lerer also Aui. das ist Auicenna Ga. oder Gali.
 das ist Galenius Pla. Platearius Pli. Plinius Dias. Diascorides Sera. Serapio Pau. Paulus et cetera vnd
 alle mal die zal da by als i ii iii iiii v vi et cetera."

48 Das „Buch der Natur" ordnet ebenfalls, wie Saurma-Jeltsch schreibt, „hierarchisch". Es beginnt beim
 Menschen von Kopf bis Fuß, danach folgen die Tiere, die Pflanzen, die Edelsteine. Saurma-Jeltsch
 (2006), S. 432 f.

Der letzte Teilbereich des Registers (fol. 357rb–359v bzw. S. 713b–718) ist zweispaltig gesetzt und gibt eine alphabetische Liste der behandelten Heilmittel nach den lateinischen Namen.[49] Es endet mit dem Kolophon von Peter Schöffer.

Nur eine Seite innerhalb des gesamten Werks ist frei gelassen (zwischen dem Vorwort und dem zweiten Teil), was dem Leser Opulenz darbietet und bereits auf den ersten Blick einen allumfassenden Eindruck vermittelt, der auch im Text verschafft werden soll. Dennoch wirkt es nicht überladen, innerhalb der Binnenstruktur wurde den Illustrationen viel Raum gegeben. Häufige Absätze und Titelblätter wirken strukturierend. Erklärende Titelblätter wurden für die Register verwendet, illustrierende „Titelblätter" für den Urintraktat und das Gesamtwerk.[50]

Habermann machte in ihrer Studie die leserfreundliche Struktur des „Gart" für seinen Erfolg verantwortlich.[51] Zwar gibt die Mainzer Erstausgabe noch keine Seitenzahlen,[52] allerdings machen Inhaltsverzeichnisse, Kapitelnummerierung und ausführliche Register eine einfache Texterschließung und schnellere Orientierung für den Leser möglich. Diese Mittel sind allgemein ein Charakteristikum des frühen Buchdrucks und werden auch im „Gart" eingesetzt, der eine übersichtliche Textgestaltung durch größere unbedruckte Abstände und Satzzeichen bietet.[53] Das nach Krankheiten und unter arzneikundlichen Aspekten zusammengestellte Register wurde mitunter sogar als eigenständiger Text rezipiert.[54]

Binnenstruktur: Pflanzenbeschreibung

> In diesem Garten findet man die Wirkungen und Tugenden von 435 Kräutern und anderen Geschöpfen, die der menschlichen Gesundheit dienen und gemeinhin in Apotheken als Arznei gebraucht werden, [...].[55]

In insgesamt 435 Kapitel werden im Verhältnis circa 382 pflanzliche, knapp 20 tierische und etwa 30 mineralische Drogen mit ihrem lateinischen und deutschen Namen benannt und auf Deutsch beschrieben.[56]

49 Dass den Nutzern ein Register nach deutschen Pflanzennamen fehlte, zeigen diverse handschriftliche Ergänzungen eines solchen Registers nach der deutschen Nomenklatur (siehe: Kap. 3.7.1.), und auch die Nachschnitte des „Gart" in Augsburg ergänzten ein gedrucktes Register nach den deutschen Pflanzennamen (z. B. die Auflage von 1488 in Augsburg; GW M09757).

50 Der Ausdruck „Titelblatt" bezieht sich auf die Blätter, die den jeweiligen Teilbereichen vorangestellt wurden. Sie müssten vielmehr „Zwischentitelblätter" o. ä. heißen. Dressendörfer verwendet beispielsweise den Begriff „Zwischentitelblatt" für den „Hortus Eystettensis": Dressendörfer (2003), S. 186. Der Begriff „Titelblatt" trifft auch nicht einwandfrei für das einleitende Bild zum „Gart der Gesundheit" zu: siehe Kap. 3.6.4.

51 Habermann (2001), S. 77 f.

52 Schon in den ersten Nachschnitten, z. B. in Augsburg 1485 und Ulm 1487, werden Seitenzahlen hinzugefügt. Der „Hortus sanitatis" ist von Anfang an mit Seitenzahlen konzipiert.

53 Diese leserfreundliche Textaufbereitung war für den Setzer durchaus mit Schwierigkeiten verbunden. Giesecke (2006), S. 98–103.

54 Habermann (2001), S. 142.

55 Bernhard von Breydenbach (1485), fol. 2v–3r.

56 Die Grenzen zwischen pflanzlich, tierisch und mineralisch sind häufig fließend. Schnell (2017).

Die Pflanzenbeschreibungen folgen einem Schema, das seit der Antike praktiziert wurde: Zunächst wird der lateinische, dann der deutsche Name der Pflanze genannt sowie die Kapitelzahl. Diese Kapitelüberschrift ist – leserfreundlich – durch eine größere Schrifttype hervorgehoben.[57] Der Text beginnt mit der erneuten Nennung der Pflanzenbezeichnung auf Latein, Griechisch und Arabisch. Es folgen Angaben, welcher Autor bzw. welche Quelle bereits über die Pflanze berichtete, welche Qualität die Pflanze besitzt (kalt, warm, trocken, feucht) und in welchem Grad sie wirksam ist. Manchmal geht der Text näher auf Farbe, Geruch und Konsistenz der Pflanze ein, seltener ist vom Wachstumsort der Pflanze die Rede. Zentral ist die Beschreibung der medizinischen Wirkung der Pflanze und wie sie zu diesem Zweck verarbeitet werden kann.[58] Seit der Antike war die Pflanze richtig beschrieben und „begriffen", also in den Kanon eingegliedert, wenn sie benannt[59] und ihre Qualität festgehalten war, nicht etwa ihr Aussehen. Diese „Lücke" in der Erfassung ist zunächst nicht direkt ersichtlich.[60] Für die Darstellung der Pflanze in Worten gab es keine Fachterminologie und im Grunde auch keine Notwendigkeit.[61] Geht man jedoch davon aus, dass man die Pflanzen, so wie man sie gesehen hat, vor Augen stellen will, ist das Bild, das ohne botanische Fachsprache auskommt, den Worten überlegen. Dieser Anspruch wird im Vorwort des „Gart" von Bernhard von Breydenbach formuliert (siehe Kap. 3.5.). Den deutschsprachigen Text des Kräuterbuchs kompilierte er nicht selbst, sondern überließ diese anspruchsvolle Tätigkeit einem Arzt.

3.3. Johann Wonnecke von Kaub – ein Humanist?

Johann Wonnecke von Kaub (auch: de Cuba; ca. 1430–1503 oder 1504; Hofarzt in Mainz und Heidelberg; ab 1484 Stadtarzt in Frankfurt am Main[62]) konnte von Baumann und Baumann als Kompilator des „Gart" belegt werden.[63] Außerdem nennt er sich u. a. am Ende von Cap. lxxvj in Zusammenhang mit der Verwendung des „rodelsteyn" (Tonerde) selbst: „Meister Johan von

57 Einige Nachschnitte (z. B. Augsburg 1486, Ulm 1487) geben der deutschen Nomenklatur ein größeres Gewicht, indem sie größere Schrifttypen nur für die deutschen Pflanzennamen verwenden, die lateinischen Namen erfolgen zu Beginn des Fließtexts. Die Ordnung nach dem lateinischen Alphabet wird dabei beibehalten. Dies zeigt, dass man bei den Nachschnitten Änderungen am ursprünglichen Programm vornahm, insbesondere um neue Käufer zu gewinnen.

58 Habermann gibt am Beispiel des Sadebaums folgende Grundstruktur des Textes vor: Nomenklatur, Qualität, morphologische Beschreibung, Arten, heilkundliche Anwendung, Rezepte: Habermann (2001), S. 297 f. Sie beschreibt außerdem den Stil des Textes genauer.

59 Giesecke (2006), S. 357: „Das botanische Wissen der Gelehrten war ein Wissen um die ‚nomen' und die in der theoretischen Literatur kanonisierten Eigenschaften und Wirkungen der Pflanzen [...]."

60 Giesecke (2006), S. 350.

61 Es gab auch keine etablierten Fachbegriffe, die das Aussehen von Pflanzen in Kategorien gefasst hätten. Z. B. unterscheidet die moderne Botanik verschiedene Blatt- und Blütenformen mit festgesteckter, erlernbarer Terminologie. Das Aussehen der Pflanze kann so in Worten dargestellt werden. Der „Gart" war hierzu auf Vergleiche angewiesen: Eine Pflanze konnte Wurzeln haben, so fein wie die der Zwiebel etc.

62 Mayer (2014), S. 134.

63 Baumann / Baumann (2010), S. III f.

Cube".[64] Als Experte für Pflanzenkunde stand er offenbar für die Illustratoren zur Verfügung (siehe Kap. 4.2.1.), was nicht zum Schluss führen darf, dass Johann Wonnecke von Kaub auch für die Beschaffung des Bildmaterials zuständig war und seine Textquellen gleichzeitig die Bildquellen[65] darstellten.[66]

3.3.1. Die Textquellen des „Gart"

Die Quellen Johanns Wonnecke von Kaub sind bis heute im Dunkeln, obwohl man sich wiederholt mit den Textquellen auseinandergesetzt hat. Die zentralen Thesen der Forschung können hier nur kurz referiert werden:

Gundolf Keil versuchte für das Verfasserlexikon unter dem Schlagwort „Gart der Gesundheit" die älteren Textquellen des Kompendiums zu erfassen, die er nicht nur auf lateinische Ursprünge zurückführt. Johann Wonnecke von Kaub selbst nennt ausschließlich lateinische Quellen in seinen Pflanzenbeschreibungen. Bernhard von Breydenbach schreibt, Johann Wonnecke, der bewährte „meyster in der artzney", habe nach seiner Weisung als Autoritäten „Galen, Avicenna, Serapion, Dioscurides, Pandectarius [Matthaeus Silvaticus], Platearius" in einem Buch zusammen gebracht.[67]

Keil hingegen argumentiert, dass dies eine irreführende Aussage sei.[68] Die Quellen des „Gart" lägen in altdeutschen Fachtexten.[69] Hauptsächlich gingen die Pflanzenbeschreibungen auf den deutschen „Macer"[70] zurück, an dessen Strukturen und Inhalte sich Johann Wonnecke von Kaub orientierte. Ungereimtheiten innerhalb der alphabetischen Abfolge erklärt Keil damit, dass es Johann Wonnecke von Kaub nicht immer möglich war, die Reihenfolge des „Macer" zu übernehmen, sodass er auch hin und wieder von der Festlegung durch das Alphabet abweicht.[71] Weitere Entlehnungen stammten aus der „Circa instans"-Tradition und dem „Liber de natura rerum" von Thomas von Cantimpré, das gegebenenfalls auch in der deutschsprachigen Übertragung durch Konrad von Megenberg vorlag.[72]

64 Johann Wonnecke von Kaub (1485): rodelsteyn, Cap. lxxvj. Ein weiteres Mal nennt er sich noch beim „Immergrün": Johann Wonnecke von Kaub (1485), Cap. lxxviij.

65 Der handschriftliche „Codex Berleburg" beispielsweise enthält einige Bildvorlagen für den „Gart", keine Textvorlagen; siehe Kap. 4.2.3.

66 Die Praxis des Zusammentragens von Texten durch einen Arzt aus einer großen zur Verfügung stehenden Bibliothek, der Zusammenarbeit von Offizin, Auftraggeber und Holzschneider-Werkstatt, sogar die Art und Weise, wie die Werke rezipiert und nachgeschnitten werden, macht den „Gart der Gesundheit" stark mit der Schedel'schen Weltchronik vergleichbar: auch hier trägt ein Arzt (Hartmann Schedel) aus einer Bibliothek (hier: seiner eigenen) den Text zusammen, die berühmte Nürnberger Werkstatt um Pleydenwurff und Wolgemut zeigt sich für die Holzschnitte verantwortlich. Koberger verlegt das Werk, das binnen kürzester Zeit in kleineren Varianten kopiert wird. Diese Entstehungsumstände können für die des undurchsichtigeren „Gart" erhellend sein. Füssel (2001), S. 7–37.

67 Zu den einzelnen Autoren und ihren Schriften, siehe oben S. 40–44.

68 Keil (1980), Sp. 1079.

69 Keil (1980), Sp. 1077. Leider gibt der Artikel keinen Aufschluss über die von Keil zitierte Quelle.

70 Jansen (2013).

71 Keil (1980), Sp. 1078.

72 Zum „Buch der Natur": Spyra (2005) und Märtl u. a. (2006).

Ulrike Jansen kann in ihrer umfassenden Untersuchung zum „Macer" nachweisen, dass Johann Wonnecke von Kaub den „Macer" weniger verwendete, als dies von Keil postuliert wurde. Vielmehr stütze der „Gart" sich auf zu dieser Zeit neuere arabische Quellen, vor allem in der Arzneizubereitung. Wie Keil schließt auch Jansen die Möglichkeit nicht aus, dass der Kompilator die „Macer"-Überlieferungen zwar nutzte, aber nicht nannte:

> Zitiert werden u. a. ‚die meister‘, ‚Pandecta‘, ‚Platearius‘, ‚meister Diascorides‘, ‚meister Galenius‘, ‚Circa instans‘, Avicenna, Plinius, Galen, ‚meister Rabbi Moyses‘, ‚Serapio in dem buch aggregatoris‘ und ‚meister Ysaac in dem buch genant de dietis particularibus‘. [...] Im ‚Hortus sanitatis germanice‘ sind die folgenden vierzehn durch die ‚Spuri Macri‘ bekannten Pflanzen und Heilmittel vertreten: Kap. 16 *Aaron*, Kap. 5 *Odermynge*, für den Holunder Kap. 161 *Ebulus attich* und Kap. 364 *Sambucus holler*, Kap. 68 *Brionia strickwortz oder raselwortz*, Kap. 279 *Nenufar –* seeblomen (*... grece nymphae*), Kap. 180 *Faba bonen*, Kap. 280 *Nux avellana haselnuß*, für *Myrica* Kap. 268 *Mirica heyde* und Kap. 407 *Tamariscus*, Kap. 218 *Iuniperus wegholler*, Kap. 357 *Salix eyn wyde*, Kap. 145 *Caseus kese*, Kap. 49 *Acetum essig*, Kap. 379 *Sulphur swebel*, Kap. 45 *Alumen alun*.[73]

Keils Auffassung, Johann Wonnecke von Kaub habe sich der lateinischen Überlieferung verschlossen, widerspricht Johannes Gottfried Mayer in dem Aufsatz „Die Wahrheit über den *Gart der Gesundheit* [...]" vehement: Die moralischen Deutungen, die mitunter in den deutschsprachigen Quellen zu finden sind, seien im Text des „Gart" nicht aufgenommen worden und zu keinem Zeitpunkt erwähne Johann Wonnecke von Kaub deutschsprachige Textquellen, sondern berufe sich ausschließlich auf lateinische Autoritäten. Die Annahme, ein humanistisch gebildeter Arzt hätte Ende des 15. Jahrhunderts ein Kräuterbuch verfasst, ohne lateinische Quellen heranzuziehen, sei schlichtweg „schwer vorstellbar".[74] Johann Wonnecke von Kaub verwende zwar das „Buch der Natur" Konrads von Megenberg – als Beispiel nennt Mayer das Efeu-Kapitel (Cap. clxiij) – die Textpassage zur Anwendung der Pflanze müsse allerdings von Dioscurides stammen, denn im „Buch der Natur" gibt es keine Heilanweisungen. Als weitere nicht genannte Textquellen vermutet er die Schriften Hildegards von Bingen[75] und den „Macer".

Mayers Spurensuche nach den Quellen des „Gart" hat bislang ergeben, dass Johann Wonnecke von Kaub seine Vorlagen nie vollständig übernahm, sondern die Pflanzenbeschreibungen aus kurzen Quellenzitaten zusammensetzte. Plinius zitierte der Mainzer Arzt mitunter sogar unter Nennung der Kapitelzahlen und offenbar so genau, dass die Angaben immer zutreffend sind.[76] Wie Jansen verweist Mayer auf die bislang weniger beachteten arabischen Quellen, die im 15. Jahrhundert kursierten. Für ihn stehen als Quellen, neben deutschen Texten, Avicenna, Plinius, Pseudo-Serapion und Isidor sowie insbesondere der „Circa instans" fest.[77]

73 Jansen (2013), S. 180 f.
74 Mayer (2011), S. 119–128.
75 Riethe (2011), S. 213–246.
76 Mayer (2014), S. 139.
77 Mayer (2011), S. 120–122.

3.3.2. Die Universitätsbibliothek Erfurt: Eine Fundgrube medizinischer Texte

Die Hauptquellen, die im „Gart" genannt und von der Forschung vermutet werden, sind für Johann Wonnecke von Kaub an einem Ort versammelt. Der Mediziner war, nachdem er sich 1448 an der Universität Köln eingeschrieben hatte, im Jahr 1451 an die Universität Erfurt gewechselt. Ihm muss folglich die dortige medizinische Büchersammlung bekannt gewesen sein.[78] Wobei noch zusätzlich mit Handschriften gerechnet werden muss, die Bernhard von Breydenbach oder Johann Wonnecke von Kaub von anderen Orten ausgeliehen oder eingekauft haben.[79]

Aus dem *Collegium Amplonianum* in Erfurt liegt ein Katalog vor, den Amplonius Rating ungefähr in den Jahren 1410–1412 anfertigte. Amplonius Rating de Bercka (gest. um 1435) war Doktor der Medizin, seine Privatsammlung von 633 Büchern bildete den Grundstock des Kollegiums, das er selbst an der Universität Erfurt gegründet hatte.[80]

Welche naturphilosophischen und medizinischen Schriften Johann Wonnecke von Kaub dort einsehen konnte, ist diesem ausführlichen Katalog zu entnehmen. Darin sind aufgeführt:

• Naturphilosophische Werke des Aristoteles, Übersetzungen seiner arabischen Kommentatoren, Schriften des Aristoteles und Avicennas zu Mineralien und Pflanzen,[81]
• Bücher zur Metaphysik bei Aristoteles, Thomas von Aquin, Platon,[82]
• zahlreiche Werke von Albertus Magnus,[83]
• diverse Schriften, die Amplonius zur Kunst der Medizin („arte medicine") besaß,[84] und die unter anderem Galen-Abschriften und Galen-Kommentare zu Hippokrates, eine Abschrift von Serapion, Dioscurides, Platearius, Avicenna etc. beinhalten.[85] Interessant ist außerdem Hinweise auf ein Herbarium in antiker Manier (?) mit Abbildungen[86] und auf den „Macer".[87]

Gleichzeitig gibt der Universitätskatalog Erfurt (verfasst zwischen 1407 und 1450) Auskunft darüber, welche Bücher ein Magister der Medizin besaß, sodass Rückschlüsse gezogen werden

78 Müller-Jahncke (1977), S. 1664.

79 So zum Beispiel der „Codex Berleburg", dessen Pflanzenbilder Vorlagen für den „Gart" lieferten. Bernhard von Breydenbach hatte sich die Handschrift, wie man einem Vermerk entnehmen kann, entliehen. Auf den Text der medizinischen Handschrift griff man allerdings nicht zurück; siehe weiter Kap. 4.2.3.

80 Döbler (2001), S. 31–33. Amplonius erwarb schon 1384 ein medizinisches Werk von Avicenna. Weitere Schriften zur Medizin kaufte er seinem seinem Vorgänger im Amt des Leib- und Hofarztes in Köln, Tilmann von Synberg, ab. Döbler (2001), S. 28.

81 Lehmann (1928), S. 31: „De philosophia naturali: [...] Primo quidam octo libri phisicorum Aristotilis cum / translacione Arabica commentatoris [...] libellus Avicenne de mineralibus [...] libri duo Aristotilis de vegetabilibus et plantis [...]".

82 Lehmann (1928), S. 42 f.

83 Die Sammlung des Amplonius drückt dessen Wertschätzung für die Schriften von Albertus Magnus aus: Anzulewicz (2001), S. 142.

84 Lehmann (1928), S. 47: „De medicina: Isti sunt libri, quos ego Amplonius habeo in arte medicine". Dass die Medizin zu den *artes* gezählt wird, ist zu diesem Zeitpunkt nicht selbstverständlich; siehe: Kap. 5.1.

85 Lehmann (1928), S. 47–58.

86 Lehmann (1928), S. 53: „herbarium antiquum Ypocratis, valde bonum cum picturis". Welche Handschrift hier gemeint ist, ist nicht mehr nachzuvollziehen.

87 Lehmann (1928), S. 54: „Macer de viribus herbarum".

können, welche Werke einem an der Universität ausgebildeten Mediziner bekannt waren. Auf-
gelistet werden unter anderem die Schriften von Serapion, Galen, Plinius, Aristoteles und Pla-
tearius.[88] Schon 1408 waren für die Nutzer der Universitätsbibliothek die naturphilosophischen
Bücher des Aristoteles, Albertus Magnus und weitere antike Schriften angekettet oder noch
anzuketten.[89]

Bereits zu Studienzeiten und später als Arzt und Autor hätte Johann Wonnecke von Kaub auf
diese für die damalige Zeit herausragende medizinische Bibliothek, die Fachtexte seit der Antike
versammelte, zurückgreifen können. Neben Autoren des Abendlands finden sich in der Biblio-
thek offen zugänglich zahlreiche medizinische Schriften, die auf arabische und jüdische Gelehrte
zurückgehen. Die Handschriftensammlung enthielt unabhängig von der mittelalterlichen Klos-
terbibliothek das Wissen byzantinischer und salernitanischer Ärzte. Auch wenn die medizinische
Fakultät die kleinste war, konnte sich von Erfurt aus ein neuer medizinischer Bildungskanon
entwickeln.[90] In diesem Umkreis könnte der Ursprung des „Gart" vermutet werden.

3.3.3. Johann Wonnecke von Kaubs neue Pflanzenordnung

Bemerkenswert sind die Anordnung der Pflanzen im „Gart" und die Synonyme, die von Jo-
hann Wonnecke von Kaub gegeben werden. Wie er bei den Textquellen aus verschiedenen
Quellen schöpfte, ordnete er auch die Kapitel in einer Reihenfolge, die nicht auf ein einzelnes
Werk zurückgeht. Der Kompilator nahm eine selbstständige Neuanordnung der Pflanzen in
der Grundstruktur des Werks vor, die sich an den großen Pflanzenlisten des Mittelalters: dem
„Circa instans", „Macer" und „Aggregator" orientiert.[91] Der „Gart" beginnt allerdings nicht,
wie es für den „Tractatus de herbis" üblich ist, mit einem Kapitel zur „Aloe", sondern, wie der
„Macer" (oder auch der „Codex Berleburg"), mit „Beifuß" („Arthemisia").[92] Der nicht nach
dem Alphabet geordnete „Aggregator" gibt die arabischen und griechischen Synonyme für die
lateinische und deutsche Nomenklatur vor.[93] Die Pflanzennamen werden nach Möglichkeit in
jeder denkbaren Übersetzung gegeben, um Verwechslungen zu vermeiden und eine eindeutige
Identifikation der Pflanze überregional zu ermöglichen.

Auch die Beschreibungen der Stoffe arrangierte er aus verschiedenen Quellen neu, je nach-
dem, was der offenbar souverän agierende Autor aus den vorhandenen Texten für sein Kräu-
terbuch für geeignet hielt. Johann Wonnecke von Kaub brachte zudem eigene medizinische
Erfahrung und Ratschläge in die Pflanzenbeschreibungen mit ein,[94] z. B. Cap. lxxviij: „oftmals

88 Lehmann (1928), S. 116 f.: „Tertius canonis cum Serapione toto, quem emi pro 10 florenis / Liber Ga-
 leni, pro 4 florenis / Simplica Plinii cum pluribus, pro 6 florenis [...] Liber de animalibus Arestotelis,
 pro 2 florenis [...] Volumen, in quo Platearius, pro 2 florenis".

89 Lehmann (1928), S. 121.

90 Kiefer (2001), S. 162–173.

91 Zu diesen Quellen siehe oben S. 41–43.

92 Dies hat Keil wohl unter anderem dazu veranlasst hat, den Ursprung des Werks im „Macer" zu ver-
 muten. Keil (1980), Sp. 1077 f.

93 Mayer (2011), S. 123.

94 Ein Charakteristikum, das Habermann v. a. später erscheinenden Kräuterbüchern zuspricht. Haber-
 mann (2001), S. 171–174.

Abb. 9: „Berwinca" (Immergrün):
Gart der Gesundheit. Mainz 1485.
München, Bayerische Staatsbiblio-
thek, 2 Inc.c.a. 1601.

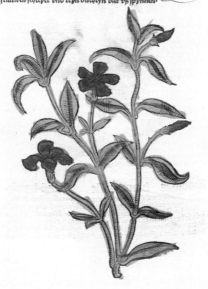

von mir erprobt"[95] oder Cap. vij: „ich rate von der Einnahme [der Pflanze] ab, weil Frösche
und Kröten darauf laichen"[96]. Widersprüchliche Angaben innerhalb der Quellen benennt er
mitunter, löst sie jedoch nicht zwingend auf, wenn beispielsweise die Gelehrten verschiedene
Wirkungsgrade angeben etc.[97] Im Gegensatz dazu neigen Kräuterbücher des 16. Jahrhunderts
zu „konziseren Darstellungen".[98]

Krankheiten werden nicht auf moralische Verfehlungen zurückgeführt, was zu dieser Zeit
keine Selbstverständlichkeit darstellt, sondern auf ein Ungleichgewicht der Säfte im Menschen.
Selten beschäftigen ihn Zauberei oder böse Geister, vielmehr wird ein Bemühen um sachliche[99]

95 Johann Wonnecke von Kaub (1485), Cap. lxxviij: „dicke mail versuecht an vil enden von mir".
96 Johann Wonnecke von Kaub (1485), Cap. vij: „Aber fur allen dingen rait ich daz in den lyp nit zú
 nemen, der vrsach halber daz die frosch vnd krotten darvff leychen […]".
97 Z. B. Johann Wonnecke von Kaub (1485), Cap. xlv: Bei „Alumen", einem Salz, wird nach dem „Circa
 instans" eine Wirkung im 4. Grade angegeben und nach „Auicenna" im 3. Grad.
98 Habermann (2001), S. 331.
99 „Zaubertricks", eine christlich-moralische Botschaft, Aberglaube etc. kommen im „Gart" praktisch
 nicht vor. Gemeint sind damit etwa solche Rezepte, wie sie im circa 30 Jahre später geschriebenen
 Löffelholz-Hausbuch (Krakau, Jagiellonische Bibliothek, Ms. Berol. germ. quart. 132) festgehalten
 wurden: Wenn man von einem tollwütigen Hund gebissen wurde, seien drei magische Worte auf
 einen Käse zu schreiben und dieser dem Hund zu essen zu geben. Oder ein Liebesrezept: Man
 schreibe den Namen der Frau, die sich verlieben soll, auf einen Apfel und warte, bis der Apfel von

Auseinandersetzung mit den Stoffen angestrebt. Folgende Passagen kommen deshalb weniger vor, geben aber darüber Aufschluss, welche Kraft bzw. Wirkung den Kräutern zugeschrieben wurde (dazu weiter: Kap. 5.3.):

> Wer dieses Kraut [Immergrün, Abb. 9] bei sich trägt, über den hat der Teufel keine Gewalt. Wenn man dieses Kraut über die Haustür hängt, kommt keine Zauberei ins Haus. [...] Mit diesem Kraut beurteilt man, in welchem Menschen böse Geister sind. Wie diese Beurteilung verläuft, führe ich nicht aus, um der Kürze willen. [...] Noch besser wirkt es, wenn es am Tag unserer Frau [Maria] mit anderen Kräutern geweiht wird.[100]

Wittekind hat im Zusammenhang mit Hartliebs „Kräuterbuch" diese Art der Pflanzendarstellung, die ohne christliche oder moralisch-höfische Implikationen auskommt, als „neuartige, humanistische Naturfrömmigkeit" beschrieben, die über die Vielfalt der göttlichen Kreation „meditiert".[101] Eine solch meditative Betrachtung und daraus folgende Offenbarung der Ordnung der Natur findet man zu Beginn des „Gart" bei Bernhard von Breydenbach:

> Häufig habe ich für mich das wundersame Werk des Schöpfers der Natur betrachtet, wie er am Anbeginn den Himmel schuf und mit schönen leuchtenden Sternen zierte, denen er die Wirkung und die Macht gegeben hat, alles unter dem Himmel zu beeinflussen; auch wie er danach die vier Elemente geschaffen hat; dem Feuer hat er eine heiße und trockene Natur gegeben, der Luft eine heiße und feuchte, dem Wasser eine kalte und feuchte, dem Erdreich eine trockene und kalte. Auch [habe ich betrachtet,] wie jener große Schöpfer der Natur danach vielerlei Arten Kräuter und allerlei Arten Tiere und zuletzt den Menschen als das Edelste aller Geschöpfe gemacht und geschaffen hat. Da offenbarte sich mir die wundersame Ordnung, die der Schöpfer diesen seinen Geschöpfen gegeben hat, da alle Wesen unter dem Himmel ihre Natur von und durch die Sterne empfangen und erhalten.[102]

Wie bei der Schöpfung des Bildprogramms für den „Gart" bleibt auch an dieser Stelle unklar, wie man sich Bernhards von Breydenbach Rolle bei der Konzeption des Texts vorzustellen hat. Autor und Auftraggeber könnten jedenfalls als Humanisten betrachtet werden. Bernhard von Breydenbach rühmte sich im Vorwort, mit dem „Gart" einen Schatz an den Tag gebracht zu haben, der bisher begraben und verborgen gewesen sei.[103] Das Ansinnen, etwas ans Licht zu fördern, das verborgen war, zum allgemeinen Nutzen, klingt humanistisch. Es liegt außerdem

selbst vom Baum fällt, danach gebe man der Frau den Apfel zu essen, wodurch sie sich verliebt etc. Rudolph (2015), S. 463 f.

100 Johann Wonnecke von Kaub (1485), Cap. lxxix: „Welcher diß krut by yme draget vber den hait der tüfel kein gewalt, Vber welcher hußdore diß krut hanget dar inne mag keynzauberey kommen [...], Mit dissem krut beweret man in welchem menschen böse geyst synt, wie die bewerunge zú gat laß ich an stan vmb kurtze willen [...], Vnd viel besser ist es so es gewyhet würde mit andern krutern vff vnser frauwen dag."

101 Wittekind (2004), S. 61.

102 Bernhard von Breydenbach (1485), fol. 2r. Weiter zu dieser Passage auch: Giesecke (2006), S. 343.

103 Bernhard von Breydenbach (1485), fol. 3r. Zur Verbreitung der Schatzmetapher in medizinischen Werken: Gadebusch Bondio (2010).

nahe, den ausgegrabenen Schatz, von dem hier die Rede ist, auf den Wissensschatz der Antike zu beziehen.

Der „Gart" ist, sowohl was die Grundstruktur als auch die Binnenstruktur der Pflanzenbeschreibungen angeht, ein Werk, das den Höhepunkt der Quellenkompilation – aus arabischen, lateinischen, salernitanischen, deutschen Textquellen – pharmazeutischen Wissens zu dieser Zeit darstellt. Johann Wonnecke von Kaub stellt sich selbst, indem er sich zusammen mit den anderen Autoritäten in den Pflanzenbeschreibungen nennt („ich", „Meister Johan von Cube"), in diese Reihe der gelehrten Ärzte. Sein „Gart der Gesundheit" bildet den Kern für die ihm nachfolgenden Kräuterbücher des 16. Jahrhunderts (siehe Kap. 3.7.2.).[104] Er sammelte und ordnete die Heilstoffe der Natur und kreierte dadurch Neues. Ein solch selbstbewusster Umgang mit der Natur und den alten Quellen charakterisiert ihn als „Wiederbelebenden" antiker Traditionen – als Humanisten. Neben dem Inhalt wurde auch auf die Textgestaltung des Kräuterbuchs durch die Druckerei größter Wert gelegt.

3.4. Neue Wege: Peter Schöffer druckt Herbarien

Allein der Kolophon des „Gart" zeigt dem Leser, ohne den Namen des Druckers zu nennen, dass er einer besonders anspruchsvoll gestalteten Inkunabel gegenübersteht. Die Schlusszeile des „Gart", die über das Entstehungsdatum Auskunft gibt, wurde in rot gedruckten Lettern über das ebenso rote Druckerzeichen gesetzt, das in der Offizin von Johann Fust und Peter Schöffer entwickelt wurde (Abb. 10).[105]

Das Drucken in anderer Farbe war sowohl eine technische Herausforderung, der sich nur wenige Drucker zu dieser Zeit stellten, als auch ein zusätzlicher Aufwand. Entweder war ein eigener Druckvorgang notwendig oder die Druckplatte musste gesondert eingefärbt werden, sodass das Rubrizieren von Hand häufig die bevorzugte Lösung blieb.[106]

Eine Schlussschrift setzte die Mainzer Offizin von Fus und Schöffer bereits seit 1457 ein, seit 1462 wurde sie durch die Marke ergänzt, die zwei an einem Ast befestigte Wappenschilde zeigt. Vereint werden hierin die beiden griechischen Buchstaben X und Λ, die für Christus und *logos* stehen. Diese Praxis der Signatur am Ende des Werks sollte vor allem vor Kopien schützen, was sich als relativ wirkungslos herausstellen sollte. Neben der Druckermarke hat Schöffer zudem leicht lesbare Drucktypen entwickelt, die unter anderem für seinen Erfolg verantwortlich gemacht werden:[107] Für den „Gart der Gesundheit" verwendete Schöffer eine in seinem Programm völlig neue halb-kursive Schrifttype (sog. „Schwabacher Type"[108]), die später ins-

104 Mayer formuliert es etwas anders: „So schuf Wonnecke mit dem Gart eine Art Quintessenz der mittelalterlichen Drogenkunde. Allerdings wählte er bei den Indikatoren recht willkürlich aus, und bei der Identifizierung der Pflanzen sind ihm zahlreiche Fehler unterlaufen [gemeint sind v. a. Übertragungsfehler bei den arabischen Pflanzennamen]." Mayer (2001), S. 126.

105 Fust stirbt schon 1466, Schöffer ist der alleinige Verleger des „Gart der Gesundheit". Zum „Unternehmer" Peter Schöffer: Lehmann-Haupt (2002). Schneider (2000), S. 212–235. Kat.Ausst. Mainz (2003).

106 Kat.Ausst. München (2009), S. 156. Zum zweifarbigen Druck bei Schöffer: Ikeda (2015).

107 Kat.Ausst. München (2009), S. 144.

108 Timm (2006), S. 305.

Abb. 10: Kolophon: Gart der Gesundheit. Mainz 28.3.1485. München, Bayerische Staatsbibliothek, 2 Inc.c.a. 1601.

besondere in seinen deutschsprachigen Werken wieder genutzt wurde, da sie sich als besonders leserfreundlich herausgestellt hatte.[109]

Ein Jahr vor dem „Gart" war bei Schöffer ein lateinisches Kräuterbuch erschienen. Der „Herbarius Moguntinus" ist mit 174 Blättern deutlich kürzer und im Quart-Format auch kleiner als der „Gart" (Abb. 11).[110] Weder die Bilder noch der Text des „Gart" gehen auf den „Herbarius Moguntinus" zurück.[111] Für beide Textkompilationen wird Johann Wonnecke von Kaub vermutet, wobei der Arzt nur für den „Gart" belegbar ist. Die Spekulation, dass der „Gart" zuerst konzipiert wurde, der „Herbarius Moguntinus" aber schließlich als erstes herausgegeben wurde, kann nicht nachgewiesen werden und ist unwahrscheinlich.[112]

Lediglich was die Struktur von Bild und Text betrifft, sind der „Gart der Gesundheit" und der Mainzer „Herbarius" gleich aufgebaut (siehe Kap. 3.6.2.): Zuerst wird in der Regel eine Pflanze abgebildet, darunter der lateinische und deutsche Name[113] genannt, und im Anschluss folgt die Pflanzenbeschreibung, die den medizinischen Nutzen der Kräuter nennt. Obwohl

109 Lehmann-Haupt (2002), S. 47.

110 Zum ersten gedruckten Mainzer Kräuterbuch: Baumann / Baumann (2010), S. 99–110. Schwabe (2006). Isphording (2008), S. 112–114. Kat.Ausst. Schweinfurt (2011), S. 90 f. Sowie: Eine Faksimileausgabe auf CD nach der Ausgabe der Sammlung Trew der Universitätsbibliothek Erlangen (mittlerweile online zugänglich): Herbarius latinus, Mainz 1484. Erlangen 2005.

111 Der „Gart" ist auch keine deutsche Übersetzung des Mainzer „Herbarius".

112 Von Baumann und Baumann überlegt, konkrete Hinweise existieren allerdings nicht: Baumann / Baumann (2010), S. 99 f.

113 Auch die Pflanzennamen in den Werken stimmen nicht überein.

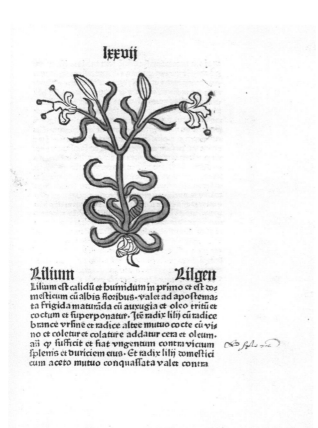

beide Kräuterbücher bei Peter Schöffer in den Druck gingen, wurden nicht die bereits vor-
handenen Holzschnitte wieder verwendet. Zumindest wäre dies eine effiziente Lösung für
den Verleger gewesen, stattdessen wurden die Illustrationen für den „Gart der Gesundheit"
gesondert hergestellt. Für diese Besonderheiten muss der Auftraggeber verantwortlich gemacht
werden. Darüber hinaus kann durch diesen Umstand die häufig aufgebrachte These entkräftet
werden, der „Gart" sei in großer Eile entstanden.[114] Wäre dies wirklich der Fall gewesen, hätte
Schöffer sicher auf vorhandenes Bildmaterial zurückgegriffen. Auch wenn nicht endgültig ge-
klärt werden kann, wann Johann Wonnecke von Kaub mit der Kompilation des Texts begann,
so ist doch sicher, dass der „Gart" ein Werk ist, das einen längeren Entstehungszeitraum von
mindestens zwei Jahren in Anspruch nahm.[115]

114 Keil weist darauf hin, dass es sich um ein lange geplantes Werk handle: Keil (1980), Sp. 1074.
115 Zum Vergleich: Die Weltchronik des Hartmann Schedel benötigte vom Vertragsabschluss mit Ko-
 berger und der Wolgemut-Werkstatt bis zum Druck etwa 15 Monate. Füssel (2001), S. 23. Die Künst-
 ler-Werkstatt erhielt 1000 Gulden als Lohn. Conrad Celtis hätte, wenn er eine Übersetzung und
 Neubearbeitung des Weltchronik-Textes angefertigt hätte, etwa 200 Gulden erhalten. So viel Entgelt
 wird auch für den Autor Hartmann Schedel angenommen. Da Koberger als „Lohndrucker" arbei-
 tete, nahm er ein großes finanzielles Risiko auf sich. Füssel (2001), S. 22. Schedel hat wahrschein-
 lich innerhalb eines Jahrs den Text für die Weltchronik – zusammen mit sechs weiteren Schreibern
 – zusammengestellt. Füssel (2001), S. 25. Seine wohlgeordnete und umfangreiche Bibliothek war

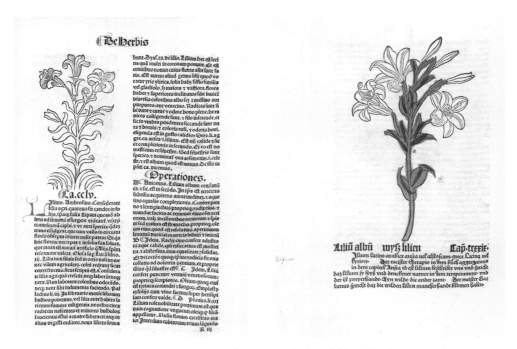

Abb. 12: Lilie: Hortus sanitatis. Mainz 1491. München, Bayerische Staatsbibliothek, 2 Inc.c.a. 2576.
Zum Vergleich: Lilie: Gart der Gesundheit. Mainz 1485. München, Bayerische Staatsbibliothek, 2 Inc.c.a. 1601.

Schöffer druckte keine Neuauflage des „Herbarius" oder des „Gart der Gesundheit", der sich auf dem Buchmarkt durchsetzte und der zu seinen umfang- und bildreichsten Werken zählt. Die Kräuterbücher blieben allgemein für den Verleger Schöffer, der in der Regel liturgische Texte druckte, eine Ausnahmeerscheinung.[116] Andere Verleger gaben Nachschnitte des „Herbarius" heraus, und sogar eine Übersetzung ins Italienische wurde vorgenommen, sodass das Buch doch als recht erfolgreich gewertet werden kann.[117] Bereits ein halbes Jahr nach seinem Erscheinen erfolgte der erste von zehn Nachschnitten des „Gart der Gesundheit" alleine in Augsburg (siehe Kap. 3.7.2.).[118] Orientierte sich der Augsburger Nachdruck von 1485 noch relativ exakt am „Gart", wurde das Kräuterbuch bis weit ins 16. Jahrhundert variiert, in verkleinerter, vereinfachter Form herausgegeben, zum umfangreicheren „Großen Gart der Gesundheit" erweitert und von einem einspaltigen zu einem platzsparenden zweispaltigen Layout verändert. Das letzte Kräuterbuch, als dessen Grundlage der „Gart" gilt,

die Grundlage für das Gelingen einer solch großen Textkompilation innerhalb kurzer Zeit. Siehe hierzu: Kat.Ausst. München (2014). Zum „Gart" sind solche Vertragsdokumente mit konkreten Zahlen nicht erhalten. Nimmt man die Aussage Bernhards von Breydenbach im Vorwort ernst, er hätte bereits vor seiner Jerusalemreise (1483) mit dem Kräuterbuch-Projekt begonnen, muss mindestens ein Entstehungszeitraum von zwei Jahren bis zum endgültigen Druck zu Grunde gelegt werden.

116 Aus dem nächsten Buchprojekt Bernhards von Breydenbach, die Pilgerreise ins Heilige Land, hatte sich Schöffer zurückgezogen.

117 Baumann / Baumann (2010), S. 104.

118 [Johann Schönsperger], Augsburg 22.8.1485. GW M09751. Schönsperger brachte von seiner „Gart"-Auflage bis 1502 zehn Neuauflagen heraus. Baumann / Baumann (2010), S. 223–240.

erschien noch 1783.[119] Wie gefragt der „Gart der Gesundheit" war, zeigt auch die Umsetzung des Werks ins Lateinische im Jahr 1491, was für ein deutschsprachiges Buch zu diesem Zeitpunkt äußerst selten ist.[120] Das lateinische Werk hat den Text des „Gart" nicht exakt übersetzt, sondern umgestellt und um einige Kapitel aus dem Bereich Tiere und Edelsteine ergänzt. Der „Hortus sanitatis" wurde 1491 von Jacob Meydenbach in Mainz verlegt (Abb. 12),[121] zahlreiche der darin gezeigten Illustrationen beruhen auf den Abbildungen des „Gart".[122] Trotz des sichtlichen Erfolgs hatte Schöffer auch hier offenbar kein Interesse mehr daran, ein weiteres Kräuterbuch herauszubringen.

Allgemein kann für den „Gart" festgehalten werden, dass man parallel zum „Nürnberger Gemeinschaftsprojekt",[123] wie Füssel die Schedel'sche Weltchronik charakterisiert hat, auch von einem „Mainzer Gemeinschaftsprojekt" sprechen kann, das durch Bernhard von Breydenbach initiiert wurde. Er engagierte hierzu nicht nur den in Mainz etablierten Drucker Peter Schöffer, der bei Gutenberg in die Lehre gegangen war, sondern auch den anerkannten Mainzer Arzt Johann Wonnecke von Kaub und den niederländischen Künstler Erhard Reuwich, der sich in Mainz angesiedelt hatte.

3.5. Der Auftraggeber und sein „Maler von Vernunft"

3.5.1. Die Zusammenarbeit von Bernhard von Breydenbach und Erhard Reuwich

Der Auftraggeber des „Gart", der Mainzer Domherr Bernhard von Breydenbach (ca. 1449–1497), hatte 1483 eine Reise ins Heilige Land unternommen.[124] Seine Reisebeschreibungen, die er mit ausklappbaren Holzschnitten von Stadtansichten veröffentlichte, waren eine Neuheit („Viel hat man diese Form zuvor noch nicht gesehen"[125]) in der gedruckten Buchillustration (Abb. 138).[126] Wie der Kompilator des „Gart", Johann Wonnecke von Kaub, studierte auch Bernhard von Breydenbach an der Universität Erfurt, allerdings an der juristischen Fakultät. Sein langjähriger Ausbildungsweg war für Domherren, die nur selten einen Doktortitel be-

119 Zu den Nachdrucken des „Gart" siehe auch: Mayer (2011) sowie Kap. 3.7.2. und Kap. 4.5.
120 Habermann (2001), S. 104.
121 Zum „Hortus sanitatis" siehe u. a. Meier (1996).
122 Schmidt (2000), S. 584–599. Isphording (2008), S. 117–120. Baumann / Baumann (2010), S. 177–222. Kat.Ausst. Schweinfurt (2011), S. 94.
123 Füssel (2001), S. 7–37.
124 Hierzu ausführlich: Timm (2006).
125 Bernhard von Breydenbach (2010), fol. 2v. Der Aspekt der „Neuheit", der in der Moderne häufig mit „besser, verbessert, nicht zu übertreffen" verbunden wird, ist in Texten des 15. Jahrhunderts selten ein Argument. Z. B. werden erst Kräuterbücher des 16. Jahrhunderts mit dem Attribut „neu" beschrieben, etwa Leonhart Fuchs: „New Kreüterbuch". Der fortschrittliche Bernhard von Breydenbach konfrontierte die Rezipienten seiner Werke in vielerlei Hinsicht mit wirkmächtigen Neuigkeiten, v. a. hervorgehoben durch: Giesecke (2006), S. 352.
126 Zum Reisebericht Bernhards von Breydenbach und den Illustrationen: Niehr (2001). Niehr (2005). Timm (2006). Wood (2008), S. 51–53, 164–172. Ross (2014). Bakker (2018). Sowie die Edition von Isolde Mozer: Bernhard von Breydenbach (2010).

saßen, ungewöhnlich und verantwortlich für eine „steile Karriere"[127] in Mainz. Bernhard von Breydenbach schrieb in seiner Vorrede[128] zum „Gart der Gesundheit" von seiner Reise ins Heilige Land, auf die ihn ein „Maler von Vernunft" („maler von vernunfft vnd hant subtiel vnd behende") begleitete, der Abbildungen von Pflanzen anfertigte, sodass auch in deutschen Landen unbekannte Pflanzenarten in ihrer „rechten Farbe und Gestalt" betrachtet werden können. Dass Bernhard von Breydenbach einen Maler auf seine Pilgerreise mitnahm, ist in jedem Fall bemerkenswert: Eine solche Fahrt war nicht nur ein finanzieller Aufwand, sondern auch mit Risiken verbunden, die nicht jeder auf sich nahm.[129]

Erhard Reuwich (ca. 1450–1505), ein aus Utrecht stammender Künstler,[130] war für das Bildprogramm und wahrscheinlich auch für die Herausgabe der Reise Bernhards von Breydenbach, der „Peregrinatio in terram sanctam",[131] verantwortlich, wodurch sein Name auch mit den Holzschnitten für den „Gart der Gesundheit" in Verbindung steht. Der Pilgerbericht erschien am 11. Februar 1486 in lateinischer und noch im gleichen Jahr am 21. Juni in deutscher Sprache. Alles weist auf eine langjährige enge Zusammenarbeit zwischen Bernhard von Breydenbach, der Offizin Schöffer und dem Künstler Reuwich (mit Werkstatt), der häufig auch als Verleger des Pilgerberichts genannt wird, hin.[132] Zwar wurden die Texte des „Gart" und der „Peregrinatio" mit der gleichen Schrifttype gesetzt und beide auf Papier mit Ochsenkopf-Wasserzeichen gedruckt, das auch für den „Gart" benutzt wurde,[133] aber Schöffers Kolophon taucht in dem Pilgerbericht nicht auf. Timm vermutet daher, dass sich Reuwich als unabhängiger Künstler den Holzschneidern, die Schöffer beschäftigte, anschloss. Die technisch anspruchsvolleren Schnitte des Kräuterbuchs sowie das Titelblatt des „Gart" schreibt man im Allgemeinen ihm zu.[134]

127 Timm (2006), S. 316.
128 Zur „Gattung" der Vorrede in Inkunabeln liefert Weinmayer (1982) eine Übersicht.
129 Dass Reuwich tatsächlich an der Reise teilgenommen hat, kann mit Hilfe von Rechnungen und den Tagebucheinträgen Bernhards von Breydenbach von seiner Reise belegt werden: Timm (2006), S. 301. Die Tagebucheinträge geben keine spezifischen Hinweise darauf, dass sich Bernhard von Breydenbach näher mit Pflanzen beschäftigt hat: Baumann / Baumann (2010), S. 133. Breydenbach wird von Wood als Reisender charakterisiert, der das Gesehene kritisch hinterfragte: Wood (2008), S. 166 f.
130 Ausführlich zu Reuwich: Timm (2006), S. 288–313. Viel lässt sich nicht gesichert über Reuwich sagen, die Forschung ist großteils auf Stilvergleiche und Vermutungen angewiesen.
131 Bernhard von Breydenbach / Erhard Reuwich: Peregrinatio in terram sanctam. Mainz 11.2.1486. GW 5075. Bernhard von Breydenbach / Erhard Reuwich: Die heyligen reyßen gen Jherusalem zuo dem heiligen grab. Mainz 21.6.1486. GW 5077.
132 Timm beschreibt die Situation wie folgt: „Wurde Peter Schöffer hier [im „Gart"] noch als Drucker des Werks ausgewiesen, so traf dies für die ‚Peregrinatio' nicht mehr zu. Wenn statt seiner der im Dienste Breidenbachs stehende Künstler Erhard Reuwich durch ein Signet eine Kennung erfährt, kann dies seinen Grund nur darin haben, dass das Reisewerk das alleinige und selbst finanzierte Werk des Mainzer Domdekans war. Peter Schöffer wird hingegen lediglich seine Druckerpressen, seine Druckutensilien sowie einige seiner Holzschneider gegen ein entsprechendes Entgelt zur Verfügung gestellt haben." Timm (2006), S. 306. Genannt wird Reuwich im Pilgerbericht in der „ungewöhnlichen Form der ‚Intentionis explicatio'": „Erhardu(m) sc(ilicet) rewich de traiecto inferiori [Utrecht]". Timm (2006), S. 288.
133 Timm (2006), S. 2 f.
134 Fuchs (2009), S. 61 f.

Gemessen am Umfang ist es allerdings nicht vorstellbar, dass am „Gart der Gesundheit" nur ein Künstler beschäftigt war. Plausibler ist wohl, dass Reuwich selbst eine Werkstatt unterhielt, die unabhängig von Schöffer agierte und die auch für die Herausgabe der Jerusalemreise verantwortlich war.[135] Zumindest scheint es unwahrscheinlich, dass Schöffer seine Holzschneider, seine Utensilien, seine Presse und sein Papier für den Druck der Pilgerreise freigab, dann aber nicht, wie beim „Gart", sein Signet einsetzte und als Verleger fungierte.[136]

3.5.2. In Sachen Pflanzenbilder: Das Vorwort Bernhards von Breydenbach

Im Vorwort[137] des „Gart der Gesundheit" macht Bernhard von Breydenbach seine Intention deutlich: Er wolle ein Buch zusammenstellen, „worin die Wirkung und Natur vieler Kräuter und anderer Geschöpfe enthalten sind, mit ihrer rechten Farbe und Gestalt, zu aller Welt Trost und allgemeinem Nutzen."[138] Er selbst habe während der Arbeit am „Gart der Gesundheit" bemerkt, „dass es viel edlere Kräuter gibt, die in den deutschen Landen nicht wachsen." Da er diese exotischen Pflanzen nicht nur nach dem „Hörensagen"[139] abbilden lassen wollte, ließ er „das begonnene Werk unvollkommen in der Feder hängen". Er pilgerte ins Heilige Land, wobei er verschiedenste Landstriche durchquerte, die er einzeln auflistet, womit er sich als Experte und Augenzeuge etabliert. Zu Hause wartete das begonnene Werk auf ihn. Um den „Gart der Gesundheit" mit Bildern zu bereichern, die nicht auf „Hörensagen" beruhten, nahm er „einen Maler von Vernunft sowie von sorgfältiger und geschickter Hand" mit sich („einen maler von vernunfft vnd hant subtiel[140] vnd behende"). Was er nicht konnte, die Pflanzen auf das Papier und anschließend in den Holzschnitt zu übertragen, übernahm ein Künstler, der mit ihm gemeinsam zum Augenzeugen wurde:

> Während wir diese Königreiche und Länder durchwanderten, habe ich mich selbst über die dortigen Kräuter mit Fleiß kundig gemacht („erfaren hab der kreuter da selbest"[141]) und ließ sie in ihrer rechten Farbe und Gestalt abbilden und entwerfen.

135 Auch die Schedel'sche Weltchronik wird von einer unabhängigen Künstler-Werkstatt illustriert in Zusammenarbeit mit der Koberger-Offizin: Füssel (2001), S. 7–37.

136 Timm (2006), S. 324. Timm nimmt an, dass Schöffer das finanzielle Risiko scheute, das der aufwendige Druck des Pilgerberichts für ihn bedeutet hätte.

137 Transkription mit Übertragung siehe S. 241–245.

138 Habermann (2001), S. 116, S. 200–207: Die Betonung der Nützlichkeit des Werks im Vorwort beschränkt sich offenbar ausschließlich auf volkssprachliche Bücher. Steht in Vorworten des 15. Jahrhunderts eher der allgemeine Nutzen im Vordergrund, wird im 16. Jahrhundert der „Nutz der Nation" betont: Giesecke (2006), S. 377–383.

139 Bernhard von Breydenbach argumentiert hier ähnlich wie Brunfels (siehe Kap. 6.). Beide wollen keine Bilder, die nicht ihren Ansprüchen genügen oder nur auf Hörensagen beruhen. Zur sprachlichen Konstruktion des Vorworts: Habermann (2001), S. 178–189.

140 Baxandall (2004), S. 153: Subtil „hebt auf körperliche Zartheit, Anmut und Verfeinerung" ab. Auch Pflanzenteile können im „Gart" als „subtil" bezeichnet werden, z. B. die dünnen, langen Wurzelhaare der Zwiebel (Rhizodermis).

141 Giesecke (2006), S. 347: „Geht es um die Erkenntnisweise, so spricht man in der Zeit gewöhnlich von ‚erfahren' und meint damit sowohl das Lernen im praktischen Handlungsvollzug, z. B. in der Werkstatt, als auch das Lernen aus der gelehrten Rede und der Schrift."

Nach seiner Rückkehr aus dem Heiligen Land veranlasste die „große Liebe"[142] zu seinem angefangenen Werk ihn dazu, es zu vollenden:

Ich nenne dieses Buch „Ortus sanitatis" auf Latein und auf Deutsch einen „Garten der Gesundheit". In diesem Garten findet man die Wirkungen und Tugenden von 435 Kräutern und anderen Geschöpfen, die der menschlichen Gesundheit dienen und gemeinhin in Apotheken als Arznei gebraucht werden, unter diesen viereinhalbhundert mit ihrer Farbe und Gestalt, so wie sie hier erscheinen. Auf dass es aller Welt, Gelehrten und Laien, nutzen möge, habe ich es auf Deutsch machen lassen.

Wie zahlreiche Vorworte am Ende des 15. Jahrhunderts enthält auch dieses eine Rechtfertigung der Verwendung von Volkssprache.[143]

„Kunterfeyung der kreuter"

Die Wendung der Vorrede, Bernhard von Breydenbach habe die Pflanzen „in iren rechten farben vnd gestalt laißen kunterfeyen vnd entwerffen", ist ungewöhnlich, denn der Begriff „kunterfeyen" wird an dieser Stelle zum ersten Mal überhaupt im Vorwort einer deutschsprachigen Inkunabel gebraucht.[144]

Die Formulierungen „kunterfeyen" und „kunterfeyung" – Bernhard von Breydenbach verwendet den Begriff sogar als Substantiv und als Verb – wurden im 16. Jahrhundert besonders in den Niederlanden für Porträt-, Landschaftsdarstellungen und eben auch Kräuterbücher herangezogen, wie Peter Parshall und Peter Schmidt ausgeführt haben.[145] Wendungen wie „Conterfey naer het leven" oder „contrafactum ad vivum" meinen Bilder, unabhängig vom Medium, die eine nachweisliche Ähnlichkeit mit ihrem Subjekt versprechen. Der Status der Bilder als Dokumente soll beim Betrachter wachgerufen werden. Zwar taucht die Formulierung „nach dem Leben gemalt" bei Bernhard von Breydenbach nicht auf, doch lässt er in seiner Beschreibung keinen Zweifel daran, dass sein Maler die Pflanzen selbst gesehen hat.[146] Der Begriff „Conterfey"

142 Es wäre zu überlegen, welches Liebeskonzept sich hier andeutet. Vermutlich handelt es sich um die Nächstenliebe, man könnte aber auch weiterdenken: Für den Autor von „De amore", Marsilio Ficino, hat die Liebe den Genuss der Schönheit zum Ziel. Die Schönheit seines Werks und der Pflanzenbilder war sicherlich auch ein Faktor für Bernhard von Breydenbach. Schönheit ist, nach Ficino, wiederum eine Anmut, die „zumeist in der Übereinstimmung mehrerer Teile entsteht [...]. Aus der Eintracht mehrerer Farben und Linien entsteht die Anmut in den Körpern [...]." Zit. nach: Kristeller (1972), S. 246–248. Zur Liebe als treibende Kraft, die zu tugendhaften und schließlich auch kreativen Taten führt: Pfisterer (2008), S. 124–127. Pfisterer (2014), S. 23–45.
143 Weinmayer (1982). Giesecke (2006), S. 377–383.
144 Soweit sich das hier überblicken ließ.
145 Parshall (1993). Daran anschließend u. a.: Wood (2008), S. 40 f. Schmidt (2010a), S. 386–393.
146 Bernhard von Breydenbach entschied sich gegen die vermittelte Rezeption und macht die unmittelbare Anschauung stark. Giesecke spitzt die Aussage sogar noch zu: „Gewiss kein zweites Reiseunternehmen war in jener Zeit so sehr in der Absicht geplant, Informationen für eine öffentliche Verbreitung im Druck zu beschaffen, wie dieses." Giesecke (2006), S. 339. Niehr führt ähnliche Reiseunternehmen mit Künstlern vor Bernhard von Breydenbach an: Niehr (2015).

impliziert die physische Nähe des Künstlers zum Subjekt.[147] „Conterfeyen" und „conterfey" ist bei Bernhard von Breydenbach neutral besetzt, dies ist nicht immer der Fall. Zunächst bedeutete der Begriff „contrefaire" im Altfranzösischen so viel wie imitieren bzw. nachbilden. Man gebrauchte ihn vor allem für Imitate von kostbaren und raren Materialien, wie Perlen, Edelsteinen und Elfenbein.[148] Damit war „conterfeyen" mit Ähnlich-Machen verbunden, allerdings eher abwertend gedacht, da das „conterfey" ein hochwertigeres Objekt ersetzte oder fälschte.[149]

Im Laufe der Zeit kann man einen Bedeutungswandel beobachten. Im Niederländischen meinte „contre feyten" oder „na maken" zunächst „fälschen, nachahmen, abbilden". Bis ins 16. Jahrhundert wird das Wortfeld erweitert, im Sinne von „kopieren, porträtieren, imitieren". Im 15. Jahrhundert taucht der Begriff verstärkt im Zusammenhang mit dem Buchdruck auf, ein „Konterfey" konnte ein Abdruck sein und das niederländische Verb „prenten" ersetzen. Die Bedeutung, die im Wort „kunterfeyung" mitschwang, kippte in der Folge ins Gegenteil. Eine „Kunterfeyung" behauptete nun Wahrheitsanspruch.[150] In den Wörterbüchern des 16. Jahrhunderts[151] wird „Konterfey" mit „Effigies" übersetzt bzw. erklärt, wodurch deutlich wird, dass etwas mehr gemeint ist als ein „Abbild", nämlich die Präsenz des abgebildeten Objekts und seine Substitution durch das Bild.[152]

Dieser Wandel könnte der Grund sein, weshalb Bernhard von Breydenbach den Begriff mehrmals verwendet. Über die reine Betonung und Nachdrücklichkeit durch die Wiederholung hinaus wird die Wendung hier für ein volkssprachiges, illustriertes Fachbuch etabliert.

147 Häufig finden wir die Formulierung „gheconterfeyt nae t'leven" auf kleinen Skizzen dort, wo normalerweise die Signatur zu vermuten wäre: Swan (1995), S. 357.

148 Im „Parzival" Wolframs von Eschenbach (3, 11–14) heißt es: „Manec wibes schoene an lose ist breit:/ ist dâ daz herze conterfeit,/ die lob ich als ich solde/daz safer ime golde." Zit. nach Parshall (1993), S. 537, Fußnote 44. Das „gefälschte" Herz in einer schönen Frau lobt das lyrische Ich so, wie man Glas, das von Gold umgeben ist, loben würde. Umgekehrt, so heißt es im Vers weiter, sei ein Rubin, von Messing gerahmt, immer noch wahr. „Wahr" / „Echt" und „Falsch" / „Gefälscht" liegen hier im künstlerischen – der Künstler oder Handwerker ist für die Materialien und ihre Gestaltung oder für die Fälschung, das „Ähnlich-Machen", verantwortlich –, aber auch im moralischen Sinne nahe beieinander. Zu dieser Parzival-Passage: Hüning (2010), S. 144–146. Wandhoff (2012), S. 164 f. Zum Zusammenhang von moralischer Wahrheit und Wahrheit im Bild: Pfisterer (2004).

149 Schmidt (2010a), S. 387.

150 Parshall (1993), S. 560 f.

151 Kusukawa arbeitete an dem Begriff „Counterfeit" im 16. Jahrhundert weiter. Während die Kräuterbücher vor Leonhart Fuchs noch Konterfeis enthielten, deren Funktion es war, die Abbildung einer einzelnen Pflanze zu geben, so wie man sie sehen kann („as they are seen"), zielten die späteren Kräuterbücher auf die Abbildungen der Pflanzen an sich ab, so wie sie gesehen werden sollten („as they ought to be seen"). Solange die Bilder „nur" Konterfeis sind, die dabei helfen, bestimmte Aspekte des Körpers oder der Pflanze zu memorieren, beeinflussen sie nicht die traditionelle Funktion von Bild oder Text. Das Konterfei erzeuge nichts Neues. Bücher wie der „Hortus sanitatis" seien Gegenstände, die die medizinischen Kräfte der Pflanze hervorhoben, ihre Konterfeis figurative Bilder alchemischer Anschauung und Piktogramme, die Charakteristika der Pflanze einprägen sollten. Kusukawa (2012), S. 8–25. Kusukawa braucht für ihre Argumentation die Dichotomie zwischen alten, beweiskräftigen Konterfeis und neuen, beweiserzeugenden Abbildungen bei Fuchs oder Vesalius. Das Problem dieses Ansatzes ist, dass das Neuartige untergeht, das der Begriff „Konterfei" an sich 1485 repräsentierte, als er sich gerade erst auf diese Weise sprachlich geformt hatte. Vielmehr müssen für jedes naturkundliche Buch des 15. und 16. Jahrhunderts die Begriffe, die für Illustrationen verwendet werden – „Konterfei", „Gestalt" etc. – jeweils neu ausgelotet werden.

152 Schmidt (2010a), S. 136.

„Farbe und Gestalt"

Außerdem fällt auf, dass Bernhard von Breydenbach in knapper Folge viermal die Formulierung „in ihrer (rechten) Farbe und Gestalt" gebraucht und damit die Authentizität seiner Pflanzenbilder unterstreicht.[153] Auf „Farbe und Figur" als Kategorie der Wahrnehmung und zentrales Erkennungsmerkmal von Personen, Tieren, Pflanzen etc. verweist bereits das Diktum von Hugo von St. Viktor (ca. 1095–1141), der Spezies als sichtbare Formen, die sowohl Farbe als auch Figur beinhalten, definiert: „Species est forma visibilis, quae continet duo, figuras et colores".[154] Der von Bernhard von Breydenbach mehrmals gegebene Hinweis auf die Richtigkeit der Farbe und Figur macht deutlich, dass sie als unumgängliche Kriterien betrachtet wurden, um die Pflanze als Ganzes abzubilden und adäquat zu repräsentieren.[155]

Der Begriff der „Gestalt" spielt in Dürers Schriften eine zentrale Rolle („das rechte Maß gibt eine gute Gestalt"[156]). In erster Linie war die Übermittlung der Gestalt des Menschen durch die Malerei gemeint, also die äußere Erscheinung des Abgebildeten. Diese Erscheinung unterliegt dem Wandel der Zeit, darin gleichen sich Kräuter und Menschen, wie Brunfels es erklärte.[157] Darüber hinaus meint die „Gestalt" die gesamte Disposition des Menschen und, übertragen auf den „Gart der Gesundheit", auch die der abgebildeten Pflanzen.

Dürer schreibt in seiner Vorrede zum Lehrbuch der Malerei, dass es für den Maler wichtig sei, darauf zu achten, unter welchem Himmelszeichen sein Lehrling geboren sei und welche Gestalt er habe. In der Proportionslehre Dürers heißt es schließlich: „Die Ursache der mannigfachen Gestalt der Menschen liegt in den vier Komplexionen" („Item wir haben mancherley gestalt der menschen ursach der fir camplexen").[158] Folglich ergaben sichtbare Zeichen Rückschlüsse auf innere Veranlagungen. Über die Gestalt – und die Farbe – sind demnach Folgerungen auf die Beschaffenheit eines Subjekts möglich, im Sinne der Signaturenlehre bzw. der Physiognomie: Die Komplexion prägt sich der äußere Gestalt ein und wird dadurch sichtbar gemacht.[159] Laut Bonnet erlaubt dies dem Abbild (des Menschen, aber hier der Pflanze) eine

153　Bernhard von Breydenbach spricht offenbar von einem idealen, kolorierten „Gart"-Exemplar. Frühe Holzschnitte sind ohne Weiteres eher mit Farbe zu denken als ohne (weiter: Kap. 4.3.).

154　Zit. nach Heinrichs (2007), S. 142.

155　Die Farbe als Identifizierungsmerkmal ist durchaus nicht selbstverständlich. Albertus Magnus präferierte den Geschmack der Pflanze gegenüber der Farbe und auch im 16. Jahrhundert wurde die Bedeutung der Farbe wieder zur Diskussion gestellt. Da Pflanzen je nach Tages- oder Jahreszeit ständigen Farbveränderungen unterworfen sind, bot die vom Maler aufgetragene Farbe als Erkennungsmerkmal oder Klassifikationskriterium keine stabile Konstante. Zu diesem „failure of colour": Freedberg (1994).

156　Dürer (1966), S. 133, 141, 148. Siehe: Bonnet (2001), S. 217. Ebenfalls zur „Gestalt des Menschen": Baxandall (2004), S. 162–172.

157　Brunfels (1532), Vorwort, XX. Capitel.

158　Dürer (1966), S. 117. Siehe: Bonnet (2001), S. 217. Bonnet hält (S. 217 f.), gelesen mit Rupprich, fest, dass die Grundlage für Dürers Schriften die Temperamentenlehre war. Die komplette äußere Gestalt des Menschen bzw. von Körpern lässt Rückschlüsse auf die innere Komplexion zu, was Dürer in diversen Schriften, z. B. bei Marsilio Ficino, nachlesen konnte.

159　Groebner weist darauf hin, dass „Komplexion" hier nicht mehr im Sinne Galens zu verstehen ist. Vielmehr ergab sich um 1500 ein sprachlicher Bedeutungswandel, das Wort wurde „physiognomisiert". Der Begriff, der zuvor noch das Innere des Körpers bezeichnet hatte, wurde nun für die äußeren Körperzeichen gebraucht. Groebner (2004), S. 93 f.

größere „Typenvielfalt", so wie sie in der Natur vorhanden ist.[160] Dass die Natur[161] verschiedene Pflanzenformen und -farben ausbildet, scheint erklärungsbedürftig gewesen zu sein, zumindest wird im „Buch der Natur" Konrads von Megenberg eine Deutung versucht auf die Frage, wie es so vielseitige Kräuter geben kann, wo die Erde doch nur ein Element ist. Dazu schreibt Konrad von Megenberg, dass die Erde, die der Mensch wahrnimmt und aus der Bäume und Kräuter wachsen, aus den vier Elementen gemischt ist: Feuer, Luft, Wasser und aus „lauter" Erde. Diese Mischung ist so vielfältig, dass die Kräuter verschiedene Arten (Qualitäten) und Gestalt annehmen.[162] Ihre innere Zusammensetzung gibt die Pflanze über ihre äußere Gestalt zu erkennen, z. B. über ihre Farbe, ihre Konsistenz, ihre Ähnlichkeit zu anderen Pflanzen etc.[163] In ihrer Kombination stellen Farbe und Gestalt die zentralen Mittel zur Identifikation der Pflanze dar, zumindest bei Bernhard von Breydenbach. Im 16. Jahrhundert sprach man in Zusammenhang mit Kräuterbüchern skeptisch von Farbe, die als stets sich verändernde Komponente und daher als problematisches Identifikationsmerkmal aufgefasst wurde.[164]

Der Topos „in rechter Farbe und Gestalt" kann über das sichtbare Erscheinungsbild der Pflanze hinaus die gesamte Natur der Pflanze bzw. die Vielfalt der Natur meinen, die im „Gart der Gesundheit" erfasst und für den Rezipienten erschlossen werden soll, sodass ein moderner Realismusbegriff rasch an seine Grenzen stößt. Die Illustrationen müssen nicht zwangsweise die sichtbare Natur repräsentieren, vielmehr veranschaulichen sie die Gesetzmäßigkeiten, die man in ihr zu erkennen meint.[165]

Vernunft

Um zu begreifen, was man unter der Formel „Maler von Vernunft" verstehen kann, muss kurz auf den Begriff der „Vernunft" eingegangen werden. Er erschließt sich aus den Erläuterungen Konrads von Megenberg im „Buch der Natur", worin die Hirnschale beschrieben

160 Bonnet (2001), S. 216: Dürer behandelte „Konstruktionsschema und Körpertypen getrennt modular, da das eine ein nahezu rein ästhetisches und das andere ein eher ethisches Problem betrifft. Außerdem konnte er auf diese Weise mehr variieren, experimentieren und der Typenvielfalt der Natur näherkommen. Die Experimente mit verschiedenen Gestalten [...] stellen also weit weniger ein stilistisches als vielmehr ein modales Problem dar."

161 Diese Ausführungen beziehen sich auf die Natur, aus der Vielheit hervorgeht. Die Elemente an sich schaffen nichts ohne göttliche Kraft. Dass Gott Vielfalt geschaffen hat, wird auf ganz anderer philosophischer Ebene auseinandergesetzt, z. B. bei Ficino: Scheuermann-Peilicke (2000), S. 69–90. Kristeller (1972), S. 214–238. Ebenso ist es auch bei Konrad von Megenberg zu entnehmen: Die Formen der Natur entstammen den himmlischen Sphären: Gottschall (2004), S. 341. Möseneder (2007).

162 Konrad von Megenberg (1475), fol. 225r [von den Kräutern]: „Es ist ein frag wie so mangerley kraut sey, das aus der erden wachs vnd doch dye erdt nur einerley ist, wann sy ist ein einveltiges element. Das verantwort man also vnd spricht das die kreüter nit wachsen noch kummen aus einveltiger erd wann das ertreich das wir sehen vnd greiffen vnd die páum vnd die kreúter aus wachsen das ist gemúschet aus den vier elementen feúer, luft, wasser vnd aus lauter erd. vnd die múschung ist so mangerley das dye kreüter manygerley art begrieffent vnd mangerley gestalt."

163 Weiter: Kap. 5.1.3.

164 Freedberg (1994).

165 Kemp (2004).

wird, zusammen mit ihren drei Kräften, die Imagination, Vernunft und Gedächtnis hei-
ßen:

> Die Hirnschale hat drei Kämmerchen. Die eine ist vorne im Haupt und in ihr ist die Kraft der
> Seele, die „fantastica" oder Imagination heißt. Was soviel wie „pilderin" bedeutet, weil sie alle be-
> kannten Dinge und Gleichnisse [Abbilder] in sich sammelt. Das andere Kämmerchen ist in der
> Mitte des Haupts und in ihr ist die Kraft der Seele, die „Intellectualis" heißt, das ist die Vernunft.
> Das dritte Kämmerchen ist ganz hinten im Haupt und darin ist die Kraft der Seele, die „Memo-
> rialis" heißt, das ist das Gedächtnis. Die drei Kräfte der Seele beinhalten den Schatz aller Erkennt-
> nis. Die erste [Kammer] wird schwanger, wenn ihr die Bilder und Gleichnisse [Abbilder] aller
> bekannten Dinge zukommen. Und die Bilder geben ihr die fünf äußeren Sinne, die Gesicht, Ge-
> hör, Geruch, Geschmack etc. heißen. Die andere Kraft in dem anderen Kämmerchen achtet und
> schätzt die Dinge der zuvor empfangenen Ebenbilder ebenso ein wie eine gewitzte Ehefrau. Die
> dritte Kraft in dem hinteren Kämmerchen behütet und verschließt getreulich die Dinge [...].[166]

Die Vernunft wohnt in der mittleren Gehirnkammer und prüft die Bilder bzw. Eindrücke, die
ihr von der vorderen Kammer, der „Imagination", übertragen werden, bevor sie ins Gedächtnis
wandern.[167] Bei einem „Maler von Vernunft" müsste es sich folglich um einen Bildner handeln,
der die gewonnenen Eindrücke klug zu übermitteln weiß. Für das Speichern und die Weiter-
gabe von Gesehenem beschritt der Künstler neue und wegweisende Mittel der Darstellung, die
hier genauer untersucht werden sollen.

In Sachen Bilder: Wissen vermitteln

Die Anhäufung an wahrheitsversichernden Formulierungen, die Bernhard von Breydenbach in
Zusammenhang mit den Bildern des „Gart" verwendet, weist auf den Anspruch hin, der mit
dem Werk verbunden war. Die Abbildungen seien von einem guten Maler angefertigt worden,
nach der eigens *in situ* wahrgenommenen Pflanze, und stammten von der direkten Beobach-
tung und nicht vom Hörensagen. Gleichzeitig wird sein Medienbewusstsein deutlich, da er die

166 Konrad von Megenberg (1475), fol. 4v–5r: „Von der hirnschal": „[...] Die hirnschal hat drey kámer-
 lyn, das ein vorn in dem haubt vnd in dem ist der sel kraft die do heisset fantastica oder ymaginaria,
 das ist als viel gesprochen als die pilderin darmb das sy aller bekantlicher ding pild vnd gedeychnuß
 in sich samelt. Das ander kámerlin ist zú mittelst in dem haubt vnd in dem ist der sel kraft die do
 heisset Intellectualis das ist vernunfft. Das dritt kámerlin ist zú hinderst in dem haubt vnd in der ist
 der sel krafft die do heysset Memorialis, das ist die gedechtnuß Die drey krefft der sel behalten den
 schatz aller bekantnuß. Die erst wirdet schwanger wann sy zúgefacht die pild vnd die geleichnuß aller
 bekantlicher ding, vnd die pild antwurtet ir die funff auswendig sinn dye do heyssen gesicht gehör
 schmecken versúchen etc. Die ander kraft in dem andern kámerlin die acht vnd schátzt dye ding vor
 enpfangen ebenpild recht als ein witzige Efraw. Die dritt kraft in dem hindersten kámerlin behüt
 vnd beschleúst getreúlich die ding [...]"
167 Dass die Wahrnehmung im Grunde neutral funktioniert und erst der Intellekt über das Wahrge-
 nommene entscheidet, siehe auch bei: Pfisterer (2004), S. 165 f. Weiter zur Wahrnehmung und ihrer
 Verarbeitung: Klemm (2013).

Bilder als vermittelnde Objekte begreift, als zuverlässige Dokumente des Erfahrenen.[168] Diese Vermittlungsbewegung erfasst die Natur mit der Intention, sie wissenschaftlich erfahrbar zu machen. Daston erläutert, dass so die unmittelbare Erfahrung, die zufällig an einem spezifischen Objekt gemacht wurde, ersetzt wird durch verarbeitete Erfahrung, die das Wesentliche bzw. Notwendige festhält. So werden Exemplare geschaffen, Arbeitsobjekte, die notwendigerweise eine Auswahl treffen und einen Bildkanon schaffen.[169]

Dieser Kanon evidenter Bilder ist an Darstellungskonventionen der jeweiligen Zeit gebunden. Nicht jedes Bild wird automatisch als glaubhaft empfunden (siehe auch Kap. 5.2.). Für das 15. Jahrhundert kann man festhalten, dass es eine große Bandbreite an Illustrationsmöglichkeiten für das Kräuterbuch gibt. Interessant ist, welche Optionen aus dem Bildkanon für den „Gart" geschöpft wurden, was man verwarf und wie bzw. ob die Darstellungen des „Gart" selbst in diese Konventionen eingriffen. Hierzu soll in einem nächsten Schritt das Bild-Text-Programm des „Gart" auseinandergesetzt werden.

3.6. Bild und Text im „Gart der Gesundheit"

In der Regel leitet im „Gart" eine Abbildung die Pflanzenbeschreibung ein.[170] So kommen für diesen Teil des Werks insgesamt 379 Illustrationen zusammen: 369 Pflanzen- und zehn Tierbilder. Ein weiteres Bild leitet den vierten Teil, den „Urintraktat", ein. Fügt man außerdem noch das für den „Gart" eigens gestaltete Titelbild hinzu (siehe Kap. 3.6.4.), enthält das Werk 381 Abbildungen. Nur drei Holzschnitte wurden doppelt verwendet: Das Alpenveilchen (Cap. ccccxviij) und die „haselwortz" (Cap. xix) teilen sich eine Illustration, ebenso der Elefantenzahn (Cap. clxxij) mit den verbrannten Elefantenknochen (Cap. ccclxxj) sowie die „Gladiolus" (Cap. cxcv) mit der „goltwortz" (Cap. xx). Demnach wurden für den „Gart der Gesundheit" 378 Holzschnitte angefertigt.

Der einspaltige Text zu jeder Pflanze kann eine halbe bis zu zweieinhalb Seiten umfassen. Zu Beginn jeder Pflanzenbeschreibung wurde ein größeres Feld für eine Initiale freigelassen, die später mit der Hand angebracht werden sollte. Eine Vielzahl der Kapitel beginnt auf der Rectoseite, die Pflanzenabbildung nimmt dabei einen Großteil der Seite ein. Der Setzer versuchte die Kapitelüberschriften und den Textanfang auf einer Seite mit den Abbildungen anzuordnen, sodass der Leser nicht gezwungen war umzublättern und die Überschriften praktisch als Beischriften der Abbildungen dienten, was eine schnelle Identifizierung erlaubte. Man konnte diese Anordnung bis etwa zur Mitte der Handschrift einhalten, danach gerät sie ins Wanken und man druckte Abbildungen auf Vorder- und Rückseite eines Blatts (z. B. Cap. clvij und clviij) oder die Kapitelüberschrift erfolgt doch erst auf der nächsten Seite. Da Bild und Kapitelüberschrift möglichst auf eine Seite passen sollten,[171] wurde der Text manchmal um die Abbildung herum gesetzt.[172] Die ungerahmten Pflanzendarstellungen werden durch den Schriftspiegel begrenzt,

168 Schmidt (2010a), S. 386–393. Wood (2008), S. 217–225.

169 Daston (2005), S. 121–124. Dazu auch: Latour (2006).

170 Nur 56 Kapitel sind nicht bebildert.

171 Lehmann-Haupt zeichnet ein eher konservatives Bild des Druckers, Peter Schöffer, der sich nur ungern von dem Muster, die Bilder auf der Rectoseite zu zeigen, löste und auf eine andere Bild-Text-Einteilung zurückgreift, um Material zu sparen. Lehmann-Haupt (2002), S. 47.

172 Ein Prinzip, das man als platzsparende Maßnahme in der niederdeutschen Version des „Gart" wie-

über den sie nicht hinausragen, sodass auch ohne Rahmung eine Geschlossenheit entsteht. Um den wegweisenden Charakter des Illustrationsprogramms des „Gart" besser aufzeigen zu können, wird zunächst ein Überblick über die verschiedenen Möglichkeiten gegeben, eine Pflanze im Kräuterbuch ins Bild zu setzen.

3.6.1. Kräuterbuchillustration im 15. Jahrhundert

Im 15. Jahrhundert hatte sich ein breites Spektrum an Optionen der Visualisierung von Kräutern in Sachtexten ausdifferenziert.

„Schautafel"

Die „Bildtafel" oder „Schautafel"[173] stellt, meist vor einem Landschaftshintergrund, mehrere repräsentative Exemplare der gleichen Art auf einer Seite dar. Die bekanntesten „Schautafeln" mit Pflanzendarstellungen zur Entstehungszeit des „Gart" stammen aus dem „Buch der Natur"[174] (Abb. 13) und aus dem Werk „Van den proprieteyten der dinghen"[175] (Abb. 14).
 Beide Schriften entstanden in der ersten Hälfte des 13. Jahrhunderts in lateinischer Sprache und wurden wenig später in Volkssprache überführt. Das „Buch der Natur" ist eine Übertragung der Schrift „Liber de natura rerum" des Thomas von Cantimpré, eines Schülers des Albertus Magnus.[176] Konrad von Megenberg nahm im 14. Jahrhundert eine Übersetzung der Schrift ins Deutsche vor. Wie der menschliche Körper aufgebaut ist, warum er krank wird und welche heilbringenden Kräfte in der Natur stecken, konnte hier in moralischen Auslegungen nachgelesen werden. Neben dem Aufbau der Welt, des Körpers, der Tiere, der Edelsteine etc. beschreibt Konrad von Megenberg 202 Arten von Bäumen und Kräutern mit ihrer heilbringenden Wirkung. Ein ebenso breites Themenspektrum (zum Kosmos, zur Medizin, zu den Steinen, zu den Pflanzen, zu den Tieren, zur Musik, zu den Farben usw.) umspannt das Werk „De proprietatibus rerum" des Franziskaners Bartholomäus Anglicus,[177] das v. a. in volkssprachlichen Übertragungen und über den Buchdruck breit rezipiert wurde. Erst in den französischen und niederdeutschen Varianten seit der Mitte des 15. Jahrhunderts wurden auch Illustrationen und „Schautafeln" gezeigt. Gerade für diese Schriften bieten sich die Bildtafeln an, da sie eine große Themenvielfalt zur „Natur" bzw. den natürlichen „Dingen" aufweisen und sich dabei leicht in verschiedene Teilbereiche gliedern lassen. Für die beschriebenen Naturbereiche (z. B. Landtiere, Wassertiere, Kriechtiere, Bäume, Kräuter, Edelsteine, Heilquellen) können die Tafeln als Zwischentitel fungieren und einen neuen Abschnitt kenntlich und schneller auffindbar machen.[178] Für den „Gart"

derfindet, die dennoch mehr Raum für die Illustrationen bietet als eine zweispaltige Variante: Gaerde der Suntheit. Lübeck: Stephan Arndes, 1492. GW M09748.

173 Saurma-Jeltsch (2006), S. 428–432.

174 Konrad von Megenberg: Buch der Natur. Augsburg 1475. GW M16426.

175 Z. B. Bartholomaeus Anglicus: Van den proprieteyten der dinghen. Haarlem 24.12.1485. GW 3423.

176 Spyra (2005). Märtl u. a. (2006).

177 Meyer (2000). Meier (2005). Ventuar (2013).

178 Dieser Abbildungsmodus ist vor allem zu finden im: „Buch der Natur", in den volkssprachigen Über-

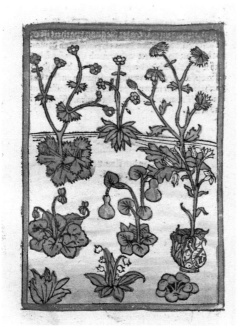

Abb. 13: „Schautafel" zum Abschnitt „von den Pflanzen": Buch der Natur. Augsburg 1475. München, Bayerische Staatsbibliothek, 2 Inc.c.a. 347.

Abb. 14: „Schautafel" zum Abschnitt „von den Pflanzen": Van den proprieteyten der dinghen. Harlem 1485. München, Bayerische Staatsbibliothek, 2 Inc.c.a. 1549 f.

bot sich diese Art der Bebilderung wenig an, da die Anordnung der Heilmittel nach dem Alphabet keine Teilbereiche wie Bäume, Tiere, Metalle oder Kräuter schuf, zu denen man „Schautafeln" hätte einbringen können.

„Herbarium pictum"

Als „Herbarium pictum"[179] wird im Folgenden der Teil einer Handschrift bezeichnet, in dem Pflanzenbilder[180] isoliert vom Fließtext gezeigt werden (Abb. 15), wie es beispielsweise auch im „Codex Berleburg" der Fall ist (S. 246–262, siehe Kap. 4.2.3.). Die Abbildungen erhalten maximal kleinere Glossen (Pflanzennamen, Synonyme, kurze Charakteristika), sodass die Pflanzennamen gut memoriert werden können.

tragungen des „De proprietatibus rerum", aber auch im „Hortus sanitatis", der die durchgängige Illustration und die „Schautafeln" kombiniert.

179 Der Begriff wurde von Schnell übernommen. Als „Herbarium vivum" bezeichnet er eine Sammlung gepresster Pflanzen oder von Naturselbstdrucken in einem Buch. Das „Herbarium pictum" kann wiederum die Form des „Herbarium vivum" imitieren und als Substituent fungieren. Schnell (2009), S. 379.

180 Die Bilder zeigen nicht nur einzelne Pflanzen (was der Begriff „Herbarium" eventuell nahelegt), sondern können auch kleine Landschaftsausschnitte, Menschen bei der Verarbeitung von Pflanzen, Steinen usw. veranschaulichen (Abb. 17–22).

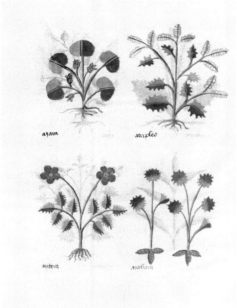

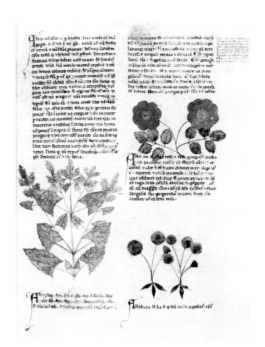

Abb. 15: Abbildungen nach der „Tractatus de herbis"-Tradition in einer medizinischen Sammelhandschrift, um 1400. Berlin, Staatsbibliothek zu Berlin, Cod. Ham. 407, fol. 234v.

Abb. 16: Tractatus de herbis, um 1300. London, British Library, Egerton 747, fol. 11r.

Auf einer Seite werden meist mehrere Exemplare nebeneinander angeordnet. Diese Art der Bebilderung findet sich in der Regel in medizinischen Sammelhandschriften, die Texte verschiedener Autoren, und möglicherweise sogar in unterschiedlichen Sprachen, zusammentragen oder zusammenbinden. Dabei wird kein zusammenhängender Text aus verschiedenen Quellen erzeugt, wie im „Gart", sondern die Einzeltexte bleiben erkennbar.

Das „Herbarium pictum" wird in der Regel am Ende solcher Sammlungen angeschlossen. So können die Bilder, durch die Loslösung von konkreten Textzusammenhängen, auf die verschiedenen medizinischen Texte der Sammelhandschrift bezogen oder als eigener „Text" innerhalb der Handschrift verstanden werden. Für den zusammenhängenden Text des „Gart" wählte man kein „Herbarium pictum" als Illustrationsform aus, sondern die „Kolumnenillustration".

„Kolumnenillustration"

Bei einem durchgehenden Bildprogramm erhält nahezu jedes Heilmittel eine eigene Abbildung. Diese „Kolumnenillustrationen"[181] gehen dem Text zum Objekt meist voran und umfassen

181 Saurma-Jeltsch (2006), S. 426–428. Saurma-Jeltsch versteht hierunter kleinformatige Abbildungen in zweispaltigen Texten, der Begriff kann aber auch auf die großformatigen Bilder des einspaltigen „Gart" angewendet werden und passt dann vor allem zum zweispaltig gesetzten „Gart".

die Breite des Schriftspiegels (Abb. 16). Besonders die „Tractatus de herbis"-Handschriften sind
auf diese Art bebildert worden. Die Illustrationen dienen unter anderem zur Unterteilung des
Texts in kurze Abschnitte, Kapitelüberschriften vergleichbar. Das Wiederauffinden und Me-
morieren bestimmter Textstellen wird durch sie grundlegend erleichtert. Gerade für eine al-
phabetische Anordnung der Kräuter wie im „Gart" bietet sich diese Variante an, im Gegensatz
zur „Schautafel". Bild und Text treten hier am dichtesten zusammen, da jede Textstelle direkt
mit der Illustration verknüpft ist, wodurch sie die Pflanzenbeschreibung im eigentlichen Wort-
sinn „erhellen" kann. Neben diesen Illustrationsmodi konstituierten sich verschiedene Inszenie-
rungsmöglichkeiten für die Pflanze im Bild. Hierbei kann die Pflanze im Bezug zum Menschen
gezeigt werden oder auch ohne ihn.

Pflanze und Mensch: Narrative Szenen

Narrative Pflanzenillustrationen setzen die dargestellten Objekte in Bezug zum Menschen, hier-
für wird meistens ein größerer Landschaftsausschnitt gezeigt (Abb. 17–19). Dabei können die
Kräuter geerntet, verarbeitet, fermentiert, von einem Gelehrten erklärt („Gelehrtenbilder"[182],
Abb. 18) werden etc.

Vor allem die „Tacuinum sanitatis"-Handschriften sind mit Illustrationen ausgestattet,
die den Menschen im Umgang mit Pflanzen darstellen (Abb. 17). Der Text geht auf arabische
Schriften des 11. Jahrhunderts zurück, seine Illustration ist insbesondere im 15. Jahrhundert be-
liebt, gerade im norditalienischen Raum. Das „Tacuinum sanitatis" behandelt die Auswirkun-
gen der Nahrung auf den menschlichen Körper unter humoralpathologischen Aspekten. Neben
Pflanzen, Kräutern, Gemüse werden auch Fleisch und Fisch berücksichtigt. Hinzu kommt die
Verknüpfung des Menschen mit den Jahreszeiten, von denen man annahm, dass sie Auswir-
kung auf das körperliche Befinden haben können: Der Herbst bringe Melancholie mit sich, der
kalt-feuchte Winter hingegen phlegmatisches Temperament etc.[183]

Das Werk legte eine einfach verständliche Methode dar, wie die Körpersäfte in Balance zu
halten seien.[184] Die Illustrationen stellen vor Augen, wie sich der Mensch die Natur medizi-
nisch zu Nutze machen kann. Saurma-Jeltsch arbeitete für diese Tradition die Komponenten
der Abbildungen heraus, die auf die Sinne verweisen. Das Fühlen, Riechen, Verarbeiten von
Kräutern wird von den Illustrationen speziell hervorgehoben und damit die sinnliche Natur-
erfahrung, die eine neue thematische Herausforderung für die Künstler darstellte. Die Bilder
laden nach Saurma-Jeltsch den Betrachter „zu virtuellen Reisen" ein (Abb. 17–19).[185] Ein „Buch
der Natur", das von der Diebold-Lauber-Werkstatt illustriert wurde, folgt dieser Abbildungs-
konvention, die das Sinnliche und Narrative stark betont: Häufig sind ein oder mehrere Ge-
lehrte zu sehen, die erklärend auf eine Pflanze deuten. Eine Frau zieht einen Balsamzweig zu
sich, um besser daran riechen zu können (Abb. 19). Pflanzen werden neben Destilliergeräten
dargestellt und verweisen dadurch auf den Geruchsinn des Betrachters. Ein Mann und eine

182 Ausführlicher bei: Saurma-Jeltsch (2006), S. 434–437.
183 Hoeniger (2006), S. 72.
184 Hoeniger (2006), S. 53.
185 Saurma-Jeltsch (2006), S. 253 f.

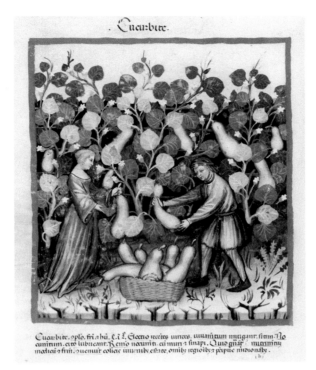

Abb. 17: Kürbis: Taciunum sanitatis. Verona (?), um 1380, Pergament.
Wien, Österreichische Nationalbibliothek, Cod. Ser. n. 2644, fol. 22v.

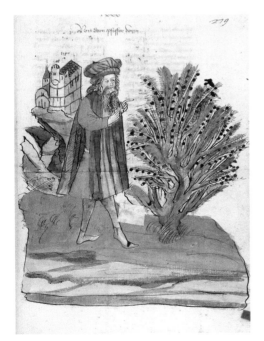

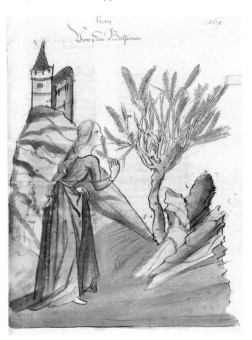

Abb. 18: Pfeffer: Buch der Natur, um 1442–1448. Heidelberg, Universitätsbibliothek, Cod. Pal. germ. 300, fol. 279r.

Abb. 19: Balsam: Buch der Natur, um 1442–1448. Heidelberg, Universitätsbibliothek, Cod. Pal. germ. 300, fol. 269r.

Frau ernten gemeinsam volle, reife Früchte, ein Vorgang, der im Bild durchaus erotische Komponenten hat.[186] Dass sich eine weibliche und eine männliche Pflanze einander zuwenden, sich liebend gegenseitig befruchten und reproduzieren, kann erotisch, aber auch im moralischen Sinne gelesen werden.[187]

Gerahmt, gepflegt, gepflanzt

Ebenso gestaltet sich die Einzeldarstellung von Pflanzen – ohne Abbildung des Menschen – äußert vielfältig: Die Pflanze kann gerahmt sein, eine gesamte Seite einnehmen oder die Breite einer Textspalte umfassen, sie kann auf einem Landschaftsgrund platziert, eingepflanzt oder eingetopft sein (Abb. 20–22). Einen großen Variantenreichtum zeigt in dieser Hinsicht das deutschsprachige „Kräuterbuch" von Johannes Hartlieb. Vor der Mitte des 15. Jahrhunderts verfasste der Arzt das Werk mit fast 170 Pflanzenbeschreibungen.[188]

Die überlieferten Hartlieb-Handschriften[189] machen deutlich, so Schnell, dass die Illustration ein „integraler Bestandteil"[190] des „Kräuterbuchs" war. Der Text beruhte auf dem Pflanzen-Abschnitt des „Buchs der Natur", dazu ergänzte Hartlieb 76 Kapitel. Drei Abschriften des „Buchs der Natur" überliefern anstatt des eigentlichen 5. Abschnitts „Von den Kräutern" das „Kräuterbuch" des Hartlieb.[191] Im Grunde kann das „Kräuterbuch" als Vertiefung eines Teilaspekts im „Buch der Natur" verstanden werden. Das Hartlieb'sche „Kräuterbuch" wurde nicht gedruckt, was vermutlich am „Gart der Gesundheit" lag, der den Bedarf an deutschsprachigen Kräuterbüchern offenbar abdeckte und dazu noch mehr Pflanzenbeschreibungen beinhaltete.

186 Hoeniger (2006), S. 73 f.

187 In den „Concordantiae Caritatis" schreibt Ulrich von Lilienfeld davon, wie sich Palmen durch nicht körperliche Vereinigung fortpflanzen: „Die Palmen neigen sich im Frühling einander zu, und indem die eine die andere mit ihren Zweigen liebkosend umfasst, werden sie gleichsam aus dem Zündstoff der gegenseitigen Liebe befruchtet. So war auch die allerseligste Jungfrau wie ein Palmbaum [...]". Zit. nach: Cermann (2014), S. 73.

188 Spyra (2005). Saurma-Jeltsch (2006). Das „Buch der Natur", das heute in Heidelberg aufbewahrt wird (Cod. Pal. germ. 300), zeigt, neben zwei „Schautafeln" mit Bäumen und anderen Pflanzen, mit insgesamt neun Baum- und sechs Pflanzen-Illustrationen bereits relativ viele Einzelabbildungen verglichen mit anderen bebilderten „Buch der Natur"-Handschriften. In der Kombination mit dem „Kräuterbuch" von Hartlieb gibt das „Buch der Natur" (Cod. Pal. germ. 311) zwei „Schautafeln" mit Bäumen und ganze 159 Einzelabbildungen wieder (plus ein Leerraum für „balsam": fol. 251r). Beide Handschriften wurden von der Diebold-Lauber-Werkstatt illustriert.

189 Bild und Text sind in folgenden Handschriften überliefert: In drei Handschriften aus den 1450er Jahren, heute in: Heidelberg (Cod. Pal. germ. 311). Michelstadt im Odenwald (Cod. D 684) und Wolfenbüttel (Cod. Guelf. 79 Aug. 2°). In drei Handschrift von ca. 1460, heute in: Isselburg, Anholt (Ms. 46), Berlin (Ms. germ. quart. 2021) und Wien (Cod. 2826). In zwei Handschriften von ca. 1470, heute in: Linz (Ms 4) und in Nürnberg (Hs. 18792) – das Germanische Nationalmuseum bewahrt noch zusätzlich eine Abschrift einer verschollenen Hartlieb-Handschrift auf, ehem. Erbach im Odenwald im Gräflich Erbach'schen Archiv.

190 Schnell (2009), S. 11–14.

191 In: Michelstadt im Odenwald, Stadtarchiv, Cod. D 684; Heidelberg, Universitätsbibliothek, Cod. Pal. germ. 311 und in der Abschrift des Kräuterbuchs aus dem GNM (siehe Fußnote 189 in Kapitel 3). Siehe auch: Schnell (2017), Nr. 70.2.

Abb. 20: Kürbis und Rettich: Hartlieb: Kräuter-
buch, um 1455/60. Heidelberg, Universitätsbiblio-
thek, Cod. Pal. germ. 311, fol. 257r und 305v.

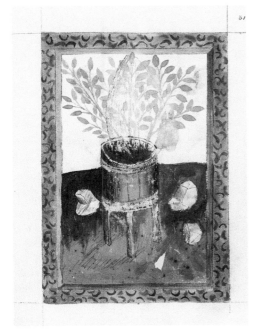

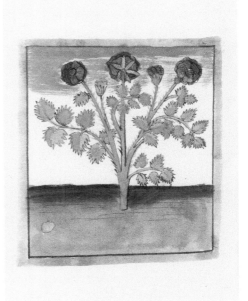

Abb. 21: Basilikum: Hartlieb: Kräuterbuch, um
1450. Wolfenbüttel, Herzog August Bibliothek,
Cod. Guelf. 79 Aug. 2°, fol. 31r.

Abb. 22: Rose: Hartlieb: Kräuterbuch, um 1465.
Anholt, Wasserburg, Fürstlich Salm-Salm'sche
Bibliothek, Ms. 46, fol. 148v. In: Kat.Ausst. Bed-
burg-Hau (2004), S. 147.

Die eingetopfte oder aus dem Boden wachsende Pflanze wird in diesen Illustrationen, die sich nicht nur auf Hartliebs „Kräuterbuch" beschränken, in einen Kontext eingebettet, der insbesondere ihren Wachstumsort berücksichtigt. Manchmal wird sogar ein Querschnitt durch den Boden gezeigt, sodass man sehen kann, welcher Teil der Pflanze ober- bzw. unterhalb der Erde wächst (Rettich: Abb. 20). So kann auch zwischen Pflanzen unterschieden werden, die kultiviert wurden oder die wild wachsen. Wenn Hopfen oder Kürbis um eine Stange gewickelt dargestellt wird oder Basilikum in einen Topf gesetzt (Abb. 21), macht dies den Eingriff des Menschen deutlich. Der Aspekt der Kultivierung und Nutzung der Pflanze steht bei diesen Illustrationen im Vordergrund. Außerdem schaffen manche Landschaftsausschnitte eine gewisse Tiefenwirkung der Abbildungen und setzen die beschriebenen Pflanzen über den Text hinaus in ihre „natürliche Umgebung" ein.

Freigestellte Pflanzen

Völlig freigestellte Pflanzen, wie sie im „Gart" gezeigt werden, ohne Landschaftselemente, Figuren und Rahmungen, kennt man vor allem aus der „Tractatus de herbis"-Tradition (Abb. 23) sowie aus den kräutermedizinischen Prachthandschriften, dem „Carrara herbal"[192] (Abb. 24) und der „Historia plantarum"[193] (Abb. 25).

Für den „Gart" bilden die „Tractatus de herbis"-Abbildungen ein zentrales Bezugssystem. Dieses hatte sich seit ca. 1300 herausgebildet – die älteste erhaltene „Tractatus de herbis"-Handschrift (Egerton 747) wird um 1300 datiert.[194] Vergleicht man die Illustrationen dieser Handschrift mit weiteren „Tractatus de herbis"-Abschriften und den französischen Übersetzungen („Livres des simples médecines"), ist festzuhalten, dass die Abbildungstradition einen hohen Grad an Stabilität vom 14. bis ins frühe 16. Jahrhundert aufweist (siehe Kap. 4.2.2.).[195] So wurden konstante Bildformeln für die Pflanzen kreiert, die ihre Identifizierung erleichtern. Deshalb ist es nicht relevant, ob die Pflanze „naturnah" abgebildet ist oder nicht, sondern, was Ivins für den „Gart" beobachtet hatte, dass die immer gleiche Überlieferung von Pflanzenformeln („exactly repeatable pictorial statements"[196]) den wissenschaftlichen Diskurs erleichtert und befördert. Dies kann schon vor dem Buchdruck für die „Tractatus de herbis"-Tradition geltend gemacht werden. Mit dem Bezug auf etablierte Pflanzenbilder konnte man sich in diesen Diskurs einbinden. Dabei werden für den

192 Das „Carrara herbal" ist eine italienische Übertragung des „Aggregator" mit großformatigen, naturnahen Illustrationen, es wird im Allgemeinen mit der medizinischen Fakultät in Padua in Verbindung gebracht, aber auch mit dem damaligen Herrscher Paduas, Francesco II. Smith vergleicht die „naturalistischen" Tendenzen der Künstler und der Herrscherfamilie: „Claiming the *natural* reasonableness to their rule, the Carrara family walked an uneasy course between the commune's claims that they were unnatural tyrants and the pope's assertion that they stood outside any divinely ordered hierarchy. The Carrara appear to have employed nature (and artisans) in order to construct a theatre of state that would bolster their claims to legitimate rule [...]." Smith (2008), S. 17.

193 Die „Historia plantarum"-Handschrift gehört zu den „Tacuinum sanitatis"-Texten. Die prachtvolle Ausstattung wird unter anderem Giovannino de' Grassi zugeschrieben und schwankt zwischen der „Tacuinum sanitatis"- (Abb. 17) und der „Tractatus de herbis"-Bildtradition (Abb. 23).

194 Zur Texttradition siehe oben: S. 41 f.

195 Givens (2006), S. 115 f.

196 Ivins (1969), S. 2.

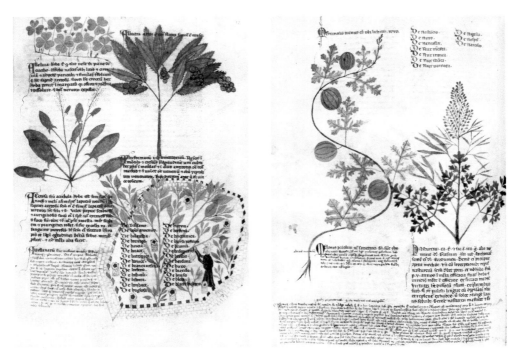

Abb. 23: Tractatus de herbis, um 1300. London, British Library, Egerton 747, fol. 12r und 66v.

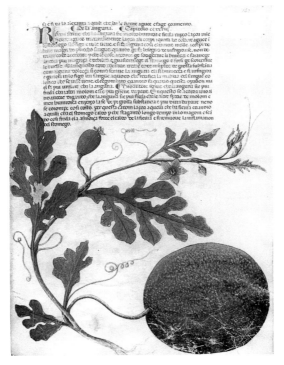

Abb. 24: Melone: „Carrara herbal". Padua, um 1400, Pergament.
London, British Library, Egerton 2020, fol. 146r.

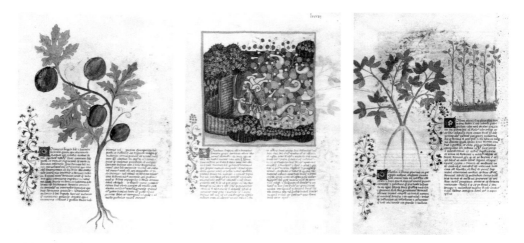

Abb. 25: Historia plantarum, um 1400, Pergament. Rom, Biblioteca Casanatense, Ms. 459, fol. 85v–86v.

„Gart" nicht nur einige der „Tractatus de herbis"-Illustrationen kopiert, das gesamte Bildprogramm knüpft visuell auch an die Repräsentationsform der „Tractatus de herbis"-Pflanzenbilder an, indem die Pflanzen freigestellt und in der Regel von der Blüte bis zur Wurzel gezeigt werden.

Es sei betont, dass alle der hier dargestellten Illustrationsprogramme die genannten Visualisierungsformen variieren. Auch die durchgehenden Darstellungen der „Tractatus de herbis"-Handschriften zeigen, neben einem Großteil an freigestellten Pflanzen, Landschaften, Menschen usw. – dies ist im „Gart" so nicht der Fall.

3.6.2. Ein neues Kräuterbuch kreieren: Zum Bild-Text-Aufbau des „Gart"

Obwohl auch andere Kombinationen mit den verschiedenen Abbildungsformen möglich gewesen wären, wie man es aus anderen Kräuterhandschriften kannte, beschränkte man sich im „Gart" konsequent auf die durchgängige Abbildung von freigestellten Pflanzenbildern. Das Abbildungsprogramm des „Gart" ist damit für seine Zeit ungewöhnlich konzise: Es werden keine Menschen im Kräuterbuch gezeigt, keine Landschaft, keine Rahmung, nur wenige Tiere erhielten einen kleines Rasenstück als Untergrund.[197] Dies kann nicht auf die Technik der Druckgraphik zurückgeführt werden, sondern stellt eine bewusste Entscheidung dar, weil man im Druck zu diesem Zeitpunkt bereits die gesamte Bandbreite der genannten Darstellungsoptionen umzusetzen wusste (Abb. 55–60).

Die Pflanzendarstellungen erhielten im „Gart" viel Raum, quantitativ wie qualitativ. Die Tierillustrationen machen nur einen geringen Anteil an Abbildungen aus, überhaupt nicht bildlich repräsentiert werden: Metalle, Edelsteine, Flüssigkeiten (z. B. Essig, Wasser, Gold, Silber). Größere Pflanzen werden im „Gart" nach Möglichkeit seitenfüllender gestaltet als kleinere. Da jedoch keine Menschen abgebildet werden, fehlt jede Relation. Wurzeln werden in der Regel, aber durchaus nicht immer mit dargestellt.

197 Auch bei keiner der erhaltenen kolorierten Varianten des „Gart" wurden Rahmungen oder Bodenstücke nachträglich hinzugefügt. Daraus lässt sich schließen, dass auch die Maler diese Illustrationsform als Programm erkannt hatten und ihm folgten.

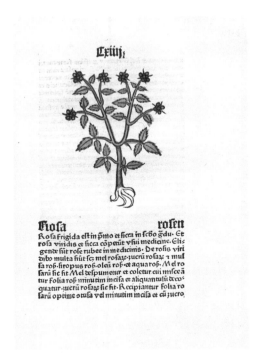

Abb. 26: Rose: Herbarius Moguntinus. Mainz 1484.
München, Bayerische Staatsbibliothek, 4 Inc.c.a.
364 m.

Abb. 27: Rose: Gart der Gesundheit. Mainz 1485.
München, Bayerische Staatsbibliothek, 2 Inc.c.a.
1601.

Bei der Suche nach ähnlichen Bildprogrammen in Handschriften fällt auf, dass man sich in
der Bild-Text-Gestaltung und der Ausführung der Illustrationen nicht, wie es bei Inkunabeln
häufig der Fall war, an der Handschrift orientierte. Die Abbildungen des „Gart" können als
großformatige Kolumnenillustrationen bezeichnet werden, wie sie aus den „Tractatus de her-
bis"-Handschriften bekannt sind. Dort finden sich allerdings kaum Bilder einzelner Pflanzen,
die nahezu die gesamte Seite füllen (Abb. 23). Indem im „Gart" jede Pflanze eine eigene Seite
erhält, wirkt das Layout klarer und strukturierter, so es wie in den Abschriften von Hartliebs
„Kräuterbuch" zu sehen ist (Abb. 20–22, 29), wobei die Abbildungen bei Hartlieb keine freige-
stellten Pflanzen zeigen, sondern eine Landschaft und meist noch einen Rahmen. Aufgrund der
großzügigen Anordnung der Illustrationen zum Text könnte man überlegen, ob man mit dem
„Gart" an kräutermedizinische Luxushandschriften anknüpfen wolle, wie das „Carrara herbal"
und die „Historia plantarum" (Abb. 24–25), die Bernhard von Breydenbach in Italien gesehen
haben könnte, die aber wiederum kein derart konzises Illustrationsprogramm aufweisen.

Die Bild-Text-Struktur des „Gart" hat weniger mit anderen Kräuterbuch-Handschriften ge-
mein und orientiert sich auch nicht an der ersten illustrierten Kräuterbuchinkunabel aus Rom
(Abb. 2). Vielmehr wurde für die fast zeitgleich entstandenen Werke „Herbarius Moguntinus"
(1484) und „Gart" (1485), die beide in der Schöffer-Offizin verlegt wurden, ein neues Layout
kreiert (Abb. 26–27), das zunächst das Pflanzenbild zeigt und dann in einer etwas größer ge-
setzten Überschrift den Pflanzennamen (lateinisch und deutsch) nennt. Die Kapitelzahl ist im
„Herbarius" über dem Pflanzenbild zu sehen, im „Gart" wird sie in die Überschrift eingebun-

den. Der Text ist einspaltig und schließt an das Pflanzenbild an, das nicht gerahmt wird.[198] Für den „Gart" übernahm man jedoch lediglich die Anordnung von Bild und Text vom Mainzer „Herbarius". Die Illustrationen, der Text, die Reihenfolge der Pflanzenbeschreibungen dienten dem „Gart" nicht als Vorlage. Zudem ist der „Gart" im Folio-Format größer und wesentlich umfangreicher (360 Bl.) als der „Herbarius Moguntinus" (174 Bl., Quart-Format).

Was die technische Ausführung der Abbildungen betrifft, überbot der „Gart" bis dahin gesehene gedruckte Naturillustrationen.[199] Bei einem Vergleich mit zeitgleich entstandenen, illustrierten Drucken zeigt sich rasch, dass die Überschneidungen, feinen Binnenschraffuren und Schattierungen sowie insbesondere die Verkürzungen eine für den Druck völlig neue Plastizität erzeugten. Die Buchseite wird, ohne einen Landschaftshintergrund zu zeigen, in die Tiefe hin geöffnet.

Die perspektivischen Pflanzenbilder des „Gart", sein klares und konzises Illustrationsprogramm und die technisch fein gearbeitete Ausführung der Holzschnitte waren in jedem Fall eine visuelle Neuheit auf dem Buchmarkt – auch die Intention des Herausgebers, die Pflanzen „in ihrer rechten Farbe und Gestalt" zu zeigen, war ein progressiver Anspruch an ein Kräuterbuch.[200] Die genannten Punkte stellen bewusste Entscheidungen der Beteiligten des Buchprojekts dar, wobei unklar bleibt, wie viel Einfluss Bernhard von Breydenbach auf seinen Künstler bei der Festlegung des Illustrationsprogramms nahm.

Im neuen Medium versuchte man jedenfalls, das Alte zu überholen und etwas Neues zu kreieren.[201] Dieser neue Typus, der sich besonders ab den 1530er Jahren durchzusetzen begann, wird mit dem botanischen, naturwissenschaftlichen Kräuterbuch assoziiert, das die „objektive" Abbildung der Pflanze anstrebt.[202] Mit Fleck kann man eine solche kulturelle Codierung einer bestimmten Illustrationsform als speziell „naturwissenschaftlich", als „wahrnehmungsleitend" bezeichnen.[203] Von einer solchen wahrnehmungsleitenden Wirkung kann man für die Erstausgabe des „Gart" ausgehen.[204]

3.6.3. Bild und Text am Beispiel der Lilie

Um einen präziseren Einblick in die Bild-Text-Beziehung geben zu können und um den neuen Umgang mit Pflanzen im „Gart der Gesundheit" sowohl in den Darstellungen als auch in den Beschreibungen zu veranschaulichen, soll im Folgenden das Lilien-Kapitel des „Gart" mit denjenigen aus zwei weiteren deutschsprachigen Kräuterbüchern verglichen werden, mit dem etwa 1440 entstandenen „Kräuterbuch" von Johannes Hartlieb[205] und dem 1532 gedruckten „Contra-

198 Siehe zu diesem ähnlichen Aufbau des Layouts auch: Schwabe (2006).
199 Gemeint sind hier ganz allgemein Tier- und Pflanzendarstellungen im Buchdruck, z. B. auch im „Buch der Natur" oder zu Aesops Fabeln (Abb. 57–60).
200 Giesecke (2006), S. 340.
201 Bernhard von Breydenbach wird von Timm zu Recht als Medienexperte bezeichnet, der geschickt zu kalkulieren verstand, was gerade am Buchmarkt gefragt war. Timm (2006), S. 323 f.
202 Smith (2008), S. 15.
203 Fleck (2011), S. 391.
204 Weiter hierzu: Kap. 4.5.
205 Die hier behandelte Abschrift entstand um 1455/60 und überliefert das „Buch der Natur" Konrads

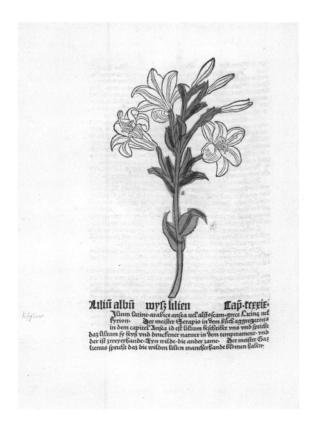

Abb. 28: Lilie: Gart der Gesundheit.
Mainz 1485. München, Bayerische Staats-
bibliothek, 2 Inc.c.a. 1601.

fayt Kreüterbúch" von Otto Brunfels.[206] Alle drei Pflanzenkapitel beginnen mit der Abbildung
einer Lilie, im Anschluss folgt die textliche Auseinandersetzung mit der Blume als Heilmittel.

Kapitel 229 (von 435 Kapiteln) im „Gart" beschreibt die weiße Lilie, „Lilium album", die
nach alphabetischer Reihung zwischen „Laurus" (Lorbeerbaum) und „Lilium Conuallinn"
(Maiglöckchen) angeordnet ist. Zusammen mit der Illustration hat das Kapitel einen Umfang
von zweieinhalb Seiten. Zuerst wird das freigestellte Bild einer Lilie gezeigt, ohne Rahmung
oder Landschaftshintergrund, sie umfasst beinahe die gesamte Seite (Abb. 28). Es fällt auf, dass
keine Wurzel zu sehen ist, obwohl im Text häufig ihre medizinische Wirkung thematisiert wird.
Um den Stengel der Pflanze sind die Blätter gruppiert, die zum Teil leicht nach vorne und hin-
ten abgenickt sind, sodass Räumlichkeit erzeugt wird. Die drei geschlossenen und drei offenen
Blüten, die sich in verschiedene Richtungen neigen, lassen durch Verkürzungen Plastizität ent-
stehen. Mit Hilfe dieser Perspektivität wird dem Betrachter vermittelt, ein naturnahes Objekt
vor Augen zu haben, wodurch das Bild der Pflanze „authentisch" erscheint.[207]

von Megenberg sowie Johannes Hartliebs „Kräuterbuch": Heidelberg, Universitätsbibliothek, Cod.
Pal. germ. 311. Zu Hartlieb siehe oben: S. 74–76. Oder: Schnell (2017), Nr. 70.2. Hayer / Schnell
(2010). Kat.Ausst. Bedburg-Hau (2004), darin insb. Wittekind (2004).

206 Otto Brunfels / Hans Weiditz: Contrafayt Kreüterbúch. Straßburg 1532. VD16 B 8503. Hierzu: Kap.
 6 oder Smith (2008).

207 Heinrichs hält für das späte 15. Jahrhundert fest, dass Naturstudien, wie Schongauers Pfingstrose und
 die Holzschnitte des „Gart", parallele Gestaltungsweisen aufweisen, obgleich es sich um zwei unter-

Eine Darstellung alleine hat im Kräuterbuch, in dem alle existierenden Heilpflanzen wieder-
gegeben werden sollen, zunächst wenig Aussagekraft, erst mit der Einordnung und Benennung
der Pflanze ist sie (nach antiken Maßstäben)[208] korrekt erfasst. Unter dem Bild der Lilie, in
hervorgehobener Schrift, sind der Name der Pflanze auf lateinisch und deutsch sowie die Ka-
pitelzahl genannt: „Lilium album wyß lilien Cap. ccxxix".[209] Diese etwas größer gesetzte Zeile
fungiert gleichzeitig als Bildunterschrift; das Objekt ist damit auf einer Seite vor Augen gestellt
und benannt. Es folgt, in kleiner Schrifttype, die Beschreibung der Pflanze, wobei vom Setzer
Platz für eine Initiale ausgespart wurde.[210] Im anschließenden Text wird der Pflanzenname er-
neut in lateinischer sowie in arabischer und griechischer Übertragung angegeben: „[L]ilium
latine. arabice ansea uel alstoscam. grece Licina uel kyrion." Hieran wird die Wichtigkeit der
korrekten Benennung und der Wiedergabe möglicher Synonyme für eine Pflanze deutlich, die
eindeutig identifizierbar sein muss, sodass Verwechslungen im medizinischen, überregionalen
Diskurs vermieden werden können.[211]

Im gesamten Text werden von Johann Wonnecke von Kaub relativ ausführlich Quellen bzw.
Autoritäten angeführt, auf die er sich beruft: „Der Meister Serapion im Buch ‚Aggregatoris‘ in
dem Kapitel ‚Ansea id est lilium‘ beschreibt uns und sprach, dass die Lilie heiß sei und trocke-
ner Natur im Temperament."[212] Um die Glaubhaftigkeit des Geschriebenen zu untermauern,
galt es, antike Autoritäten aufzurufen und eventuell auch genaue Textstellen zu benennen. Da-
bei geht es weniger darum, diese Stellen ausfindig machen zu können, denn die Namen der
Mediziner und Philosophen genügten, um beweiskräftige Texte zu erzeugen.[213]

Die Nennung des Temperaments der Pflanze wiederum gibt dem Leser bereits erste Hinweise
auf die medizinische Verwendung.[214] Man weiß nun, dass ein Überschuss an kalt-feuchten Säften

schiedliche Medien handelt: „Auch in medizinischen Pflanzenbüchern des 15. Jahrhunderts wird
Wert auf den Eindruck gelegt, dass eine bestimmte Pflanze aus einer bestimmten Perspektive wieder-
gegeben ist. [...] Offenbar verlieh die komplizierte, perspektivische Darstellung dem Bild Authentizi-
tät. Dafür spricht, dass selbst in einfacheren Holzschnittillustrationen der Zeit auf perspektivische
Verkürzung und auf eine variantenreiche Stellung der Blätter und Blüten nicht verzichtet wurde."
Heinrichs (2007), S. 142. Weiter zur Evidenz des Bilds: Kap. 5.2.

208 Siehe oben: S. 48 f.

209 Johann Wonnecke von Kaub (1485), Cap. ccxxix.

210 Obwohl viele der für diese Arbeit gesichteten „Gart"-Exemplare im Nachhinein koloriert wurden,
wurden in den seltensten Fällen die Initialen für jedes Pflanzenkapitel eingefügt. Dafür wurden häu-
fig noch Rubrizierungen gesetzt. Die von Hand einzufügenden Initialen und die Rubrizierungen
sind eigentlich typisch für die Handschrift und zeigen, dass man sich mit dem Buchdruck nicht
schlagartig vom alten Medium löst. Zu dieser Übergangszeit siehe beispielsweise: Kat.Ausst. Mün-
chen (2009).

211 Zur Bedeutung des Namens bzw. der korrekten Benennung von Objekten siehe auch: Wood (2008),
S. 53–59.

212 Johann Wonnecke von Kaub (1485), Cap. ccxxix: „Der meister Serapio in dem búch aggregatoris in
dem capitel Ansea id est lilium beschribet vns vnd spricht daz lilium sy heyß vnd druckener natuer
in dem temperament [...]." Zu den Textquellen des „Gart" siehe: Kap. 3.3.1.

213 Siehe oben: Kap. 3.1.1. Die Textquellen den „Gart" sind nicht hinreichend erforscht, es existiert keine
kritische Edition.

214 Diese für den Leser zentrale Information wird durchgängig für alle Heilmittel in Kräuterbüchern bis
ins 16. Jahrhundert gegeben.

mit Hilfe der heiß-trockenen Lilie ausgeglichen werden kann.[215] Danach beschreibt der Autor die zwei verschiedenen Arten der Lilie, wilde und zahme, und zählt die Farben der wilden Lilie auf, dabei stützt er sich auf Galen:

> Der Meister Galen sagt, dass die wilden Lilien verschiedene Blumen [gemeint sind Blüten] haben. Die einen sind von weißer Farbe, viele von himmlischem Blau und viele sind purpurfarben. Er sagt, die wilden Lilien nennt man Iris, weil sie so viele Farben haben wie ein Regenbogen. Sie können den Menschen erhitzen, besonders die Lilien mit den blauen Blumen. Diese Lilien haben knotige Wurzeln, die gut riechen. [...] Außerdem sagen die Meister, dass die blauen Lilien, die man Schwertlilien nennt, große Heilkraft besitzen, besonders die Wurzeln.[216]

Die knotige Wurzel wird nur beschrieben und nicht in der Abbildung gezeigt, auch der nicht darstellbare Geruch, Geschmack, die Konsistenz oder Haptik sowie die verschiedenfarbigen Ausprägungen der Pflanze werden vermittelt. Häufig schildert Johann Wonnecke von Kaub die Farben über Vergleiche mit anderen bekannten Pflanzen, um den richtigen Farbton zu treffen: „Es gibt auch gelbe Lilien, die die gleichen Blätter haben wie die blauen. Ihre Blüten sind safranfarben. Es gibt auch Lilien, die weiß blühen. Diese Lilien haben weichen Samen, süße Wurzeln, die dick wie Finger sind, und wachsen gerne unter den Bäumen im Schatten."[217] Da der Ort, an dem die Pflanze wächst, nach damaliger Vorstellung Auswirkung auf die medizinische Wirkung des Heilkrauts haben konnte, findet er im Text meist Erwähnung.[218] Bei den Illustrationen des „Gart" spielt der Wachstumsort hingegen keine Rolle; ob die Pflanze wild wächst, kultiviert werden kann, im Gras oder Wald zu finden ist, muss der Rezipient zuerst nachlesen.

Bild und Text ergänzen sich folglich nach Möglichkeit; das, was man durch die Illustration nicht erfahren kann, wird beschrieben. Im Text wiederum sind Pflanzendetails ausgespart, die in der Abbildung zu sehen sind, wie die Proportionen der Pflanze, die Form der Blütenblätter, offene und geschlossene Blüten oder die etwas längeren Fruchtknoten sowie die darum gruppierten Staubblätter der Lilie. Solche Elemente sind nur schwer in Worte zu fassen, was auch daran liegt, dass keine botanischen Fachbegriffe existierten, mit denen man die Pflanze bis in die kleinste Einzelheit beschreiben konnte.[219] Mit Hilfe des Bilds kann das Problem der fehlen-

215 Siehe hierzu auch: Kap. 5.1.3.

216 Johann Wonnecke von Kaub (1485), Cap. ccxxix: „Der meister Galienus spricht daz die wilden lilien mancherhande blomen haben. Die eyn synt wyß far etlich hymmel blae far. etlich purpuren far. Er spricht auch daz die wilden lilien synt genant yris vnd vmb der mancher hande farbe heyssent sie yris. das ist als vil gesprochen als eyn regenbogen der auch mancherley farbe in ym hait. also haben auch die wilden lilien mancher hande farbe an yn. Sie synt von natuer den menschen nitzigen vnd subtylen vnd sunderlich die lylienn mit den blaen blomen. Die selbigen blaen lilien haben wúrtzeln die synt knodicht vnd riechen fast wól. [...] Item die meister sprechen daz die blaen lylien die man swertlyn heysset gar vil do gent an yn habent vnd sunderlich an der wúrtzel."

217 Johann Wonnecke von Kaub (1485), Cap. ccxxix: „Eß synt auch wilde lylien die haben auch bletter glich den blaen vnd haben blomen die synt glich von farben dem saffran. vnd synt auch lylien also gestalt die haben wyß blomen. Diß lylien haben samen der ist weych. Die wúrtzell ist fuße vnd eyns fyngers dicke. vnd wachsen gern vnder den baumen vnd vnder dem scheden."

218 Vgl. Kap. 5.3.1.

219 Ein hilfreiches Glossar zu wiederkehrenden Begriffen im Kräuterbuch des 15. Jahrhunderts liefern: Hayer / Schnell (2010), S. 139–150. Zur heutigen botanischen Terminologie: Strasburger (2014), S. 540.

den Begrifflichkeit umgangen und ein Exemplar vor Augen gestellt werden. Nachdem die Gestalt der Lilie geschildert wurde, werden im Text Hinweise zu ihrer medizinischen Anwendung gegeben („Diese Wurzeln soll man Mitte März ausgraben, in kleine Scheiben zerschneiden und zum Trocknen aufhängen, bis sie fast verdorrt sind [...]"[220]), komplexere Rezepte genannt („Gegen die Wassersucht und geschwollenen Bauch vermische und zerstoße: ein Quentchen Majoran und die Wurzel der Schwertlilie, ein Quentchen weißer Nieswurz, zehn Gerstenkörner und ein halbes Quentchen Veilchenblüten und nimm dies als Brühe ein, es vertreibt die genannten Krankheiten und andere Krankheiten, auch wenn man sie schon lange mit sich herum getragen hat."[221]) sowie verschiedene Gelehrte aufgelistet, die sich zum „Gegenstand Lilie" und seiner Heilkraft geäußert haben. Dabei vermeidet Johann Wonnecke von Kaub Wiederholungen nicht, sondern führt beispielsweise nacheinander auf, dass bei Galen und im „Circa instans" zu finden sei, dass die Wurzel der Lilie Geschwüre erweichen lasse. Offenbar kommt es mehr auf das möglichst vollständige Aneinanderreihen von Autoritäten an, wodurch die Evidenz des Gesagten gesteigert wird:

> Der Meister Galen schreibt und sagt im siebten Buch, genannt „simplicium farmacorum"[222], dass die heimischen Lilien gemischter Natur sind, besonders die Blüten. Das Öl der heimischen Lilien ist auf den Bauch gestrichen gut für ihn. Es erwärmt die kalten Gemüter und erweicht die Feuchtigkeit im Inneren. Die Wurzel soll man gesotten auf harte Geschwüre aufgetragen, damit sie weich werden.
>
> Der Meister Serapion sagt, dass die Lilienwurzeln gebraten und danach gestoßen mit Rosenwasser vermischt das Heilige Feuer [auch als Antoniusfeuer bekannt] wegnimmt. [...] Auf offene Wunden gelegt, lassen sie das Fleisch darin wachsen. Sie reinigen auch den Bauch der Frau zur Geburt.
>
> Im „Circa instans" schreiben und sagen die Meister, dass die Wurzeln von den heimischen Lilien gesotten, gestoßen, mit Schmalz oder Baumölen vermischt und auf Geschwüre gelegt sie erweicht. [Es folgt ein längeres Rezept für eine schmerzlindernde Salbe aus der Wurzel der weißen Lilie und weiteren Zutaten.] Wasche das Pulver der blauen Lilie gesotten mit Rosenwasser, das macht das Gesicht schön.
>
> Der Meister Platearius[223] schreibt und sagt, dass gesottene und gestoßene Lilienwurzel, zusammen mit Rosenöl gemischt, gegen Verbrennungen hilft, wenn man es darauf streicht. [Es folgt Rezept für die Erzeugung von Stuhlgang.][224]

220 Johann Wonnecke von Kaub (1485), Cap. ccxxix: „Diß wúrtzel sal man vß graben in dem mittel deß mertzen vnd sal die zursnyden zú cleynen schyben vnd die vfhencken vnd laißen dorren."

221 Johann Wonnecke von Kaub (1485), Cap. ccxxix: „Für die wassersucht vnd fur den geswollen buch Nym eyn quintyn meyron vnd swerel wúrtzel eyn quintyn vnd wyß nyeßwúrtzel zehen gersten korner swer vnd violn blomen eyn halb quintyn vnd mische diß gestoissen zú samen vnd mym diß in eyner erweyß brüe eß verdrybet die obgeschriben krankheyt vnd ander wil krankheyt vnd ander vil krankheyt die der mensche lange zyt by yme gedragen hait."

222 Gemeint ist Galens „De simplicibus medicamentorum", vgl. Mayer (2014), S. 138.

223 Autor des „Circa instans", um 1150: siehe oben S. 41.

224 Johann Wonnecke von Kaub (1485), Cap. ccxxix: „Der meister Galienus in dem syebenden búch genant simplicium farmacorum beschribet vns vnd spricht daz die heymschen lylien gemister natuer synt vnd sunderlich die blomen do von. Das óle von den heymschen lylien ist gar gút sich do mit gestrichen vff den buch. Eß erwormet fast die erkalten múter vnd erweichet die feuchtikeyt die dar

Abb. 29: Lilie: Hartlieb: Kräuterbuch.
Heidelberg, Universitätsbibliothek, Cod.
Pal. germ. 311, fol. 286v.

Die Überlieferungstradition zur medizinischen Anwendung der Lilie ist relativ konstant; auch in den beiden Vergleichsbeispielen, den Kräuterbüchern von Hartlieb und von Brunfels, kann man nachlesen, dass Lilien Geschwüre erweichen, ein schönes Gesicht machen, gegen das Antoniusfeuer helfen, den Frauen die Geburt erleichtern und Verbrennungen lindern, Stuhlgang erzeugen sowie giftige Schlangenbisse heilen. Welche Neuerungen bieten nun Bild und Text im „Gart" im Vergleich mit früher entstandenen Kräuterbüchern?

In seinem um 1440 verfassten „Kräuterbuch" greift Hartlieb in weiten Teilen auf das „Buch der Natur" von Konrad von Megenberg (entstanden um 1350) zurück, weshalb beide Texte häufig zusammen überliefert wurden.[225] Alle Abschriften des „Kräuterbuchs" von Hartlieb beinhal-

inne verhertet ist. Die würzel gesotten vnd vff die harten gewern geleyt machet sye zú hant zytigen. Der meister Serapio spricht daz lylien würzeln gebraten vnd darnach gestoissen vnd darvnder gemischet rosen wasser beneme das heylig feuer. […] Also geleyt vff wunden machet wachsen das fleisch dar inne. Auch also geleyt vff den buch der frauwen reyniget sye zú yrer geburt. In dem búch genant circa instans beschriben vns die meister vnd sprechen daz die würtzeln von den heymschen lilien gesotten vnd gestoissen vnd darvnder gemischet reynbergen smaltz oder baum ólen vnd geleyt vff geswern weychet fast wól. […] Das puluer von den blaen lilien gesotten mit rosen wasser vnd do mit geweschen das antlitz machet eß gar húbsch. Der meister Platearius beschribet vns vnd spricht daz lilien würtzeln gestotten vnd gestoißen vnd darvnder gemischet rose óle ist fast gút fur den brant an dem libe ob man die stat do mit bestrichet. […]"

225 Anstatt des 5. Abschnitts des „Buch der Natur" zu den Kräutern wird dann das umfangreichere „Kräuterbuch" von Hartlieb eingefügt. Während sich der „Gart" zum größten Teil auf die Heilpflanzen konzentriert, wird hier weit umfassender versucht, die Natur im Buch abzubilden, was sich auch

ten Illustrationen, was das Werk zu einem idealen Vergleichsbeispiel für den „Gart" macht, da man davon ausgehen kann, dass bei der Konzeption der Handschriften Bild und Text von Anfang an als Kombination angelegt waren. Hartliebs „Kräuterbuch" beinhaltet 173 Kapitel zu elf Tieren und 162 Pflanzen in alphabetischer Reihenfolge (zum Vergleich im „Gart": 435 Kapitel).[226] Wie im „Gart" sind die Pflanzen im „Kräuterbuch" nach ihren lateinischen Namen geordnet.

In einer erhaltenen Abschrift des „Kräuterbuchs" von Hartlieb (Abb. 29; UB Heidelberg, Cod. Pal. germ. 311, um 1455/60) umfassen das Bild der Lilie und ihre Beschreibung lediglich eine Buchseite (zum Vergleich im „Gart": zweieinhalb Seiten).[227] Die Pflanze wird durch drei Lilien illustriert, die aus einer einfachen Grünfläche wachsen, die sich nicht weiter in die Tiefe erstreckt. Durch das Rasenstück ist keine Wurzel zu sehen. Die mittlere Lilie ragt steil nach oben, die anderen neigen sich leicht nach links und rechts von ihr ab, wobei die linke Blüte noch geschlossen ist. Aus den anderen Blütenköpfen wachsen, vom (unbekannten) Illustrator deutlich hervorgehoben, jeweils drei gelbe Staubblätter. Die Pflanzen sind leicht schattiert, allerdings wenig plastisch. Nicht zuletzt wegen der roten Rahmung der Illustration wirken die Pflanzen gedrungen und die Proportionen dadurch unausgewogen.

Der Text zur Lilie setzt mit einer roten, zweizeiligen L-Lombarde ein, der lateinische und deutsche Pflanzenname wird genannt. Ihr Aussehen hält Hartlieb nur knapp fest, da er davon auszugehen scheint, dass die Pflanze geläufig ist:

> Lilium heißt die Lilie. Das Kraut ist gut bekannt[228] und hat schöne weiße Blumen mit sechs Blättern und in der Mitte einen kleinen gelben Nagel [Fruchtknoten], darum stehen kleine „Dingl" [Staubblätter] mit gelben Häuptern. Die Lilie ist heiß und feucht, wie Platearius[229] sagt. [Es folgen kurz die oben genannten medizinischen Anwendungsbereiche.][230]

Im Gegensatz zum „Gart" wird auf Bezeichnungen der Pflanzen im Arabischen oder Griechischen im „Kräuterbuch" verzichtet, auch werden keine Erntezeiten oder komplexeren Rezepte mit Mengenangaben gegeben. Außerdem führt Johann Wonnecke von Kaub eine Vielzahl an Autoritäten an, während Hartlieb lediglich Platearius als Quelle nennt, ein konkretes Werk oder andere Gelehrte werden nicht erwähnt. Dadurch wirkt der Text stärker „aus einem Guss", da Wiederholungen und Aufreihungen vermieden werden und damit möglicherweise einhergehende Widersprüche in den Quellen. Diese stellt der Autor des „Gart" unaufgelöst nebeneinander (s. o. Kap. 3.3.1.). Weil im „Kräuterbuch" nur ein Gelehrter genannt wird, fällt die Überfülle an Autoritäten bei Johann Wonnecke von Kaub umso stärker auf, es galt scheinbar

in den Illustrationen zeigt, die „noch stark in der Tradition der lateinischen Enzyklopädien verankert sind." Schnell (2017), Nr. 70.2.

226 Zum Bild-Text-Verhältnis in allen erhaltenen Abschriften von Hartliebs „Kräuterbuch" hält Schnell fest, dass die Illustrationen keinen Textbezug aufweisen und keine Tendenz festzustellen ist, Naturbeobachtung in die Darstellungen einfließen zu lassen, vielmehr folge man der Tradition: Schnell (2017), Nr. 70.2.

227 Beschreibung der Handschrift durch: Miller (2007).

228 Es ist nicht eindeutig, auf wen Hartlieb sich hier bezieht, da sowohl der Leser als auch „in der Medizin bekannt" gemeint sein könnte.

229 Wie im „Gart" wird auch der Autor des „Circa instans" als Quelle genannt.

230 Lilie in Hartliebs „Kräuterbuch": Nach der Edition von Hayer / Schnell (2010), S. 112 f. Lilie im „Buch der Natur" Konrads von Megenberg: Nach der Edition von Luff / Steer (2003), V.47 (S. 440).

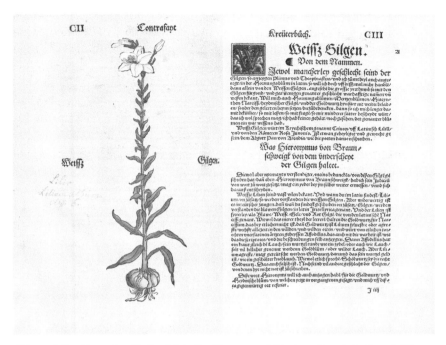

Abb. 30: Lilie: Contrafayt Kreüterbúch. Straßburg 1532. München, Bayerische Staatsbiblio-
thek, Rar. 2264.

weniger, einen homogenen Text zu schaffen, sondern möglichst divers und vollständig Quellen
anzuführen.

Dafür versucht Hartlieb, was im „Gart" dem Bild überlassen wird, die Blüte der Lilie ge-
nauer zu erfassen. Dabei greift er wegen der fehlenden Terminologie auf alltägliche Gegen-
stände zurück, die dem Pflanzenbestandteil ähnlich sehen, z. B. der Nagel, der den Fruchtkno-
ten bezeichnet. Es fällt auf, dass im Text die Unterschiede zwischen Fruchtknoten und Staub-
blättern deutlicher hervorkommen als im Bild.[231]

Sowohl bei Hartlieb als auch im „Gart" wird weitgehend auf christliche Auslegungen oder
etwa Parabeln verzichtet. So heißt es im „Buch der Natur" Mitte des 14. Jahrhunderts, das Hart-
lieb abgesehen von dieser Passage weitgehend übernommen hatte, im Kapitel zur Lilie noch,
dass Gott seine Mutter mit der Lilie verglichen habe, die ohne Sünde sei:

Der höchste Gott vergleicht seine Mutter mit der Lilie und sagt: „Mein Leib [...] ist Gestalt
unter anderen Töchtern, die auf der Erde sind, so wie die Lilie Gestalt ist unter den dornigen
Stauden." Welch ein schönes Wort: Obwohl Maria unter den Sündern ist, trägt sie kein Zeichen
von dorniger Sünde, zarte Maria voll der Gnade [...].[232]

231 Zum Blütenaufbau im Lehrbuch der Pflanzenwissenschaft: Strasburger (2014), S. 540.
232 Lilie im „Buch der Natur" Konrads von Megenberg: Nach der Edition von Luff / Steer (2003), V.47
	(S. 440).

Auch wenn im 15. und 16. Jahrhundert solche Darlegungen unüblich sind, kann man doch im „Gart", bei Hartlieb und Brunfels anhand der Anwendungsgebiete der Lilie nachvollziehen, dass die Lilie mit Reinheit und ganz allgemein mit der Mutter verbunden ist: Sie reinigt, macht schön, ist gut für die Gebärmutter (die als „muter" bezeichnet wird) und hilft bei der Geburt. Bei Brunfels wird sogar angeführt, dass die weiße Lilie die Frauen keusch mache.

Im „Contrafayt Kreüterbúch" von Brunfels beginnt das Kapitel zur weißen Lilie mit einer ganzseitigen Darstellung der Blume (Abb. 30), um sie herum angeordnet ist lediglich die Seitenzahl, die Seitenüberschrift und der deutsche Pflanzenname („Weissz Gilgen").[233] Da der Autor nicht alphabetisch vorgeht, sondern versucht, ähnlich anmutende Pflanzen zusammenzustellen,[234] ist die weiße Lilie gemeinsam mit anderen Lilien zu finden (z. B. der goldenen, blauen und gelben Lilie). Verglichen mit dem „Gart" ist das Lilien-Kapitel bei Brunfels etwa doppelt so lang,[235] liest man hingegen genauer, haben sich die gegebenen Informationen kaum verändert. Dagegen gliedern nun Unterüberschriften, die mit größeren Typen gesetzt sind, den Text.[236] Von den bisherigen Kräuterbuchautoren versucht Brunfels sich deutlich abzugrenzen, indem er eine eigenständige Ordnung der Pflanzen schafft; außerdem fokussiert er sich ausschließlich auf pflanzliche Heilmittel; Tiere oder Mineralien kommen im „Contrafayt Kreüterbúch" nicht vor. Weiterhin beschränkt sich Brunfels in seinem Werk auf einheimische Arten und stellt 130 Pflanzen vor, die er z. T. sogar mit mehreren Darstellungen (insg. 176 Holzschnitte[237]) von Hans Weiditz illustrieren ließ. Der Anspruch an das Kräuterbuch hatte sich Anfang des 16. Jahrhunderts deutlich verändert. Während Bernhard von Breydenbach in seinem Vorwort noch betont, dass er alle Heilpflanzen aufnehmen wolle, insbesondere die seiner Auffassung nach edleren Kräuter, die er im Morgenland wähnte,[238] ist für Brunfels die Konzentration auf die deutschsprachigen Gebiete programmatisch.[239]

Dagegen stimmen der „Gart" und das „Contrafayt Kreüterbúch" in der Art und Weise der Darstellung der Kräuter überein, es werden freigestellte Pflanzen ohne Rahmung oder Landschaft abgebildet. Hans Weiditz veranschaulicht die weiße Lilie mit einer geöffneten und einer geschlossenen Blüte, im Hintergrund entfaltet sich ein weiterer Blütenkopf. Die Blätter kreisen von oben bis unten um den Stengel, der aus einer knolligen Wurzel herauswächst, die abweichend von der Illustration von Reuwich und bei Hartlieb dargestellt ist.[240] Im Vergleich zu der Abbildung von Weiditz hatte Reuwich für den „Gart" die Unterschiede zwischen Fruchtknoten

233 Im „Gart" war bei jeder Abbildung zuerst der lateinische und dann der deutsche Pflanzenname als Beischrift vorhanden, dort ordnete man die Pflanzen in alphabetischer Reihenfolge nach den lateinischen Namen.

234 Brunfels unterscheidet nach Pflanzenfamilien sowie männlichen und weiblichen Exemplaren. „Unter Familie versteht Brunfels gleiches Aussehen oder verwandte medizinische Wirkungen, als männlich gilt ihm starker Wuchs und kräftige, dunkle Farben." Isphording (2008), S. 131, Nr. 35.

235 Brunfels (1532), S. CII–CV.

236 Dies deckt sich mit den Analysen von Habermann, die festgestellt hat, dass sich die Kräuterbücher des 16. Jahrhunderts vor allem in Anordnung und Textgliederung vom „Gart" unterscheiden. Habermann (2001), S. 376.

237 175 Pflanzendarstellungen und ein Wappen von Straßburg.

238 Bernhard von Breydenbach (1485), fol. 2v.

239 Giesecke (2006) beschreibt diese Tendenz als „Nationalisierung des Wissens" (S. 382).

240 Brunfels war die Darstellung der Wurzeln offenbar besonders wichtig, jedes seiner Pflanzenbilder zeigt auch die Wurzel. Swan (2011), S. 187.

und Staubblättern differenzierter herausgearbeitet. Was die Plastizität und kunstvollen Verkür-
zungen betrifft, steht der „Gart" dem Kräuterbuch von 1532 nicht nach. In beiden Fällen und
mit gleichen künstlerischen Mitteln suggeriert die freigestellte Pflanze dem Betrachter Natur-
nähe und Authentizität.

Der Beginn des Kapitels zur weißen Lilie wird bei Brunfels mehrfach markiert, zuerst wird in
größerer Schrift der Name der Pflanze erneut genannt: „Weissz Gilgen. / Von dem Nammen."
Es folgt eine W-Initiale, die von drei Putten umspielt wird („Wiewol mancherley geschlecht
seind [...]"), woraufhin andere Lilienarten („Geschlecht") genannt werden. Brunfels betont,
dass er nur von der weißen Lilie handeln will, trotzdem führt er die weiteren Arten auf und
beendet den Abschnitt mit der Feststellung, dass niemand wahres Wissen über diese verschiede-
nen Arten habe.[241] Erst jetzt wird der Name der Lilie in lateinischer und griechischer Sprache ge-
nannt, wobei Brunfels arabisch im Gegensatz zum „Gart" beiseitelässt. Stärker als bisher rückt
die korrekte Bezeichnung der Pflanzen in den Mittelpunkt sowie Vorschläge für eine optimierte
Benennung. Dabei sollen insbesondere festgefahrene Irrtümer „unerfahrener Ärzte" behoben
werden.[242] Gerade der „Gart" und seine Nachfolger hatten die Notwendigkeit einer Fachsprache
für den wissenschaftlichen Diskurs über Pflanzen deutlich gemacht, was in Brunfels' Ringen
um die Begriffe zum Ausdruck kommt.[243]

Äußerst knapp behandelt Brunfels das Aussehen der Lilie. Seine Darstellung ergänzt, was
die Illustration nicht wiedergeben kann, den Geruch und Geschmack sowie den Wachstumsort
oder die Größe der Lilie:

> Aussehen der Lilien: Keine Blume wächst höher als die Lilie, ihr Stengel ist drei Ellen hoch, oben
> neigt und öffnet sich zart die Blume. Selten hat die Lilie zwei Stengel. Die Blume ist schnee-
> weiß [...]. Keine Blume hat einen stärkeren, edleren Geruch. Blütezeit und Wachstumsort: Ihre
> Blütezeit ist Anfang Juni, sie wächst nur in Gärten und kultivierten Orten. Temperament: Die

241 Brunfels (1532), S. CIII: „Wiewol mancherley geschlecht seind der Gilgen [...] so will ich doch vff
 dissz mal nicht handeln, dann allein von den Weissen Gilgen. [...] Will mich auch Hornungsblúmen,
 Mertzenblúmen, Hiacynthen, Narcissi, heydnischer Gilgen, vnd der Goldwurtz hynfürt nit
 weiter beladen [...]. dann so ich mich lenger damit bekümmer, so mit lesen, so mit fragen, so mir
 minderer statter bescheydt würt, das ich wol sprechen mag, ich hab keinen gehört, noch gesehen,
 der genanter blúmen ein war wissens hab." (Obwohl die Lilie verschiedene Arten hat [...], will ich
 nur von der weißen Lilie sprechen. [...] Ich will die Februars-, Märzblumen, Hyazinthen, Narzissen,
 heidnische Lilien und Sumpf-Schwertlilie hier nicht weiter behandeln [...]. Als ich mich länger mit
 ihnen beschäftigte, habe ich festgestellt, dass ich niemanden kenne, der wahres Wissen über die ge-
 nannten Blumen hat.)
242 Brunfels (1532), S. CIII: „Dann Goldwurtz ist Lilium [...] wechst allezeit in den wálden, vnd wilden
 orten, vnd wúrt von etlichen torechten vnerfarenen ártzten geheyssen Affodillus. [...] Dann Affo-
 dillus hat ein kraut gleich dem Lauch, sein wutzel runde wie ein zybel, oder auch wie Lauch, solt vil
 billicher genennt werdern Goldblúm, oder wilder Lauch." („Goldwurtz" [Sumpf-Schwertlilie] ist
 eine Lilie, sie wächst immer im Wald und an nicht kultivierten Orten und wird von vielen törichten
 und unerfahrenen Ärzten „Affodillus" genannt. [...] „Affodillus" hat Stengel, die dem Lauch glei-
 chen, seine Wurzeln sind wie runde Zwiebeln oder wie Lauch, daher sollte er besser Goldblume oder
 wilder Lauch genannt werden.)
243 Für die gedruckten Sachbücher des frühen 16. Jahrhunderts wurde beobachtet, dass sie versuchten,
 eine eigene deutsche Fachsprache zu entwickeln, die sich nicht nur vom Mittelalter absetzen sollte,
 sondern auch von arabischen Einflüssen. Noe (2008), S. 66 f.

Blume der Lilie hat ein vermischtes Temperament […], sie hat im Geschmack etwas Bitteres
[…]. Die Wurzel gilt als warm und feucht im 2. Wirkungsgrad.[244]

Zuletzt werden alle bekannten Anwendungsgebiete für die Heilpflanze aufgelistet, die weit-
gehend mit dem „Gart" übereinstimmen. Dabei verzichtet Brunfels, abgesehen von Galen und
Dioscurides, auf die Nennung antiker Quellen und zitiert hauptsächlich eine aktuellere, deut-
sche Quelle, Hieronymus von Braunschweig (gest. 1512),[245] da niemand mehr über die Lilie wis-
se.[246] Der Rückgriff auf zeitgenössische oder kürzlich verstorbene Autoritäten hängt mit einem
gesteigerten Selbstbewusstsein der Kräuterbuchautoren zusammen, die ihre eigenes Wissen und
das ihrer Zeitgenossen mehr noch in die Texte einbringen, als es der Autor des „Gart" tat. Man
legte im 16. Jahrhundert darauf Wert, die eigene Autorität gegenüber antiken oder arabischen
Ärzten zu untermauern.[247]

Im Vergleich der drei Werke wird deutlich, dass das Bild- und Textprogramm des „Gart"
von den bis 1485 bekannten Kräuterbüchern losgelöst hatte und neue Wege beschritt. Dies zeigt
sich unter anderem daran, dass man sich im „Gart" intensiv der antiken und mittelalterlichen
Überlieferung zuwandte und verstärkt Autoritäten sowie ihre Schriften anführte. In Bezug auf
das Bild-Text-Programm der drei Kräuterbücher ist festzustellen, dass das Bild im „Gart" und
bei Brunfels nicht ohne Verlust vom Text getrennt werden könnte. Vielmehr sind beide Medien
für eine überzeugende, evidente Darstellung der gesamten Gestalt der Pflanze und ihrer Eigen-
schaften aufeinander angewiesen. Mit Helmut Puff kann man von einem Bildtext sprechen,
wobei das Bild ebenso gelesen werden muss wie der Text und es auch nicht wiederholt, was
bereits im Text gesagt wurde und umgekehrt.[248] Wo beispielsweise Hartlieb noch versucht, dem
Leser das Aussehen des Fruchtknotens der Lilie genau vor Augen zu stellen, bleibt dies bei Brun-
fels und bei Johann Wonnecke von Kaub dem Bild überlassen; die beiden Autoren ergänzen
stattdessen durch ihre Beschreibung z. B. des Geschmacks und Geruchs die Illustration, sodass
Bild und Text sich gegenseitig erhellen. Während Schnell für das „Kräuterbuch" von Hartlieb
feststellt, dass die Illustrationen „keinen eigenständigen naturkundlichen Erkenntnisgewinn an-

244 Brunfels (1532), S. CIIII: „Gestalt der Gilgen. Kein blúm ist die hóher wechst weder ein Gilg. Ir stengel
 ist .iii. ellenbogen hoch, welcher dieweil er oben zart, so neyget sich alwegen die blúm. Man findet sel-
 ten das ein Gilg .ii. stengel hab. Dit blúm schnee weissz […]. Kein blúm ist die ein sterckeren, edeleren
 gerich von ir gebe. Zeyt vnd statt. Ire zeit ist im anfang des Brachmonats, vnnd wachßet allein in den
 gárten vnd gebawen orten. Complexion. Die blúm von der Gilgen, hat an ir ein vermischte temperatur,
 […] im geschmack etwas bitter […]. Die wurtzel würt geachtet warm vnd feücht, vff den .ii. grade."
245 Hieronymus von Braunschweig war u. a. Verfasser eines Destillierbuchs (erstmals 1500 gedruckt,
 Abb. 112), das seit 1505 auch zusammen mit dem „Gart" herausgegeben wurde. Hieronymus Brun-
 schwig: Liber de arte distillandi. Straßburg: Johann Grüninger, 8.5.1500. GW 5595.
246 Brunfels (1532), S. CIII.
247 Hinzu kommt bei Brunfels eine deutlichere Betonung der deutschen Landschaft: Man beschränkte sich
 für das Kräuterbuch auf einheimische Pflanzen und legte Wert auf die Gelehrsamkeit der nationalen Au-
 toren. Müller / Pfisterer (2011), S. 17: „Die Volkssprachen sind besonders attraktive Felder der *aemulatio*,
 des Wettstreits mit den Sprachen der klassischen Antike wie des Wettstreits untereinander […]."
248 Puff (2014), S. 330 f. Puff greift hier auf die Forschung von Mieke Bal zur „Bildtextwissenschaft" und
 W. J. T. Mitchell zum „image-text" zurück, wobei es vermieden werden soll, Bild und Text gegen-
 einander auszuspielen.

Abb. 31: Titelblatt: Herbarius Moguntinus.
Mainz 1484. München, Bayerische Staatsbibliothek, 4 Inc.c.a. 364 m.

strebten", [249] ist der Erwerb und die Weitergabe von Wissen mit Hilfe des Bilds für den „Gart" und das „Contrafayt Kreüterbúch" programmatisch, wobei zu bedenken ist, dass sich Brunfels in seinen Schriften selbst eher skeptisch gegenüber der Illustration von Herbarien geäußert hat (siehe hierzu: Kap. 6).

Insgesamt ist festzuhalten, dass mit dem „Gart" ein Werk geschaffen wurde, das neue Maßstäbe setzte, was das Quellenstudium, die Fachsprache rund um die Pflanze oder die Visualisierungsstrategien von naturwissenschaftlichen Texten betrifft.

3.6.4. Das Tor in den Garten der Gelehrten: Zum Titelbild

Für den „Gart" gestaltete Reuwich eigens einen Holzschnitt, der nachträglich vorne eingeklebt wurde (Abb. 162). Ein einleitendes Bild zu einem spezifischen Werk ist bis zu diesem Zeitpunkt eine Ausnahmeerscheinung. Habermann nennt dieses Blatt ein Titelbild, da es keinen Titelholzschnitt im klassischen Sinne darstellt, wie er im 16. Jahrhundert gedruckten Werken vorangeht und Autor, Titel und weitere Informationen zum Buch meist als prachtvolle Bild-Text-Kombination wiedergibt (Abb. 36). [250] Als erstes Titelblatt überhaupt bezeichnet sie demgegenüber die erste Seite des „Herbarius Moguntinus", das den Titel, den Erscheinungsort, das Erscheinungsjahr des Werks nennt und das Signet Peter Schöffers zeigt (Abb. 31). [251]

Das Titelbild des „Gart" zeigt eine Gruppe Gelehrter, die sich dicht gedrängt in einem Garten versammelt hat. Die sich überkreuzenden Blickachsen und verschiedenen Gesten weisen auf eine rege Diskussion hin. Einzelne Gesprächspartner wenden sich einander zu, manche scheinen die Unterhaltung gespannt mitzuverfolgen. Solche Disputationsdarstellungen sind, wie Hülsen-Esch zeigen konnte, die gängige Ikonographie für Gelehrte im Spätmittelalter. Die Tugenden der Beredsamkeit und Gelehrsamkeit werden als charakteristisch für die soziale Gruppe der Gelehrten vermittelt. [252]

Insgesamt haben sich dreizehn Männer unter freiem Himmel getroffen, die durch ihre Tracht und Kopfbedeckungen als Gelehrte zu erkennen sind. Zehn stehende Figuren befinden sich im Mittelgrund des Bilds, davor haben drei Männer in einem Halbrund Platz genommen.

249 Schnell (2017), Nr. 70.2.
250 Habermann (2001), S. 79: „Die wichtige Errungenschaft des Titelblatts kann für ein sinnvolles Katalogisieren und Bibliographieren nicht bedeutend genug veranschlagt werden. Reduzierend auf die Grundkonstanten Autor – Titel – Druckort und -jahr ist zudem eine schnelle und eindeutige Identifizierung des im Druck erscheinenden Werks gewährleistet."
251 Habermann (2001), S. 110.
252 Hülsen-Esch (2006), S. 323, S. 350.

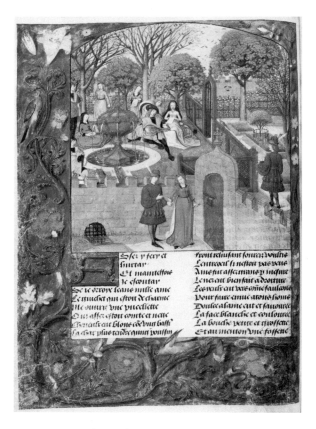

Abb. 32: Liebesgartenszene: Roman de la Rose, um 1495. London, British Library, Harley 4425, fol. 12v.

Das Zentrum des Holzschnitts bildet die mittlere, sitzende Figur, die ein Buch in Händen hält. Frontal blickt sie – als einzige – aus dem Bild heraus auf den Betrachter und erhebt ihren linken Arm so, als würde sie ihn in der Runde willkommen heißen. Links und rechts von ihr sitzen zwei Männer der mittleren Figur zugewandt. Die linke Gestalt hat ein Buch zum Studium aufgeschlagen, während die rechte eine Pflanze nach oben hebt und ein Buch griffbereit neben sich abgelegt hat.

Als Bodenfläche ist ein Rasenstück zu erkennen, aus dem einige Pflanzen, darunter ein Rosenbusch, empor sprießen. Zwei Bäume bilden den Hintergrund der Szene. Gerahmt ist der Holzschnitt mit einem Torbogen, aus dessen steinernen Säulen Pflanzenornamente wachsen, die den Bogen so umspielen, dass sich ein Eingangstor in den Garten für den Betrachter eröffnet. In der Mitte des Torbogens ist mit Hilfe eines Gürtels ein leerer Wappenschild befestigt, der über den Köpfen der Gruppe hängt.

Der Holzschnitt führt einen idealtypischen Garten vor, der durch eine Trennung in Rasenstück und Baumbereich bestimmt ist (Abb. 32). Separiert werden diese beiden Ebenen häufig durch eine Sitzgelegenheit. Bekannt sind diese zweigeteilten Gartenanlagen unter anderem durch Schilderungen des Albertus Magnus, der Mitte des 13. Jahrhunderts in seinem Werk „De Vegetabilibus" einen solchen Garten beschreibt, sowie durch zahlreiche spätmittelalterliche Buchillustrationen und Gemälde.[253] Der verschlossene Garten stellt bei Albertus einen Ort des

253 Wie spätmittelalterliche Gärten tatsächlich angelegt waren, ist nur noch schwer zu rekonstruieren: Haunschild (2005).

Rückzugs dar, der nur eingeweihten Personen zugänglich ist. Für den Betrachter des Titelblatts im „Gart der Gesundheit" hat sich dieser Zugang geöffnet. Hinter der Pforte begegnet ihm kein Lustgarten, sondern ein Ort des Philosophierens.

Als Besitzer des „Gart" konnte man das leere Wappen des Holzschnitts nutzen, um sich als Gelehrter in die Gruppe zu integrieren.[254] Geschickt spielt der Künstler so mit der Realitätsebene des Lesers und der Bildebene, die weiter in das Buch hinein verweist und die der Betrachter wie ein Eingangstor passiert. Im „Gart" trifft er auf Naturphilosophen und Ärzte, die er aus den antiken Schriften kennt oder die Bernhard von Breydenbach und Johann Wonnecke von Kaub als Quellen erwähnen: Galen, Avicenna, Serapion, Dioscurides, Pandectarius [Matthaeus Silvaticus],[255] Platearius[256] Plinius etc. Die Gelehrten sind im Holzschnitt namentlich nicht durch Beischriften identifiziert. Zu erkennen ist eine heterogene Gruppe, in der alle Altersstufen sowie verschiedene Religionen bzw. Kulturen vertreten sind. Einige Männer tragen zeitgenössische Frisuren und Gewandung, die ihnen ein jugendliches Aussehen verleihen. Die linke Sitzfigur hat einen Teil ihrer Mütze in einem langen Zipfel über die Schulter geworfen, wie es im 15. Jahrhundert im nordalpinen Raum Mode war.[257] Des Weiteren waren für Gelehrte an Universitäten schwere, lange Gewänder üblich, wie sie bei den Männern im Vordergrund zu sehen sind. Durch ihre Schwere und Länge verlangsamten sie die Schritte und verliehen den Trägern eine raumgreifende Silhouette. Beides deutete schon im Auftreten Würde an, eine Wirkung, die sich die Gelehrten der Zeit zu Nutze machten.[258] Auf manchen Köpfen sitzt eine traditionell rote *cappa*, die an Universitäten als Zeichen der Doktorwürde getragen wurde (Abb. 33).[259] Andere Gelehrte mit Turban oder erfundenem Kopfschmuck entstammen dem Kulturbereich des Morgenlands. Auf einem Turban und einem Mantel sind Schriftzeichen erkennbar, die wohl keine konkrete Bedeutung haben, aber an einen arabischen oder jüdischen Kontext denken lassen.[260] Die elaborierte mittlere Figur trägt einen aus dem Orient stammenden, luxuriösen Damaststoff als Schultermantel, der mit Edelsteinen besetzt ist und mit einer kostbaren Schnalle zusammengehalten wird. Der aufgeklappte Filzhut lässt darauf schließen, dass es sich um einen griechischen Arzt oder Philosophen handelt.[261] Obwohl einige Männer in zeitgenössischen Gewändern abgebildet wurden, verweisen solche Darstellungen doch immer auf antike Autoritäten.[262] Dass antike Figuren für den Betrachter problemlos in derzeit modische Stoffe gehüllt werden können, zeigen einige Jahre später die Schedel'sche Weltchronik

254 Z. B. hat sich Jacobus Prandl im „Gart"-Exemplar der BSB München 2 Inc.c.a. 1601 eingetragen.

255 Wit geht davon aus, dass mit „Pandectarius" der Autor des „Opus pandectarum medicinae" (Anfang des 14. Jahrhunderts), Matthaeus Silvaticus, gemeint ist (siehe S. 42 f.). Wit (1992), S. 178.

256 Autor des „Circa instans" (um 1150). Siehe oben: S. 41.

257 Vielen Dank an Kerstin Merkel für zahlreiche Hinweise zur Mode.

258 Hülsen-Esch (2003). Hülsen-Esch (2006).

259 Hülsen-Esch (2006), S. 99–107.

260 Wood (2008), S. 275–279: Das fremde Alphabet verbildlicht automatisch eine andere Welt und Kultur, die ohne Hilfe nicht eindeutig gelesen und decodiert werden kann.

261 Vgl. Pisanellos Darstellungen des byzantinischen Kaisers Johann VIII. Palaeologus: Abb. 34.

262 Hülsen-Esch (2006), S. 207 f., S. 299 f. Auch wenn Hülsen-Esch ihre Untersuchungen auf Italien und Frankreich konzentriert hat, kann vieles auch für das deutschsprachige Gebiet geltend gemacht werden. Zu Autoritäten und dem Bild als Autorität: Wimböck (2004). Ein Anachronismus kann hier im Bild beides ausdrücken, Legitimität und Kontinuität von Wissen: Nagel / Wood (2010), S. 45–50, S. 85–96.

Abb. 33: Hartmann Schedel (Selbstporträt?), in: Matthaeus Silvaticus de Salerno: Pandecta synonymarum et medicinarum simplicium aggregatarum, 15. Jahrhundert. München, BSB, Clm 30, vor fol. 1.

Abb. 34: Pisanello: Skizze von Kaiser Johann VIII. Palaeologus, 1438, Feder auf Papier. Paris, Museé du Louvre, Les collections du département des arts graphiques, Inv.-Nr. MI 1062, verso.

Abb. 35: Demosthenes und Aristoteles im zeitgenössischen Gewand: Chronica, Fünftes Zeitalter. Nürnberg 1493. München, Bayerische Staatsbibliothek, 2 Inc.c.a. 2922.

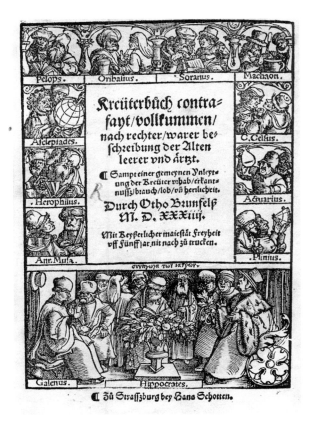

Abb. 36: Titelblatt: Contrafayt Kreüter-
búch. Straßburg 1534. München, Bayeri-
sche Staatsbibliothek, 4 M.med. 45 c.

(Abb. 35) oder das Titelblatt des „Contrafayt Kreüterbúch" von Otto Brunfels (Abb. 36). Hier
wird eine Gruppe zeitgenössisch gekleideter Gelehrter in einem Innenraum versammelt, die um
einen Blumenstrauß platziert miteinander disputieren, in Büchern blättern oder mitgebrachte
Pflanzen genauer betrachten. Die Bildunterschrift weist zwei Männer als „Hippocrates" und
„Galenus" aus. Als Rahmen für den Buchtitel dient eine Galerie, in der weitere antike Autoren
und mythologische Gestalten porträtiert und benannt werden, darunter „Plinius", „Macha-
on"[263] und „Celsus". Für Hülsen-Esch wird durch die zeitgenössische Kleidung eine „Identi-
fikation mit der Tradition medizinischen Wissens" ermöglicht.[264]

Im Holzschnitt von Reuwich kann sich der Betrachter des „Gart" in diesem Sinne nicht
nur mit den anwesenden zeitgenössisch gekleideten Ärzten identifizieren und an Traditionen
anknüpfen, sondern er hat durch ein leeres Wappen auch einen Raum im Bild zugewiesen be-
kommen, in den er sich einschreiben kann. Der „Gart"-Besitzer Jacobus Prandl („IP") skizzierte
auf das Wappenfeld einen Baum auf drei Hügeln und versah darüber hinaus die anwesenden
Gelehrten mit Beischriften.[265] Klar lesbar ist lediglich der Name Serapion, weiterhin kann Galen
und Dioscurides noch erahnt werden. Die exponierte mittlere Figur wurde in ihrer luxuriösen
Kleidung bereits vom zeitgenössischen Betrachter als griechischer *homo famosus* erkannt. So ver-

263 „Machaon": Arzt im Heerlager der Griechen vor Troja, siehe: Mazal (1981), S. 53.
264 Hülsen-Esch (2006), S. 300.
265 „Gart"-Exemplar: 2 Inc.c.a. 1601, BSB München (Abb. 162).

wundert es nicht, dass über ihr in Großbuchstaben der Namensrest [Ari]STOT[eles] zu lesen ist.

Die Darstellungen von leeren Wappen tauchen in veränderter Form in anderen Titelbildern wieder auf. Im Gegensatz dazu ist auffällig, dass Reuwichs Erfindung, die Gelehrten in einem Garten zu platzieren, von anderen Künstlern nicht wieder aufgegriffen wurde. Hierzu seien zwei Beispiele angeführt:

Abb. 37: Titelblätter: Dis ist das Buch der Cirurgia. Augsburg 1497. München, Bayerische Staatsbibliothek, 2 Inc.c.a. 3451 a.

Die „Cirurgia" von 1497 wird sogar durch zwei ganzseitige Holzschnitte eingeleitet, die zusammen gelesen werden können (Abb. 37). Zunächst ist die Theorie angesprochen: Die Schüler werden in Kommunikation mit dem Lehrer gezeigt, während eine Figur aus dem Fenster auf die Landschaft blickt, eventuell um nicht nur am Buch, sondern an der Natur zu lernen. Im nächsten Bild ist erneut eine Unterrichtssituation in einer Apotheke zu sehen, die einerseits praxisbezogener ist und andererseits den Betrachter auf mnemotechnischer Ebene anspricht und ihn zum Memorieren auffordert. Darüber hinaus sind auf den Apothekergefäßen eine Reihe an Wappen dargestellt, wobei die zwei mittleren Schilde, auf die der Lehrmeister deutet, leer blieben. Wie beim „Gart" konnte sich der Besitzer hier einschreiben.[266]

Die Gelehrtengespräche oder der Unterricht finden in Darstellungen des 15. und 16. Jahrhunderts in einer idealtypischen Situation im Innenraum statt, nur Reuwich lässt die Gelehrten gemeinsam im Freien sowohl in Büchern als auch an der Natur studieren. Die Theorie bei alten Autoritäten

266 Saurma-Jeltsch (2006), S. 432.

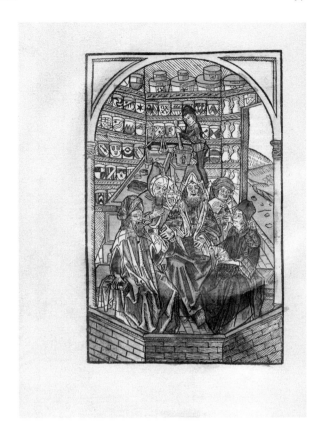

Abb. 38: Titelbild: Gart der Gesundheit.
Augsburg 1486. München, Bayerische
Staatsbibliothek, 2 Inc.c.a. 1771 b.[268]

zu begreifen, deren Gestalt in ihren Schriften festgehalten[267] wurde und nun wieder im Bild und
im „Gart" lebendig werden, wird ergänzt durch das praktische Naturstudium, das dem Betrachter
ebenso anempfohlen wird. Widersprechen sich die Quellen, die der Autor des „Gart" zitiert, löst er
die gegensätzlichen Positionen nicht immer auf, es bleibt dem Leser überlassen, sich eine Auffassung
zu bilden. Manchmal schreibt er auch von seinen eigenen Erfahrungen als Arzt und reiht sich so
als Meister Johann Wonnecke von Kaub unter die Gelehrten ein. Das eigenständige Erfahren der
Pflanzenwelt zur Überprüfung und Erweiterung der Informationen aus alten Büchern ist als Idee
bei Reuwichs Titelbild und ebenso im Text fassbar. Wie ungewöhnlich dabei die Szene unter freiem
Himmel scheint, veranschaulich eine neue Fassung des Holzschnitts aus der Augsburger „Gart"-Aus-
gabe von 1493, auf dem die Gelehrten des „Gart" in eine Apotheke gesetzt werden und lediglich ein
Landschaftsausschnitt erhalten blieb (Abb. 38). Auch das Gelehrtengespräch im Titelblatt bei Brun-
fels findet in einem Innenraum statt, in den die Pflanzen mitgebracht wurden.

Reuwich spielt in seinem Titelbild womöglich auf das Paradies als Garten und Ursprung der
Pflanzenwelt an. Die beiden Bäume im Hintergrund legen diese Lesart zumindest nahe. Sie
sind als Zitrusbaum und Palme zu identifizieren, die besonders in ihrer Kombination auf den
Garten Eden hindeuten.

267 Der Text, der die Gestalt der Person besser festhält als das Bild, ist ein im 15. Jahrhundert bekannter
 Topos, der z. B. im Holzschnitt des Erasmus von Dürer verwendet wird. Dazu u. a.: Robert (2004).
268 Nachdruck in: Gart der Gesundheit. Augsburg 1493. München, Bayerische Staatsbibliothek, 2
 Inc.c.a. 2877.

Abb. 40: Ca. ccccxxix: „Zua sive musa": Hortus sa-
nitatis. Mainz 1491. München, BSB, 2 Inc.c.a. 2576.

Abb. 39: Ca. xliij: „Arbor vel lignum vite paradisi":
Hortus sanitatis. Mainz 1491. München, BSB,
2 Inc.c.a. 2576.

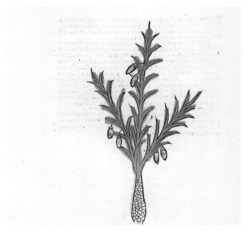

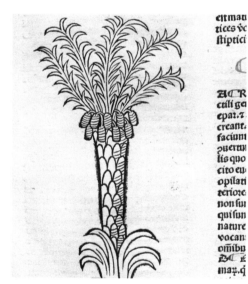

Abb. 41: Cap. cxlj: „Dactilus" (Dattelpalme): Gart
der Gesundheit. Mainz 1485. München, BSB,
2 Inc.c.a. 1601.

Abb. 42: Ca. cliiij: „Dactilus" (Dattelpalme):
Hortus sanitatis. Mainz 1491. München, BSB,
2 Inc.c.a. 2576.

Der Zitrusbaum gibt sich durch seine prallen, runden Früchte zu erkennen, die an den
nach oben ragenden Ästen in Richtung Himmel weisen. Diese Grundform taucht im „Hor-
tus sanitatis" wieder auf, wo diese „Baumformel" zusätzlich in Verbindung mit der Schlange
(Abb. 39) bzw. Adam und Eva (Abb. 40) erscheint. Neben dem Zitrusbaum als Baum der
Erkenntnis sind zwei weitere Baumarten charakteristisch für den Paradiesgarten: die Dat-

Abb. 43a: Sündenfall: Chronica. Nürnberg 1493, fol. 7r. München, BSB, 2 Inc.c.a. 2922.

Abb. 43b: Zum Vergleich: Titelbild: Gart der Gesundheit. Mainz 1485. München, BSB, 2 Inc.c.a. 1601.

Abb. 44: Lehrszene: „Manfredus" (Tractatus de herbis). Paris, Bibliothèque nationale de France, Ms. lat. 6823, fol. 1r.

telpalme[269] (Abb. 41–42) und der Drachenbaum, so wie sie im Paradies der Schedel'schen Weltchronik nebeneinander auftreten (Abb. 43). Mit dem Zitrusbaum und der Palme als typischen Paradiesbäumen verleiht Reuwich der Illustration eine zeitliche Dimension von der Erschaffung der Pflanzen bis in den Garten seiner Zeit.

Weitere mögliche Assoziationsebenen sollen an dieser Stelle noch angedacht werden:

Eventuell werden in der hervorgehobenen, mittleren Figur des „Gart"-Titelbilds zwei Gestalten miteinander verschränkt: die des antiken Arztes bzw. Naturphilosophen und die Christusfigur, bei der die zwölf Begleiter als Jünger gedacht werden können. In bildlichen Darstellungen kann Christus durchaus als Heiler, Gärtner und manchmal sogar als Apotheker auftreten.[270] Die Verweise auf ein göttliches Eingreifen oder eine christliche

269 Die Dattelpalme ist mit dem Paradies verbunden: Baumann / Baumann (2010), S. 249, S. 115 f. Mazal (1988), S. 76 f.

270 Leoni (1996), S. 78. Die Lebensgeschichte Christi wird an einigen Stellen mit dem Garten verknüpft: das Gebet am Ölberg, seine Erscheinung vor Maria Magdalena, die ihn mit einem Gärtner verwech-

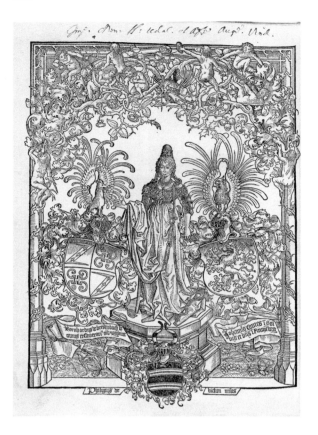

Abb. 45: Titelbild: Peregrinatio. Mainz 1486. München, Bayerische Staatsbibliothek, 2 Inc.c.a. 1725.

Lesart sind in diesem Titelbild allerdings stark zurückgedrängt, was programmatisch auch für den gesamten „Gart" festgestellt werden kann, in dem durchwegs auf die Begründung von Krankheiten durch moralische Bedingungen oder Fehlverhalten gegenüber christlichen Werten verzichtet wird (Kap. 5.1.).[271] In der „Manfredus"-Handschrift zeigt das einleitende Bild noch die Hand Gottes, die auf den Gelehrten einwirkt, der seinen Schülern die mitgebrachten Pflanzen erklärt (Abb. 44).

Der Garten als Ort der Gelehrsamkeit war ein Topos, die nicht nur bei Reuwich, sondern auch in Texten bei Erasmus von Rotterdam oder Dante Ausdruck findet. Erasmus lässt sein „Geistliches Gastmahl" im Garten stattfinden, Dante verortet die antiken Philosophen[272] in einem Garten in der Vorhölle. Der Garten wird von beiden als ein idealer Ort für den freien

selt. Die Vorstellung von Christus, der wie ein Samen auf die Erde fiel, um daraus aufzuerstehen, dessen Frucht und Heilsversprechen über die Welt Verbreitung findet, formt ihn metaphorisch zugleich zum Gärtner, heilenden Apotheker und zur Pflanze (z. B. Weinstock) selbst. Einen Überblick zum „Christus Medicus"-Thema liefert: Gollwitzer-Voll (2007).

271 Habermann (2001), S. 185, 201 f.

272 Der Hinweis auf Dantes Garten der Gelehrten in der Vorhölle stammt von Oliver Primavesi, der darin eine Metapher für das antike Wissen vermutet, das als typologischer Vorgänger des christlichen Wissens gedacht wurde. Damit wäre auch die Überschneidung einer antiken Gelehrtenfigur mit der Christusfigur als Titelbild des „Gart" schlüssig.

Gedankenaustausch inszeniert.[273] Das Titelbild des „Gart" kann als „Garten der Beredtheit"[274] verstanden werden, in den der Leser, der um Naturkenntnis bemüht ist, eintreten kann. Reuwich denkt möglicherweise auch über den Status der Pflanze in der Kunst nach, die er als Künstler umformen und bis zum Ornament hin verflechten kann, das aus einer Säule emporwächst (vgl. auch sein Titelbild zur „Peregrinatio": Abb. 45). Diese Bandbreite differenziert er in seinem Holzschnitt von unten nach oben, vom wilden Gewächs zum künstlerischen Ornament aus: Auf dem Rasenstück wachsen Kräuter aus dem Boden, daneben ragen die im Garten kultivierten Pflanzen empor. Eine Pflanze ist als wissenschaftlicher Gegenstand in die Diskussionsrunde mit eingebracht. Über allem windet sich das Pflanzenornament zu einem Torbogen, das ein Wappen trägt. Schließlich wird dem Künstler auch die Bedeutung der Pflanzen für die Heraldik[275] kaum entgangen sein.

3.7. Zur Rezeption des „Gart der Gesundheit"

3.7.1. Die Leser des „Gart"

Über die ersten Rezipienten des „Gart" ist nichts bekannt. Die Provenienzen[276] geben erst ab Mitte des 16. Jahrhunderts Auskunft über Nutzer aus den verschiedensten sozialen Bereichen. Ärzte[277] und Apotheker[278] besaßen den „Gart", aber auch Juristen[279] und Angehörige der Kir-

273 Zum paradiesischen Garten, den Erasmus von Rotterdam in seiner Schrift „Das geistliche Gastmahl" (1518) geschaffen hat, um Gelehrte dort zu versammeln: Scholz / Schütte (2005), S. 34. Zum Philosophengarten bzw. Humanistengarten: Lauterbach (2004), insb. S. 43–64.

274 Lauterbach (2004), S. 50: Zum Garten des Eusebius bei Erasmus schreibt Lauterbach: „Der wichtigste Wesenszug der Gärten des Eusebius ist die Beredtheit". Eusebius lehre nicht in der freien, sondern in der kultivierten Natur, die Sprache der Natur zu verstehen. Zu humanistischen Elementen in den Titelholzschnitten im „Gart" und im Reisebericht vgl. auch den Vortrag von Hoppe „Erhard Reuwich zu Mainz. Ein Pictor Doctus vor Dürer" (2018, Zentralinstitut für Kunstgeschichte, München), der online zu finden ist.

275 Habermann (2001), S. 176.

276 Die Informationen stammen aus dem Inkunabelkatalog der Universität Tübingen (www.inka.uni-tuebingen.de; letzter Zugriff: 13.09.2019).

277 Ein Exemplar aus der UB Heidelberg (Signatur: P 2460-2 qt. INC) besaß der Arzt Johannes Mirgel aus Lindau (gest. 1561). Er vererbte den „Gart" innerhalb der Familie. Das Exemplar der UB Tübingen (Signatur: Bi 224.2) besaß der Obermedizinalrat und Direktor der Psychiatrischen Anstalt in Zwiefalten Karl von Schäffer. Das Exemplar der UB Freiburg (Signatur: Ink. 40 T 2676, c) besaß der Freiburger Arzt Georg Jacob Pfost (gest. 1846). Schäffer und Pfost stifteten ihre umfangreichen Bibliotheken den jeweiligen Universitätsbibliotheken. Den „Gart" hatten sie vermutlich als Sammlerstücke erworben.

278 Das „Gart"-Exemplar der UB Würzburg (Signatur: I.t.f. 603) besaß Anfang des 17. Jahrhunderts zunächst der Nürnberger Arzt Melchior Gottschich und schließlich der Apotheker Nicolaus Hötting aus Ochsenfurt.

279 Das Exemplar der Herzogin Anna Amalia Bibliothek Weimar (Signatur: Inc 135) besaß Mitte des 16. Jahrhunderts ein Dr. jur. Martin Marstaller. Er war Rat des Herzogs Bogislav XII. von Pommern und Erzieher von dessen Söhnen. Das Exemplar der BSB München 2 Inc. s.a. 598 besaß Ende des 16. Jahrhunderts der Notar Elias Helmner.

Abb. 46: „Gart"-Exemplar
2 Inc.c.a. 1601 (BSB Mün-
chen): Randzeichnungen
(Essigbehälter, Figur,
Schweißbad).

che[280] sowie zahlreiche Klosterbibliotheken.[281] Dass der „Gart" durchaus für den Gebrauch von
ausgebildeten Ärzten und Apothekern nützlich und durchdacht war, zeigt ein Vergleich mit
dem „Thesaurus medicaminum" aus dem Jahr 1479. Der Text dieses handschriftlichen Kräuter-
buchs wurde von dem Züricher Apotheker Hans Minner zusammengestellt und entspricht in
Struktur und Inhalt stark dem einige Jahre später gedruckten „Gart".[282] Offenbar bestand aus
den Reihen der Ärzte und Apotheker eine Nachfrage nach Kompilationen dieser Art.

Diverse und unterschiedlich lange Glossen, nachträglich eingefügte Bilder, Register und eine
getrocknete Pflanze[283] bezeugen, dass der „Gart" scheinbar nicht nur in den Bücherregalen auf-
bewahrt, sondern auch gelesen und weiter kommentiert wurde. Es existieren sogar handschrift-
liche Kopien.[284]

280 In das Exemplar der BSB München 2 Inc.c.a. 1601 hat Jacobus Prandl Mitte des 16. Jahrhunderts
sein Wappen eingetragen. Er war Canonicus im Kollegiatstift St. Veit in Freising. Zuvor hatte sie
ein Georg Riß aus dem Kollegiatstift St. Johann in Freising besessen. Es zeigt Glossen verschiedener
Hände.

281 Die „Gart"-Inkunabel 2 Inc.c.a. 1600 kam aus dem Münchner Karmelitenkloster in die Bayerische
Staatsbibliothek.

282 Ursula Schmitz vertritt in der Einleitung zu der von ihr transkribierten Ausgabe des „Thesaurus me-
dicaminum" sogar die Auffassung, die beginnende deutschsprachige „Pharmakobotanik" hätte besser
das Kräuterbuch von Minner gedruckt statt die Kompilation von Johann Wonnecke von Kaub. Diese
sei lediglich im Auftrag entstanden, Minner hingegen habe ganz im Sinne des Humanismus über-
sichtlicher, präziser und näher an den Quellen gearbeitet. Was genau Johann Wonnecke von Kaub
„weniger humanistisch" macht als Minner, wird nicht deutlich. Da Minners Werk jedoch nicht ge-
druckt wurde, was Schmitz der „Schichtzugehörigkeit" des Autors zuschreibt, blieb es wirkungslos.
Ob Minner eine Drucklegung seines Werks plante oder wie Johann Wonnecke von Kaub im Auftrag
handelte, bleibt in Schmitz' Darstellung unklar. Schmitz (1974), S. 40 f.

283 Wann die getrocknete Pflanze (Löwenzahn?) in das „Gart"-Exemplar, das heute in der BSB München
unter der Signatur 2 Inc.c.a. 2067 aufbewahrt wird, gelegt wurde, lässt sich nicht mehr feststellen.
Dies kann ein Indiz sein, dass in den „Gart" häufiger getrocknete Pflanzen gelegt wurden und die
Besitzer damit eigene Sammlungen anlegten. Bernhard Schnell, der verschiedenste Kräuterbücher im
Original eingesehen hat, bestätigt diesen Umgang mit Kräuterbüchern im Allgemeinen.

284 Augsburg, Staats- und Stadtbibliothek, 4° Cod 132. Straßburg, Bibliothèque nationale et universitaire
de Strasbourg, Ms.2.152. Ein Auszug aus dem „Gart" ist handschriftlich erhalten in: München, Bay-

Abb. 47: „Gart"-Exemplar
2 Inc.c.a. 1771 b (BSB München):
ergänztes Titelblatt.

Das „Gart"-Exemplar der BSB München 2 Inc.c.a. 1601 zeigt mehrere Glossen von verschiedenen Händen; notiert werden vor allem Anwendungsgebiete, z. B. gegen Fieber (Cap. xlj, Teufelsdreck), bei Warzen (Cap. lxv, Basilikum), gegen die Pest (Cap. lxxvj „rodelsteyn", Tonerde). Im selben Exemplar fallen außerdem kleinere Randzeichnungen auf, die von einem Nutzer ergänzt wurden. Das Essig-Kapitel wird von einem Essigbehälter eingeleitet (Cap. xlix „Acetum"). Im Cap. xlv „Alumen" wird ein Schweißbad mit dem Salz empfohlen, das seitlich dargestellt wurde. Zusätzlich wurde die Figur eines Gelehrten (?) zu Beginn des Kapitels eingefügt (Abb. 46). Von kleineren Kommentaren und Strichzeichnungen am Rande abgesehen, beinhaltet das „Gart"-Exemplar längere Glossen (z. B. unter Cap. lxxxv „Schelwortz") und ein vierseitiges, handschriftlich eingefügtes Pflanzenregister am Ende des Buchs. In diesem Register findet sich eine Auswahl deutscher Pflanzennamen in alphabetischer Reihenfolge mit der entsprechenden Kapitelangabe im „Gart".

Einen Hinweis zur Nutzung des „Gart" für den Unterricht kann ein weiteres „Gart"-Exemplar der BSB München (2 Inc.c.a. 1771 b) geben,[285] das das Münchener Jesuitenkolleg Mitte des 17. Jahrhunderts besaß. Dort wurde 1663 nicht nur der Titel „Gartten der gesundheit" auf einem Vorsatzblatt eingetragen (Abb. 47), sondern auch ein 22-seitiges, handschriftliches Register ergänzt: „Register úber dißes Búech, an welchem blat Jedes kráut nach ordnúng deß Alphabets befinden, vnd wie es aúf teitsch genent wirdet." Eventuell wurde der „Gart" im Kolleg zum Studieren oder Unterrichten verwendet.

Den „Gart" begriff der Rezipient demnach, wie es von Swan für das 16. und 17. Jahrhundert beschrieben wurde, als offenes Objekt, das Ergänzungen erlaubt, ohne die darin bestehende Ordnung der Natur zu stören.[286] Daneben zeigt die intensive Arbeit an den Exemplaren, dass

erische Staatsbibliothek, Cgm 728. Zu allen Abschriften: Schnell (2017), Nr. 70.3. sowie unten Kap. 4.5.

285 Das Exemplar beinhaltet zudem von einer anderen Hand (16. Jahrhundert?) Hinweise gegen die „Pestilenz", die am Ende des Werks hinzugefügt wurden.

286 Zur Nutzung botanischer, naturwissenschaftlicher Bücher: Swan konnte die wichtige Rolle der

das Werk auch Jahrzehnte später nicht als überholt galt, sondern weiter genutzt wurde. Wie groß die Nachfrage nach dem Text war, kann seine Rezeption bis ins 18. Jahrhundert deutlich machen.

3.7.2. Der Text des „Gart" reist weiter

Der „Gart" wurde in Augsburg[287], Straßburg[288], Basel[289] und Ulm[290] nachgeschnitten und mehrmals neu aufgelegt, wobei die Sprache im Text vom jeweiligen Dialekt des Erscheinungsorts geprägt ist. 1492 erfolgte eine Übersetzung ins Niederdeutsche, die bei Stephan (auch: Steffen) Arndes[291] in mehreren Auflagen verlegt wurde. In Straßburg wurde der „Gart" auch im 16. Jahrhundert noch mehrfach gedruckt.[292]

Der Text des „Gart" ist darüber hinaus die Grundlage diverser Weiterbearbeitungen.[293] Eine Bearbeitung des „Gart" erscheint bei Johann Prüß in Straßburg (1507)[294] mit dem deutschen

Kräuterbücher für das Universitätsstudium und das Erschließen der Natur aufzeigen. Die Kräuterbücher seien offene Gegenstände, die mit Hilfe von „cutting and pasting" Hinzufügungen ermöglicht. Swan (2008), S. 69. Siehe auch: Egmond (2017), S. 49–67. Botanische Bilder wurden als Quelle des Wissens betrachtet, sortiert, geordnet, verglichen – mit anderen gedruckten Bildern oder Zeichnungen – und zusätzlich zu Informationen aus Büchern oder eigener Anschauung untersucht. Kusukawa (2011), S. 195. Außerdem war es spätestens seit dem 16. Jahrhundert üblich, im Sommer im botanischen Garten und im Winter mit Hilfe von (illustrierten) Büchern zu unterrichten. Kusukawa (2012), S. 1.

287 16 Nachschnitte sind allein innerhalb der Jahre 1485–1502 erschienen, davon elf in Augsburg: [Johann Schönsperger], 22.8.1485. GW M09751. [Johann Schönsperger, 1485/86]. GW M0975120. Johann Schönsperger, 5.6.1486. GW M09754. Johann Schönsperger, 7.3.1487. GW M09756. Johann Schönsperger, 15.12.1488. GW M09757. Johann Schönsperger, 13.8.1493. GW M09758. Johann Schönsperger, 10.5.1496. GW M09759. Johann Schönsperger, 13.5.1499. GW M09761. [Johann Schönsperger, um 1500]. GW M09763. [Johann Schönsperger]. GW M0976310. Johann Schönsperger, 1502. VD16 W 4357 unter dem Titel: „Herbarius zú teütsch vnd von aller hand Kreüttern".

288 [Straßburg: Johann Grüninger, um 1488–94]. GW M09739. [Straßburg: Johann Grüninger, um 1485–86]. GW M09741.

289 [Basel: Michael Furter, um 1487–90]. GW M09764.

290 Ulm: Konrad Dinckmut, 31.3.1487. GW M09746.

291 Die niederdeutsche Version des „Gart der Gesundheit" erschien 1492 in Lübeck bei Arndes (GW M09748): „Gaerde der Suntheit". Mayer bezeichnet das umfangreiche Werk als „Riesen", da es eine Übersetzung des „Gart" mit Hinzufügungen aus dem „Promptuarium medicinae" von 1483 und des gerade erst 1491 erschienenen „Hortus sanitatis" darstellt. Mayer (2011), S. 27.

292 Straßburg: Johann Grüninger, 1529. VD16 W 4367. Straßburg: Balthasar Beck, 1530. VD16 W 4362. Der „kleyn Gart der Gesundheit. Darin ist begriffen Regiment desz lebens Marsilij Ficinj [...]" ist wohl als Zusatz zum „Gart der Gesundheit" gedacht, bei: Straßburg: Jakob Cammerlander, 1543. VD16 K 1263. 1529 erscheint in Straßburg ein sehr verkürzter, deutscher „Ortus Sanitatis" mit einem 19-seitigen Kräuterbuchteil. VD16 H 5126. Auch in Augsburg brachen die Nachschnitte des „Gart" im 16. Jahrhundert nach den Schönsperger-Drucken nicht ab, z. B. Augsburg: Heinrich Steiner von Augsburg, 1534. VD16 W 4364.

293 Mayer (2011), S. 127 f.

294 Straßburg: Johann Prüß, 1507. VD16 W 4358 unter dem Titel: „In disem Buoch ist der Herbary: oder Krüterbuoch: genant der gart der gesuntheit". Straßburg: Johann Prüß, 1507. VD16 ZV 22673 unter

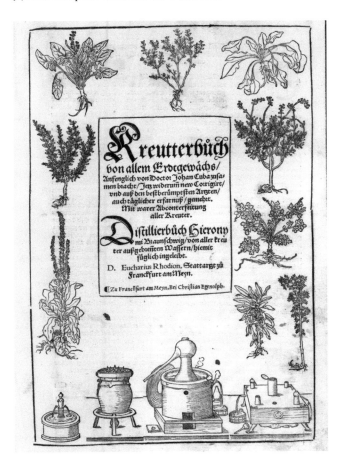

Abb. 48: Titelblatt: Kreutterbuch.
Frankfurt a. M. 1533. München,
Bayerische Staatsbibliothek, Res/2
Phyt. 59 a.

„Gart"-Text sowie den Kapiteln über Tiere und Steine aus dem lateinischen „Hortus sanitatis"
in einer Ausgabe, die aus zwei Bänden besteht („Großer Gart der Gesundheit").

Eucharius Rößlin d. J. verband den „Gart" mit dem „Kleinen Destillierbuch" (1500)[295] von
Hieronymus Brunschwig. Er war, wie sein Vater und Johann Wonnecke von Kaub, Stadtarzt
in Frankfurt am Main. Da Rößlin auch Fehler ausbesserte, kann man diese Ausgabe mit Mayer
als „Revision" des „Gart der Gesundheit" bezeichnen.[296] Sie erschien 1533 in Frankfurt am Main
bei Christian Egenolff unter dem Titel: „Kreutterbúch von allem Erdtgewáchs, Angefertigt von
Doctor Johan Cuba zusammenbracht, Jetz widerum new Corrigirt [...]"[297] (Abb. 48). Da in die-

dem Titel: „Ortus Sanitatis. De herbis et plantis. De animalibus et reptilibus. De Avibus et volatili-
bus. De piscibus et natatilibus. De Lapidibus [...]".

295 Straßburg: Johann Grüninger, 8.5.1500. GW 5595.

296 Mayer (2011), S. 127.

297 Frankfurt a. M.: Christian Egenolff, 1533. VD16 W 4363. Der vollständige Titel lautet: Kreutterbúch
 von allem Erdtgewáchs, Angefertigt von Doctor Johan Cuba zusammenbracht, Jetz widerum new
 Corrigirt vnd aus den bestberúmptsten Artzten auch táglicher erfarnuß gemehrt. Mit warer Ab-
 conterfeitung aller Kreuter. Distillierbúch hieronymi Braunschwig von aller kreuter außgerennten
 Wassern hiermit fúglich ingeleibt. D. Eucharius Rhodion, Stadtartzt zú franckfurt am Meyn. Zu
 Franckfurt am Meyn, Bei Christian Egenolph.

sem Exemplar die Tiere und edlen Gesteine nicht vorkamen, folgte noch eine weitere Version des „Gart" von Rößlin, in der er die Tiere und Steine aus dem „Hortus sanitatis" in einer deutschen Übersetzung mit dem „Gart" verband. Das Werk erhielt den Titel „Kräuterbuch von aller Kräuter, Getier, Gestein und Metall Natur Nutz und Gebrauch"[298] und erschien 1536. Mehrere Auflagen folgten und eine Übersetzung ins Lateinische durch den Marburger Medizinprofessor Theodor Dorstenius: „Botanicon"[299] (1540). Rößlins Nachfolger, Adam Lonitzer, war gleichfalls als Bearbeiter der Rößlin'schen „Gart"-Fassungen tätig und brachte 1557 eine erneute „Gart-Bearbeitung" auf den Markt: „Kreuterbúch, New zugericht".[300] Das letzte Lonitzer-Kräuterbuch[301] erschien 1783 in Augsburg.

298 Frankfurt am Main: Christian Egenolff d. Ä, 1536. VD16 R 2871. „von allerley Thieren, Vóglen, Vischen oder Mórwunder, vnd Edlem gstein Natur nutz vnd Gebrauch".
299 Frankfurt am Main: Christian Egenolff d. Ä, 1540. VD16 D 2442. Mit den Illustrationen der deutschen Ausgabe von 1533.
300 Frankfurt am Main: Christian Egenolff d. Ä (Erben), 1557. VD16 L 2416. Zu Lonitzers Kräuterbuch: Hartmann (2006), Kat.Ausst. Schweinfurt (2011), S. 112. Zu den Illustrationen der „Gart"-Nachschnitte: Isphording (2008), S. 123–129, S. 145–148, S. 151 f. und S. 156 f.
301 Vollständiges Kräuterbuch oder Das Buch über alle drey Reiche der Natur. VD18 14828324-001.

4. Strategien der Vervielfältigung

Im Folgenden soll den Werkstattstrategien zur Bebilderung eines Kräuterbuchs mit über 370 Holzschnitten nachgegangen werden. Es wurde bereits aufgezeigt, auf welche Art und Weise Pflanzen im Kräuterbuch dargestellt wurden, wobei nur das Resultat und nicht die Prozesse zur Herstellung der Pflanzenbilder betrachtet wurden.

4.1. Übertragungsprozesse: Von der Pflanze zum Holzschnitt

Im Vorwort des „Gart" wird das Bewusstsein Bernhards von Breydenbach darüber deutlich, dass die Übertragung einer Pflanze ins Bild einen Experten erfordert. Er nahm einen Maler mit auf seine Reise, um ihn „konterfeien und entwerfen" zu lassen und um die Pflanzen „in ihrer rechten Farbe und Gestalt" zeigen zu können. Während er vor Ort die Kräuter selbst „erfuhr", überließ er den Übertragungsprozess ins Bild dem Künstler.[1] Diese Passage verrät, dass es ein Problembewusstsein für die Schwierigkeit der Visualisierung gab, und die zentrale Rolle, die dem Künstler bei einem solchen Unterfangen zukam. Für die Anfertigung von Pflanzenillustrationen existierten mehrere Möglichkeiten, die kurz vorgestellt und für die „Gart"-Abbildungen ausgelotet werden sollen: Der Illustrator kann aus einem anderen Kräuterbuch kopieren oder aber das frische oder gepresste Exemplar abzeichnen.[2]

Der Entwurfsvorgang zur Herstellung von Bildern nach der lebenden Pflanze ist höchst zeitintensiv. Um 376 Pflanzen-Holzschnitte auf diese Weise anzufertigen, hätte der „Gart" eine jahrelange Produktion in Anspruch genommen. Die Werkstatt griff daher mit Sicherheit auf Abbildungen eines anderen Pflanzentraktats als Vorlagen zurück.[3] Allein aus ökonomischer Sicht ist dies die Arbeitsweise, die man für den Großteil der Pflanzenillustrationen im „Gart" voraussetzen muss. Der Traditionswert, der diesen Abbildungen innewohnt, ist dabei nicht zu unterschätzen, immerhin können sich Bild und Text auf ältere, anerkannte Autoritäten zurückführen lassen.[4]

1 Bernhard von Breydenbach (1485), fol. 3r.

2 Eine weitere Möglichkeit wäre ein Pflanzenabdruck (Abb. 207–208). Die Technik zur Herstellung eines Naturselbstdrucks wird schon im 15. Jahrhundert beschrieben und ausgeführt, z. B. in einer Salzburger Sammelhandschrift (M I 36). Das bekannteste Beispiel ist der Pflanzenabdruck eines Salbeiblatts, das vermutlich durch Melzi nach der Beschreibung von Leonardo da Vinci im „Codex Atlanticus" ausgeführt wurde: Reeds (2006), S. 205–215. Zum Naturselbstdruck als „substitutivem Bildakt", das den Körper enthält: Bredekamp (2010), S. 178–183.

3 Gombrich (1999), S. 99.

4 Saurma-Jeltsch (2006), S. 437.

Das Vorwort Bernhards von Breydenbach suggeriert, der Maler habe die Pflanzen direkt vor Augen gehabt, also an der Natur seine Bilder „entworfen".[5] Dieser Vorgang ist durchaus komplex: Die Pflanzen stehen als Modell nicht in unbegrenzter Dauer zur Verfügung. Da sie in der Regel zur Zeit des höchsten Blütenstands abgebildet werden sollten, muss der Maler zunächst die volle Reife abwarten. Ist die Pflanze aus dem Erdreich entfernt, denn im Grunde will man auch die Wurzel[6] abbilden, stehen dem Maler nur wenige Stunden zur Verfügung, um seinen Gegenstand festzuhalten.[7] Weniger aufwendig ist die Verwendung gepresster Pflanzenexemplare, die auf einer Reise leichter zu transportieren sind. Gepresst ist die Pflanze das gesamte Jahr hindurch haltbar gemacht, wenn auch in etwas veränderter Farbigkeit, da sie beim Trocknen häufig ausbleicht. Da nur wenige Herbarien[8] erhalten sind, gibt es keine Erkenntnisse darüber, wie üblich das Anlegen von Sammlungen gepresster Pflanzen im 15. Jahrhundert war.[9]

Zu diesen Übertragungsprozessen sei vorab betont, dass sie nichts über das Erscheinungsbild der Pflanzenabbildung aussagen. Eine naturgetreu aussehende Darstellung darf nicht zu dem Schluss führen, dass sie vom Original abgebildet wurde. Ebenso wenig muss eine Zeichnung, auf der geschrieben steht, sie sei „nach dem Leben"[10] gestaltet worden, beim Betrachter eine „realistischen" Eindruck erzeugen.[11] Einzig der Augenschein und die Technik des Künstlers entscheiden darüber, ob für den Betrachter etwas „real"[12] bzw. echt aussieht oder nicht. Der Künstler muss

5 Baumann und Baumann weisen nachdrücklich darauf hin, dass Reuwich und sein Auftraggeber die Pflanzen auf ihrer Reise gar nicht gesehen haben konnten, da diese zum Zeitpunkt der Jerusalemreise keine Blütezeit hatten: Baumann / Baumann (2010), S. 139.

6 Die Wurzel ist meist der wichtigste Bestandteil der Pflanze zur Gewinnung von Heilmitteln und daher für das Kräuterbuch von Interesse.

7 Im 16. Jahrhundert schrieb Aldrovandi, „dass der Maler seine Sujets in frischem Zustand vor sich haben müsse und empfiehlt für das Abzeichnen von Pflanzen, die der Erde entnommen bzw. abgeschnitten worden sind, eine Frist von einer Stunde." Felfe (2013), S. 183. Demnach muss es eine Praxis des Naturstudiums gegeben haben.

8 „Herbarien" meint an dieser Stelle: Bücher, die mit getrockneten Pflanzen versehen sind. Der Begriff etablierte sich erst ab dem 16. Jahrhundert für diesen Sammlungstypus.

9 Quellen aus dem 16. Jahrhundert berichten von dieser Praxis unter Ärzten, Apothekern, Besitzern von Gärten und Sammlern: Gepresste Pflanze wurden zu Herbarien zusammengestellt, zur Identifikation versandt oder dienten als Geschenk unter Kräutersammlern. Eventuell wollten gemalte oder gedruckte Pflanzenbücher auch diese Form der Pflanzensammlung, ein Herbarium, imitieren und nicht so sehr die lebenden Pflanzen. Ein viel zitiertes Beispiel für eine Illustration nach dem gepressten Exemplar vor dem 16. Jahrhundert stammt aus dem „Carrara herbal". Das darin gezeigte Veilchen sieht danach aus, als wäre es nach einem gepressten Exemplar gestaltet worden (Abb. 163).

10 Zur Formulierung „nach dem Leben" u. a.: Swan (1995) und Felfe (2013).

11 Gombrich greift als Beispiel häufig auf die Zeichnung eines Löwen aus dem 13. Jahrhundert zurück. Auf der Skizze wurde der Vermerk „nach dem Leben" angebracht. Gombrich nimmt zwar an, dass der Zeichner, Villard de Honnecourt, tatsächlich einen Löwen am Hof gesehen hat, sich aber an die ihm bekannte Tradition hielt und diese mit Naturbeobachtung kombinierte, was Gombrich als „selective naturalism" bezeichnet. Um ein überzeugendes Abbild der Natur zu schaffen, sei nötig: ein gutes Auge, eine geschickte Hand und der Wunsch, ein Abbild der Natur zu schaffen. Gombrich (1999), S. 93. Stets gebe es dabei für den Künstler eine „Formel", eine Folie, die hinter der Naturbeobachtung liege: Gombrich (1999), S. 99.

12 In seinem Kommentar „Per symbola ad astra" hält Wolfgang Kemp fest, dass in der Forschung „Realismus nicht sein darf". In der Geisteswissenschaft wird nicht nur der Begriff vermieden, sondern alles, was realistisch aussieht, müsse sofort auf etwas Höheres bzw. nicht Sichtbares verweisen. Zwar,

darin geübt sein, Lebendigkeit im Bild zu suggerieren.[13] Für die weitere Analyse des „Gart" sollen
daher keine Entscheidungen getroffen werden, ob ein Bild nach einer gepressten, einer gemalten
oder einer wirklichen Pflanze abgebildet wurde, oder ob es naturnah ist oder nicht.

4.2. Varianten und Kopien im „Gart der Gesundheit"

Die Werkstattpraxis für die Holzschnitt-Illustrationen des „Gart der Gesundheit" erweist sich
bei genauem Hinsehen als eine geschickt angewendete Form aus Kopie,[14] Variation und Neu-
kombination.[15] So entsteht ein Werk, das zwar Traditionen aufnimmt, sich aber dennoch grund-
legend von anderen Kräuterbüchern unterscheidet. Wie man es für andere Werkstätten dieser
Zeit annimmt, kann man auch bei der Reuwich-Werkstatt mit einem großen Fundus an Mate-
rial rechnen, der sich aus internen und externen Vorlagen zusammensetzte. Vorstellbar ist eine
Mischung an Pflanzenbüchern, Zeichnungen der Werkstattmitarbeiter nach der Natur, gepress-
ten Pflanzen oder nach Details aus Gemälden, Stundenbüchern etc.

In Verkündigungsszenen, Altargemälden und Gebetbüchern florierten Ende des 15. Jahr-
hunderts die Abbildungen von Pflanzen. Jan van Eyck und Rogier van der Weyden etablierten
praktisch europaweit stilllebenhafte, „realistische" Pflanzenstudien als Details in größeren Bild-
kompositionen.[16] Insbesondere als niederländischer Künstler dürfte Reuwich mit diesen Dar-
stellungen vertraut gewesen sein oder etwa mit Stephan Lochners pflanzenreichem Altar der
Kölner Stadtpatrone von ca. 1445 (Abb. 164).[17]

4.2.1. Vorlagen als Betriebskapital

Der Umgang mit Tier- und Pflanzenstudien in der Werkstatt Pleydenwurffs und Wolgemuts[18]

so schreibt Kemp, sei Realismus eine Anschauungsform, dies dürfe aber nicht dazu veranlassen, die
Leistung eines Jan van Eyck zu ignorieren. In diesem Sinne sei hier auch von „realen" Bildern gespro-
chen, deren Leistung es ist, naturnahe Abbildungen erzeugen zu wollen. Kemp (2015).

13 Reeds und Kusukawa betonen, dass die Illustrationen, die am „natürlichsten" erscheinen, am stärks-
ten vom Künstler konstruiert wurden. Reeds (1990), S. 766–768. Reeds (2006), S. 205–207. Kusu-
kawa (2012), S. 4–8.

14 Mensger (2012). Für eine begriffliche Annäherung und weitere Literaturhinweise zur Praxis des Ko-
pierens siehe: Augustyn / Söding (2010a).

15 Zur Varianten-Praxis der Cranach-Werkstatt: Hinz (1994), S. 174–179.

16 Siehe z. B. Suckale (2009).

17 Albrecht Dürer ließ den Altar in Köln eigens aufschließen und vermerkte dies auch in seinem Tage-
buch: Unverfehrt (2007), S. 107. Weiter zu Pflanzendarstellungen in der nordalpinen Kunst des
15. Jahrhunderts: Kaufmann (1993) oder Behling (1957). Eine detaillierte Aufbereitung der Pflanzen-
symbolik im Lochner-Altar liefert: Comes (2013).

18 Die Werkstatt und ihr großes Œuvre, das Malerei und Druckgraphik umfasst, ist gut erforscht,
weshalb sie sich an dieser Stelle als Fallbeispiel anbietet. Zur Malerei legte Suckale (2009) einen aus-
führlichen Katalog und eine Monographie zur „Erneuerung der Malkunst vor Dürer" vor. Auch die
Nürnberger Ausstellung „Der frühe Dürer" (2012) beschäftigte sich intensiver mit der Werkstatt, die
den jungen Dürer ausbildete. In der Werkstatt wurden die Holzschnitte für den Schatzbehalter und
die Schedel'sche Weltchronik geschaffen, wofür man Stadtansichten von Reuwich aus der „Pilgerreise

soll anschaulich machen, wie man sich den Einsatz von Bildvorlagen in der Reuwich-Werkstatt vorstellen kann. Außerdem kann man davon ausgehen, dass es neben einzelnen Zeichnungen auch Musterbücher in der Werkstatt Reuwichs gab. Erichsen nennt eine solche Materialsammlung das „Betriebskapital"[19] einer Werkstatt, auf das in Kopie und Variation zurückgegriffen werden konnte.[20]

Vorzeichnungen

Die Nürnberger Wolgemut-Pleydenwurff-Werkstatt, in der Dürer seine Lehrjahre verbrachte, setzte ihre Rasenstücke am Rand der Gemälde mit Hilfe von Vorzeichnungen zusammen. Einige Darstellung von Pflanzen sind in verschiedenen Gemälden aus der Werkstatt immer wieder in leichten Variationen anzutreffen (Abb. 166–189). Beispielsweise stellt Wolgemut im sog. Zwickauer-Altar eine Mohnblume erneut dar (Abb. 167),[21] die er schon im Katharinen-Altar in der Lorenz Kirche zu Nürnberg gezeigt hatte (Abb. 166).[22] Beim Zwickauer-Altar von Wolgemut sind sich die Restauratoren bislang nicht sicher, ob es sich bei den Tieren und Pflanzen, die der Maler an den äußeren Tafeln des komplexen Klappaltars (Abb. 168) anbrachte, nicht um bemalte Holzschnitte handelt. Wolgemut hat die Objekte so geschickt ins Gemälde eingefügt, dass man nicht sagen kann, welche Technik hier zu Grund liegt. Man konnte jedoch nachwei-

ins Heilige Land" aufnahm, sodass man mit der Formsprache Reuwichs vertraut war. Zur Weltchronik, die der Arzt Hartmann Schedel verfasste: Füssel (2001). Kat.Ausst. München (2014).

19 Erichsen (1994), S. 180.

20 Auch die Schulung der Jüngeren an der Hand der Werkstatt-Meister mit Hilfe von Vorlagen und deren Umsetzung in größere Kunstwerke spielte dabei eine Rolle. Die Lilie und Schwertlilie an den Außenseiten des Zwickauer-Altars könnten von Schülern nach Vorlagen Wolgemuts ausgeführt worden sein, da hier – beispielsweise in der Darstellung der Vase – sein sicherer Umgang mit der Perspektive fehlt (Abb. 175). Dürer schreibt in der Einleitung zu seinem Lehrbuch, dass der Schüler nach guten Künstlern kopieren soll, bis er eine freie Hand erlangt: „Item er mus van guter wercklewt kunst erstlich vill abmachen, pis daz er ein freie hant erlangt." Dürer (1966), S. 99. Siehe auch: Buck (2012), S. 90. Zur „Natur als Lehrmeister": Hess (2012).

21 Ebenso gleichen sich die Darstellungen innerhalb der Werkstatt bei: Wegerich (Abb. 170–171), Schwertlilie (Abb. 172–175), Veilchen (Abb. 176–177), Borretsch (Abb. 180–181), Hahnenfuß (Abb. 182–184) oder Schlüsselblume (Abb. 187–188). Dass es sich hierbei nicht um zufällige Ähnlichkeiten handelt, kann ein Vergleich mit Abbildungen derselben Pflanze in anderen Altargemälden um 1460 veranschaulichen (Abb. 178–179, 185–186).

22 Einmal wird die Pflanze neben den schlafenden Jüngern am Ölberg gezeigt. Im Katharinen-Altar rückt der Mohn, der symbolisch für Schlaf oder Tod stehen kann, noch näher in den Zusammenhang von Schlafen, Erwachen und Tod, da er hier neben dem wiederaufgefundenen Kreuz Christi wächst. Der Legende nach erkannte man das wahre Kreuz daran, dass es einen Toten zum Leben erweckte. Der Künstler wägte offensichtlich ab, welche Vorlage er in einem bestimmten Kontext auf sinnstiftende Weise einsetzen konnte. Die medizinischen oder natürlichen Eigenschaften, die einer Pflanze zugeschrieben oder an ihr beobachtet werden, können symbolischen Gehalt generieren: Im „Gart" heißt es über Mohn (Abb. 153), dass sein schwarzer Samen tödlich sei. Aus seinem weißen Samen, gemischt mit Milch und Eiweiß, könne man ein Pflaster gewinnen. Es sorge für Ruhe und lasse wohl schlafen. Überhaupt sei die Pflanze nur für äußerliche Anwendungen zu empfehlen. Johann Wonnecke von Kaub (1485), Cap. ccxcix.

sen, dass es sich um aufgeklebtes Papier handelt.[23] Dieser Einsatz reproduzierbarer Elemente verweist auf die effiziente Arbeitsweise der Werkstatt.

Einige Motivkombinationen mit Tieren und Pflanzen tauchen an den Bildrändern der Werkstatt derart signifikant auf, dass Suckale sogar von einer Art „Signatur im Bild" spricht.[24] Als Beispiel nennt er den aus dem Boden herausgenommenen Pflasterstein, aus dessen Stelle eine Pflanze hervorsprießt (Abb. 171). Dabei ging es offenbar nicht darum, eine Vorlage immer wieder exakt gleich umzusetzen, sondern neu zu kombinieren, zu drehen, zu wenden, um neue Darstellungsformen zu schaffen und den Eindruck der „Neuheit"[25] zu erwecken.

Musterbücher

Neben Vorzeichnungen wird die Werkstatt von Reuwich auch Musterbücher[26] besessen haben. Für die Illustrationen der Jerusalemreise des Bernhard von Breydenbach zog Reuwich jedenfalls Musterbücher heran, was man an den Darstellungen der indischen Ziegen nachvollziehen kann (Abb. 49–51). Niehr führt als Vorlagen das sog. Rothschild-Musterbuch aus dem Louvre (Abb. 49) oder Illustrationen aus den Reiseberichten des Cyriakus von Ancona an. Timm nennt außerdem das Skizzenbuch von Giovannino de' Grassi (Abb. 50), dem auch das illustrierte Kräuterbuch „Historia plantarum" (Abb. 25) zugeschrieben wird.[27] Als Teilnehmender der Pilgerreise Bernhards von Breydenbach könnte Reuchwich Werke von Giovannino de' Grassi auf dem Weg durch Italien gesehen haben. Über den Kupferstich und Holzschnitte fanden die Bildfindungen aus Muster-

23 Bodechtel / Eisenbein (2008), S. 128. Wie Pflanzen kann auch der aufgeklebte Hase (Abb. 168) als gemalte Variante wieder in Tafeln der Werkstatt vorkommen (Abb. 169).

24 Suckale (2009), S. 393–401, Abb. S. 400. Nelken statt der Signatur tauchen beispielsweise in der Werkstatt der sog. Berner Nelkenmeister auf: Gutscher-Schmid (2007).

25 Zur Relevanz der Wiedergabe neuer Bildformen (auch schon vor 1600), die Staunen und Bewunderung hervorrufen sollen: Pfisterer (2011a).

26 Zum Musterbuch: Scheller (1995). Zu Tierdarstellungen und ihren Vorlagen (Musterbücher, Zeichnungen): König-Lein (1997), S. 63–74. König-Lein schreibt, dass mit einer hohen Verlustrate bei den Zeichnungen, die als Vorlagen dienten, zu rechnen ist, da die Zeichnung als eigenständiges Kunstwerk erst um 1500 in Erscheinung tritt. Die Spuren in den erhaltenen Musterbüchern ließen jedenfalls auf einen starken Gebrauch innerhalb der Werkstätten schließen. König-Lein (1997), S. 70 f. Ames-Lewis gibt zu bedenken, dass die Gattung „Musterbücher" nicht nur als Quelle des Künstlers für spätere Kunstwerke gesehen werden darf, sondern die Zeichnung als eigenständige Form der Schulung des Künstlers begriffen werden muss, der vom Meister lernt: „Copying from a modelbook was always an important means by which the master and his assistants could keep their hand and eye in practice, by which the new apprentice could acquire initial training in his master's style, and by which natural forms could be transcribed by any member of the workshop into pictorial compositions or decorative embellishments." Ames-Lewis (1987), S. 1. Ebenso: Kusukawa (2011), S. 203.

27 Niehr (2001), S. 289–291. Als Bildquellen für die Tierdarstellungen nimmt Niehr Musterbücher an, die man sich in Italien besorgte. Siehe auch: Timm (2006), S. 229–242. Dass man als Künstler versuchte, an Musterbücher und Vorlagen zu gelangen, zeigt u. a. Dürers Versuch, ein Musterbuch des Jacopo de' Barbari zu erwerben. Das Musterbuch wiederum befand sich im Besitz der Margarete von Österreich, Statthalterin der Niederlande, die es 1521 nicht an Dürer veräußern wollte. Außerdem besaß Dürer mehrere Zeichnungen von Künstlerkollegen. Dazu ausführlich: Smith (2011).

Abb. 49: Unbekannter Künstler: Hänge-
ohrziegen, um 1400, Federzeichnung.
Sog. Rothschild oder Florentiner Mus-
terbuch. Paris, Musée du Louvre, Les
collections du département des arts
graphiques, Inv.-Nr. 756 DR, fol. 3r.

Abb. 50: Giovannino de' Grassi: Tier-
abbildungen, um 1380, kolorierte
Federzeichnung. Musterbuch. Ber-
gamo, Biblioteca Civica, Ms VII.14,e,
fol. 4v–5r.

Abb. 51: Tiere im Heiligen Land: Peregrinatio.
Mainz 1486. München, Bayerische Staatsbibliothek,
2 Inc.c.a. 1725.

Abb. 52: Musterbuchseite: „Bayerische Bild-
Enzyklopädie", um 1520. Erlangen, Universitäts-
bibliothek, MS. B 200, fol. 89v.

Abb. 53: Dürer-Werkstatt: Madonna mit Iris, um 1500–1510.
London, National Gallery, NG5592.

Abb. 54: Albrecht Dürer: Iris, um 1503,
Aquarell, Deckfarbe. Bremen, Kunsthalle,
Inv.-Nr. 35. In: Kat.Ausst. Wien (1985), S. 66.

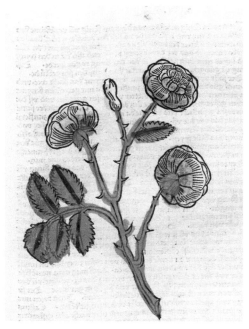

Abb. 55: Meister der Spielkarten: Rosen, um 1440, Kupferstich. Boston, Museum of Fine Arts, Boston, Inv.-Nr. 1981.80.

Abb. 56: Rose: Gart der Gesundheit. Mainz 1485. München, Bayerische Staatsbibliothek, 2 Inc.c.a. 1601.

büchern außerdem noch weitere Verbreitung.[28] Reuwichs Abbildungen im Reisebericht werden ihrerseits wieder zum „Musterbuch", wenn der darin gezeigte Tier-Holzschnitt (Abb. 51) ohne weiteren Textzusammenhang in einer Handschrift aus den 1520er Jahren wieder auftaucht (Abb. 52).[29] Das Kopieren „naturwissenschaftlicher" Bilder in andere Medien und Zusammenhänge sorgte – nach Kusukawa – nicht nur dafür, dass sie als Dekoration und der Bewunderung der Natur dienten, sondern sie treten damit gleichzeitig in einen größeren visuellen und kulturellen Kontext ein. Dabei stellt die Natur sowohl faszinierendes Studienobjekt als auch Schönheit *per se* dar.[30] Schmidt beschrieb den Reisebericht als eine Mischung aus „topografisch präzisem Naturstudium, Typik und Erfindung."[31] Eine solche Diversität besteht gleichsam im „Gart der Gesundheit".

Möchte man sich ein Bild davon machen, wie Werkstatt-Vorlagen bei Reuwich ausgesehen haben könnten, kann man an Dürers Pflanzenstudien einer Akelei[32] oder einer Schwertlilie denken (Abb. 190, 53–54) sowie an die bekannte Pfingstrosenstudie von Schongauer, die der Künstler für die 1473 entstandene „Maria im Rosenhag" verwendete.[33] Nicht nur italienische Muster-

28 Ames-Lewis (1987), S. 2.

29 Rudolph (2015), S. 466–473.

30 Kusukawa (2011), S. 203.

31 Schmidt (2000), S. 590

32 Die Akelei und andere Pflanzenstudien werden mittlerweile Mitarbeitern in der Werkstatt Albrecht Dürers zugeschrieben. Die Schwertlilie gehört weiterhin zum Œuvre Dürers. Kat.Ausst. Frankfurt (2013), S. 46 f.

33 Kat.Ausst. Wien (1985). Dürer besaß wahrscheinlich neben weiteren Zeichnungen Schongauers auch die Pfingstrosenstudie. Kat.Ausst. Frankfurt (2013), S. 44 f. Zum Verhältnis von Schongauer, Pley-

Abb. 57: Meister der Berliner Passion (Israhel van Meckenem d. Ä.?): Rehbock und Hirsche, um 1475, Kupferstich. London, British Museum, Inv.-Nr. 1845, 0809.190.

Abb. 58: Hirschjagd: Fabulae. Augsburg um 1483, g viij recto. München, Bayerische Staatsbibliothek, 2 Inc.s.a. 13.

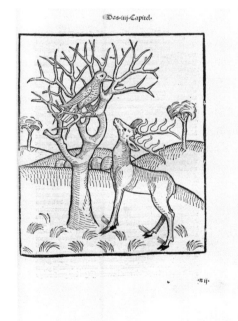

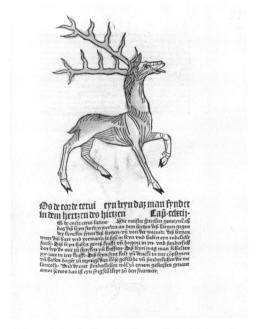

Abb. 59: Das buoch der weißhait der alten weisen. Ulm 1483, n ij. München, Bayerische Staatsbibliothek, 2 Inc.c.a. 1308.

Abb. 60: Hirsch: Gart der Gesundheit. Mainz 1485. München, Bayerische Staatsbibliothek, 2 Inc.c.a. 1601.

denwurff, Wolgemut und Dürer: Kemperdick (2004), S. 227–234, der v. a. Pleydenwurffs Bedeutung für die jüngere Künstlergeneration betont. Weiter: Suckale (2009), S. 215–217. Buck (2012), S. 100. Zur Buchmalerei in der Werkstatt: Georgi (2013).

bücher und Druckgraphiken, sondern auch Materialien aus dem deutschsprachigen – überhaupt internationalen – Raum kommen als mögliche Bildvorlagen in Frage, was unter anderem ein Kupferstich des Meisters der Spielkarten veranschaulichen soll, auf dem fünf Rosenblüten abgebildet sind (Abb. 55). Es muss Spekulation bleiben, ob die Reuwich-Werkstatt genau diese oder ähnliche Kupferstiche des Meisters der Spielkarten oder des Meisters der Berliner Passion (Israhel van Meckenem d. Ä.?) bzw. Abbildungen aus dem Buchdruck (Abb. 55–60) überhaupt kannte oder womöglich sogar besaß, um sie als Vorlage heranziehen zu können.[34]

Naturstudium, Typik, Erfindung

Vorzeichnungen von Tieren, Städten, Menschen, Landstrichen, die für einen späteren, größeren Kontext geschaffen wurden, kennt man von Wolgemut, Pleydenwurff oder Dürer, der unter anderem zahlreiche Zeichnungen während seiner Reise in die Niederlande anfertigte.[35] Darunter befindet sich eine Silberstiftzeichnung eines 93-jährigen Antwerpeners, den Dürer – fasziniert vom hohen Alter des Mannes – selbst besuchte, um ein Porträt anzufertigen (Abb. 61). Später nahm er die Gesichtszüge des Alten zum Anlass für eine neue Skizze bzw. als Vorstudie zu einem Hieronymus-Gemälde.[36] Dabei ist anschaulich nachvollziehbar, wie einige Veränderungen genügen, um das Porträt, das auf die genaue Abbildung der Gesichtszüge abzielt, in einen Hieronymus-Typus zu überführen.

In der zweiten Zeichnung (Abb. 62) legt der Alte die Hand an die Stirn und schlägt die Augen nachdenklich nieder, sodass ein melancholischer Gestus entsteht. Aus dem etwas verwildert anmutenden Bart werden sauber in Locken gelegte Strähnen. Im Gemälde, das aus den Skizzen hervorging (Abb. 63), blickt Hieronymus schließlich wieder – wie zuvor der Alte – aus dem Bild heraus; die eine Hand an die Stirn gelegt, weist er mit der anderen auf den Totenschädel im Vordergrund und lädt den Betrachter zur Kontemplation ein. Die Zeichnung von einer einzelnen Person ist vollständig in dem Hieronymus- bzw. Melancholiker-Typus aufgegangen. Anhand dieses Beispiels wird nachvollziehbar, dass sich Naturbeobachtung und Typisierung nicht gegenseitig ausschließen, sondern auch für das zu schaffende Pflanzenbild fruchtbar ineinander übergreifen.

Um ein Bild von einer typischen Pflanze zu kreieren, das für die gesamte Art stehen soll, reicht die Zeichnung nach der Natur bzw. das Darstellen einer „individuellen" Pflanze eventuell nicht aus. Für das illustrierte Kräuterbuch kreiert der Künstler Exemplare, indem er die charakteristischen Merkmale einer Pflanze hervorhebt, abgebrochene Blätter weglässt bzw. ergänzt, den Blick des Betrachters auf die wichtigsten Bestandteile der Pflanze lenkt etc.[37] Oder er greift

34 Wenn man Hoppes Annahme folgt, dass das Stundenbuch „The Hunting Hours" (Abb. 165; London, British Library, Egerton 1146) von Reuwich stammt (Fußnote 76 in Kapitel 2), würde das bedeuten, dass der Künstler bereits mit einer Menge an eigenen Vorlagen von Tier- und Pflanzenstudien im Gepäck in Mainz ankam.

35 Zum Naturstudium in der zweiten Hälfte des 15. Jahrhunderts und Dürers Landschaftsskizzen: Hess (2012).

36 Zu Dürers Reise in die Niederlade: Eising (2013).

37 Hans Weiditz beispielsweise zeigt im Kräuterbuch von Otto Brunfels (1530) Bilder von Pflanzen mit abgebrochenen Stängeln und mit von Insekten angebissenen Blättern, die mehr eine individuelle Pflanze erkennen lassen als ein Exemplar.

Abb. 61: Albrecht Dürer: Por-
trät eines 93-jährigen Mannes,
1521, Pinsel in Schwarz, weiß
gehöht auf grundiertem Papier.
Berlin, Kupferstichkabinett,
Inv.-Nr. KdZ 38. In: Kat.Ausst.
Frankfurt a. M. (2013), S. 335.

Abb. 62: Albrecht Dürer:
Studie zum heiligen Hierony-
mus im Studierzimmer (auch:
Kopfstudie eines alten Man-
nes), 1521, Pinsel in Schwarz
und Grau auf grundiertem
Papier. Wien, Albertina,
Inv.-Nr. 3167. In: Kat.Ausst.
Frankfurt a. M. (2013), S. 336.

Abb. 63: Albrecht Dürer: Der heilige
Hieronymus im Studierzimmer, 1521,
Eichenholz. Lissabon, Museu Na-
cional de Arte Antiga, Inv.-Nr. 828
Pint. In: Kat.Ausst. Frankfurt a. M.
(2013) S. 339.

auf ein Pflanzenbild zurück, das einen etablierten Typus zeigt, und gestaltet das Bild so um, dass
welke Blätter zu sehen sind, abgebrochene Wurzelteile oder ähnliche Details, die suggerieren,
die gerade aus der Erde genommene Pflanze sei abgebildet worden. Da es vielfältige Möglich-
keiten im kreativen Umgang mit den Vorlagen gibt, seien es frische oder getrocknete Pflanzen,
Zeichnungen oder Musterbücher, soll im Folgenden weiter herausgearbeitet werden, wie mit
den für den „Gart" bekannten Modellen umgegangen wurde.

4.2.2. Reproduktion von etablierten Bildformen

Pflanzenformeln: Die „Tractatus de herbis"-Tradition

Die einzigen Kräuterbücher mit einer derart großen Anzahl an Illustrationen, wie sie für die Bebil-
derung des „Gart der Gesundheit" benötigt wurde, und mit einer autorisierten Bildtradition waren
zum Ende des 15. Jahrhunderts die „Tractatus de herbis"-Handschriften.[38] Zahlreiche „Gart"-Illus-
trationen sind auf diese Tradition zurückzuführen. Eine singuläre Handschrift ist nicht als Vorlage
erkennbar, vielmehr weist die Bebilderung im „Tractatus de herbis" eine große Kontinuität auf
und wurde immer wieder relativ exakt kopiert, um Wiedererkennbarkeit zu gewährleisten.[39]

38 Baumann (1974). Collins (2000). Givens (2006).

39 Wood nennt Bildtraditionen, die glaubhafte Darstellungen erzeugen: Replica chains. Wood (2008),
 S. 36–42.

Hier soll daher nicht versucht werden, ein einzelnes Vorbild für den „Gart" ausfindig zu machen oder zu zeigen, mit welcher Handschriftenbebilderung der „Gart" mehr Gemeinsamkeiten aufweist als mit anderen.[40] Vielmehr sollen die Pflanzenbilder in den Handschriften der „Tractatus de herbis"-Tradition als konstantes Bezugssystem verstanden werden, das sich vor der Entstehung des „Gart" so weit etabliert hatte, dass es wiedererkennbare Pflanzenbilder (re-)produzierte.[41] Auf diese Bildformel-Sammlung griff man für den „Gart" zurück und konnte damit eindeutig identifizierbare Pflanzenillustrationen schaffen sowie autorisierte, wahre Bilder[42] erzeugen.

Pflanzen erfassen, Bilder multiplizieren

Das Speichern und Weitergeben von Informationen, wie dies in Kräuterbüchern der Fall ist, setzt einen gewissen Anschluss an vorhandene Bildtraditionen und Modelle voraus, die zwar neu kombiniert werden können, aber dennoch identifizierbar bleiben müssen, um Authentizität zu suggerieren. Einmal als Bildform eingeprägt, kann z. B. „Cyperus" (Zypergras) leicht wiedererkannt werden (Abb. 64). Dabei spielt es keine Rolle, ob die Illustration mit dem Aussehen der jeweiligen Pflanze übereinstimmt oder nicht. Gerade bei exotischeren Pflanzen war ein Vergleich mit der realen Pflanze für den zeitgenössischen Betrachter überhaupt nicht möglich, das Bild als Stellvertreter musste für ihn erkennbar sein. Es kommt also nicht darauf an, ob man die Pflanze „in realiter" wiederfindet, sondern dass sie benannt, gezeigt und beschrieben wird, womit das Exemplar in die Ordnung der Pflanzen bzw. der Natur aufgenommen ist und im Kräuterbuch seinen Platz gefunden hat.[43] Die veristische Darstellung einer Pflanze kann dabei nicht immer die primäre Funktion der Illustrationen im Kräuterbuch gewesen sein. Die Reproduktion von immer gleichen Bildtypen erhöht den Wiedererkennungswert des Bilds. Für den Nutzer bedeutet dies die Möglichkeit der Kennzeichnung, Klassifizierung und Ordnung der Dinge.[44]

Das Bild wird damit zum Symbol, das vom eingeweihten Kenner überzeitlich und überregional gelesen werden kann. Damit wird nicht nur in einem Bild die Zeit angehalten, sondern auch eine komplette Neukonfiguration der Bilder im Laufe der Zeit verhindert. Dies schien ein probates Mittel zu sein, um ein System herauszubilden, das identifizierbare Typen wiedergibt.

40 Ausführliche Listen geben: Schuster (1929). Baumann / Baumann (2010), S. 119–121.

41 Ähnlich wie Ivins (1969) für den Buchdruck bzw. den „Gart" selbst dargelegt hat.

42 Wimböck (2004), S. 29–33: Zur Vermittlung von Autorität durch Wiederholung. Zu „Reproduktion und Wahrheit": Schmidt (2010b).

43 Ebenso wenig spielt es eine Rolle, ob man wundersame Wesen (Einhörner, Kranichschnäbler, Hundsköpfige) schon einmal gesehen hatte, sie mussten lediglich im System der von Gott geschaffenen Welt eingeordnet sein. Saurma-Jeltsch (2006), S. 459 f.

44 Pichler / Ubl (2014), S. 54 f. Pichler und Ubl weisen in diesem Zusammenhang auf Goodman hin, der den Begriff des „Etiketts" einführt, als das das Bild fungiert. Goodman (1997), S. 48 f., S. 63 f.

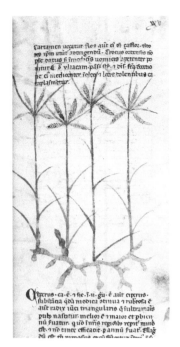

Abb. 64: „Cyperus" (Zypergras) aus drei verschiedenen Handschriften, die der „Tractatus de herbis"-Tradition zugeordnet werden, und aus dem „Gart": Von links nach rechts: Egerton 747, fol. 25r (um 1300; British Library). Cod. Ham. 407, fol. 241v (um 1400; Staatsbibliothek zu Berlin). Hs. K II 11, fol. 9v (um 1450; Universitätsbibliothek Basel). Unten: Gart der Gesundheit. Mainz 1485 (München, BSB, 2 Inc.c.a. 1601).

Autorisierte Merkmale, wahre Bilder

Im Pflanzenbild können distinguierende Merkmale einer Pflanze deutlich betont werden. Ein markantes Blattmuster, wie das der „Incensaria"[45] (Abb. 65), eine auffällige Wurzelform oder -farbe, wie die der Braunwurz (Abb. 66), oder einprägsame Formen von Blättern, Blüten, Früchten, wie sie bei der „Tribuli marini"[46] (Abb. 67) auftritt, werden im „Gart" aus der „Tractatus de herbis"-Tradition aufgenommen. Hierbei handelt es sich um exotische Pflanzen, die in Europa wenig bekannt waren.

Autorisiertes Wissen um die Beschaffenheit, das Aussehen, die Wirkung der Pflanze wurde nicht über wirklichkeitsnahe Abbildungen vermittelt, sondern über tradierte Illustrationsformeln und über den Text. Bild und Text stützen sich dabei gegenseitig in ihrer Beweiskraft. An der veristischen Abbildung als beweiskräftiges Mittel, das ganz unabhängig vom Text Evidenz vermitteln kann, ist man in der Entstehungszeit des „Gart" noch nicht vollständig angelangt.[47]

45 Man ist sich hier nicht sicher, welche Pflanze überhaupt gemeint sein könnte.

46 Auch in diesem Fall ist eine eindeutige Zuschreibung an eine Pflanze nicht möglich.

47 Zur Evidenz des Bilds, mit einer ausführlichen Bibliographie: Wimböck / Leonhard / Friedrich (2007), S. 11–38. Im Bezug auf den Autorisierungsprozess wahrer Bilder ist hier nachzulesen, wie Gesehenes zu Gewusstem wird: „Die Wechselwirkung von Sichtbarkeit, visueller Wahrnehmung und deren Bewertung setzte eine Sinngenese in Gang, die ebenso anthropologischen wie historischen Voraussetzungen unterliegt. Autorisierungsprozesse etwa lassen dominante Bilder entstehen, die ihrerseits kulturprägend wirken und allgemein anerkannte ‚wahre' Bilder hervorbringen. [...] Die Herstellung eines ‚Images', d. h. eines autoritären bzw. autorisierten Bildes findet gerade in

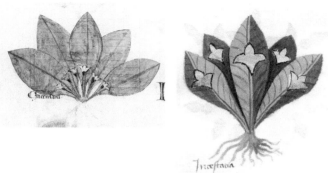

Abb. 65: „Incensaria" („brenwortz") aus drei verschiedenen Handschrif-
ten, die der „Tractatus de herbis"-Tradition zugeordnet werden, und
aus dem „Gart": Von links nach rechts: Egerton 747, fol. 50v (um 1300;
British Library). Cod. Ham. 407, fol. 256r (um 1400; Staatsbibliothek zu
Berlin). Hs. K II 11, fol. 17r (um 1450; Universitätsbibliothek Basel). Gart
der Gesundheit. Mainz 1485 (München, BSB, 2 Inc.c.a. 1601).

Kusukawa erläutert, dass manche Bilder so viel Autorität besaßen, dass sie sogar kopiert wur-
den, wenn das lebende Objekt als Modell zu Verfügung stand, worin sich ein Respekt gegen-
über antikem Wissen abzeichne. Im Miteinander wurde gezeigt, dass Bild und Text auf auto-
risiertem Wissen beruhten.[48] Anders formuliert: Die Abbildungen des „Gart" durften in man-
chen Punkten nicht zu innovativ sein, sich nicht zu sehr von der Tradition unterscheiden, sonst
waren sie nicht glaubhaft.[49]

den Naturwissenschaften großen Anklang, obwohl hier eigentlich die von den Objekten ausgehende
Beobachtung vorherrschen sollte. Ist jedoch einmal ein überzeugendes, ‚wahres' Bild entstanden,
wird das Gesehene zum Gewussten und erlangt auf diese Weise Eingang in den Wissenskanon einer
Kultur. Die Darstellung wird zum beglaubigten Dokument des Gesehenen, Bild und Auge schieben
sich (scheinbar) übereinander." Wimböck / Leonhard / Friedrich (2007), S. 13 f.

48 Kusukawa (2011), S. 206
49 Diese Beobachtung deckt sich mit Timms Ausführungen zur „Peregrinatio in terram sanctam" von
 Bernhard von Breydenbach und Erhard Reuwich. Timm nimmt an, dass die Abbildungen im Reise-
 bericht nicht von Zeichnungen vor Ort stammen, sondern Autorität vermitteln, weil sie sich an Kon-
 ventionen orientieren und bereits existierende Bilder im Gedächtnis des Betrachters aufrufen. Timm
 (2006), S. 121–194. Saurma-Jeltsch bringt das Aufeinandertreffen von wirklichkeitsgetreuen Bildern
 und tradierten Formen auf den Punkt: „An der Tradition orientierte Chiffren und der Verzicht auf
 beobachtende Schilderung unterstützen den Anspruch des Textes, durch die Tradition autorisiertes
 Wissen zu vermitteln [...]. Bilder, die einen Verismus allenfalls nur innerhalb tradierter Formeln
 zulassen und diesem Prinzip selbst dann folgen, wenn in anderen Zusammenhängen die gleichen
 Maler durchaus wirklichkeitsgetreuere Bilder eingebracht hatten, unterstützen somit den Anspruch,
 eine durch Gewährsleute der Vergangenheit abgesicherte Wahrheit wiederzugeben." Saurma-Jeltsch
 (2006), S. 439 f.

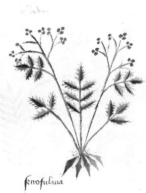
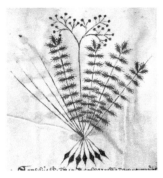

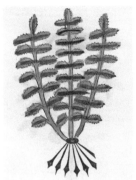

Abb. 66: „Scrofularia" (Braunwurz) aus drei verschiedenen Hand-
schriften, die der „Tractatus de herbis"-Tradition zugeordnet werden,
und aus dem „Gart": Von links nach rechts: Egerton 747, fol. 91r (um
1300; British Library). Cod. Ham. 407, fol. 276r (um 1400; Staats-
bibliothek zu Berlin). Hs. K II 11, fol. 29v (um 1450; Universitäts-
bibliothek Basel). Gart der Gesundheit. Mainz 1485 (München, BSB,
2 Inc.c.a. 1601).

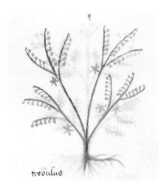
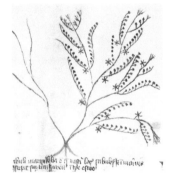

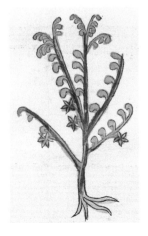

Abb. 67: „Tribuli marini" („mere disteln") aus drei verschiedenen
Handschriften, die der „Tractatus de herbis"-Tradition zugeordnet
werden, und aus dem „Gart": Von links nach rechts: Egerton 747,
fol. 102r (um 1300; British Library). Cod. Ham. 407, fol. 281v (um
1400; Staatsbibliothek zu Berlin). Hs. K II 11, fol. 33r (um 1450; Uni-
versitätsbibliothek Basel). Gart der Gesundheit. Mainz 1485 (Mün-
chen, BSB, 2 Inc.c.a. 1601).

Häufig ist in der Forschung zu lesen, dass der „Gart" in zwei verschiedene Abbildungsmodi zerfällt: einen „schematischen" für exotische, einen „naturnahen" für einheimische Pflanzen. Dies ist tatsächlich der Fall, sollte aber nicht als Nachteil oder Fehlerhaftigkeit des „Gart" interpretiert werden.[50] Vielmehr ist es eine nachvollziehbare Strategie der Legitimierung der Illustrationen, wenn sich Abbildungen außereuropäischer Kräuter gängiger Formen bedienen. Vor allem bei exotischen Pflanzen müssen zunächst die Abbildungen, die an die Tradition anknüpfen, als evident gelten. Saurma-Jeltschs Feststellung, dass Künstler traditionellen Prinzipien dann folgen, wenn sie an der Tradition „abgesicherte Wahrheit" wiedergeben möchten, auch wenn sie andernorts „durchaus wirklichkeitsgetreue Bilder eingebracht haben",[51] kann hier in innerhalb eines Werks nachvollzogen werden.[52]

Umgang mit bekannten Pflanzen

Im Umgang mit bekannteren, einheimischen Pflanzen war man etwas freier und konnte sich von traditionellen Bildformeln lösen. Vergleicht man die oben gezeigten Abbildungen fremder Pflanzen (Abb. 64–67), ist zu begreifen, dass man sehr nahe an den Illustrationen der „Tractatus de herbis"-Handschriften blieb und so ein wiedererkennbares Bild schuf. Ganz anders verfuhren die Illustratoren des „Gart" mit einheimischen Heilkräutern. Hier konnte man andere Vorlagen verwenden oder direkt mit der Natur vergleichen, nicht nur, weil die Pflanze zur Verfügung stand, sondern weil Existenz und Aussehen einer gelben Lilie (Abb. 68), einer Mohnblume (Abb. 69), eines Veilchens (Abb. 191) nicht unter Beweis gestellt werden mussten.

So trifft der Betrachter im „Gart" sowohl auf veristisch anmutende Abbildungen, die sich durch größere Plastizität, mehr Binnenschraffuren und Verkürzungen auszeichnen, als auch auf umrisshafte Formen.[53] Die jeweiligen technischen Ausführungen sagen nichts über die Evidenz oder Naturnähe des Pflanzenbilds aus. Im „Gart" ist beispielsweise die Alraune (Abb. 70) anspruchsvoll gestaltet: Die Blätter weisen in ihrem eleganten Schwung eine Verkürzung auf, ebenso wie der nach vorne gedrehte Fuß der weiblichen Wurzel. Ihre Körperlichkeit wird mit Hilfe feiner Binnenschraffuren erzeugt. Die Schattierungen sind so stimmig über die linke Seite gelegt, dass ein Lichteinfall von rechts unten suggeriert wird. Ihr in zierliche Locken gelegtes Haar schmiegt sich sanft um den rechten Oberarm. Den Kopf seitlich geneigt, richtet sie ihren

50 Dass die außereuropäischen Pflanzen, die Bernhard von Breydenbach auf seiner Reise gesehen haben will, zum Zeitpunkt seiner Reise nicht in Blüte standen, ist zwar aus botanischer Sicht interessant (Baumann / Baumann [2010], S. 139), hier soll jedoch die These stark gemacht werden, dass dies für das Bildprogramm des „Gart" nicht relevant ist.

51 Saurma-Jeltsch (2006), S. 439 f.

52 Sicherlich wird es für die Illustratoren des „Gart" schlichtweg einfacher gewesen sein, die einheimischen Pflanzen wirklichkeitsgetreuer zu gestalten, als exotische Pflanzen. Dennoch hätte es auch andere Möglichkeiten gegeben, den „Gart" visuell einheitlicher zu bebildern, z. B. weniger exotische Pflanzenbilder oder überhaupt weniger Bilder; man hätte auch den Text nur auf die einheimischen Pflanzen beschränken können, so wie Otto Brunfels es 1530 tat; eine veristisch gestaltete Pflanze hätte mehrmals für verschiedene Exemplare stehen können; andere Bildvorlagen hätten besorgt werden können etc. Diesen Optionen ging man jedoch nicht nach.

53 Erst in Pflanzenbüchern ab dem 16. Jahrhundert wird diese visuelle Heterogenität als Defizit aufgefasst.

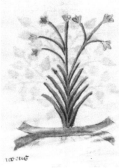
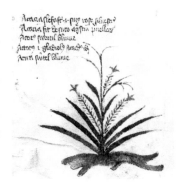

Abb. 68: „Acorus" (Gelbe Lilie) aus drei verschiedenen Handschrif-
ten, die der „Tractatus de herbis"-Tradition zugeordnet werden, und
aus dem „Gart": Von links nach rechts: Egerton 747, fol. 5v (um 1300;
British Library). Cod. Ham. 407, fol. 231r (um 1400; Staatsbibliothek
zu Berlin). Hs. K II 11, fol. 2v (um 1450; Universitätsbibliothek Basel).
Gart der Gesundheit. Mainz 1485 (München, BSB, 2 Inc.c.a. 1601).

Blick nach untern, ihre Hände verdecken die Scham. Die Haltung der weiblichen Wurzel lässt
an die *Venus pudica* denken, also an den Frauentypus schlechthin.

 Dass die dicken, verästelten Pfahlwurzeln der Alraune anthropomorphe Züge annehmen
können, wurde in Pflanzenbüchern des Mittelalters häufig betont. Die Alraunen erhielten von
den Illustratoren dabei je nach Geschlecht der Pflanze eine Wurzel, die wie ein Männer- oder
ein Frauenkörper geformt ist, was sie zu einem leicht erkennbaren Objekt in jedem Kräuter-
buch macht. In den „Tractatus de herbis"-Handschriften wird dieses Charakteristikum zuguns-
ten einer eventuell als sachlicher empfundenen Darstellung aufgegeben bzw. stark zurückge-
nommen (Abb. 70).[54] Im „Gart" wird erneut eine Frauengestalt für die Wurzel der Alraune
entworfen. Allein durch die technische Gestaltung, die eine exakte Observierung des Gegen-
stands unter einer Lichtquelle impliziert, wirkt das Bild wahr.[55] Daran, dass der Betrachter einer
weiblichen Pflanze gegenübersteht, wird kaum ein Zweifel bestehen. Die innere Gestalt oder
Form der Alraune wird durch das äußere Bild nachvollziehbar, auch wenn es keine naturgetreue
Abbildung ist.

54 Der „Herbarius Moguntinus" (1484) zeigt die Alraune ebenfalls ohne menschliche Wurzel.
55 Weiterhin zur „Konstruiertheit" wissenschaftlicher Bilder: Bredekamp u. a. (2008). Bredekamp u. a.
 (2003), S. 15.

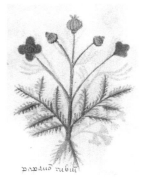

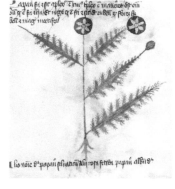

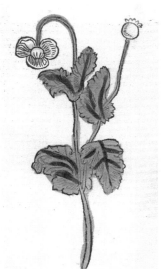

Abb. 69: „Papauer" (Mohn)
aus drei verschiedenen Hand-
schriften, die der „Tractatus
de herbis"-Tradition zug-
eordnet werden, und aus
dem „Gart": Von links nach
rechts: Egerton 747, fol. 73v
(um 1300; British Library).
Cod. Ham. 407, fol. 241v
(um 1400; Staatsbiblio-
thek zu Berlin). Hs. K II
11, fol. 23v (um 1450; UB Basel). Gart der Gesundheit. Mainz 1485
(München, BSB, 2 Inc.c.a. 1601).

Umgang mit Exotischem

Für den „Gart" lässt sich nicht verabsolutieren, dass alle einheimischen Pflanzen immer natur-
getreuer aussehen als die „Exotika". Der wilde Apfel (Holzapfelbaum[56], Abb. 71), den die Künst-
ler direkt am Objekt hätten studieren können bzw. sicher aus eigener Anschauung kannten,
ohne weit reisen zu müssen, ist eher umrisshaft und mit wenig Binnenschraffur gebildet. Da-
durch kann keine Tiefenwirkung entstehen, dennoch beinhaltet das Bild alles, was den Apfel-
baum ausmacht. Von den Wurzeln über den Stamm mit Verästelungen und Blättern bis hin zur
runden Frucht ist alles vorhanden. Es spielt keine Rolle, ob das Bild „schematisch" ist oder de-
tailliert, es zählt die „Nachahmung bestimmter lebenswichtiger und entscheidender Aspekte".[57]

56 Es ist auffällig, dass alle Bäume im „Gart" im Vergleich zu den Kräutern eher umrisshaft gezeigt sind.
 Dies muss keinen spezifischen Grund haben. Man könnte jedoch überlegen, ob es mit der medizi-
 nischen Wirkung zusammenhängt, die bei Bäumen als weniger stark eingestuft wurde als bei niedrig
 wachsenden Kräutern (siehe: Kap. 5.3.).
57 Gombrich (1973), S. 23.

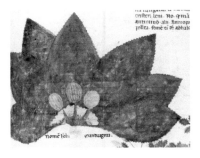

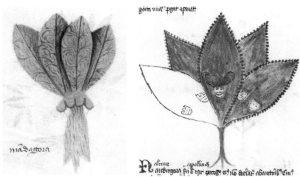

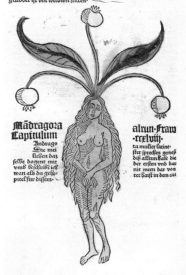

Abb. 70: „Mandragora" (Alraune) aus drei verschiedenen Hand-
schriften, die der „Tractatus de herbis"-Tradition zugeordnet
werden, und aus dem „Gart": Von links nach rechts: Egerton
747, fol. 61r (um 1300; British Library). Cod. Ham. 407, fol. 262r
(um 1400; Staatsbibliothek zu Berlin). Hs. K II 11, fol. 19v (um
1450; Universitätsbibliothek Basel). Unten: Gart der Gesundheit.
Mainz 1485 (München, BSB, 2 Inc.c.a. 1601).

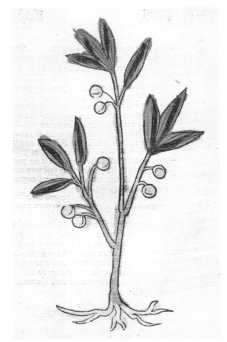

Abb. 71: Holzapfel (wilder Apfel): Gart
der Gesundheit. Mainz 1485. München,
Bayerische Staatsbibliothek, 2 Inc.c.a.
1601.

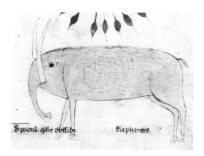

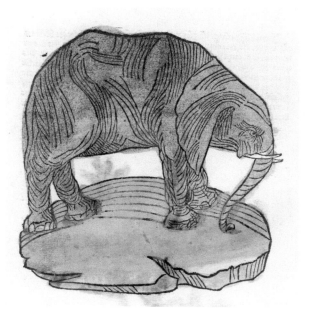

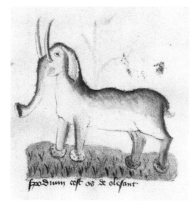

Abb. 72: „Spodium" (gebranntes Elfenbein) aus zwei verschiedenen Handschriften, die der „Tractatus de herbis"-Tradition zugeordnet werden, und aus dem „Gart":
Oben, links : Egerton 747, fol. 91r (um 1300; British Library). Unten, links: Cod. Ham. 407, fol. 276r (um 1400; Staatsbibliothek zu Berlin). Rechts: Gart der Gesundheit. Mainz 1485 (München, BSB, 2 Inc.c.a. 1601).

Der Elefant, ein exotisches Exemplar, das man gewöhnlich im „Tractatus de herbis"-Kontext antrifft (Abb. 72), ist im Gegensatz zum Apfelbaum detailreich ausgearbeitet. Eigentlich sind zwar nur seine Knochen als medizinisches Mittel von Interesse, dennoch bildete man immer das gesamte Tier ab. Im „Gart der Gesundheit" wird der Elefant sogar zwei Mal gezeigt: unter Elfenbein und unter „Spondium" (verbrannte Elefantenknochen oder verbranntes Elfenbein).[58]

Die Illustration des Tieres ist auffällig naturnah: Die Stoßzähne, die für gewöhnlich nicht besonders treffend erfasst sind, werden relativ exakt verortet. Die „Stampfer" sind keine Hufe oder Pfoten.[59] Der Körperumriss gleicht nicht dem einheimischer Tiere, wie Kühen oder anderen großen Vierbeinern. Kein Pelz oder Fell überzieht den Körper, sondern eine ledrige, faltige Haut. Allein die Steifheit der Beine mag darauf hinweisen, dass man auch im Spätmittelalter noch annahm, Elefanten hätten keine Knie.[60]

58 Die doppelte Verwendung von Holzschnitten ist im „Gart" höchst selten. Diese kann eventuell ein Hinweis darauf sein, dass man die Illustration für besonders gelungen hielt.

59 Indem man das exotische Tier visuell nahe an einheimische, bekannte Tiere heranrückt, belegt das Bild seine Existenz. Saurma-Jeltsch nennt dieses Phänomen die „Belegbarkeit des Ungewöhnlichen durch das Gewöhnliche". Saurma-Jeltsch (2006), S. 441–445.

60 Auch bei scheinbar beobachteter Natur warnt Niehr vor zu schnellen Rückschlüssen, da sich in den Tierdarstellungen immer auch schon das Wissen um die Art entlarvt, wie beispielsweise die Kenntnis, der Elefant besitze keine Knie.

Abb. 73: „Spodium" (gebranntes Elfenbein) bzw. Elfenbein in ver-
schiedenen „Gart"-Ausgaben: Von links nach rechts: Augsburg 1485
(BSB, 2 Inc.c.a. 1602). Augsburg 1486 (BSB, 2 Inc.c.a. 1771 b). Ulm
1487 (BSB, 2 Inc.c.a. 1913).

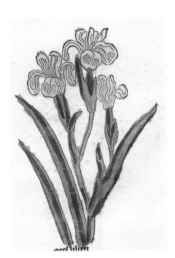
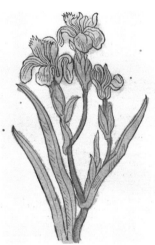
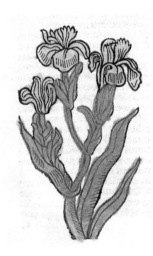

Abb. 74: Gelbe Lilie in verschiedenen „Gart"-Ausgaben: Von links nach rechts: Mainz 1485 (BSB, 2 Inc.c.a.
1601). Augsburg 1485 (BSB, 2 Inc.c.a. 1602). Augsburg 1486 (BSB, 2 Inc.c.a. 1771 b).

Der Exot löst sich deutlich von traditionellen Darstellungen[61] – zumindest in der ersten
Ausgabe des „Gart". Schon in den ersten Nachschnitten aus Augsburg, in denen ansonsten
die Holzschnitte des Mainzer „Gart" sehr sorgfältig kopiert wurden (zum Vergleich die gelbe
Lilie: Abb. 74), sind erste Tendenzen zu sehen, die das Elefanten-Bild wieder – bewusst oder
unbewusst – näher an bekanntere, traditionellere Abbildungen heranrückten (Abb. 73). Die
Stoßzähne wirken in den Augsburger Ausgaben nicht mehr so harmonisch platziert wie in der
Mainzer Ausgabe, die „Stampfer" sind hufartiger.

61 Siehe hierzu: Grape-Albers (1977), S. 21–37, insb. S. 31 und S. 33: Darstellungen von Elefanten aus
 verschiedenen, mittelalterlichen Handschriften; darunter zwei naturnahe Abbildung von Matthew
 Paris von 1255 nach einem Elefanten, der Mitte des 13. Jahrhunderts im Tower of London gehalten
 wurde. Dass Reuwich diese Zeichnungen kannte, kann ausgeschlossen werden. Die Bilder fand kei-
 nen Eingang in Pflanzen- oder Tierbücher der Zeit und konnte daher auch nicht rezipiert werden.

1487, in der Ulmer Ausgabe, und ebenso in der zeitgleichen Straßburger Ausgabe, hat sich
das Aussehen des Elefanten so weit verändert, dass man offenbar eine Darstellung gefunden
hat, die auf allgemeine Akzeptanz stieß. Diese Elefantenabbildung, die das Tier mit zusammen-
gerückten, pfotenartigen Beinen von einer schmalen Anhöhe herunterblickend illustriert, wird
von fast allen „Gart"-Ausgaben nach 1487 und für den lateinischen „Hortus sanitatis" über-
nommen. Man konnte sich allem Anschein nach nicht zu unvermittelt von der traditionellen
Ikonographie entfernen, zumindest nicht bei Illustrationen von exotischen Exemplaren.

4.2.3. Einfach kopieren? Der „Codex Berleburg"

Während die meisten Vorlagen für den „Gart" nicht exakt greifbar sind, konnte eine medizini-
sche Sammelhandschrift mit Pflanzenbildern bestimmt werden, die Bernhard von Breydenbach
1475 erworben hatte. Mehrere Abbildungen aus dem sog. „Codex Berleburg"[62] wurden für den
„Gart" kopiert.[63]

Der „Codex Berleburg" als Vorlage

Der heutige Aufbewahrungsort des „Codex Berleburg" ist unbekannt. Eine Einsicht ins Origi-
nal ist nicht mehr möglich, es existiert lediglich ein Farbmikrofiche der gesamten Handschrift,
der zusammen mit einer wissenschaftlichen Beschreibung 1991 herausgegeben wurde.[64] Zu die-
sem Zeitpunkt wurde die um 1430 angefertigte Handschrift noch in Berleburg aufbewahrt. Die
medizinische Sammelhandschrift besteht aus verschiedenen Teilen und enthält von fol. 267r bis
356r ein „Herbarium pictum"[65] mit insgesamt 86 ganzseitigen, in Deckfarben ausgeführten Pflan-
zenabbildungen, daneben der deutsche Pflanzenname. Die Kräuter wurden mit einer Ausnahme
auf der Rectoseite dargestellt, auf den Versoseiten wurden vereinzelt lateinische und deutsche
Synonyma verzeichnet. Welches Ordnungsprinzip der Reihenfolge der Abbildungen zu Grunde
liegt, konnte bislang nicht geklärt werden. Es wurde kein Text aus der Handschrift für den „Gart"
herangezogen, sie diente ausschließlich als Bildvorlage. Was ihre Anordnung und den Text zur
jeweiligen Pflanze betrifft, könnten die Werke kaum unterschiedlicher sein. Vor allem die vonein-
ander abweichende Anordnung der Pflanzen kann beim Kopieren schnell zur Unübersichtlichkeit
führen.

Die Art, wie man die Bilder aus dem Codex übernahm, gibt Aufschluss darüber, wie in der
Reuwich-Werkstatt mit Vorlagen umgegangen wurde: Einige Pflanzenbilder aus dem „Codex
Berleburg" wurden relativ exakt kopiert, manche leicht verändert und andere wiederum stark

62 Olim Berleburg, Fürst. Sayn-Wittgenstein'sche Bibliothek, Cod. RT 2/6 (ehem. F4).

63 Wolf-Dieter Müller-Jahncke konnte nachweisen, dass einige Illustrationen des „Gart" aus dem so
 genannten „Codex Berleburg" kopiert wurden und Bernhard von Breydenbach seit 1475 den Codex
 in seinem Besitz hatte. Müller-Jahncke (1977).

64 Die Ausgabe zum Mikrofiche mit ausführlicher Beschreibung und weiteren Literaturangaben: Mül-
 ler-Jahncke (1991).

65 Der Begriff wurde von Schnell übernommen. Gemeint ist, dass das Herbarium aus Abbildungen und
 Nennung der Pflanzennamen (mit Synonymen) besteht: Schnell (2009), S. 406.

variiert.[66] Wie viele Abbildungen der Handschrift als Vorlage dienten, ist daher nicht ohne Weiteres zu klären. In der Forschung schwankt die Anzahl der kopierten Pflanzen zwischen 5[67], 16[68] und 17[69] Exemplaren. Im Folgenden wird argumentiert, dass eventuell bis zu 31 Abbildungen für den „Gart der Gesundheit" aufgegriffen wurden (Abbildungsvergleich: siehe S. 246–262). Schnell warf zudem die Frage auf, warum man für den „Gart der Gesundheit" nicht auf alle 86 Abbildungen des „Codex Berleburg" zurückgriff.[70] Die Verwirrung, die innerhalb der Forschung über die Bezüge der beiden Werke zueinander besteht, lässt sich nicht vollständig auflösen. Ein Blick auf die Strategie der Werkstatt bei der Übertragung der Bilder aus der Handschrift in den „Gart" soll neue Möglichkeiten ausloten.

Eine Frage der Ordnung

Eine erste Schwierigkeit beim Kopieren aus dem „Codex Berleburg" besteht in der Anordnung. Die deutschen Pflanzenbezeichnungen, die beide Werke geben, stimmen für die kopierten Abbildungen in der Regel überein, was erstaunlich ist, denn die Reihenfolge ist in beiden Fällen eine andere:

Während die Handschrift nicht erkennen lässt, nach welchem Kriterium die Pflanzen angereiht wurden, wurde der „Gart" nach dem Alphabet der lateinischen Pflanzennamen geordnet. Sogar mit heutigen technischen Mitteln und mit Hilfe botanisch aufgearbeiteter Listen, die die deutschen und lateinischen Pflanzennamen enthalten, ist es kompliziert, Bildvergleiche anhand der Nomenklatur anzustellen. Hat man ausgehend vom „Codex Berleburg" den entsprechenden deutschen Kräuternamen[71] im „Gart der Gesundheit" gefunden, fällt auf, dass für den „Gart" die korrekte Pflanze aus dem „Codex Berleburg" ausgewählt und kopiert wurde. Beispielsweise ist die Ochsenzunge im „Gart" eine Kopie der Ochsenzunge des „Codex Ber-

66 Das „Muoßore"-Bild wurde im „Gart" (Cap. xxviij) wohl versehentlich auf den Kopf gestellt – die Nachschnitte übernehmen diesen „Fehler".

67 1991 schreibt Müller-Jahncke, dass „nur fünf, im Kodex durch einen Kreis gekennzeichnete Abbildungen unverändert in den ‚Gart der Gesundheit': ‚Basilien' (278r), ‚Selbey' (309r), ‚Muoßore' (313r), ‚Phaffenkrudt' (314r) und ‚Genßdistel' (315r)" Eingang fanden. Müller-Jahncke (1991), S. 81. Die von Müller-Jahncke genannten Kopien sind, mit Ausnahme des Salbeis, eng am Original und seitenverkehrt wiedergegeben.

68 Müller-Jahncke hat 1977 darauf aufmerksam gemacht, dass insgesamt 16 Illustrationen aus dem „Codex Berleburg" stammen und mehrere weitere Abbildungen zumindest als Vorlage dienten, allerdings etwas abgeändert wurden. Da Müller-Jahncke 1991 argumentiert, Bernhard von Breydenbach habe während seiner Pilgerreise den „Codex Berleburg" als Vorlage verworfen, um eigene Illustrationen für den „Gart" anfertigen zu lassen, beließ er es nur noch bei fünf durch einen Kreis gekennzeichnete Vorlagen. Schnell betont, dass man nicht weiß, wann dieses Kennzeichnungssystem, das sich am Mikrofiche nicht mehr nachvollziehen lässt, angebracht wurde. Schnell (2009), S. 407.

69 Baumann und Baumann geben insgesamt 17 Illustrationen an, die aus dem „Codex Berleburg" übernommen wurden (siehe Tabelle S. 246). Sie übernehmen 2010 alle von Müller-Jahncke 1977 vorgeschlagenen Zuschreibungen und ergänzen als Vorlage noch fol. 272r aus dem „Codex Berleburg": Drußkrutt (*Sedum telephium*). Die Zuschreibung des Salbeis als Vorlage, die Müller-Jahncke 1991 machte, übernehmen sie nicht.

70 Schnell (2009), S. 407.

71 Es gibt nur Unterschiede aufgrund unterschiedlicher Schreibarten.

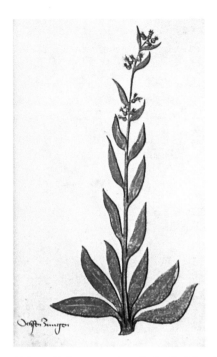
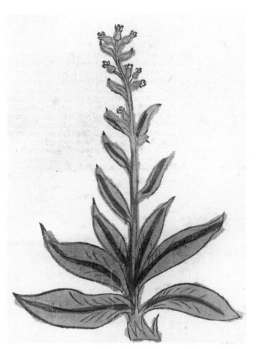

Abb. 75: Ochsenzunge im „Codex Berleburg" (fol. 308r) und im „Gart" (BSB, 2 Inc.c.a. 1601).

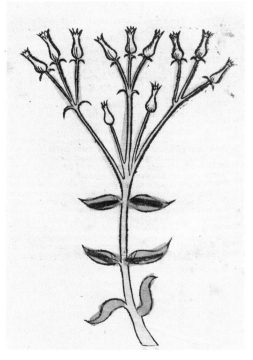

Abb. 76: „Bieuoerkrudt" im „Codex Berleburg"
(fol. 274r) und im „Gart" (BSB, 2 Inc.c.a. 1601).

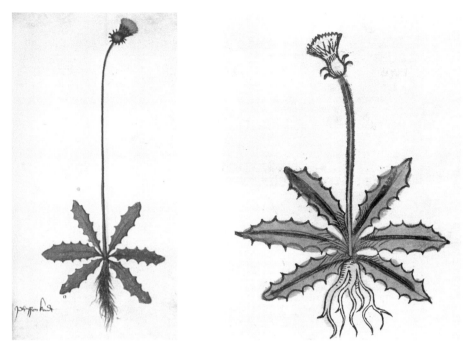

Abb. 77: „Phaffenkrudt" im „Codex Berleburg" (fol. 314r) und im „Gart" (BSB, 2 Inc.c.a. 1601).

Abb. 78: „Pungen" im „Codex Berleburg" (fol. 304r) und „Gart" (BSB, 2 Inc.c.a. 1601).

Abb. 79: „Bernvinckel" im „Codex Berleburg" (fol. 325r) und im „Gart" (BSB, 2 Inc.c.a. 1601).

leburg". Im „Gart" ist die Pflanze aber unter dem Buchstanden B („Buglossa") zu finden (Abb. 75).

Für etwa 30 von 86 Pflanzen diente der „Codex Berleburg" als Vorlage. Von diesen 30 Exemplaren stimmen nur vier nicht mit den deutschen Pflanzennamen im „Gart" überein: „Bieuoerkrudt", „Phaffenkrudt", „Pungen", „Bernvinckel" (Abb. 76–79). Unter den verschiedenen Synonymen, die im „Codex Berleburg" für Bieuoerkrudt aufgelistet werden,[72] wird das Kraut auch als „Centaurea" bezeichnet, dieser lateinische Name entspricht wiederum der Benennung im „Gart". Bei „Phaffenkrudt", „Pungen" und „Bernvinckel" sind ähnliche Synonyma nicht in der Handschrift zu finden, ein rascher Vergleich mit den heutigen wissenschaftlichen Bezeichnungen der Pflanzen zeigt jedoch, dass offenbar in beiden Werken dasselbe Kraut gemeint war.[73]

Abgesehen von diesen vier Beispielen kann eine so hohe Übereinstimmung der deutschen Pflanzennamen in einer Zeit, in der es noch keine einheitliche botanische Nomenklatur gab, kein Zufall sein.[74] Wie muss man sich also den Übertragungsvorgang zwischen den Bildern der

72 Die Synonyme für das Kraut befinden sich auf fol. 273v.

73 Zumindest kommen Müller-Jahncke (1991) und Baumann / Baumann (2010) unabhängig voneinander zu denselben botanischen Identifikationen anhand der Bilder im „Codex Berleburg" und im „Gart", die die Forscher jeweils als „eindeutig erkennbar" einstufen.

74 Das zeigt allein die Synonymliste, die den Pflanzenabbildungen des „Codex Berleburg" beigegeben sind. Diese Ausführungen widersprechen dem Befund bei Baumann und Baumann. Sie konstatieren eine hohe Zahl falsch zugeordneter Bilder und schreiben Johann Wonnecke von Kaub daher keine großen botanischen Kenntnisse zu. Dies mag aus Sicht eines modernen Botanikers zutreffen, muss

Handschrift und dem gedruckten Buch vorstellen? Es liegt nahe anzunehmen, dass nicht zuerst das Bildmaterial für den „Gart der Gesundheit" entstand, sondern für die erste Planungsphase die Auswahl der aufzunehmenden Pflanzen und ihre alphabetische Sortierung nach den lateinischen Namen zu denken ist. Ist diese Namensliste mit ihren deutschsprachigen Entsprechungen erst einmal festgelegt, folgen Text und schließlich das Bild. Für die Abbildungen ist es bei der Übertragung vom „Codex Berleburg" in den „Gart" wichtig, dass die Namen übereinstimmen, also das richtige Bild zur korrekten Bezeichnung gefunden wird. Hier stellt man in der Planung eventuell fest, dass bereits ein anderer Holzschnitt für den entsprechenden Textabschnitt existiert, dass man also die Kopie aus dem „Codex Berleburg" nicht benötigt. Vielleicht ist es auch schwierig, bei der Anordnung des „Codex Berleburg", die nicht mit der Ordnung nach den lateinischen Pflanzennamen im „Gart" übereinstimmt, das korrekte Bild zu finden, und man verzichtet deshalb auf die Kopie. Da eine festgeschriebene Nomenklatur nicht existiert, ist es äußerst komplex, aus dem „Codex Berleburg" das übereinstimmende Bildmaterial auszuwählen. Der Künstler hatte daher vermutlich einen Experten an der Hand, der beratend zur Seite stand.

Wie wichtig die Register und Anordnungen innerhalb von Kräuterbüchern sind, zeigen die nachträglich eingefügten handschriftlichen wie auch die gedruckten Register (siehe Kap. 3.7.). Das Verzeichnis nach den lateinischen Pflanzennamen, das im „Gart der Gesundheit" gegeben wird, reichte nicht aus und wurde durch deutsche Pflanzenregister ergänzt.

Die Entscheidung, den „Gart" nach den lateinischen Pflanzennamen anzuordnen, machte das Kopieren aus Vorlagen mit deutschen Pflanzennamen komplizierter, allerdings wird auf diese Weise das Kommunizieren über Pflanzen international möglich, indem der Text zwar deutschsprachig ist, die Reihenfolge im Text sich jedoch an der universelleren Sprache orientiert.[75] Das ist zumindest der Anspruch Bernhards von Breydenbach an das Buch, das „in die Welt gehen soll".[76] Bilder und Nomenklatur sind jedenfalls für diejenigen „lesbar", die kein Deutsch sprechen. Damit stellte man sicher, dass untereinander immer von derselben Pflanze die Rede ist. Ein Umstand, der für den Umgang mit Pflanzen von maßgeblicher Bedeutung ist. Die Pflanzen fanden so ihren Weg in eine größere „Forschungsgemeinschaft".[77] Die Anordnung im „Gart" ist ebenso für die lateinische Übersetzung und für Nachschnitte des Werks praktisch anwendbar.

Bildberatung

Das Erkennen der richtigen Bildvorlage für den Text erfordert zunächst Wissen um die Pflanze. Die Abbildung des Farns wird im „Codex Berleburg" nicht benannt, von der „Gart"-Werkstatt, eventuell von Johann Wonnecke von Kaub selbst, aber als solcher erkannt und für das Farnkraut kopiert (Abb. 80). Es liegt daher nahe anzunehmen, dass die Werkstatt für die Abbildungen auf die Beratung eines Pflanzenkenners zurückgriff, um keine falschen bzw. um identifizierbare Bilder zu produzieren.

aber für ein Werk des 15. Jahrhunderts neu verhandelt werden. Baumann / Baumann (2010), S. 126. Behling hingegen schreibt, dass die Initiatoren des „Gart" durchaus botanische Kenntnisse besaßen. Behling (1957), S. 88.

75 Ivins (1948), S. 55 f.

76 Bernhard von Breydenbach (1485), fol. 3v.

77 Ogilvie (2008).

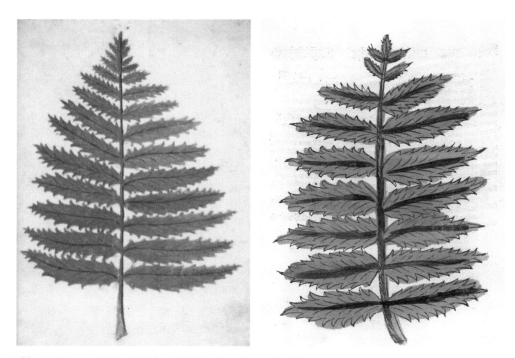

Abb. 80: Farn im „Codex Berleburg" (fol. 331r) und im „Gart" (BSB, 2 Inc.c.a. 1601).

Der „Gart" gibt dem Nutzer nicht nur eine einheitliche Nomenklatur, sondern auch das „richtige" und vielfach reproduzierte Bild zur Pflanze, sodass man mit Ivins von einer „visuellen Kommunikation" sprechen kann.[78] Parshall und Landau gehen in ihrer Argumentation noch weiter: Das Überprüfen und Standardisieren von Illustrationen („Making illustrations was a way of checking facts") öffne den Weg für eine neue Klassifikation von Pflanzen.[79] Der „Gart der Gesundheit" nimmt nicht die Klassifikation von Carl von Linné (gest. 1778) vorweg,[80] eine gewisse „Familienähnlichkeit" unter Pflanzen mag aber doch bei der Formgebung aufgefallen sein. So wurde die Abbildung des „Grensinck" (Gänsefingerkraut) aus dem „Codex Berleburg" für den „Gart der Gesundheit" neben dem „Grensyng" auch für den „Odermynge" (Ackerkraut oder Gemeiner/Kleiner Odermennig) und eventuell die „Nessel" (Brennnessel) herangezogen. Gänsefinger- und Ackerkraut gehören beide in die Familie der Rosengewächse, die Brennnesseln bilden eine eigene Familie in der Ordnung der „Rosales" (Rosenartigen Pflanzen). Die Formen ihrer Laubblätter sind sehr ähnlich, sodass das eine Bild aus dem „Codex Berleburg" in Variation für drei Illustrationen im „Gart der Gesundheit" Verwendung finden kann (Abb. 81).[81] Die Abbildungen aus dem „Codex Berleburg" könnten zusätzlich mit anderen Vorlagen (z. B. „Tractatus de herbis"-Handschriften) oder mit der Natur abgeglichen und dementsprechend abgeändert worden sein.

78 Ivins (1969).
79 Landau / Parshall (1994), S. 257–258. Weiter: Parshall (1993). Smith (2006).
80 Zu Linné: Ford (2003), S. 567 f.
81 Zur heutigen Pflanzensystematik: Strasburger (2014), S. 504–542.

Abb. 81: „Grensinck" aus dem „Codex Berleburg" im Vergleich zu verschiedenen rosenartigen Pflanzen im „Gart" (BSB, 2 Inc.c.a. 1601):
„Grensinck" (fol. 283r). Cap. v: „odermynge". Cap. cccxviij: „grensyng". Cap. cccxj: „nesseln".

Zum Vergleich: „Agrimonia", „odermynge" (Ackerkraut) in der „Tractatus de herbis"-Tradition und in der Natur:
Links: London, British Library, Egerton 747, fol. 9v. Mitte: Berlin, Staatsbibliothek zu Berlin, Cod. Ham. 407, fol. 233v.

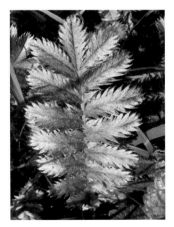

Neue Pflanzenbilder?

Das Gänsefingerkraut, das Ackerkraut und die Brennnessel wurden nicht exakt kopiert. Das Ackerkraut erhielt im Gart der Gesundheit einen sanften Schwung im Stengel sowie ein leicht abgeknicktes Blatt und unten ein Nebenblatt. Das Gänsefingerkraut zeigt zwei Blattreihen weniger, die Blätter wirken außerdem etwas länger und schlanker. Die für die beiden Kräuter signifikante Anordnung der Blätter – jeweils zwei große und dazwischen zwei kleinere

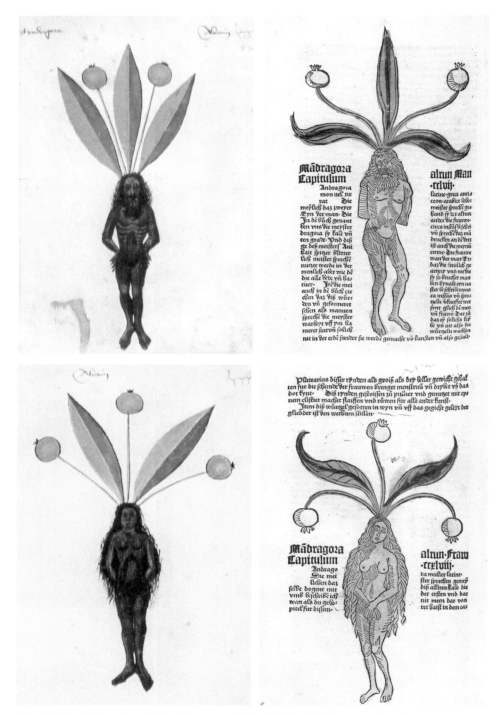

Abb. 82: Männliche und weibliche Alraune im „Codex Berleburg" (fol. 355r, 356r) und im „Gart" (BSB, 2 Inc.c.a. 1601).

Abb. 83: Leberkraut im „Codex Berleburg" (fol. 317r) und im „Gart" (BSB, 2 Inc.c.a. 1601).

gegenüberliegende Blätter und zum Abschluss ein dreigeteiltes Blatt – wurde jeweils beibehalten. Die Brennnessel, die in der Natur einen etwas anderen Blätterstand, aber ebenso gezackte Blätter besitzt wie Gänsefinger- und Ackerkraut, erhielt zusätzlich im „Gart der Gesundheit" eine kleine Wurzel. Das Einfügen leichter Schwünge und Drehungen sorgt im „Gart" dafür, dass die Abbildungen plastischer, bewegter und dadurch auch lebendiger erscheinen als die Darstellungen im „Codex Berleburg". Besonders auffällig wird diese Art der Variation bei den Illustrationen zur männlichen und weiblichen Alraune. Die Drehungen der Blätter und Stängel sowie die Aktualisierung der Vorlage durch etwas Schwung in Hüfte und Schultern und einer Neigung des Kopfes hat dafür gesorgt, dass man die Alraunen-Darstellungen nicht als Kopie aus dem „Codex Berleburg" gedeutet hat[82] (Abb. 82). Eine Variation findet sich ebenfalls bei der Darstellung des „Leberkrudts" (Labkraut bzw. Waldmeister, Abb. 83), das statt mit einem mit drei Stängeln gezeigt wird, die sich in verschiedene Richtungen biegen. Die sternförmigen Blätter, die sich mit viel Abstand an dem Stängel anordnen, sind als wiedererkennbares Charakteristikum geblieben.

Nimmt man nun einen freieren Umgang mit den Abbildungen aus dem „Codex Berleburg" an, der Drehungen, Schwünge, Hinzufügung zusätzlicher Elemente etc. unter Beibehaltung distinguierender Merkmale erlaubt, könnten noch weitere Abbildungen als mögliche Vorlagen zur Diskussion gestellt werden. Die Holzschnitte konnten dabei so stark erweitert und variiert werden, dass die Vorlage kaum mehr zu erkennen sind. Bei der Hauswurz entschied man sich

82 Eventuell möchte man hier auch nicht mehr von Kopie, sondern von Variation sprechen. Ein Vergleich von Alraunen-Darstellungen zu dieser Zeit kann jedoch deutlich machen, dass die Vorlage für den „Gart" aus dem „Codex Berleburg" stammt.

beispielsweise dagegen, eine Aufsicht zu zeigen, und drehte die Pflanze seitlich – die Kräuter im „Gart" werden in der Regel seitlich gezeigt (S. 250).[83] Beschaffenheit und Aussehen der Hauswurz war der Werkstatt sicher aus eigener Erfahrung bekannt,[84] sodass es sich hier um ein Ineinandergreifen von eigener Anschauung und Vorlage handeln könnte.[85] Ebenso verfuhr man gegebenenfalls bei Täschelkraut (S. 251) und Akelei (S. 254), wo Blüten hinzugefügt wurden. Betonie (S. 249), Rittersporn (S. 252), Heiligenkraut (S. 253), Melisse (S. 257), Fingerkraut (S. 259) und Eisenkraut (S. 262) kommen weiterhin als Vorlagen in Frage.[86]

Bei der Herstellung der Pflanzenbilder nach Vorlagen gab es für die Künstler der Reuwich-Werkstatt die Möglichkeit, sich nah an einem Muster zu orientieren oder freier zu rezipieren. Außerdem konnte man die Abbildungen mit lebenden oder gepressten Exemplaren vergleichen.[87] Modelle aus Pflanzenbüchern oder Zeichnungen konnten miteinander kombiniert werden, indem man beispielsweise aus der einen Vorlage die Blätter und aus der anderen die Blüten übernahm. Kopieren ist dabei nicht als einfacher Prozess zu verstehen, in dem das Muster eins zu eins übernommen wird, vielmehr wird an einer Grundlage weitergearbeitet. Wie man an der relativ naturnahen Elefanten-Illustration nachvollziehen kann, durften sich die Abbildungen dabei nicht zu sehr von der Bildtradition entfernen, denn in jedem Fall steht die Wiedererkennbarkeit der Pflanze im Vordergrund. Für die Illustrationen des „Gart" wurde selten detailgenau kopiert, sondern eher, wie es bei der Werkstatt von Pleydenwurff und Wolgemut zu beobachten ist, variiert und neu kombiniert, sodass man für das Kräuterbuch zu einem eigenständigen Bildprogramm kam.

4.3. Pflanzen kolorieren

Der kolorierte Holzschnitt

Die früh entstandenen Holzschnitte waren mit kräftigen Umrissen und wenigen Binnenschraffuren ausgestaltet. Im Anschluss an den Druck wurde der Holzschnitt in der Regel von einem Maler koloriert.[88] Unterblieb das Kolorieren, beispielsweise aus finanziellen Gründen, kam es durchaus vor, dass der Käufer des Holzschnitts selbst zum Pinsel griff und zumindest kleine Akzente setzte.[89] Die technischen Analysen von Thomas Primeau ergaben, dass die meisten ko-

83 Nur Quendel (Thymian; Cap. cccxlviij) und die Eidechse (Cap. ccclxxxiij) werden von oben gezeigt.

84 Hauswurz war eine Pflanze, die man gerne auf dem Hausdach anbrachte, um – so glaubte man – Blitze ableiten zu können. Karin Leonhard sei an dieser Stelle für diesen Einblick in den Umgang mit Pflanzen im Spätmittelalter gedankt.

85 Der „Gart" weicht bei der Darstellung der Hauswurz im Vergleich zu anderen Kräuterbüchern so stark ab, dass nur der „Codex Berleburg", ein verlorenes Modell oder die Naturanschauung als Vorlage in Frage kommen.

86 Pflanzenbilder, die hier neu als Vorlage diskutiert werden, sind durch einen Stern markiert: S. 246–262.

87 Nach dem Prinzip des „selective naturalism": Bekannte Traditionen werden mit Naturbeobachtung kombiniert. Gombrich (1999), S. 93.

88 Für das Wissen um die Theorie, Behandlung und Herstellung der Farbe im Mittelalter sind die Studien von Roosen-Runge (1967), Ploss (1977), Gage (1999) und Gage (2001) mit ausführlicher Bibliographie hilfreich. Weitere Untersuchungen zur Farbigkeit im Mittelalter und im Buchdruck: Bennewitz (2011). Kat.Ausst. Baltimore (2002).

89 Für Hartmann Schedel ist bekannt, dass er unkolorierte Drucke nachträglich verzierte. Kat.Ausst. München (2014), S. 99.

lorierten Drucke kurz nach ihrer Entstehung bzw. noch vor dem Binden des Buchs professio-
nell koloriert wurden, eine nachträgliche Farbgebung ist extrem selten. Das Kolorieren von
Drucken war, das konnten Primeaus Studien zeigen, eine völlig gängige Praxis.[90] Man muss da-
von ausgehen, dass der Formschneider schon im Vorfeld mit einer nachträglichen Kolorierung
seines Werks rechnete.[91] Hier kann eine Parallele zu den Künstlern gezogen werden, die Skulp-
turen anfertigten. Den meisten Bildschnitzern muss bewusst gewesen sein, dass ihre Werke aus
Holz mit Farbe gefasst werden sollten.[92] Ein unkolorierter Holzschnitt muss, wie die ungefasste
Skulptur,[93] zunächst als „unfertig" betrachtet werden.[94]

Maler lasierten die Holzschnitte mit stark verdünnten Farben, um die schwarzen, gedruckten
Linien nicht völlig zu überdecken. Die Farbe überschreitet häufig die Umrisslinie, besonders
wenn mit Schablonen gearbeitet wird, um Farbe zu applizieren.[95] Das schnelle, manufakturhafte
Kolorieren ist kein Gedanke, der mit der Druckgraphik einsetzte, sondern der bereits zuvor für
Handschriften beobachtet werden kann, beispielsweise jene, die aus der Diebold-Lauber-Werk-
statt stammen. Hier besteht die Illustration aus einer Kombination aus schwarzen Umrisslinien,
die mit einer Feder gezogen werden, und zügig aufgetragener Farbe (Abb. 18–19).[96]

Der Vorgang des Druckens und Kolorierens ist ein arbeitsteiliger Ablauf. In vielen Fällen ist
unklar, ob die vielen Hände, die ein gedrucktes Buch vor seiner Fertigstellung durchwandert
hat, in einer Werkstatt versammelt waren. Zumindest waren Maler und Drucker in verschiede-
nen Zünften angesiedelt und hatten unterschiedlichste Rechte zur Nutzung von Farbe. Hinzu
kommen die Briefmaler der Einblattholzschnitte, die häufig mit den Malern in Konkurrenz um
die Gebrauchsrechte der Farbe standen.[97] In den Niederlanden gab es einige Städte, in denen
Maler mit opaken Farben getrennt von Malern mit transparenten Farben arbeiteten, die für Holz-

90 Primeau (2002), S. 50.

91 Primeau hält als Ergebnis seiner Studie fest: „It is evident that fifteenth-century printmakers intended
 certain woodcuts to be colored." Primeau (2002), S. 65.

92 Im Fall von Riemenschneiders Magdalenen-Altar (auch: Münnerstädter Altar) legte z. B. der Auftrag
 bereits fest, dass später eine Farbfassung angebracht werden sollte. Mehrere Beiträge im Sammelband
 von Chapuis (2004) befassen sich mit der „polychromen" Skulptur bei Riemenschneider.

93 Zu dem hier vereinfacht und nur angerissenen Themengebiet der nicht kolorierten Skulptur: Taubert
 (2015). Taubert unterscheidet deutlicher, als es bis jetzt in der Forschung der Fall war, zwischen „nicht
 polychromierten", „halbgefassten" und „partiell bemalten holzfarbenen" Bildwerken (S. 93). Erst
 genaue Analysen der Restauratoren können herausarbeiten, ob Holzbildwerke „auf Farblosigkeit hin"
 konzipiert sind (S. 80).

94 Zur Kolorierung von Holzschnitten: Kat.Ausst. Baltimore (2002). Einen präzisen Umriss gibt: Kör-
 ner (2013). Aus Sicht der Restauratoren: Oltrogge u. a. (2009) und Oltrogge (2009). Einzelstudien
 und Beobachtungen zur Farbigkeit im 15. und frühen 16. Jahrhundert liefern v. a.: Bushart (2011).
 Grandmontagne (2009). Fehrenbach (2003). Fehrenbach (2005). Fehrenbach (2010). Freedberg
 (1994). Schäffner (2009). Augustyn (2003): Augustyn nimmt nicht zwingend an, dass Kolorierung
 einen Lesehilfe für die Holzschnitte darstellt. Schneider hingegen schreibt, der Druck bilde die Basis,
 die mit Hilfe der Farbe weiterentwickelt wird: Schneider (2013), S. 39–40.

95 Mayer schreibt, Schönsperger und Grüniger hätten für ihre Nachschnitte des „Gart" auch Schablo-
 nen für die Kolorierung entwickelt. Mayer (2011), S. 126.

96 Saurma-Jeltsch (2001).

97 Beim Einblattholzschnitt spricht man vom Briefmaler. Oltrogge (2009), S. 299. Zu Briefmalern:
 Timann (1995).

schnitte gebraucht wurden.[98] Diese strengen Regelungen für die Zünfte galten wiederum nicht für freie Reichsstädte wie Nürnberg.[99]

Der Übergang von der kolorierten Papierhandschrift zum farbig gefassten Holzschnitt stellte für die Maler keine tiefgreifende Veränderung dar. Ihre Palette blieb im Grunde während des 15. Jahrhunderts gleich. Das praktische Wissen zur Farbverwendung und zu den Materialien hatte eine lange Tradition und war überregional verbreitet, sodass die Maler des 15. Jahrhunderts in Handschrift und Druck in ganz Europa sehr ähnlich arbeiteten.[100]

Während die Kolorierung – durch das Setzen von Schlaglichtern, feinen Farbübergängen etc. – beim Betrachter noch zusätzlich Körperlichkeit und Lebendigkeit erzeugen kann (Abb. 192), verdeckte sie auf der anderen Seite die immer intensiver werdende Plastizität der Holzschnitte (Abb. 193). Auch der Farbauftrag, der zumal etwas einfach wirken kann, ist mit großen Herausforderungen verbunden. Oltrogge bestätigt für die Kolorierungen einen hohen technischen Standard, was den Auftrag, die Haltbarkeit und den Nuancenreichtum betrifft. Die Künstler wussten, wie sie Farbe anrühren und mischen mussten, um ein strahlendes, langanhaltendes Ergebnis und subtile Farbnuancen zu erzeugen.

Die wasserlöslichen Farbmittel zur Kolorierung von Holzschnitten wurden in Rezeptbüchern „durchliuchtige" oder „durchschînige varwen" genannt.[101] Die „durchscheinige Farbe" gewinnen die Maler „aus Beeren des Kreuzdorns (*Rhamnus cathartica*), die, im Mörser zerstampft, einen grünen Farbton liefern", sowie aus „Blättern der Schwertlilie, der Raute, des Nachtschattens sowie de[n] Beeren der Rainweide und [den] schwarzen Johannisbeeren [...]. Blaue Saftfarben stellten sich die spätmittelalterlichen Maler aus Heidelbeeren, Indigo und Kornblumen her."[102] Erhaltene Rezeptbücher geben Aufschluss über die langwierige Farbherstellung und die ideale Weise des Farbauftrags auf Papier.[103] An diesen neuen Untergrund, der erst seit ca. 1400 Verwendung fand, musste die Farbe angepasst werden. Die Analysen von Primeau bestätigen, dass die Rezepte, die in den „Malerbüchlin" beschrieben wurden, auch in der Praxis zur Anwendung kamen. Grün wird entweder über Kupferpigmente[104] erzeugt oder über Pflanzenfarbe.[105] Primeau

98 Hier zur komplexen Rechtslage: Stock (1998). Dackerman (2002).

99 Trotzdem durften auch in Nürnberg beispielsweise Briefmaler für ihre Holztafeln keine beweglichen Lettern für ihre Texte verwenden. Timann (1995), S. 3.

100 Oltrogge u. a. (2009), S. 277.

101 Ploss (1977), S. 84.

102 Ploss (1977), S. 84. Schon ein flüchtiger Blick in seine Monographie lässt erkennen, wie wichtig die Pflanzen für die Herstellung von Färber- und Malstoffen waren. Ploss nutzt häufig Abbildungen aus dem „Hortus sanitatis", um die Pflanzen zu zeigen, aus denen die Farbmittel gewonnen werden. Inhalt und Farbstoff sind im Kräuterbuch aufs engste verbunden. Mehr zu den Farbmitteln findet man bei: Oltrogge u. a. (2009).

103 Clarke (2001). Dunlop (1990). Thorndike (1959). Thorndike (1960).

104 „On early woodcuts with hand-applied colors, green areas have a coarse surface appearance. This is due to the fact that many copper-based pigments, including natural and synthetic malachite, loose their color if they are too finely ground. On later prints there is a notably wider range of tone, particle appearance, and transparency of the green pigments that colorists used." Primeau (2002), S. 56.

105 Die Farben aus Kreuzdorn verblassen leicht, sodass die meisten von Primeau untersuchten Drucke nicht-organisches Grün aus Kupferverbindungen aufwiesen. Allerdings wurden für Primeaus Studie keine Kräuterinkunabeln analysiert. Primeau (2002), S. 56.

vermutet, dass neben Grün auch ein gelber Farbton aus Kreuzdorn gewonnen wurde.[106] Die breit aufgetragenen Pinselstriche, die über die Umrisslinie hinweggleiten, wirken auf den heutigen Betrachter unachtsam. Dies ist allerdings eine ästhetische Fragestellung, die im 15. Jahrhundert offenbar anders gewichtet wurde.[107] Die hochwertige Farbqualität zeichnete sich durch ihre lange Haltbarkeit aus. Zudem achteten die Maler explizit darauf, welche Farbmittel sie einsetzten, wodurch sie über die Materialität hinaus symbolischen Gehalt generieren konnten.[108]

Kolorierte Kräuterbuchinkunabeln

Die Kolorierung in den Kräuterbuchinkunabeln des 15. Jahrhunderts ist äußerst einheitlich:[109] Als Farben verwendete man immer Grün, Rot, Gelb, meistens noch Braun, seltener Grau, Schwarz und Blau, auf die man am einfachsten verzichten konnte. Dominant sind ein oder zwei Grüntöne. Die Blätter und Pflanzenteile, die oberirdisch wachsen, werden mit diesem Grün lasiert. In machen Fällen sind die Blütenstängel oder Baumstämme gelb, rötlich, bräunlich. Sollten Wurzeln vorhanden sein, werden diese farblos belassen oder ebenso gelb, rötlich, bräunlich lasiert. Dieses Gelb, Rot, Braun taucht, wahrscheinlich aus praktischen, zeitsparenden Gründen, häufig in der Blüte und den Früchten wieder auf. Seltener kommen kräftigere Blau- und Rottöne vor, die den Blüten und Früchten der Pflanze vorbehalten sind.[110]

An dieses Schema der Farbgebung hielt man sich auffallend konstant, sowohl für die Pflanzen, die man aus eigener Anschauung und Erfahrung kannte, als auch für exotische Exemplare (z. B. indische Nuss: Abb. 194). Die einheimischen, geläufigen Blüten und Früchte erhielten im Grunde immer den Farbton, den sie ebenso in der Natur annehmen (z. B. Oregano: Abb. 194). Eventuell gab es auch ein koloriertes Exemplar in der Werkstatt, an dem sich die Maler orientierten konnten.[111]

106 Gelb konnte nur schwer von der Papieroberfläche für eine Analyse gelöst werden, sodass man hier auf Quellen angewiesen ist, wie der gelbe Farbton zustande kam. „Historical sources, however, report that several plant extracts were available for making yellow dyes and lake pigments. As mentioned previously, buckthorn berries, depending upon their ripeness at the time they were harvested, were the source for both green and yellow pigments. [...] The various yellow dyes have a very similar appearance and were probably used indiscriminately by print colorists." Primeau (2002), S. 59 f.

107 Oltrogge u. a. (2009), S. 277.

108 Als Beispiel behandelt Primeau einen Holzschnitt, der eine Kreuzigung zeigt. Statt alle Elemente mit demselben Rotton zu kolorieren, wechselte der Maler für das Blut Christi zu einem Rot mit höherem Materialwert. Primeau (2002), S. 64 f.

109 Als medizinischer Text war das Kräuterbuch prinzipiell mit weniger Schmuck und Pracht auszustatten als gedruckte Bücher mit sakralem Inhalt. Die Kolorierung und Ausstattung war der Textgattung angemessen, als zusätzliches Beiwerk dennoch sicher mit Extrakosten für den Käufer verbunden. Augustyn (2003), S. 14. Es ist – in einem groben Überblick – nicht zu sagen, ob Kräuterbücher häufiger koloriert wurden als andere Inkunabeln, also ob die Käufer hier mehr Wert auf kolorierte Exemplare legten. Ab ca. 1500 veränderte sich die Art und Weise der Kolorierung von Holzschnitten, sodass sich die Aussagen hier auf das 15. Jahrhundert beschränken. Interessant wäre auch eine technische Analyse zur Verwendung von Farbe in Pflanzenbücher.

110 In einer „Hortus sanitatis"-Ausgabe, die heute in der Universitätsbibliothek Salzburg aufbewahrt wird (W II 251), kam in manchen Teilen glänzendere Lackfarbe zum Einsatz.

111 Diese Methode ist z. B. für die Werke von Conrad Gessner und Leonhart Fuchs überliefert: Kusukawa (2011), S. 199 f. Kusukawa (2012), S. 77–81.

Die Koloristen haben vermutlich zudem einen Blick auf den Pflanzennamen geworfen, der direkt unter dem Bild stand und einen Hinweis auf die Farbe enthalten konnte. Die Pflanzen, deren Namen eine Farbe beinhalten (gelbe Lilie, Schwarzwurzel), wurden normalerweise in der entsprechenden Farbe gezeigt. Ebenso erscheinen in späteren „Gart"-Ausgaben die Kelche, wie es die Beischrift „Gold" und „Silber" besagt, in gold-gelbem bzw. silber-grauem Farbton (Abb. 195).[112] Gold und Silber galten als heilende Metalle und konnten beispielsweise durch wertvolle Prunkstücke im Bild repräsentiert werden.

Da die Maler aus Pflanzen und Metallen, die in den Kräuterbüchern beschrieben werden, ihren Farbstoff gewannen, kann ihr Wissen um die Pflanze sicher als umfangreich angesehen werden. Es ist beispielsweise auffällig, dass das zum Färben und Destillieren geeignete Sandelholz stets mit Rot koloriert wurde, was entweder darauf hindeutet, dass die Maler die gesamte Beschreibung zu Sandelholz lasen, die besagt, dass die Pflanze rot ist,[113] oder die Beischrift „Sandelholtz" als Information genügte, da man es als rotes Farbmittel kannte (Abb. 196).[114]

Die Maler arbeiteten mit feinen, auf den ersten Blick nicht sofort wahrzunehmenden Nuancen, wie die subtile Farbgebung der Akelei-Blüte veranschaulicht, auf deren äußere Blütenränder ein hellerer Farbton gelegt wurde als auf den inneren Teil der Blüte. Oder man erzeugte zweifarbige Blüten, indem man einen Teil der Blütenblätter farblos ließ, wie bei der Pfingstrose, wodurch mit einfachen Mitteln eine zarte Wirkung entstand. Je nachdem, wie stark man die Farbe verdünnte, konnten mit einer Farbe verschiedene Töne erzielt werden (Abb. 197).

Drei Grundfarben reichten den Koloristen im Grunde aus, um die ganze Vielfalt der Pflanzen in verschiedene Farbkombinationen zu tauchen und um den Eindruck zu erzeugen, dabei immer die richtige Farbe gewählt zu haben. Das Unbekannte wurde so nahe wie möglich an das Vertraute angeglichen. Die exotische „indische Nuss" (Abb. 194) wurde, wie alle anderen Nüsse im „Gart", auch mit Gelb koloriert. Diese „optische Affinität" beweist das Ungewöhnliche durch das Geläufige und offenbart zugleich für den Betrachter die „Zusammengehörigkeit der Dinge" in der Natur.[115]

4.4. Pflanzen formen

4.4.1. Der Künstler erzeugt Pflanzenvielfalt

Nur wenige Details können in der Natur eine unterschiedliche Pflanze ausmachen, ebenso in der Kunst, die diese feinen Unterschiede zudem noch hervorheben und veranschaulichen kann.[116] Dass manchmal das Hinzufügen oder Weglassen eines zusätzlichen Stängels, Blatts, ei-

112 Natürlich gibt es auch Ausnahmen, z. B. sind in einer Augsburger „Gart"-Ausgabe von 1493 (BSB München 2 Inc.c.a. 2877) beide Pokale gelb koloriert.

113 Sicher hat man nicht jedes Mal im Text nachgelesen, welche Farbe anzubringen ist, zumal auch nicht jeder Text eine Beschreibung der Pflanzenfarbe liefert.

114 Anhand des Bilds selbst kann das Sandelholz jedenfalls nicht identifiziert werden.

115 Saurma-Jeltsch (2006), S. 442–445. Die Ausführungen von Saurma-Jeltsch beziehen sich auf die Form exotischer Wesen, dasselbe Prinzip kann allerdings auch für die Farbe anwendbar gemacht werden.

116 Kusukawa (2011), S. 194.

Abb. 84: Wiesenlabkraut (links) und Waldmeister (rechts) im „Codex Berleburg" (fol. 316r, 317r).

ner Blüte, Wurzel etc. ausreicht, um für Variation zu sorgen, wenn man für ähnlich aussehende
Pflanzen nicht ein und dasselbe Bild verwenden möchte, ist eine Praxis, die schon im „Codex
Berleburg" vorgeführt wird. Darin ist das „Lydgengel" (Wiesenlabkraut) eine solche Variation
zur Darstellung des Waldmeisters, beide gehören zur Gattung der Labkräuter (Abb. 84).

Wie man es eventuell im „Codex Berleburg" bzw. an der Natur beobachtet hatte, gab man
auch im „Gart" Variationen, indem man eine Grundstruktur neu kombinierte (Abb. 85). Ko-
riander, Anis und Kümmel sehen sich als Doldenblüter relativ ähnlich und bekamen auch ähn-
liche Illustrationen, die die mehrfach geteilten Blätter und die Doppeldolden als Blüten an-
deuten.[117] Nach diesem Muster wurden weitere Pflanzen abgebildet, die eine ähnliche Blattform
(Hahnenfuß) oder kleine, runde Früchte ausbilden (Kubeben-Pfeffer).

Im „Gart der Gesundheit" vermied man es außerdem, denselben Holzschnitt für verschie-
dene Pflanzen zu verwenden.[118] Nur drei Abbildungen, die man eventuell auch als künstlerisch
besonders gelungen empfand, sind doppelt wiedergegeben (Abb. 72, 86): Alpenveilchen (Cap.
ccccxviij) und „haselwortz" (Cap. xix); Elefantenzahn (Cap. clxxij) und verbrannte Elefanten-
knochen (Cap. ccclxxj); „Gladiolus" (Cap. cxcv) und „goltwortz" (Cap. xx). Die doppelte Ver-
wendung der Illustrationen fällt kaum auf, da die Kapitel im Werk weit voneinander entfernt
liegen. Außerdem ist die Doppelung nicht abwegig. So zeigen die Texte zum Elefantenzahn

117 Auch hier treten wieder „Familienähnlichkeiten" zu Tage, sodass Landau und Parshalls Aussage, dass
 auf diese Art und Weise durch das Bild erste Ansätze der modernen Klassifikation von Pflanzen sicht-
 bar werden, nachvollziehbar wird. Landau / Parshall (1994), S. 257–258. Zur heutigen botanischen
 Ordnung siehe: Strasburger (2014), S. 906–915.

118 Dies ist beim „Hortus sanitatis" von 1491 nicht mehr der Fall.

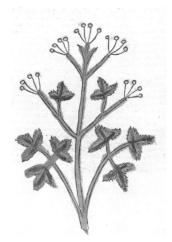

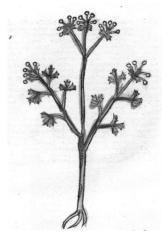

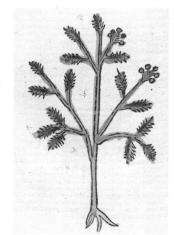

Cap. ciiij: Koriander Cap. xv: Anis Cap. cxv: Kümmel

Abb. 85: Gart der Gesundheit.
Mainz 1485. München, Bayeri-
sche Staatsbibliothek, 2 Inc.c.a.
1601.

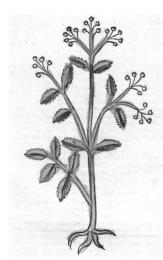

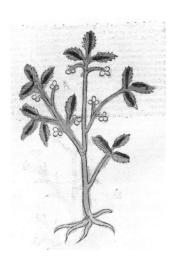

Cap. vij: Hahnenfuß Cap. cxvij: Kubeben-Pfeffer

und zu den Elefantenknochen jeweils das Bild eines Elefanten (Abb. 72). Die „Gladiolus" („geel
swerteln"; Deutsche Schwertlilie) und die „goltwortz" (Sumpf-Schwertlilie) sind zwei verschie-
dene Arten der Schwertlilie. Das Alpenveilchen (Cap. ccccxviij: „erde epfel") und die Gewöhn-
liche Haselwurz (Cap. xix) haben botanisch gesehen zwar nichts gemeinsam, allerdings eine
sehr ähnliche Blattform. Lässt man die charakteristischen Blüten des Alpenveilchens weg, wie
dies in der Illustration im „Gart" der Fall ist, und zeigt nur die gestielten Laubblätter, kann ein
Bild für beide Pflanzen stehen[119].

119 Baumann und Baumann haben die Bilder zu Alpenveilchen und Haselwurz jeweils als „naturnah"
 eingestuft. Auch hier könnte man wieder vermuten, dass diese Information zwischen der Werkstatt
 und einem Pflanzenkenner abgesprochen sein müsste.

Abb. 86: Gart der Gesundheit. Mainz 1485. München, Bayerische Staatsbibliothek, 2 Inc.c.a. 1601:
Cap. cxcv: Deutsche Schwertlilie. Cap. xx: Sumpf-Schwertlilie. Cap. ccccxviij: Alpenveilchen.

Abb. 87: Gart der Gesundheit. Mainz 1485. München, Bayerische Staatsbibliothek, 2 Inc.c.a. 1601:
Cap. xxvij: Gelbe Samen der Rose. Cap. cccxxxvij: Rose.

Für das Illustrationsprogramm des „Gart" ist das Streben zu beobachten, eine möglichst
große Vielfalt an Pflanzendarstellungen wiederzugeben, die den Variantenreichtum der Natur
veranschaulicht. Beispielsweise wurde für die Rose und das weiter Kapitel zu „Rosensamen"
nicht der gleiche Holzschnitt verwendet (Abb. 87), auch wenn es sich – wie bei den oben ge-
nannten doppelten Holzschnitten – angeboten hätte. Manchmal werden zu einem Kapitel
nicht nur eine, sondern zwei oder drei Heilmittel gezeigt (Abb. 88), wie beim Knoblauch (Cap.
iiij), den Muscheln (Cap. lvij), der Königskerze (Cap. cx) etc.
 Die Vielfältigkeit deutet sich dabei nicht in verschiedenen „Szenen" an, in die die Pflanzen
eingebettet werden. Sie werden nicht eingepflanzt gezeigt oder in Bezug zum Menschen. Die

Abb. 88: Gart der Gesundheit. Mainz 1485. München, Bayerische Staatsbibliothek, 2 Inc.c.a. 1601:
Cap. cx: Wollkraut (Königskerzen). Cap. iiij: Knoblauch.

Diversität drückt sich vielmehr über die Form aus. Langsam ertastet das Auge beim Blättern die
Vielfalt und Schönheit der geschaffenen Natur und deren offene Ordnung,[120] die Hinzufügun-
gen von Neuentdeckungen erlaubt,[121] die Formen miteinander kombiniert und ähnliche, aber
nicht immer dieselbe Gestalt ausbildet.

4.4.2. Lebendige Bewegung an der Bildoberfläche

Das Potential der Kunst besteht darin, die Präsenz des abwesenden oder schwer zugänglichen
Naturobjekts steigern zu können, indem Lebendigkeit im Bild erzeugt wird.[122] Laut Fehren-
bach resultiert die spannungsvolle und formal schwer zu bestimmende Lebendigkeit eines Ab-
bilds aus dem Oszillieren zwischen Distanz und Präsenz bzw. Erreichbarkeit eines Objekts.[123]
Um optimale Bedingungen zu suggerieren, kann die Illustration beispielsweise die gepresste
oder unvollständige Pflanze ergänzen, und insbesondere kann sie das vergängliche Studienob-
jekt haltbar machen.[124] Lebendige Pflanzenbilder, so Kusukawa, ermöglichen es, das Subjekt
zu visualisieren und es gleichzeitig in ein nicht-individuelles Exemplar zu überführen. Diese
„epistemologische Bewegung", die intendiert, ein wahres Abbild der Natur zu schaffen („truth
to nature", „Naturwahrheit"), ist nach Daston und Galison das Charakteristikum vormoderner
Naturstudien. Naturwahrheit meint dabei nicht Mimesis, sondern eine vom Künstler gegebene

120 Kusukawa (2011), S. 206.
121 Dabei ist klar, dass Gott das gesamte Pflanzenreich am Beginn der Welt erschuf.
122 Zum Lebendigkeitstopos der Renaissance: Fehrenbach (2003). Fehrenbach (2005). Fehrenbach
 (2010).
123 Fehrenbach (2003), S. 156.
124 Kusukawa (2012), S. 191–203.

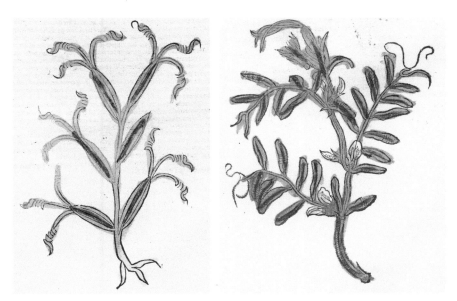

Abb. 89: Gart der Gesundheit. Mainz 1485. München, Bayerische Staatsbibliothek, 2 Inc.c.a. 1601:
Cap. lxviij: Zaunrübe. Cap. cclxxxvij: „Wicken".

Interpretation der beobachteten Natur, mit der er synthetisierend und selektierend umgeht und dadurch eine mimetische Wirkung erzeugt.[125]

Bewegte Schwünge und Formen von Wurzeln, Blättern und Stängeln nennt Kusukawa in Parallele zur antiken Rhetorik *enargeia*: Lebendige Details sollen dem Zuhörer das Gefühl geben, einer Sache selbst beigewohnt zu haben.[126] Unter diesem Aspekt betrachtet, fällt auf, dass die Abbildungen des „Gart" tatsächlich dazu tendieren, einmal die Zweidimensionalität der Buchseite aufzulösen und weiterhin Bewegung in das Pflanzenbild zu setzen. Durch Verkürzungen, Überschneidungen und das Suggerieren natürlicher Lichtquellen wird Körperlichkeit im Bild erzeugt. Eine natürlich scheinende Schattierung erweckt zudem den Eindruck, der Künstler habe die Pflanze selbst vor Augen gehabt und so das Verhalten von Licht und Schatten an ihrer Oberfläche exakt beobachten können. Die Blüten und Blätter drehen sich in verschiedene Richtungen, sodass Mehransichtigkeit und eine Drehung im Pflanzenkörper entsteht, die für lebendige Bewegung sorgt (Abb. 89).[127]

125 Kusukawa (2012), S. 191. Gelesen mit: Daston / Galison (2007), S. 17–27. Im 17. Jahrhundert schließlich beschreibt der Naturforscher Robert Hooke seine Suche nach der „wahren Form": Um die Form eines Objekts begreifen zu können, betrachtete er es mehrmals in verschiedenen Positionen und unter diversen Lichteinfällen. Niekrasz / Swan (2006), S. 779. Hierzu auch: Kemp (1990), S. 131 f.

126 Kusukawa (2012), S. 9. Kusukawa greift damit für die Pflanzenbilder auf, was Fehrenbach in seinem Beitrag „Calor nativus – Color vitale" ausgeführt hatte: Fehrenbach (2003), S. 153. Siehe auch Kap. 5.2.2.

127 Schon Behling beschreibt die Lebendigkeit der „Gart"-Illustrationen, die vom „Geist der Gotik" erfasst wurden: „In zahlreichen Beispielen wird die Pflanze von einer stürmischen Bewegung ergriffen. Blätter, Stamm und Blüte kräuseln sich, als ob sie kochten, auch da, wo die Natur der Pflanze eine solche Gestalt nicht unbedingt vorschreibt, wie bei dem Veilchen [...] oder dem Boretsch [...]. Ein Aufrauschen geht durch den pflanzlichen Leib, erfasst die Spornblüten und Blätter von Viola [...] und lässt die Blätter der Boretschpflanze emporzüngeln [...]. Es ist der Geist der Spätgotik, der diese Formen treibt [...]." Behling (1957), S. 95.

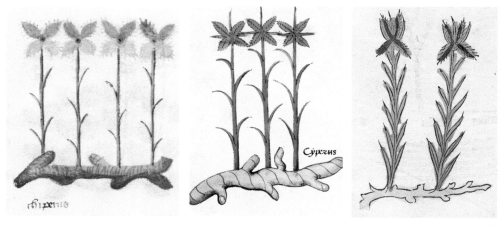

Abb. 90: Zypergras: Von links nach rechts: „Tractatus de herbis"-Tradition (Berlin, SBB, Cod. Ham. 407, fol. 241r). Livre de simples médecines (Paris, BnF, Ms. fr. 12322, fol. 146v). Gart der Gesundheit. Mainz 1485 (München, BSB, 2 Inc.c.a. 1601, Cap. cxij).

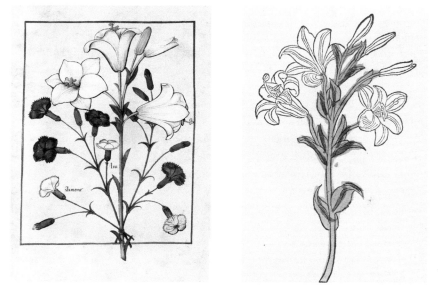

Abb. 91: Lilie: Links: Livre de simples médecines (Paris, BnF, Ms. fr. 12322, fol. 174r).
Rechts: Gart der Gesundheit. Mainz 1485 (München, BSB, 2 Inc.c.a. 1601).

Ein Vergleich mit einer zwischen 1487 und 1495 entstandenen „Livre des simples médecines"-Handschrift soll aufzeigen, dass sich diese Verlebendigung an der Bildoberfläche an verschiedenen Orten – ausgehend von derselben Bildtradition – im Kräuterbuch bemerkbar machte. Heute befindet sich die Handschrift in St. Petersburg,[128] eine Kopie von ca. 1520–1530 wird in der Bibliothèque nationale in Paris aufbewahrt.[129] Sowohl dem „Gart" als auch dem

128 Livre des simples médecines, Russische Nationalbibliothek, St. Petersburg, Ms Fr. F. v. VI 1. Die Illustrationen werden Robinet Testard zugeschrieben. Avril (1986), S. 269–272.

129 Livre des simples médecines, BnF, Paris, Ms. fr. 12322, fol. 137r–149v: Illustrationen (als „Herbarium

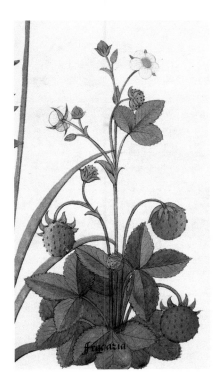
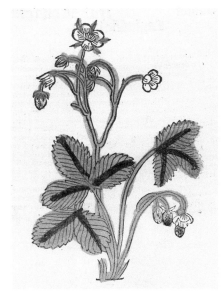

Abb. 92: Erdbeere: Links: Livre de simples médecines
(Paris, BnF, Ms. fr. 12322, fol. 153r).
Rechts: Gart der Gesundheit. Mainz 1485 (München,
BSB, 2 Inc.c.a. 1601, Cap. cxc).

„Livre de simples médecines" liegt als Bezugskonstante die „Tractatus de herbis"-Tradition[130] zu
Grunde.[131]

Für beide Bildprogramme wurde versucht, die Zweidimensionalität der „Tractatus de her-
bis"-Illustrationen durch mehr Körperlichkeit und weniger symmetrische Formen zu ersetzen,
ohne sich dabei ganz von ihr zu entfernen (Abb. 90). Durch Bildtechniken wie Schattierungen,
Überschneidungen und perspektivische Verkürzungen wird beim Betrachter der Eindruck von
Lebendigkeit und Naturnähe erzeugt (Abb. 91–92).[132] Der in der Renaissance weit verbreitete
Topos der Lebendigkeit soll im Folgenden noch eingehender betrachtet werden.

pictum" im Anschluss an den Text). Faksimile der Handschrift mit Kommentar: Malandin (1986).
Statt auf das Original muss im Folgenden auf die Kopie zurückgegriffen werden.

130 Als Vergleichsbeispiel wird hier die „Tractatus de herbis"-Handschrift Cod. Ham. 407 aus Berlin
herangezogen.

131 Ob den Illustratoren der „Livre des simples médecines"-Handschrift der „Gart" bekannt war, lässt
sich nicht mehr feststellen. Entweder zeigt die Ähnlichkeit der Abbildungen, dass das Bildkonzept
des „Gart" internationalen Anklang fand oder, dass man an verschiedenen Orten und in unterschied-
lichen Medien über dieselbe Bildtradition zu ähnlichen visuellen Ergebnissen kam.

132 Bredekamp u. a. (2003), S. 15.

4.4.3. Vitale Pflanzenbilder

Die Bildformel der „Lebendigkeit" gilt als Grundprinzip der Renaissance, die sich selbst mit Metaphern der Vitalität umgab (Erneuerung, Wiedergeburt, Wiedererwachsung).[133] Wie Fehrenbach schreibt, ist sie mehr als ein technischer oder modaler Aspekt, der mit Perspektive, Plastizität, Bewegung und Ähnlichkeit mit dem Subjekt verbunden ist: „Mimesis als bloße detailreiche Kopie des Gegenstands garantiert [...] noch keine Lebendigkeit."[134] Die oben beschriebenen Bildtechniken, die im „Gart" Anwendung fanden, würden demnach zwar Pflanzenvielfalt, lebendige Bewegung und Naturnähe an der Oberfläche erzeugen, die Lebendigkeit der Pflanzenbilder seien damit aber noch nicht hinreichend erschlossen. Über die Fertigkeiten der Künstler hinausgehend soll daher die Vorstellung von Lebendigkeit in der Renaissance, die auf die Antike zurückgeht, an die Abbildungen des „Gart" herangetragen werden.

Nach antiker Theorie sei ohne das Zusammenführen von Wärme und Kälte kein Leben möglich. Neben dem Wachsen und Vergehen sowie der Fortpflanzung liege die Lebendigkeit in der Hitze, der inneren Wärme und auch in der Körperfarbe.[135] In jedem Körper fügten sich, angefangen bei den vier Grundelementen, einzelne Bestandteile zusammen. Die Natur forme aus ihnen lebendige Gestalten. Der Prozess der Verlebendigung durch die Natur wird in einer Illustration des Rosenromans zur Anschauung gebracht (Abb. 198).[136] Die menschlichen Einzelteile hat die als Schmiedin verkörperte Natur schon bereitgelegt, über die Hitze fügt sie sie zusammen. Die Verlebendigung kommt in der Darstellung über die Farbe zum Ausdruck: Sind die verschiedenen Teile des Menschen noch fahl und grau, ist die fast fertige Gestalt so gefärbt, dass sie lebendiger wirkt.

Im Pflanzenbuch wird die Farbe als Träger von Lebendigkeit virulent: Auf der Palette des Koloristen verbinden sich nämlich nicht nur Farben, sondern in ihnen auch die vier Grundelemente, aus denen alles Leben besteht (dazu ausführlicher: Kap. 5.).[137] Sie sind nicht einfach nur den vier Elementen zugeordnet, sie sind, so wie die Pflanze, an sich trocken, feucht, warm, kalt, und die Pflanze ist die Substanz der Farbe. Kurz: Die Pflanzenfarbe belebt das Pflanzenbild.[138]

An dieser Stelle wäre zu überlegen, ob solche substantiellen Fragen auch zur Aussage Bernhards von Breydenbach führten, die Pflanzen seien in ihrer rechten Gestalt und Farbe wiedergegeben. Die Farbe gehört zum lebendigen Subjekt, das für den „Gart" erkundet und konterfeit wurde.

133 Zu „Lebendigkeit" im Metzler-Lexikon Kunstwissenschaft: Fehrenbach (2011), S. 273–277.

134 Fehrenbach (2003), S. 155.

135 Diese antike Vorstellung, die auf Platon und Aristoteles zurückgeht, ist noch im Spätmittelalter präsent. Fehrenbach (2003), S. 158. Leonhard (2013), S. 344.

136 Kruse (2006), S. 116–118. Modersohn führt diese Darstellungen, die im Rosenroman ab dem 14. Jahrhundert illustriert werden, auf eine verstärkte Aristotelesrezeption zurück. Modersohn (1997), S. 155–158.

137 Zur „Kohäsion" der Farbe: Fehrenbach (2005), S. 4–17.

138 Leonhard (2013), S. 235 f.: „Dass Farben über substanzielle Eigenschaften verfügen, weil sie aus Pflanzen, Beeren, Wurzeln, aus Erde, Steinen und Mineralien gewonnen wurden, war bis weit in das 17. Jahrhundert hinein die naheliegendste Antwort auf die Frage, warum man ihnen so starke wahrnehmungspsychologische Kraft zuschreiben konnte."

4.4.4. Gestalt formen und fortpflanzen – in Kunst und Natur

Bei der Bildfindung für den „Gart" wurde von den Künstlern kombiniert, sie reproduzierten und variierten Vorlagen oder erzeugten Ähnlichkeiten, um wiedererkennbare Pflanzenbilder zu generieren. Die Künstler arbeiteten praktisch an der Natur, formten und schnitten in Holz, brachten Pflanzen(-Bilder) hervor. Während ihrer kreativen Tätigkeit mag ihnen aufgefallen sein, dass in diesem Prozess eine Analogie zur Vorstellung besteht, wie in der Natur selbst Vervielfältigung und Formfindung stattfindet. Die produktiven Kombinationen der Natur und Kunst wurden nämlich im ausgehenden 15. Jahrhundert ähnlich imaginiert.[139]

Neben einer formativen, „oberen" Kraft,[140] die in naturphilosophischen Texten unterschiedlich benannt wird – ein Beweger, die himmlischen Sphären, göttlicher Einfluss, die Sterne –, existierte auch die „untere", gestaltende Natur oder der gestaltende Künstler, die beide Formen aus Materie bilden.[141] Diese Zweiteilung findet sich u. a. im Kapitel „Was dem Entstehen und dem Wachstum der Pflanze dient" von Petrus de Crescentiis, in dem von der formativen Kraft der Sterne die Rede ist. Er differenziert zwischen einer universalen, oberen und einer erdbezogenen, niederen Kraft, die die Pflanze formt. Der Samen und die Faulstoffe beinhalten gemeinsam die Kraft, die Pflanze entstehen zu lassen, diese erhalten sie von der niederen, natürlichen und oberen, universalen Sphäre:

> Die Kräuter und alles, was mit in der Erde steckenden Wurzeln grünt und wächst, braucht eines
> oder mehr von fünf Dingen, nämlich Samen, Faulstoffe, Wasserfeuchtigkeit, Pflanzung, Pfrop-
> fung [...]. Von diesen fünf Dingen hat das erste in sich die Kraft, die Pflanze zu formen; in ihm
> ist gleichzeitig die Material- und Wirkursache enthalten. Was aber die formative Kraft betrifft, so
> empfängt sie sie von der Kraft der Sterne. [...] Das eine, nämlich der Samen, hat die Fähigkeit zu
> formen aus einer Kraft der niederen Welt; das andere, nämlich der Faulstoff, hat diese Fähigkeit
> aus der universalen oberen Kraft. Diese beiden tragen nur zum Entstehen der Pflanze bei; [...].[142]

In der Vorstellung des Spätmittelalters konnte die ewig formende – und daher unvergängliche – Natur aus dem Samen immer wieder ähnlich aussehende Nachkommen erzeugen. Über die Fortpflanzung[143] bleibe die Natur lebendig.[144] Sie setze nämlich aus verschiedenen Teilen Gestalten zusammen, die Ähnlichkeit mit dem Subjekt vorwiesen, von dem sie abstammen, deshalb würden Kinder ihren Eltern ähnlich sehen. Indem die Natur immer wieder aus dem Samen ähn-

139 Zur Analogie zwischen der kreativen Natur und dem kreativen Künstler: Kruse (2006). Silver / Smith (2002). Smith (2004) in ihrer breit rezipierten Studie: The body of the artisan. Smith (2008). Moritz (2010). Zur Göttin Natur im Mittelalter: Modersohn (1997).

140 Zur *virtus formativa* im Bezug zum menschlichen Körper: Klemm (2013), S. 168–172. Pfisterer (2014), S. 46–62.

141 Kruse (2006), S. 116–118. Im Gegensatz zur Natur oder zum Künstler schuf Gott aus dem Nichts, ohne Materie.

142 Petrus de Crescentiis (2007), Bd. 1, S. 109 f.

143 Lebendigkeit hatte, nach Aristoteles, verschiedene Voraussetzung und bedinge unterschiedliche Grade der Bewegung, nämlich Wahrnehmung, Atmung, Ernährung und Fortpflanzung, die in Pflanzen, Tieren, Menschen unterschiedlich verteilt und abgestuft seien. Weiter zu den verschiedenen Abstufungen in der *Scala naturae*: Leonhard (2013), S. 33–47.

144 Kruse (2006), S. 116.

liche Pflanzen formt, stirbt zwar die Pflanze im Winter, erwächst aber im Frühjahr neu.[145] Die Natur musste nicht immer Gleichartiges schaffen, sie konnte aus der bestehenden Materie auch Neues kreieren, indem sie neue Formen schnitt und prägte.[146] Um diesen komplexen Arbeitsprozess der Natur zu veranschaulichen, wurde sie mit dem schaffenden Künstler verglichen.[147]

Eine weitere Parallele verbindet so die Arbeit der Natur mit jener der Künstler des „Gart": Die Künstler schufen Pflanzenformen, indem sie kopierten, variierten, aus verschiedenen Werken kombinierten, aus ähnlichen Formen neue Abbilder kreierten. Wird die Arbeit der Natur im Text des Rosenromans mit dem Schneiden und Prägen mit Hilfe von Siegeln beschrieben,[148] lässt sich diese Metapher mühelos auf den Druck übertragen: Waren die Pflanzen des „Gart" erst einmal aus der Materie Holz herausgeschnitten, konnten sie immer neu geprägt bzw. gedruckt werden und sich so „fortpflanzen", dass, wie in der Natur, die Vergänglichkeit überwunden werden kann: Das Pflanzenbild wird lebendig.

Die Formfindungen von Natur und der Kunst wurden nicht nur miteinander verglichen, sondern auch gegeneinander ausgelotet.[149] Die Kunst konnte dabei im Verhältnis zur Natur zwischen zwei Polen oszillieren: als Nachahmerin der Natur (*imitatio*, *mimesis*), die selbst „bildnerisches Vermögen"[150] (*natura naturans*) besitzt,[151] oder als diejenige, die die Natur, die nur einzelne Formen hervorbringt, vervollständigt und ihr in Anmut und Schönheit überlegen ist.[152] Diese „dynamische Konstellation" stellt die Triebfeder für die Kreativität und die Selbstreflexion der Künstler dar.[153] Vor allem bei Pflanzenbildern stellt sich die Frage, ob man den Illustrator als Nachahmer der Natur versteht, der ihre Formen ins Bild setzt und dabei dem Betrachter ihre

145 Zu diesem Bildkonzepten in der Frühen Neuzeit: Pfisterer (2014). Zum „biologischen Renaissancebegriff": Trier (1961). Natur und Kunst waren im 15. Jahrhundert metaphorisch eng miteinander gekoppelt, nicht umsonst sprach Dürer in seiner Proportionslehre von der „Wiedererwachsung" der Kunst: Aus dem Samen der Antike erwächst nach dem mittelalterlichen Winter eine neue Epoche. Die Antike wird so zu den Eltern der Renaissance, deren Formen Ähnlichkeit zur Antike versprechen.

146 Kruse (2006), S. 116.

147 Beispielsweise heißt es in Albertis „De pictura": „Schließlich ist mit beiden Händen zu greifen, dass sogar die Natur selbst ein Vergnügen daran findet, sich als Malerin zu betätigen." Alberti (2002), S. 245.

148 Kruse (2006), S. 116.

149 Zum kreativen Potential der *aemulatio*: Müller / Pfisterer (2011), darin v. a. zum Wettstreit mit der Natur: S. 10 f. Das enorme Themenspektrum von Kunst und Natur im Wettstreit in der Renaissance kann hier nur angedeutet und nicht erschöpfend auseinandergesetzt werden. Weiter dazu z. B. die zwei Bände „Künste und Natur in Diskursen der Frühen Neuzeit" hrsg. v. Laufhütte (2000).

150 Felfe (2014), S. 158.

151 Kruse (2006) gibt an dieser Stelle ein Zitat von Wilhelm von Conches (gest. um 1155), S. 118: „Das Werk der Natur, obschon es in sich endet, bleibt im Samen bestehen. Das Werk des Künstlers, das die Natur imitiert, bleibt weder bestehen noch erzeugt es aus sich etwas. Also bezieht das Werk der Schöpfung aus seinem ewigen Künstler das Sein, das Werk der Natur dagegen besteht durch die Nachkommenschaft fort, das Werk des Menschen bezieht [von seinem Künstler] die Vergänglichkeit."

152 So z. B. Thomas von Aquin in Rückgriff auf Aristoteles. Krause (2010), S. 61–71. Weiter: Kruse (2006), S. 127 f. Modersohn (1997), S. 151–154. Weiterhin zum Naturverständnis, das sich gerade in der Zeit, in der der „Gart" erscheint, in einer Umbruchphase befindet: Blumenberg (1957) zur „Nachahmung der Natur".

153 Felfe (2014), S. 153.

Abb. 93: Knoblauch: Gart der Ge- Abb. 94: Titelblatt: Von menschlicher Proportion. Nürnberg 1528.
sundheit. Mainz 1485. München, München, BSB, Rar. 612.
BSB, 2 Inc.c.a. 1601.

Anmut und Vielfalt vor Augen stellt, oder ob der Künstler an machen Stellen versuchte, die
Schönheit der Natur sogar noch zu überbieten.

Die Reflexion darüber, dass der Künstler an der Natur und analog zu ihr arbeitet sowie
Pflanzen formt und hervorbringt, macht sich im „Gart" eventuell in ganz „unnatürlichen" or-
namentalen Schwüngen bemerkbar. Gerade bei einer der ersten Abbildungen wird die natürli-
che Gestalt des Knoblauchs in der Wurzel zu einem kunstvoll geschwungenen Band umgeformt
(Abb. 93). Diese ornamentale Geste des Künstlers ist vielmehr aus der Kalligraphie oder aus
Dekorationselementen im Buch bekannt (Abb. 94).[154] Die geschaffenen Formen der Natur und
des Künstlers stoßen hier in einem nahezu spielerischen Wettstreit aufeinander.

4.5. Die Pflanzenillustrationen reisen weiter

> Nun fahre hin, du edler und schöner Garten, den Gesunden zu Trost, Hoffnung und Hilfe, den
> Kranken zu Nutz.[155]

Bernhard von Breydenbach meinte in seinem Vorwort sicher nur seinen „Gart", der in die Welt
hinausfahren solle, aber andere Drucker erkannten das Potential des Werks und begannen es
eigenständig zu verlegen. Eigentlich sollte der Kolophon Schöffers Kopien verhindern, aber
bereits ein halbes Jahr nach dem Erscheinen erfolgte in Augsburg der erste Nachschnitt, ver-
mutlich durch Johann Schönsperger.[156] Dabei bedingt die Technik des Nachschneidens, dass die
Illustrationen mitunter spiegelbildlich wiedergegeben werden.

154 In Dürers Traktat zu den menschlichen Proportionen finden sich beispielsweise solche Zierelemente
 zwischen längeren Absätzen im Text.
155 Bernhard von Breydenbach (1485), fol. 3v.
156 [Johann Schönsperger], 22.8.1485. GW M09751. Zu den Nachschnitten: Baumann / Baumann
 (2010), S. 223–240. Mayer (2014). Schnell (2017).

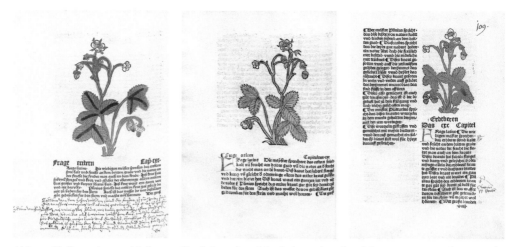

Abb. 95: Erdbeere in verschiedenen „Gart"-Ausgaben: Von links nach rechts: Mainz 28.3.1485. Folio, 360 Bl. (München, BSB, 2 Inc.c.a. 1601). Augsburg 22.8.1485. Folio, 370 Bl. (München, BSB, 2 Inc.c.a. 1602). Augsburg 5.6.1486. Folio, 258 Bl. (München, BSB, 2 Inc.c.a. 1771 b).

Die erste Augsburger Kopie ist noch relativ nahe am Original. Mit der Zeit beließ man es jedoch nicht bei wenigen Veränderungen, sondern ging offen und experimentierfreudig mit dem Illustrationsprogramm um. Diese Umstellungen geben darüber Auskunft, was die Verleger wünschten bzw. von welchen Publikumserwartungen sie ausgingen.[157] Zunächst wurde die Größe der Illustrationen stark reduziert, da man sie einem zweispaltigen Layout anpasste und dadurch ca. 100 Blätter sparen konnte (Abb. 95). Das Buch war nun für den Herausgeber weniger materialintensiv, also günstiger, und für den Nutzer handlicher.[158]

Neue Illustrationen für die „Gart"-Nachschnitte

Mit der Augsburger Ausgabe vom 5.6.1486 kamen neue und andere Illustrationen zum ursprünglichen Bildprogramm hinzu.[159] Die Tiere, Metalle und Edelsteine erhielten mehr Abbildungen (Abb. 96–97).[160] Diese stammten mitunter aus Buchillustrationen, die man aus anderen Zusammenhängen kannte, sodass sich die visuelle „Vernetzung"[161] erweiterte. Außerdem konnten die Verleger Holzschnitte wiederverwenden, die sie für andere Werke eingesetzt hatten. Der silberne Kelch oder weitere Behälter, die repräsentativ für ein Metall stehen, lassen beispiels-

157 Außerdem ermöglichen die in diesem Kapitel gemachten Beobachtungen zum Bildprogramm erstmals eine genauere Einordnung der Abschriften und nicht näher datierbaren Nachschnitte des „Gart".

158 Ebenso verfuhr man beispielsweise bei den Nachschnitten der Schedel'schen Weltchronik. Kat.Ausst. München (2014), S. 134–148.

159 Johann Schönsperger, 5.6.1486. GW M09754.

160 In den Ausgaben in Augsburg und Ulm fügte man mehr Tier- und Metallbilder hinzu, in den Straßburger Ausgaben hauptsächlich Tiere.

161 Saurma-Jeltsch (2006), S. 445–457.

Abb. 96: Neue Bilder im „Gart": Tonerde, Ochse, Silber. Augsburg 5.6.1486.
München, Bayerische Staatsbibliothek, 2 Inc.c.a. 1771 b.

Abb. 98: Heiltumsbuch.
Wien 1502, fol. b recto.
München, Bayerische
Staatsbibliothek, Rar.
1747.

Abb. 97: Essig: Gart der Gesundheit.
Augsburg 1486. München, Bayerische
Staatsbibliothek, 2 Inc.c.a. 1771 b.

weise – auch wenn man es zunächst nicht beabsichtigte – an Heiltumsdarstellungen[162] denken,
die Reliquien eines Kirchenschatzes festhalten (Abb. 98).[163]

Das Fehlen der Abbildungen zu Metallen, Edelsteinen und Flüssigkeiten in der ersten Aus-
gabe des „Gart" wurde offenbar als Mangel empfunden, worauf die hinzugekommenen Illus-
trationen oder auch die Stichzeichnungen eines Nutzers hindeuten, der beispielsweise einen
Essigkrug ergänzte (Abb. 46). Dass im „Gart" von 1485 darüber hinaus keine Menschen, keine
Landschaft, keine narrativen Szenen und nur wenige Tiere abgebildet sind, wurde für die Nach-
schnitte ab 1486 nicht wiederholt. In den Ausgaben aus Augsburg, Straßburg und Ulm zerbeißt
der Biber einen Baum, der Hirsch frisst Gras oder der Hase springt durch den Wald (Abb. 99).

162 Abb. 98: verschiedene Heiltümer: Heiltumsbuch. Wien: Johannes Winterburger 1502. VD16 H 3281.
163 Cárdenas (2013). Cordez (2015). Zotz (2015). Und: weiter Kap. 5.3.

Abb. 99: Biber, Hase, Hirsch: Gart der Gesundheit. Ulm 1487.
München, Bayerische Staatsbibliothek, 2 Inc.c.a. 1913.

Abb. 100: Fuchs: Gart der Gesund- Abb. 101: Fabulae. Augsburg um
heit. Ulm 1487. München, Bayerische 1483, e iij recto. München, Bayerische
Staatsbibliothek, 2 Inc.c.a. 1913. Staatsbibliothek, 2 Inc.s.a. 13.

Diese Umstrukturierungen haben durchaus Konsequenzen für das eigentliche Illustrationsprogramm.

Im Mainzer „Gart" erhielten Hirsch, Biber oder Hase maximal eine kleine Grünfläche, auf der sie verortet sind. Für die Edelsteine waren keine Abbildungen vorgesehen. Menschen, die „rodelstein" (Tonerde) anbieten oder die Kräuter verarbeiten, gibt es in der Erstausgabe nicht, dafür in den Nachschnitten. Während man also zunächst versucht, Platz und Papier zu sparen, fügte man auf der anderen Seite weitere Illustrationen und damit auch Assoziationsfelder ein, die bei der ursprünglichen Variante bewusst ausgeschlossen wurden. Beispielsweise zeigt die Fuchs-Illustration ab 1487 häufig im Hintergrund einen Baum mit einem Vogel darauf, der of-

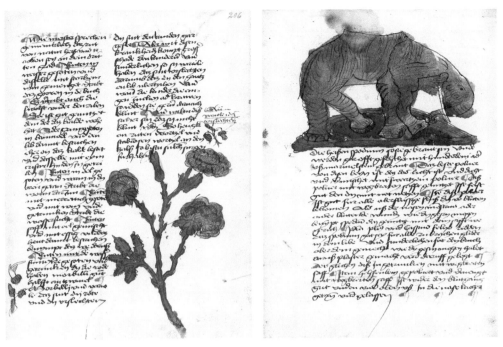

Abb. 102: Rose und Elefant: „Gart"-Abschrift, kurz nach 1485. Straßburg, Bibliothèque nationale et universitaire de Strasbourg, Ms.2.152, fol. 206r und 227v.

fenbar mit dem Fuchs interagiert (Abb. 100). Diese Szene erinnert an eine bekannte und in den Drucken häufig dargestellte Episode aus Aesops Fabeln (Abb. 101), in denen die Eigenschaften des Fuchses nicht medizinisch, sondern moralisierend ausgelegt werden.[164] Hatte man in der Erstausgabe des „Gart" sowohl im Bild als auch im Text solche Deutungen vermieden und sich auf medizinische Kontexte konzentriert, werden sie nun durch die Illustrationen wachgerufen.

Handschriftliche Kopien des „Gart"

Betrachtet man unter den genannten Gesichtspunkten eine Abschrift des „Gart", die heute in Straßburg aufbewahrt wird, wird deutlich, dass man für die Handschrift nur die Druckausgabe von 1485 als Vorlage genutzt haben konnte.[165] In der Abschrift werden ausschließlich

164 Auch in Kräuterbüchern des 16. Jahrhunderts werden solche Illustrationen gezeigt, z. B. bei Hierony-
 mus Bock: siehe Kap. 6.

165 Die Münchener Sammelhandschrift Cgm 728, die auch eine „Gart"-Abschrift mit nur wenigen Il-
 lustrationen enthält, verwendete vermutlich die Mainzer Erstausgabe als Vorlage. Es sieht so aus, als
 wären die Abbildungen durchgepaust worden. Die Augsburger „Gart"-Abschrift (Staats- und Stadt-
 bibliothek, 4° Cod. 132) beruht auf dem ersten Augsburger Nachschnitt von 1485. Siehe auch: Schnell
 (2017), Nr. 70.3. Weitere (auch nicht illustrierte) Abschriften des „Gart" sind im Handschriftencen-
 sus zu finden, die Liste wird laufend erweitert und aktualisiert (http://www.handschriftencensus.de/
 werke/831; letzter Zugriff: 13.09.2019).

Darstellungen gezeigt, die im Mainzer Original zu finden sind, keine Hinzufügungen. Dafür wechselt der Kopist eigenständig zwischen einem ein- und einem zweispaltigen Layout hin und her (Abb. 102).

Insgesamt sind drei illustrierte Abschriften des „Gart" erhaltenen, die alle kurz nach 1485 anhand des ersten Mainzer oder ersten Augsburger Exemplars entstanden sind, was wiederum die große Nachfrage aufzeigt, die für den „Gart" bestand und die zügige und zahlreiche Kopien des Werks zur Folge hatte.

„Hortus sanitatis"

1491 erschien der „Hortus sanitatis" mit 1066 Abbildungen,[166] für den man das zweispaltige Layout der „Gart"-Nachschnitte sowie die meisten „Gart"-Illustrationen übernahm (Abb. 103). Dem wurden noch zahlreiche Darstellungen hinzugefügt, wobei im Gegensatz zum „Gart" häufig ein Holzschnitt für verschiedene Pflanzen Verwendung finden konnte.

Die Änderungen im Bildprogramm, die bereits in den ersten Nachschnitten des „Gart" vorkamen, wurden für den „Hortus sanitatis" aufgenommen und erweitert. So beinhaltet das Werk ein eigenes Kapitel zu Tieren und Edelsteinen mit diversen ganzseitigen Zwischentitelbildern, mehr Tier- und Metallabbildungen als die Mainzer Erstausgabe sowie mehr Szenen, die in einer zumindest angedeuteten Landschaft stattfinden. Den „Gart" und seine Nachschnitte versuchte man offenbar rein quantitativ zu überbieten.

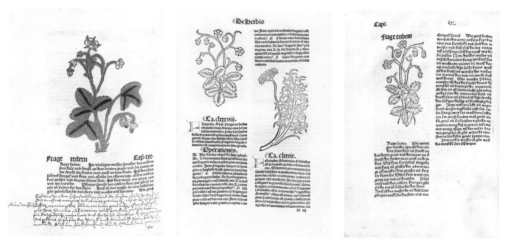

Abb. 103: Erdbeere:
Links: Gart der Gesundheit. Mainz 28.3.1485. Folio, 360 Bl. (München, BSB, 2 Inc.c.a. 1601).
Mitte: Hortus sanitatis. Mainz 23.6.1491. Folio, 906 S. (München, BSB, 2 Inc.c.a. 2576).
Rechts: Gart der Gesundheit. Straßburg um 1488/94 [vermutlich nach Erscheinen des „Hortus sanitatis"].
Folio, 224 Bl. (München, BSB, 2 Inc.s.a. 598).

166 Hortus sanitatis. Mainz: Jacob Meydenbach, 23.6.1491. GW n0166. Zum Text des „Hortus sanitatis"
 siehe auch: Isphording (2008), S. 118–121. Baumann / Baumann (2010), S. 177–222. Mayer (2011),
 S. 127. Kat.Ausst. Schweinfurt (2011), S. 94.

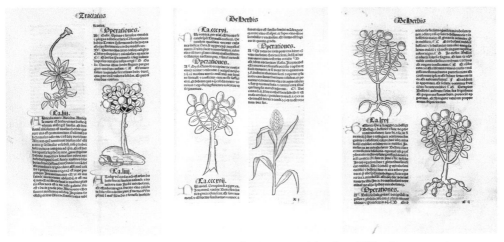

Abb. 104: Verschiedene Bäume im „Hortus sanitatis". Mainz 1491. München, BSB, 2 Inc.c.a. 2576.

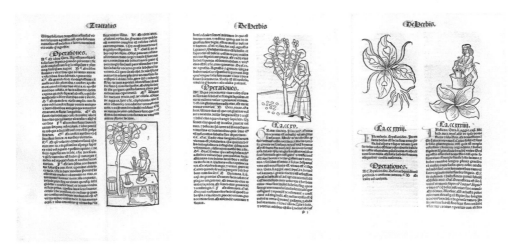

Abb. 105: Mensch und Pflanze im „Hortus sanitatis". Mainz 1491. München, BSB, 2 Inc.c.a. 2576.

Charakteristisch für das Illustrationsprogramm des „Hortus sanitatis" ist unter anderem eine eigene Bildformel für „Baum", die beliebig variiert werden kann, um verschiedene Exemplare zu schaffen (Abb. 104). Außerdem werden mehr Menschen gezeigt, die mit den beschriebenen Heilmitteln umgehen, sodass man wiederum an die in den „Gart"-Illustrationen nicht realisierte „Tacuinum sanitatis"-Ikonographie (Abb. 17–19) erinnert ist, denn die Stoffe werden nun von den Figuren gekocht, geschmeckt, gewogen, gerochen, geerntet etc. (Abb. 105). Generell kann man festhalten, dass im „Hortus sanitatis" die gesamte Bandbreite der Visualisierungsmöglichkeiten ausgeschöpft wurde, die sich im 15. Jahrhundert darboten (siehe Kap. 3.6.1.).[167]

167 Dies ist eine Bewegung im Bildprogramm, die man im „Gart" (1485) explizit nicht vollzogen hat, da man sich hier auf ein sehr einheitliches Illustrationsprogramm festgelegt hatte (Kap. 3.6.1.).

„Gaerde der Suntheit"

Eine andere Richtung als der „Hortus sanitatis" (1491) schlug der niederdeutsche „Gaerde der Suntheit" (1492 in Lübeck) ein, der sich wieder näher am „Gart" von 1485 orientierte.[168] Das Folio-Format des „Gart" wurde im „Gaerde" zu einem Quart-Format verkleinert. Den Text setzte man wieder einspaltig, dafür aber vermehrt um die Pflanzen herum, da auf diese Weise Platz gespart werden konnte. Versuchte man im „Hortus sanitatis" eine quantitative Steigerung zum „Gart", setzte man in der niederdeutschen Version auf eine dekorative Ausstattung und anspruchsvolle Technik (Abb. 106). Beispielsweise wurden aufwendig und detailreich gestaltete Initialen gedruckt, die man nun nicht mehr von Hand einfügen musste. Statt eines einfachen Brunnens, der für das Wasser steht, entschied man sich für einen Brunnen mit gotischem Aufbau (Abb. 107). Die Darstellungen der Pflanzen gewinnen im „Gaerde" insgesamt wieder mehr an Raum: Es werden keine Landschaften gezeigt, kaum Menschen und wenig Tiere.[169]

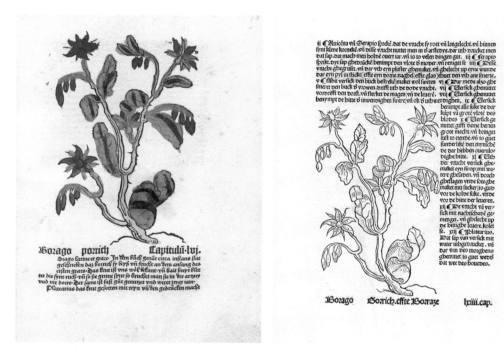

Abb. 106: Borretsch: Gart der Gesundheit. Mainz 1485. Folio, 360 Bl. München, BSB, 2 Inc.c.a. 1601. Gaerde der Suntheit. Lübeck 1492. Quart, 324 Bl. Berlin, SBB, 4° Inc 1483.

168 Gaerde der Suntheit. Lübeck: Stephan Arndes, 1492. GW M09748. Der Text ist eine Übersetzung des „Gart" mit Hinzufügungen aus dem „Promptuarium medicinae" von 1483 und des „Hortus sanitatis": Mayer (2011), S. 27. Hierzu auch: Isphording (2008), S. 120.

169 Auch wenn sich der „Gaerde" wieder der Erstausgabe des „Gart" annäherte, wurden doch kleinere Veränderungen vorgenommen. So illustrierte man z. B. andere Tiere als im „Gart" von 1485.

Abb. 107: Wasser: Hortus sanitatis. Mainz 1491. München, BSB, 2 Inc.c.a. 2576.
Gaerde der Suntheit. Lübeck 1492. Berlin, SBB, 4° Inc 1483.

Offenbar kannte man beide Illustrationsprogramme, das der Mainzer Ausgabe, das man für den „Gaerde" technisch so präzise wie möglich kopierte, sowie das des „Hortus sanitatis", aus dem auch einige ausgewählte Abbildungen einfügt wurden, die man aber mit mehr Details verfeinerte und damit den restlichen Darstellungen optisch anpasste.

Weitere Rezeptionskontexte der „Gart"-Illustrationen

Die Rezeption der „Gart"-Illustrationen ist nicht nur für Kräuterbücher, sondern auch für andere Werke nachweisbar. An den Ausgaben der „Biblia, deutsch", die ebenfalls durch den Augsburger „Gart"-Verleger Schönsperger herausgegeben wurden,[170] wird deutlich, dass sich die Darstellung des Elefanten nach der Veröffentlichung des „Gart" veränderte. Sie bekam stärker die Züge des Elefanten aus dem „Gart" (Abb. 108).[171] Der Grund für diese Veränderung ist sicherlich nicht darin zu sehen, dass man die Naturnähe zum Tier erkannte, sondern dass die Illustration als glaubwürdig wahrgenommen wurde.[172]

170 Folglich muss man in der Werkstatt den „Gart"-Elefanten gekannt haben.

171 In der dargestellten Szene tritt Eleazar gegen den Elefanten im Kampf an.

172 Weiter zur Evidenz der Bilder: Kap. 5.2. Außerdem wäre zu überlegen, ob die „Gart"-Darstellung des Elefanten für eine „Schautafel" im Werk „Van den proprieteyten der dinghen" (Buch 18: „zu den Landtieren") herangezogen wurde, das ein halbes Jahr nach Erscheinen des „Gart" am 24.12.1485 in Haarlem veröffentlicht wurde (Abb. 199–201). Allerdings sind hier die Rezeptionswege völlig unklar.

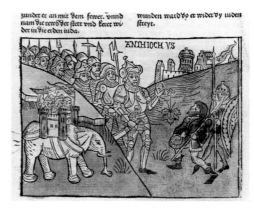

Abb. 108a: Elefant: Biblia, deutsch. Koberger, Nürnberg 1483. München, BSB, Rar. 288.

Abb. 108b: Elefant: Biblia, deutsch. [Grüninger], Straßburg 1485. München, BSB, 2 Inc.c.a. 1555.

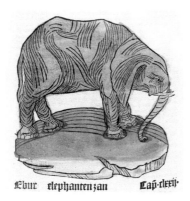

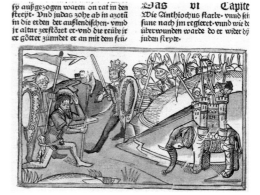

Abb. 108c: Elefant: Gart der Gesundheit. Schöffer, Mainz 1485. München, BSB, 2 Inc.c.a. 1601.

Abb. 108d: Elefant: Biblia, deutsch: Schönsperger, Augsburg 1487. München, BSB, 2 Inc.c.a. 1880.

Ebenso gingen die Abbildungen des „Gart der Gesundheit" nicht spurlos an den illustrierten naturkundlichen Ratgebern vorbei, die in ganz Europa herausgegeben wurden. Der gedruckte „Macer"[173] von 1477 erschien noch ohne Abbildungen, um 1500 brachte man eine bebilderte Auflage (in Genf?) auf den Markt, wahrscheinlich um zusätzliche Käufer zu gewinnen.[174] Die Illustrationen des lateinischen „Macer" sind Kopien aus dem „Gart der Gesundheit", die stark verkleinert und außerdem mit gedruckten Rahmen versehen wurden. Im französischen Kräuterbuch „Le grant herbier en francoys"[175] von circa 1521 finden sich diverse „Gart"-Abbildungen gerahmt und verkleinert wieder, ebenso im ersten englischsprachigen Kräuterbuch von 1526

173 Das Lehrgedicht stammt aus dem 11. Jahrhundert und beschreibt über 60 Heilpflanzen (S. 41).

174 Macer Floridus: De viribus herbarum. [Genf, um 1500]. GW M19663.

175 Le grant herbier en francoys. Paris: Jean Jehannot [1521]. Ein Exemplar bspw. in Saint-Omer, Bibliothèque numérique, Inc. 1627-70. Zum „grant herbier": Givens (2006), S. 136 f. Baumann / Baumann (2010), S. 226 f.

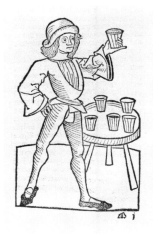

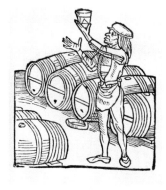

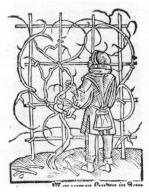

Abb. 110: Buch 4 zum Weinanbau und zur Weinlagerung. Speyer 1493.
München, BSB, 2 Inc.c.a. 2845.

Abb. 109: „Vinum": Hortus sani-
tatis. Mainz 1491. München, BSB,
2 Inc.c.a. 2576.

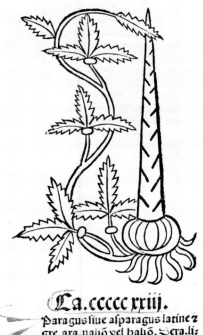

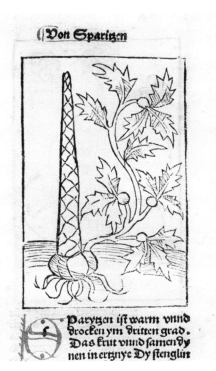

Abb. 111: Spargel: Hortus sanitatis. Mainz 1491. München, Bayerische Staatsbibliothek, 2 Inc.c.a. 2576.
Ruralia commoda. Speyer 1493. München, Bayerische Staatsbibliothek, 2 Inc.c.a. 2845.

Abb. 112a: Zwischentitel im „Destillierbuch" und
Haselwurz-Wasser. München, BSB, 2 Inc.c.a. 3867.

Abb. 112b: Zum Vergleich, Haselwurz im „Gart".
München, BSB, 2 Inc.c.a. 1601.

„The grete herball"[176]. Künstler waren demnach über die Genzen des deutschsprachigen Gebiets
hinaus mit der Bildsprache des „Gart" vertraut.

Nach 1491 wurden die „Gart"- und „Hortus sanitatis"-Abbildungen rasch zu einem Bild-
Vorrat verwoben und für weitere Illustrationsprogamme fruchtbar gemacht. Die deutsche „Ru-
ralia commoda"[177] von 1493 zeigt insbesondere im dritten Teil „zu den Feldfrüchten" und dem

176 The grete herball. S. l.: Peter Treueris, 1526. Exemplar bspw. in: London, British Library, STC /
 52:11. Zum „grete herball": Givens (2006), S. 137–144. Baumann / Baumann (2010), S. 226 f. Knight
 (2009), S. 44–49.

177 Ruralia commoda. Petrus de Crescentiis zu teutsch, mit Figuren. [Speyer] 1.10.1493. (Folio, 236 Bl.).
 GW 7831. Hierzu: Isphording (2008), S. 120 f. Kat.Ausst. Schweinfurt (2011), S. 88 f. Eine Edition
 erfolgte durch Vollmann: Petrus de Crescentiis (2007/2008).

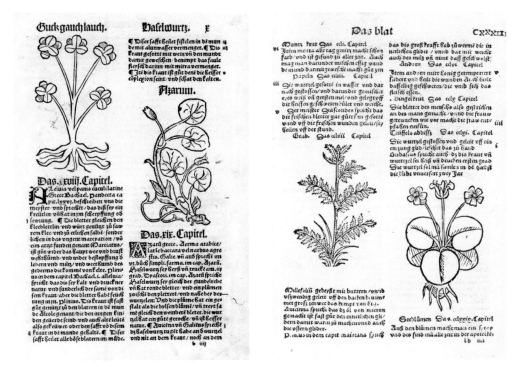

Abb. 113: Kreüterbuch. Straßburg 1527. München, BSB, Res/2 Phyt. 113.

Abb. 114: Ortus sanitatis, deutsch. Straßburg 1529. München, BSB, Res/2 Med.g. 55.

sechsten „vom Garten, der Natur und der Nutzbarkeit der Kräuter" Illustrationen, die unter anderem aus dem „Gart" sowie dem „Hortus sanitatis" stammen.

Die Darstellungen landwirtschaftlicher Arbeit in der „Ruralia commoda" sind weniger von den narrativen Illustrationen des „Hortus sanitatis" kopiert, sondern vielmehr abgeleitet (Abb. 109–110). Offensichtlich waren die Abbildungen aus dem medizinischen Kontext nicht konkret genug für das Werk zur Landwirtschaft. Man fertigte also eigens „landwirtschaftlichere" Illustrationen an, die die Arbeit an der Natur präziser vorführen, als es im „Hortus sanitatis" überhaupt notwendig gewesen wäre. Teilweise ergänzte man die Darstellungen aus der „Gart"- bzw. „Hortus sanitatis"-Tradition so, dass sie den Ansprüchen an das agrarische Bildprogramm genügten. Der Spargel[178] und weitere Pflanzen werden beispielsweise nicht freigestellt gezeigt, sondern es wird im Bild genau markiert, welcher Teil unter und welcher über der Erde wächst (Abb. 111).

Das Destillierbuch von Hieronymus Brunschwig (Abb. 112), das 1533 mit der „Gart"-Bearbeitung von Rößlin zusammengelegt wurde, nahm schon in der ersten Auflage von 1500 zahlreiche Pflanzenillustrationen aus der „Gart"- bzw. „Hortus sanitatis"-Tradition auf und rahmte die Abbildungen ein.[179] Diese gedruckten Rahmungen können in der ersten Auflage sogar Binnen-

178 Die Spargel-Darstellung stammt aus der „Gart"-Tradition.

179 Hieronymus Brunschwig: Liber de arte distillandi. Straßburg: Johann Grüninger, 8.5.1500. GW 5595. Hierzu: Isphording (2008), S. 123 f. bzw. zu den „Gart"-Bearbeitungen: Kap. 3.7.2.

Abb. 115: D-Initiale: Ortus Sanitatis. Straßburg 1529.
München, BSB, Res/2 Med.g. 55.

Abb. 116: K-Initiale mit Putten als Gärtner: Brun-
fels: Contrafayt Kreüterbúch. Straßburg 1532.
München, BSB, Rar. 2264.

ornamente aufweisen. Das Destillierbuch und damit auch die Kräuterillustrationen werden 1505
zusammen mit einer deutschen Übertragung des Marsilio Ficino „Zum langen und gesunden
Leben" herausgegeben.[180]

Für die Darstellungen aus der „Gart"-Tradition ist allgemein festzuhalten, dass die Illustrati-
onen im Laufe der Zeit immer stärker vereinfacht wurden. Auch wenn die Abbildungen zuneh-
mend „holzschnittartig" und flacher wirken, bleibt der Mainzer „Gart" als Ursprung der Bilder
erkennbar.[181] Das Kräuterbuch von 1527 und der im Gegensatz zum ursprünglichen Umfang
stark reduzierte „ortus sanitatis" in deutscher Sprache von 1529 zeigen beispielsweise diese weni-
ger plastischen Illustrationen (Abb. 113–114).[182] Dass die Werke weiterhin den gleichen Anspruch
erheben wie der „Gart" von 1485, nämlich antike Herbarien wiederzubeleben, kann an einem
Detail festgemacht werden: Beide Kräuterbücher zeigen gedruckte Initialen mit spielenden und
musizierenden Putten in antiker Manier (Abb. 115), was vermutlich zum Ausdruck bringen soll,
dass man sich hier auf antike Traditionen beruft – ein optisches Statement, das auch in Otto
Brunfels' Kräuterbüchern wieder zu finden ist (Abb. 116).

Die Kräuterbuchillustrationen ab 1530

Die Tendenz zur Vereinfachung der Holzschnitte, die vom „Gart" von 1485 ausgegangen waren,
änderte sich abrupt mit dem Erscheinen des „Herbarum vivae eicones" (1530) und „Contrafayt
Kreüterbúch" (1532) von Otto Brunfels.[183] Der Autor kündigt in den Vorworten seiner Kräuter-

180 Hieronymus Brunschwig: Liber de arte distillandi Simplicia et Composita. [Straßburg] 1505. VD16 B
 8718. Hierzu: Isphording (2008), S. 125.

181 Langsam muss auch damit gerechnet werden, dass Kopisten den ursprünglichen „Gart" von 1485
 nicht mehr kannten, sondern sich wiederum auf Nachschnitte bezogen. Gerade in Straßburg war
 der Bestand an Pflanzenbildern zu dieser Zeit relativ dicht, einmal durch die „Gart"-Nachschnitte
 und seine weiteren Bearbeitungen sowie durch die später hinzukommenden Kräuterbücher von Otto
 Brunfels und Hieronymus Bock.

182 Kreuterbuch. Straßburg 1527. VD16 W 4360. Ortus Sanitatis. Straßburg 1529. VD16 H 5126.

183 Otto Brunfeld / Hans Weiditz: Herbarum vivae eicones. Straßburg 1530. VD16 B 8499. Otto Brun-
 fels / Hans Weiditz: Contrafayt Kreüterbúch. Straßburg 1532. VD16 B 8503. Zu den Kräuterbüchern

bücher an, etwas völlig Neues kreiert zu haben, wobei er sich von allen Vorläufern lossagt.[184] Obwohl es seine Erklärung kaum vermuten ließe, haben dem Illustrator des Werks, Hans Weiditz, eventuell manche Abbildungen des „Gart" von 1485 als Vorbild gedient (z. B. bei Aronstab, Erdbeere, Gelber Lilie, Gladiole, Haselwurz, Wegwarte; Abb. 117–118, 202–203).

Was das Bildprogramm von Weiditz betrifft, war man wieder an der ursprünglichen „Gart"-Variante angekommen, nachdem in den „Gart"-Nachschnitten zahlreiche Ergänzungen erfolgt waren, die Illustrationen stark verkleinert worden waren und das ursprüngliche Kräuterbuch von 1485 mit weiteren Kapiteln zu Tieren und Mineralien erweitert bzw. mit anderen Werken kombiniert worden war. Im Mainzer „Gart" und in Brunfels' Kräuterbüchern werden Illustrationen mit freigestellten, großformatigen Pflanzenbildern gezeigt, die weder Mensch noch Landschaft wiedergeben. Außerdem engagierte man einen Künstler und Holzschneider,[185] um für technisch aufwendige „Konterfeis"[186] nach der Natur zu sorgen.[187]

An dieser Art der Abbildungen führt von nun an in der Kräuterbuchillustration kein Weg mehr vorbei. Die fein gearbeiteten Holzschnitte stellen die Pflanze möglichst naturnah und plastisch vor Augen. Man legte Wert auf einen natürlich wirkenden Lichteinfall sowie Verkürzungen und Drehungen, die Bewegung und Lebendigkeit andeuten sollen. Die hier vollzogene Schleife des Illustrationprogramms zu einer Bildsprache, die im „Gart" ihren Ausgangspunkt nimmt, wurde bislang übersehen bzw. von Brunfels ganz bewusst unterschlagen, indem er den neuartigen Charakter seines illustrierten Kräuterbuchs hervorhob.[188]

und ihren Illustrationen u. a.: Habermann (2001), S. 274–291. Isphording (2008), S. 131–134. Kat. Ausst. Schweinfurt (2011), S. 97 f.

184 Brunfels (1532), Vorwort, XX. Capitel. Siehe auch: Kap. 6.

185 Weiditz war ein Schüler von Hans Burgkmair. Kat.Ausst. Schweinfurt (2011), S. 98. Die Vorzeichnungen des Künstlers für die Kräuterbücher von Brunfels sind deshalb erhalten geblieben, weil der Schweizer Arzt Felix Platter in den 1550er Jahren die Zeichnungen ausschnitt und in sein Herbarium neben gepresste Pflanzenexemplare einklebte. Conrad (2006), S. 34–37. Egmond (2017), u. a. S. 171–175.

186 Das wahre Abbild der Pflanze soll wiedergegeben werden, das sagt schon der Titel des Werks von Brunfels: „Contrafayt Kreüterbúch". Diesen Anspruch findet man bereits im „Gart".

187 Weiditz achtete streng darauf, immer Wurzeln zu zeigen. Im Gegensatz zum „Gart" hatte er wesentlich weniger Abbildungen anzufertigen, da bei Brunfels nur einheimische Pflanzen und keine Tiere gezeigt werden.

188 Smith schreibt, dass es eigentlich Brunfels' Künstler, Hans Weiditz, zugeschrieben werden müsste, die naturwissenschaftliche Illustration erfunden zu haben. Dass sich Weiditz für die gleiche Visualisierungsstrategie entschied wie Erhard Reuwich in der Erstausgabe des „Gart", bleibt ungesagt. Dafür wird erwähnt, dass Weiditz bereits zur dritten Künstlergeneration gehört, die Naturbeobachtung auf diese Weise umsetzte. Zur ersten Generation rechnet Smith Martin Schongauer, also einen Zeitgenossen Reuwichs, der von der flämischen Malerei beeinflusst sei, und zur zweiten Albrecht Dürer: Smith (2008), S. 15. Smith's Ausführungen würden neben Schongauer auch auf den Utrechter Künstler Erhard Reuwich zutreffen. Heinrichs hat auf die parallele Darstellungsweise von Pflanzen bei Schongauer und Reuwich hingewiesen: Heinrichs (2007), S. 142. Allerdings ist Reuwich heute weniger bekannt als Dürer oder Schongauer, weshalb er häufig übersehen wird; Zeitgenossen müssen mit seinen Darstellungen besser vertraut gewesen sein. Dass beispielsweise Dürer die Illustrationen von Reuwich in der Nürnberger Werkstatt von Wolgemut und Pleydenwurff gesehen hat, kann mit Sicherheit angenommen werden, da beispielsweise einige Abbildungen in der dort produzierten Schedel'schen Weltchronik aus Reuwichs Werken stammen. Smith müsste folglich nicht bis zum „Carrara herbal" (siehe oben: Abb. 24, Kap. 3.6.1.) zurückgehen, um Vorbilder für Hans Weiditz zu finden, Reuwichs „Gart" liegt wesentlich näher: Smith (2008), S. 15–25.

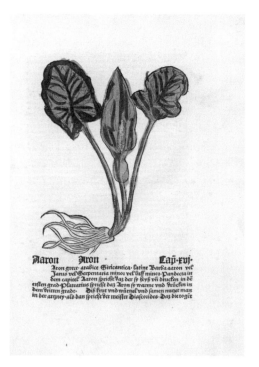

Abb. 117: Aronstab: Brunfels: Herbarvm Vivae Eicones. Straßburg 1530. München, BSB, Res/2 A.gr.b. 576. Gart der Gesundheit. Mainz 1485. München, BSB, 2 Inc.c.a. 1601.

Rößlin übernahm schon im Jahr 1533 für seine „Gart"-Bearbeitung Illustrationen aus Brunfels' Kräuterbuch.[189] Die Darstellungen der Pflanzen, die Brunfels' Werk nicht lieferte, wurden weiterhin aus dem „Gart" übernommen, sodass man nicht sagen kann, dass die Traditionslinie der „Gart"-Abbildungen nach Brunfels abbricht (Abb. 119). Vielmehr war man Mitte des 16. Jahrhunderts offenbar derart mit den Pflanzenbildern vertraut, dass einige Illustrationen aus den „Gart"-Bearbeitungen durch Adam Lonitzer wie Kombinationen aus Bildern der neuen Kräuterbücher von Otto Brunfels oder Leonhart Fuchs[190] mit den „Gart"-Abbildungen anmuten (Abb. 120, 204).

Dabei wurden die Illustrationen des „Gart" aktualisiert, indem sie häufig eine Wurzel oder mehr Blätter oder andere Details bekamen. Ebenso wurden sie technisch mit noch feineren Schraffierungen und Schattierungen sowie mitunter aufwendigeren Drehungen im Pflanzenkörper auf den neuesten Stand gebracht.[191]

Außerdem könnte man nicht nur Weiditz, sondern folgerichtig auch Erhard Reuwich zuschreiben, die naturwissenschaftliche Illustration erfunden zu haben (weiter hierzu: Kap. 5.2.).

189 Eucharius Rößlin d. J.: Kreutterbuch. Frankfurt: Christian Egenolff, 1533. VD16 W 4363. Zu den „Gart"-Bearbeitungen siehe oben: Kap. 3.7.2.

190 Leonhart Fuchs / Heinrich Füllmaurer / Albrecht Meyer / Veit Rudolf Speckle: De historia stirpium commentarii insignes. Basel 1542. VD16 F 3242. Leonhart Fuchs / Heinrich Füllmaurer / Albrecht Meyer / Veit Rudolf Speckle: New Kreüterbuch. Basel 1543. VD16 F 3243. Zu den Illustrationen bei Fuchs ausführlich: Kusukawa (2012).

191 Wie begehrt die Pflanzenabbildungen mittlerweile geworden waren, zeigt eine Herausgabe des Frank-

Abb. 118: Wegwarte: Brunfels: Contrafayt Kreüterbúch. Straßburg 1532. München, BSB, Rar. 2264. Gart der Gesundheit. Mainz 1485. München, BSB, 2 Inc.c.a. 1601.

Christian Egenolff, der Verleger der „Gart"-Bearbeitungen, musste sich wegen der Kopien der Illustrationen aus Brunfels' Kräuterbuch vor Gericht verantworten. Nicht Brunfels, sondern sein Herausgeber, Johannes Schott, hatte Anklage erhoben. Egenolff verwies darauf, dass sein Kräuterbuch schließlich auf das von Johannes von Kaub, also den „Gart", zurückgehe und eine Kopie dreißig Jahre nach dessen Ersterscheinung nicht verboten sei. Außerdem sei die Form der Pflanzen in der Natur so angelegt, sodass eine Ähnlichkeit der Bilder nichts Ungewöhnliches sei und verschiedene Künstler sich nun einmal mit demselben Subjekt beschäftigten.[192] Dieses Argument versuchte schließlich Leonhart Fuchs zu widerlegen, indem et betonte, dass keine Pflanze immer dieselbe Form ausbilde. Als Fuchs ebenfalls gegen Egenolff Beschwerde wegen der Kopien aus seinem Kräuterbuch einreichte, brach ein Streit aus, in den verschiedene Gelehrte der Zeit hineingerieten und im Zuge dessen Fuchs' Werk wiederum als bloßes Konglomerat aus früheren Herbarien bezeichnet wurde.[193] Zu diskutieren wäre, was diese „neuen Kräuterbücher" – im Gegensatz zu den „Gart"-Bearbeitungen von Rößlin und Lonitzer – im Einzelnen ausmacht: die

furter Druckers Egenolff d. Ä., der die „Gart"-Bearbeitungen von Lonitzer verlegte: 1535 brachte er das „Herbarum imagines vivae. Der kreuter Lebliche Contrafaytung" mit 225 Pflanzenbilder heraus, das ganz ohne Text auskam. Kat.Ausst. Schweinfurt (2011), S. 98 f. Siehe auch: Isphording (2008), S. 143 f.

192 Kusukawa (2012), S. 87–89. Wie die Verhandlungen gegen Egenolff verblieben, ist nicht belegt.

193 Kusukawa (2012), S. 125 f.

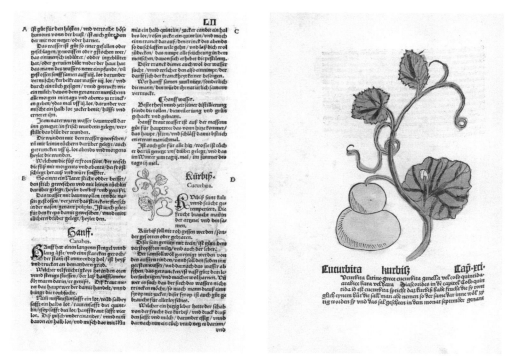

Abb. 119: Kürbis: Rößlin: Kreutterbuch. Frankfurt am Main 1533. München, BSB, Res/2 Phyt. 59 a.
Gart der Gesundheit. Mainz 1485. München, BSB, 2 Inc.c.a. 1601.

Texte jedenfalls, so konnte Habermanns Studie zeigen,[194] blieben relativ konstant, was sich änderte, waren v. a. die Anordnung und die Abbildungen, deren Finessen im Holzschnitt und in der Kolorierung durch die Künstler ab 1530 zunehmend gesteigert wurden, mit dem Ziel ein lebendiges, plastisches und vollständiges Bild der Pflanze zu erzeugen. Eindeutig waren diese neuen Illustrationen die Streitpunkte der Autoren und Verleger. Die Diskussionen um die Reproduktionen der Pflanzendarstellungen regten ein produktives Nachdenken zum Status des Bilds an, wodurch sich eine eigene Kategorie der „wissenschaftlichen Illustration" herauszukristallisieren begann.[195]

Den Abschluss der 300jährigen Tradition der „Gart"- und „Hortus sanitatis"-Illustrationen markiert Adam Lonitzers Bearbeitung, die noch im 18. Jahrhundert aufgelegt wurde und die in manchen Details nicht über ihren Ausgangspunkt im 15. Jahrhundert hinwegtäuschen kann.[196] Das Kräuterbuch von 1783 beginnt bei Adam und Eva: Es stellt den Apfelbaum mit einer Schlage und dem ersten Menschenpaar darunter dar. So hatte man bereits den Baum der Erkenntnis im „Hortus sanitatis" von 1491 charakterisiert (Abb. 121). Der „Fehler", der im „Gart" 1485 passiert war, die „mußore" auf den Kopf zustellen, blieb bis ins 18. Jahrhundert erhalten (Abb. 122), obwohl er zwischenzeitlich in einigen Ausgaben des „Hortus sanitatis" ausgebessert worden war (Abb. 104, links).

194 Habermann (2001), S. 76.

195 Kusukawa (2012), S. 125–131.

196 Balthasar Ehrhart /Adam Lonitzer / Peter Uffenbach: Vollständiges Kräuterbuch oder Das Buch über alle drey Reiche der Natur. Augsburg: Wolff, 1783. VD18 14828324-001.

Abb. 120: Gelbe Lilie: Adam Lonitzer: Kreuterbuch. Frankfurt am Main 1578. (München, BSB, 2 L.impr.c.n.mss. 72). Brunfels: Contrafayt Kreüterbúch. Straßburg 1532. (München, BSB, Rar. 2264). Gart der Gesundheit. Mainz 1485. (München, BSB, 2 Inc.c.a. 1601).

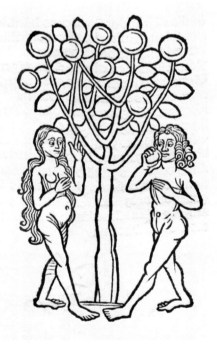

Abb. 121: Paradiesbaum: Adam Lonitzer: Vollständiges Kräuterbuch oder Das Buch über alle drey Reiche der Natur. Augsburg 1783. (München, BSB, 2 Phyt. 350 u). Hortus sanitatis. Mainz 1491. (München, BSB, 2 Inc.c.a. 2576).

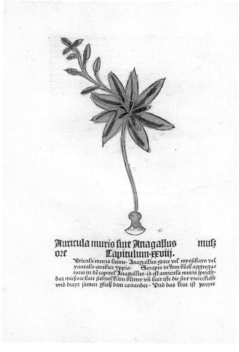

Abb. 122: „Mußore": Gart der Gesundheit. Mainz 1485. (München, BSB, 2 Inc.c.a. 1601). Lonitzer: Vollständiges Kräuterbuch oder Das Buch über alle drey Reiche der Natur. Augsburg 1783. (München, BSB, 2 Phyt. 350 u).

Neben der enormen Bandbreite der Rezeption der „Gart"-Darstellungen über mehrere Jahrhunderte hinweg, die sich neben den Nachschnitten und Bearbeitungen des „Gart der Gesundheit" auch in weiteren Werken nachweisen lassen, sollte anhand dieses Überblicks vor allem deutlich werden, dass die Bildsprache und das Illustrationsprogramm von Erhard Reuwich von den „neuen" Kräuterbüchern im 16. Jahrhundert übernommen wurden.

5. Die Natur und Kraft der Pflanzen erfahren

Der Umgang des Rezipienten mit der Pflanze als heilsstiftendem Objekt sowie mit dem „Gart der Gesundheit" als autoritätsstiftendem und medizinischem Werk soll im Folgenden nachvollzogen werden. Dabei kann man von verschiedenen Lesern (Gelehrten, Ärzten, Apothekern, Kräuterbuchautoren, Laien etc.) und voneinander unabhängigen Rezeptionsebenen ausgehen. Schließlich gab auch Bernhard von Breydenbach kein spezielles Zielpublikum vor, an das er sich richtete: Gelehrten und Laien solle der „Gart" von Nutzen sein.[1]

5.1. Gesundheit durch Beobachtung

Wie der Leser mit dem „Gart der Gesundheit" verfahren soll, macht Bernhard von Breydenbach in den ersten Sätzen seines Kräuterbuchs deutlich: Er betont, dass der Schöpfer der Natur Kraft verliehen habe. Diese Kraft finde sich in den Sternen wieder und in den vier Elementen, aus denen alles Leben bestehe, aus dem heißen, trockenen Feuer, der heißen, feuchten Luft, dem kalten und feuchten Wasser und aus dem Erdreich mit seiner kalten und trocken Beschaffenheit. Dies sei die „wundersame Ordnung" der Natur. Die Elemente und Temperamente solle der Mensch im Gleichgewicht halten, sonst werde er von Krankheit und Tod heimgesucht. Die Pflanze könne für den Menschen medizinisch nützlich sein, ihn vor dem Tod schützen, seine Säfte im Gleichgewicht halten oder im Falle einer Krankheit ausgleichen.

Beim Vergleich mit anderen Kräuterbüchern kommt Habermann zu dem Schluss, dass das Vorwort Bernhards von Breydenbach eine wissenschaftliche Begründung für die Entstehung von Krankheiten gibt und dabei auf Schilderungen schrecklicher Körperzustände oder die Rückführung auf moralische Bedingungen verzichtet. Die Bewegung der Seele (*movere*) stehe weniger im Vordergrund als das Belehren (*docere*). Der „Gart" sei damit auf dem aktuellen Wissensstand der Zeit und richte sich insbesondere gegen nicht universitär ausgebildete, aber dennoch praktizierende „Ärzte".[2]

5.1.1. Aufwertung des Universitätsgelehrten und der Naturbeobachtung

Der Aufstieg der Naturwissenschaft in der Frühen Neuzeit und der frühe Buchdruck werden häufig in Zusammenhang gebracht. Insbesondere das gedruckte Bild, auf das man „hochgradig

1 Bernhard von Breydenbach (1485), fol. 3r.
2 Habermann (2001), S. 185, 201 f.

angewiesen" war, gilt als integraler Bestandteil dieses Zusammenspiels.[3] Gerade für die medizinischen Fächer, Pflanzenkunde und Anatomie, wurden eine Vielzahl an Buchillustrationen produziert.[4] Auch der „Gart" leistet zu dieser „Renaissance der Naturbeobachtung und -wissenschaften"[5] einen entscheidenden Beitrag, der in diesem Kapitel präziser herausgearbeitet werden soll.

Wie andere zeitgleich entstandene Sachbücher grenzte sich der „Gart" von Badern und Nichtgelehrten ab und wertete dadurch gleichzeitig die ärztliche, wissenschaftliche Praxis auf.[6] In einem Vorwort des Werks „Astronomica" von Johannes Regiomontanus findet sich beispielsweise ein Verweis auf Täuscher, die sich mit falschen Federn schmücken: „Man verlacht mit Recht den törichten Haufen der Halbwisser, die sich gewöhnlich den Titel Seher geben."[7] Johannes Regiomontanus ließ in seiner Kritik die Relevanz der sachgemäßen Ausbildung und eines festen Wissenskanons für die Gelehrten erkennen.[8]

Indem der „Gart" einen kräuterkundlichen Wissenskanon auch außerhalb von Klöstern – und Klostergärten – zugänglich machte, erfuhr der universitär gebildete Mediziner eine Aufwertung.[9] Die medizinischen Fakultäten waren an den Universitäten im 15. Jahrhundert stets die kleinsten.[10] Gemessen an den Doktoren der Philosophie, Theologie, Juristerei befand sich die Gelehrtengruppe der Ärzte noch in einer Phase der Etablierung als freie Kunst, die durch gedruckte Sachbücher befördert werden konnte.[11] In der „Margarita philosophica", die 1503 in Straßburg erschien, erweiterte der Verfasser, Georg Reisch, die sieben freien Künste (*septem artes liberales*), indem er vermehrt naturwissenschaftliche Aspekte hinzufügte, darunter auch die Heilkunst (*medicina*), die als eine Unterkategorie der Philosophie dargestellt wurde.[12] Für Hülsen-Esch bedeutet die „Unterordnung" der Medizin unter die Philosophie gleichzeitig ihre Autoritätsbegründung: Sie wurde dadurch als freie Kunst in den Kanon der Wissenschaften ein-

3 Swan (2011), S. 186. Siehe auch: Park / Daston (2006a).

4 Meier (1999). Swan (2011), S. 186. Kusukawa (2012).

5 Swan (2011), S. 186.

6 Hülsen-Esch (2006), S. 296 f.

7 Übersetzt von Wuttke (1996), S. 464.

8 Wuttke (1996), S. 463 f.

9 Giesecke (2006), S. 589: „Natürlich hat diese „wissenschaftliche" Wahrheit nichts mehr mit der göttlichen Wahrheit gemein. Sie wird gerade nicht als das Ergebnis von Kommunikation und Interaktion erlebt, sie verlangt keine Klostermauern, keine Zügelung der ‚curiositas', nicht Kontemplation, sondern aktives Handeln." Im 16. Jahrhundert schritt die Reformierung der medizinischen Fakultäten weiter voran: Kusukawa (2012), S. 101–103.

10 Jankrift erklärt, dass bis ins 15. Jahrhundert das Problem der Etablierung der Medizin an den Universitäten existierte, z. T. wurde „unter dem Deckmantel der Philosophie" Medizin studiert. Entsprechend gab es nur wenig Absolventenzahlen. Jankrift (2003), S. 10., S. 47 f.

11 Mit den zahlreichen gedruckten naturwissenschaftlichen Büchern verbindet man auch die zunehmende Etablierung der entsprechenden Fächer an der Universität. Zum gedruckten Buch als „Objekt des Aufschwungs der modernen Wissenschaft": Eisenstein (1997), S. 170–230. Weiter: Giesecke (2006), v. a. S. 631. Wuttke (1996), S. 278 f. Von der Botanik als universitärem Fach ist man allerdings noch weit entfernt. Pflanzenkunde war Sache der medizinischen Ausbildung, der Pharmazie oder der Sammler. Erst im Laufe des 18. Jahrhundert bildete sich die Botanik als eigenes Fach heraus, das auf der Suche nach „Vätern" auf Brunfels, Fuchs und Bock stieß. Zuerst bei: Meyer (1857), S. 295. Hierzu: Nickelsen (2000), S. 14 f. Reeds (1991).

12 Noe (2008), S. 65.

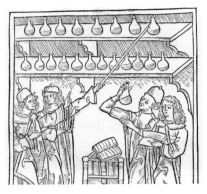

Abb. 123: Harnschau: Hortus sanitatis. Mainz 1491, Beginn des „tractatus de urinis". München, BSB, 2 Inc.c.a. 2576.

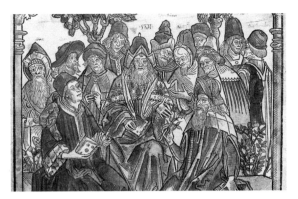

Abb. 124: Titelbild: Gart der Gesundheit. Mainz 1485. München, BSB, 2 Inc.c.a. 1601.

Abb. 125: Johannes Regiomontanus: Chronica. Nürnberg 1493. München, BSB, 2 Inc.c.a. 2922.

Abb. 126: München, BSB, Clm 13, fol. 17v: Porträt des Lehrers von Hartmann Schedel, Matteo Boldiero, 1465. In: Kat.Ausst. München (2014), S. 70.

geführt.[13] Gerade die gedruckte Ratgeberliteratur schuf einen verstärkten Aufschwung der Naturwissenschaften und förderte „Textsorten, die Handlungs- und Erfahrungswissen transportieren".[14]

13 Hülsen-Esch (2006), S. 300. Eine parallele Entwicklung ist in der bildenden Kunst festzustellen, die sich im selben Zeitraum als freie Kunst etablierte, ebenfalls indem man ihre mathematischen und rhetorischen Grundlagen hervorhob. Hierzu: Boehm (2003).

14 Müller (1993), S. 174. Als Beispiel können Naturbeschreibungen und Heilkunde, Bergbau, Messkunst sowie Perspektivenlehre genannt werden.

Die Aufwertung der Universitätsgelehrten erfolgte nicht nur durch den Text, auch zwischen dem Bild und den Autoritäten entstand ein Verhältnis, das auf Wechselwirkung beruhte. So inszenierte das evidente Bild die Gelehrten, die dabei waren, ihr Wissen zu etablieren. Sie werden bei der Betrachtung ihrer Gegenstände vorgeführt, häufig umgeben von Büchern, die wiederum auf den tradierten Kanon verweisen (Abb. 123–126). Hinzu kommt die Illustration von Fachbüchern als zentrale Komponente von Ordnungs- und Differenzierungsversuchen, die auf Beobachtung beruhten und versuchten, Aussagen glaubhaft zu vermitteln und zu vermehren.[15]

Die Beobachtung als Fundament für den Gewinn von Erkenntnis ist kein selbstverständlicher Gedanke. Grob formuliert, galt in der mittelalterlichen Philosophie Beobachtung als nützlich, aber sie war nicht die Basis für die Erzeugung naturwissenschaftlicher Kenntnis.[16] Diese Überzeugung geriet gegen Ende des 15. Jahrhunderts ins Wanken: Giesecke arbeitet in seiner Monographie zum frühen Buchdruck eine Aufwertung der empirischen Beobachtung in den Sachbüchern kurz vor 1500 heraus.[17] Mit Hilfe der Sinne sollte die Natur studiert, ihre Zeichen entschlüsselt und der Körper beobachtet werden, was zu dieser Zeit ganz im Einklang mit Aristoteles stand, dem „leidenschaftliche[n] Beobachter der Natur".[18] Für den „Gart" wurde bereits festgehalten, dass der Arzt, Johann Wonnecke von Kaub, seine medizinischen Kenntnisse in die Kompilation einbrachte, von der Einnahme gewisser Kräuter abriet und von eigenen Erfahrungen berichtete.[19] Die eigene Beobachtung wurde auch dem Leser des „Gart" angeraten.

<center>5.1.2. Harnschau</center>

Der „Gart" ist kein botanisches Werk zur Identifikation von Pflanzen, sondern ein medizinisches Buch, mit dessen Hilfe der Rezipient zum Verständnis für die heilende Wirkung der Pflanze auf den menschlichen Körper gelangen konnte. In diesem Sinne kann man den „Gart" auch als Anleitung zu „Selbstmedikation"[20] für den Laien verstehen. Wie sich dies im Einzelnen gestalten kann, soll im Folgenden auseinandergesetzt werden. Dazu muss sowohl das zeitgenössische medizinische Verständnis dargestellt werden, das sich auch im „Gart" widerspiegelt, als auch die Verfahren zur Behebung von Krankheiten, die man selbst anwenden konnte. Hierfür war zuerst die detaillierte Beobachtung des eigenen Körpers notwendig und in einem zweiten Schritt die Betrachtung der Pflanze, die man zu medizinischen Zwecken zu sich nahm.

Ursache von Krankheit, Erhalt der Gesundheit

Der Mensch sei, so konnte man unter anderem im „Buch der Natur" nachlesen, gemischt aus den vier Elementen Feuer, Luft, Wasser und Erde. Darin gleiche er den Steinen und Geschmeiden (Metallen), Pflanzen, Tieren und all dem, das aus den Elementen gemacht sei. Deshalb

15 Wimböck (2004), S. 9–14.
16 Daston (2011), S. 126.
17 Giesecke (2006), S. 346–349. Ebenso: Wuttke (1996), S. 209 f. Daston (2011).
18 Leonhard (2013), S. 34.
19 Siehe: Kap. 3.3.3.
20 Habermann (2001), S. 201.

sei der Mensch der ganzen Welt gleich, ein „Mikrokosmos".[21] Im Spätmittelalter wurde diese komplexe Theorie des Ineinandergreifens von Körperdispositionen (Mikrokosmos) und Umwelt (Makrokosmos) vielfach beschrieben und in der Buchmalerei mit Hilfe von Schemata zur Anschauung gebracht.[22] Die Vorstellung vom Aufbau der Welt und des Körpers aus den Elementen darf gewissermaßen als Grundwissen des Lesers des „Gart" vorausgesetzt werden.

Die vier Elemente wurden mit Hilfe der Qualitäten charakterisiert und den vier Körpersäften zugeordnet, die diese Qualität ebenfalls besitzen. Durch diese Grundordnung konnten Krankheiten auf „wissenschaftlicher" Basis geklärt, diagnostiziert und behandelt werden. Waren die inneren Säfte im Ungleichgewicht, wurde man nach dieser Anschauung krank. Daher hatte die Qualität der Pflanze, die im „Gart" immer angegeben wird, einen zentralen Stellenwert. Sie erlaubte es dem Rezipienten durch das Heilkraut regulierend auf die Körpersäfte einzuwirken. So ging man davon aus, dass ein kalt-feuchtes Kraut helfe, um warm-trockene Beschwerden auszugleichen und umgekehrt.[23]

Wusste man um das eigene Temperament, also welcher Saft den Körper dominierte, konnte die Einnahme von Kräutern Krankheiten auch vorbeugen. Aufgrund dieser Theorie sollten beispielsweise cholerische Gemüter, die von Natur aus als schnell erhitzbar galten, auf kalte Nahrung zurückgreifen, um ihre Körpersäfte auszugleichen. Danach konnte jeder Leser speziell für sein Temperament abwägen, welche Pflanze er zu sich nehmen sollte, da für ihn ein empfindlicher Zusammenhang zwischen Gesundheit und Nahrung bestand.[24] Dieses Wissen war nicht nur für Ärzte oder Apotheker von größter Bedeutung, sondern auch für die Zubereitung von Speisen, die auf das jeweilige menschliche Temperament abgestimmt sein sollten, um Krankheiten oder Melancholie zu vermeiden.[25] Eine gesunde Lebensführung sei, nach Aristoteles, bedingt durch den sensiblen Ausgleich von Gegensätzen.[26] Dieses innere Gleichgewicht gestaltete sich für jeden Körper anders, sodass ein Choleriker den „Gart" anders gelesen und genutzt haben wird als ein Sanguiniker.

Ein Harntraktat im Kräuterbuch

Woher sollte man allerdings wissen, welches Temperament man sei oder ob die Krankheit, die die Körpersäfte beeinflusste, durch ein kaltes oder warmes Kraut zu behandeln wäre? Um das eigene Temperament oder den inneren Zustand der Säfte bzw. die Krankheit im Körper zu erkennen, galt besonders die Harnschau als erfolgsversprechend.[27] Diverse Urintraktate kamen um 1500 auf den Markt, die das Wissen um diese Jahrhunderte alte Praxis der Medizin beschrieben: Der Harn des Menschen sei abhängig von den Komplexionen und den Elementen, heißt es im „Fasciculus

21 Konrad von Megenberg (1475), fol. iv.
22 Ohly (1999), S. 15–44.
23 Zur Praxis der Heilkunde im Spätmittelalter: Müller-Jahncke (1985). Oder: Riha (2005).
24 Hierzu der Sammelband „Der Koch ist der bessere Arzt": Hofmeister-Winter u. a. (2014).
25 So wird beispielsweise im „Gart" festgehalten, dass „kein Fleisch so melancholisch macht wie das des Hasen." Johann Wonnecke von Kaub (1485), Cap. ccxlviij.
26 Zur Bedeutsamkeit des Maßhaltens und der Vermeidung von Melancholie: Klibansky / Panofsky / Saxl (1992), S. 39–199.
27 Zur Geschichte und Praxis der Uroskopie: Stolberg (2009).

Abb. 127: Beginn des Urintraktats: Gart der Gesundheit. Mainz
1485. München, Bayerische Staatsbibliothek, 2 Inc.c.a. 1601,
fol. 341r.

medicinae", der 1491 in Venedig gedruckt wurde (Abb. 205).[28] Die Beurteilung von Konsistenz,
Farbe, Geruch und Geschmack des Harns als Diagnoseverfahren wird dort erklärt. Bei Ulrich
Pinders 1506 in Nürnberg erschienenem „Epiphanie medicorum Speculum videndi vrinas homi-
num" werden 20 möglichen Färbungen des Urins illustriert und gedeutet (Abb. 206).[29] Auch der
„Gart der Gesundheit" enthält einen Harntraktat, der in Bezug zu den Pflanzenbeschreibungen
gesetzt werden kann: Da die Harnschau ein bekanntes Mittel zur Untersuchung des Körpers
darstellte, durfte sie in einem Werk, das der menschlichen Gesundheit nützen sollte, nicht feh-
len. Die genaue Beobachtung des Körpers und des Gesundheitszustands ging der Einnahme der
Heilmittel voraus. Zunächst sei das Verfahren der Harnschau beschrieben sowie die Bestimmung
der menschlichen Temperamente und im Anschluss die Krankheitsdiagnose mit Hilfe des Urins.

Der Harntraktat des „Gart" ist nicht mit einem Urinfarbkreis illustriert, sondern beginnt mit
einer dem Text vorgestellten Abbildung (Abb. 127). Sie zeigt einen Arzt mit Harnfläschchen, der
die übliche Geste der Harnschau vollführt. Indem er das durchsichtige Harnglas ins Licht hält,
kann er Farbe und Konsistenz überprüfen, die – genau wie Geruch und Geschmack – Rück-
schlüsse auf das Temperament und die Krankheit des Patienten zulassen. Gebracht wurde der
Harn von einer Frau, die einen dafür vorgesehenen Behälter mit sich führt. Da der Harn beim
Transport verfälschenden Einwirkungen ausgesetzt war, musste er besonders sorgsam behandelt
werden. Der im Harn enthaltene *spiritus* durfte nicht entweichen. Er musste deshalb vor Wind
und anderen Umwelteinflüssen, die die Beurteilung des Harns beeinflussen konnten, geschützt

28 Georgius de Ferrariis: Fasciculus medicinae. Venedig 26.7.1491. GW M14176.
29 Ulrich Pinder: Epiphanie medicorum Speculum videndi vrinas hominum. Nürnberg 1506. VD16 ZV
 12488.

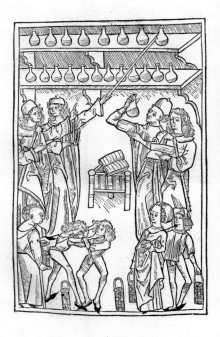

Abb. 128 (links): Unten von links nach rechts: Phlegmatiker, Choleriker, Sanguiniker. Hortus sanitatis. Mainz 1491, Beginn des „tractatus de urinis". München, BSB, 2 Inc.c.a. 2576.

Abb. 129 (oben): Zum Vergleich: Sanguiniker, um 1450. München, BSB, Cgm 28, fol. 31r.

werden.[30] Farbe und Konsistenz geben Auskunft über das Temperament: Dünner und roter Urin wurde dem Choleriker zugeordnet, dicker und roter dem Sanguiniker, dünner und weißer dem Melancholiker, dicker und weißer dem Phlegmatiker (Tab. 1).[31]

Auf einer Darstellung aus dem „Hortus sanitatis" verraten die Patienten ihre Komplexion in ihrem Verhalten und durch ihre Physiognomie (Abb. 128): Links trägt ein Phlegmatiker einen Korb mit Urin, den er den Ärzten zur Harnschau geben will. Besonders seine hohe Stirn macht sein Temperament sichtbar. Neben ihm raufen sich zwei Choleriker, die von Sanguinikern beobachtet werden. Die Aussage dieser Abbildung liegt auf der Hand: Man braucht nicht zwingend die Urinschau, um das Temperament des Menschen zu erkennen, denn die verschiedenen Typen erschließen sich dem geschulten Auge ebenso durch die Physiognomie und ihr Verhalten. Mag man das Temperament bereits am Äußeren des Patienten erkannt haben, bedurfte es der Harnschau, um deren Krankheiten diagnostizieren zu können.

Im Harntraktat des „Gart" heißt es: Wenn man die Natur und Komplexion der Krankheit erkennen will, muss man um die „Natur und Gestalt" des Harns wissen. Jeder Mensch („yglich mensch") könne durch seinen Harn erkennen, welche Krankheit in ihm „sündiget"[32].[33] Man ist

30 Stolberg (2009), S. 60–62.

31 Johann Wonnecke von Kaub (1485), fol. 341v.

32 Für die Beschreibung des Zustands des Körpers oder der Krankheit werden häufig moralisierende Bezeichnungen gebraucht: die Krankheit „sündigt", die Leber ist „böse" etc.

33 Johann Wonnecke von Kaub (1485), fol. 341v. Er nennt als Quelle für den Traktat den „hochgelehrten Meister Constantinus". Constantinus Africanus, der aus Karthago stammte und in Salerno

folglich aufgefordert, sich selbst mit Vorsicht und konstant zu beobachten, gemäß dem Schema, das die Elemente und ihre Eigenschaften, die menschlichen Temperamente mit den dominierenden Säften bzw. wo diese Säfte entstehen, sowie die Farbe und Konsistenz des Urins in Beziehung setzt:

Feuer	Luft	Erde	Wasser
warm-trocken	warm-feucht	kalt-trocken	kalt-feucht
Choleriker	Sanguiniker	Melancholiker	Phlegmatiker
Gelbe Galle	Blut	Schwarze Galle	Schleim
Galle	Herz	Milz	Gehirn
dünner, roter Harn	dicker, roter Harn	dünner, weißer Harn	dicker, weißer Harn

Tab. 1

Weiter wird im „Gart der Gesundheit" erläutert, dass 19 oder 20 verschiedene Harnfarben existierten, und erklärt, auf welche körperlichen Beschwerden sie hinweisen. Für diese durch den „Gart" angeratene Selbstbeobachtung berücksichtigte man die Lebenswelt des Betrachters: So könne der Harn bleich sein wie halb gesottenes Fleisch, Gelb wie ein unreifer („vnzydiger") Apfel oder ein reifer Apfel, Rot wie nicht pures („unpuer") Gold, Safran, pures Blut, roter oder schwarzer Wein. Wenn der Urin weiß sei wie Milch, deute dies auf Gicht hin. Sei der Harn grüner oder schwarzer Gestalt, bedeute dies Kälte und eine tödliche Feuchtigkeit. Dies verweise darauf, dass die natürliche Hitze des Menschen verzehrt sei.[34] Die Beschreibung der Harnfarbe folgt dabei nicht nur dem realen Erscheinungsbild des Harns, sondern kann auch dessen Qualität zum Ausdruck bringen.[35] Die Sinne können für die „geheimen Hinweise" der Natur, die sich in Farbe, Konsistenz, Geschmack und Geruch offenbarten, geschult werden.[36] Das ständige Beobachten,[37]

praktizierte, übertrug im 11. Jahrhundert Schriften zum Harn und weitere medizinische Werke ins Lateinische. Seine Übersetzungen übten besonderen Einfluss auf dieses Diagnoseverfahren in Europa aus: Stolberg (2009), S. 44, S. 83. Dass genau dieser Autor genannt wird, zeigt erneut die präzise Quellenkenntnis Johanns Wonnecke von Kaub.

34 Johann Wonnecke von Kaub (1485), fol. 342r.

35 Es handelt sich bei den verschiedenen Harnfarben aber nicht um „reine Phantasieprodukte", wie Stolberg schreibt: Stolberg (2009), S. 48.

36 Der Aristoteles zugeschriebene Traktat „Secretum secretorum" hat solche Zeichen des fremden und eigenen Körpers für den Kenner deutbar gemacht. Groebner (2004), S. 91–94. Siehe auch: Ryan / Schmitt (1982). Innere und äußere Komplexion stehen im engsten Zusammenhang und sind gemeinsam zu denken. So wird deutlich, wie es zu einer Begriffsverschiebung kommen konnte: „Komplexion" deutete bei Galen auf die „unsichtbaren Säfte". Groebner spricht schließlich von einer „Physiognomisierung" des Begriffs „Komplexion" ab 1500, da nun die äußeren Zeichen des Körpers gemeint sind. Groebner (2004), S. 93 f. Siehe auch: Möseneder (2007). Man könnte auch von der Signaturenlehre als Grundlage für den „Gart der Gesundheit" sprechen, denn die Pflanzen geben in Geruch, Farbe und Konsistenz Hinweise auf ihre Heilwirkung. Die v. a. mit der Signaturenlehre verbundene Vorstellung, dass der Umriss der Pflanze auf die analog geformte Körperstelle verweist und so die Wirksamkeit abzeichnet, hat sich im „Gart der Gesundheit" nicht niedergeschlagen. Dieses Denken in Analogien prägte nach Michel Foucault die Diskurse der Renaissance. Foucault (1971), S. 46–77.

37 Die regelmäßige Selbstbeobachtung wird z. B. auch bei Geiler von Kaysersberg empfohlen. Groebner

das Schärfen der Sinne zur Wahrnehmung kleinster Veränderungen kann mit dem „Gart der Gesundheit" einstudiert und praktiziert werden. In einem nächsten Schritt konnte man mit Hilfe der Sinne die Pflanze beurteilen und Rückschlüsse auf ihre Qualitäten ziehen, um zu heilen oder Säfte auszugleichen.

5.1.3. Pflanzenschau

Zwar konnte der Leser in der Regel alle notwendigen Informationen zur Behandlung von Krankheiten aus dem „Gart" beziehen. Allerdings war nicht jeder Rezipient gleich: Jedes Temperament benötigte im Sinne der Säftelehre eine andere Behandlung. Darüber hinaus mussten, nach dieser Anschauung, Umwelteinflüsse auf die Pflanze berücksichtigt werden, da sie verändernd auf die heilenden Eigenschaften der Kräuter wirken konnten. Damit war auch nicht jede Pflanze ständig gleich.[38] Ebenso waren die Auskünfte zu einer Pflanze im „Gart" nicht immer konzise. Wenn sich die Quellen widersprachen, löste Johann Wonnecke von Kaub dies nicht zwingend auf. Der aufmerksame Betrachter der Pflanze konnte, unterrichtet anhand des „Gart" oder das Werk hinzuziehend, eigenständige Beobachtungen treffen und den „Gart" dadurch intensiver auf die eigenen Bedürfnisse beziehen. Hier soll die These vertreten werden, dass der „Gart" als offen gestaltetes Kompendium zu verstehen ist, das den Rezipienten zum Einbringen eigener Erkenntnisse anregt und zur vorsichtigen Überprüfung und Abstimmung der Heilmittel auf den eigenen Körper auffordert.

Die Qualität der Pflanze, die nach diesem Prinzip die Wirkung der Heilkräuter ausmachte, konnte über die Konsistenz, den Geruch und Geschmack sowie die Farbe ertastet und abgelesen werden. Ist sie von weicher Konsistenz, deutet dies auf mehr Feuchtigkeit in der Pflanze hin. Geruch und Geschmack der Pflanze wurden im „Gart" in die Beschreibung mit einbezogen und mit Adjektiven wie gut, scharf oder bitter charakterisiert: Ingwer hat einen guten Geruch und ist „scharf und auf der Zunge dem Pfeffer gleich", also soll er als Heilmittel bei einem „bösen Magen" eingesetzt werden und besonders bei einem „Magen der erkaltet ist". Überhaupt nütze er allen Menschen, die „innerlich erkaltet sind", womit die Melancholiker und Phlegmatiker angesprochen wären.[39] Der Geruch kann auch als „kalt"[40] beschrieben werden: Die Rose sei kalt und trocken, ihr kalter Geruch helfe den „Cholerikern", die „heiß und trocken

(2004), S. 93: „Es sei auf dem Weg zur Seligkeit unverzichtbar, *sein selbs war* (zu) *nemen*. [...] *Auff die eygen complexion* müsse man seine Aufmerksamkeit richten, so Geiler, und die körperlichen Zeichen der eigenen Natur zu entziffern suchen." Die Versorgung von Kranken, die er in deutlichen Worten von der Obrigkeit einforderte, und die Pflege der Gesundheit war ein zentrales Anliegen des Predigers (mit Dank für diesen Hinweis an Kristina Freienhagen-Baumgardt).

38 Schon bei Dioscurides ist nachzulesen, dass das Wetter und der Wachstumsort Einfluss auf die Eigenschaften der Pflanzen ausübt: Dioscurides (2002), Buch I, Abschnitt 6. Siehe auch: Schmitz (1998), Bd. 1, S. 179 f.

39 Johann Wonnecke von Kaub (1485), Cap. ccccxxxiiij.

40 Die beschreibenden Adjektive sind häufig mit der Qualität verbunden. Daher treten auch ungewöhnliche Kombinationen auf, wie kalter Geruch, grüner Urin, schwarzer Harn, die man stets auf die Qualität beziehen muss: Ein kalter Geruch oder ein grüner bzw. schwarzer Urin deuten auf eine kalte Qualität hin.

von Geblüt sind".[41] Für Albertus Magnus galt vor allem der Geschmack, besonders der Früchte und Samen, als sicheres Indiz für die Qualität der Pflanze, aber auch ihr Geruch, ihre Farbe und Form.[42] Die Farbe kann beispielsweise auf den Verwendungszusammenhang hinweisen: Rote Pflanzenbestandteile helfen häufig in Sachen des Bluts: Sie wirken blutstillend, abschwellend, bei Menstruationsschmerzen etc. Diese Beispiele sollen in einem nächsten Schritt abstrahiert werden, um sie für Pflanzen unabhängig vom Text anwendbar zu machen.

Die Qualität der Farbe

Je nachdem, welche Farbe bei einer Pflanze dominiert, können weitere Rückschlüsse auf ihre Qualitäten und ihren daraus folgenden Anwendungsbereich gezogen werden. Deshalb ist es notwendig, darauf einzugehen, wie Farbe und Qualitäten miteinander in Beziehung stehen. Die zeitgenössische Vorstellung, wie Farbe bzw. Farbveränderung in Pflanzen-Körpern zustande kommt, ist Ende des 15. Jahrhunderts von den zentralen Texten des Aristoteles (u. a. „De anima", De coloribus") und seinen Kommentatoren[43] geprägt.[44] Der bis ins 17. Jahrhundert weit rezipierte Traktat „De coloribus" wurde im 15. Jahrhundert Aristoteles zugeschrieben, stammt aber vermutlich von einem Aristoteles-Schüler.[45] Zur Pflanzenfarbe bzw. Farbveränderung innerhalb ein und desselben Körpers wird in „De coloribus"[46] erklärt:

> Aus vielerlei Gründen ist klar, dass alle Farbänderungen mit dem Reifungsvorgang zusammenhängen. [...] In allen Pflanzen ist die Ausgangsfarbe das Grasgrüne. Denn sowohl Sprossen wie auch Blätter und Früchte sind zu Anfang grasgrün [von Farbe]. [...] Mit zunehmender Schwärze der Feuchtigkeit wird das Grasgrüne stark gesättigt und lauchähnlich. [...] Bei [den Sprossen] aber, bei denen sich das Feuchte nicht mit den Strahlen der Sonne mischt, bleibt die Farbe weiß [...]. Deshalb sind auch bei allen Gewächsen die oberirdischen Teile zunächst gelbgrün, die unterirdischen aber, Stengel und Wurzeln, [sind weiß].[47]

Die Ausgangsfarbe der Pflanze sei demnach Hellgrün, je mehr Feuchtigkeit hinzukommt, desto dunkler färbe sie sich bzw. desto satter werde sie.[48] Feuchtigkeit und dunkle Farbe wurden miteinander verbunden, ebenso Trockenheit und helle Farbe. Je stärker der helle, trockene Pflan-

41 Johann Wonnecke von Kaub (1485), Cap. cccxxxvij.
42 Schmitz (1998), Bd. 1, S. 332. Zur Wahrnehmungspsychologie und Sinnesphysiologie des Albertus Magnus: Theiss (1997).
43 Z. B. griff Robert Grosseteste für sein „De colore" (um 1225) auf Aristoteles zurück. Der bis ins 15. Jahrhundert tradierte Traktat „De proprietatibus rerum" von Bartholomaeus Anglicus nimmt Grossetestes Ausführungen zu Licht und Farbe fast wörtlich wieder auf, sodass man auf eine Kenntnis der aristotelischen Farbtheorie im 15. Jahrhundert schließen kann. Hierzu der kurze Kommentar von Greti Dinkova-Bruun u. a. in: Grosseteste (2013), S. 47 f. Weiterführend: Meier (2005). Heinrichs (2007), S. 36–42.
44 Heinrichs (2007), S. 137.
45 Leonhard (2012), S. 243.
46 Aristoteles (1999).
47 Aristoteles (1999), 794b–795a.
48 Leonhard (2012), S. 243 f.

zenkörper mit Feuchtigkeit zusammenkomme, desto dunkler werde er. Der hellgrüne Farbton werde satter, der Pflanzensaft verdicke sich und lase daher auch weniger Licht durchströmen, weshalb die Pflanze dunkler erscheine.[49] Heinrichs hat dieses Phänomen mit dem treffenden Begriff „lichtdicht" umschrieben.[50]

Die Gegensatzpaare, von denen man annahm, dass sie in einem Pflanzenkörper aufeinandertreffen und seine langsame Farbveränderung bedingen, können auf diese Weise gegenübergestellt werden:

Helligkeit	Dunkelheit
warm, trocken (Feuer)	feucht, kalt (Wasser)
wenig „lichtdicht"	stark „lichtdicht"
Hellgrün	Dunkelgrün

Tab. 2

Heinrichs stellt heraus, dass die Farbe eines Körpers im späten Mittelalter nicht im Sinne Newtons aufgefasst werden darf, vielmehr muss das Farbverständnis in Analogie zur Chemie gedacht werden.[51] Denn nach Demokrit und Platon resultierte eine Mischung aus Rot bzw. Wärme und Dunkelblau bzw. Feuchtigkeit in einem gesättigten Grün, so wie es oben in „De coloribus" beschrieben wurde. Bei Demokrit heißt es weiter: „Dunkelgrün mischt sich aus Scharlachrot und Dunkelblau"[52] und bei Platon: „Braunrot und Schwarz ergibt Lauchfarbe."[53] Das bedeutet, dass sich Farbzusammensetzungen in der Pflanze nicht auf die Pigmente bezogen, wie sie dem Maler zur Verfügung stehen (für ihn ergibt Rot gemischt mit Blau oder Schwarz kein Grün), sondern dass sie auf elementare Phänomene innerhalb der Natur zurückgeführt wurden.[54]

Welche Farbe eine Pflanze in der Natur annimmt, war folglich in der antiken Farbtheorie ein Resultat aus dem Zusammenspiel der Elemente und ihrer Qualitäten. Wärme und Kälte, Feuchtigkeit und Trockenheit seien für die farbliche Erscheinung des Pflanzenkörpers verantwortlich.[55] Nicht nur die Farbe der Kräuter wurde aus diesem elementaren Reigen abgeleitet, sondern auch die Heilkräfte, die in der Pflanze stecken. Für die Farbtheorie am Ende des 15. Jahrhunderts kann festgehalten werden, dass die Farbskala[56] zwischen Weiß, also ext-

49 Leonhard (2012), S. 249.

50 Auch Robert Grosseteste und Bartholomaeus Anglicus beschreiben Anfang des 13. Jahrhunderts das Phänomen der Lichtdurchlässigkeit bzw. Lichtundurchlässigkeit. Grosseteste (2013), S. 16 f. u. S. 47 f.

51 Heinrichs (2007), S. 138. Heinrichs analysiert dazu: Aristoteles (1999), 792a–792b.

52 Bei Platon überliefert, zit. nach: Leonhard (2012), S. 244 (Platon: „De Sensibus", 77).

53 Zit. nach Leonhard (2012), S. 244 (Platon: „Timaios", 67d–68c).

54 Für die Antike arbeitete Rowe heraus, dass Homer in seinen Werken keine Farben nannte, sondern Vergleiche mit bestimmten Qualitäten zog, die sich zwischen Hell und Dunkel (schimmernd, matt) bewegen. So wurde der Himmel z. B. als ehern beschrieben: Rowe (1974). Auf die „Schwierigkeit, über Farbe zu sprechen" macht Meier (2006) aufmerksam.

55 Analysiert bei: Leonhard (2012), S. 243 f.

56 Leonhard betont in ihren Schriften zur Farbe, dass in der Vorstellung der Frühen Neuzeit (und davor) durchaus eine Farbskala existierte. Ebenso: Barasch (1978), S. 171–184. Gage (1999).

remer Helligkeit, und Schwarz, Dunkelheit oszilliert.[57] Licht sei zudem die Voraussetzung für
die Sichtbarkeit von Farbe, die zwischen den beiden Extremen auftaucht.[58] Die Pole Weiß und
Schwarz spiegelten sich nicht nur in den Gegensatzpaaren Hell und Dunkel wider, sondern
auch in Wärme und Kälte:[59]

Feuer		Luft		Erde		Wasser		
Helligkeit						Dunkelheit		
Wärme, Trockenheit						Kälte, Feuchtigkeit		
Weiß	Gelb	Rot	Violett	Grün	Blau	Schwarz	/	Weiß

Tab. 3

In der Praxis, z. B. in Urintraktaten, ist häufig zu beobachten, dass Weiß sowohl mit Helligkeit
und Trockenheit als auch mit Kälte und Feuchtigkeit in Verbindung gebracht werden konnte.[60]
Im „Gart" heißt es: „Alle Dinge werden aus Wärme rot, aus Kälte weiß, aus Trockenheit dünn
und aus Feuchtigkeit dick[61]."[62]

Das Mischverhältnis der Qualitäten müsse innerhalb eines Körpers nicht immer konstant
sein. Reifungsprozesse, Alterung, Vertrocknen, das Hinzufügen von Hitze etc. könne zu Farb-
veränderungen führen, was auch von Aristoteles mit den Qualitäten in Verbindung gebracht
wurde („Körperfarbe": z. B. wird der Körper im Alter trocken, werden die Haare weiß). Im
Gegensatz dazu kann ein und dieselbe Pflanze verschiedene natürliche Farben annehmen, was
nicht mit Hilfe der Qualitäten erklärt wird. Dass die wilde Lilie „weiß", „blau" oder „pur-
pur" sein kann, wird mit der natürlichen Farbe des Regenbogens in Zusammenhang gebracht
(„Lichtfarbe"):[63] So wie der Regenbogen mancherlei Farbe an sich hat, so trägt auch die wilde
Lilie manche Farbe an sich.[64]

Die Verbindung zwischen Qualität und Farbe kann um weitere durch die Sinne wahrnehm-
bare Komponenten ergänzt werden, sodass der zeitgenössische Betrachter zu einem Urteil über
die Eigenschaften der Pflanze gelangen kann.

57 Bei Aristoteles gibt es bis zu sieben Farben: Weiß, Gelb, Rot, Violett, Grün, Blau, Schwarz. Diese
 Farbskala hängt u. a. mit den Farben des Regenbogens zusammen. Leonhard (2013), S. 354 (Aristote-
 les: „De meteorologica" 347 b 31–375 a 1 und „De sensu et sensibilibus" 442 a 20–25).
58 Z. B. so beschrieben bei Marsilio Ficino. Siehe: Barasch (1978), S. 143.
59 Heinrichs (2007), S. 137.
60 Deshalb ist Weiß in der Tabelle 3 zwei Mal genannt.
61 Dünn ist hier als wenig lichtdicht zu verstehen, dick als gesättigt / lichtdicht.
62 Johann Wonnecke von Kaub (1485), fol. 341v.
63 Leonhard analysiert die Unterschiede bei Aristoteles zwischen der Körperfarbe, wie sie in der Natur
 entsteht (chemisch), und der Lichtfarbe (optisch) und der Pigmentmischung der Maler: Leonhard
 (2013), S. 332–370.
64 Johann Wonnecke von Kaub (1485), Cap. ccxxix: „als eyn regen bogen der auch macherley farbe in
 ym hait, also haben auch die wilden lilien mancher hande farben an yn." Zum verwendeten Farb-
 wortschatz in Kräuterbüchern des 16. Jahrhundert weist Seidensticker nach, dass Bock, Brunfels und
 Fuchs auf den „Gart der Gesundheit" zurückgegriffen haben, ohne jedoch näher auf den „Gart" ein-
 zugehen. Seidensticker (2010), S. 45.

Mit allen Sinnen: die Pflanze beurteilen

Alle menschlichen Sinne sind gefragt, um die Qualität der Pflanzen erkennen zu können. Der Sehsinn, der speziell für die Erfassung der Farbe verantwortlich ist, steht dabei in Zusammenhang mit den anderen Sinnen – zumindest schreibt dies Aristoteles – und wird nicht abgekoppelt betrachtet. Geruch und Geschmack beruhen, wie die Farben Schwarz und Weiß, auf Gegensatzpaaren: Bitterkeit und Süße.[65] Die oben ausgeführte Tabelle zur Farbe (Tab. 3) lässt sich so um die weiteren sinnlich erfahrbaren Eigenschaften ergänzen:

Feuer		Luft		Erde		Wasser		
Helligkeit						Dunkelheit		
Wärme, Trockenheit						Kälte, Feuchtigkeit		
wenig „lichtdicht"						stark „lichtdicht"		
dünn						dick		
hart						weich		
süß						bitter		
Weiß	Gelb	Rot	Violett	Grün	Blau	Schwarz	/	Weiß

Tab. 4

Das Zusammenspiel der Sinne gibt nach diesem Schema das Temperament der Pflanze zu erkennen: Kräuter mit hellen, süßen Bestandteilen werden häufig einer trockenen Natur zugeordnet. Dunkle, satte Bestandteile der Pflanze werden mit kalter und feuchter Qualität in Verbindung gebracht.[66]

Da die Qualität der Pflanze nicht als Konstante, sondern als veränderbare Variable betrachtet wurde, war es notwendig, auf die Umwelteinflüsse zu achten, die auf die Pflanze einwirkten. Der Wachstumsort der Pflanze spiele für ihre Komplexion eine entscheidende Rolle. Wachse sie in kalten, trockenen Gebieten, werde sie insgesamt kalte-trockene Qualitäten ausbilden, was sich bis dahin steigern lässt, dass zu beachten war, zu welcher Jahreszeit und zu welcher Stunde die Pflanze geerntet werden sollte oder wie man sie lagerte. Schon Dioscurides erklärte:

> Das Sammeln [von Kräutern] etwa ist bei heiterem Wetter angezeigt, denn es besteht ein großer Unterschied, ob dieses bei Trockenheit oder bei Regen geschieht, auch, ob die Fundorte im Gebirge, hochgelegen, dem Winde ausgesetzt und karg sind, weil hier größere Kraft und Wirksamkeit erwartet werden darf. Pflanzen an ebenen, feuchten, schattigen und windstillen Plätzen sind im Allgemeinen wirkungsschwächer, besonders wenn sie zur Unzeit geerntet werden oder schlaff und welk sind.[67]

65 Nach: Leonhard (2013), S. 373.
66 Zur Verbindung der menschlichen Sinne mit der körperlichen Gesundheit in Zusammenhang mit Medizin und Diätetik: Rippmann (2015), S. 57–75.
67 Dioscurides (2002), Buch I, Abschnitt 6. Siehe auch: Schmitz (1998), Bd. 1, S.179 f.

An einem heiß-trockenen Sommertag geerntet oder trocken gelagert, würden die Säfte der Pflanze entsprechend reagieren. Daraufhin könne die Wirkung der Droge gesteigert oder verändert werden.[68] Wie man es am Beispiel des Urins gesehen hat, können nach dieser Vorstellung schon kleinste Einwirkungen durch die Elemente essentielle Auswirkung auf die Beschaffenheit des Harns bzw. der Pflanze haben.[69]

Auch Petrus de Crescentiis führt in seinem Werk zur Landwirtschaft an, dass die Pflanzen die „Eigenschaften des Standorts, an dem sie wachsen", annehmen.[70] Gift, das auf die Pflanzen abgegeben werde, könne Kräuter schädlich machen.[71] Das Wissen um die Veränderbarkeit der Qualität konnte aber auch genutzt werden, um die Pflanze grundlegend zu wandeln oder zu „heilen", wie Petrus de Crescentiis schreibt: Beschädigte Pflanzen können durch den Eingriff in die Säfte des Pflanzenkörper ebenso ausgeglichen werden, wie es im Menschen möglich sei. Dass er die heilsame Wirkung auf den Pflanzenkörper mit der Heilung des menschlichen Körpers gleichsetzt, offenbart das Verständnis um die elementaren Bestandteile von Lebewesen, die in allen Körpern ähnlich funktionierten:

Mit demselben Kunstgriff werden bisweilen auch Wildpflanzen in Gartenpflanzen umgewandelt. Es wird ihnen nämlich die wilde Feuchtigkeit entzogen, und ihre Körper werden wie durch ein Heilmittel verändert. Ihre körperliche Beschaffenheit wandelt sich in eine andere, so wie der Arzt einen üblen Saft ableitet und anschließend gute Nahrung reicht und mit wechselnden Speisen bestrebt ist, gutes Blut zu erzeugen.[72]

Im „Gart der Gesundheit" geht man folglich nicht nur von einem „Maler von Vernunft",[73] sondern auch von einem Leser von Vernunft aus, der mit Hilfe der Sinne wahrnehmbare Kategorien abwägt und Entscheidungen trifft.[74] Ihm selbst ist es auferlegt, seine Sinne zu schulen und einzuschätzen, welches Kraut eine heilsame, säfteausgleichende Wirkung verspricht.[75] Die sinnliche Wahrnehmung ist dabei als aktive Beurteilung des Gegenstands anhand bestimmter Kategorien gedacht:[76] Um zu einem richtigen Urteil zu gelangen, wird nach Aristoteles unter

68 Das Immergrün solle man beispielsweise besser an der Luft und nicht in der Sonne trocknen lassen: Johann Wonnecke von Kaub (1485), Cap. lxxix.

69 Siehe oben: S. 178 f. Oder bei: Stolberg (2009), S. 60–62.

70 Petrus de Crescentiis (2007), Bd. 1, S. 405.

71 Johann Wonnecke von Kaub betont: „ich rate davon ab [wilden Eppich] zu sich zu nehmen, da Frösche und Kröten darauf laichen." Weil diese als giftige Tiere galten, werde durch sie auch die Pflanze beeinträchtigt. Johann Wonnecke von Kaub (1485), Cap. vij. Zur giftigen Kröte siehe auch: Leonhard (2013), S. 182–187.

72 Petrus de Crescentiis (2007), Bd. 1, S. 106 f.

73 Bernhard von Breydenbach (1485), fol. 3r.

74 Giesecke (2006), S. 589 f.: „Erkenntnis wird [in der frühen Neuzeit] eine zielgerichtete, auf vielfältige Hilfsmittel angewiesene leibliche Handlung, die in ungeteilter Verantwortung der Betrachter/Beschreiber abläuft. Der einzelne Mensch erscheint [...] als Subjekt des Erkennens."

75 Wahrnehmung war nicht immer aktiv gedacht, der Körper konnte auch passiv aufnehmen, sogar Wahrnehmung „erleiden". Klemm (2013), S. 180: Bei Ficino wird die Wahrnehmung als ein Zusammenspiel von Aktivität und Passivität beschrieben.

76 Dass man anhand sinnlicher Wahrnehmung zum richtigen Verständnis gelangt, war durchaus nicht immer selbstverständlich und im Mittelalter sogar höchst umstritten. Besonders Thomas von Aquin

anderem die „Farbe" benötigt, die über den Sehsinn zukommt, sowie die „Gestalt", die über mehrere Sinnen aufgenommen wird.[77] Demnach finden die einzelnen Fähigkeiten der menschlichen Sinne bei der Beurteilung der Pflanze Entfaltung, ein Prozess, der selbst wiederum als heilsam für die Seele galt.[78]

5.2. Naturbeobachtung auf Reisen

In diesem Kapitel sollen die Buchprojekte Bernhards von Breydenbach, der „Gart" (1485) und die Pilgerreise ins Heilige Land (1486), aufeinander bezogen werden. In beiden Drucken wird der Anspruch erhoben, auf Reisen Gesehenes, also für den Rezipienten nicht Präsentes, zu vermitteln. Die Evidenzverfahren, die dazu in Bild und Text angewendet werden, sollen genauer untersucht werden. Ebenso die Rezeption der Darstellungen in weiteren wissenschaftlichen Zusammenhängen, die darüber Aufschluss geben kann, ob man die Illustrationen in den Werken Bernhards von Breydenbach als glaubhaft empfand.

5.2.1. Präsenz vermitteln

Dass Bernhard von Breydenbach schreibt, er habe eine Sache selbst erkundet und im Bild wiedergeben lassen, damit der Rezipient des „Gart" die Pflanze selbst sehen kann, muss als innovativer Gedanke zu dieser Zeit betont und gewertet werden. Liest man das „Gart"-Vorwort genauer,[79] wird deutlich, dass die Augenzeugenschaft Bernhards von Breydenbach und seines Malers, den er auf die Pilgerreise nach Jerusalem mitnahm, etabliert werden soll. Nicht auf dem Hörensagen, also dem Bericht einer weiteren Instanz, sondern auf der direkten Erfahrung würden die Illustrationen beruhen.[80] Gerade der Gesichtssinn, also die Wahrnehmung über die Augen, wurde im zeitgenössischen Diskurs als überlegene Sinnesleistung diskutiert: Über das Auge gelange man am schnellsten zu einem klaren Urteil.[81] In ihrer Kombination und im neuen Medium versuchen Bild und Text den Eindruck der Präsenz zu leisten.[82] Das Bild wird dadurch nicht automatisch zum mimetischen Abbild erklärt, sondern zum Zeugnis von Gesehenem, dem es zufällt, Fakten und Erkenntnisse festzuhalten und zu vermitteln.

sprach sich für einen Zusammenhang von sinnlicher Wahrnehmung und Erkenntnisgewinn aus, was zeigt, dass es gerade nicht selbstverständlich war. Heinrichs (2007), S. 41.

77 Heinrichs (2007), S. 39. Siehe auch: „Aristotle on the Sense-Organs": Johansen (1998), S. 215–225. An dieser Stelle sei darauf verwiesen, dass die Wahrnehmungskategorien „Farbe und Gestalt" im Vorwort von Bernhard von Breydenbach mehrfach aufgerufen werden. Dadurch sollte vermutlich auch betont werden, dass man die Pflanzen sowohl wahrgenommen als auch erkannt hat bzw. dass der „Gart" die Möglichkeit bietet, die Pflanzen auf richtige Weise zu erkennen.

78 Heinrichs (2007), S. 49. Auch die ästhetische Beschaffenheit der Bildkunst des 15. Jahrhunderts fordere, so Heinrichs, die menschliche Seele auf diese Weise heraus. Heinrichs (2007), S. 39–43.

79 Siehe unten S. 241–245.

80 Bernhard von Breydenbach (1485), fol. 2v.

81 Z. B. bei Leonardo da Vinci, siehe: Klemm (2013), S. 150–157.

82 Schmidt (2010b), S. 136 f.

Die dargestellten Beobachtungen[83] können im Falle der Zusammenarbeit von Bernhard von Breydenbach und Erhard Reuwich topographischer oder naturwissenschaftlicher Natur sein. „Gart" und „Peregrinatio", deren Illustrationen gegenseitig den Kontakt mit den Originalen bezeugen, ergänzen und unterstützen sich in ihrem Anspruch, evidente Bilder nach der eigenen Erfahrung zu erzeugen.[84] Reisen und Reiseberichte galten bereits im Mittelalter als zentrales Mittel zur Welterkenntnis, durch die die Distanz zu den gesehenen Ländern überbrückt werden sollte.[85] Bernhard von Breydenbach engagierte für diese Vermittlung von Beobachtung einen Maler und generierte gerade in diesem Zusammenspiel Wissen. Seine Buchprojekte stehen in direktem, beweiskräftigem Bezug zueinander: Einerseits wird weitreichende topographische, geographische und ethnographische Kenntnis auf der Pilgerfahrt angesammelt und in der „Peregrinatio" veröffentlicht (Abb. 130, 138, 143), andererseits entsteht umfassendes Wissen zu selbst gesehenen Heilpflanzen im „Gart".

83 Zum „Beobachten": Daston (2011).
84 Ross (2014), S. 44–47. Bakker (2018).
85 Zu Reisen und Welterfahrung: Huschenbett (1991).

Dabei wird nicht, wie beispielsweise in „De proprietatibus rerum" oder im „Buch der Natur", ein Überblick über die ganze Welt gegeben, sondern ein Teilaspekt der Welt herausgegriffen und vertieft. Dieses Streben danach, „Spezialwissen" zu erzeugen, das sich zu einem umspannenden Wissensschatz zusammenfügt, kann als übergreifende Tendenz für das Ende des 15. Jahrhundert festgestellt werden, wo im Bereich „Sachbücher" zu einer großen Bandbreite an Einzelthemen Veröffentlichungen erfolgten.[86] Gerade die erfolgreichen wissenschaftlichen Werke sind in der Regel illustriert bzw. sind aufgrund der Illustrationen erfolgreich.[87]

Was Latour für den Sachtext am Beginn der Neuzeit im Allgemeinen ausgeführt hat, kann entsprechend für das wissenschaftliche Bild gesagt werden: Wenn der Künstler in der Lage ist, dem Betrachter eine große Anzahl von Dingen an einem Ort zu präsentieren, ist dies für die Konstruktion von Fakten relevant, dadurch wird „ohne zusätzliche Ursache eine neue Welt aus der alten hervortreten."[88]

5.2.2. Evidenzverfahren in Bild und Text

In seinen beiden Werken reiht Bernhard von Breydenbach Wahrheitsbekundungen aneinander.[89] Sein „Gart"-Vorwort unterstreicht die Evidenz des Texts, aber vor allem des Bilds. Einleuchtende (was der Wortbedeutung von *evidentia* nahe liegt) Abbildungen des selbst Erkundeten sollen dem Rezipienten vor Augen gestellt werden. Der Begriff *evidentia* stammt aus dem Bereich der Rhetorik und spricht, wie die *energeia*, die Verlebendigung, und die *enargeia*,[90] die Detaillierung, insbesondere den sinnlichen Wahrnehmungsbereich an.[91] Evident sind Aussagen, die „unmittelbar einsichtig sind und sinnvollerweise nicht bestritten werden können." Außerdem entfalte die Evidenz „eine besonders starke Wirkung auf Verstand, Imagination und Affekte".[92] Nach Müller haben die Begriffe *enargeia* und *evidentia* eine hohe wahrnehmungsansprechende Qualität – in beiden Fällen „dominiert der Gesichtssinn".[93]

Die Beobachtungen, die Bernhard von Breydenbach auf seiner Reise gemacht hat (wie er sich „selbst über die dortigen Kräuter mit Fleiß kundig gemacht" hat), werden dem Rezipienten durch verschiedene Techniken im Text der Vorrede vermittelt. Die Präsenz des Objekts, seine „Augenscheinlichkeit", soll durch die Re-Präsentation des Abwesenden erzeugt werden. Auf diese Weise wird der Leser mit den Reisenden zum Augenzeugen.[94] Lebendig und detailreich wird im Vorwort die Entstehung des „Gart" veranschaulicht: Aus der eigenen Betrachtung der

86 Ventura (2013), S. 99 f.
87 Swan (2008).
88 Latour (2006), S. 275.
89 Zum Reisebericht insb. Timm (2006), S. 325–327. Sowie: Niehr (2001). Niehr (2005). Wood (2008),
 S. 51–53, 164–172. Ross (2014). Bakker (2018). Bernhard von Breydenbach (2010).
90 Siehe auch Kap. 4.4.2.
91 Müller (2007), S. 62. Müller setzt in seinem Beitrag genau den Unterschied zwischen *enargeia* und
 energeia auseinander.
92 Müller (2007), S. 61.
93 Müller (2007), S. 61.
94 Müller (2007), S. 62: „*Evidentia* bedeutet also zugleich Ganzheit und Differenziertheit, Statik und
 Bewegung, Simultanität und Sukzessivität, Unmittelbarkeit und Vermitteltheit."

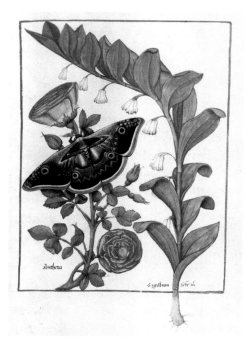
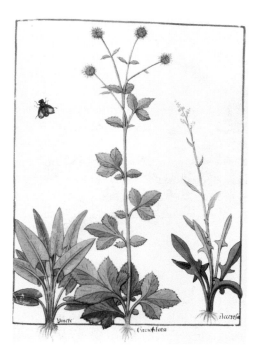

Abb. 131: Paris, Bibliothèque nationale de France, Ms. fr. 12322, fol. 143v, 144v.

Natur offenbarte sich Bernhard von Breydenbach die Ordnung der Schöpfung.[95] In einem zwei-
ten Schritt gibt er diese Offenbarung im Medium des Buchs weiter. Daher, so meint er, existiere
keine nützlichere Arbeit für ihn als die am „Gart der Gesundheit". Dennoch ließ er sein Werk
„in der Feder hängen" und trat eine Pilgerreise an. An verschiedensten Orten habe er viele edle
Pflanzen selbst erkunden können und in rechter Farbe und Gestalt konterfeien lassen.[96] Nicht
nur der Text, sondern insbesondere die Pflanzenbilder sollen das Abwesende repräsentieren und
für den Betrachter unmittelbar lebendig machen. Um ein überzeugendes, evidentes Bild zu kre-
ieren, können vom Künstler verschiedene wahrheitsversichernde Topoi oder Mittel eingesetzt
werden, die die Glaubhaftigkeit und Beweiskraft der Abbildungen unterstreichen können.
 Der Illustrator des Petersburger „Livre des simples médecines" setzte beispielsweise Insek-
ten als *trompe l'œil* auf verschiedene Buchseiten und suggerierte damit, dass der Schmetterling
und die Fliege von seiner Kunstfertigkeit getäuscht und von den gemalten Pflanzen angezogen
wurden – als wären sie echt (Abb. 131).[97] Oder die Heilmittel wurden in einer detailreichen
Landschaft gezeigt, dort, wo man ihnen in der Natur bzw. „in Wahrheit" begegnen konnte
(Abb. 132).

95 Bernhard von Breydenbach (1485), fol. 2r.
96 Bernhard von Breydenbach (1485), fol. 2v.
97 Dieser wahrheitsversichernde Bildtopos geht auf die Antike zurück: Der Maler Zeuxis schaffte es
 durch seine Kunstfertigkeit, Vögel zu täuschen, die anflogen, um von seinen gemalten Trauben zu
 picken. Die bekannte Episode wird bei Bryson analysiert. Dem Maler Parrhasios gelang es nämlich
 nicht nur „niedere Lebewesen" zu täuschen, sondern sogar den Maler Zeuxis selbst. Bryson (1990),
 S. 30 f.

Abb. 132: Paris, Bibliothè-
que nationale de France,
Ms. fr. 12322, fol. 168r.

Solche Evidenz vermittelnde Zeichen durch die Hand des Künstlers können im 16. Jahrhun-
dert als „gekünstelt" und daher dem naturwissenschaftlichen Text nicht angemessen gelten.[98]
Das Bild, das „Naturwahrheit" schafft, zeichnet sich vielmehr durch die kunstvolle Technik und
das vermeintliche Studium an der Natur aus. Alle weiteren Komponenten im Bild, die Evidenz
erzeugen konnten, wurden für das illustrierte Kräuterbuch praktisch verworfen. Leonhart Fuchs
legte für die Pflanzenbilder in seinem Werk „De historia stirpium" ausdrücklich fest, dass nichts
eingefügt werden solle, womit Künstler sonst Ruhm erlangten: Keine Landschaften, keine Rah-
mungen und keine Schatten, die die Pflanze auf die Buchseite wirft, sollten gezeigt werden. Er
forderte Bilder, die seiner Auffassung nach näher an der Wahrheit lagen, solche, die keine Künst-
lerindividuen sichtbar machen (Abb. 155, 159–160, 204). Von den Illustratoren verlangte er eine
einfache, natürliche Form der Pflanze (*nativa forma*).[99] Anhand der Aussagen von Fuchs wird

98 Bock (1551), bij recto: Hieronymus Bock verlangte für sein Kräuterbuch von seinem Künstler, David
 Kandel, eine „ungekünstelte, schlichte und doch wahrhaftige Form der Pflanze" zu finden. Siehe
 weiter Kap. 6.

99 Fuchs (1542), fol. α 6 verso: „Quod ad picturas ipsas attinet, quae certe singulae ad vivarum stirpium
 lineamenta et effigies expressae sunt, unicè curavimus ut essent absolutissimae, atque adeo ut quae-

Abb. 133: Leonhart Fuchs /
Heinrich Füllmaurer / Albrecht
Meyer / Veit Rudolf Speckle:
New Kreüterbuch. Basel 1543.
München, Bayerische Staats-
bibliothek, Rar. 2037.

vis stirps suis pingeretur radicibus, caulibus, foliis, floribus, seminibus ac fructibus, summam adhi-
buimus diligentiam. De industria verò et data opera cavimus ne umbris, aliisque minus necessariis,
quibus interdum artis gloriam affectant pictores, nativa herbarum forma obliteraretur: neque passi
sumus ut sic libidini suae indulgerent artifices, ut minus subinde veritati pictura responderet.“ Über-
setzung von De Angelis (2011), S. 228: „Was die Bilder selbst betrifft, die gewiss einzeln gemäß den
Grundzügen und Abbildern (*effigies*) lebendiger Pflanzen darstellt sind, so haben wir uns einzig da-
rum gekümmert, dass sie vollkommen (*absolutissimae*) seien, und zwar so sehr, dass wir die höchste
Mühe daran verwendet haben, dass jede Pflanze mit ihren Wurzeln, Stengeln, Blättern, Blüten, Sa-
men und Früchten abgemalt wurde. Dennoch haben wir absichtlich und mit Mühe versucht, dass
nicht mit Schatten und anderen weniger notwendigen Tricks, durch welche die Malerei mitunter
dem Ruhm in der Kunst nacheifert, die natürliche Form (*nativa forma*) der Pflanzen vernachlässigt
wurde. Noch haben wir erlaubt, dass die Künstler ihren Wünschen derart nachgaben, dass hinterher
das Bild weniger der Wahrheit entsprach.“ Siehe hierzu: Swan (2006), S. 71 f. Niekrasz / Swan (2006),
S. 780. De Angelis (2011).

deutlich, dass evidente Pflanzenbilder möglichst ihre Herstellung durch den Künstler verbergen, dass sie „einfach ‚da' sein" sollten.[100] Fuchs' Zeichner und Holzschneider erzeugten über ihre ausgezeichnete Technik ein in diesem Sinne „wahres" Bild der Pflanzen, wodurch sich wiederum ihre Kunstfertigkeit offenbarte: durch die Beherrschung von Verkürzung und Perspektive, durch die natürlich wirkende Lichtführung, die die Beobachtung am Objekt suggeriert und die im Holzschnitt durch immer feiner werdende Linien geschaffen werden konnte. Auf der letzten Seite des Kräuterbuchs von Leonhart Fuchs wurden sie in einer Darstellung festgehalten (Abb. 133), die den Zeichner vor der frischen Pflanze, die in eine Vase gesteckt wurde, abbildet. In der Szene wird zuerst von den „Pictores" die Pflanze gezeichnet und auf Holz übertragen, im Anschluss fertigt der „Sculptor" den Holzschnitt.[101] Auch diese Abbildung gehört zu den in Wort und Bild angeführten Versicherungen, dass die Illustrationen im gesamten Werk nach dem Augenschein kreiert wurden.

Die gleichen Kriterien, wie Fuchs sie bei seinen Künstlern einforderte, können auch für die Illustrationen des „Gart" geltend gemacht werden. Es werden keine Landschaften gezeigt, keine Rahmungen und keine Schatten, lediglich die freigestellte Pflanze.[102] Die Techniken der Verlebendigung der Bildoberfläche und das Illustrationsprogramm, das sich auf die Pflanze „an sich" konzentriert, wurden bereits beschrieben.[103] Der Prozess der Vermittlung von Abwesendem soll durch die Suggestion von Präsenz möglichst unbemerkt bleiben. Bilder und Worte können gleichermaßen Lebendigkeit (*energeia*) und einleuchtende Wahrheit (*evidentia*) vermitteln. Das Bild, das die Präsenz des Künstlers als Vermittlungsfigur verdrängt, ist dem Wort gewissermaßen überlegen: Der Rezipient kann das Objekt selbst sehen und ist nicht auf die Beschreibung in Worten durch den Autor angewiesen.[104]

Mit Hilfe des versierten Künstlers konnten Natureindrücke vermittelt werden, da er die Wiedergabe von Natur im Bild beherrschte und so zur Instanz für wissenschaftliche Abbildungen wurde. Der Künstler und die Naturbeobachtung zu wissenschaftlichen Zwecken treten auf diese Weise in eine enge Verbindung ein.[105] Möchte der Wissenschaftler seine Beobachtungen wiedergeben, muss er entweder selbst zeichnerisch begabt sein oder zumindest einen fähigen Maler beschäftigen.[106] Anfang des 16. Jahrhunderts erklärte Leonardo da Vinci den Zusam-

100 Müller (2007), S. 62. Die Verlebendigung eines künstlichen Objekts, das deshalb so präsent wirkt, weil es so kunstfertig geschaffen wurde, dass es sogar den eigenen Schöpfer des Kunstwerks täuschen konnte, kommt in der Pygmalion-Episode bei Ovid in dem bekannten Vers zum Ausdruck: „So verbarg die Kunstfertigkeit die Kunst". Kruse (2006), 122–128.

101 Die Bezeichnungen „Sculptor" und „Pictor" verweisen in zwei unterschiedliche Berufszweige. Maler und Formschneider waren in der Regel nicht in einer Zunft vereint. Den Formschneider trifft man in einer Werkstatt zusammen mit Künstlern, die mit Holz arbeiten, sei es im Relief oder in Vollplastik. Kusukawa (1997), S. 404–406.

102 Vgl. auch bei Egmond (2017), u. a. S. 232 f.

103 Siehe oben: Kap. 4.4.

104 Müller (2007), S. 66. Zum Vorwort im Kräuterbuch von Leonhart Fuchs, der schreibt, dass nur ein Narr leugnen würde, dass Bilder eine Sache besser beschreiben können als Worte: Kusukawa (1997). Kusukawa (2012).

105 Daston (2011). Bakker (2018) versteht die von Bernhard von Breydenbach herausgegebenen Werke als Diptychon, die neue Standards für bebilderte, naturwissenschaftliche Texte setzten.

106 Hierzu: Felfe (2015b). Leonhard (2007). Speziell mit einer Passage zum Künstler auf Reisen im 16. und 17. Jahrhundert: Thimann (2007).

menhang von Wissenschaft, Kunst und Natur sogar zu einer natürlichen, familiären Beziehung: Wissenschaft (*scientia*) sei die Tochter der Natur und die Malerei sei aus der Natur geboren.[107]

5.2.3. Wissenschaftliche Bilder (re-)produzieren

Die Glaubhaftigkeit der Bilder in den Werken Bernhards von Breydenbach ist für ihren Erhalt im Kanon der naturwissenschaftlichen und topographischen Abbildungen zentral. Wird keine Evidenz vermittelt, wird das Bild nicht kopiert und kann nicht in den Gelehrtendiskurs eintreten. Das Bild muss sich also vernetzen. Schmidt spricht in diesem Zusammenhang von einem „virtuellen Original", das Objekte festhält, die sonst nicht gesehen werden könnten, und das durch seine Reproduktion Autorität erfährt.[108] Ein Künstler, der evidente Bilder erzeugt, die allen einleuchten, kann dabei zur Autorität erhoben werden und sogar traditionelle Bildformen ersetzen.

Als Beispiel dafür kann Dürers Einblattholzschnitt eines Rhinozeros gelten, der schon bei Zeitgenossen weite Verbreitung fand (Abb. 135). Der beigegebene Text soll, wie das Vorwort Bernhards von Breydenbach, das Bild als wahres Abbild bestätigen und das Tier vergegenwärtigen. Evidenz wird beispielsweise durch das Datum vermittelt, das die Ankunft des Nashorns am Hofe des Königs von Portugal festhält. Zugleich untermauert die Wendung „in all seiner Gestalt abgebildet (Abconterfect)" die Glaubhaftigkeit der Abbildung. Weiterhin wird die Farbe des Rhinozeros beschrieben. Indem es mit anderen Tieren (Schildkröte, Elefant) verglichen wird, können Verknüpfungspunkte zum Wissen des Betrachters hergestellt werden. Ebenso werden Passagen aus Tierbüchern des Mittelalters im Text zu Dürers Rhinozeros überliefert, damit kein völliger Bruch mit der Tradition besteht: Es sei allgemein bekannt, dass der Feind des Nashorns der Elefant sei. Diese Wahrheit, die nicht bewiesen werden musste, soll das evident zu machende Bild stützen.[109]

Dürer selbst hatte das Tier nie vor Augen gehabt, sein Aussehen erfuhr er aus Briefen. Der Erfahrungsbericht genügte, um im Holzschnitt von einem Konterfei nach der Gestalt des Rhinozeros zu sprechen. Dabei ist es für den Betrachter irrelevant, ob der Künstler das Tier tatsächlich gesehen hatte.[110] Der Betrachter, so Swan, gibt sich der durch Bild und Text vermittelten Illusion von Realität und Naturnähe bereitwillig hin.[111] Zugespitzt formuliert, hat der Rezipient auch keine andere Wahl, da *evidentia* neben der rhetorischen auch eine epistemische Komponente hat: evidente Bilder muss man für wahr halten.[112] Zudem setzt das Unterscheiden einer naturgetreuen von einer naturfernen Darstellung Erfahrung mit dem Objekt voraus. Das Konterfei eines Elefanten oder Rhino-

107 Niekrasz / Swan (2006), S. 786.

108 Latour (2006).

109 Mehr zum Hintergrund des Nashorns als diplomatisches Geschenk am Hof zu Lissabon: Bedini (2006). Zu Dürers Rhinozeros im Wissensdiskurs: Dackerman (2011), S. 162–171. Dackerman sieht in Dürers Darstellung eines Nashorns nicht nur den Impuls zu einer Beschreibung der Natur, sondern auch die Tendenz, künstlerische Formen zu schaffen, die mit der Natur in Konkurrenz treten.

110 Swan (1995), S. 358.

111 Parshall (1995), S. 329. In seinem Beitrag „Imago contrafacta" vergleicht Parshall diesen Betrachter mit Narziss. Parshall (1993), S. 554.

112 Müller (2007), S. 66. In einem anderen Medium, der Skulptur, aber im gleichen Zusammenhang, der scheinbar „realistischen" Wiedergabe von Abwesendem im Bild, hält Wood fest: „Likeness is an effect generated not by literal analogic correspondence to a real model, but by an excess of information with respect to the apparent function of the image." Wood (2008), S. 139.

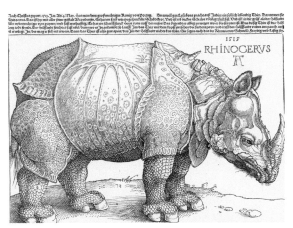

Abb. 134: Elefant: Gart der Gesundheit.
Mainz 1485. München, Bayerische Staats-
bibliothek, 2 Inc.c.a. 1601.
.

Abb. 135: Albrecht Dürer: Rhinozeros, 1515, Holzschnitt.
Frankfurt am Main, Städel Museum, Graphische Samm-
lung, Inv.-Nr. 31588. In: Kat.Ausst. Frankfurt a. M. (2013),
S. 307.

Abb. 136: Hans Burgkmair d. Ä.: Rhi-
nozeros, 1515, Holzschnitt. Einzig er-
haltener Holzschnitt: Albertina, Wien,
Inv.-Nr. 1934/123. In: Kat.Ausst. Cam-
bridge, Mass. (2011), S. 177.

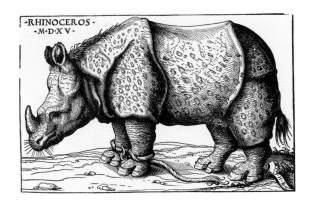

zeros kann zu diesem Zeitpunkt in Europa nicht durch einen Vergleich mit dem lebendigen Tier
überprüft werden. Man war auf das Bild angewiesen, das zum „virtuellen Original" wurde.

Kaum eine in Europa entstandene Elefanten-Abbildung kann im 15. Jahrhundert als natur-
näher gelten als jene, die für den „Gart" angefertigt wurde (Abb. 134).[113] Die Darstellung wäre
ideal gewesen, um eine alte Abbildungstradition zu ersetzen und sie über den Buchdruck in
Umlauf zu bringen. Im Gegensatz zu Dürers Nashorn wurde der Elefant des „Gart" jedoch im
Kontext der naturwissenschaftlichen Illustration nicht rezipiert, obwohl die Darstellung des
Rhinozeros und des Elefanten formal analog funktionieren. Das Elefantenbild der „Gart"-Erst-
ausgabe erfuhr eine rasche Umgestaltung und Anpassung an traditionelle Formen und ging
damit nicht in den Gelehrtendiskurs ein.[114]

113 Eventuell hat der Künstler das Tier tatsächlich gesehen. Im Vergleich sind z. B. auch in Italien die
 Elefanten-Darstellungen zu dieser Zeit noch nicht sehr naturgetreu: König-Lein (1997), S. 40 f.

114 Ebenso erging es dem Rhinozeros-Holzschnitt von Hans Burgkmair d. Ä., der zeitgleich mit Dürers
 Darstellung entstand und sich, obgleich naturnäher, nicht durchsetzen konnte (Abb. 136). Kat.Ausst.
 Cambridge, Mass. (2011), S. 175 f.

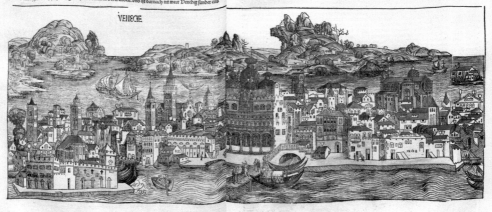

Abb. 137: Venedig-Ansicht: Chronica. Nürnberg 1493. München, Bayerische Staatsbibliothek, 2 Inc.c.a. 2922.

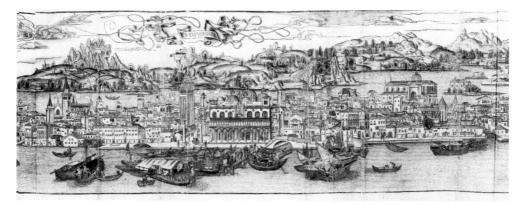

Abb. 138: Ausschnitt aus der ausklappbaren Venedig-Ansicht: Peregrinatio. Mainz 1486. München, Bayerische Staatsbibliothek, 2 Inc.c.a. 1725.

Arſinoe.

ISſe ſtatt wie Strabo ſchreibt hatt vor langen zeiten Crocodilſtatt ge heiſſen. Dan die Egypter habe an diſſem ort ſunderlichen vereret das ongeheüwer thier Crocodil/haben es für heylig gehabt vnd jm ſunder lich prieſter gehalten die ſein gewartet haben vnd das erneret. Sie haben jm zů eſſen geben brot/fleiſch/wein/vnd andere der gleichen ding ſo die bilger do hin bracht haben dem thier zů opffern. Darvon ſchreibt Strabo alſo/der es zů ſeinen zeiten auch heym geſůcht hat. Als ich an das ort kam diſz thier zů be ſehen/waren auch ſunſt andere leüt do hin kommenn/vnder wölchen was ein treflicher man der eins groſſen anſehens was/der hett mit jm bracht ein küch en/gebraten fleiſch/vnd ein fleſchen vol gůts ſüſſes weins. Vnd nach dem die prieſter vnſz hetten gefürt an den ſee/in dem ſich diſz thier ſtets halt/vnd zů zey gen ſeine heyligkeit/funden wir das grauſam thier an dem geſtaden des ſees/

Crocodil.

Salamandra

wer on ſchade oder ver letzung lebe mag. Man braucht diſſe ſchläg zů etlichen tüchern/vn die werde ſo werhafft dar von das ſie in keine feü wer möge verbrenen/ ſunder ſo ſie onſauber

Groſz korn.

us daſz das korn ſo groſz bey jnen wirt/das ein jedes kornlin gar nahe ſo groſz wirt als bey vns der gantz äher. Darzů ſchreibt Curtius/das diſz land dem künig Dario wid den groſſen Alexäder zů ſchickte dreyſſig tauſent reüter mit pferden. Vnd wie wol es alſo vil pferd hat/hat es doch darneben auch die be ſten kämelthier/die vil beſſer in diſem land dann in Syria oder Arabia gefallen. Sie brauchen ſie zů den ſchweren leſten zůtrage/ dann diſer thier natur iſt/das ſie mit groſſer ſorgfeltigkeit ghan/vn mögen groſz arbeit vnd ein langwerigen durſt leiden. Vier tag lang mögen ſie on truncken ſein/vnd wann ſie zů waſſer kommen trincken ſie ſo faſt/das ſie all en vbergange durſt erfüllen. Sie trin cken mit groſſem luſt das trüb waſſer/vnd das lauter fliehen ſie.

Der Elefant ist dabei ein Einzelfall, die restlichen Illustrationen des „Gart" und die topographischen Bilder der Pilgerreise sowie die darin gezeigten Tierbilder wurden zum Teil bis in das

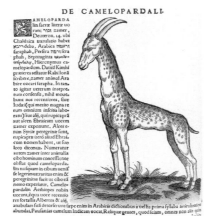

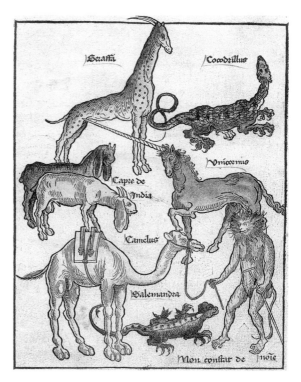

Abb. 142: Giraffe: Historiae animalium. Zürich 1551, S. 160. Zürich, Zentralbibliothek, NNN 41.

Abb. 143: Peregrinatio. Mainz 1486. München, BSB, 2 Inc.c.a. 1725.

18. Jahrhundert weitergegeben und im wissenschaftlichen Kontext rezipiert. Neben Kräuterbüchern zog man die „Gart"-Illustrationen auch für das Werk von Petrus de Crescentiis zur erfolgreichen Landwirtschaft und den „Macer" heran. Sie wurden von Hand kopiert und mit weiteren Schriften zur Gesundheit, zur Medizin und Destillierkunst kombiniert (siehe Kap. 4.5.). Die Städtedarstellungen von Erhard Reuwich aus der Pilgerfahrt gingen z. B. in die Schedel'sche Weltchronik ein (Abb. 137–138). Sebastian Münsters „Cosmographia" (1544) zeigt, neben Dürers Rhinozeros, auch Reuwichs Abbildungen eines Krokodils, Salamanders und Dromedars (Abb. 139–141).[115] Conrad Gessner übernahm für seine „Historiae animalium"[116] einige Tiere aus der Pilgerreise Bernhards von Breydenbach (Abb. 142–143).

Die Evidenz der Bilder und die Autorität des Künstlers, der glaubhafte und neue Bilder erzeugt, liegen nahe beieinander und werden durch das neue Reproduktionsmedium befördert.[117] Gessner, der die Gestalt von Giraffe,[118] Elefant und Nashorn für die „Historiae animalium" (Bd. 1: Zürich 1551) nicht an der Natur überprüfen konnte, verließ sich be-

115 Sebastian Münster: Cosmographia in welcher begriffen aller Völcker Herschafften, Stetten und namhafftiger Flecken [...]. Basel 1544. GV16 M 6689. Unter anderem wurde die „Cosmographia" auch von David Kandel mit Holzschnitten ausgestattet, kurz darauf begann der Straßburger Künstler mit den Pflanzenholzschnitten für Hieronymus Bocks Kräuterbuch. Zu Kandel: Châtelet-Lange (2007).

116 Conrad Gessner: Historiae animalium. Zürich 1551. VD16 G 1723.

117 Dazu zahlreiche Beispiele in: Landau / Parshall (1994). Kat.Ausst. Cambridge, Mass. (2011). Swan (2011).

118 Die Illustration der „Seraffa" von Reuwich wurde für Gesners „Camelopardali" verwendet, beide Male ist die Giraffe gemeint.

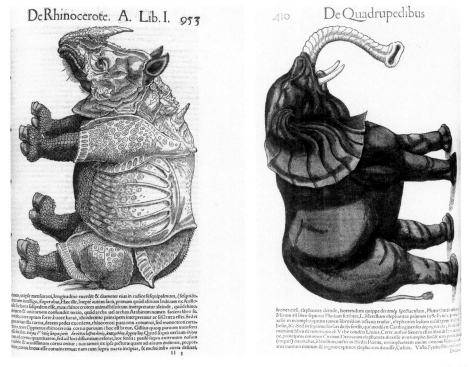

Abb. 144: Rhinozeros und Elefant: Historiae animalium. Zürich 1551, S. 953, 410. Zürich, Zentralbibliothek, NNN 41.

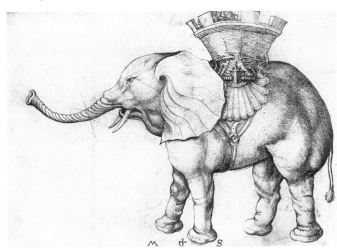

Abb. 145: Martin Schongauer: Elefant, um 1483, Kupferstich. New York, The Metropolitan Museum of Art, Inv.-Nr. 1986.1241.2.

zeichnenderweise nicht auf die Tradition mittelalterlicher Tierbücher, sondern auf die Autorität von Künstlern und Werken, deren Darstellungen für ihn offenbar glaubhafte Abbildungen lieferten. Als Quellen für die Illustrationen nennt er Martin Schongauer,[119] Albrecht Dürer und

119 Zur Wertschätzung von Schongauers Graphiken im späten 15. und 16. Jahrhundert: Roth (2010).

„ein deutsches Buch, das das Heilige Land beschreibt"[120]. Reuwichs Name hatte demnach keinen
hohen Bekanntheitsgrad, seine Bilder waren hingegen im Gelehrtendiskurs präsent – und ihnen
wurde Autorität zugeschrieben. Reuwich selbst hatte, neben Künstlern wie Schongauer oder Dü-
rer (Abb. 144–145), mit den Illustrationen des „Gart" und der „Pilgerfahrt" die Verfahren und
Konstruktion evidenter Bilder, die Naturbeobachtung wiedergeben und Wissen vermitteln sollen,
auf entscheidende Weise mitgeprägt.[121]

5.3. Die Kraft der Kräuterbilder

Zuletzt soll differenzierter auf die Heilkraft der Kräuter eingegangen werden. Im Mittelpunkt
der Überlegungen steht dabei, ob die Wirkung der Kräuter und die der Kräuterbilder auf den
menschlichen Körper ähnlich gedacht werden kann, ohne dass davon ausgegangen wird, dass
im „Gart" diese Engführung angelegt ist. Es soll hier vielmehr eine mögliche Lesart durch den
Betrachter aufgezeigt werden. Um sich der Analogie zwischen der Wirkung der Kräuter und der
Wirkmacht ihrer Abbildungen anzunähern, ist es notwendig, sich die spätmittelalterliche Vor-
stellung vom Wirken und Heilen vor Augen zu führen.

5.3.1. Die Heilkraft der Kräuter

Die Kräuter seien von Gott mit Kräften ausgestattet worden, um dem Menschen nützlich zu
sein. Ihre Wirkung würden sie deshalb entfalten, weil sie, wie der Mensch, aus den vier Ele-
menten zusammengesetzt seien. Ihre Qualitäten hätten Einfluss auf den menschlichen Körper.[122]
Diese basale Erklärung der Pflanzenkräfte wird im „Gart" gegeben und deckt sich weitestgehend
mit anderen Schriften zu Kräutern und Pflanzen. In den meisten Fällen begründete sich die
Wirkung der Pflanze aus ihren elementaren Bestandteilen. Demnach kann die Wirksamkeit der
Dinge auch ohne aktive Einwirkung Gottes gedacht werden, die Qualitäten im menschlichen
und pflanzlichen Körper reagieren „von selbst" miteinander. Diese Vorstellung wurde insbeson-
dere von Albertus Magnus und Thomas von Aquin befördert.[123] Die Heilkraft der Kräuter gehe
von der Mischung der „Elementequalitäten" aus, schreibt Petrus de Crescentiis im sechsten Buch
zur erfolgreichen Landwirtschaft und bezieht sich dabei auf Albertus Magnus.[124] In der Medizin
gebe es nichts, „was mehr verwendet wird" als Kräuter. Sie könnten Hitze und Kälte erzeugen,
diese würden den Körper aber verzehren, wenn nicht noch eine weitere Kraft, neben den Ele-
menten, in ihnen Wirkung fände, und diese sei die „Kraft des Himmels".[125]

120 Gessner gibt hiermit, nicht allzu genau, als Quelle den Reisebericht Bernhards von Breydenbach für
 die Giraffe an. Zit nach: Kat.Ausst. Cambridge, Mass. (2011), S. 178.
121 Die „Evidenzverfahren" funktionieren dabei keinesfalls immer gleich, sie sind gesellschaftlich ge-
 prägt: Müller (2007), S. 67.
122 Bernhard von Breydenbach (1485), fol. 2r.
123 Spyra (2005), S. 4. Dazu auch: Grubmüller (1999).
124 Petrus de Crescentiis (2007), Bd. 1, Buch VI: „Von den Gärten und von der Natur und dem Nutzen
 der Kräuter".
125 Petrus de Crescentiis (2007), Bd. 1, S. 402.

Abb. 146: *Scala naturae*: Liber de intellectu. Paris 1510, fol. 120r. München, Bayerische Staatsbibliothek, 2 Ph.u. 14.

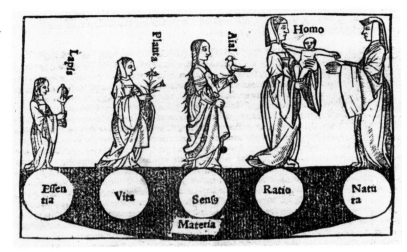

Mit der einfachen Erklärung, die Kräuter seien aus den Elementen geschaffen und diese hätten Wirkung auf den Körper, gab man sich in den theoretischen Schriften zur Pflanze nicht zufrieden. Die Elemente würden nur die Art und Weise der Wirkung vorgeben. Zusätzlich wurde die Ursache der starken Wirkung der Kräuter auf den Menschen im Bereich der himmlischen Sphären gesucht:

> Diese [heilenden] Kräfte haben sie [die Kräuter] nämlich nicht von den Elementen, aus denen sie zusammengesetzt sind, auch nicht von der Zusammensetzung selber – denn die Zusammensetzung verleiht nicht eigentlich Kraft, sondern bestimmt die Kraft des Zusammensetzenden als aktive oder passive –, vielmehr kommen diese Wirkweisen und Eigenschaften von der Spezies als ganzer, verursacht von den Kräften des Himmels und von der Kraft des Lebenshauchs [*spiritus*].[126]

Die geringe Kraft des Lebenshauchs bedinge eine hohe Wirkkraft auf den Menschen. Petrus de Crescentiis unterscheidet dabei zwischen den hochgewachsenen Pflanzen und Bäumen, die weniger starke Wirkung erzeugen, und den wirkungsstarken Kräutern, die nahe am fruchtbaren, feuchten Boden bzw. der Materie angesiedelt sind. Der „vegetative Lebenshauch" in den Kräutern sei schwach, neben den Edelsteinen stünden sie der Materie am nächsten.[127]

Steine und Metalle wurden in der *Scala naturae*, deren Abbildung im „Liber de intellectu"[128] von Charles de Bouelles einfallsreiche Bildformen hervorgebracht hat, ganz unten angesiedelt (Abb. 146), ganz oben stand der Mensch, der, nach Aristoteles, neben dem Nährvermögen auch Sinnes- und Vernunftvermögen besitze.[129] Dennoch verfügten die Steine und Kräuter über Lebenshauch, allerdings sei dieser – im Gegensatz zu Mensch und Tier – nur schwach ausgeprägt. Gerade deshalb entfalteten die Steine und Kräuter den größten Einfluss auf den menschlichen

126 Petrus de Crescentiis (2007), Bd. 1, S. 403.
127 Petrus de Crescentiis (2007), Bd. 1, S. 402. Ähnlich bei: Albertus Magnus (1992), VI 265 f.
128 Charles de Bouelles: Liber de intellectu. Paris 1510.
129 Zur *Scala naturae*: Leonhard (2013), S. 33–47. Zur Kraft der Steine in Natur und Kunst: Felfe (2015a).

Körper, weil sie ihre Kraft auf direktem Wege – ungefiltert – empfingen: von den Sternen oder durch das Licht der Sonne. Die in sie hineingegebene „Form" (*forma*) werde direkt ein- und abgegeben. Diese Formen werden, nach Albertus Magnus und Petrus de Crescentiis, „von den Bewegern der Sternbahnen durch die Figuren der Sterne in die dem Werden unterworfenen Dinge eingegossen".[130]

Die durch den „Beweger der Sternbahnen" veranlassten Formen würden sogar wirkmächtiger in den Körper eingreifen als die „Seele [*anima*], wenn sie entsprechende Formen in den [...] menschlichen Körper einströmen lässt":[131]

> Diese Formen, die sich der Baustoffe der Dinge bemächtigen, die entstehen und vergehen können, lassen sich in vielen Wirkungen bei Steinen und Pflanzen nachweisen.[132]

In den menschlichen Körper könnten demnach zwei unterschiedliche Formen einströmen: die der Seele sowie die der Pflanzen und Steine, die ihre Formen wiederum direkt aus den Sphären erhalten, die sich der Substanz der niederen Lebewesen bemächtigten. Interessant ist, dass die Formen, die in den menschlichen Körper durch die Seele einströmen, bei Petrus de Crescentiis als Bilder gedacht werden, die den Menschen zum Handeln antreiben:

> Das Bild einer Frau [*forma feminae*], das im Intellekt existiert, [bewegt] von sich aus zu geschlechtlicher Aktivität [...]. Auch das Bild einer künstlerischen Tätigkeit [*forma artis*] bewegt von sich aus und sucht die Werkzeuge, die seinen Zwecken dienlich sind.[133]

Ebenso könne die Form der Kräuter in den Menschen einfließen – sogar noch stärker als die der Seele – und ihn heilen. Petrus de Crescentiis erzeugte in seiner Beschreibung Bilder, die mit dem Akt der Reproduktion und damit der erneuten Formfindung und Weitergabe von Form einhergehen: die des Menschen durch „geschlechtliche Aktivität" und die der bildenden Kunst.[134] Nicht nur Steine und Kräuter, sondern auch die Bilder der Vorstellung könnten demnach auf den Menschen eine Wirkung entfalten.

Im Rückgriff auf Albertus Magnus hält Konrad von Megenberg im „Buch der Natur" fest, dass die Pflanze ihre Kraft nicht nur aus den Elementen bezieht, sondern auch aus den Sternen.[135] Sie wirken auf die gleiche „wundersame Weise wie die Steine" („als wunderleich werch würchent als die stain"). Im Kapitel „Zu den Kräutern" erklärt er:

> Nun kannst du fragen, [...] ob die Kräuter ihre ganze Kraft aus der Mischung der Elemente haben? So sage ich: Nein! Denn sie haben ihre wundersame Wirkung von der Kraft der Sterne, die sich in ihre Form gedrückt hat, ganz so wie eine geistige Form oder ein Ebenbild einer geschätzten Sache (eines geliebten Dings), das in den Spiegel deiner Vernunft gedrückt ist und das dich von einer Stätte an die andere zieht. In dieser Weise wirkt die Kraft der Sterne in den Kräutern,

130 Petrus de Crescentiis (2007), Bd. 1, S. 403.
131 Petrus de Crescentiis (2007), Bd. 1, S. 404.
132 Petrus de Crescentiis (2007), Bd. 1, S. 404.
133 Petrus de Crescentiis (2007), Bd. 1, S. 404. Ähnlich bei: Albertus Magnus (1992), VI 268.
134 Zur Parallelführung von künstlerischem Akt und Zeugungsakt: Pfisterer (2014), S. 46–96.
135 Hierzu: Vögel (2006), S. 265. Mayer (1995), S. 328.

und dazu helfen die starken Kräfte der heiligen Worte, mit denen man Gott anruft und die Kräuter beschwört und segnet, und auch die Edelsteine, so wie man das Weihwasser segnet.[136]

Demnach geht auch Konrad von Megenberg nicht davon aus, dass die Kräuter ihre Kraft lediglich aus der Mischung der vier Elemente erhielten, sondern ebenso von den Sternen.[137] Diese drücken die Form – darin stimmt er mit Petrus de Crescentiis überein – in die Kräuter. Das geistige Bild einer Sache drücke sich wiederum in den Spiegel der Vernunft ein, was den Leser an einen bildlichen Prozess erinnert, nämlich an den Abdruck, den ein Siegel im Wachs hinterlasse.[138] Die Imagination erlaubt es, Distanz zu überbrücken: von einem Ort zu einem anderen werde man durch das Vorstellungsbild, die aktive Erinnerung, gezogen. Nach Aristoteles funktioniert das Bild im Gedächtnis wie ein Wachsbild, das auf das Siegel verweist.[139] Die Distanz zum Original wäre, so Konrad von Megenberg, durch das geistige Bild zu überbrücken. Während er von Bildern ausgeht, die den Geist bewegen können, gehen Petrus de Crescentiis und Albertus Magnus weiter und sprechen von geistigen Bildern, die den menschlichen Körper zur Handlung bewegen. Ein nächster Schritt wäre, an Bilder zu denken, die den Körper beeinflussen können. Darauf wird noch einzugehen sein.

5.3.2. Heilige als Heilmittel

Konrad von Megenberg schreibt weiter, dass die Kraft der Kräuter und Edelsteine durch heilige, segnende Worte verstärkt werden kann – so wie man es bei Weihwasser tut. Dies erinnert an eine für den „Gart" sonst eher ungewöhnliche Textstelle, da sie für den modernen Leser in den von der Medizin abgetrennten Bereich des Glaubens fällt:

Die „Rittersblume" (Rittersporn, Abb. 147) helfe besonders dem, der sie „in Wachs gedrückt, bei einer Messe zur Heiligen Otila um den Hals [...] trägt, dessen Augen bleiben gesund, solange er lebt. Diese Blume hat die liebe Jungfrau Otilia besonders in Ehren gehabt, weshalb von ihnen solche Gewalt kommt."[140]

Medizinische und religiöse Heilwirkung sind allerdings im 15. Jahrhundert nicht voneinander abzugrenzen. Odilia (auch: Ottilia) konnte nach dieser Vorstellung die Kraft des Ritter-

136 Konrad von Megenberg (1475), Cap. „zu den Kräutern": „nu maht dû frâgen ains, [...] ob diu kräuter ir kreft all haben von der mischung der vier element? sô sprich ich: nain! wan si habent wunderleicheu werch von der stern kreften, die sich in ir form drückent, reht sam ain gaistleich form oder ain ebenpild ains geminten dinges, daz in den spiegel deiner vernunft ist gedrückt, daz zeuht dich von ainer stat an die andern; reht in der weis würkent der stern kreft in der kräuter art, und dar zuo helfent ze stunden die starken kreft der hailingen wort, dâ mit man got anruofet und die kräuter beswert und gesegnet und auch daz edel gestain, sam man daz weichwazzer gesegnet."

137 Gottschall (2004), S. 344.

138 Das gleiche Bild hatte bereits Aristoteles für das Gedächtnis gebraucht. Aristoteles (2004), 450a, 29–32 (S. 65): „So nämlich muss man sich offenbar den Vorgang denken, der durch die Wahrnehmung in der Seele und in dem Teil des Körpers sich abspielt, der die Wahrnehmung enthält: das Erlebnis, dessen Vorhandensein man Gedächtnis nennt, ist wie ein Gemälde, weil die ablaufende Bewegung gleichsam einen Eindruck des Wahrnehmungsbildes zurücklässt, wie wenn man mit einem Ring gesiegelt hat."

139 Zu diesem Akt des Eindrückens siehe auch: Bredekamp (2010), S. 178–183. Baader (2005).

140 Konrad von Megenberg (1485), Cap. xcvj.

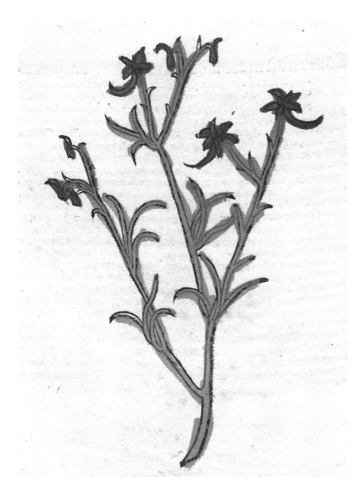

sporns offenbar verstärken und innerhalb der Pflanze bewahren, ohne dass diese mit der Zeit
verloren ging. Sie selbst kam der Legende nach blind zur Welt und wurde bei ihrer Taufe ge-
heilt. Die Heilige ruft man daher bei Augenleiden an.[141]

Heilsvermittlung über heilige Reliquien, Segnungen, Ikonen sind sogar sehr ähnlich zu den-
ken und für den Körper gleichermaßen wirksam wie Kräuter oder Steine. Ein direkter Kontakt
zum heiligen Objekt vom Sehen bis hin zur Berührung und Einverleibung verspricht heilende,
gesundheitsbefördernde Wirkung.[142]

Das Anbringen von edlen Steinen auf Reliquien kann damit vielschichtiger gedacht wer-
den als die Aufwertung des einfachen Materials (Knochen, Stoffe, Hölzer etc.). Einerseits
können die wertvollen Steine Heiligkeit verdeutlichen, andererseits geht von beiden Materia-
lien heilsspendende Kraft aus (Abb. 148). Von den Reliquien versprachen sich die Betrachter

141 Keller (1984), S. 453–455.
142 Schnitzler (2002). Gormans / Lentes (2007). Martin Luther sprach sich deutlich gegen das Weihen
 von Kräutern als abergläubische Praxis aus. Kat.Ausst. Hamburg (1983), S. 5. Zur Kräuterweihe im
 „Handwörterbuch des deutschen Aberglaubens": Marzell (2005), Sp. 440–446. Zu Heiligen als Hei-
 ler: Kolmer (1993).

Abb. 148: Der Heilige (das Reliquiar des Heiligen?) und die Edelsteine werden zusammen gezeigt: Darstellung zum Abschnitt „von den Steinen": Buch der Natur. Augsburg 1475. München, Bayerische Staatsbibliothek, 2 Inc.c.a. 347.

bei Heiltumsweisungen[143] über das Seelenheil hinaus auch körperliche Gesundheit.[144] Zu den Weisungen, bei denen man die Reliquien selbst sehen konnte, trug man kleine Spiegel mit sich, die das göttliche Heil einfangen sollten. Über den Kontakt zur Reliquie, dem wahren Körper des Heiligen, kann das Spiegel-Bild die Heilskraft aufbewahren und selbst wirkmächtig werden.[145]

Nun kann man sich fragen, ob der unmittelbare Kontakt, den Bernhard von Breydenbach mit den Kräutern auf seiner Reise ins Heilige Land gesucht hat, auch deshalb so stark betont wird, weil von den Pflanzen, die an heiligen Orten wachsen, besondere Heilwirkung ausgeht, die man sich letztendlich auch vom „Gart der Gesundheit" erhoffte.

143 Zu Reliquien und Heiltumsweisungen: Cordez (2015) oder Cárdenas (2013), mit einem Kapitel zu „Maß und Gestalt" bzw. der Wirklichkeit der Abbildungen im Heiltumsbuch (S. 285–294).

144 Über die unterschiedlichen Heilungsmöglichkeiten im Mittelalter und der Frühen Neuzeit aus medizinhistorischer Sicht: Schipperges (1990).

145 Wolf (2002), S. 137. Wolf schreibt, dass Johannes Gutenberg in Straßburg in den 1430er Jahren Spiegelzeichen anfertigte.

Abb. 149: Bußpsalm gerahmt von Pilgerzeichen: Stundenbuch. Gent oder Brügge, um 1515. Wien, Österreichische Nationalbibliothek, Cod. 1979, fol. 108r.

Abb. 150: Betende Stifter gerahmt von Rosenkränzen. Umkreis des Meisters der Maria von Burgund: Legende des heiligen Adrian, vor 1483. Wien, ÖNB, Cod. Ser. n. 2619, fol. 3v. In: Kat.Ausst. Wien (1987), Abb. 10.

Dass der Wachstumsort der Pflanzen Einfluss auf ihre Natur ausüben kann, ist bereits dargestellt worden.[146] Ebenso können Heilige und heilige Orte die Komplexion der Pflanze verändern und ihre Kräfte befördern.[147] Da nach dieser Theorie von solchen Pflanzen mehr Heilkraft ausgeht, kann man sicher annehmen, dass sie in getrockneter Form von Pilgerreisen mitgebracht wurden.[148] Später konnten die getrockneten Pflanzen in Stundenbüchern zu den Gebeten geklebt oder gesteckt werden und eine zusätzliche Heilskomponente darstellen, sodass Körper und Geist gleichermaßen gesund bleiben. Die gleiche Praxis existierte für Pilgerzeichen, die man von den Reisen mitbrachte und in das persönliche Gebetbuch einfügte.[149] Sie verweisen auf den heiligen Ort, den man bereiste, bzw. die Reliquie, mit der man dort in Kontakt getreten war. Das Bild konnte diese Zeichen der Pilgerfahrt, des Erfahrenen, als *trompe l'œil* ersetzen. Dieses sollte suggerieren, dass die Pilgerzeichen oder Pflanzen eingesteckt oder eingenäht wurden (Abb. 149–152).

146 Siehe oben: S. 185 f.

147 Von einigen Pflanzen wird gesagt, sie seien direkt am Fuß des Kreuzes aus dem Blut Christi erwachsen: Leoni (1996), S. 80.

148 Kaufmann (1993), S. 33–43.

149 Im Gegensatz zu den Pflanzen sind diese Abzeichen heute z. T. noch in Stundenbüchern erhalten geblieben: Kaufmann (1993), S. 37–43. Ebenso bei: Bredow-Klaus (2009), S. 25–66. Zu Gnadenbildern und ihrer Heilswirkung im Zeitalter der Reproduzierbarkeit: Schmidt (2010a).

Abb. 151: Maria Magdalena gerahmt von eingesteck-
tem Schmuck: Stundenbuch, um 1500, Pergament.
London, British Library, Add. 35313, fol. 231v.

Abb. 152: „Eingesteckte" Pflanzen in einem Mai-
länder Stundenbuch, um 1510, Pergament. Phila-
delphia, Free Library of Philadelphia, Lewis E 207,
fol. 2r.

Heilswirksame Objekte werden im gemalten Rahmen der Stundenbücher miteinander kom-
biniert und kunstvoll arrangiert, sodass stets ein Bezug zum Mittelbild oder Text entsteht: Ro-
senkränze, aus wirkmächtigen Bestandteilen (Perlen, Korallen),[150] Pflanzen und Edelsteine wer-
den neben dem Gebet oder Betenden platziert.[151] Pflanzen tauchen dabei entweder als *trompe
l'œil* auf, die neben dem Sehsinn auch den Tast- und Geruchssinn ansprechen, oder zeigen in
ihrer Kombination mit Edelsteinen, dass ihre Wirkung mit diesen vergleichbar ist, so wie es bei
Konrad von Megenberg beschrieben wurde.

In der Legende des heiligen Adrian (Wien, ÖNB, Cod. Ser. n. 2619), eine Handschrift, die
im Umkreis des Meisters der Maria von Burgund entstanden ist, werden alle bei Konrad von
Megenberg angeführten heilenden Objekte und Handlungen (Kräuter, Edelsteine und heilige
Worte, mit denen man Gott anruft) vor Augen geführt (Abb. 150): die heiligen Worte stehen
im Mittelpunkt des Bilds, das mit Rosenkränzen und Blüten gerahmt ist, deren Stempel durch
Edelsteine ersetzt wurden.[152] Die Rosenkränze verweisen auf das Gebet und sind aus heilendem

150 Zu den Wirkmechanismen von Korallen und Korallenamuletten sowie letztlich zu bildlich darge-
stellten Korallen: Saß (2012).

151 Zu diesen „Heilsrahmen": Bredow-Klaus (2009), S. 67–134.

152 Dargestellt sind nach Dagmar Thoss: Korallen- und Perlenrosenkränze, Emailblüten, dazwischen
große Perlen. Kat.Ausst. Wien (1987), Nr. 19.

Material, sodass hier eine Kombination aus geistiger und körperlicher Wirksamkeit stattfindet.[153]

Im Medium des illustrierten Gebetbuchs werden die verschiedenen Bildebenen häufig so feinsinnig miteinander verschränkt, dass sich ein Nachdenken über die Bilder selbst oder im Geist präsente Bilder und ihre Wirkung auf den Betrachter offenbart.[154] Das *trompe l'œil* schafft einen direkten Bezug zum Körper und der eigenen Realitätsebene. Man soll versucht werden, zu greifen, eine Fliege wegzuwischen etc. und aktiviert über das getäuschte Auge den Tastsinn. Der Körper soll zudem über das Bild vergangene oder immer wiederkehrende Ereignisse erneut erfahren. Auf diese Weise kann die eigene Pilgerreise oder das Gebet zu Heiligen, die Passion Christi, das Leiden Mariens etc. geistig vor Augen geführt und im Bild wiederholt präsent gemacht werden.[155] Durch diese geistige Bewegung wird räumliche sowie zeitliche Distanz überbrückt. Die Illustrationen des Stundenbuchs können diese innere Bewegung unterstützen und das Bild als „präsent machende" Vermittlungsinstanz vorführen, indem sie die Kraft der Seele aktivieren. Dabei spielt für den Rezipienten der einstmals bestehende direkte Kontakt zum heiligen Körper oder Objekt eine Rolle.[156] In einem Stundenbuch, das heute in London aufbewahrt wird (British Library, Add. 35313), vermitteln kleine Nadeln (Abb. 151) den Eindruck, die Pflanzen und Edelsteine wären auf der Buchseite festgesteckt worden, in der Mitte steht Maria Magdalena mit Salbgefäß in einer Landschaft, die an den Ort bzw. den Garten erinnern soll, an dem sie Christus nach der Auferstehung antraf und der auch von den Pilgern besucht werden konnte.[157]

Die Vermittlung zwischen heiligem Objekt und Betrachter funktioniert, nach Konrad von Megenberg, über das tatsächliche und das geistige Bild, das „Ebenbild einer geschätzten Sache (eines geliebten Dings), das in den Spiegel deiner Vernunft gedrückt ist, und das dich von einer Stätte an die andere zieht".[158] Die Möglichkeit soll hier eröffnet werden, die heilsame Wirkung von abgebildeten Objekten auf Körper und Geist zu denken, die entweder mit Heiligen in Kontakt standen (Pilgerzeichen) oder selbst heilsam sind (Edelsteine, Pflanzen) oder besser: beides.

So sollte auch der Rittersporn nicht nur einfach zur Messe der heiligen Odilia mitgebracht, sondern im Wachs haltbar gemacht werden. Dieses Verfahren macht das Heilkraut wiederum zu einem Bild, das aufbewahrt und angesehen werden kann. Der schützende Talisman oder, zugespitzt formuliert, das Kräuter-Bild verspricht gerade Heilung für das Organ des Sehens. Das Drücken in Wachs, das sicher in erster Linie zur Konservierung dient, wiederholt in zweiter Linie den Prozess des Eindrückens von Form in den Körper.

153 Kat.Ausst. Wien (1987), Nr. 19: Die Handschrift entstand für Ludwig XI., der den heiligen Adrian verehrte, der vor plötzlichem Tod und gegen die Pest schütze sollte. Ludwig XI., der auf fol. 3v zusammen mit seiner Ehefrau vor dem Retabel des heiligen Adrian in Grammont gezeigt wird, war selbst schwer krank und erhoffte sich Heilung durch Gebete und Stiftungen an St. Adrien de Grammont, dem Aufbewahrungsort der Reliquien des Heiligen.

154 Bredow-Klaus (2009), S. 135–188.

155 Zum Sehen mit dem physischen und dem geistigen Auge: Gormans / Lentes (2007) oder für das 16. Jahrhundert: De Angelis (2011).

156 Kaufmann (1993), S. 18–40.

157 Zumindest schreibt Bernhard von Breydenbach in seinem Pilgerbericht, er habe den Garten gesehen: Bernhard von Breydenbach (2010), fol. 49r.

158 Konrad von Megenberg (1475), Cap. „zu den Kräutern".

5.3.3. Kraft der Kräuterbilder

An dieser Stelle kann man, über die Kraft der Kräuter selbst hinaus, über die Wirksamkeit von Kräuter-Bildern auf den Körper nachdenken. Vom Garten versprach man sich beispielsweise eine positive Wirkung auf Körper und Seele. Das Spazieren durch den Garten aktiviere die Sinne, gleiche die Körpersäfte aus und vertreibe die Melancholie.[159] Dass sich das Betrachten von Objekten oder Farben positiv auf das Gemüt des Menschen auswirkt, konnte von der Farbforschung insbesondere für Grün nachgewiesen werden. Da der allgemeine Eindruck der kolorierten Kräuterbuchinkunabeln von einem satten Grünton dominiert ist, soll hier kurz auf die „rekreative" Wirkung von Grün auf das Auge und den Körper im Allgemeinen eingegangen werden. Die elementare Kraft dieser Farbe wird schon in frühmittelalterlichen Quellen thematisiert. In den „Etymologiae" (6, II) schreibt Isidor, dass Grün das Auge der Maler erfrische, und deutet dabei das „rekreative" Potential der Farbe an:

> [...] man solle keine goldenen Deckfelder in den Bibliotheken anbringen und keine anderen Bodenplatten als solche aus Marmor von Carystos, weil der Glanz des Goldes die Augen schwächt und die grüne Farbe des carysteischen Marmors sie erfrischt. Denn auch diejenigen, die Münzkunst erlernen, legen myrthengrüne Tücher unter ihre Münzmatrizen [...], und die Maler tun dasselbe, um ihre angestrengten Augen durch ihre grüne Farbe zu erfrischen.[160]

Im Hochmittelalter dichtete Baldricus Burgulianus (Carmen 12, ludendo de tabulis suis): „Grün soll eure Farbe sein, welche den Augen wohltut" („Sit vobis oculos viridis color ad recreandos").[161] Diese Kraft entfaltete die Farbe deshalb, weil sie mit der heilenden Wirkung von Edelsteinen in Verbindung stand. Schließlich lag die einfachste Erklärung für die Wirkung der Farbe auf den Menschen darin, dass sie aus heilenden Metallen, Pflanzen, Steinen besteht.[162] Der grüne Smaragd wurde in der Antike als Heilmittel für die Augen verstanden, pulverisiert verarbeitete man ihn zu einer Salbe.[163] In seinem Werk „De vita" setzt sich Marsilio Ficino mit der Farbe auseinander, darin beschreibt er Grün als positiv für Auge und Seele. Das ausgewogene Temperament und die Eigenschaften des Grüns solle man für sich nutzbar machen.[164] Der „Gart" als grüner, für die Augen erquicklicher Garten kann also nach zeitgenössischem Verständnis beim Blättern und Betrachten der kolorierten Pflanzenbilder, deren grüner Farbstoff vermutlich aus Pflanzenfarbe bestand, rekreative Wirkung entfalten.

159 Diese „diätetische Bedeutung" des Lustgartens ist u. a. bei Alberti, Albertus Magnus oder Petrus de Crescentiis beschrieben, allerdings bislang nur wenig erforscht: Lauterbach (2004), S. 58.

160 Zit. nach: Steinmann (2013) S. 54 f.

161 Zit. nach: Steinmann (2013), S. 232 f.

162 Leonhard (2013), S. 235 f.

163 Schäffner (2009), S. 147. Almut Schäffner untersucht in ihrer Dissertation „Terra verde" die Bedeutung des Grüns für die Malerei und Kunsttheorie der Renaissance. Karin Westerwelle zur „Säkularisierung" der Farbe Grün in der Literatur: Westerwelle (2014). Zur vielfältigen Bedeutung von Grün bei Hildegard von Bingen: Meier (1972). Außerdem zur Verbindung von Edelsteinen, Farbe und medizinischer Wirkung: Meier (1977).

164 Nach: Schäffner (2009), S. 155.

Dass Naturselbstdrucke von Pflanzen eventuell für den Betrachter eine positive Wirkung versprachen, hat Chojecka im Zusammenhang mit einer Bilderhandschrift von ca. 1520 vermutet.[165] Ihre Analyse ergab, dass in der sog. Krakauer „Bild-Enzyklopädie" sieben verschiedene Heilpflanzen mehrmals abgedruckt wurden (Abb. 207), am häufigsten: Scharfgarbe, Knöterich und Hahnenfuß.[166] Es ist nicht davon auszugehen, dass die Naturselbstdrucke lediglich eine dekorative Komponente der Handschriften darstellten. Sie stehen dort im Zusammenhang mit der Abwehr von schwarzer Magie, als Talismane sowie vor allem als heilsame Objekte für den Körper und sollen offenbar eine naturmagische Wirkung entfalten.[167] Die Naturselbstdrucke bezeugen den direkten Kontakt zum Objekt, der die Grundlage für dieses aktiv wirkende Pflanzen-Bild ist.[168]

In einer weiteren „Bild-Enzyklopädie", die in Analogie zur Krakauer Handschrift gestaltet ist, wurden ebenfalls auf diversen Seiten Naturselbstdrucke angebracht (Abb. 208–209). Relativ unvermittelt stößt der Betrachter dort auf eine Seite, auf der in Form einer Federzeichnung eine Koralle[169] angebracht wurde (zum Vergleich: Abb. 210) und auf der es heißt: In Worten, Kräutern und Steinen liegt viel Kraft (Abb. 209).[170] Schreibt man Naturselbstdrucken eine Wirksamkeit auf den Betrachter zu, kann man sie an dieser Stelle auch für die gezeichnete Koralle annehmen.[171] Schließlich konnte das Einprägen des Bilds allein als zuträglich für die Seele dargestellt werden.[172] Ficino beschreibt in „De vita" die Heilsamkeit von Pflanzen, aber auch von künstlich geschaffenen Zeichen oder Talismanen, die für ihn in einem gemeinsamen, kosmischen Zusammenhang stehen.[173] Heilwirkung besteht nach Ficino aus dem Zusammenspiel der

165 Die Bilderhandschrift wird heute in Krakau aufbewahrt. Eine ähnliche Handschrift existiert außerdem in Erlangen. Beide Handschriften enthalten Naturselbstdrucke sowie zahlreiche Abbildungen und sind in Bayern um 1520 angefertigt worden, sie werden als „Bayerische Bild-Enzyklopädien" bezeichnet. Rudolph (2015), S. 466–478. Wimböck (2004), S. 13 f. Ausführlich zur Krakauer Handschrift: Chojecka (1982).

166 Chojecka (1982), S. 19.

167 Einen Überblick zum Gebrauch von Talismanen und naturmagischen Objekten sowie dem Magie-Begriff bis in die Frühe Neuzeit: Möseneder (2009). Otto (2011). Mulsow (2010). Zur Magie im Mittelalter: Kieckhefer (1992).

168 Zu diesem substitutiven Bildakt: Bredekamp (2010), S. 178–186.

169 Die Koralle galt als Meeresbaum oder Meerespflanze, siehe auch: Böhme (2007).

170 Im oberen Teil der Seite ringen zwei Figuren miteinander; dies gehört noch zum vorangegangenen Teil der Handschrift, die auch ein Ringbuch enthält. Im unteren Bereich wird eine Cholerikerin dargestellt, die dabei ist, mit einem Besen o. ä. auf ihren Mann einzuschlagen, der mit abwehrender Geste gezeigt wird. Die „Ehezwist"-Szene ist nur schwer erkennbar, zu dieser Zeit jedoch recht geläufig und auch in der Krakauer Handschrift zu finden: Chojecka (1982), S. 108. Zwischen diesen Szenen, die beide mit Kraft zusammenhängen, steht das Sprichwort: „In Worten, Kräutern und Steinen liegt viel Kraft" (darunter ein weiteres Mal in Latein; das Sprichwort existiert noch in einer weiteren Version: „In verbis in herbis et in lapidibus est deus", siehe: Gerhardt / Schnell [2002]). Zwischen dem Mann und seiner Frau sieht man die Naturselbstdrucke, die auf der anderen Seite angebracht wurden, durch das Papier schimmern. Diese „Flecken" wurden teilweise mit schwarzer Tinte umfahren und in das Bild integriert. Als Federzeichnung wird vom Maler der Handschrift ein Stück einer Koralle dargestellt.

171 Zu Korallenbildern, die als Amulette getragen werden konnten: Saß (2012), S. 24–29.

172 Heinrichs (2007), S. 24 f., S. 36 f. Zu bildmagischen Vorstellungen in der Frühen Neuzeit: Bredekamp (1995). Silver / Smith (2002). Zur aktiven Eigenmacht des Bilds: Bredekamp (2010).

173 Scheuermann-Peilicke (2000), S 165–167.

Gestirne,[174] die ihre „Qualitäten" in die Pflanzen eingießen, ähnlich, wie es Petrus de Crescentiis für die „Formen" darlegte.[175] Die *virtus* der Pflanzen kann auch anhand ihres künstlich geschaffenen Bilds wirksam werden. Durch den Betrachter wird die Wirkkraft der Bilder befördert, der sich die Bilder im Geist einprägen und sie wiederholt präsent machen sollte.[176] Eventuell versprachen sich die Rezipienten des „Gart der Gesundheit" von den abgebildeten Heilmitteln in diesem Sinne auch eine aktive Wirkung auf den eigenen Körper.[177]

174 Bei Klibensky, Panofsky und Saxl wurden Ficinos Ausführungen ausführlich analysiert: „Die Wirkungen, die von den irdischen Dingen ausgehen, die Heilkraft der Medikamente, der mannigfache Einfluss des Dufts von Pflanzen, die psychologische Wirkung der Farben [...] – all das ist in Wahrheit nicht diesen Dingen zuzuschreiben, sondern kommt nur dadurch zustande, dass der Gebrauch bestimmter Stoffe oder die Ausübung bestimmter Tätigkeiten, um mit Ficinos Worten zu reden, denjenigen Gestirnen ‚exponiert', mit deren Qualitäten die entsprechende Stoffe gesättigt sind oder deren Natur der betreffenden Tätigkeit angeglichen ist." Klibansky / Panofsky / Saxl (1992), S. 385 f.

175 So sei, nach Ficino, die Muskatnuss gesättigt mit der Qualität der Sonnenstrahlen und die Pfefferminze mit der Qualität der Sonne und Jupiters zugleich: Klinbansky / Panofsky / Saxl (1992), S. 380.

176 Leonhard (2013), S. 215, Fußnote 66: „[...] dass die Einbildungskraft bzw. die Betrachtung von Bildern den Körper beeinflussen kann, war bereits von Galen (De sanitate tuenda) geäußert und im 15. und 16. Jahrhundert vor allem über die Schriften von Marsilio Ficino (1433–1499) und Theophrastus Paracelsus propagiert worden." Bei Ficino gibt es an dieser Stelle einen Zwischenschritt: Die äußeren Bilder können nicht im Körper haften, nur die Bilder, die die Seele entwirft, die viel reiner sind als die äußeren Bilder. Indem die äußeren Bilder die reinen Bilder der Seele entstehen lassen, können sie auf Körper wirken. Ficino (1994), Oratio sexta, VI (207). Hannah Baader arbeitete heraus, dass nach dieser Vorstellung Menschen mit starker Imagination entweder als gefährdeter oder begabter galten, da das eingeprägte Bild sich in ihnen intensiver entfalten konnte. Baader (2005), S. 149.

177 Im Grunde hatte im „Gart" auch ein Kontakt zur Pflanze stattgefunden, nämlich über den Auftraggeber und den Maler auf der Pilgerfahrt ins Heilige Land. Zur „ansteckenden Wirkung" von Talismanen und letztlich auch Bildern: Baader (2005). Sie betont, dass um 1500 die „intensive Suche nach einer natürlichen Magie zu einem ebenso intensiven Nachdenken über die Kraft der Imagination geführt hat." Baader (2005), S. 135. Die Beschäftigung mit magischen Praktiken am Beginn der Frühen Neuzeit betrachtet Baader nicht als Sache der Volkskultur, sondern als Thema der Naturwissenschaft. Baader (2005), S. 136.

6. KRÄUTERBÜCHER OHNE BILDER?

Im Hinblick auf das Illustrationsprogramm sowie der Art und Weise, wie Pflanzen dargestellt werden sollten, waren dem Mainzer „Gart der Gesundheit" von 1485 grundsätzliche Gedanken zur Bebilderung eines Kräuterbuchs vorangegangen. Dem Vorwort Bernhards von Breydenbach sind einige dieser Gesichtspunkte zu entnehmen, die für die Pflanzenbilder des „Gart" zentral waren, wie derjenige der Wiedergabe der wahren Gestalt der Pflanze sowie der Vermittlung von Erfahrenem durch das Bild. Weitere Perspektiven auf die Illustration von Kräuterbüchern eröffnen die Vorworte von Otto Brunfels, Leonhart Fuchs und Hieronymus Bock im 16. Jahrhundert, die wiederum Rückschlüsse auf bedeutsame Aspekte für die Pflanzenbilder im „Gart" zulassen, wie denjenigen der Wiedererkennbarkeit von lebenden Objekten oder des Erkenntnisgewinns mittels Darstellungen. Außerdem erlaubt ein Blick von der ersten Hälfte des 16. Jahrhunderts zurück in die 1480er Jahre eine differenzierte Kontextualisierung der Kräuterbücher von Brunfels, Fuchs und Bock, die bislang – vor allem was die frühneuzeitliche, naturwissenschaftliche Illustration betrifft – stets als völlige Neuheiten gewertet wurden.[1]

In der Frühen Neuzeit wurde das Bild im naturwissenschaftlichen Buch zum viel diskutierten Gegenstand.[2] Die Autoren des 16. Jahrhunderts offenbaren in ihren Vorworten ihr Verhältnis zu der verbreiteten „Lust auf Malerei"[3] („lust zum gemelde") in Kräuterbüchern.[4] Während Fuchs ein vehementer Verteidiger des Pflanzenbilds war, sind Brunfels und Bock eher als Skeptiker zu bewerten, die erst seitens ihrer Verleger überzeugt werden mussten, Pflanzen abzubilden. Im Gelehrtenstreit um das Bild kristallisierten sich im 16. Jahrhundert zwei Hauptargumente gegen die Illustration heraus, die beide ineinander übergreifen und die auf antike Autoren, Plinius d. Ä. und Galen, zurückgeführt wurden.[5] Zum einen wurde im Rückgriff

1 Dabei war den Kräuterbuchautoren vor allem wichtig zu vermitteln, sich von der Bildtradition des Mittelalters völlig gelöst und etwas Neues herausgebracht zu haben. Im Titel der Kräuterbücher von Bock und Fuchs steckt jeweils das Wort „neu". Park und Daston beschreiben diese Tendenz des „Age of New" innerhalb der Naturwissenschaften des 16. Jahrhunderts, stets etwas Neues in Text und Bild kreieren zu wollen und sich von der mittelalterlichen Tradition abzusetzen: Park / Daston (2006a), S. 1–6. Aber auch die heutige Forschung hat die Neigung, den spätmittelalterlichen „Gart" gegenüber den frühneuzeitlichen Kräuterbüchern zu übersehen. So spielt der „Gart" bei Kusukwa (2012) beispielsweise keine Rolle.

2 Kusukawa zeichnet diesen Bilddiskurs im 16. Jahrhundert nach: Kusukawa (2012), S. 98–177. Einen kurzen Überblick liefert: Swan (2011). Da im 16. Jahrhundert lediglich Autoren oder manchmal Verleger zu diesem Thema Stellung nahmen, fehlen die Argumente der Künstler völlig.

3 Rihel (1539), S. 1.

4 Für das 16. Jahrhundert kann man, nach Ogilvie, geradezu eine „Explosion" an Bildern in naturkundlichen Werken beobachten. Ogilvie (2003), S. 141.

5 Siehe: Plinius (1985), Buch 25, Kap. IV. Vgl. Zitat in Fußnote 14 von Kapitel 1. Über die präzise Aussage Galens war man sich uneinig. Fuchs argumentierte beispielsweise, dass Galen seine vermeint-

auf Plinius die Schwierigkeit der Darstellung des lebendigen Objekts betont und zum anderen vertraten Galenisten die Ansicht, dass nur durch das Wort und nicht durch das Bild wahre Erkenntnis zu gewinnen sei.[6]

So vermag das Bild keine Zeitlichkeit darzustellen, schreibt Brunfels in seinem Vorwort von 1532.[7] Eine Abbildung allein könne das Aussehen der Pflanzen nicht festhalten, da sie sich in kurzer Zeit so stark veränderten, dass es leicht zu Irrtümern („grossz yrthumb") kommen könne.[8] Im Grunde müsse man eine Pflanze vier Mal abbilden, um sie in allen Wachstumsphasen zu zeigen.[9] Folglich galt es, für die Illustration das lebendige Objekt so abzubilden, dass keine Irrtümer, Verwechslungen oder falsche Identifikationen entstehen konnten.

Die Wiedererkennbarkeit der Pflanze für den Rezipienten wird durch die Darstellungen des „Gart" auf verschiedene Arten ermöglicht. Zum einen griff man auf die vorhandene Bildtradition von Kräuterbüchern zurück, die über einen längeren Zeitraum hinweg ein kontinuierliches Bildprogramm hervorgebracht hatten, also auf die „Tractatus de herbis"-Tradition. Im Anschluss daran konnten sowohl wiedererkennbare als auch glaubhafte Abbildungen der Pflanzen erzeugt werden. Dabei wurden die Bilder aus dieser Tradition so weit variiert, dass mehr Lebendigkeit innerhalb des Pflanzenbilds entstand. Weiterhin konnte man sich, gerade was die Wiedererkennbarkeit einheimischer Pflanzen betraf, weiter von der Tradition entfernen und fertigte zunehmend naturnahe Abbildungen für den „Gart", die suggerieren sollten, der Künstler habe sie nach dem lebenden Objekt dargestellt. Um die Pflanze in verschiedenen Wachstumsphasen erkennbar zu machen, wurden in den Abbildungen des „Gart" möglichst verschiedene Details der Pflanze veranschaulicht, die zu ihrer Identifizierung beitragen konnten, wie Blüten und Knospen. Beispielsweise wird beim Schlafmohn sowohl die Blüte als auch die Mohnkapsel gezeigt (Abb. 153). Anzeichen von Zeitlichkeit werden ebenfalls gegeben, wenn das „Gewöhnliche Hirtentäschel" (*Capsella bursa-pastoris*) schon im Begriff ist, zu welken (Abb. 154).

Um unwiderruflich zu beweisen, dass ein Bild durchaus mehrere Wachstumsstadien darstellen konnte, ließ Leonhart Fuchs einige Pflanzen in seinem Kräuterbuch von 1542 so abbilden, dass sie gleichzeitig sowohl Blüten als auch Früchte tragen (Abb. 155),[10] woran deutlich wird, wie verbreitet dieser Einwand von Plinius gegen das Pflanzenbild war.[11]

liche Kritik an Bildern nur darauf bezogen habe, dass man Wissen nicht allein aus Bildern – und aus Texten (nur anhand der Pflanze selbst) – beziehen könne. Andere Autoren wiederum verwarfen Bilder aufgrund dieses Arguments völlig. Hierzu: Kusukawa (2012), S. 128–131.

6 Man kann diese Argumente in naturwissenschaftlichen Diskussionen bis in die Moderne weiterverfolgen: Ford (2003), S. 565.

7 Insgesamt greift Brunfels für diese erste, deutschsprachige Geschichte der Kräuterbücher in 33 Kapiteln, die als Vorwort für sein „Contrafayt Kreüterbúch" (1532) fungiert, in großen Teilen auf die „Naturalis historia" von Plinius zurück. Dilg (1978), S. 74–76. Habermann (2001), S. 170–223.

8 Brunfels (1532), Vorwort, XX. Capitel.

9 Die Pflanzen gleichen dem Menschen darin, schreibt Brunfels, dass auch sie einem zeitlichen Ablauf (Kindheit, Jugend, Mannesalter, Reife) unterworfen sind, der in vier Stufen begriffen wird: Knospen, Blütezeit, die Zeit des Befruchtens, die Zeit des Welkens. Brunfels (1532), Vorwort, XX. Capitel. Zum Aspekt der Zeitlichkeit im Pflanzenbild des 16. Jahrhunderts: Rudolph (2016).

10 Kusukawa analysiert diese Art der Darstellung bei Fuchs als bewusst gesetzte Argumente gegen den Einwand von Plinius d. Ä., Bilder können keine Zeitlichkeit veranschaulichen. Kusukawa (2012), S. 115.

11 Dass Fuchs diese synchronen Pflanzenbilder nicht erfunden hat, sondern diese schon um 1400 exis-

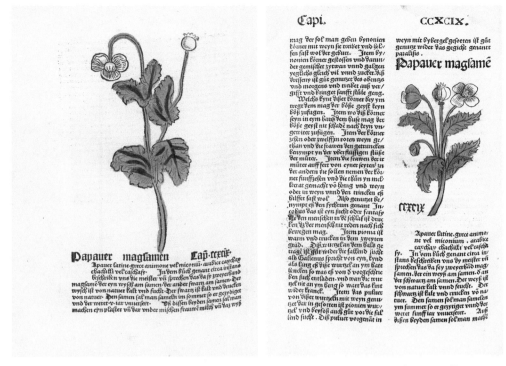

Abb. 153a: Schlafmohn: Gart der Gesundheit. Mainz 1485. München, BSB, 2 Inc.c.a. 1601.

Abb. 153b: Schlafmohn: Gart der Gesundheit. Straßburg um 1487. München, BSB, 2 Inc.s.a. 600.

Weiterhin sprach man sich gegen die Illustrationen von naturwissenschaftlichen Texten aus, da man die Ansicht vertrat, dass sie kein Wissen erzeugen würden. Wort und Bild werden hierbei als Oppositionen verstanden.[12] Ein in diesem Zusammenhang immer wieder zitierter Faktor war die Lebendigkeit und Farbigkeit der Pflanzen, die man im Bild nicht adäquat wiedergeben könne. Das beschreibende Wort wird über die Illustration gestellt, weil es die Farbe und Gestalt differenziert darzustellen vermöge. Lediglich über das Wort oder die direkte Anschauung gelange man zu wahrem Wissen.[13] Nützlicher als Abbildungen, schreibt Brunfels in diesem Zusammenhang, seien deshalb Gärten, um „zur Erkenntnis über Kräuter" zu gelangen. Dort

tieren, konnte Schnell anhand einer Apuleius-Handschrift aufzeigen: Schnell (2017), Nr. 70.1. Eine Edition ist 2018 erschienen.

12 Dies hat sich, nach Ford, bis heute in naturwissenschaftlichen Werken kaum geändert. Er gibt zu Bedenken, dass die Vertreter der Naturwissenschaften allerdings kaum abstreiten können, dass das Bild eine zentrale Komponente in ihren Disziplinen darstellt, dies gelte insbesondere für die Botanik, die einen reichen Fundus an Bildmaterial hervorgebracht hat. Ford (2003), S. 565. Einen Überblick zu diesem Fundus vermittelt die Aufsatzsammlung „The art of natural history. Illustrated treatises and botanical paintings": O'Malley / Meyers (2008).

13 Vgl. hierzu die Argumente von Bock, die über das Vorwort von seinem Verleger, Wendel Rihel, überliefert sind: Rihel (1539), S. 1. Bock meinte, dass es im Druck nicht möglich sei, die Farbigkeit der Pflanze wiederzugeben. Zum „failure of colour": Freedberg (1994).

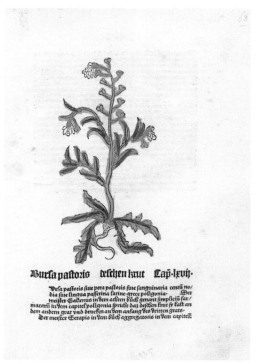

Abb. 154: Hirtentäschel: Gart der Gesundheit. Mainz 1485. München, Bayerische Staatsbibliothek, 2 Inc.c.a. 1601.

Abb. 155: Schlehdorn: Fuchs: De historia stirpium. Basel 1542. London, Wellcome collection.

könne man am lebendigen Objekt studieren, ohne auf die „tote Linie" des Bilds angewiesen zu sein.[14]

Um an der Pflanze und anhand von Schriften forschen zu können, war Otto Brunfels eigens von Straßburg nach Hornbach gereist, um Hieronymus Bock zu treffen. Bock berichtet, Brunfels habe ihm geraten, sein Wissen im Buch festzuhalten, nachdem er seine Pflanzensammlung und Aufzeichnungen zu Kräutern gesehen habe.[15] Daraufhin brachte Bock 1539 ein eigenes Kräuterbuch ohne Abbildungen auf den Markt.[16] Wendel Rihel, der Drucker des „New

14 Brunfels (1532), Vorwort, XXI. Capitel: „Wie die Alten gárten gepflanzet haben, da mit sye kámen zú erkantnütz der kreüter. [...] Es seind noch etliche andere gewest, diweil (wie obgesagt) kreüter malen, múgsam vnd gefárlich zútreffen, haben sye ynen eygen gárten gepflantzet. Als Antonius Castor zú Rom, daruff eygen bawleüt gehalten, vnd allerley geschlecht der kreüter darinn gepflantzet, damit sye solich nit mit todten linien abcontrafeyt, sonder lebendig vnnd augenscheinlich wachßen sehen." Zwar geht diese Passage erneut auf Plinius d. Ä. zurück (Plinius [1985], Buch 25, Kap. V.), von den toten Linien der Bilder war dort allerdings noch keine Rede. Brunfels verschärft das Argument hier noch einmal, indem er Tod und Leben direkt gegenüberstellt.

15 Bock (1551), fol. b ij recto – b ij verso.

16 Hieronymus Bocks erstes Kräuterbuch war 1539 noch unbebildert, er beugte sich schließlich den

Kreütter Buch" von Bock, sieht sich dazu veranlasst, das Fehlen der Illustrationen in einem
eigenen Vorwort zu kommentieren. Er versichert dem Leser, dass er willens gewesen sei, neue
Figuren von frischen Kräutern abmalen zu lassen und zu jedem Kraut ein wahrhaftes Abbild
zu drucken. Der Schreiber, Hieronymus Bock, habe dies jedoch nicht für gut befunden und
ihm von aufwendigen, teuren Bildern abgeraten, da sie für den Verstand des Lesers nicht viel
leisteten und nicht der Erkenntnis dienten. Bock habe ihn, so schreibt Wendel weiter, davon
überzeugt, dass es im Bild nicht möglich sei, die feinen Unterschiede der Pflanzen zu beschrei-
ben, dies müsse in Worten geschehen.[17] Das Wissen, das in anderen illustrierten Büchern nur
vom „vngewissem augenschein" her komme, stamme in Bocks Kräuterbuch vom „rechtem ver-
standt".[18] Bock argumentierte also gegen die Verwendung von Pflanzenbildern, weil er die Na-
turbeobachtung durch den Künstler als unzuverlässige Wissensquelle betrachtete.[19]

Dagegen äußerte sich wiederum Fuchs in seinem Kräuterbuch von 1542 und hob dabei die
Illustrationen als der Sprache überlegenes Mittel der Darstellung hervor: „Wer mit klarem Ver-
stand würde ein Bild verurteilen, welches eine Sache klarer ausdrücken kann als der Wortge-
wandteste, der versucht eine Sache nachzuzeichnen."[20] Die Möglichkeit, das Abwesende präsent
zu machen bzw. das ephemere Objekt über seine Lebensdauer hinaus zu erhalten, waren starke
Argumente für die Verwendung von Pflanzenbildern. Die Gegenargumente von Brunfels und
Bock machen im Umkehrschluss diese Vorteile der Illustrationen deutlich und geben gleich-
zeitig Aufschluss zum Anspruch, den Bernhard von Breydenbach an sein Kräuterbuch herange-
tragen hatte: Im „Gart" sollten die Pflanzen in „rechter Farbe und Gestalt" gezeigt werden, die
der Auftraggeber zusammen mit dem Künstler, Erhard Reuwich, auf der Reise ins Heilige Land

Anforderungen des Markts und gab 1546 ein Kräuterbuch mit Illustrationen heraus. Hieronymus
Bock: Kreüterbuch, darinn Underscheidt Namen und Würckung der Kreutter, Stauden, Hecken
unnd Beumen sampt ihren Früchten, so inn Deütschen Landen wachsen. Straßburg: Wendel Rihel,
1551. VD16 B 6017. [2. Aufl. 1546: VD16 B 6016. 1. Aufl. 1539 ohne Illustrationen: VD16 B 6015.].
Hieronymus Bock: De stirpium, maxime earum, quae in Germania. Straßburg 1552. VD16 B 6026.
Zu Bocks Kräuterbüchern: Hoppe (1969). Isphording (2008), S. 146 f. Kat.Ausst. Schweinfurt (2011),
S. 102.

17 Rihel (1539), S. 1: „Wisse lieber Leser, das ich lang in willens gewesen, fur dieß new kreüter Búch,
newe figuren von den frischen kreüttern abmalen zúlassen, vnnd bei eyn yedes kräut sein wahrhafftig
abbildung zú trucken. Welches mein vorhaben, Herren Hieronymum den schreibern nit hat für
gút angesehen, sunder hat mir geratten, das ich keyn arbeyt anwendet, die den kauffer am gelt be-
schweret, vnnd am verstand den leser nit vil dienen móchten, […], Dann wan war die farben nit wol
zútrucket, vnd also yedes geschlecht sein gemeldes hette, so würde das búch zú groß vnnd am kauff
zú schwere werden. […] Aber damit dem leser nichts abgehe, hab er sich beflissen, yedes kraut, mit
allen seinen geschlechten deutlich zúbeschreiben, vnd durch alle vmbstende vnd eygentschafft, als an
stengeln, zincken, kraut, bletter, blúmen, safft, farben vnd der gleichen von allen andern eygentlich
zúvnderscheyden."
18 Rihel (1539), S. 1.
19 Wenn man möchte, solle man sich zu diesem Buch noch ein weiteres Buch mit schönen Abbildungen
(„figuren") kaufen, wie sie derzeit allerorts verlegt werden. Rihel (1539), S. 1.
20 Fuchs (1542), fol. β recto: „quis quaeso sanae mentis picturam contemneret, quam constat res multò
clarius exprimere, quàm verbis ullis, etiam eloquentissimorum, deliniari queant." Kusukawa versteht
dies insbesondere als Absage an den Galenisten Janus Cornarius, der diverse Werke zur Medizin ex-
plizit ohne Abbildungen veröffentlichte. Kusukawa (2010), S. 125–131.

selbst erkundet hatte.[21] Die Herausforderung an die Abbildungen bestand darin, die nicht vor Ort verfügbare, vergängliche Pflanze präsent werden zu lassen und im Bild zu erhalten. Damit deckt sich offenbar die Auffassung zum Potential des Pflanzenbilds von Leonhart Fuchs mit der von Bernhard von Breydenbach. Das transportable Bild bringt die Erfahrung in einen größeren Diskurs ein und schafft dadurch die Möglichkeit der Erkenntnis.[22]

Schließlich fielen auch die von Hieronymus Bock vorgebrachten Argumente gegen das Bild nicht auf fruchtbaren Boden. Die nächsten Ausgaben seines Kräuterbuchs erschienen mit zahlreichen Abbildungen des Künstlers David Kandel (Abb. 156, 158, 161).[23] In der Vorrede von 1551 bedankt sich Bock bei seinem Künstler, mit dem er an den Pflanzenbildern gearbeitet hatte, indem er seiner „wohlwollend gedenkt", und stellt ihn als „jungen Knaben" und schlichten Künstler dar:[24]

> Der junge David hat alle Kräuter, Stauden, Hecken und Bäume, wie ich sie ihm darlegte, auf das aller ungekünsteltste, schlichteste und doch wahrhaftigste [gezeichnet], nichts hat er dazu getan noch weggelassen, sondern jedes Gewächs so, wie es war,[25] mit der Feder präzise abgezeichnet („abgegriffen").[26]

Kandel hat demnach für Bock die Abbildungen anhand der wörtlichen Beschreibung der Pflanzen („wie ich sie ihm darlegte") entworfen.[27] Der Künstler sollte nichts selbstständig hinzufügen, sondern ein schlichtes Bild der Beschreibung anfertigen, die er erhalten hatte. Damit wird Kandel zur ausführenden, aber nicht eigenständig agierenden Hand des Autors stilisiert, was ihn für Bock zum idealen Illustrator seines Werks machte.[28]

21 Bernhard von Breydenbach (1485), fol. 2v.

22 Hierzu u. a.: Latour (2006).

23 War das Kräuterbuch von Bock ohne Abbildungen noch wenig erfolgreich, wurden seine Kräuterbücher mit Illustrationen gekauft. Zu Bocks Kräuterbüchern und der Problematik des Abbildens und Beschreibens im Naturbuch: Hoppe (1969) und Hoppe (1970).

24 Bock (1551), b i verso. Das Vorwort dieser zweiten Auflage ist länger als das der ersten von 1546. Vgl. auch: Giesecke (2006), S. 690. Kandel (gest. um 1596) war zum Zeitpunkt des Erscheinens der Erstauflage des Kräuterbuchs von 1546 etwa 25 Jahre alt. Er war auch für Stephan Münsters „Cosmographia" (1544) als Illustrator tätig. Zum Künstler, der auch als Maler tätig war: Châtelet-Lange (2007), v. a. S. 17–19.

25 Bock lässt offen, in welcher Form der Künstler die Pflanzen, die er abbilden sollte, vor sich hatte. Die Beschreibung des Arbeitsprozesses durch Bock legt jedenfalls nicht sofort nahe, wie es andere Autoren zu dieser Zeit suggerieren, der Künstler hätte „von der lebenden" Pflanze abgezeichnet.

26 Bock (1551), b ij recto: „der selbig Jung David hat alle Kreüter, Stauden, Hecken vnnd Beum, wie ich ihm die selben fürgelegt auffs aller Einfaltigst, schlechst, vnd doch Warhafftigst, nichts dazú, noch daruon gethon, sondern wie ein jedes Gewáchs an ihm selber war, mit der feder seüberlich abgegriffen."

27 Bock (1551), b ij recto.

28 Betrachtet man alle Illustrationen des Pflanzenbuchs von Bock, stellt man fest, dass Kandel in einigen Fällen doch nicht ganz nach der Anweisung Bocks gearbeitet haben kann bzw. dieser ihm mehr Freiheiten gelassen hat, als man zuerst annehmen könnte. Zumindest wirkt es nicht schlicht und ungekünstelt, wenn Kandel unter dem Maulberbaum das Drama von Pyramus und Thisbe darstellt, deren Blut die Maulbeeren gefärbt hatten; oder wenn, wie es in einigen „Gart"-Ausgaben nach 1485 bereits der Fall war (Abb. 100), Fuchs und Rabe/Elster(?) im Bild auftauchen (Abb. 156). Diese nar-

Abb. 156: David Kandel: Birnbaum und Maulbeerbaum. Hieronymus Bock: Kreüterbuch. Straßburg 1551. München, Bayerische Staatsbibliothek, Res/2 Phyt. 25.

Während bei Bock noch etwas im Unklaren gelassen wird, ob sein Künstler die Pflanze selbst vor Augen hatte, wird dies bei Fuchs deutlich: Nach seiner Auffassung stellte das Naturstudium die maßgebliche Voraussetzung für das evidente Pflanzenbild dar. Dabei wies er seine Illustratoren dazu an, eine natürliche Form (*nativa forma*) der Pflanze zu kreieren: Nichts, was dem Maler sonst Ruhm einbringe, solle das Pflanzenbild zeigen. Diese natürliche Form erforderte einen technisch geschickten Künstler, der einerseits lebendige und wahre Bilder erzeugt und andererseits sein Kunstschaffen verbirgt.[29] Die Aussagen der Kräuterbuchautoren über ihre Bilder und Künstler geben an dieser Stelle einen Einblick, was die Illustration im Kräuterbuch von der Kunst unterscheidet, die dem Maler Ruhm bringen soll.[30] Gleichfalls mit der Pflanze selbst war auch ihr Abbild zum eigenständigen Gegenstand wissenschaftlicher Auseinandersetzung geworden.[31]

Die Anforderung an eine „naturwissenschaftliche Illustration", wie sie bei Fuchs im Detail festgehalten wurde, deckt sich mit dem Bildkonzept des „Gart", für das Erhard Reuwich Pflanzenbilder erzeugte, die die freigestellte Pflanze zeigen, also ohne Landschaftshintergrund, menschliche Figuren oder ähnliches, womit der Maler sonst Ruhm erwerben würde. Reuwich suggeriert durch einen natürlich wirkenden Lichteinfall, Verkürzungen und Drehungen im Pflanzenkörper, die Bewegung andeuten, dass er die Pflanze *ad vivum* darstellt. Dass der Illus-

rativen Szenen bringt Kandel erst im letzten Teil des Kräuterbuch, zu den Bäumen, hier haben die menschlichen und tierischen Figuren den Vorteil, dass sie die Größe des Baums veranschaulichen sowie Gelehrsamkeit in Bezug auf andere Wissensgebiete, wie antike Erzählungen, verdeutlichen. Ähnliche Darstellungen sind auch im botanischen „Album" von Pietro Antonio Michiel zu finden, vgl. Egmond (2017), S. 113–125.

29 Fuchs (1542), fol. α 6 verso. Vgl. auch: Swan (2006), S. 71 f. Niekrasz / Swan (2006), S. 780. De Angelis (2011).

30 Hierzu ausführlich: Kusukawa (2012), S. 114–123.

31 Kusukawa (2012), S. 29–47.

 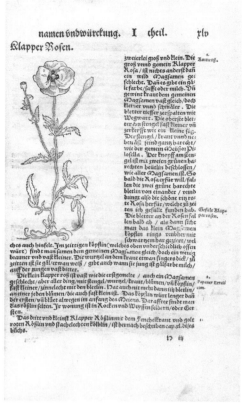

Abb. 157: Klatschmohn: Brunfels: Contrafayt Abb. 158: Klatschmohn: Bock: Kreüterbuch. Straß-
Kreüterbúch. Straßburg 1532. München, Bayerische burg 1551. München, Bayerische Staatsbibliothek,
Staatsbibliothek, Rar. 2264. Res/2 Phyt. 25.

trator die Pflanze kennen und auch gesehen haben muss, sind Ansprüche, die man im 16. Jahr-
hundert für die Illustratoren von Kräuterbüchern formulierte und die ebenso bei Bernhard von
Breydenbach deutlich werden, wenn er schreibt, Reuwich habe die Pflanzen nach der Natur
„konterfeit".[32]

Man betonte schließlich so stark, dass die Künstler die Pflanze nach der Natur gezeichnet
hatten, dass man andere Prozesse verbarg, durch die man auch Pflanzenbilder kreieren konnte,
insbesondere das Kopieren nach älteren Vorlagen. Trotzdem ist zu beobachten, dass man wei-
terhin im 16. Jahrhundert Darstellungen aus Vorlagen heranzog – einige Abbildungen bei
Fuchs sind in variierter Form aus Brunfels entnommen, Kandel wiederum kopierte für das
Kräuterbuch von Bock aus Fuchs und Brunfels (Abb. 157–161). Dass die Künstler bei der auf-
wendigen Herstellung von Kräuterbüchern auf das Kopieren aus anderen Werken angewiesen
waren, wurde nach Möglichkeit nicht offenbart. Die Strategien des Kopierens und Variierens
der Vorlagen durch die Künstler ähneln der Arbeitsweise, wie man sie bei der Übertragung
der Pflanzenbilder aus dem „Codex Berleburg" im „Gart" angewendet hatte: Indem man die

32 Bernhard von Breydenbach (1485), fol. 2v.

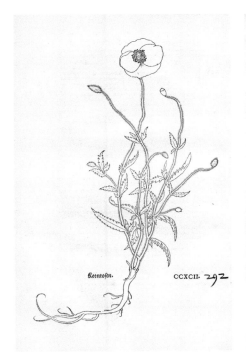

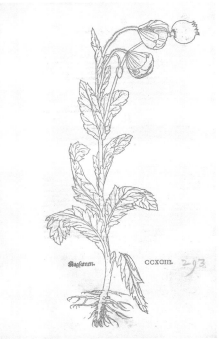

Abb. 159: Klatschmohn: Fuchs: New Kreüter-
buch. Basel 1543. München, Bayerische Staats-
bibliothek, Rar. 2037.

Abb. 160: Schlafmohn: Fuchs: New Kreüter-
buch. Basel 1543. München, Bayerische Staats-
bibliothek, Rar. 2037.

Abb. 161: Schlafmohn: Bock: Kreüterbuch.
Straßburg 1551. München, Bayerische Staatsbib-
liothek, Res/2 Phyt. 25.

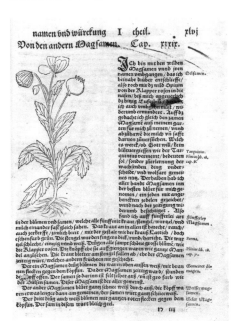

Pflanze etwas dreht oder um Details wie Blätter
oder Blüten erweitert, kann man die Vorstellung
erzeugen, ein neues Pflanzenbild nach der Natur
geschaffen zu haben. Unabhängig vom tatsäch-
lichen Arbeitsprozess des Künstlers wird im Vorwort
bei Bernhard von Breydenbach deutlich, dass das
Naturstudium durch den Künstler für die Bebilde-
rung des Kräuterbuchs das zu bevorzugende Dar-
stellungsmittel repräsentiert. Obwohl auch Erhard
Reuwich auf Vorlagen zurückgriff, wird suggeriert,
der Künstler habe ausschließlich nach der Natur
gezeichnet. Dieser Impuls, der hier im „Gart der
Gesundheit" gesetzt wird, ist wiederum für die na-
turwissenschaftliche Illustration des 16. Jahrhun-
derts maßgeblich.

Abschließend sollen Aspekte in Betracht gezogen werden, die für die Rezeption des „Gart" als impulsgebendes Werk für die illustrierten Pflanzenbücher des 16. Jahrhunderts hinderlich waren.

Allen hier betrachteten Kräuterbüchern liegt die Intention zugrunde, Wissen festzuhalten und mit den Mitteln des Buchdrucks einem größeren Publikum zur Verfügung zu stellen.[33] Dabei steht Brunfels 1530 mit seinem Kräuterbuch[34] einer großen Konkurrenz auf dem Markt gegenüber, die durch den „Gart der Gesundheit" bzw. seine zahlreichen Nachschnitte und Nachbearbeitungen erzeugt wurde. Um sein Werk etablieren zu können, nimmt Brunfels eine Abwertung aller bisherigen gedruckten Kräuterbücher vor. Als schlechte Drucke klassifiziert er sie aufgrund ihrer Verwendung kostengünstiger Verfahren, fehlender Kennerschaft, falscher Beschreibungen und zweifelhafter Quellen. So schlecht seien diese Drucke, dass „etliche schreiben: Sie geben keinen Pfifferling für Kräuterbücher".[35] Zwar nennt Brunfels kein konkretes Werk, allerdings konnte er im Grunde nur auf das bis dahin verbreitetste Kräuterbuch anspielen, den „Gart der Gesundheit".[36] Die Konkurrenzsituation auf dem Buchmarkt muss Brunfels' Argumentation und Rhetorik bedingt haben, denn andererseits hatte er die Wiederaufnahme der antiken Kunst doch gerade für die Zeit postuliert, in der der „Gart" erschienen war.[37] In der Neuzeit hat sich diese Beurteilung der gedruckten Kräuterbücher vor Brunfels als unpräzise Objekte weiter fortgesetzt.[38]

Von diesem Urteil abweichend sollte hier die These vertreten werden, dass das Illustrationsprogramm und die Evidenzstrategien der Kräuterbücher des 16. Jahrhunderts bereits in der Erstausgabe des „Gart" von 1485 angelegt waren. Nicht nur der Text des „Gart" hatte neue Maßstäbe gesetzt, auf die Brunfels zu reagieren hatte,[39] sondern vor allem auch die Illustrationen und das Bildprogramm.

33 Den Vorteil der größeren Reichweite durch den Buchdruck formuliert: Brunfels (1532), Vorwort, XXI. Capitel.

34 Otto Brunfeld / Hans Weiditz: Herbarum vivae eicones. Straßburg 1530. VD16 B 8499. Zwei Jahre später folgte die deutschsprachige Ausgabe: Otto Brunfels / Hans Weiditz: Contrafayt Kreüterbúch. Straßburg 1532. VD16 B 8503.

35 Brunfels (1532), Vorwort, XX. Capitel [eigene Hervorhebung]: „Die anderen aber haben soliche in dem Truck vnder standen wie wir der selbigen vilfaltig vnd mancherley gattung gesehen aber dieweil sye den **kosten gespart** vnd villeicht auch **der waren kunst nicht bericht** alle verhymplet vnnd nichts rechtschaffens worden so der figuren halb die **blößlich gefyßiert** so der **beschreibung welche deß mertheyl falsch** vnnd **auß nochgültigen verachtlichen búcheren gezogen**. Do hár man dann mag abnemen das es nicht so ein schlecht verachtlich ding ist vmb kreüter búcher wie etlich schreiben **sye geben nicht ein pfifferling vmb alle kreüter búcher** so recht vnd ausszer den Alten worhafftig beschriben sye músten sonst von Discoride vnd Plinio auch nicht halten ja es músten ire eygene beschreybungen von den Theriacks kreüteren auch nichts gelten die sye doch vß dem Dioscoride vnnd Plinio anziehen."

36 Im Vorwort von Brunfels existieren diverse implizite Anspielungen auf den „Gart", z. B. schreibt Brunfels, dass „manche" ihr – schlechtes – Kräuterbuch sogar einen „Schatz" nennen, dies scheine ihm allerdings wenig angebracht: Brunfels (1532), Vorwort, XX. Capitel. Im Vorwort des „Gart" wird das Werk als „zu Tage gebrachter Schatz, der bislang verborgen lag" bezeichnet: Bernhard von Breydenbach (1485), fol. 3r.

37 Siehe oben: Kap. 1.

38 Habermann (2001), S. 112 f.

39 Habermann (2001), S. 376.

Ein weiterer Gesichtspunkt trennt den „Gart" von den Humanisten des 16. Jahrhunderts: seine Deutschsprachigkeit. Brunfels gab sein Kräuterbuch „Herbarum vivae eicones"[40] (1530) zuerst in lateinischer Sprache heraus, die zudem mit Originalzitaten griechischer Autoritäten oder griechischen Pflanzennamen durchwebt ist. Es ist vorstellbar, dass sich Brunfels nicht nur von der Konkurrenz absetzen wollte, sondern auch vom Einfluss eines 50 Jahre zuvor erschienenen Werks, das vom Auftraggeber allein als deutschsprachiges Kräuterbuch konzipiert worden war. Ganz in Brunfels' Tradition richtet man in der heutigen Auseinandersetzung mit illustrierten naturwissenschaftlichen Büchern das Augenmerk zuerst auf die lateinischen Werke[41] und übersieht dabei die Innovationen, die von einem deutschsprachigen Kräuterbuch von 1485, dem „Gart der Gesundheit", ausgegangen waren.

40 Otto Brunfeld / Hans Weiditz: Herbarum vivae eicones. Straßburg 1530. VD16 B 8499.
41 Kusukawa vergleicht in der Einleitung ihrer Monographie die lateinischen Kräuterbücher des
 16. Jahrhunderts mit dem lateinischen „Hortus sanitatis" von 1491, sodass der deutschsprachige
 „Gart" von 1485 wegfällt und damit auch sein innovatives Illustrationsprogramm, das sich deutlich
 vom „Hortus sanitatis" unterscheidet (siehe Kap. 4.5.). Kusukawa (2012), S. 17 f.

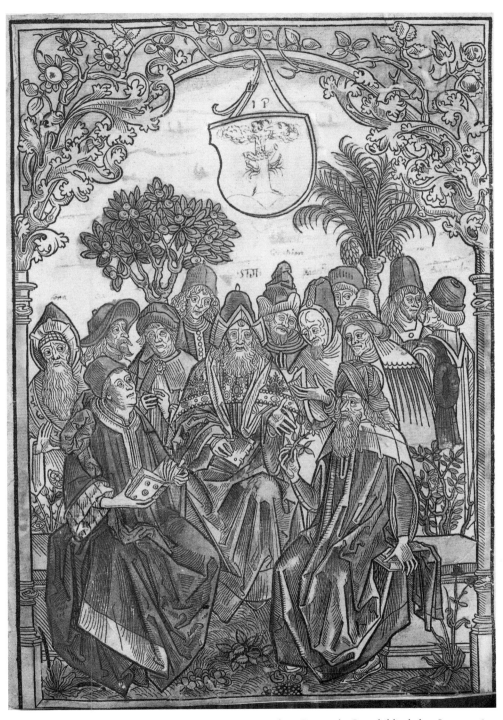

Abb. 162: Titelbild: Gart der Gesundheit. Mainz 1485. München, Bayerische Staatsbibliothek, 2 Inc.c.a. 1601.

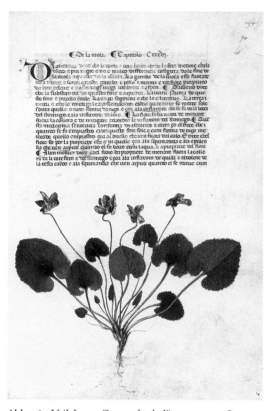

Abb. 163: Veilchen: „Carrara herbal", 1375–1400. London, British Library, Egerton 2020, fol. 94r.

Abb. 165: Schwertlilie: „The Hunting Hours", um 1480. London, British Library, Egerton 1146, fol. 168v.

Abb. 164: Stephan Lochner: Altar der Kölner Stadtpatrone. Geschlossene Seite: Verkündigung, Detail: Lilie, um 1440. Tempera auf Eichenholz. Dom zu Köln.

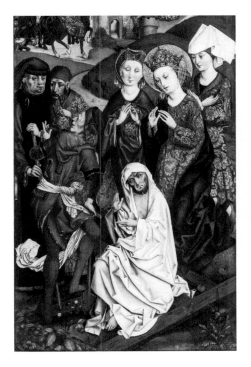

Abb. 166: Michael Wolgemut: Katharinen-Altar. Auffindung des wahren Kreuzes, Detail: Mohnblume, ca. 1495. Öl auf Holz. St. Lorenz, Nürnberg.

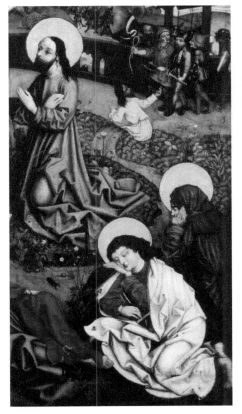

Abb. 167: Michael Wolgemut: Zwickauer-Altar. Christus am Ölberg, Detail: Mohnblume, ca. 1497. Öl auf Holz. St. Marien, Zwickau.

Abb. 168: Michael Wolgemut: Zwickauer-Altar, nördlicher Standflügel, Detail: Hase, ca. 1497. Papierapplikation. St. Marien, Zwickau.

Abb. 169: Pleydenwurf-Wolgemut-Werkstatt: Apostelabschied, Detail: Hase, ca. 1465. Öl auf Holz. München, Alte Pinakothek, Inv. Nr. 1494.

Abb. 170: Hans Pleydenwurff und Werkstatt: Auferstehung, Detail: Wegerich, 1465. München, Alte Pinakothek, Inv.-Nr. 666.

Abb. 171: Hans Schüchlin (Pleydenwurff Schüler) und Werkstatt: Anbetung der Könige, Detail als „Signatur" (?): Fehlender Pflasterstein, darin wächst ein Wegerich, 1469. Pfarrkirche, Tiefenbronn.

Abb. 172: Links, Hans Pleydenwurff: Thomas von Aquin, Detail: Schwertlilie, um 1460. Öl auf Holz. Nürnberg, Germanisches Nationalmuseum, Gm130.
Abb. 173: Mitte, Michael Wolgemut: Zwickauer-Altar: Verkündigung, Detail: Lilie und Schwertlilie, um 1497. Öl auf Holz. St. Marien, Zwickau.
Abb. 174: Rechts, Michael Wolgemut: Rosenkranzaltar: Verkündigung, Detail: Schwertlilie, um 1460. St. Lorenz, Nürnberg.

Abb. 175: Michael Wolgemut: Zwickauer-Altar, Vasen mit Lilien und Schwertlilien.
Äußeren Tafeln der Predella (Zustand nach der Kittung), ca. 1497. Öl auf Holz. St. Marien, Zwickau.

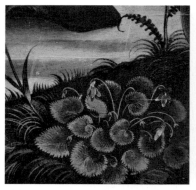 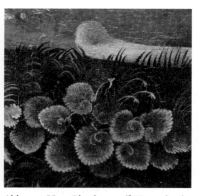

Abb. 176: Hans Pleydenwurff: Heiliger
Dominikus, Detail: Veilchen, um 1460.
Öl auf Holz. Nürnberg, Germanisches
Nationalmuseum, Gm129.

Abb. 177: Hans Pleydenwurff: Kreuzabnahme
Christi, Detail: Veilchen, 1462. Öl auf Holz.
Nürnberg, Germanisches Nationalmuseum,
Gm1127.

Zum Vergleich: Etwa zeitgleich
entstandene Veilchen in Rasen-
stücken von Altar-Gemälden:
Abb. 178: Links, Johann
Koerbecke: Die Anbetung des
Kindes, 1457. Nürnberg, GNM,
Gm1400.
Abb. 179: Rechts, Rothenburger
Meister: Verkündigung, um
1470. Nürnberg, GNM, Gm235.

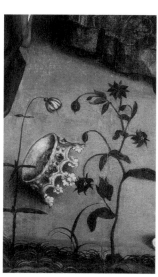

Abb. 180: Links, Hans
Pleydenwurff und Werk-
statt (Hans Schüchlin):
Marter der Heiligen Bar-
bara, Detail: Borretsch, um
1460. Prag, Nationalgale-
rie, Inv.-Nr. O 10106.

Abb. 181: Rechts, Hans
Pleydenwurff und Werk-
statt: Kreuzabnahme,
Detail: Borretsch, 1465.
München, Alte Pinako-
thek, Inv.-Nr. 664.

Abb. 182: Links, Hans Pleydenwurff und Werkstatt (Hans Schüchlin): Marter der Heiligen Barbara, Detail:
Hahnenfuß, um 1460. Prag, Nationalgalerie, Inv.-Nr. O 10106.
Abb. 183: Mitte, Hans Pleydenwurff und Werkstatt: Christus am Ölberg, Detail: Hahnenfuß, 1465.
München, Alte Pinakothek, Inv.-Nr. 663.
Abb. 184: Rechts, Hans Pleydenwurff und Werkstatt: Kreuzigung, Detail: Hahnenfuß, 1465.
München, Alte Pinakothek, Inv.-Nr. 664.

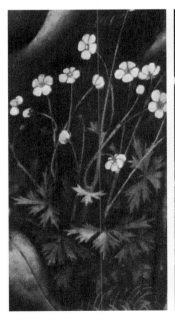 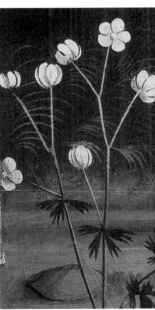

Zum Vergleich: Etwa zeitgleich
entstandene Hahnenfüße in Ra-
senstücken von Altar-Gemälden:
Abb. 185: Links, Meister der
Kemptener Kreuzigung: Kalva-
rienberg, um 1460/1470. Nürn-
berg, GNM, Gm879.
Abb. 186: Rechts, Hans Pleyden-
wurf: Thomas von Aquin, um
1460. Öl auf Holz. Nürnberg,
GNM, Gm130.

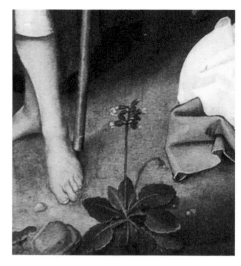

Abb. 187: Hans Pleydenwurff und Werkstatt:
Kreuzigung, Detail: Schlüsselblume, 1465.
München, Alte Pinakothek, Inv.-Nr. 670.

Abb. 188: Pleydenwurf-Wolgemut-Werkstatt:
Apostelabschied, Detail: Schlüsselblume,
ca. 1465. Öl auf Holz. München, Alte Pinako-
thek, Inv. Nr. 1494.

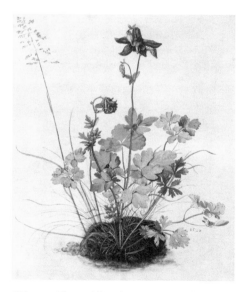

Abb. 190: Ehem. Albrecht Dürer zugeschrieben:
Akelei, um 1520. Aquarell, Deckfarben. Wien,
Albertina, Inv.-Nr. 3182.

Abb. 189: Hans Pleydenwurff: Domini-
kus, Detail: Akelei, um 1460. Öl auf Holz.
Nürnberg, Germanisches Nationalmuseum,
Gm129.

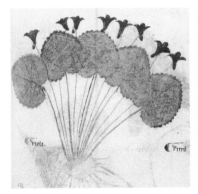

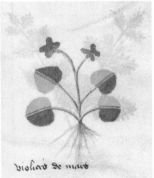

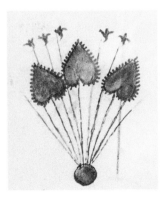

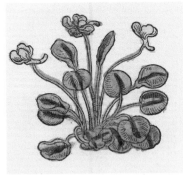

Abb. 191: „Viola" (Veilchen) aus drei verschiedenen Handschriften, die der „Tractatus de herbis"-Tradition zugeordnet werden, und aus dem „Gart":
Von links nach rechts: Egerton 747, fol. 103r (um 1300; British Library). Cod. Ham. 407, fol. 282r (um 1400; Staatsbibliothek zu Berlin). Hs. K II 11, fol. 32v (um 1450; Universitätsbibliothek Basel). Unten: Gart der Gesundheit. Mainz 1485 (München, BSB, 2 Inc.c.a. 1601).

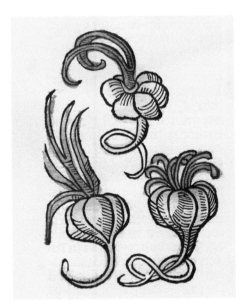

Abb. 192: Knoblauch:
Gart der Gesundheit. Augsburg 1486 (koloriert: München, BSB, 2 Inc.c.a. 1771 b).
Gart der Gesundheit. Augsburg 1496 (unkoloriert: München, BSB, 2 Inc.c.a. 3339).

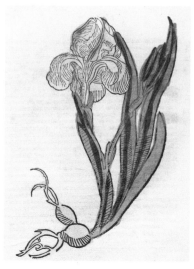
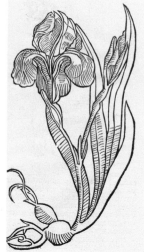

Abb. 193: Schwertlilie:
Gart der Gesundheit. Mainz
1485 (koloriert: München, BSB,
2 Inc.c.a. 1601).
Gaerde der Suntheit. Lübeck
1492 (unkoloriert: Berlin, SBB,
4° Inc 1483).

Abb. 194: „Nux india" (Cap. cclxxxiiij)
und Oregano (Cap. cclxxxv) in verschie-
denen „Gart"-Ausgaben:
Oben: Mainz 1485 (München, BSB,
2 Inc.c.a. 1601).
Unten: Ulm 1487 (München, BSB,
2 Inc.c.a. 1913).
Rechts: Augsburg 1486 (München, BSB,
2 Inc.c.a. 1771 b).

Abb. 195: Gold und Silber: Gart der Gesundheit. Augsburg 1486.
München, Bayerische Staatsbibliothek, 2 Inc.c.a. 1771 b.

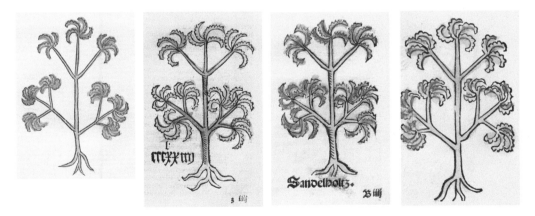

Abb. 196: Sandelholz in verschiedenen „Gart"-Ausgaben:
Von links nach rechts: Mainz 1485 (BSB, 2 Inc. c.a. 1601). Straßburg um 1487 (BSB, 2 Inc.s.a. 600).
Ulm 1487 (BSB, 2 Inc.c.a. 1913). Augsburg 1493 (BSB, 2 Inc.c.a. 2877).

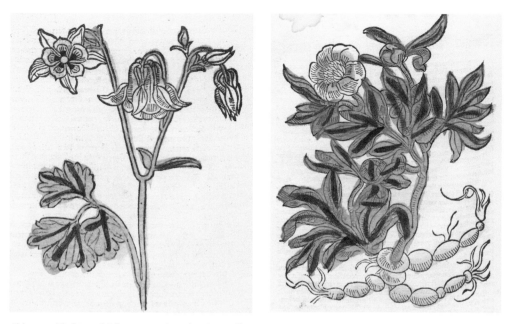

Abb. 197: Akelei und Pfingstrose. Gart der Gesundheit. Mainz 1485. München, Bayerische Staatsbibliothek, 2 Inc.c.a. 1601.

Abb. 198: Natur in der Schmiede: Roman de la Rose, um 1495. Pergament. London, British Library, Harley 4425, fol. 140r.

Abb. 199: Darstellung zum Abschnitt „zu den Landtieren": De proprietatibus rerum, franz. von Jean Corbichon. Lyon: Matthias Huß, 12.11.1482. Frankfurt, Universitätsbibliothek, Inc. qu. 700.

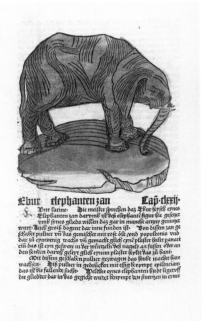

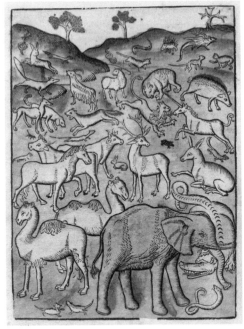

Abb. 200: Elefant: Gart der Gesundheit. 28.3.1485. München, Bayerische Staatsbibliothek, 2 Inc.c.a. 1601.

Abb. 201: Darstellung zum Abschnitt „zu den Landtieren": Van den proprieteyten der dinghen. Haarlem: Jakob Bellaert, 24.12.1485. München, Bayerische Staatsbibliothek, 2 Inc.c.a. 1549 f.

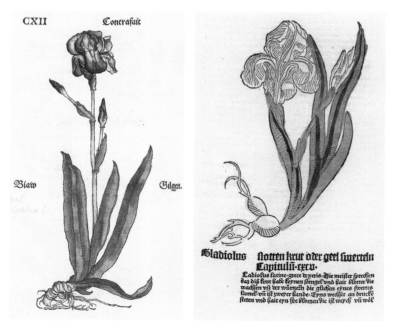

Abb. 202: Gladiole:
Otto Brunfels: Contrafayt Kreüterbúch. Straßburg 1532. München, Bayerische Staatsbibliothek, Rar. 2264.
Gart der Gesundheit. Mainz 1485. München, Bayerische Staatsbibliothek, 2 Inc.c.a. 1601.

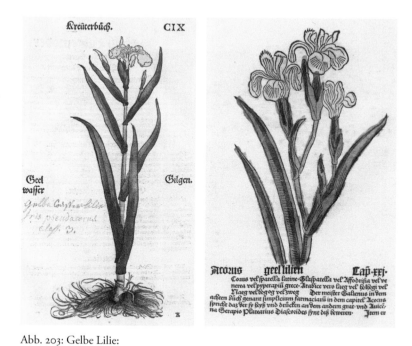

Abb. 203: Gelbe Lilie:
Otto Brunfels: Contrafayt Kreüterbúch. Straßburg 1532. München, Bayerische Staatsbibliothek, Rar. 2264.
Gart der Gesundheit. Mainz 1485. München, Bayerische Staatsbibliothek, 2 Inc.c.a. 1601.

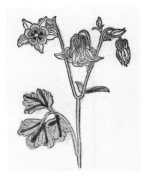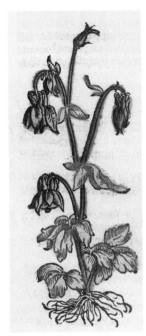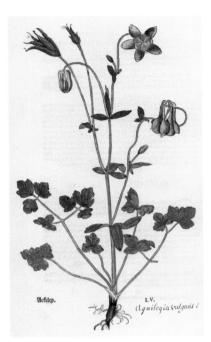

Abb. 204: Akelei:
Von links nach rechts:
Gart der Gesundheit. Mainz
1485. München, BSB,
2 Inc.c.a. 1601.
Adam Lonitzer: Kreuter-
buch. Frankfurt am Main
1578. München, BSB, 2 L.
impr.c.n.mss. 72.
Leonhart Fuchs: New Kreü-
terbuch. Basel 1543. London,
Wellcome Collection.

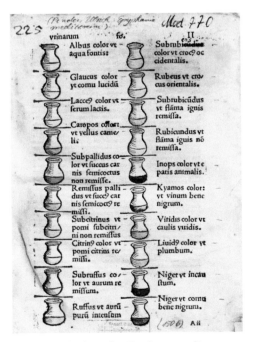

Abb. 205: Fasciculus medicinae. Venedig Abb. 206: Ulrich Pinder: Epiphanie medicorum
1522 [Erstausgabe 1491], S. 1. München, BSB, Speculum videndi vrinas hominum. Nürnberg
2 Med.g. 85. 1506, Aii. München, BSB, 999/Med.770.

Abb. 207: „Bayerische Bild-Enzyklopädie". Krakau, Jagiellonische Bibliothek, Cod. 35/64, fol. 63v: Jeder Mensch ist aus den vier Elementen erschaffen.

Abb. 208: „Bayerische Bild-Enzyklopädie". Erlangen, Universitätsbibliothek, MS. B 200, fol. 56r: Verschiedene Kräuter.

Abb. 209: „Bayerische Bild-Enzyklopädie". Erlangen, Universitätsbibliothek, MS. B 200, fol. 125r: In Worten, in Kräutern und Steinen liegt viel Kraft.

Abb. 210: Koralle (Cap. cxxx): Gart der Gesundheit. Mainz 1485. München, BSB, 2 Inc.c.a. 1601.

Das Vorwort des „Gart“ mit Übertragung ins Neuhochdeutsche[1]

[Fol. 2r:] Offt vnd vil habe ich by mir selbst betracht die wundersam werck des schepfers der natuer wie er am anbeginde den hymel hait beschaffen vnd gezieret mit schonen leúchtenden sternen den er zú inflússen in alles das vnder dem hymel ist krafft vnd macht geben hait. Auch wie er dar nach die vier element beschaffen hait Das feúwer hitzigk vnd drúcken die lúfft heyß vnd feúcht das wasser kalt vnd feúcht das ertrich trucken vnd kalt yglichem sein natuer geben Auch wie der selb gróß meister der natúer darnach gekreút mancherley natúer vnd allerley geschlecht thier vnd zú letzt den menschen vnder allen creatúren das edelst gemacht hait vnd beschaffen. Dar mit ynfiel mir die wundersam ordenung die der schepfer den selbigen sein creaturen hait geben also das alles das vnder dem hymel wesen hait sein natuer von vnd durch die stern entpheet vnd helt Auch das ynne eym ygklichen das in den obgemelten vier elementen entspringet wechset lebt ader swebt eß sey ertz gesteyn gekreut oder thier seyn vermischet die vier natuer der element hitze kelt feúchtikeyt vnd drúckenheyt Vnd also zú vermercken ist die berurten vier natuer auch ym menschlichen korper vermischt oder vermenget seyn in eyner maß vnd temperament bequeme des menschen leben vnd natúer. In welcher maß proporcion oder temperament die weil der mensch steet ist er frisch vnd gesunt

Häufig habe ich für mich das wundersame Werk des Schöpfers der Natur betrachtet, wie er am Anbeginn den Himmel schuf und mit schönen leuchtenden Sternen zierte, denen er die Wirkung und die Macht gegeben hat, alles unter dem Himmel zu beeinflussen; auch wie er danach die vier Elemente geschaffen hat; dem Feuer hat er eine heiße und trockene Natur gegeben, der Luft eine heiße und feuchte, dem Wasser eine kalte und feuchte, dem Erdreich eine trockene und kalte. Auch [habe ich betrachtet,] wie jener große Schöpfer der Natur danach vielerlei Arten Kräuter[2] und allerlei Arten Tiere und zuletzt den Menschen als das Edelste aller Geschöpfen gemacht und geschaffen hat. Da offenbarte sich mir die wundersame Ordnung, die der Schöpfer diesen seinen Geschöpfen gegeben hat, da alle Wesen unter dem Himmel ihre Natur von und durch die Sterne empfangen und erhalten. Auch [habe ich betrachtet,] dass in allem, was in den oben genannten vier Elementen seinen Ursprung hat, wächst, lebt oder schwimmt, sei es Erz [Metall], Gestein, Pflanze oder Tier, die vier Eigenschaften der Elemente, nämlich Hitze, Kälte, Feuchtigkeit und Trockenheit, vermischt sind. Und auch zu vermerken ist, dass die genannten vier Naturen auch im menschlichen Körper vermischt oder vermengt sind, wie es dem menschlichen Leben und seiner Natur angemessen ist. Solange der Mensch in solchem Maß, Proportion oder Temperament bleibt, ist er frisch und gesund.

1 Nicola Zotz sei für die Unterstützung bei der Übertragung gedankt.

2 Die Wörter „Kräuter“ und „Pflanzen“ werden synonym verwendet.

So er aber tridt oder felt vß dem temperament
ader maß der vier naturen das dan geschicht
so die hitz gantz vberhant nympt vnd arbeyt
die kelt zú dempfen oder widerumb die kelt
die hitze anhebet zú vnterdrucken oder der
mensch vol kalter feúchtigkeit wirt oder seiner
feutchtikeyt vber die maß entsetzt fellet der
mensch von nótwegen in krangheyt vnd nehet
dem tode Vrsach aber solichs egemelten bruchs
der vier natur temperament yn welchem des
menschen gesuntheyt vnd leben steet seyn
viel ytzunt des hymels gifftig vnd verborgen
inflúß wider des menschen natur dan dervmb
stehende lufft vnreynikeyt vnd vergifftigung Nu
vnbeqweme speiß ader dranck Oder beqweme
aber nit in rechter maß ader zeyt genommen
furwar als leicht wolt ich dir zelen die bletter
vff den bawmen ader die santkorner ym mer als
ich dir erzelen vnd erkleren solt alle die ding die
eyn vrsach sein abfals von dem temperament
der vier naturen vnd ein anfang des menschen
kranckheit Darumb so vmbsteen den menschen
tusent vnd aber tusent perickel vnd ferlichkeit
keyn augenblick ist er seiner gesuntheit oder
lebens gantz sicher.

Do ich solichs betrachten was fiel mir auch yn
wie der schópfer der natur der vnß yn solche
ferlickeit gesatzet hat wider mit einem andern
gnedigklich versehen hait das ist mit allerley
geschlecht kreúter thieren vnd ander creaturen
den er krafft vnd macht gegeben hat dye
obberurten vier natueren widerbrengen wircken
geben vnd dempfen Eyn kraút hitziget das
[Fol. 2v:] ander kúlet ygklichs nach dem gradt
seiner natuer vnd complexion Des glichen vil
ander creaturen vff dem ertrich vnd yn dem
wasser dem menschen durch den schepfer der
naturen syn leben vffenthelt Durch welcher
kreuter vnd creaturen krafft der kranck mensch
in den vier naturen temperament vnd zú synes
leibes gesuntheit widder mag komen Synt den
mal aber der mensch vff erden nit grossers nit
edelers schatz haben mag dan seyns leibes
gesuntheyt ließ ich mich beduncken daz ich nit
erlichers nit nutzers oder heilgers werck oder
arbeyt begen mochte dan ein búch zú

Wenn er aber aus dem Temperament oder Maß der
vier Naturen tritt oder fällt, was dann geschieht,
wenn die Hitze ganz überhand nimmt und die
Kälte zu verdrängen versucht oder wiederum die
Kälte beginnt, die Hitze zu unterdrücken oder
der Mensch voll kalter Feuchtigkeit wird oder
seine Feuchtigkeit über die Maßen verliert, so
fällt der Mensch notwendigerweise Krankheit
anheim oder nähert sich dem Tode; Ursache
eines solch besagten Ungleichgewichts der
Mischung der vier Naturen, von welchen die
menschliche Gesundheit und das Leben abhängt,
sind eher schädliche und verborgene Einflüsse
des Himmels auf die Natur des Menschen als die
Verschmutzung stehender Luft, Unreinlichkeit
oder Vergiftung oder unbekömmliche Speise oder
Trank oder bekömmliche, aber nicht im rechten
Maß oder zur rechten Zeit aufgenommene
Speise oder Trank – genauso einfach könnte ich
versuchen für dich alle Blätter an den Bäumen
zu zählen oder alle Sandkörner im Meer, wie
ich dir alle die Dinge erzählen und erklären
könnte, die einen Abfall von dem Temperament
der vier Naturen verursachen und ein Auslöser
menschlicher Krankheit sind. So steht der
Mensch tausend und abertausend Gefahren
gegenüber, keinen Augenblick ist er seiner
Gesundheit oder seines Lebens ganz sicher.

Als ich darüber nachdachte, fiel mir auch ein, wie
der Schöpfer der Natur, der uns solchen Gefahren
ausgesetzt hat, uns auf der anderen Seite mit einer
Gnade versehen hat und zwar mit allerlei Arten
von Kräutern, Tieren und anderen Geschöpfen,
denen er Wirkung und Macht gegeben hat, die
oben genannten vier Naturen wiederzubringen,
ihre Wirkung zu unterstützen oder sie zu dämpfen.
Ein Kraut ist wärmend, ein anderes kühlend, jedes
nach dem Grad seiner Natur und Beschaffenheit.
Auf gleiche Weise erhalten viele andere Geschöpfe
auf der Erde und im Wasser das menschliche
Leben durch den Schöpfer der Natur, denn
durch die Wirkung dieser Kräuter und Geschöpfe
kommt der Kranke zur [ausgewogenen] Mischung
der vier Naturen und zur Gesundheit zurück.
Dem Menschen ist auf Erden kein größerer
Schatz gegeben als seine Gesundheit, was mich
zur Einsicht brachte, dass ich keine ehrlichere,
nützlichere oder heiligere Arbeit unternehmen
könne, als ein Buch zusammenzustellen, worin die

samen brengen dar yn vieler kreuter vnd ander creaturen krafft vnd natuer mit yren rechten farben vnd gestalt wurden begriffen zú aller welt troist vnd gemeynen nutz Demnach habe ich solichs lóblichs werck lassen anfahen durch einen meyster in der artzney geleret der nach myner begirde vß den bewerten meistern in der artzney Galieno Auicenna Serapione Diascoride Pandecta Plateario vnd andern viel kreuter krafft vnd naturen in ein búch zú samen hait bracht

Vnd do ich vff entwerffunge vnd kunterfeyung der kreuter gangen byn in mitteler arbeyt vermerckt ich das viel edeler kreuter syn die in dissen teutschen landen nit wachsen Darvmb ich die selben in irer rechten farbe vnd gestalt anders entwerffen nicht mocht dan von hóren sagen Deßhalben ich solichs an gefangen werck vnfolkomen vnd in der fedder hangen ließ so lange biß ich zú erwerben gnade vnd ablaß mich fertiget zú ziehen zú dem heiligen grabe auch zú dem berg synay da der lieben iungfrauwen sant katherinen korper rastet vnd ruwet Doch daz solich edel angefangen vnd vnfolkommen werck nit hynderstellig bliebe auch daz myn fart nicht allein zú myner selen heyl sunder aller welt zú stadt mocht komen Nam ich mit mir einen maler von vernunfft vnd hant subtiel vnd behende

Vnd so mir von teutsch landen greiset haben durch welsch lant Histrian vnd dar nach durch die Schlauoney oder Wyndesche landt Croacien Albaney dalmacien auch durch die krieschen lande Corfon Moream Candiam Rodhiß vnd Ciprien biß in das gelopt lant vnd in die heiligen stat Iherusalem vnd von dan durch cleyn arabien gegen dem berg synay von dem berg synai gegen dem roten mere gegen alcair Babilonien vnd auch allexandrien in Egipten vnd von dan widder in Candien in durch wanderung solcher konigrich vnd landen Ich mit fliß mich erfaren hab der

Wirkung und Natur vieler Kräuter und anderer Geschöpfe enthalten sind, mit ihrer rechten Farbe und Gestalt, zu aller Welt Trost und allgemeinem Nutzen. Ich habe ein solch löbliches Werk bei einem Meister in Auftrag gegeben, einem Gelehrten der Arznei, der nach meiner Weisung aus den bewährten Meistern in der Arznei – Galen, Avicenna, Serapion, Dioscurides, Pandectarius [Matthaeus Silvaticus], Platearius und anderen – die Wirkung und Natur vieler Kräuter in einem Buch zusammengetragen hat.

Und als ich mich daran gemacht habe, [das Buch] zu entwerfen und die Kräuter abzubilden, merkte ich, dass es viel edlere Kräuter gibt, die in den deutschen Landen nicht wachsen. Weil ich diese Kräuter in ihrer rechten Farbe und Gestalt nicht anders darstellen konnte als vom Hörensagen, habe ich das begonnene Werk unvollkommen in der Feder hängen lassen, so lange bis ich mich aufmachte zum heiligen Grab zu ziehen, um Gnade und Ablass zu erwerben, und auch zum Berg Sinai, wo der Körper der lieben Jungfrau Katharina rastet und ruht. Damit solch edel begonnenes, unvollendetes Werk nicht hinten angestellt bliebe und damit meine Fahrt nicht alleine zu meinem Seelenheil, sondern aller Welt zum Nutzen gereiche, nahm ich mit mir einen Maler von Vernunft sowie von sorgfältiger und geschickter Hand.

Und so reisten wir von deutschen Landen; durch welsche Lande [Italien]; Istrien und danach durch die „Schlauoney oder Wyndesche" Lande [etwa: Illyrien, Balkanregion]: Kroatien, Albanien, Dalmatien; auch durch die griechischen Lande: Korfu, Morea [Peloponnes], Heraklion [auch „Candiam" genannt, Kreta], Rhodos und Zypern bis in das gelobte Land und die heilige Stadt Jerusalem und von dort durch „Kleinarabien" [Palästina, Ägypten] zum Berg Sinai und von dem Berg Sinai zum roten Meer bis Kairo [ein Stadtteil wurde Babylon genannt] und auch Alexandria in Ägypten und dann wieder nach Heraklion [Kreta].[3] Während wir diese Königreiche und Länder durchwanderten, habe ich mich selbst über die dortigen Kräuter

3 Zu den geographischen Bezeichnungen und Übertragungen vgl. Timm (2006), S. 66–70, S. 121–177.

kreuter da selbest vnd die in iren rechten farben vnd gestalt laißen kunterfeyen vnd entwerffen Vnd nach dem mit gottes hulff widder in teutsch lant vnd heym kommen byn die groß liebe die ich zú dissem werck han gehabt hait mich beweget das zú volenden als nu mit der gottes hulff vol bracht ist Vnd nennen diß búch zú latin Ortus sanitatis vff teutsch ein gart der gesundheit In welchem garten man findet cccc vnd

[Fol. 3r:] xxxv kreuter mit anderen creaturen krafft vnd dogenden zú des menschen gesuntheyt dynenden vnd gemeinlich in den apoteken zú artzney gebrucht werden vnder dissen by den vierdhalp húndert mit iren farben vnd gestalt als sie syn hie erschynen vnd vff daz es aller welt gelerten vnd leyen zú nútze komen moge habe ich eß in teútsch laißen machen. Diß búch wurt geteylt in funff teil Das erst ist die fur rede ytzunt hie berúret Das ander teyl ist von den nachfolgenden kreútern vnd ander creaturen krafft vnd dogent in ordenung des alphabets Das drit teyll wirt syn eyn register von kreútern zú laxieren zú krefftigen Item von den wól richenden Item von den gummi Item von den fruchten samen vnd wurzeln Item von edel gesteyntz Item von den dieren vnd was von yn entspringet vnd also was zú artzney dinet geminlich Das vierd teil von allen farben das harnes vnd waz eyn yglich farbe bedeutet Das funfft teil vnd das letzt wurd seyn ein register behende zú fynden von allen gebresten vnd krankheyten der menschen wie die syn mogen

mit Fleiß kundig gemacht und ließ sie in ihrer rechten Farbe und Gestalt abbilden und entwerfen. Und da ich mit Gottes Hilfe wieder in deutschen Landen und zu Hause ankam, hat die große Liebe zu diesem Werk mich dazu bewogen, das zu vollenden, was nun mit Gottes Hilfe vollbracht ist. Ich nenne dieses Buch „Ortus sanitatis" auf Latein und auf Deutsch einen „Garten der Gesundheit".

In diesem Garten findet man die Wirkungen und Tugenden von 435 Kräutern und anderer Geschöpfe, die der menschlichen Gesundheit dienen und gemeinhin in Apotheken als Arznei gebraucht werden, unter diesen viereinhalbhundert mit ihrer Farbe und Gestalt, so wie sie hier erscheinen. Auf dass es aller Welt, Gelehrten und Laien, nutzen möge, habe ich es auf Deutsch machen lassen. Dieses Buch wurde in fünf Teile geteilt. Der erste ist die Vorrede, jetzt und hier, der zweite Teil ist von den Wirkungen und Tugenden der Kräuter und anderer Geschöpfen in alphabetischer Reihenfolge. Der dritte Teil wird ein Register sein von Kräutern, die abführen, die kräftigen, die wohl riechen. Außerdem von gummiartigen Kräutern, von Früchten, von Samen, von Wurzeln, von Edelsteinen, von Tieren und tierischen Produkten und was gemeinhin als Arznei dient. Der vierte Teil von allen Farben des Harns und was eine jede Farbe bedeutet. Der fünfte und letzte Teil wird ein Register sein, damit man leichter alle Gebrechen und Krankheiten der Menschen, welcher Art auch immer, finden kann.

Nu far hyn alle lande du edeler vnd schóner gart du eyn ergetzunge den gesunden eyn troist hoffenúnge vnd húlff den krancken der dyn nutz dyn frucht gnugsam uß sprechen moge lebet keyn mensche Ich dancke dir schópffer hymels vnd ertrichs der den kreutern vnd anderen creaturen yn dissem garten begriffen krafft gegeben haist daz du mir solichs gnad diesen schatz der bißher der gemeyn begraben vnd verborgen ist gewest haist vergunnget an den dag zú brengen Dir sey eer vnd lob ytzunt vnd zú ewigen zyten Amen

Nun fahre hin, du edler und schöner Garten, eine Freude für die Gesunden, zu Trost, Hoffnung und Hilfe für die Kranken. Deinen Sinn und Nutzen genügend ausdrücken kann kein Mensch. Ich danke dir, Schöpfer des Himmels und der Erde, der du den Kräutern und anderen Geschöpfen, die in diesem Garten sind, Wirkung gegeben hast, dass du mir solche Gnade erwiesen hast, diesen Schatz an den Tag zu bringen, der bisher für die Allgemeinheit begraben und verborgen war, dir sei Ehre und Lob in Ewigkeit. Amen.

TAFELN 2

VERGLEICH: „CODEX BERLEBURG" – „GART DER GESUNDHEIT"

Bei den hier gezeigten Digitalisaten von einem Mikrofiche handelt es sich um Fotos unterschiedlicher Qualität, die vom „Codex Berleburg" angefertigt und 1991 als Farb-Mikrofich herausgegeben wurden. Da der heutige Aufbewahrungsort des „Codex Berleburg" nicht bekannt ist, können keine besseren Aufnahmen beschafft werden. Dennoch sollen hier möglichst viele Vergleiche in Farbe gezeigt werden, die schlechte Qualität der Aufnahmen muss dabei in Kauf genommen werden.

Die mit * gekennzeichneten Abbildungen werden an dieser Stelle als weitere mögliche Vorlagen vorgeschlagen. Die Anordnung der Abbildungen ergibt sich aus der Reihenfolge, wie sie im „Gart" erscheinen.

Wissenschaftlicher Name	Kapitel „Codex Berleburg"	Capitel „Gart der Gesundheit"
Pyrola minor	271	316
Sedum telephium	272	238
Alchemilla vulgaris	273	32
Centaurium erythraea	274	83
Leucanthemum vulgare	275	193
Amaranthus blitum	277	189
Ocimum basilicum	278	65
Veronica beccabunga	304	360
Anchusa officinalis	308	54
Lamium album	311	69
Hieracium pilosella	313	28
Leontodon hispidus	314	212
Crepis capillaris	315	167
Vinca minor	325	428
Dryopteris filix-mas	331	183
Solanum nigrum	332	349
Asplenium scolopendrium	348	351

Vergleiche von Baumann/Baumann (2010), S. 112.

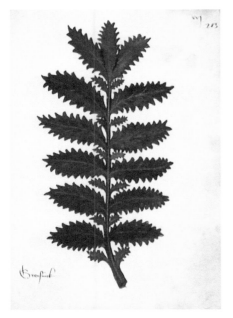

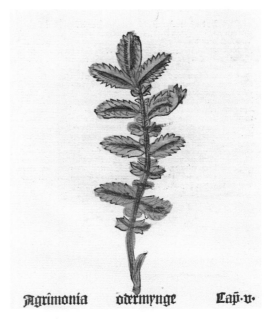

fol. 283r: Grensinck (Potentilla anserina)* Cap. v: odermynge

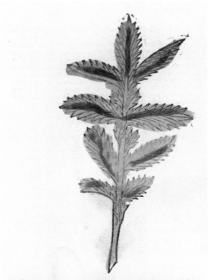

Cap. cccxviij: grensyng

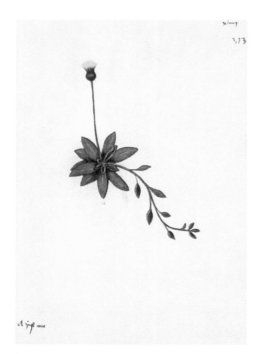

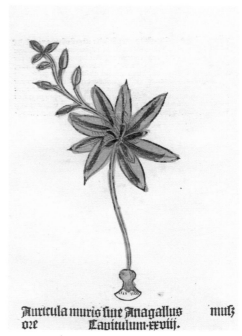

fol. 313r: Muoßore (Hieracium pilosella)
[Müller-Jahncke 1977, 1991]

Cap. xxviij: mußore

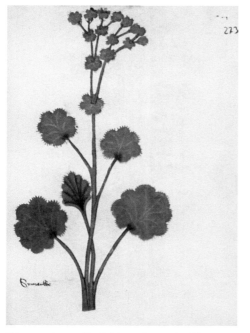

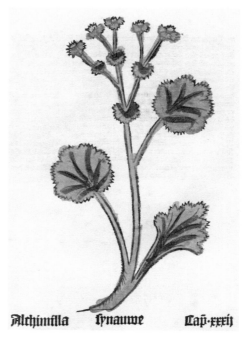

fol. 273r: Synnaulbe (Alchemilla xanthochlora)
[Müller-Jahncke 1977]

Cap. xxxij: synauwe

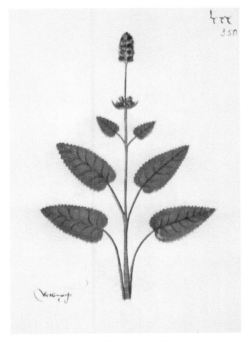

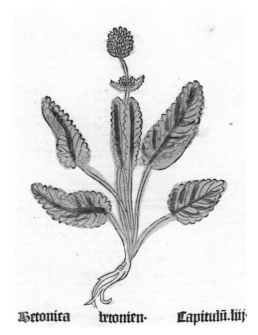

fol. 350r: Bethonijge (Betonica officin)*

Cap. liij: betonien

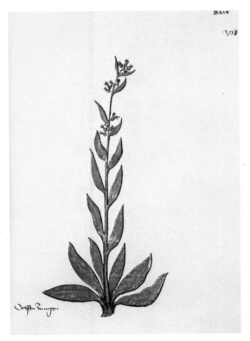

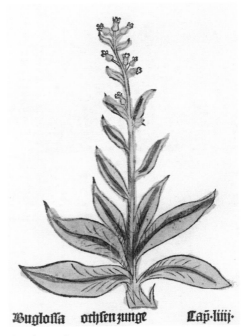

fol. 308r: Ochsen Zungen (Anchusa officinalis)
[Müller-Jahncke 1977]

Cap. liiij: ochsenzunge

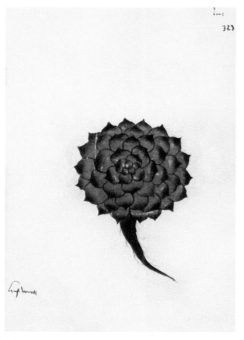

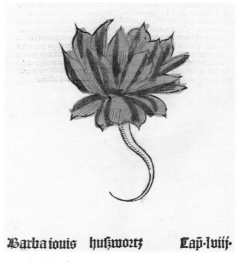

fol. 323r: Hußwurtz (Sempervivum tectorum)* Cap. lviij: hußwortz

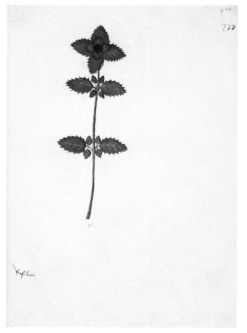

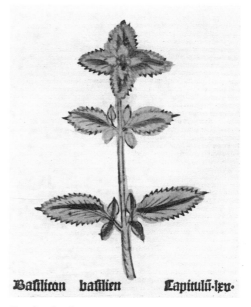

fol. 278r: Basilien (Ocimum basilicum) Cap. lxv: basilien
[Müller-Jahncke 1977, 1991]

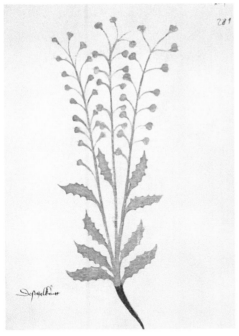 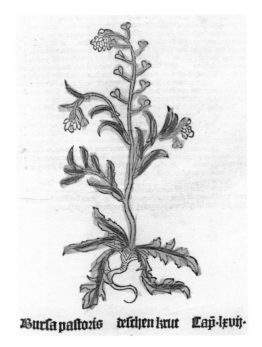

fol. 281r: Deschelkrutt (Capsella bursa pastoris)* Cap. lxvij: deschenkrut

fol. 311r: Binsaug (Lamium album) Cap. lxix: bynßauge
[Müller-Jahncke 1977]

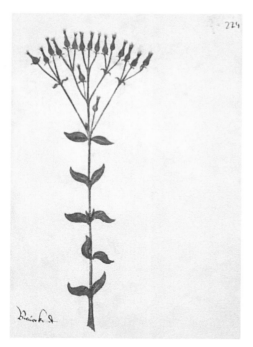

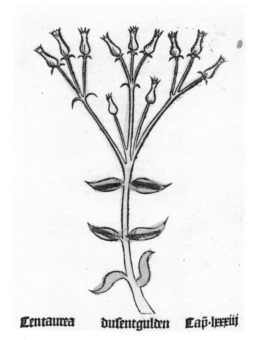

fol. 274r: Bieuoerkrudt (Centaurium umbellatum) [Müller-Jahncke 1977]

Cap. lxxxiij: dusentgulden (Centaurium erythraea)

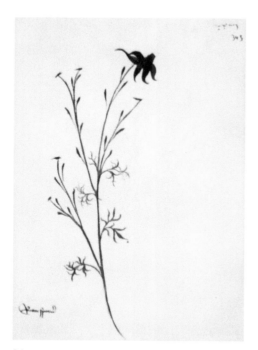

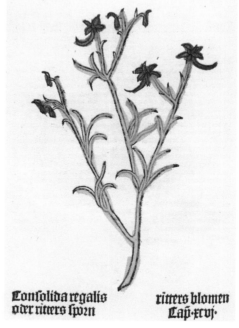

fol. 343r: Rittersporn (Delphinium consolida)*

Cap. xcvj: rittersblomen

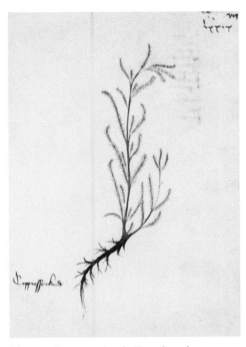

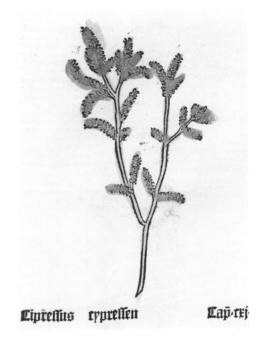

fol. 349r: Cyppressenkrudt (Santolina chamaecy-
parissus)*

Cap. cxj: cypressen

fol. 317r: Leberkrudt (Galium odoratum)*

Cap. clvj: lebberkrut

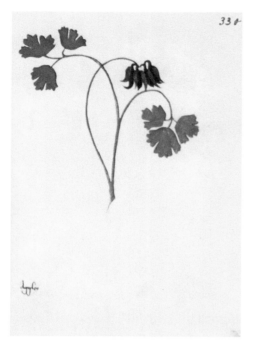

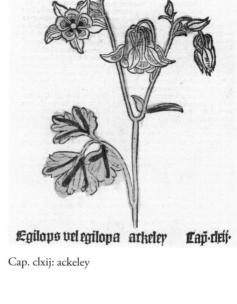

fol. 330r: Aggleij (Aquilegia vulgaris)*

Cap. clxij: ackeley

fol. 315r: Genßdistel (Sonchus oleraceus)
[Müller-Jahncke 1977, 1991]

Cap. clxvij: genßzunge

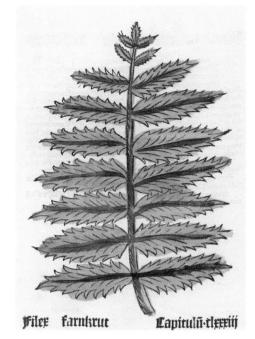

fol. 331r: keine Bezeichnung (nach Müller-Jahncke: ein Wurmfarn) (Dryopteris filix-mas) [Müller-Jahncke 1977]

Cap. clxxxiij: farnkrut

fol. 277r: Floramor (Amaranthus caudatus) [Müller-Jahncke 1977]

Cap. clxxxix: Floramor

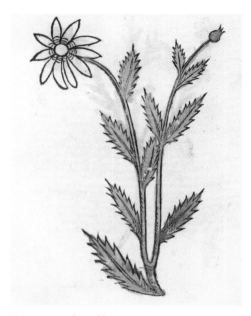

fol. 275r: Johannsblumenkrudt (Chrysanthemum leucanthemum) [Müller-Jahncke 1977]

Cap. cxciij: iohans blomen

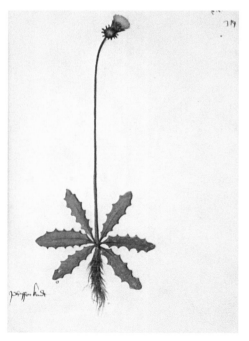

fol. 314r: Phaffenkrudt (Leontodon hispidus) [Müller-Jahncke 1977, 1991]

Cap. ccxij: zytloiß (Leontodon hispidus)

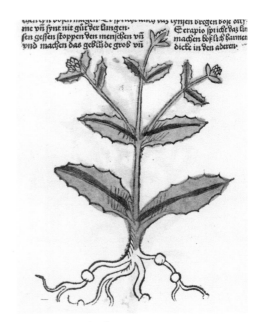

fol. 272r: Drußkrutt (Sedum telephium) Cap. ccxxxviij: drußwortz
[Baumann / Baumann 2010]

fol. 301r: Mutterkrudt (Melissa officinalis)* Cap.: ccl: muterkrut

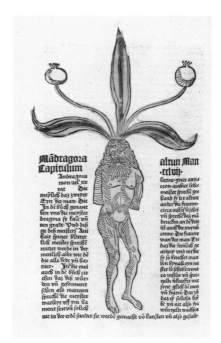

fol. 355r: Mandragora (Mandragora officin)* Cap. cclvij: alrun Man

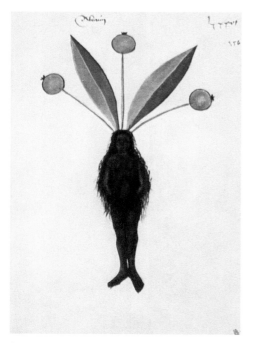

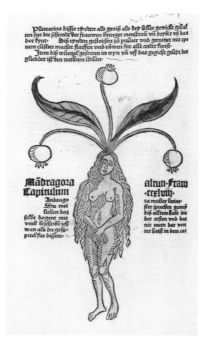

fol. 356r: Mandragora (Mandragora officin)* Cap. ccxlviij: alrun Fraw

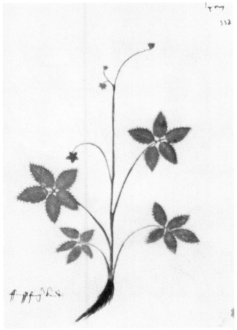

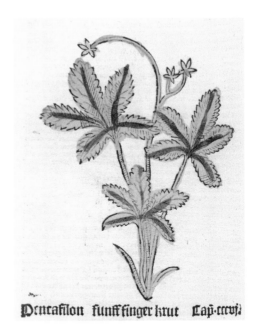

fol. 337r: Ffunffing[er]krudt (Potentilla repans)*

Cap. cccvj: funfffingerkrut

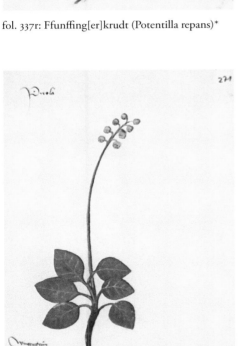

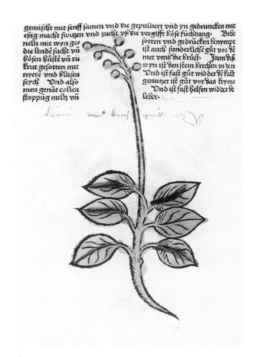

fol. 271r: Wintergruon (Pyrola rotundifolia)
[Müller-Jahncke 1977]

Cap. cccxvj: wintergrun

fol. 309r: Selbey (Salvia officinalis)
[Müller-Jahncke 1991, von Baumann / Baumann
2010 nicht übernommen]

Cap. cccxlvij: Salvia heysset selbe

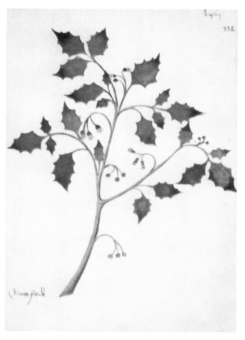

fol. 332r: Nachtschade (Solanum nigrum)
[Müller-Jahncke 1977]

Cap. cccxlix: nachtschede

fol. 348r: Hirtzzungen (Phyllitis scolopendrium) Cap. ccclj: hirtz zunge
[Müller-Jahncke 1977]

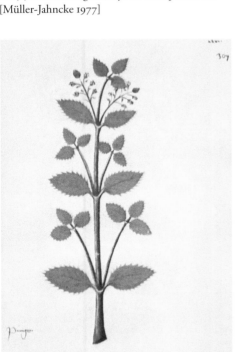

fol. 304r: Pungen (Veronica beccabunga) Cap. ccclx: bornkrasse (Veronica beccabunga)
[Müller-Jahncke 1977]

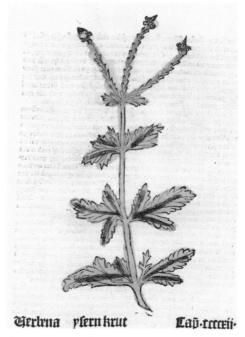

fol. 310r: ysenkrutt (Verbena officinalis)*

Cap. ccccxij: ysernkrut

fol. 325r: Bervinckel (Vinca minor)
[Müller-Jahncke 1977]

Cap. ccccxxviiij: wasserpfeffer (Vinca minor)

VERZEICHNIS

Handschriften und Drucke

Die Handschriften und Drucke sind nach Aufbewahrungsort bzw. Ort der Drucklegung geordnet.

Anholt (heute: Stadtteil von Isselburg)
- Johannes Hartlieb: Kräuterbuch, um 1460. Fürstlich Salm-Salm'sche Bibliothek; Anholt, Wasserburg: Ms. 46.

Augsburg
- Bartholomäus Metlinger: Ein Regiment der jungen Kinder. Augsburg: Johann Bämler, 28.8.1474. GW M23083.
- Konrad von Megenberg: Buch der Natur. Augsburg: Johann Bämler, 1475. GW M16426.
- Rudolf von Hohenberg: Regimen sanitatis, das ist von der Ordnung der Gesundheit. Augsburg: Johann Bämler, 13.11.1475. GW M37273.
- Aesop: Fabulae. [Augsburg: Anton Sorg, nicht vor 1483]. GW 347.
- Bernhard von Breydenbach / Johann Wonnecke von Kaub / Erhard Reuwich: Gart der Gesundheit, Ausgaben und Nachbearbeitungen:
 - [Johann Schönsperger], 22.8.1485. GW M09751.
 - Abschrift, kurz nach 1485. Staats- und Stadtbibliothek, Augsburg: 4° Cod. 132.
 - [Johann Schönsperger, 1485/86]. GW M0975120.
 - Johann Schönsperger, 5.6.1486. GW M09754.
 - Johann Schönsperger, 7.3.1487. GW M09756.
 - Johann Schönsperger, 10.5.1496. GW M09759.
 - Johann Schönsperger, 13.8.1493. GW M09758.
 - Johann Schönsperger, 13.5.1499. GW M09761.
 - [Johann Schönsperger]. GW M0976310.
 - Johann Schönsperger, 15.12.1488. GW M09757.
 - [Johann Schönsperger, um 1500]. GW M09763.
 - Johann Schönsperger, 1502. VD16 W 4357.
 - Heinrich Steiner, 1534. VD16 W 4364.
- Hieronymus Brunschwig: Dis ist das Buch der Cirurgia. Augsburg: Johann Schönsperger, 12.[14]97. GW 5594.
- Balthasar Ehrhart / Adam Lonitzer / Peter Uffenbach: Vollständiges Kräuterbuch oder Das Buch über alle drey Reiche der Natur. Augsburg: Wolff, 1783. VD18 14828324-001.

Basel
- Circa instans, um 1450. Universitätsbibliothek, Basel: Hs. K II 11
- Bernhard von Breydenbach / Johann Wonnecke von Kaub / Erhard Reuwich: Gart der Gesundheit. [Basel: Michael Furter, um 1487–90]. GW M09764.
- Sebastian Münster: Cosmographia in welcher begriffen aller Völcker Herschafften, Stetten und namhafftiger Flecken [...]. Basel: Heinrich Petri, 1544. VD16 M 6689.
- Leonhart Fuchs / Heinrich Füllmaurer / Albrecht Meyer / Veit Rudolf Speckle: De historia stirpium commentarii insignes. Basel: Michael Isengrin, 1542. VD16 F 3242.
- Leonhart Fuchs / Heinrich Füllmaurer / Albrecht Meyer / Veit Rudolf Speckle: New Kreüterbuch. Basel: Michael Isengrin, 1543. VD16 F 3243.

Berleburg (olim)

o „Codex Berleburg", medizinische Sammelhandschrift, um 1450. Ehem. Fürst. Sayn-Wittgenstein'sche Bibliothek, Berleburg: Cod. RT 2/6 (ehem. F4).

Berlin

o Medizinische Sammelhandschrift, um 1400. Staatsbibliothek zu Berlin: Cod. Ham. 407.

o Johannes Hartlieb: Kräuterbuch, um 1460. Staatsbibliothek zu Berlin: Ms. germ. quart. 2021.

Bologna

o Matthaeus Silvaticus: Liber pandectarum medicinae, omnia medicine simplicia continens. [Bologna]: Johann Vurster, 1474. GW M42128.

Erlangen

o „Bayerische Bild-Enzyklopädie", um 1520. Universitätsbibliothek Erlangen: MS. B 200.

Ferrara

o Johannes Serapion: Breviarium medicinae. Ferrara 1488. GW M41681.

Florenz

o Marsilio Ficino: De triplici vita. Florenz: Antonio Miscomini, 3.12.1489. GW 9882.

Frankfurt am Main

o Eucharius Rößlin d. J.: Kreutterbuch [„Gart"-Bearbeitung]. Frankfurt: Christian Egenolff, 1533. VD16 W 4363.

o Eucharius Rößlin d. J.: Kreuterbúch von allerley Thieren, Vóglen, Vischen oder Mórwunder, vnd Edlem gstein Natur nutz vnd Gebrauch. Frankfurt: Christian Egenolff d. Ä., 1536. VD16 R 2871.

o Theodor Dorstenius: Botanicon [lat. Übertragung von Rößlins Kräuterbuch]. Frankfurt: Christian Egenolff d. Ä., 1540. VD16 D 2442.

o Adam Lonitzer: Kreuterbúch [„Gart"-Bearbeitung]. Frankfurt: Christian Egenolff d. Ä. (Erben), 1557. VD16 L 2416.

o Adam Lonitzer: Kreuterbuch. Frankfurt: Christian Egenolff d. Ä. (Erben), 1578. VD16 L 2422.

Genf

o Macer Floridus: De viribus herbarum. [Genf: Jean Belot, um 1500]. GW M19663.

Haarlem

o Bartholomaeus Anglicus: Van den proprieteyten der dinghen. Haarlem: Jacob Bellaert, 24.12.1485. GW 3423.

Heidelberg

o Konrad von Megenberg: Buch der Natur, um 1442–1448. Universitätsbibliothek Heidelberg: Cod. Pal. germ. 300.

o Konrad von Megenberg: Buch der Natur / Johannes Hartlieb: Kräuterbuch, um 1455–1460. Universitätsbibliothek Heidelberg: Cod. Pal. germ. 311.

Isselburg siehe Anholt

Krakau

o „Bayerische Bild-Enzyklopädie", um 1520. Jagiellonische Bibliothek, Krakau: Cod. 35/64.

Linz

o Johannes Hartlieb: Kräuterbuch, um 1470. Bibliothek des Oberösterreichischen Landesmuseums, Linz: Ms 4.

London

o Pseudo-Apuleius Platonicus, um 1150. British Library, London: Harley 1585.

o Tractatus de herbis, um 1300. British Library, London: Egerton 747.

o „Carrara herbal", um 1400. British Library, London: Egerton 2020.

o Stundenbuch, um 1480. British Library, London: Egerton 1146.

o Roman de la Rose, um 1490. British Library, London: Harley 4425.

o Stundenbuch, um 1500. British Library, London: Add. 35313.

Lübeck

o Gaerde der Suntheit. Lübeck: Stephan Arndes, 1492. GW M09748.

Lyon

o De proprietatibus rerum, franz. von Jean Corbichon. Lyon: Matthias Huß, 12.11.1482. GW 3415.

Magdeburg

o Promptuarium Medicinae. Magdeburg: Bartholomäus Ghotan, 31.6.1483. GW M35662.

Mailand

o Liber aggregatus in medicinis simplicibus. Mailand: Antonius Zarotus, 1473. GW M41685.

Mainz

o Herbarius Moguntinus. Mainz: Peter Schöffer, 1484. GW 12268.

o Bernhard von Breydenbach / Johann Wonnecke von Kaub / Erhard Reuwich: Gart der Gesundheit. Mainz: Peter Schöffer, 28.3.1485. GW M09766.

o Bernhard von Breydenbach / Erhard Reuwich: Peregrinatio in terram sanctam. Mainz 11.2.1486. GW 5075.

o Bernhard von Breydenbach / Erhard Reuwich: Die heyligen reyßen gen Jherusalem zuo dem heiligen grab. Mainz 21.6.1486. GW 5077.

o Hortus sanitatis. Mainz: Jacob Meydenbach, 23.6.1491. GW n0166.

München

o Kalender und Praktika, um 1450. Bayerische Staatsbibliothek, München: Cgm 28.

o Matthaeus Silvaticus de Salerno: Pandecta synonymarum et medicinarum simplicium aggregatarum, 15. Jahrhundert. Bayerischen Staatsbibliothek, München: Clm 30.

o Matthaeus de Bolderiis: Aggregatio simplicium medicinarum diversorum auctorum secundum aureolas Avicennae ordinatarum, 1464. Bayerische Staatsbibliothek, München: Clm 13.

o Arzneibuch, um 1485. Bayerische Staatsbibliothek, München: Cgm 728.

Neapel

o Macer Floridus: De viribus herbarum. Neapel: Arnold von Brüssel, 9.5.1477. GW M19661.

Nürnberg

o Johannes Hartlieb: Kräuterbuch, um 1470. Germanisches Nationalmuseum, Nürnberg: Hs. 18792.

o Heinrich Steinhöwel: Büchlein der Ordnung der Pestilenz, mit Widmungsvorrede des Autors an die Bürgerschaft von Ulm. [Nürnberg: Drucker der Rochuslegende, um 1484]. GW M43857.

o Hartmann Schedel / Michael Wolgemut: Chronica. Nürnberg: Anton Koberger, 1493. GW M40796.

o Ulrich Pinder: Epiphanie medicorum Speculum videndi vrinas hominum. Nürnberg: Ulrich Pinder, 1506. VD16 ZV 12488.

o Albrecht Dürer: Vier Bücher von menschlicher Proportion. Nürnberg: Hieronymus Andreae, 1528. VD16 D 2859.

Odenwald

o Konrad von Megenberg: Buch der Natur / Johannes Hartlieb: Kräuterbuch, um 1455. Stadtarchiv Michelstadt im Odenwald: Cod. D 684.

Paris

o Livre des simples médecines. Bibliothèque nationale de France, Paris: Ms. fr. 12322. Online (schwarz-weiß): https://gallica.bnf.fr/ark:/12148/btv1b90610505 (letzter Zugriff: 13.09.2019).

o Charles de Bouelles: Liber de intellectu. Paris 1510.

o Le grant herbier en francoys. Paris: Jean Jehannot, [1521].

Rom

o Historia plantarum, um 1400. Biblioteca Casanatense, Rom: Ms. 459. Online: https://www.wdl.org/fr/item/11560/ (letzter Zugriff: 13.09.2019).

o Herbarium Apuleii Platonici. [Rom: Johannes Philippus de Lignamine, um 1481/82]. GW 2300.

Salzburg
o Sammelhandschrift, um 1425. Universitätsbibliothek Salzburg: M I 36.
St. Petersburg
o Livre des simples médecines. Russische Nationalbibliothek, St. Petersburg: Ms Fr. F. v. VI.
Speyer
o Petrus de Crescentiis zu teutsch, mit Figuren: Ruralia commoda. [Speyer: Peter Drach],
 1.10.1493. GW 7831.
Straßburg
o Bernhard von Breydenbach / Johann Wonnecke von Kaub / Erhard Reuwich: Gart der Gesund-
 heit, Ausgaben und Nachbearbeitungen:
 o Abschrift, kurz nach 1485. Bibliothèque nationale et universitaire de Strasbourg:
 Ms.2.152.
 o [Johann Grüninger, um 1485–86]. GW M09741.
 o [Johann Grüninger, um 1488/94]. GW M09739.
 o Johann Grüninger, 1529. VD16 W 4367.
 o Balthasar Beck, 1530. VD16 W 4362.
 o Johann Prüß, 1507. VD16 W 4358.
o Hieronymus Brunschwig: Liber de arte distillandi. Straßburg: Johann Grüninger, 8.5.1500. GW
 5595.
o [Straßburg: Johann Grüninger,] 1505. VD16 B 8718.
o Sog. „Großer Gart". Straßburg: Johann Prüß, 1507. VD16 ZV 22673.
o Kreüterbuch. Straßburg: Balthasar Beck, 1527. VD16 W 4360.
o Ortus Sanitatis. Straßburg: Johann Grüninger, 1529. VD16 H 5126.
o Otto Brunfeld / Hans Weiditz: Herbarum vivae eicones. Straßburg: Johann Schott, 1530. VD16
 B 8499.
o Otto Brunfels / Hans Weiditz: Contrafayt Kreüterbúch. Straßburg: Johann Schott, 1532. VD16
 B 8503.
o Otto Brunfels / Hans Weiditz: Contrafayt Kreüterbúch. Straßburg: Johann Schott, 1534. VD16
 B 8504.
o Kleyn Gart der Gesundheit. Darin ist begriffen Regiment desz lebens Marsilij Ficinj. Straßburg:
 Jakob Cammerlander, 1543. VD16 K 1263.
o Hieronymus Bock: Kreüterbuch, darinn Underscheidt Namen und Würckung der Kreutter,
 Stauden, Hecken unnd Beumen sampt ihren Früchten, so inn Deütschen Landen wachsen.
 Straßburg: Wendel Rihel, 1551. VD16 B 6017. (2. Aufl. 1546: VD16 B 6016. 1. Aufl. 1539 ohne
 Illustrationen: VD16 B 6015.).
o Hieronymus Bock: De stirpium, maxime earum, quae in Germania. Straßburg: Wendel Rihel,
 1552. VD16 B 6026.
Ulm
o Johannes de Capua: Das buoch der weißhait der alten weisen. Ulm: Lienhart Holl, 1483. GW
 M13180.
o Bernhard von Breydenbach / Johann Wonnecke von Kaub / Erhard Reuwich: Gart der Gesund-
 heit. Ulm: Konrad Dinckmut, 31.3.1487. GW M09746.
Venedig
o Plinius Secundus, Gaius: Historia naturalis. Venedig: Johann von Speyer, 1469. GW M34312.
o Georgius de Ferrariis: Fasciculus medicinae. Venedig: Johannes und Gregorius de Gregoriis,
 26.7.1491. GW M14176.
o Johannes Serapion: Breviarium medicinae. Venedig: Boneto Locatello für Ottaviano Scoto,
 16.12.1497. GW M41687.

Wien

o Taciunum sanitatis, um 1380. Österreichische Nationalbibliothek, Wien: Cod. Ser. n. 2644.

o Johannes Hartlieb: Kräuterbuch, um 1460. Österreichische Nationalbibliothek, Wien: Cod. 2826.

o Gebetbuch, vor 1483. Österreichische Nationalbibliothek, Wien: Cod. Ser. n. 2619.

o Heiltumsbuch: In disem Puechlein ist Verzaichent das Hochwirdig Heyligtu(m)b In der Loblichen stat Wienn In Osterreich alle iar an Sontag nach dem Ostertag zezaigen pfligt. Wien: Johannes Winterburger, 1502. VD16 H 3281.

o Stundenbuch, um 1515. Österreichische Nationalbibliothek, Wien: Cod. 1979.

Wolfenbüttel

o Johannes Hartlieb: Kräuterbuch, um 1455. Herzog August Bibliothek, Wolfenbüttel: Cod. Guelf. 79 Aug. 2°.

Zürich

o Conrad Gessner: Historiae animalium. Zürich: Christoph Froschauer d. Ä., 1551. VD16 G 1723.

S.L.

o The grete herball. S.l.: Peter Treueris, 1526.

Literaturverzeichnis

Abeele / Meyer (2005)

Bartholomaeus Anglicus, „De proprietatibus rerum". Texte latin et réception vernaculaire – Lateinischer Text und volkssprachige Rezeption. Hrsg. v. Baudouin van den Abeele / Heinz Meyer. Tornhout 2005.

Ackerman (1985)

James S. Ackerman: Early Renaissance „naturalism" and scientific illustration. In: Ellenius (1985), S. 1–17.

Alberti (2002)

Leon Battista Alberti: Das Standbild. Die Malkunst. Grundlagen der Malerei. Hrsg., komm., übers. v. Oskar Bätschmann u. a. Darmstadt 2002.

Albertus Magnus (1992)

Albertus Magnus: De vegetabilibus. Buch VI, Traktat 2. Lat.-dts. Übers. u. Komm. v. Klaus Biewer. Stuttgart 1992.

Ambrosio (2015)

Chiara Ambrosio: Picturing knowledge in the Sixteenth Century. [Book Review:] Picturing the Book of Nature. Images, Text, and Argument in Sixteenth-Century Human Anatomy and Medical Botany by Sachiko Kusukawa. In: Studies in History and Philosophy of Science. Part C: Studies in History and Philosophy of Biological and Biomedical Sciences. Vol. 50 (2015), S. 83–86.

Ames-Lewis (1987)

Francis Ames-Lewis: Modelbook Drawings and the Florentine Quattrocento Artist. In: Art History. Vol. 10, No. 1 (1987), S. 1–11.

Amsler (1925)

Hans Amsler: Ein handschriftlicher illustrierter Herbarius aus dem Ende des 15. Jahrhunderts und die medizinisch-botanische Literatur des Mittelalters. Zürich 1925.

Anagnostou u. a. (2011)

A passion for plants. Materia medica and botany in scientific networks from the 16th to 18th centuries. Hrsg. v. Sabine Anagnostou u. a. Stuttgart 2011.

Anderson (1977)

Frank J. Anderson: An illustrated history of the herbals. New York 1977.

Anzulewicz (2001)
Henryk Anzulewicz: Die Handschriften des Albertus Magnus in der Bibliotheca Amploniana. In: Kat.Ausst. Erfurt (2001), S. 142–153.

Arber (1912)
Agnes Arber: Herbals. Their origin and evolution. A chapter in the history of botany 1470–1670. Cambridge 1912.

Arber (1960)
Agnes Arber: Sehen und Denken in der biologischen Forschung. Reinbek 1960.

Aristoteles (1999)
Aristoteles: Opuscula V. De coloribus. Werke in deutscher Übersetzung. Bd. 18 / V. Berlin 1999.

Aristoteles (2004)
Aristoteles: De memoria et reminiscentia. Werke in deutscher Übersetzung. Bd. 14 Parva Naturalia, T. 2. Berlin 2004.

Assman / Strohm (2010)
Magie und Religion. Hrsg. v. Jan Assmann / Harald Strohm. München 2010.

Auge / Gadebusch Bondio (2006)
Gesundheit im Buch: Gedruckte medizinische Kostbarkeiten der Greifswalder Universitätsbibliothek. Hrsg. v. Oliver Auge / Mariacarla Gadebusch Bondio. Greifswald 2006.

Augustyn (2003)
Wolfgang Augustyn: Zur Gleichzeitigkeit von Handschrift und Buchdruck. In: Dicke / Grubmüller (2003), S. 5–47.

Augustyn / Leuschner (2007)
Kunst und Humanismus. Festschrift für Gosbert Schüßler. Hrsg. v. Wolfgang Augustyn / Eckhard Leuschner. Passau 2007.

Augustyn / Söding (2010)
Original – Kopie – Zitat. Kunstwerke des Mittelalters und der Frühen Neuzeit: Wege der Aneignung – Formen der Überlieferung. Hrsg. v. Wolfgang Augustyn / Ulrich Söding. Passau 2010.

Augustyn / Söding (2010a)
Wolfgang Augustyn / Ulrich Söding: Original – Kopie – Zitat. Versuch einer begrifflichen Annäherung. In: Augustyn / Söding (2010), S. 1–14.

Avril (1986)
François Avril: Etude codicologique et artistique. In: Malandin (1986), S. 268–283.

Baader (2005)
Hannah Baader: Frühneuzeitliche Magie als Theorie der Ansteckung und die Kraft der Imagination. In: Schaub (2005), S. 133–151.

Bächtold-Stäubli u. a. (2005)
Handwörterbuch des deutschen Aberglaubens. Hrsg. v. Hanns Bächtold-Stäubli u. a. Augsburg 2005 [Nachdruck von Berlin 1933].

Bakker (2018)
Boudewijn Bakker: Bernhard von Breydenbach and Erhard Reuwich of Utrecht. Pioneers in the theory and practice of the lifelike printed image. In: Simiolus 40 (2018), S. 231–257.

Barasch (1978)
Moshe Barasch: Light and color in the Italian Renaissance theory of art. New York 1978.

Barral i Altet (1990)
Artistes, artisans et production artistique au Moyen Age. Bd. 3: Fabrication et consommation de l'œuvre. Hrsg. v. Xavier Barral i Altet. Paris 1990, S. 271–293.

Baumann (1974)
Felix Andreas Baumann: Das Erbario Carrarese und die Bildtradition des Tractatus de herbis. Ein Beitrag zur Geschichte der Pflanzendarstellung im Übergang vom Spätmittelalter zur Frührenaissance. Bern 1974.

Literaturverzeichnis 269

Baumann (1998)

Susanne Baumann: Pflanzenabbildungen in alten Kräuterbüchern. Die Umbelliferen in der Herbarien- und Kräuterbuchliteratur der frühen Neuzeit. Stuttgart 1998.

Baumann / Baumann (2010)

Brigitte Baumann / Helmut Baumann: Mainzer Kräuterbuch-Inkunabeln. „Herbarius Moguntinus" (1484), „Gart der Gesundheit" (1485), „Hortus sanitatis" (1491). Wissenschaftshistorische Untersuchung der drei Prototypen botanisch-medizinischer Literatur des Spätmittelalters. Stuttgart 2010.

Baxandall (2004)

Michael Baxandall: Die Kunst der Bildschnitzer. Tilman Riemenschneider, Veit Stoß und ihre Zeitgenossen. München 2004 (4. Aufl.).

Bedini (2006)

Silvio A. Bedini: Der Elefant des Papstes. Stuttgart 2006.

Behling (1957)

Lottlisa Behling: Die Pflanzen in der mittelalterlichen Tafelmalerei. Weimar 1957.

Behling (1964)

Lottlisa Behling: Die Pflanzenwelt der mittelalterlichen Kathedrale. Köln / Graz 1964.

Behling (1989)

Lottlisa Behling: Zur Ikonographie einiger Pflanzendarstellungen von Dürer. In: Koreny (1989), S. 43–56.

Belliger (2006)

ANThology. Ein einführendes Handbuch zur Akteur-Netzwerk-Theorie. Hrsg. v. Andréa Belliger. Bielefeld 2006.

Bennewitz (2011)

Farbe im Mittelalter. Materialität – Medialität – Semantik. Hrsg. v. Ingrid Bennewitz. 2 Bde. Berlin 2011.

Benthien / Weingart (2014)

Handbuch Literatur & Visuelle Kultur. Hrsg. v. Claudia Benthien / Brigitte Weingart. Berlin u. a. 2014.

Bernhard von Breydenbach (1485)

Bernhard von Breydenbach: Vorwort, Gart der Gesundheit. Mainz 1485.

Bernhard von Breydenbach (2010)

Bernhard von Breydenbach: Peregrinatio in terram sanctam. Frühneuhochdeutscher Text und Übersetzung. Hrsg. v. Isolde Mozer. Berlin / New York 2010.

Birkhan (2012)

Helmut Birkhan: Pflanzen im Mittelalter. Eine Kulturgeschichte. Wien u. a. 2012.

Blair (2006)

Ann Blair: Natural Philosophy. In: Park / Daston (2006), S. 265–406.

Blum (2010)

Gerd Blum: Zur Geschichtstheologie von Vasaris „Vite" (1550). Kunstgeschichte als „große Erzählung" und Bildsystem. In: Ganz / Thürlemann, S. 271–288.

Blumenberg (1957)

Hans Blumenberg: Nachahmung der Natur. In: Studium Generale 10 (1957), S. 266–283.

Blunt (1950)

Wilfrid Blunt: The art of botanical illustration. London 1950.

Blunt / Raphael (1979)

Wilfrid Blunt / Sandra Raphael: The illustrated herbal. New York 1979.

Bock (1551)

Hieronymus Bock: Kreüterbuch. Straßburg 1551.

Bodechtel / Eisenbein (2008)

Steffi Bodechtel / Manfried Eisbein: Zur Restaurierungsgeschichte. In: Der Zwickauer Wolge-

mut-Altar. Beiträge zu Geschichte, Ikonographie, Autorschaft und Restaurierung. Hrsg. v. Landes-
amt für Denkmalpflege Sachsen. Görlitz 2008, S. 135–148.
Boehm (2003)
Gottfried Boehm: Der Topos des Anfangs. Geometrie und Rhetorik in der Malerei der Renaissance.
In: Pfisterer / Seidel (2003), S. 48–60.
Böhme (2007)
Hartmut Böhme: Koralle und Pfau. Schrift und Bild im Wiener Dioskurides. In: Helas (2007),
S. 54–72.
Bonnet (2001)
Anne-Marie Bonnet: „Akt" bei Dürer. Köln 2001.
Bredekamp (1993)
Horst Bredekamp: Antikensehnsucht und Maschinenglauben. Die Geschichte der Kunstkammer
und die Zukunft der Kunstgeschichte. Berlin 1993.
Bredekamp (1995)
Horst Bredekamp: Repräsentation und Bildmagie der Renaissance als Formproblem. München 1995.
Bredekamp (2010)
Horst Bredekamp: Theorie des Bildakts. Frankfurter Adorno-Vorlesung. Berlin 2010.
Bredekamp u. a. (2003)
Horst Bredekamp u. a.: Bildwelten des Wissens. In: Bildwelten des Wissens. Kunsthistorisches Jahr-
buch für Bildkritik. Bilder in Prozessen. 1,1 (2003), S. 9–20.
Bredekamp u. a. (2008)
Das technische Bild. Kompendium zu einer Stilgeschichte wissenschaftlicher Bilder. Hrsg. v. Horst
Bredekamp u. a. Berlin 2008.
Bredekamp u. a. (2010)
Imagination und Repräsentation. Zwei Bildsphären der Frühen Neuzeit. Hrsg. v. Horst Bredekamp
u. a. München u. a. 2010.
Bredow-Klaus (2009)
Isabel von Bredow-Klaus: Heilsrahmen. Spirituelle Wallfahrt und Augentrug in der flämischen
Buchmalerei des Spätmittelalters und der frühen Neuzeit. München 2009 (3. Aufl.).
Breidbach (2005)
Olaf Breidbach: Bilder des Wissens. Zur Kulturgeschichte der wissenschaftlichen Wahrnehmung.
München 2005.
Brunfels (1532)
Otto Brunfels: Contrafayt Kreüterbúch. Straßburg 1532.
Bryson (1990)
Norman Bryson: Looking at the overlooked. Four essays on still life painting. Cambridge, Mass.
1990.
Büchsel u. a. (2003)
Das Porträt vor der Erfindung des Porträts. Hrsg. v. Martin Büchsel u. a. Mainz 2003.
Buck (1969)
Zu Begriff und Problem der Renaissance. Hrsg. v. August Buck. Darmstadt 1969.
Buck (2012)
Stephanie Buck: Tradition und Herausforderung. Dürers früheste Figurenstudien. In: Kat.Ausst.
Nürnberg (2012), S. 90–100.
Burkart u. a. (2010)
Le trésor au Moyen Âge. Discours, pratiques et objets. Hrsg. v. Lucas Burkart u. a. Florenz 2010.
Bushart (2011)
Magdalena Bushart: Schwarz auf weiß. Medienreflexion im druckgraphischen Werk Albrecht Alt-
dorfers. In: Bildwelten des Wissens. Kunsthistorisches Jahrbuch für Bildkritik. Graustufen. 8,2
(2011), S. 74–85.

Büttner / Wimböck (2004)
Das Bild als Autorität. Die normierende Kraft des Bildes. Hrsg. v. Frank Büttner / Gabriele Wimböck. Münster 2004.

Cárdenas (2013)
Livia Cárdenas: Die Textur des Bildes. Das Heiltumsbuch im Kontext religiöser Medialität des Spätmittelalters. Berlin 2013.

Cermann (2014)
Regina Cermann: Stephan Schreiber und der Uracher Hof samt Neuinterpretation der Palme Graf Eberhards im Bart. In: Stadt, Schloss und Residenz Urach. Hrsg. v. Staatliche Schlösser und Gärten Baden-Württemberg / Klaus Gereon Beuckers. Regensburg 2014, S. 53–83.

Chapuis (2004)
Tilman Riemenschneider, c. 1460–1531. Hrsg. v. Julien Chapuis. New Haven u. a. 2004.

Châtelet-Lange (2007)
Liliane Châtelet-Lange: Straßburger Bürgerfrömmigkeit und der Maler David Kandel (1520/1530–1592/1596). In: Anzeiger des Germanischen Nationalmuseums (2007), S. 7–28.

Chojecka (1982)
Ewa Chojecka: Bayerische Bild-Enzyklopädie. Das Weltbild eines wissenschaftlich-magischen Hausbuches aus dem frühen 16. Jahrhundert. Baden-Baden 1982.

Clarke (2001)
Mark Clarke: The Art of All Colours. Mediaeval Recipe Books for Painters and Illuminators. London 2001.

Clausberg (2006)
Karl Clausberg: [Wiedergelesen:] Ernst H. Gombrich: Art and Illusion. In: Bildwelten des Wissens. Kunsthistorisches Jahrbuch für Bildkritik. Bilder ohne Betrachter. 4,2 (2006), S. 105 f.

Collins (2000)
Minta Collins: Medieval herbals. The illustrative traditions. London 2000.

Comes (2013)
Elisabeth Margarete Comes: Ein Garten Eden. Die Pflanzen auf Stefan Lochners Altar der Stadtpatrone. Berlin 2013.

Conrad (2006)
Dennis Conrad: Hans Weiditz. In: Kat.Ausst. Frankfurt a. M. / München (2006), S. 34–37.

Cook (2007)
Harold J. Cook: Medicine. In: Park / Daston (2006), S. 407–434.

Cordez (2015)
Philippe Cordez: Schatz, Gedächtnis, Wunder. Die Objekte der Kirchen im Mittelalter. Regensburg 2015.

Dackerman (2002)
Susan Dackerman: Painted Prints in Germany and the Netherlands. In: Kat.Ausst. Baltimore (2002), S. 9–48.

Dackerman (2011)
Susan Dackerman: Dürer's Indexical Fantasy. The Rhinoceros and Printmaking. In: Kat.Ausst. Cambridge, Mass. (2011), S. 162–171.

Daston (2005)
Lorraine Daston: Bilder der Wahrheit, Bilder der Objektivität. In: Huber (2005), S. 117–153.

Daston (2011)
Lorraine Daston: Observation. In: Kat.Ausst. Cambridge, Mass. (2011), S. 126–133.

Daston / Galison (2007)
Lorraine Daston / Peter Galison: Objektivität. Frankfurt a. M. 2007.

De Angelis (2011)
Simone De Angelis: Sehen mit dem physischen und dem geistigen Auge. Formen des Wissens, Vertrauens und Zeigens in Texten der frühneuzeitlichen Medizin. In: Jaumann (2011), S. 211–254.

Dicke / Grubmüller (2003)
> Die Gleichzeitigkeit von Handschrift und Buchdruck. Hrsg. v. Gerd Dicke / Klaus Grubmüller. Wiesbaden 2003.

Dilg (1978)
> Peter Dilg: Vom Ansehen der Arzneikunst. Historische Reflexionen in Kräuterbüchern des 16. Jahrhunderts. In: Sudhoffs Archiv. Bd. 62, H. 1 (1978), S. 64–79.

Dilg (1995)
> Inter folia fructus. Gedenkschrift für Rudolf Schmitz. Hrsg. v. Peter Dilg. Frankfurt a. M. 1995.

Dilg (2003)
> Natur im Mittelalter. Konzeption – Erfahrungen – Wirkungen. Hrsg. v. Peter Dilg. Berlin 2003.

Dilg / Keil (1991)
> Peter Dilg / Gundolf Keil: Kräuterbuch. In: Lexikon des Mittelalters. Hrsg. v. Robert-Henri Bautier u. a. Bd. 5. München u. a. 1991, Sp. 1476 f.

Dioscurides (2002)
> Pedanius Dioscurides aus Anazarba: Fünf Bücher über die Heilkunde. Aus dem Griech. übers. von Max Aufmesser. Hildesheim u. a. 2002.

Döbler (2001)
> Eckehart Döbler: Amplonius der Büchersammler. In: Kat.Ausst. Erfurt (2001), S. 26–37.

Dressendörfer (2003)
> Werner Dressendörfer: Blüten, Kräuter und Essenzen. Heilkunst alter Kräuterbücher. Darmstadt 2003.

Dressendörfer (2012)
> Werner Dressendörfer: Durch die Blume gesprochen. Pflanzen im „Himmelsgarten" von St. Michael zu Bamberg. Symbolik, Botanik, Medizin. Gerchsheim 2012.

Dunlop (1990)
> Louisa Dunlop: Pigments and painting materials in fourteenth- and early fifteenth-century Parisian manuscript illumination. In: Barral i Altet (1990), S. 271–293.

Dürer (1966)
> Albrecht Dürer: Schriftlicher Nachlass. Bd. 2: Die Anfänge der theoretischen Studien. Das Lehrbuch der Malerei: Von der Maß der Menschen, der Pferde, der Gebäude; Von der Perspektive; Von Farben. Ein Unterricht alle Maß zu ändern. Hrsg. v. Hans Rupprich. Berlin 1966.

Egmond (2017)
> Florike Egmond: Eye for Detail. Images of Plants and Animals in Art and Science, 1500–1630. London 2017.

Eisenstein (1997)
> Elizabeth L. Eisenstein: Die Druckerpresse. Kulturrevolutionen im frühen modernen Europa. Wien u. a. 1997.

Eising (2013)
> Erik Eising: Geschäft und Vergnügen zugleich. Albrecht Dürers Reise in die Niederlande. In: Kat. Ausst. Frankfurt a. M. (2013), S. 332–337.

Ellenius (1985)
> The natural sciences and the arts. Aspects of interaction from the Renaissance to the 20th century. Hrsg. v. Allan Ellenius. Stockholm 1985.

Erichsen (1994)
> Johannes Erichsen: Vorlagen und Werkstattmodelle bei Cranach. In: Kat.Ausst. Kronach (1994), S. 180–185.

Fehrenbach (2003)
> Frank Fehrenbach: Calor nativus – Color vitale. Prolegomena zu einer Ästhetik des „Lebendigen Bildes" in der Frühen Neuzeit. In: Pfisterer / Seidel (2003), S. 151–170.

Fehrenbach (2005)
 Frank Fehrenbach: Kohäsion und Transgression. Zur Dialektik lebendiger Bilder. In: Pfisterer / Zim-
 mermann (2005), S. 1–40.
Fehrenbach (2010)
 Frank Fehrenbach: Eine Zartheit am Horizont unseres Sehvermögens. Bildwissenschaft und Leben-
 digkeit. In: Kritische Berichte 3 (2010), S. 32–45.
Fehrenbach (2011)
 Frank Fehrenbach: Lebendigkeit. In: Pfisterer (2011b).
Felfe (2013)
 Robert Felfe: Naer het leven. Eine sprachliche Formel zwischen bildgenerierenden Übertragungs-
 vorgängen und ästhetischer Vermittlung. In: Fritzsche u. a. (2013), S. 165–195.
Felfe (2014)
 Robert Felfe: Figurationen im Gestein. Ko-Produktionen zwischen Kunst und Natur. In: Gastel u. a.
 (2014), S. 153–175.
Felfe (2015a)
 Robert Felfe: Naturform und bildnerische Prozesse. Elemente einer Wissensgeschichte in der Kunst
 des 16. und 17. Jahrhunderts. Berlin 2015.
Felfe (2015b)
 Robert Felfe: Zeichnen als Weltentfaltung versus Suche nach Ordnung von Conrad Gessner bis John
 Ruskin. In: Kat.Ausst. Heidelberg (2015), S. 33–43.
Ficino (1994)
 Marsilio Ficino: Über die Liebe oder Platons Gastmahl. Übers. v. Karl Paul Hasse. Hrsg. u. eingel. v.
 Paul Richard Blum. Hamburg 1994.
Findlen (2006)
 Paula Findlen: Natural History. In: Park / Daston (2006), S. 435–468.
Fischel (2009)
 Angela Fischel: Natur im Bild. Zeichnung und Naturerkenntnis bei Conrad Gessner und Ulisse
 Aldrovandi. Berlin 2009.
Fischer (1927)
 Hermann Fischer: Die heilige Hildegard von Bingen. Die erste deutsche Naturforscherin und Ärz-
 tin, ihr Leben und Werk. München 1927.
Fischer (1929)
 Hermann Fischer: Mittelalterliche Pflanzenkunde. München 1929 [Nachdruck Hildesheim 1967].
Fleck (2011)
 Ludwig Fleck: Schauen, Sehen, Wissen. In: Ludwig Fleck: Denkstile und Tatsachen. Gesammelte
 Schriften und Zeugnisse. Hrsg. v. Claudia Zittel u. a. Berlin 2011, S. 390–418.
Fohrmann (2005)
 Gelehrte Kommunikation. Wissenschaft und Medium zwischen dem 16. und 20. Jahrhundert. Hrsg.
 v. Jürgen Fohrmann. Wien u. a. 2005.
Ford (2003)
 Brian J. Ford: Scientific Illustration in the Eighteenth Century. In: Lindberg u. a. Bd. 4 (2003),
 S. 561–583.
Foucault (1971)
 Michel Foucault. Die Ordnung der Dinge. Eine Archäologie der Humanwissenschaften. Frankfurt
 a. M. 1971.
Frasca-Spada / Jardine (2000)
 Books and Sciences in History. Hrsg. v. Marina Frasca-Spada / Nick Jardine. Cambridge 2000.
Freedberg (1994)
 David Freedberg: The failure of colour. In: Onians (1994), S. 245–262.
Friedrich / Telle (2009)

Pharmazie in Geschichte und Gegenwart. Festgabe für Wolf-Dieter Müller-Jahncke zum 65. Geburtstag. Hrsg. v. Christoph Friedrich / Joachim Telle. Stuttgart 2009.

Fritzsche u. a. (2013)

Ad fontes! Niederländische Kunst des 17. Jahrhunderts in Quellen. Hrsg. v. Claudia Fritzsche u. a. Petersberg 2013.

Fuchs (1542)

Leonhart Fuchs: De historia stirpium commentarii insignes. Basel 1542.

Fuchs (2009)

Reimar Walter Fuchs: Die Mainzer Frühdrucke mit Buchholzschnitten 1480–1500. Stuttgart 2009 [Nachdruck von 1958].

Füssel (2001)

Hartmann Schedel: Weltchronik. Kolorierte Gesamtausgabe von 1493. Einl. u. Komm. v. Stephan Füssel. Köln u. a. 2001.

Gadebusch Bondio (2010)

Gadebusch Bondio, Mariacarla: Thesaurus sanitatis. Zu Tradition und Erfolg der Schatzmetapher in der Medizin. In: Burkart u. a. (2010), S. 103–128.

Gage (1999)

John Gage: Die Sprache der Farben. Bedeutungswandel der Farbe in der bildenden Kunst. Ravensburg 1999.

Gage (2001)

John Gage: Farben in Kulturgeschichte und Naturwissenschaft. Von der Antike bis zur Gegenwart. Leipzig 2001.

Ganz / Thürlemann (2010)

Das Bild im Plural. Mehrteilige Bildformen zwischen Mittelalter und Gegenwart. Hrsg. v. David Ganz / Felix Thürlemann. Berlin 2010, S. 271–288.

Gastel u. a. (2014)

Paragone als Mitstreit. Hrsg. v. Joris van Gastel u. a. Berlin 2014.

Georgi (2013)

Katharina Georgi: Illuminierte Gebetbücher aus dem Umkreis der Nürnberger Pleydenwurff-Wolgemut-Werkstatt. Petersberg 2013.

Gerhardt / Schnell (2002)

In verbis in herbis et in lapidibus est deus. Zum Naturverständnis in den deutschsprachigen illustrierten Kräuterbüchern des Mittelalters. Hrsg. v. Christoph Gerhardt / Bernhard Schnell. Trier 2002.

Giesecke (2006)

Michael Giesecke: Der Buchdruck in der frühen Neuzeit. Eine historische Fallstudie über die Durchsetzung neuer Informations- und Kommunikationstechnologien. Frankfurt a. M. 2006 (4. Aufl.).

Givens (2005)

Jean A. Givens: Observation and Image-Making in Gothic Art. Cambridge 2005.

Givens (2006)

Jean A. Givens: Reading and Writing the Illustrated „Tractatus de herbis", 1280–1526. In: Givens u. a. (2006), S. 115–145.

Givens u. a. (2006)

Visualizing Medieval Medicine and Natural History, 1200–1550. Hrsg. v. Jean A. Givens u. a. Aldershot u. a. 2006.

Goehl (2000)

Editionen und Studien zur lateinischen und deutschen Fachprosa des Mittelalters. Hrsg. v. Konrad Goehl u. a. Würzburg 2000.

Göing u. a. (2013)

Collectors' knowledge. What is kept, what is discarded. – Aufbewahren oder wegwerfen. Wie Sammler entscheiden. Hrsg. v. Anja-Silvia Göing u. a. Leiden u. a. (2013).

Gollwitzer-Voll (2007)

Woty Gollwitzer-Voll: Christus Medicus – Heilung als Mysterium. Interpretationen eines alten Christusnamens und dessen Bedeutung in der Praktischen Theologie. Paderborn u. a. 2007.

Gombrich (1960)

Ernst H. Gombrich: Art and Illusion. A Study in the Psychology of Pictorial Representation. New York 1960.

Gombrich (1973)

Ernst H. Gombrich: Meditationen über ein Steckenpferd. Von den Wurzeln und Grenzen der Kunst. Wien 1973 (2. Aufl.).

Gombrich (1982)

Ernst H. Gombrich: The Image and the Eye. Further Studies in the Psychology of Pictorial Representation. Oxford 1982.

Gombrich (1994)

Ernst H. Gombrich: Das forschende Auge. Kunstbetrachtung und Naturwahrnehmung. Frankfurt u. a. 1994.

Gombrich (1999)

Ernst H. Gombrich: The Uses of Images. Studies in the Social Function of Art and Visual Communication. London 1999.

Goodman (1997)

Nelson Goodman: Sprachen der Kunst. Entwurf einer Symboltheorie. Frankfurt a. M. 1997.

Gormans / Lentes (2007)

Das Bild als Erscheinung. Die Gregorsmesse im Mittelalter. Hrsg. v. Andreas Gormans / Thomas Lentes. Berlin 2007.

Gottschall (2004)

Dagmar Gottschall: Konrad von Megenbergs Buch von den natürlichen Dingen. Ein Dokument deutschsprachiger Albertus-Magnus-Rezeption im 14. Jahrhundert. Leiden u. a. 2004.

Grandmontagne (2009)

Michael Grandmontagne: Farbe bekennen: Von Figuren und Fassmalern. Bedeutungsaspekte mittelalterlicher Skulpturenpolychromie. In: Kat.Ausst. Bonn (2009), S. 138–159.

Grape-Albers (1977)

Heide Grape-Albers: Spätantike Bilder aus der Welt des Arztes. Medizinische Bilderhandschriften der Spätantike und ihre mittelalterliche Überlieferung. Wiesbaden 1977.

Groebner (2004)

Valentin Groebner: Der Schein der Person. Steckbrief, Ausweis und Kontrolle im Europa des Mittelalters. München 2004.

Grosseteste (2013)

Robert Grosseteste: The Dimensions of Colour. Robert Grosseteste's „De colore". Hrsg., übers. u. komm. v. Greti Dinkova-Bruun u. a. Toronto 2013.

Grubmüller (1999)

Klaus Grubmüller: Nature ist der ander got. In: Robertshaw (1999), S. 3–17.

Gutscher-Schmid (2007)

Charlotte Gutscher-Schmid: Nelken statt Namen. Die spätmittelalterlichen Malerwerkstätten der Berner Nelkenmeister. Bern 2007.

Habermann (2001)

Mechthild Habermann: Deutsche Fachtexte der frühen Neuzeit. Naturkundlich-medizinische Wissensvermittlung im Spannungsfeld zwischen Latein und Volkssprache. Berlin u. a. 2001.

Handschriftencensus (online)

Handschriftencensus. Eine Bestandsaufnahme der handschriftlichen Überlieferung deutschsprachiger Texte des Mittelalters: http://www.handschriftencensus.de.

Hartmann (2006)

Katja Hartmann: Das „Kreuterbuch" des Adam Lonitzer. In: Auge / Gadebusch Bondio (2006), S. 69–73.

Hauschild (2005)

Stephanie Hauschild: Die sinnlichen Gärten des Albertus Magnus. Ostfildern 2005.

Hayer / Schnell (2010)

Johannes Hartlieb: Kräuterbuch. Zum ersten Mal kritisch hrsg. v. Gerold Hayer und Bernhard Schnell. Wiesbaden 2010.

Heilmann (1964)

Karl Eugen Heilmann: Kräuterbücher in Bild und Geschichte. München 1964.

Heinrichs (2007)

Ulrike Heinrichs: Martin Schongauer. Maler und Kupferstecher. Kunst und Wissenschaft unter dem Primat des Sehens. Berlin u. a. 2007.

Helas (2007)

Bild/Geschichte. Festschrift für Horst Bredekamp. Hrsg. v. Philine Helas u. a. Berlin 2007.

Hess (2012)

Daniel Hess: Die Natur als vollkommene Lehrmeisterin der Kunst. In: Kat.Ausst. Nürnberg (2012), S. 117–131.

Heydeck (2003)

Kurt Heydeck: Fachliteratur, Fachprosa. In: Kat.Ausst. Berlin (2003), S. 340 f.

Hinterwaldner u. a. (2008)

Topologien der Bilder. Hrsg. v. Inge Hinterwaldner u. a. München u. a. 2008.

Hinz (1994)

Berthold Hinz: Sinnwidrig zusammengestellte Fabrikate? Zur Varianten-Praxis der Cranach-Werkstatt. In: Kat.Ausst. Kronach (1994), S. 174–179.

Hoeniger (2006)

Cathleen Hoeniger: The Illuminated „Tacuinum sanitatis" Manuscripts from Northern Italy ca. 1380–1400. Sources, Patrons, and the Creation of a New Pictorial Genre. In: Givens u. a. (2006), S. 52–81.

Höfinghoff (1996)

Alles was Recht war. Rechtsliteratur und literarisches Recht. Hrsg. v. Hans Höfinghoff. Essen 1996.

Hofmeister-Winter u. a. (2014)

Der Koch ist der bessere Arzt. Zum Verhältnis von Diätetik und Kulinarik im Mittelalter und in der Frühen Neuzeit. Hrsg. v. Andrea Hofmeister-Winter u. a. Frankfurt am Main u. a. 2014.

Hoppe (1969)

Brigitte Hoppe: Das Kräuterbuch des Hieronymus Bock. Stuttgart 1969.

Hoppe (1970)

Brigitte Hoppe: Abbilden und Beschreiben in der Naturforschung. In: Veröffentlichungen des Forschungsinstituts des Deutschen Museums für die Geschichte der Naturwissenschaften und der Technik A / 54. Hrsg. v. Forschungsinstitut für die Geschichte der Naturwissenschaften und der Technik. München 1970, S. 71–90.

Huber (2005)

Einbildungen. Hrsg. v. Jörg Huber u. a. Wien u. a. 2005.

Hülsen-Esch (2003)

Andrea von Hülsen-Esch: Gelehrte in Gruppen, oder: das Gruppenporträt vor der Erfindung des Gruppenporträts. In: Büchsel u. a. (2003), S. 173–189.

Hülsen-Esch (2006)
Andrea von Hülsen-Esch: Gelehrte im Bild. Repräsentation, Darstellung und Wahrnehmung einer sozialen Gruppe im Mittelalter. Göttingen 2006.

Hüning (2010)
Heinrich Hüning: Würfelwörter und Rätselbilder im Parzivalprolog Wolframs von Eschenbach. Frankfurt a. M. u. a. 2010.

Hunt (1996)
The Italian Garden. Art, Design and Culture. Hrsg. v. John Dixon Hunt. Cambridge 1996.

Huschenbett (1991)
Reisen und Welterfahrung in der deutschen Literatur des Mittelalters. Hrsg. v. Dietrich Huschenbett u. a. Würzburg 1991.

Ikeda (2015)
Mayumi Ikeda: The Fust and Schöffer Office and the Printing of the Two-colour Initials in the 1457 Mainz Psalter. In: Stijnman / Savage (2015), S. 69–75.

Inkunabelkatalog (online)
Inkunabelkatalog der Universität Tübingen: http://www.inka.uni-tuebingen.de.

Isphording (2008)
Eduard Isphording: Kräuter und Blumen. Kommentiertes Bestandsverzeichnis der botanischen Bücher bis 1850 in der Bibliothek des Germanischen Nationalmuseums Nürnberg. Nürnberg 2008.

Ivins (1948)
William M. Ivins: A neglected Aspect of Early Printmaking. In: The Metropolitan Museum of Art Bulletin 7 (1948), S. 51–69.

Ivins (1969)
William M. Ivins: Prints and visual communication. Cambridge, Mass. 1969 [Erstauflage: 1953].

Jaeger (2005–2012)
Enzyklopädie der Neuzeit. Hrsg. v. Friedrich Jaeger u. a. 16 Bde. Stuttgart 2005–2012.

Jankrift (2003)
Kay Peter Jankrift: Krankheit und Heilkunde im Mittelalter. Darmstadt 2003.

Jansen (2013)
Ulrike Jansen: „Spuria Macri". Ein Anhang zu „Macer Floridus, De viribus herbarum". Einl., Übers., Komm. v. Ulrike Jansen. Berlin u. a. 2013.

Jauman (2011)
Diskurse der Gelehrtenkultur in der Frühen Neuzeit. Ein Handbuch. Hrsg. v. Herbert Jaumann. Berlin. 2011.

Johann Wonnecke von Kaub (1485)
Johann Wonnecke von Kaub: Gart der Gesundheit. Mainz 1485.

Johansen (1998)
Thomas Kjeller Johansen: Aristotle on the sense-organs. Cambridge 1998.

Kat.Ausst. Baltimore (2002)
Painted prints. The revelation of color in Northern Renaissance & Baroque engravings, etchings & woodcuts. Hrsg. v. Susan Dackerman. University Park, Pa. 2002.

Kat.Ausst. Bedburg-Hau (2004)
Pflanzenkunde im Mittelalter. Das Kräuterbuch von 1470 der Wasserburgen Anholt und Moyland. Hrsg. v. Ron Manheim u. a. Bedburg-Hau 2004.

Kat.Ausst. Berlin (2003)
Aderlass und Seelentrost. Die Überlieferung deutscher Texte im Spiegel Berliner Handschriften und Inkunabeln. Hrsg. v. Peter Jörg Becker / Eef Overgaauw. Mainz 2003.

Kat.Ausst. Berlin (2009)
Cranach und die Kunst der Renaissance unter den Hohenzollern. Kirche, Hof und Stadtkultur. Hrsg. v. der Generaldirektion der Stiftung Preußische Schlösser u. a. Berlin u. a. 2009.

Kat.Ausst. Bonn (2009)
Schöne Madonnen am Rhein. Hrsg. v. Robert Suckale. Leipzig 2009.

Kat.Ausst. Cambridge, Mass. (2011)
Prints and the Pursuit of Knowledge in Early Modern Europe. Hrsg. v. Susan Dackerman u. a. Cambridge, Mass. 2011.

Kat.Ausst. Colmar (1991)
Der hübsche Martin. Kupferstiche und Zeichnungen von Martin Schongauer (ca. 1450–1491). Hrsg. v. Fedja Anzelewsky. Colmar 1991.

Kat.Ausst. Cremona / New York (2004)
Painters of reality. The legacy of Leonardo and Caravaggio in Lombardy. Hrsg. v. Andrea Bayer u. a. New York 2004.

Kat.Ausst. Dresden (2013)
Mit den Gezeiten. Frühe Druckgraphik der Niederlande. Hrsg. v. Tobias Pfeifer-Helke u. a. Petersberg 2013.

Kat.Ausst. Erfurt (2001)
Der Schatz des Amplonius. Die große Bibliothek des Mittelalters in Erfurt. Hrsg. v. Kathrin Paasch. Erfurt 2001.

Kat.Ausst. Frankfurt a. M. (2013)
Dürer. Kunst – Künstler – Kontext. Hrsg. v. Jochen Sander u. a. München u. a. 2013.

Kat.Ausst. Frankfurt a. M. / München (2006)
Gärten. Ordnung – Inspiration – Glück. Hrsg. v. Sabine Schulze. Ostfildern 2006.

Kat.Ausst. Hamburg (1983)
Luther und die Folgen für die Kunst. Hrsg. v. Werner Hofmann u. a. München 1983.

Kat.Ausst. Heidelberg (2015)
Lernt zeichnen! Techniken zwischen Kunst und Wissenschaft 1525–1925. Hrsg. v. Maria Heilmann u. a. Passau 2015.

Kat.Ausst. Karlsruhe (2012)
Déjà-vu? Die Kunst der Wiederholung von Dürer bis YouTube. Hrsg. v. Ariane Mensger u. a. Bielefeld / Berlin 2012.

Kat.Ausst. Kronach (1994)
Lucas Cranach. Ein Maler-Unternehmer aus Franken. Hrsg. v. Claus Grimm u. a. Regensburg 1994.

Kat.Ausst. Mainz (2000)
Gutenberg – Aventur und Kunst. Vom Geheimunternehmen zur ersten Medienrevolution. Hrsg. v. der Stadt Mainz. Mainz 2000.

Kat.Ausst. Mainz (2003)
Peter Schöffer: Bücher für Europa. Bearb. v. Cornelia Schneider. Mainz 2003.

Kat.Ausst. Mainz (2005)
Bilderlust und Lesefrüchte. Das illustrierte Kunstbuch von 1750 bis 1920. Hrsg. v. Katharina Krause u. a. Leipzig 2005.

Kat.Ausst. München (2009)
Als die Lettern laufen lernten. Medienwandel im 15. Jahrhundert. Inkunabeln aus der Bayerischen Staatsbibliothek München. Hrsg. v. Bettina Wagner. Wiesbaden 2009.

Kat.Ausst. München (2014)
Welten des Wissens. Die Bibliothek und die Weltchronik des Nürnberger Arztes Hartmann Schedel (1440–1514). Hrsg. v. Bettina Wagner. München 2014.

Kat.Ausst. Nürnberg (2012)
Der frühe Dürer. Hrsg. v. Daniel Hess u. a. Nürnberg 2012.

Kat.Ausst. Schweinfurt (2011)
Gart der Gesundheit. Botanik im Buchdruck von den Anfängen bis 1800. Hrsg. v. Irmgard Müller u. a. Halle 2011.

Kat.Ausst. Washington (2009)
: The woodcut in fifteenth-century Europe. Hrsg. v. Peter Parshall. New Haven u. a. 2009.

Kat.Ausst. Wien (1985)
: Albrecht Dürer und die Tier- und Pflanzenstudien der Renaissance. Hrsg. v. Fritz Koreny. München 1985.

Kat.Ausst. Wien (1987)
: Flämische Buchmalerei. Handschriftenschätze aus dem Burgunderreich. Bearb. v. Dagmar Thoss. Graz 1987.

Kaufmann (1993)
: Thomas DaCosta Kaufmann: The mastery of nature. Aspects of art, science and humanism in the Renaissance. Princeton, NJ 1993.

KdiH (1991ff.)
: Katalog der deutschsprachigen illustrierten Handschriften des Mittelalters (KdiH). Begonnen von Hella Frühmorgen-Voss und Norbert H. Ott. Hrsg. v. Ulrike Bodemann u. a. Bd. 1ff. München 1991ff.

Keil (1980)
: Gundolf Keil: Gart der Gesundheit. In: Verfasserlexikon. Bd. 2 (1980), Sp. 1072–1092.

Keil (1982)
: Fachprosa-Studien: Beiträge zur mittelalterlichen Wissenschafts- und Geistesgeschichte. Hrsg. v. Gundolf Keil u. a. Berlin 1982.

Keil (1983)
: Gundolf Keil: Hortus sanitatis. In: Verfasserlexikon. Bd. 4 (1983), Sp. 154–163.

Keil (1993)
: „ein teutsch puech machen". Untersuchungen zur landessprachlichen Vermittlung medizinischen Wissens. Hrsg. v. Gundolf Keil. Wiesbaden 1993.

Keil (1995)
: Würzburger Fachprosa-Studien. Beiträge zur mittelalterlichen Medizin-, Pharmazie- und Standesgeschichte aus dem Würzburger Medizinhistorischen Institut. Hrsg. v. Gundolf Keil. Würzburg 1995.

Keller (1984)
: Hiltgart L. Keller: Reclams Lexikon der Heiligen und biblischen Gestalten. Legende und Darstellung in der bildenden Kunst. Stuttgart 1986 (5. Aufl.).

Kemp (1990)
: Martin Kemp: Taking It on Trust. Form and Meaning in Naturalistic Representation. In: Archivs of Natural History 17 (1990), S. 127–188.

Kemp (2004)
: Martin Kemp: Leonardo and the Idea of Naturalism: Leonardo's Hypernaturalism. In: Kat.Ausst. Cremona / New York (2004), S. 65–73.

Kemp (2005)
: Martin Kemp: Bilderwissen. Die Anschaulichkeit naturwissenschaftlicher Phänomene. Köln 2005.

Kemp (2015)
: Wolfgang Kemp: Per symbola ad astra. Neues von der Deutungskunst. Gastkommentar. In: arthistoricum, 24.6.2015. Online: http://blog.arthistoricum.net/beitrag/2015/06/24/per-symbola-ad-astra/ (letzter Zugriff: 13.09.2019).

Kemperdick (2004)
: Stephan Kemperdick: Martin Schongauer. Eine Monographie. Petersberg 2004.

Kieckhefer (1992)
: Richard Kieckhefer: Magie im Mittelalter. München 1992.

Kiedroń / Rimm (2014)
: Early Modern Print Culture in Central Europe. Proceedings of the Young Scholars Section of the Wrocław Seminars. Hrsg. v. Stefan Kiedroń / Anna-Maria Rimm. Beslau 2014.

Kiefer (2001)

Jürgen Kiefer: Die mittelalterliche europäische Medizin im Spiegel der Handschriftensammlung des Amplonius Rating de Bercka. In: Kat.Ausst. Erfurt (2001), S. 162–175.

Klebs (1918)

Arnold C. Klebs: Herbals of the Fifteenth Century. Incunabula Lists. Portland, Maine 1918.

Klemm (2008)

Tanja Klemm: Hirnphysiologie und Bildwerdung. Der „Traum des Doktors" von Albrecht Dürer. In: Hinterwaldner u. a. (2008), S. 225–242.

Klemm (2013)

Tanja Klemm: Bildphysiologie. Wahrnehmung und Körper in Mittelalter und Renaissance. Berlin 2013.

Klibansky / Panofsky / Saxl (1992)

Raymond Klibansky / Erwin Panofsky / Fritz Saxl: Saturn und Melancholie. Frankfurt a. M. 1992.

Knight (2009)

Leah Knight: Of Books and Botany in Early Modern England. Sixteenth-Century Plants and Print Culture. Farnham u. a. 2009.

Köbele u. a. (2014)

Literarische Säkularisierung im Mittelalter. Hrsg. v. Susanne Köbele u. a. Berlin 2014.

Kölbl (1966)

Hortus sanitatis Deutsch des Johann Wonnecke von Cube bei Peter Schöffer am 28. März 1485 in Mainz. Reprint 1966. Hrsg. v. Konrad Kölbl. Grünwald b. München 1966.

Kolmer (1993)

Lothar Kolmer: Heilige als magische Heiler. In: Mediaevistik 6 (1993), S. 153–175.

König-Lein (1997)

Susanne König-Lein: Simile alla Natura. Die Darstellung exotischer Tiere in der Florentiner Malerei des Quattrocento. Weimar 1997.

Konrad von Megenberg (1475)

Konrad von Megenberg: Buch der Natur. Augsburg 1475.

Koreny (1989)

Albrecht Dürer und die Tier- und Pflanzenstudien der Renaissance. Symposium. Die Beiträge der von der Graphischen Sammlung Albertina vom 7. bis 10. Juni 1985 veranstalteten Tagung. Hrsg. v. Fritz Koreny. Wien 1989 (Jahrbuch der Kunsthistorischen Sammlung in Wien 82/83).

Koreny (1991)

Fritz Koreny: Studienblatt Pfingstrose. In: Kat.Ausst. Colmar (1991), S. 107–112.

Körner (2013)

Hans Körner: Albrecht Dürer. Der Apelles der schwarzen Linien. In: Kat.Ausst. Frankfurt a. M. (2013), S. 74–79.

Krampl u. a. (2015)

Par tous les sens: Mit allen Sinnen. Hrsg. v. Ulrike Krampl u. a. Zürich 2015.

Krause (2010)

Andrej Krause: Thomas von Aquin über das Verhältnis von Kunst und Natur. In: Moritz (2010), S. 61–71.

Kristeller (1972)

Paul Oskar Kristeller: Die Philosophie des Marsilio Ficino. Frankfurt a. M. 1972.

Kruse (2006)

Christiane Kruse: Menschenbilder und Menschenbildner im Rosenroman. Nature, art und Pygmalion. In: Marek (2006), S. 115–133.

Kusukawa (1997)

Sachiko Kusukawa: Leonhart Fuchs on the Importance of Pictures. In: Journal of the History of Ideas. Vol. 58, No. 3 (1997), S. 403–427.

Kusukawa (2000)
Sachiko Kusukawa: Illustrating Nature. In: Frasca-Spada / Jardine (2000), S. 90–113.

Kusukawa (2010)
Sachiko Kusukawa: The sources of Gessner's pictures for the „Historia animalium". In: Annals of Science 67/3 (2010), S. 303–328.

Kusukawa (2011)
Sachiko Kusukawa: The role of images in the development of Renaissance natural history. In: Archives of natural history 38.2 (2011), S. 189–213.

Kusukawa (2012)
Sachiko Kusukawa: Picturing the Book of Nature. Images, Text, and Argument in Sixteenth-Century Human Anatomy and Medical Botany. Chicago u. a. 2012.

Ladner (1969)
Gerhart B. Ladner: Pflanzensymbolik und der Renaissancebegriff. In: Buck (1969), S. 336–394 [engl. 1961].

Landau / Parshall (1994)
David Landau / Peter Parshall: The Renaissance Print. 1470–1550. New Haven u. a. 1994.

Latour (2006)
Bruno Latour: Drawing Things Together. Die Macht der unveränderlich mobilen Elemente. In: Belliger (2006), S. 258–307 [engl. 1986].

Laufhütte (2000)
Künste und Natur in Diskursen der Frühen Neuzeit. Hrsg. v. Hartmut Laufhütte. 2 Bde. Wiesbaden 2000.

Lauterbach (2004)
Christiane Lauterbach: Gärten der Musen und Grazien. Mensch und Natur im niederländischen Humanistengarten 1522–1655. München u. a. 2004.

Lefèvre u. a. (2003)
The Power of Images in Early Modern Science. Hrsg. v. Wolfgang Lefèvre u. a. Basel u. a. 2003.

Lehmann (1928)
Mittelalterliche Bibliothekskataloge Deutschlands und der Schweiz. Bd. 2: Bistum Mainz, Erfurt. Bearb. v. Paul Lehmann. München 1928.

Lehmann-Haupt (2002)
Hellmut Lehmann-Haupt: Peter Schöffer aus Gernsheim und Mainz. Wiesbaden 2002.

Leonhard (2007)
Karin Leonhard: Kritik an der Hand. Zum Verhältnis von Wissenschaftler und Zeichner in der frühen Mikroskopie. In: Wimböck u. a. (2007), S. 237–264.

Leonhard (2012)
Karin Leonhard: Weiße Erde, Blume, Frucht. Zur Kultivierung von Farbe im barocken Stilleben. In: Leuker (2012), S. 241–260.

Leonhard (2013)
Karin Leonhard: Bildfelder. Stilleben und Naturstücke des 17. Jahrhunderts. Berlin 2013.

Leoni (1996)
G. Leoni: Christ the Gardener and the chain of symbols. The gardens around the walls of sixteenth-century Ferrara. In: Hunt (1996), S. 60–92.

Leuker (2012)
Die sichtbare Welt. Visualität in der niederländischen Literatur und Kunst des 17. Jahrhunderts. Hrsg. v. Maria-Theresia Leuker. Münster u. a. 2012.

Levi D'Ancona (1977)
Mirella Levi D'Ancona: The Garden of the Renaissance. Botanical Symbolism in Italian Painting. Florenz 1977.

Lindberg u. a. (2003–2013)
 The Cambridge History of Science. Hrsg. v. David C. Lindberg u. a. Cambridge u. a. 2003–2013.
Luff / Steer (2003)
 Konrad von Megenberg: Buch der Natur. Würzburger Forschungen 2: Kritischer Text nach Hand-
 schriften. Hrsg. v. Robert Luff und Georg Steer. Tübingen 2003.
Malandin (1986)
 Matthaeus Platearius: Le livre des simples médecines d'après le manuscrit français 12322 de la Biblio-
 thèque nationale de Paris. Hrsg. v. Ghislaine Malandin. Paris 1986.
Marek (2006)
 Bild und Körper im Mittelalter. Hrsg. v. Kristin Marek. München 2006.
Marr (2012)
 Alexander Marr: [Book Review:] Prints and the Pursuit of Knowledge in Early Modern Europe. In:
 Renaissance Quarterly. Vol. 65, Nr. 2 (2012), S. 516–518.
Märtl u. a. (2006)
 Konrad von Megenberg (1309–1374) und sein Werk. Das Wissen der Zeit. Hrsg. v. Claudia Märtl
 u. a. München 2006.
Marzell (2005)
 Heinrich Marzell: „Kräuterweihe". In: Bächtold-Stäubli u. a. (2005), Sp. 440–446.
Mayer (1995)
 Johannes Gottfried Mayer: Konrad von Megenberg und Paracelsus. Zu einem Wendepunkt in der
 volkssprachigen naturwissenschaftlichen Literatur des Spätmittelalters. In: Keil (1995), S. 322–336.
Mayer (2001)
 Johannes Gottfried Mayer: Höhepunkte der Klostermedizin. Der „Macer floridus" und das Her-
 barium des Vitus Auslasser. Hrsg. mit einer Einl. und dt. Übers. v. Johannes Gottfried Mayer. Erw.
 Reprintaufl. der Orig.-Ausg. von 1832. Holzminden 2001.
Mayer (2011)
 Johannes Gottfried Mayer: Die Wahrheit über den „Gart der Gesundheit" und sein Weiterleben in
 den Kräuterbüchern der Frühen Neuzeit. In: Anagnostou u. a. (2011), S. 119–128.
Mayer (2014)
 Johannes Gottfried Mayer: Das „Leipziger Drogenkompendium" und der „Gart der Gesundheit".
 Ein Vergleich. In: Vaňková (2014), S. 133–142.
Mayer u. a. (2009)
 Johannes Gottfried Mayer u. a.: Die Pflanzen der Klostermedizin in Darstellung und Anwendung.
 Mit Pflanzenbildern des Benediktiners Vitus Auslasser (15. Jh.) aus dem Clm 5905 der Bayerischen
 Staatsbibliothek München. Baden-Baden 2009.
Mazal (1981)
 Otto Mazal: Pflanzen, Wurzeln, Säfte, Samen. Antike Heilkunde in Miniaturen des Wiener Diosku-
 rides. Graz 1981.
Mazal (1988)
 Otto Mazal: Der Baum. Symbol des Lebens in der Buchmalerei. Graz 1988.
Meier (1972)
 Christel Meier: Die Bedeutung der Farben im Werk Hildegards von Bingen. In: Frühmittelalterliche
 Studien 6 (1972), S. 245–355.
Meier (1977)
 Christel Meier: Gemma spiritalis. Methode und Gebrauch der Edelsteinallegorese vom frühen
 Christentum bis ins 18. Jahrhundert. München 1977.
Meier (1996)
 Christel Meier: Der „Hortus sanitatis" als enzyklopädisches Buch. Zur Pragmatisierung traditionel-
 len Wissens und ihrer Realisierung in der Illustration. In: Höfinghoff (1996), S. 191–200.
Meier (1999)

Christel Meier: Bilder der Wissenschaft. Die Illustration des „Speculum maius" von Vinzenz von Beauvais im enzyklopädischen Kontext. In: Frühmittelalterliche Studien 33 (1999), S. 252–286.

Meier (2005)

Christel Meier: Text und Kontext. Steine und Farben bei Bartholomäus Anglicus in ihren Werk- und Bedeutungszusammenhängen. In: Abeele / Meyer (2005), S. XX–XXX.

Meier (2006)

Christel Meier: Von der Schwierigkeit, über Farbe zu reden. In: Scheffel u. a. (2006), S. 81–100.

Mensger (2012)

Ariane Mensger: Déjà-vu. Von Kopien und anderen Originalen. In: Kat.Ausst. Karlsruhe (2012), S. 30–45.

Meyer (1857)

Ernst H. F. Meyer: Geschichte der Botanik. Studien. 4. Band. Königsberg 1857.

Meyer (2000)

Heinz Meyer: Die Enzyklopädie des Bartholomäus Anglicus. Untersuchungen zur Überlieferungs- und Rezeptionsgeschichte von „De proprietatibus rerum". München 2000.

Miller (2007)

Matthias Miller: Cod. Pal. germ. 311. Konrad von Megenberg: Buch der Natur / Hartlieb: Kräuter- buch. In: Miller / Zimmermann, S. 40–43. Online: http://www.ub.uni-heidelberg.de/digi-pdf-kata- logisate/sammlung2/werk/pdf/cpg311.pdf (letzter Zugriff: 13.09.2019).

Miller / Zimmermann (2007)

Die Codices Palatini germanici in der Universitätsbibliothek Heidelberg. Bd. 8: Cod. Pal. germ. 304–495. Hrsg. v. Matthias Miller / Karin Zimmermann. Wiesbaden 2007.

Modersohn (1997)

Mechthild Modersohn: Natura als Göttin im Mittelalter. Ikonographische Studien zu Darstellungen der personifizierten Natur. Berlin 1997.

Morgan (1985)

Elke Boesherz Morgan: Studien zum spätmittelalterlichen Kräuterbuch „Gart der Gesundheit". Ein Beitrag zur deutschen medizinischen Fachprosa des 15.–16. Jahrhunderts. Ann Arbor, Mich. 1985 [Mikrofilm].

Moritz (2010)

Ars imitatur naturam. Transformationen eines Paradigmas menschlicher Kreativität im Übergang vom Mittelalter zur Neuzeit. Hrsg. v. Arne Moritz. Münster 2010.

Möseneder (2007)

Karl Möseneder: Paracelsus. Über die „kraft und tugent" von Bildern, schattenhafte Kunstwerke und den vollkommenen Künstler als „signator perfectus". In: Augustyn / Leuschner (2007), S. 169–185.

Möseneder (2009)

Karl Möseneder: Paracelsus und die Bilder. Über Glauben Magie und Astrologie im Reformations- zeitalter. Tübingen 2009.

Müller (1993)

Jan-Dirk Müller: Überlegungen zu Michael Giesecke: Der Buchdruck in der Frühen Neuzeit. Eine historische Fallstudie über die Durchsetzung neuer Informations- und Kommunikationstechnolo- gien, Frankfurt/M. 1991. In: Internationales Archiv für Sozialgeschichte der deutschen Literatur 18 (1993), S. 168–178.

Müller (2007)

Jan-Dirk Müller: „Evidentia" und Medialität. Zur Ausdifferenzierung von Evidenz in der Frühen Neuzeit. In: Wimböck u. a. (2007), S. 59–84.

Müller u. a. (2011)

Aemulatio. Kulturen des Wettstreits in Bild und Text (1450–1620). Hrsg. v. Jan-Dirk Müller u. a. Berlin / Boston 2011.

Müller / Pfisterer (2011)

Jan-Dirk Müller / Ulrich Pfisterer: Der allgegenwärtige Wettstreit in den Künsten der Frühen Neuzeit. In: Müller u. a. (2011), S. 1–34.

Müller-Jahncke (1977)

Wolf-Dieter Müller-Jahncke: „Deßhalben ich solichs an gefangen werck vnfolkomen ließ". Das Herbar des „Codex Berleburg" als eine Vorlage des „gart der Gesundheit". In: Deutsche Apotheker-Zeitung 117 (1977), Sp. 1663–1671.

Müller-Jahncke (1984)

Wolf-Dieter Müller-Jahncke: Die Pflanzenabbildung in Renaissance und Frühbarock. Ein Überblick. In: Pharmazeutische Zeitung 129 (1984), Sp. 2543–2549.

Müller-Jahncke (1985)

Wolf-Dieter Müller-Jahncke: Astrologisch-magische Theorie und Praxis in der Heilkunde der frühen Neuzeit. Stuttgart 1985.

Müller-Jahncke (1987)

Wolf-Dieter Müller-Jahncke: Die botanische Illustration des 14. und 15. Jahrhunderts in Italien. In: Prinz u. a. (1987), S. 75–81.

Müller-Jahncke (1991)

Wolf-Dieter Müller-Jahncke: Älterer deutscher „Macer" – Ortolf von Baierland „Arzneibuch" – „Herbar" des Bernhard von Breidenbach – Färber- und Maler-Rezepte. Die oberrheinische medizinische Sammelhandschrift des Kodex Berleburg. Berleburg, Fürstlich Sayn-Wittgenstein'sche Bibliothek, Cod. RT 2/6. Farbmikrofiche-Edition. Einf., Berschr. v. Wolf-Dieter Müller-Jahncke u. a. München 1991.

Müller-Jahncke (1995)

Wolf-Dieter Müller-Jahncke: Die Pflanzenabbildung im Mittelalter und in der frühen Neuzeit. In: Dilg (1995), S. 47–64.

Mulsow (2010)

Martin Mulsow: Talismane und Astralmagie. Zum Übergang von involviertem zu distanziertem Wissen in der Frühen Neuzeit. In: Assmann / Strohm (2010), S. 135–158.

Nagel / Wood (2010)

Alexander Nagel / Christopher S. Wood: Anachronic Renaissance. New York 2010.

Nickelsen (2000)

Kärin Nickelsen: Wissenschaftliche Pflanzenzeichnungen – Spiegelbilder der Natur? Botanische Abbildungen aus dem 18. und frühen 19. Jahrhundert. Bern 2000.

Niehr (1998)

Klaus Niehr: Mimesis, Stilisierung, Fiktion in spätmittelalterlicher Porträtmalerei. Das sog. Gothaer Liebespaar. In: Marburger Jahrbuch für Kunstwissenschaft 25 (1998), S. 79–104.

Niehr (2001)

Klaus Niehr: „als ich das selber erkundet vnd gesehen hab". Wahrnehmung und Darstellung des Fremden in Bernhard von Breydenbachs „Peregrinationes in Terram Sanctam" und anderen Pilgerberichten des ausgehenden Mittelalters. In: Gutenberg-Jahrbuch 76 (2001), S. 269–300.

Niehr (2005)

Klaus Niehr: Ideal oder Porträt? Das Bild vom Kunstwerk. In: Kat.Ausst. Mainz (2005), S. 9–26.

Niehr (2015)

Klaus Niehr: [Rezension:] Ross, Elizabeth: Picturing experience in the early printed book. Breydenbach's „Peregrinatio" from Venice to Jerusalem, 2014. In: H-ArtHist, 23.2.2015. Online: http://arthist.net/reviews/8099 (letzter Zugriff: 13.09.2019).

Niekrasz / Swan (2006)

Carmen Niekrasz / Claudia Swan: Art. In: Park / Daston (2006), S. 786–791.

Nissen (1951/1966)

Claus Nissen: Botanische Buchillustration. Ihre Geschichte und Bibliographie. 2 Bde. Stuttgart 1951 [3. Bd: Supplement: Stuttgart 1966].

Nissen (1956)
 Claus Nissen: Kräuterbücher aus fünf Jahrhunderten. Medizinhistorischer und bibliographischer Beitrag. München u. a. 1956.
Noe (2008)
 Geschichte der Buchkultur. Bd. 6: Renaissance. Hrsg. v. Alfred Noe. Graz 2008.
Ogilvie (2003)
 Brian W. Ogilvie: Image and Text in Natural History, 1500–1700. In: Lefèvre u. a. (2003), S. 141–166.
Ogilvie (2008)
 Brian W. Ogilvie: The Science of Describing. Natural History in Renaissance. Chicago u. a. 2008 (2. Aufl.).
Ohly (1999)
 Friedrich Ohly: Zur Signaturenlehre der frühen Neuzeit. Bemerkungen zur mittelalterlichen Vorgeschichte und zur Eigenart einer epochalen Denkform in Wissenschaft, Literatur und Kunst. Stuttgart u. a. 1999.
Olariu (2014)
 Dominic Olariu: The Misfortune of Philippus de Lignamine's Herbal or New Research Perspectives in Herbal Illustrations from an Iconological Point of View. In: Kiedroń / Rimm (2014), S. 39–62
Oltrogge (2009)
 Doris Oltrogge: Illuminating the Print. The Use of Color in Fifteenth-Century Prints and Book Illumination. In: Kat.Ausst. Washington (2009), S. 299–316.
Oltrogge u. a. (2009)
 Doris Oltrogge u. a.: The Pigments on Hand-Colored Fifteenth-Century Relief Prints from the Collections of the National Gallery of Art and the Germanisches Nationalmuseum. In: Kat.Ausst. Washington (2009), S. 277–298.
O'Malley / Meyers (2008)
 The art of natural history. Illustrated treatises and botanical paintings, 1400–1850. Hrsg. v. Therese O'Malley / Amy R. W. Meyers. New Haven, Conn. 2008.
Onians (1994)
 Sight & insight. Essays on art and culture in honour of E. H. Gombrich at 85. Hrsg. v. John Onians. London 1994.
Otto (2011)
 Bernd-Christian Otto: Magie. Rezeptions- und diskursgeschichtliche Analysen von der Antike bis zur Neuzeit. Berlin 2011.
Pächt (1950)
 Otto Pächt: Early Italian Nature Studies and the Early Calendar Landscape. In: Journal of the Warburg and Courtauld Institutes 13 (1950), S. 13–47.
Palmer / Speckenbach (1990)
 Nigel F. Palmer / Klaus Speckenbach: Träume und Kräuter. Studien zur Petroneller „Circa instans"-Handschrift und zu den deutschen Traumbüchern des Mittelalters. Köln u. a. 1990.
Park / Daston (2006)
 The Cambridge History of Science. Bd. 3: Early Modern Science. Hrsg. v. Katharine Park / Lorraine Daston. Cambridge u. a. 2006, S. 1–17.
Park / Daston (2006a)
 Katharine Park / Lorraine Daston: The Age of New. In: Park / Daston (2006), S. 1–17.
Parshall (1993)
 Peter Parshall: Imago contrafacta. Images and Facts in the Northern Renaissance. In: Art History. Vol. 16, No. 4 (1993), S. 554–579.
Parshall (1995)
 Peter Parshall: Introduction. Art and curiosity in northern Europe. In: Word & Image. Vol. 11, No. 4 (1985), S. 327–331.

Petrus de Crescentiis (2007/2008)

Petrus de Crescentiis: Erfolgreiche Landwirtschaft. Ein mittelalterliches Lehrbuch. Eingel., übers. u. mit Anm. versehen v. Benedikt Konrad Vollmann. Bd. 1/2. Stuttgart 2007/2008.

Pfisterer (2004)

Ulrich Pfisterer: *Visio* und *veritas*. Augentäuschung als Erkenntnisweg in der nordalpinen Malerei am Übergang von Spätmittelalter zu Früher Neuzeit. In: Büttner / Wimböck (2004), S. 151–203.

Pfisterer (2008)

Ulrich Pfisterer: Lysippus und seine Freunde. Liebesgaben und Gedächtnis im Rom der Renaissance oder: Das erste Jahrhundert der Medaille. Berlin 2008.

Pfisterer (2011a)

Ulrich Pfisterer: Die Erfindung des Nullpunktes. Neuheitskonzepte in den Bildkünsten, 1350–1650. In: Pfisterer / Wimböck (2011), S. 7–85.

Pfisterer (2011b)

Metzler-Lexikon Kunstwissenschaft. Ideen, Methoden, Begriffe. Hrsg. v. Ulrich Pfisterer. Stuttgart u. a. 2011 (2. Aufl.).

Pfisterer (2014)

Ulrich Pfisterer: Kunst-Geburten. Kreativität, Erotik, Körper in der Frühen Neuzeit. Berlin 2014.

Pfisterer / Seidel (2003)

Visuelle Topoi. Erfindung und tradiertes Wissen in den Künsten der italienischen Renaissance. Hrsg. v. Ulrich Pfisterer / Max Seidel. Berlin / München 2003.

Pfisterer / Wimböck (2011)

„Novità". Neuheitskonzepte in den Bildkünsten um 1600. Hrsg. v. Ulrich Pfisterer / Gabriele Wimböck. Zürich 2011.

Pfisterer / Zimmermann (2005)

Animationen, Transgressionen. Das Kunstwerk als Lebewesen. Hrsg. v. Ulrich Pfisterer und Anja Zimmermann. Berlin 2005.

Pichler / Ubl (2014)

Wolfram Pichler / Ralph Ubl: Bildtheorie zur Einführung. Hamburg 2014.

Plinius (1985)

C. Plinius Secundus d. Ä.: Naturkunde, lateinisch – deutsch. Buch XXV. Medizin und Pharmakologie: Heilmittel aus dem Pflanzenreich. Hrsg. und übers. v. Roderich König in Zusammenarbeit mit Joachim Hopp und Wolfgang Glöckner. Darmstadt 1985.

Ploss (1977)

Emil Ploss: Ein Buch von alten Farben. Technologie der Textilfarben im Mittelalter mit einem Ausblick auf die festen Farben. München 1977 (4. Aufl.).

Portmann u. a. (1974)

The realms of colour. Die Welt der Farben. Le monde des couleurs. Hrsg. v. Adolf Portmann u. a. Leiden 1974.

Primeau (2002)

Thomas Primeau: The Materials and Technology of Renaissance and Baroque Hand-Colored Prints. In: Kat.Ausst. Baltimore (2002), S. 49–78.

Prinz u. a. (1987)

Die Kunst und das Studium der Natur von 14. zum 16. Jahrhundert. Hrsg. v. Wolfram Prinz u. a. Weinheim 1987.

Puff (2014)

Helmut Puff: Textualität und Visualität um 1500. In: Benthien / Weingart (2014), S. 321–340.

Reeds (1990)

Karen Reeds: [Rezension:] Albrecht Dürer and the Animal and Plant Studies of the Renaissance by Fritz Koreny, Pamela Marwood, Yehuda Shapiro. In: Isis. Vol. 81, No. 4 (1990), S. 766–768.

Reeds (1991)

Karen Reeds: Botany in Medieval and Renaissance Universities. New York 1991.

Reeds (2006)
 Karen Reeds: Leonardo da Vinci and Botanical Illustration. Nature Prints, Drawings, and Woodcuts
 ca. 1500. In: Givens u. a. (2006), S. 205–237.
Reeds / Kinukawa (2013)
 Karen Meier Reeds / Tomomi Kinukawa: Medieval Natural History. In: Lindberg u. a. Bd. 2 (2013),
 S. 569–589.
Riethe (2011)
 Peter Riethe: Hildegard von Bingen. Eine aufschlussreiche Begegnung mit ihrem naturkundlich-me-
 dizinischen Schrifttum. Marburg 2011.
Riha (1994)
 Ortrun Riha: Wenn das Denken das Sein bestimmt … Überlegungen zum Realitätsgehalt der
 deutschsprachigen Medizinliteratur des Mittelalters. In: Mediaevistik 7 (1994), S. 203–221.
Riha (1995)
 Ortrun Riha: Die subjektive Objektivität der mittelalterlichen Medizin. In: Berichte zur Wissen-
 schaftsgeschichte 18 (1995), S. 1–13.
Riha (2005)
 Heilkunde im Mittelalter. Hrsg. v. Ortrun Riha. München 2005 (Das Mittelalter 10,1).
Rihel (1539)
 Hieronymus Bock: Kreüterbuch, darinn Underscheidt Namen und Würckung der Kreutter, Stau-
 den, Hecken unnd Beumen sampt ihren Früchten, so inn Deütschen Landen wachsen. Mit einem
 Vorwort des Verlegers Wendel Rihel. Straßburg 1539.
Rimmele / Stiegler (2012)
 Marius Rimmele / Bernd Stiegler: Visuelle Kulturen / Visual Culture zur Einführung. Hamburg
 2012.
Rippmann (2015)
 Dorothee Rippmann: Sehen, Riechen, Tasten, Schmecken. Eine Archäologie des Geschmacks. In:
 Krampl u. a. (2015), S. 57–75.
Robert (2004)
 Jörg Robert: Evidenz des Bildes, Transparenz des Stils. Dürer, Erasmus und die Semiotik des Por-
 träts. In: Büttner / Wimböck (2004), S. 205–226.
Robertshaw (1999)
 Natur und Kultur in der deutschen Literatur des Mittelalters. Hrsg. v. Alan Robertshaw. Tübingen
 1999.
Roosen-Runge (1967)
 Heinz Roosen-Runge: Farbgebung und Technik frühmittelalterlicher Buchmalerei. Studien zu den
 Traktaten „Mappae Clavicula“ und „Heraclius“. 2 Bde. München u. a. 1967.
Ross (2014)
 Elizabeth Ross: Picturing experience in the early printed book. Breydenbach's „Peregrinatio“ from
 Venice to Jerusalem. University Park, Pa. 2014.
Roth (2010)
 Michael Roth: Überlegungen zur zeichnerischen Aneignung druckgraphischer Arbeiten des
 15. Jahrhunderts. In: Augustyn / Söding (2010), S. 353–371.
Rowe (1974)
 Christopher Rowe: Conceptions of Colour and Colour Symbolism in the Ancient World. In: Port-
 mann u. a. (1974), S. 327–364.
Rudolph (2015)
 Pia Rudolph: Hausbücher (Nr. 49a.). In: KdiH. Bd. 6 (2015), S. 442–478.
Rudolph (2016)
 Pia Rudolph: Printed Growth. Temporality in Sixteenth- and Seventeenth-Century Herbal Books.
 In: Zimmermann (2016), S. 453–466.

Ryan / Schmitt (1982)

Pseudo-Aristotle: The Secret of Secrets. Sources and Influences. Hrsg. v. Walter F. Ryan / Charles B. Schmitt. London 1982.

Saß (2012)

Maurice Saß: Gemalte Korallenamulette. Zur Vorstellung eigenwirksamer Bilder bei Piero della Francesca, Andrea Mantegna und Camillo Leonardi. Online veröffentlicht unter: kunsttexte.de 1/2012, S. 1–53 (https://edoc.hu-berlin.de/handle/18452/8299; letzter Zugriff: 13.09.2019).

Saurma-Jeltsch (2001)

Lieselotte E. Saurma-Jeltsch: Spätformen mittelalterlicher Buchherstellung. Bilderhandschriften aus der Werkstatt Diebold Laubers in Hagenau. 2 Bde. Wiesbaden 2001.

Saurma-Jeltsch (2006)

Lieselotte E. Saurma-Jeltsch: Vom Sachbuch zum Sammelobjekt. Die Illustrationen im Buch der Natur Konrads von Megenberg. In: Märtl u. a. (2006), S. 421–484, 539–553.

Schäffner (2009)

Almut Schäffner: Terra verde. Entwicklung und Bedeutung der monochromen Wandmalerei der italienischen Renaissance. Weimar 2009.

Schaub (2005)

Ansteckung. Zur Körperlichkeit eines ästhetischen Prinzips. Hrsg. v. Mirjam Schaub. Paderborn / München 2005.

Schausten u. a. (2012)

Die Farben imaginierter Welten. Zur Kulturgeschichte ihrer Codierung in Literatur und Kunst vom Mittelalter bis zu Gegenwart. Hrsg. v. Monika Schausten u. a. Berlin 2012.

Scheffel u. a. (2006)

Ästhetische Transgressionen. Festschrift für Ulrich Ernst zum 60. Geburtstag. Hrsg. v. Michael Scheffel u. a. Trier 2006.

Scheller (1995)

Robert W. Scheller: Exemplum. Model-Book Drawings and the Practice of Artistic Transmission in the Middle Ages (ca. 900–ca. 1470). Amsterdam 1995.

Scheuermann-Peilicke (2000)

Wolfgang Scheuermann-Peilicke: Licht und Liebe. Lichtmetapher und Metaphysik bei Marsilio Ficino. Zürich u. a. 2000.

Schiedermair (2007)

Wolfgang Schiedermair: Pflanzenmalerei in drei unterfränkischen Kirchen. Ikonographie, Kunstgeschichte und aktuelle Bedeutung in Bezug auf die Entwicklung von Medizin und Pharmazie. Würzburg 2007.

Schipperges (1990)

Heinrich Schipperges: Der Garten der Gesundheit: Medizin im Mittelalter. München 1990.

Schmidt (2000)

Peter Schmidt: Zur Produktion und Verwendung von Druckgrafik in Mainz im 15. Jahrhundert. In: Kat.Ausst. Mainz (2000), S. 584–599.

Schmidt (2010a)

Peter Schmidt: Heilsvermittlung und Reproduktion. Die Mediengeschichte der „Gnadenbildkopie" im ausgehenden Mittelalter. In: Augustyn / Söding (2010), S. 373–403.

Schmidt (2010b)

Peter Schmidt: Die Erfindung des vervielfältigten Bildes. Reproduktion und Wahrheit im 15. Jahrhundert. In: Bredekamp u. a. (2010), S. 119–147.

Schmidt (2010)

Sebastian Schmidt: „dan sy machten dy vürtrefflichen künstner reich". Zur ursprünglichen Bestimmung von Albrecht Dürers Selbstbildnis im Pelzrock. In: Anzeiger des Germanischen Nationalmuseums (2010), S. 65–82.

Schmitz (1998.2005)

Rudolf Schmitz: Geschichte der Pharmazie. 2 Bde. Eschborn 1998.2005.

Schmitz (1974)
Ursula Schmitz: Hans Minners „Thesaurus medicaminum". Würzburg 1974.

Schneider (2000)
Cornelia Schneider: Mainzer Drucker – Drucker in Mainz. In: Kat.Ausst. Mainz (2000), S. 190–235.

Schneider (2013)
Paulo Schneider: Vom Gebrauch der Bilder. In: Kat.Ausst. Dresden (2013), S. 33–41.

Schnell (2003)
Bernhard Schnell: Pflanzen in Bild und Text. Zum Naturverständnis in den deutschsprachigen illustrierten Kräuterbüchern des Spätmittelalters. In: Dilg (2003), S. 442–461.

Schnell (2005)
Bernhard Schnell: „Als ich geschriben vant von eines wises meister hant". Die deutschen Kräuterbücher des Mittelalters – Ein Überblick. In: Riha (2005), S. 116–131.

Schnell (2009)
Bernhard Schnell: Die Pflanzenabbildungen in den deutschsprachigen Handschriften des Mittelalters. Ein Werkstattbericht. In: Friedrich / Telle (2009), S. 395–423.

Schnell (2017)
Bernhard Schnell: Kräuterbücher (Nr. 70.). In: KdiH. Bd. 7 (2017), S. 506–543.

Schnell / Crossgrove (2003)
Bernhard Schnell: Der deutsche „Macer": Vulgatfassung. Mit einem Abdruck des lateinischen Macer Floridus „De viribus herbarum". Kritisch hrsg. v. Bernhard Schnell in Zusammenarbeit mit William Crossgrove. Tübingen 2003.

Schnitzler (2002)
Norbert Schnitzler: Illusion, Täuschung und schöner Schein. Probleme der Bilderverehrung im späten Mittelalter. In: Schreiner u. a. (2002), S. 221–242.

Scholz / Schütte (2005)
Leander Scholz / Andrea Schütte: „Heiliger Sokrates, bitte für uns!" Simulation und Buchdruck. In: Fohrmann (2005), S. 23–153.

Schreiber (1924)
Wilhelm Ludwig Schreiber: Die Kräuterbücher des XV. und XVI. Jahrhunderts. Stuttgart 1924.

Schreiner u. a. (2002)
Frömmigkeit im Mittelalter. Politisch-soziale Kontexte, visuelle Praxis, körperliche Ausdrucksformen. Hrsg. v. Klaus Schreiner u. a. München 2002.

Schulze (2011)
Christian Schulze: Antike Botanik zwischen praktischer Anwendung und taxonomischen Überlegungen. In: Kat.Ausst. Schweinfurt (2011), S. 9–26.

Schuster (1926)
Julius Schuster: Secreta Salernitana und Gart der Gesundheit. Eine Studie zur Geschichte der Naturwissenschaften und Medizin des Mittelalters. In: Mittelalterliche Handschriften. Paläographische, kunsthistorische, literarische und bibliotheksgeschichtliche Untersuchungen. Festgabe zum 60. Geburtstag von Hermann Degering. Leipzig 1926, S. 203–237.

Schwabe (2006)
Fabian Schwabe: Das Mainzer Kräuterbuch. In: Auge / Gadebusch Bondio (2006), S. 65–68.

Seidensticker (2010)
Peter Seidensticker: Aisthesis. Wahrnehmung von Farben in den Pflanzenbeschreibungen der frühen deutschen Kräuterbücher. Stuttgart 2010.

Silver / Smith (2002)
Larry Silver / Pamela H. Smith: Splendor in the Grass. The Powers of Nature and Art in the Age of Dürer. In: Smith / Findlen (2002), S. 29–62.

Smith (2004)
Pamela H. Smith: The body of the artisan. Art and experience in the scientific revolution. Chicago u. a. 2004.

Smith (2006)

Pamela H. Smith: Art, Science and Visual Culture in Early Modern Europe. In: Isis. Vol. 97, No. 1 (2006), S. 83–100.

Smith (2008)

Pamela H. Smith: Artisanal Knowledge and the Representation of Nature in Sixteenth-Century Germany. In: O'Malley / Meyers (2008), S. 15–31.

Smith (2011)

Jeffrey Chipps Smith: The 2010 Josephine Waters Bennett Lecture. Albrecht Dürer as Collector. In: Renaissance Quarterly. Vol. 64, No. 1 (2011), S. 1–49.

Smith / Findlen (2002)

Merchants & Marvels. Commerce, Science, and Art in Early Modern Europe. Hrsg. v. Pamela H. Smith / Paula Findlen. New York u. a. 2002.

Smith / Schmidt (2007)

Making Knowledge in Early Modern Europe. Practices, Objects and Texts, 1400–1800. Hrsg. v. Pamela H. Smith / Benjamin Schmidt. Chicago / London 2007.

Spyra (2005)

Ulrike Spyra: Das „Buch der Natur" Konrads von Megenberg. Die illustrierten Handschriften und Inkunabeln. Köln u. a. 2005.

Stadler (1896–1900)

Hermann Stadler: Kleine Schriften zu Dioskorides und zur Geschichte der alten Medicin und Botanik. 11 Bde. Leipzig u. a. 1896–1900.

Stannard (1999)

Jerry Stannard: Pristina medicamenta. Ancient and Medieval Medical Botany. Aldershot u. a. 1999.

Stannard / Stannard (1999)

Jerry Stannard / Katherine E. Stannard: Herbs and Herbalism in the Middle Ages and Renaissance. Aldershot u. a. 1999.

Steinmann (2013)

Martin Steinmann: Handschriften im Mittelalter. Eine Quellensammlung. Basel 2013.

Stijnmann / Savage (2015)

Printing colour 1400–1700. History, techniques, functions and receptions. Hrsg. v. Ad Stijnman / Elizabeth Savage. Leiden u. a. 2015.

Stock (1998)

Jan van der Stock: Printing Images in Antwerp. The Introduction of Printmaking in a City, Fifteenth Century to 1585. Rotterdam 1998.

Stolberg (2009)

Michael Stolberg: Die Harnschau. Eine Kultur- und Alltagsgeschichte. Köln u. a. 2009.

Strasburger (2014)

Lehrbuch der Pflanzenwissenschaften. Begr. v. Eduard Strasburger, neu bearb. v. Joachim W. Kadereit u. a. Berlin u. a. 2014 (36. Aufl.).

Suckale (2009)

Robert Suckale: Die Erneuerung der Malkunst vor Dürer. 2 Bde. Petersberg 2009.

Sudhoff (1907)

Karl Sudhoff: Tradition und Naturbeobachtung in den Illustrationen medizinischer Handschriften und Frühdrucke vornehmlich des 15. Jahrhunderts. Leipzig 1907.

Swan (1995)

Claudia Swan: *Ad vivum, naer het leven, from life*. Defining a mode of representation. In: Word & Image. Vol. 11, No. 4 (1985), S. 353–372.

Swan (2006)

Claudia Swan: The Uses of Realism in Early Modern Illustrated Botany. In: Givens u. a. (2006), S. 239–249.

Swan (2008)

 Claudia Swan: The Uses of Botanical Treatises in the Netherlands, c. 1600. In: O'Malley / Meyers (2008), S. 63–82.

Swan (2011)

 Claudia Swan: Illustrated Natural History. In: Kat.Ausst. Cambridge, Mass. (2011), S. 186–192.

Taubert (2015)

 Johannes Taubert: Zur Oberflächengestalt der so genannten ungefassten spätgotischen Holzplastik. In: Taubert u. a. (2015), S. 79–96.

Taubert u. a. (2015)

 Farbige Skulpturen. Bedeutung, Fassung, Restaurierung. Hrsg. v. Johannes Taubert u. a. München 2015.

Telesko (2001)

 Werner Telesko: Die Weisheit der Natur. Heilkraft und Symbolik der Pflanzen und Tiere im Mittelalter. München u. a. 2001.

Theiss (1997)

 Peter Theiss: Die Wahrnehmungspsychologie und Sinnesphysiologie des Albertus Magnus. Ein Modell der Sinnes- und Hirnfunktion aus der Zeit des Mittelalters. Frankfurt a. M. 1997.

Thimann (2007)

 Michael Thimann: „Idea" und „Conterfei". Künstlerisches und wissenschaftliches Zeichnen in der Frühen Neuzeit. In: Thimann u. a. (2007), S. 15–30.

Thimann u. a. (2007)

 Disegno. Der Zeichner im Bild der Frühen Neuzeit. Hrsg. v. Michael Thimann u. a. München u. a. 2007.

Thorndike (1959)

 Lynn Thorndike: Some Medieval Texts on Colours. In: Ambix. Vol. 7, No. 1 (1959), S. 1–24.

Thorndike (1960)

 Lynn Thorndike: Other Texts on Colours. In: Ambix. Vol. 8, No. 2 (1960), S. 53–70.

Timann (1995)

 Ursula Timann: Untersuchungen zu Nürnberger Holzschnitt und Briefmalerei in der ersten Hälfte des 16. Jahrhunderts. Mit besonderer Berücksichtigung von Hans Guldenmund und Niclas Meldeman. Münster u. a. 1995 (2. Aufl.).

Timm (2006)

 Frederike Timm: Der Palästina-Pilgerbericht des Bernhard von Breidenbach von 1486 und die Holzschnitte Erhard Reuwichs. Die „Peregrinatio in terram sanctam" (1486) als Propagandainstrument im Mantel der gelehrten Pilgerschrift. Stuttgart 2006.

Trier (1961)

 Jost Trier: „Wiederwuchs". In: Archiv für Kulturgeschichte 43 (1961), S. 177–187.

Unverfehrt (2007)

 Gerd Unverfehrt: Da sah ich viel köstliche Dinge. Albrecht Dürers Reise in die Niederlande. Göttingen 2007.

Vaňková (2014)

 Fachtexte des Spätmittelalters und der Frühen Neuzeit. Tradition und Perspektiven der Fachprosa- und Fachsprachenforschung. Hrsg. v. Lenka Vaňková. Berlin 2014.

Ventura (2013)

 Iolanda Ventura: Changing Representations of Botany in Encyclopaedias from the Middle Ages to the Renaissance. In: Göing u. a. (2013), S. 97–143.

Verfasserlexikon (1978–2008)

 Die deutsche Literatur des Mittelalters. Verfasserlexikon. Begründet von Wolfgang Stammler, fortgeführt von Karl Langosch. Zweite, völlig neu bearbeitete Auflage unter Mitarbeit zahlreicher Fach-

gelehrter. Hrsg. v. Kurt Ruh / Burghart Wachinger u. a. 14 Bde. Berlin / New York 1978–2008.

Vögel (2006)

Herfried Vögel: Zur anthropozentrischen Konzeption des Buchs der Natur Konrads von Megenberg. In: Märtl u. a. (2006), S. 251–270.

Wandhoff (2012)

Haiko Wandhoff: Schwarz auf Weiß – Rot auf Weiß. Heraldische Tinkturen und die Farben der Schrift im „Parzival" Wolframs von Eschenbach. In: Schausten u. a. (2012), S. 147–168.

Warnke (2009)

Martin Warnke: Cranachs „Wiedererwachsung". Bemerkungen zum Berliner „Jungbrunnen". In: Kat.Ausst. Berlin (2009), S. 72–79.

Weinmayer (1982)

Barbara Weinmayer: Studien zur Gebrauchssituation früher deutscher Druckprosa. Literarische Öffentlichkeit in Vorreden zu Augsburger Frühdrucken. München u. a. 1982.

Westerwelle (2014)

Karin Westerwelle: Grün als Farbe der Landschaft in Petrarcas Canzoniere. In: Köbele u. a. (2014), S. 285–310.

Wimböck (2004)

Gabriele Wimböck: Die Autorität des Bildes. Perspektiven für eine Geschichte vom Bild in der Frühen Neuzeit. In: Büttner / Wimböck (2004), S. 9–41.

Wimböck u. a. (2007)

Evidentia. Reichweiten visueller Wahrnehmung in der Frühen Neuzeit. Hrsg. v. Gabriele Wimböck u. a. Münster 2007.

Wimböck / Leonhard / Friedrich (2007)

Gabriele Wimböck / Karin Leonhard / Markus Friedrich: „Evidentia". Reichweiten visueller Wahrnehmung in der Frühen Neuzeit. In: Wimböck u. a. (2007), S. 11–38.

Wit (1992)

Histoire du développement de la biologie. Bd. 1. Hrsg. v. Hendrik C. D. de Wit. Lausanne 1992.

Wittekind (2004)

Susanne Wittekind: Das Anholter-Moyländer Kräuterbuch des Johannes Hartlieb. Überlegungen zu Ausstattung und Anspruch der Handschrift. In: Kat.Ausst. Bedburg-Hau (2004), S. 54–61.

Wolf (2002)

Gerhard Wolf: Schleier und Spiegel. Traditionen des Christusbildes und die Bildkonzepte der Renaissance. München 2002.

Wood (2008)

Christopher S. Wood. Forgery, Replica, Fiction. Temporalities of German Renaissance Art. Chicago / London 2008.

Wried (2001)

Klaus Wriedt: Erfurt als Universität und Studienort im Spätmittelalter. In: Kat.Ausst. Erfurt (2001), S. 20–25.

Wuttke (1996)

Dieter Wuttke: Renaissance-Humanismus und Naturwissenschaft in Deutschland. In: Dieter Wuttke: Dazwischen. Kulturwissenschaft auf Warburgs Spuren. Bd. 2. Baden-Baden 1996, S. 455–481.

Zimmermann (2016)

Vision in motion. Streams of sensation and configurations of time. Hrsg. v. Michael F. Zimmermann. Zürich / Berlin 2016.

Zotz (2015)

Nicola Zotz: Heiltumsbücher (Nr. 52). In: KdiH. Bd. 6 (2015), S. 325–366.

REGISTER

Handschriften und Drucke

Die Handschriften und Drucke sind nach Aufbewahrungsort bzw. Ort der Drucklegung geordnet.

Personen und Werke